# MARCEL DUCHAMP

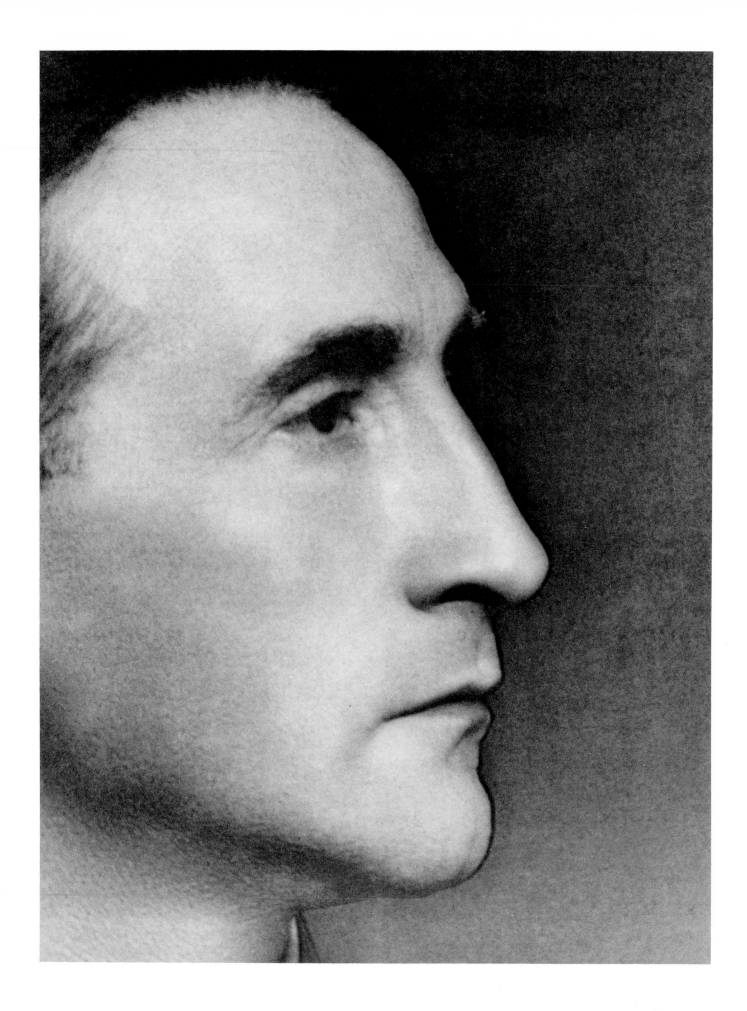

THE MUSEUM OF MODERN ART
AND
PHILADELPHIA MUSEUM OF ART

# MARCEL DUCHAMP

EDITED BY
ANNE D'HARNONCOURT
AND
KYNASTON MCSHINE

Copyright © 1973 by The Museum of Modern Art
All rights reserved
Library of Congress Catalog Card Number 72-95075
Cloth Binding ISBN 0-87070-296-3
Paperbound ISBN 0-87070-295-5
Designed by Carl Laanes
Type set by York Graphic Services, Inc., York, Pennsylvania
Color by Eastern Press, Inc., New Haven, Connecticut
Printed and bound by Halliday Lithograph, Inc., West Hanover, Massachusetts

THE MUSEUM OF MODERN ART
11 West 53rd Street
New York, New York 10019

PHILADELPHIA MUSEUM OF ART
Benjamin Franklin Parkway at 26th Street
Philadelphia, Pennsylvania 19101

Printed in the United States of America

Frontispiece: *Marcel Duchamp.* Photograph by Man Ray. 1930
The Museum of Modern Art, New York. Gift of James Thrall Soby

Endpapers: Puns by Duchamp from *Box in a Valise.* 1941

## PREFACE

As the third quarter of the twentieth century draws to a close, it becomes increasingly clear how profoundly the elusive life and art of Marcel Duchamp have influenced the development of modern art. Duchamp was one of those rare great artists who possess the ability to foreshadow the future. Ever since 1913, when his *Nude Descending a Staircase* created a sensation at the Armory Show in New York, his prophetic vision has elicited a wide range of emotions, challenging traditional attitudes and aesthetic conventions. It is impossible to view the art of the post–World War II era without recognizing the impact of Duchamp on the younger generation of artists.

However, widespread recognition of Duchamp as one of the major twentieth-century artists is a relatively recent occurrence. The first comprehensive retrospective exhibition, deftly titled "By or of Marcel Duchamp or Rrose Sélavy," was organized by Walter Hopps in 1963 at the Pasadena Art Museum. Three years later, Richard Hamilton assembled "The Almost Complete Works of Marcel Duchamp" under the aegis of the Arts Council of Great Britain at the Tate Gallery in London. By the time of Duchamp's death in 1968, his achievements were appreciated by a wider public, and, more significantly, by a younger generation of artists who now acknowledged him as a major figure in their thinking. The present exhibition comes at a moment in history when we may begin to gauge his contribution to twentieth-century art.

This book is published on the occasion of an exhibition organized by the Philadelphia Museum of Art and The Museum of Modern Art, and shared by The Art Institute of Chicago, the city that witnessed Duchamp's first one-man show in 1937 at the Arts Club. The Trustees of the museums owe a great debt of gratitude to the National Endowment for the Arts, which has provided significant funds to make this major exhibition possible. Such a grant is once again evidence of the breadth of the National Endowment's activities, which have contributed so impressively in recent years to the vitality of the creative arts in America.

A special debt of gratitude is owed to Mme Marcel Duchamp, whose assistance and enthusiasm have been an unfailing source of encouragement to the staffs of both museums. Her patience with details and her generosity in sharing information and insights have been of invaluable aid in this undertaking. On behalf of the Trustees of the museums, we also wish to express sincere thanks to the many lenders who have graciously consented to share their works by Duchamp with a wide audience.

A staggering amount of work has gone into the organization of the exhibition and the publication of the accompanying volume. To all those who have given so unstintingly of their time, and especially the writers of the essays and statements in this book, the participating museums are profoundly grateful.

Those most responsible for this vast undertaking have been Anne d'Harnoncourt, Curator of Twentieth Century Painting at the Philadelphia Museum of Art, and Kynaston McShine, Curator in the Department of Painting and Sculpture at The Museum of Modern Art. Both curators,

supported at every point by the staffs of the two museums, have patiently dealt with the many responsibilities involved in the organization and installation of the exhibition and the preparation of this book. Their enthusiasm and hard work have brought about an exhibition and a publication which can only nurture that deeper appreciation which Marcel Duchamp's extraordinary achievement deserves.

*Richard E. Oldenburg, Director*　　　　　　*Evan H. Turner, Director*
*The Museum of Modern Art*　　　　　　*Philadelphia Museum of Art*

## ACKNOWLEDGMENTS

MARCEL DUCHAMP himself served as "benevolent technician" for all previous major exhibitions and publications of his work. His absence from this venture is deeply felt, but the full and generous cooperation of many people in several countries has attested to the range of his friendships and the extent to which his life and work exerted a fascination upon those who knew him well and many who never met him.

Our personal debt of gratitude to Mme Marcel Duchamp is immeasurable. She has been an extraordinarily patient and kind "collaborator," and every phase of this project has been enlivened by her enthusiastic and thoughtful support. We are especially indebted to her for making available an important body of archival material and photographs, and for graciously consenting to the publication of Duchamp's notes for his 1964 slide lecture "Apropos of Myself," which appear in the catalog section of this book.

As every Duchampian project must, this book and the exhibition it accompanies owe much to the thorough scholarship and detailed information provided by Robert Lebel and Arturo Schwarz in their respective monographs on Duchamp. They have been more than generous in sharing their knowledge, and their complete cooperation has facilitated our task enormously. As generous lenders, as contributors of essays to this volume, and as the sources of invaluable advice and aid, they have shown a goodwill that we acknowledge with profound appreciation.

The two comprehensive exhibitions devoted to Duchamp in the past decade have been a source of both inspiration and documentary material. We owe much to the insight and experience of two "old hands" at the Duchampian game: Walter Hopps allowed us to use the chronology he first prepared for his 1963 exhibition catalog as the basis of our own, and Richard Hamilton took much trouble to help us trace elusive works and archival information.

To the authors of the essays and to the many who participated in the "Collective Portrait of Marcel Duchamp" goes a special tribute for their patience with editorial details and their invaluable contributions to our knowledge and understanding of Duchamp which enhance this volume.

Many museum colleagues and scholars have provided invaluable information on Duchamp's life and work. To Alfred H. Barr, Jr., William Camfield, Henry Clifford, Sidney Geist, John Golding, George Heard Hamilton, William S. Lieberman, William Rubin, Michel Sanouillet, Roger Shattuck,

James Thrall Soby, and Carl Zigrosser go our profound thanks. Olga Popovitch, Conservateur of the Musées de Rouen, has been of particular assistance in tracing unlocated works by Duchamp in France as well as sharing her knowledge of his career.

Many others among Duchamp's friends and colleagues have kindly shared their recollections with us and have provided much illuminating material. We are especially grateful to John Cage, William Copley, Merce Cunningham, Enrico Donati, Peggy Guggenheim, Frank Brookes Huba-chek, Sidney Janis, Dr. Robert Jullien, Alfred Levitt, Julien Levy, Man Ray, Robert Motherwell, Hans Richter, Louise Varèse, Isabelle Waldberg, and Beatrice Wood. Carroll Janis made available the unpublished transcripts of taped interviews with Duchamp made by Harriet and Sidney Janis and himself in 1953. Joseph Solomon gave us access to his collection of books and archival material on Duchamp.

Among those who went to much trouble to assist the research and documentation for this project, particular mention should be made of Doris Bry, Jack Collins, Alan Fern, Emily W. Harvey, Mrs. Nicolas Iliopou-los, Dieter Keller, Richard Morphet, Mrs. Ugo Mulas, Moira Roth, Carl Solway, Werner Spies, Shuzo Takiguchi, and Art Services, Paris. Anselmo Carini at The Art Institute of Chicago, Louise Svendsen of The Solomon R. Guggenheim Museum, and Fernande E. Ross and Alice Lee Pearson of the Yale University Art Gallery also provided valuable information. We are also grateful to Mrs. McFadden Staempfli for her generous support of the catalog research.

We are particularly grateful to Jean Leymarie, Conservateur en Chef of the Musée National d'Art Moderne, Paris, for facilitating loans from France, and to Alan Shestack, Director of the Yale University Art Gallery, for the enthusiastic cooperation of his institution and its Société Anonyme Collection. Particular thanks are also due to Arne H. Ekstrom and Xavier Four-cade for their assistance with countless details throughout the preparation of the exhibition and their contribution of much information for the catalog.

For graciously making archival material available we wish to thank Elizabeth S. Wrigley of the Francis Bacon Library, Claremont, California, Donald C. Gallup and Marjorie G. Wynne of the Yale Collection of Ameri-can Literature at the Beinecke Rare Book and Manuscript Library, Yale Uni-versity, William Woolfenden of the Archives of American Art, New York, and Jean Prinet of the Bibliothèque Nationale, Paris.

Bernard Karpel in his inimitable way has provided this publication with a scholarly bibliography. Rachel Phillips of Vassar College and Elmer Peterson of The Colorado College swiftly and ably translated two of the es-says which appear here. We would also like to thank the many photographers who permitted the reproduction of their photographs of Duchamp and his work in this volume.

This undertaking has involved many of our colleagues at both museums during the several years since its inception. Without their cooperation this

book and the exhibition it accompanies could not have been realized. We are especially grateful to the two Directors, who have supported this complex project with enthusiasm and conviction, and we join them in expressing our own indebtedness to Michael Botwinick, Assistant Director for Art of the Philadelphia Museum of Art, and Richard Palmer, Coordinator of Exhibitions at The Museum of Modern Art. They have supervised the many details involved in the organization of this project, with the skilled support of Barbara Chandler, Registrar of the Philadelphia Museum of Art, and Elizabeth L. Burnham, Associate Registrar at The Museum of Modern Art.

We especially wish to acknowledge the contribution of Francis Kloeppel, who expertly and patiently guided this book through all of its phases. His perceptive suggestions were invaluable, and he was ably assisted by Nora Conover. Another special expression of thanks must go to Carl Laanes, whose design for this book expanded our own conception of it. We wish to thank Jack Doenias, who oversaw the printing and general production of the book, and Frances Keech, who handled many details of correspondence for permissions. The support and advice of Carl Morse, Editor in Chief at The Museum of Modern Art, are gratefully acknowledged.

The debt owed to our respective departments is immeasurable, particularly that to Margaret Kline, Curatorial Assistant at the Philadelphia Museum of Art, and Jane Necol, Curatorial Assistant at The Museum of Modern Art. Both put in long hours of research, provided many new facts and ideas, and gave untiring attention to innumerable details. Our special thanks go also to Dorothy Jacobson of the Philadelphia Museum of Art and Jane Adlin of The Museum of Modern Art, who have handled the voluminous correspondence, typed much of the manuscript, and carried out the many related tasks with skill and good humor. Linda Creigh, formerly of The Museum of Modern Art staff, also performed heroic feats of typing. Larry Becker and Heidi Nivling volunteered able research assistance in Philadelphia. Both museum libraries have readily coped with the various challenges of this project, as have the staff photographers Alfred J. Wyatt in Philadelphia and Kate Keller in New York.

Among many other members of the museums' staff who have assisted in various ways we should like to thank: George Marcus, Kneeland McNulty, and Theodor Siegl of the Philadelphia Museum of Art, and Mikki Carpenter, Riva Castleman, Helen Franc, Betsy Jones, Jennifer Licht, Richard Tooke, and William Williams of The Museum of Modern Art.

Finally, we wish to express our appreciation to many friends who have willingly assisted in solving problems or have patiently listened to us during the many months of preparation of this book and exhibition. They gave encouragement and support when needed. It has been impossible to list here all those who have so liberally given of their time, skill, and knowledge to this project. We gratefully acknowledge all such assistance, and are appreciatively aware that any venture involving Marcel Duchamp must inevitably be the product of the combined efforts of many collaborators.

*A.d'H. and K.McS.*

# CONTENTS

# CHRONOLOGY

## 1887

Henri-Robert-Marcel Duchamp born near Blainville (Seine-Inférieure), in Normandy, on July 28 to Justin-Isidore (known as Eugène) Duchamp and Marie-Caroline-Lucie Duchamp (née Nicolle). Duchamp's maternal grandfather Emile-Frédéric Nicolle was a painter and engraver. His father was a notary, whose disapproval of an artist's career for his sons caused Duchamp's two elder brothers to change their name when they went against his wishes. Gaston (born 1875) called himself Jacques Villon and became a painter and engraver, while Raymond (born 1876) assumed the partial pseudonym Duchamp-Villon and became a sculptor. Their sister Suzanne (born 1889, and closest to Duchamp in age) also became a painter. Two more children completed the family: Yvonne (born 1895) and Magdeleine (born 1898).

Despite the striking difference in ages (almost a decade) between the three pairs of siblings, family ties were and remained close, with shared interests in music, art, and literature. Chess was a favorite pastime.

## 1902

Begins painting. Group of landscapes done at Blainville considered to be his first works.

## 1904

Graduates from the Ecole Bossuet, the *lycée* in Rouen.

Joins his elder brothers in Paris in October and lives with Villon in Montmartre on the Rue Caulaincourt. Studies painting at the Académie Julian until July 1905 but by his own account prefers to play billiards.

Paints family, friends, and landscapes in a Post-Impressionist manner.

## 1905

Following the example of Villon, executes cartoons for *Le Courrier Français* and *Le Rire* (continues this intermittently until 1910).

Volunteers for military service. To obtain special classification, works for a printer in Rouen and prints a group of his grandfather's engraved views of that city. As an "art worker," receives exemption from second year of service.

Duchamp family moves into house at 71 Rue Jeanne d'Arc, Rouen, where they continue to live until the death of both parents in 1925.

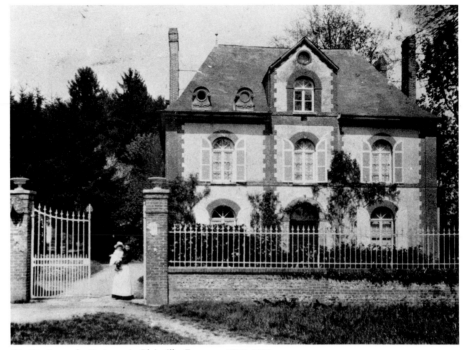

The Duchamp family home in Blainville, France, c. 1890–1900.

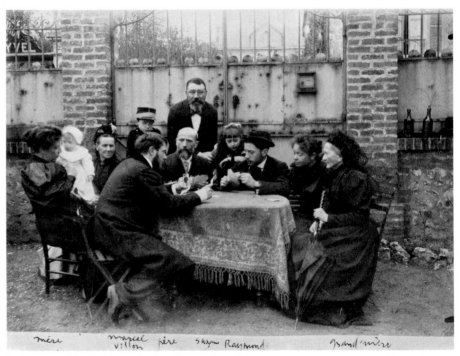

Family group. Mme Duchamp holding Yvonne, Marcel, Jacques, M. Duchamp, Suzanne, Raymond, Mme Catherine Duchamp (Marcel's grandmother), Blainville, 1896.

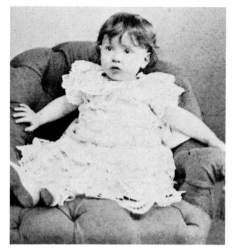

Marcel at the age of one.

Marcel at the age of nine.

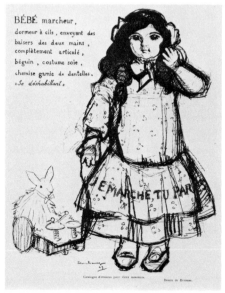

BÉBÉ marcheur, dormeur à cils, envoyant des baisers des deux mains, complètement articulé, béguin, costume soie, chemise garnie de dentelles, «Se déshabillant».

LE MARCHE, TU PAR

*Bébé marcheur* ("*Catalog of New Year's gifts for old gentlemen*"). Cartoon by Duchamp for *Le Courrier Français*, January 1, 1910.

## 1906

Resumes painting in Paris in October, living on the Rue Caulaincourt. With Villon, associates with cartoonists and illustrators.

## 1908

Moves out of Montmartre and establishes residence at 9 Avenue Amiral de Joinville, just outside of Paris in Neuilly, until 1913.

## 1909

Exhibits publicly for the first time at the Salon dès Indépendants (two works). Three works included in the Salon d'Automne.

Exhibits at the first exhibition of the Société Normande de Peinture Moderne at the Salle Boieldieu in Rouen (December 20–January 20, 1910), organized by a friend, Pierre Dumont. Designs poster for the exhibition.

## 1910

Most important "early works" executed in this year. Paintings with a debt to Cézanne and Fauve coloring (*Portrait of the Artist's Father* and *Bust Portrait of Chauvel*) are followed by work with a new symbolic element (*Portrait of Dr. Dumouchel* and *Paradise*).

Attends Sunday gatherings of artists and poets at his brothers' studios at 7 Rue Lemaître in Puteaux (a Parisian suburb adjacent to Neuilly). The group includes Albert Gleizes, Roger de La Fresnaye, Jean Metzinger, Fernand Léger, Georges Ribemont-Dessaignes, Guillaume Apollinaire, Henri-Martin Barzun, the "mathematician" Maurice Princet, and others.

Around this time, meets Francis Picabia, probably introduced by Pierre Dumont. Shows four works at the Salon des Indépendants and five (including *The Chess Game*) at the Salon d'Automne.

Becomes "Sociétaire" of the Salon d'Automne and is thus permitted to enter paintings in the Salon without submission to jury.

## 1911

Continues work with symbolic overtones and begins paintings related to Cubism, with emphasis on successive images of a single body in motion. Aware of the chronophotographs of Etienne-Jules Marey and perhaps affected by similar ideas in the current work of Frank Kupka (his brothers' neighbor in Puteaux).

Shows *The Bush* and two landscapes at the Salon des Indépendants.

Executes a series of drawings and paintings analyzing the figures of two chess players (his brothers). Final painting executed by gaslight, as an experiment.

Marriage of his sister Suzanne to a pharmacist from Rouen. (The marriage ends in divorce a few years later.)

Exhibits again at Société Normande de la Peinture Moderne, Rouen. The Société sponsors an exhibition with the Cubist group in Paris at the Galerie d'Art Ancien et d'Art Contemporain, in which *Sonata* is included.

Shows *Young Man and Girl in Spring* and *Portrait (Dulcinea)* at Salon d'Automne.

Executes a group of drawings (of which three are known) inspired by poems of Jules Laforgue.

Toward the end of the year, paints *Sad Young Man in a Train* (a self-portrait) and oil sketch for *Nude Descending a Staircase*.

Duchamp-Villon asks his friends, including Gleizes, La Fresnaye, Metzinger, and Léger, to do paintings for the decoration of his kitchen at Puteaux. Duchamp executes *Coffee Mill,* his first painting to incorporate machine imagery and morphology.

## 1912

Climactic year of his most important oil-on-canvas works.

Paints *Nude Descending a Staircase,* which he submits to the Salon des Indépendants in March. Members of the Cubist hanging committee (including Gleizes and Henri Le Fauconnier) are disturbed by the painting and ask his brothers to intercede with him to at least alter the title. He withdraws the painting.

Attends opening of Futurist exhibition at Bernheim-Jeune gallery in February and pays several visits to the show.

During the spring, executes series of studies culminating in the mechanomorphic painting *King and Queen Surrounded by Swift Nudes.*

*Nude Descending a Staircase* is first shown in public at the Cubist exhibition at the Dalmau Gallery in Barcelona in May.

From friendship of Duchamp, Picabia, and Apollinaire there develop radical and ironic ideas challenging the commonly held notions of art. This independent activity precedes the official founding of Dada in Zurich, 1916.

With Picabia and Apollinaire, attends performance of Raymond Roussel's *Impressions d'Afrique* at the Théâtre Antoine, probably in May.

Crucial two-month visit to Munich during July and August, where he paints *The Passage from the Virgin to the Bride* and the *Bride,* and executes the first drawing on the theme of *The Bride Stripped Bare by the Bachelors.* Returns home by way of Prague, Vienna, Dresden, and Berlin.

Gleizes and Metzinger include him in their book *Du Cubisme,* published in Paris in August (*Sonata* and *Coffee Mill* reproduced).

In October, takes a car trip to the Jura mountains near the Swiss border with Apollinaire, Picabia, and Gabrielle Buffet. Records this stimulating event in a long manuscript note.

Begins to preserve notes and sketches jotted on stray pieces of paper which will eventually serve as a cryptic guide to the *Large Glass* and other projects, and which he will publish later in facsimile editions (*Box of 1914,* the *Green Box, A l'infinitif* ).

*Nude Descending a Staircase* finally shown in Paris at the Salon de la Section d'Or (October 10–30) at the Galerie de la Boétie, organized by the Duchamp brothers and their friends. Five other works by Duchamp also included.

Walter Pach visits Duchamp and his brothers and selects four works by Duchamp for inclusion in the International Exhibition of Modern Art (the Armory Show).

### 1913

A year of critical change in the artist's career. Virtually abandons all conventional forms of painting and drawing. Begins to develop a personal system (metaphysics) of measurement and time-space calculation that "stretches the laws of physics just a little." Drawings become mechanical renderings. Three-dimensional objects become quasi-scientific devices: e.g., *Three Standard Stoppages,* a manifestation of "canned chance" that remained one of the artist's favorite works.

Experiments with musical composition based on laws of chance.

Begins mechanical drawings, painted studies, and notations that will culminate in his most complex and highly regarded work: *The Bride Stripped Bare by Her Bachelors, Even* (the *Large Glass*), 1915–23. Begins first preparatory study on glass: *Glider Containing a Water Mill in Neighboring Metals.*

Employed as librarian at the Bibliothèque Sainte-Geneviève, Paris.

Spends part of summer at Herne Bay, Kent, England, where he works on notes for the *Large Glass.*

In October, moves out of Neuilly studio back into Paris, to apartment at 23 Rue Saint-Hippolyte.

Mounts a bicycle wheel upside down on a kitchen stool as a "distraction," something pleasant to have in the studio. This object becomes a distant forerunner of the Readymades and also foreshadows a later preoccupation with rotating machines that produce optical effects.

In New York, *Nude Descending a Staircase* becomes the focus of national attention and controversy at the Armory Show (February 17–March 15) and travels with the show to Chicago and Boston. It is bought sight unseen by dealer Frederic C. Torrey from San Francisco for $324. Chicago lawyer Arthur Jerome Eddy buys *Portrait of Chess Players* and *King and Queen Surrounded by Swift Nudes* from the show. The architect Manierre Dawson buys the fourth work, *Sad Young Man in a Train,* thus giving the artist his first (perhaps greatest?) commercial success.

In winter of this year, draws full-scale study for the *Glass* on the plaster wall of the Rue Saint-Hippolyte studio.

Publication in Paris of Apollinaire's *Les Peintres cubistes,* with its prophetic assessment of Duchamp's contribution to modern art (*The Chess Game,* 1910, reproduced).

### 1914

Continues work on major studies for the *Large Glass: Chocolate Grinder, No. 2; Network of Stoppages; Glider;* and another work on glass, *Nine Malic Molds.*

Collects a small group of notes and one drawing in the *Box of 1914,* of which three photographic replicas are made.

Buys a *Bottlerack* at a Paris bazaar and inscribes it. Adds touches of color to a commercial print and calls it *Pharmacy* (executed again in an edition of three, a favorite number for Duchamp). These constitute the first full-fledged appearances of the (still unnamed) genre Readymade, an unprecedented art form involving the infrequent selection, inscription, and display of commonplace objects chosen on the basis of complete visual indifference. Thus quietly begins a revolution whose effects continue to expand as artists propose the intrusion of wholly nonart elements into the aesthetic frame of reference.

With the outbreak of war, Villon and Duchamp-Villon are mobilized. Walter Pach, returning to France in autumn, urges Duchamp (exempt from service on account of his health) to visit the United States.

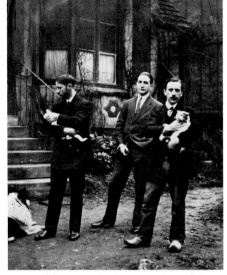

Jacques Villon, Marcel Duchamp, and Raymond Duchamp-Villon at Puteaux, 1912.

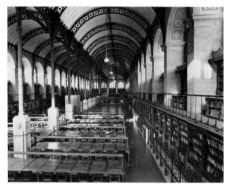

Bibliothèque Sainte-Geneviève, Paris, where Duchamp was employed as a librarian in 1913.

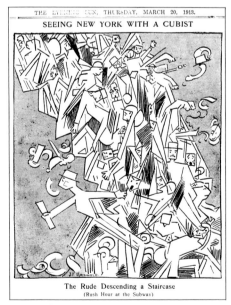

"The Rude Descending a Staircase." *The New York Evening Sun,* 1913.

Prior to first visit to New York, sends seven works (probably through Pach) to two exhibitions of modern French art at the Carroll Gallery there. Collector John Quinn purchases two paintings and a watercolor.

Sails on the S.S. *Rochambeau* to New York, arriving June 15, and greeted as a celebrity. Pach meets the boat, takes Duchamp directly to see Louise and Walter Arensberg, who at once become his close friends and enthusiastic patrons. In their apartment at 33 West 67th Street, Arensberg begins to assemble what will be the largest collection of Duchamp's work, assisted by the artist.

Lives with the Arensbergs for three months; moves to furnished apartment at 34 Beekman Place for month of October.

Later this fall, establishes a studio at 1947 Broadway (Lincoln Arcade Building). Acquires two large glass panels and begins work on the *Large Glass* itself.

Buys and inscribes two more manufactured objects (snow shovel and ventilator), for which he now coins term "Readymade."

Through efforts of Pach and Quinn, obtains job as librarian at French Institute for a brief period.

First published statement, "A Complete Reversal of Art Opinions by Marcel Duchamp, Iconoclast," in September issue of *Arts and Decoration* (New York), followed by a number of brief interviews in the New York press.

Meets Man Ray, who becomes lifelong friend and fellow conspirator.

Circle of artists and poets with whom he mingles until 1918, often at lively gatherings at the Arensbergs, includes: Albert and Juliette Gleizes, Gabrielle Buffet and Picabia, Jean and Yvonne Crotti, John Covert, Charles Demuth, Charles Sheeler, Morton Schamberg, Joseph Stella, Marsden Hartley, Walter Pach, Louise and Allen Norton, Mina Loy, Arthur Cravan, Elsa Baroness von Freytag-Loringhoven, Isadora Duncan, William Carlos Williams, Beatrice Wood, Edgard Varèse, Marius de Zayas, Fania and Carl Van Vechten, and Wallace Stevens. Evenings at the Arensbergs involve vigorous debates on current art and literature, the planning of exhibitions and "little magazines," and much chess-playing.

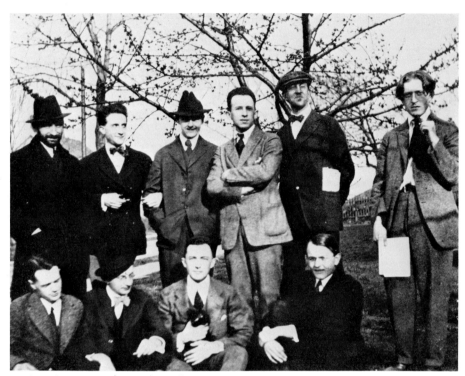

Members of the Others group, Rutherford, New Jersey, spring 1916. Front row (l. to r.): Alanson Hartpence, Alfred Kreymborg, William Carlos Williams (with "Mother Kitty"), Skip Cannell. Back row (l. to r.): Jean Crotti, Marcel Duchamp, Walter Arensberg, Man Ray, R. A. Sanborn, Maxwell Bodenheim.

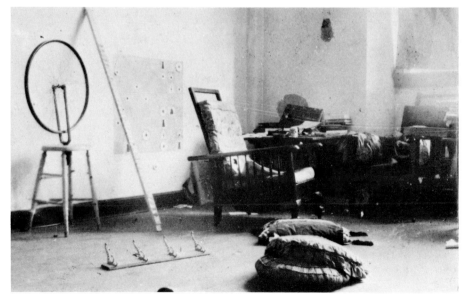

Duchamp's studio at 33 West 67th Street, 1917–18.

1916

Two Readymades are shown, together with five paintings and drawings (including both *Chocolate Grinders*), in an exhibition of mod-

ern art at the Bourgeois Gallery, New York (April 3–29).

Included in "Four Musketeers" exhibition at Montross Gallery, New York (April 4–22), with Gleizes, Metzinger, and Crotti.

Henri-Pierre Roché arrives in New York and joins Arensbergs' circle. Roché becomes close friend of Duchamp, and they later collaborate in several ventures of buying and selling art on commission.

In October, moves from Lincoln Arcade Building into studio above Arensbergs at 33 West 67th Street. The Arensbergs gradually acquire ownership of the *Large Glass* in return for paying his rent.

About this time, makes a replica of the *Bicycle Wheel* (the original had remained in Paris) and hand-colors a full-scale photograph of the *Nude Descending a Staircase* for Arensberg. Importance of "original" or "unique" work of art thus brought into question.

As a founding member of the Society of Independent Artists, Inc., meets with Arensberg, Pach, John Sloan, George Bellows, and others to plan first exhibition with motto "No Jury. No Prizes. Hung in Alphabetical Order." Serves as chairman of hanging committee, with Bellows and Rockwell Kent.

Meets Katherine S. Dreier, also involved with Independents.

### 1917

Resigns from board of directors of Society of Independent Artists upon rejection of his Readymade *Fountain,* which he submitted under the pseudonym "R. Mutt" for their first annual exhibition. Arensberg also resigns in protest; *Fountain* is photographed by Alfred Stieglitz.

During Independents exhibition at the Grand Central Galleries, New York (April 10–May 6), organizes with Picabia a lecture in the galleries by Arthur Cravan, which ends in a scandalized uproar.

With aid of Roché, Arensberg, and Beatrice Wood, promotes the publication of two Dadaist reviews, *The Blind Man* and *Rongwrong.*

Becomes friendly with Carrie, Ettie, and Florine Stettheimer, three wealthy and cultivated sisters to whom he gives occasional French lessons. Other means of making a modest living include translations of French correspondence for John Quinn.

In October, takes a job for several months at French Mission for the War, as secretary to a captain.

### 1918

With execution for Katherine Dreier of *Tu m',* his first oil painting in four years, which takes him several months to complete, Duchamp gives up painting altogether.

When the United States enters the war, he moves to Buenos Aires, where he continues his creative activity for nine months. Sails from New York August 13 on the S.S. *Crofton Hall,* arriving in Argentina about a month later.

Takes a small apartment at 1507 Sarmiento and works on drawings for the *Large Glass.*

Executes third glass study, *To Be Looked at with One Eye, Close to, for Almost an Hour.*

Attempts to organize a Cubist exhibition in Buenos Aires; writes to Gleizes, Henri-Martin Barzun, and Marius de Zayas in New York, but the project does not materialize. Informs Arensbergs by letter that, "according to my principles," he will not exhibit his own work. He asks them not to lend anything of his to exhibitions in New York.

Plays chess avidly, and designs set of rubber stamps to record games and to permit him to play chess by mail.

Deeply distressed by death of Raymond Duchamp-Villon in France on October 9, which is followed a month later by the death of Apollinaire. Makes plans to return to France.

### 1919

Joins chess club in Buenos Aires and plays constantly, to the point where he refers to himself as a "chess maniac."

Marriage of Suzanne Duchamp to Jean Crotti in Paris in April. Duchamp sends her instructions from Buenos Aires for *Unhappy Readymade* to be executed at long distance on the balcony of their Paris apartment.

Despite his desire not to exhibit, three drawings included in "Evolution of French Art" organized by Marius de Zayas at the Arden Gallery, New York, in May.

Returns to Europe, sailing June 22 from Buenos Aires on the S.S. *Highland Pride.*

Stays with Picabia in Paris until the end of the year, with intermittent visits to his family in Rouen.

Establishes contact with the Dada group in Paris and joins gatherings at the Café Certà near the Grands Boulevards; group includes André Breton, Louis Aragon, Paul Eluard, Tristan Tzara, Jacques Rigaut, Philippe Soupault, Georges Ribemont-Dessaignes, and Pierre de Massot.

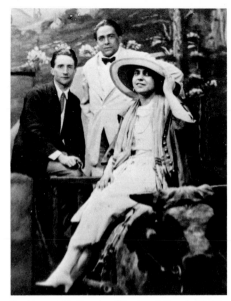

Duchamp with Beatrice Wood and Francis Picabia, at Coney Island, New York, 1917.

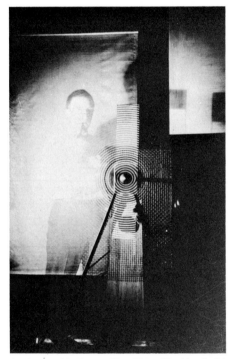

Duchamp with *Rotary Glass Plates* (*Precision Optics*) in motion, New York, 1920.

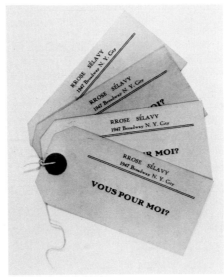

Baggage tags for Rrose Sélavy. Stettheimer Archive, Beinecke Library, Yale University, New Haven, Connecticut.

Duchamp as Rrose Sélavy, photographed by Man Ray in New York, c. 1920–21.

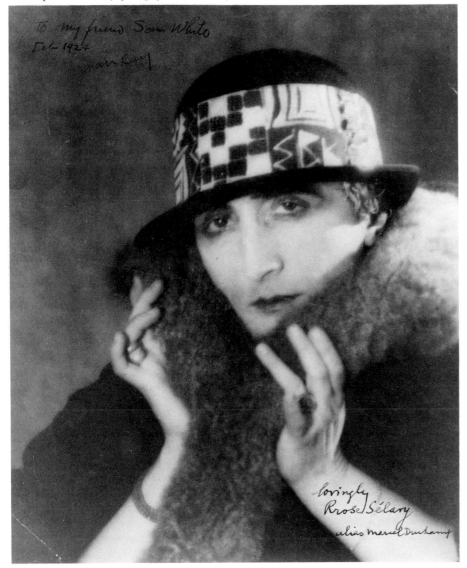

Using reproduction of the Mona Lisa as a Readymade, executes scurrilous *L.H.O.O.Q.,* which becomes a talisman for the Dada movement.

### 1920

Returns to New York for the year in January, bringing *50 cc of Paris Air* as a present for Arensberg.

A version of *L.H.O.O.Q.* (without goatee) published by Picabia in March issue of *391* in Paris.

Takes a studio at 246 West 73rd Street, where, with the assistance of Man Ray, he executes *Rotary Glass Plates* (*Precision Optics*), his first motor-driven construction.

Collaborates with Man Ray on experimental anaglyphic film shot with two synchronized cameras. Man Ray photographs "dust breeding" on the *Large Glass.*

With Katherine Dreier and Man Ray, conceives and founds (on April 29) the Société Anonyme: Museum of Modern Art 1920. The pioneering activity of this organization presents eighty-four exhibitions by 1939 as well as numerous lectures and publications, and builds up a large permanent collection of international modern art. Duchamp serves first as chairman of the exhibition committee and later for many years as secretary to the Société.

Contributes work to first and third Group Exhibitions of the Société in its headquarters at 19 East 47th Street, New York.

Louis Eilshemius, discovered by Duchamp in the 1917 Independents, given his first one-man show by the Société.

Joins Marshall Chess Club, New York.

In winter, moves back into Lincoln Arcade Building, which witnesses birth of "Rose Sélavy," a feminine alter-ego who lends her name henceforth to published puns and Readymades.

Photographed by Man Ray in his guise as a woman.

Another variation on the concept of the Readymade, *Fresh Widow,* is constructed to his design by a carpenter.

### 1921

With Man Ray, edits and publishes single issue (April) of *New York Dada,* including contributions by Tzara and Rube Goldberg.

In reply to invitation to enter Salon Dada (June 6–30) at the Galerie Montaigne in Paris, sends rude cable PODE BAL, dated June 1. Exhibition organizers are forced to hang placards bearing only catalog numbers (28–31) in space reserved for his work.

Sails for Europe on the *France* in June and spends next six months with the Crottis at 22 Rue la Condamine, Paris.

Man Ray arrives in Paris in July; Duchamp meets him at the station. During the summer, they continue film experiments with revolving spirals in Villon's garden at Puteaux.

First puns published in July issue of *391*, Paris.

As Rrose Sélavy, signs Picabia's painting *L'Oeil cacodylate,* which is shown at the Salon d'Automne and later hung in the Paris restaurant Le Boeuf sur le Toit.

Has hair cropped in the pattern of a comet (with a star-shaped tonsure) by Georges de Zayas.

Ownership of unfinished *Large Glass* passes to Katherine Dreier when Arensbergs move permanently to California in the late fall.

Writes Arensbergs of his plans to return to New York to complete the *Large Glass,* and mentions his intention to find a job in the movies "not as an actor, but rather as assistant cameraman."

### 1922

Sails for New York on S.S. *Aquitania* on January 28 to continue work on the *Large Glass* in the Lincoln Arcade studio. Occupied with silvering and scraping the Oculist Witnesses section of the *Glass.*

Gives French lessons.

With Leon Hartl, another French expatriate artist in New York, starts fabric-dyeing establishment which fails after about six months.

Designs layout for selection of art criticism by his friend Henry McBride. *Some French Moderns Says McBride* published by Société Anonyme, New York, in small edition.

Experiments with the secret truth of numbers, applied to games.

In a letter to Tzara in Paris, proposes lucrative scheme for marketing a gold insignia with the letters DADA as a "universal panacea" (the project was never realized).

Publication of first major critical essay on Duchamp, by André Breton, in October issue of *Littérature* (Paris).

Poet and medium Robert Desnos in Paris apparently receives puns "in a trance" from Rrose Sélavy in New York, and Breton publishes them in December issue of *Littérature.*

### 1923

Ceases work on the *Large Glass* and signs

it, having brought it to a state of incompletion.

Returns to Europe in mid-February on the S.S. *Noordam* via Rotterdam.

Settles in Paris, where he remains until 1942, save for occasional trips around Europe and three brief visits to New York (1926–27, 1933–34, 1936).

Moves into the Hotel Istria, 29 Rue Campagne-Première. Man Ray has a studio nearby. Friendship with Brancusi.

Meets Mary Reynolds, an American widow living in Paris, and they establish a close friendship that lasts for several decades.

Works on optical disks, later used in *Anémic Cinéma.*

Travels to Brussels in March, where he spends several months, during which he participates in his first major chess tournament.

His passion for chess involves serious training and professional competition, which absorb increasing amounts of time for about the next ten years.

Member of the jury for this year's Salon d'Automne.

The idea reaches the public that Duchamp has ceased to produce art.

### 1924

In the course of several trips to Monte Carlo, perfects a roulette system whereby one "neither wins nor loses."

Works all year on motorized *Rotary Demisphere,* commissioned by Paris collector Jacques Doucet.

Gives French lessons to Americans in Paris.

Death of John Quinn, New York, July 28..

Issues a major group of puns, published by Pierre de Massot in Paris as *The Wonderful Book: Reflections on Rrose Sélavy.*

Becomes chess champion of Haute-Normandie.

Appears with Man Ray, Erik Satie, and Picabia in René Clair's film *Entr'acte,* which is shown during the intermission of the Instantanéist ballet *Relâche* by Picabia and Satie, produced by the Swedish Ballet at the Théâtre des Champs-Elysées in December. Also appears in a brief tableau as Adam to Brogna Perlmutter's Eve, probably in a single evening performance of the review *Ciné Sketch* (on December 24?) during the short run of the ballet.

### 1925

Duchamp's mother dies on January 29; his father dies on February 3.

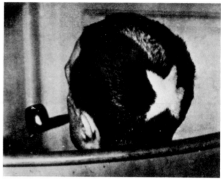

Duchamp with haircut by Georges de Zayas, Paris, 1921.

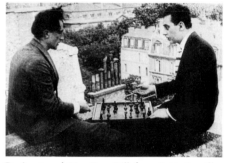

Duchamp and Man Ray. Still from *Entr'acte,* a film by René Clair with scenario by Picabia. The film was shown during the intermission of the ballet *Relâche,* Paris, 1924.

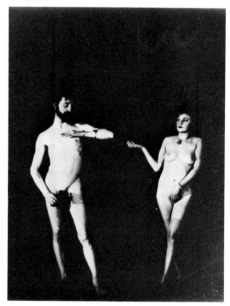

Duchamp and Brogna Perlmutter as Adam and Eve in Picabia's *Ciné Sketch,* performed December 24(?) during the short run of the ballet *Relâche,* Paris, 1924.

Participates in chess tournament, Nice, for which he designs poster.

Completes *Rotary Demisphere,* which he asks Doucet not to lend to any exhibition.

Continues to work on his roulette system.

### 1926

Incorporates optical experiments and puns into *Anémic Cinéma,* a seven-minute movie filmed in collaboration with Man Ray and Marc Allégret.

Sponsors sale of eighty paintings, watercolors, and drawings by Picabia at Hôtel Drouot, Paris, on March 8 (catalog introduction signed by Rrose Sélavy).

Begins speculative purchases and sales of art works, many on behalf of the Arensbergs, an activity ironically counter to his lifelong aversion to the commercial aspects of art.

Rents top-floor studio at 11 Rue Larrey in Paris, which he is to occupy for next sixteen years.

Société Anonyme commissions *Portrait of Marcel Duchamp* by Antoine Pevsner.

Travels to Milan and Venice in May. Assists Katherine Dreier in the organization of the International Exhibition of Modern Art sponsored by the Société Anonyme at the Brooklyn Museum (November 19–January 9, 1927). Exhibition includes 307 works by artists from twenty-three countries.

Sails on the *Paris* on October 13 to New York, where he arranges a Brancusi exhibition at the Brummer Gallery (November 17–December 15). Stays with Allen Norton at 111 West 16th Street. During exhibition meets Julien Levy.

Arranges showing for *Anémic Cinéma* at Fifth Avenue Theatre.

The *Large Glass* shown publicly for first time at the International Exhibition in Brooklyn. This work is accidentally shattered in transit following the exhibition. Its condition remains undiscovered until the *Glass* is removed from storage by Katherine Dreier several years later.

### 1927

With Roché and Mrs. Charles Rumsey, and at Brancusi's request, arranges to buy John Quinn's collection of Brancusi sculpture before the public auction in February. Also buys back three of his own paintings before Quinn sale.

Brief visit to Chicago in January to arrange Brancusi exhibition at the Arts Club there (January 4–18).

Returns to Paris in late February and moves into 11 Rue Larrey studio, where he installs

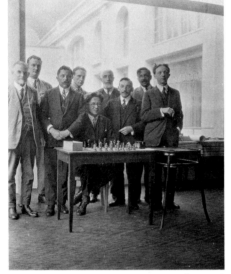

Duchamp with other chess players at the Fifth French Championship, Chamonix, 1927 (he ranked seventh).

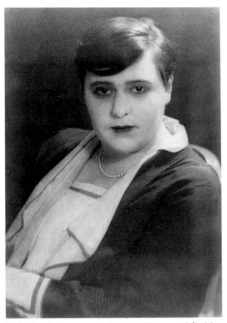

Lydie Sarazin-Levassor, Paris, 1927. Photograph by Man Ray.

one door that serves two doorways. (The door is removed in 1963 and shown as an independent work of art.)

Continues chess activity in a pattern characteristic of the next five years: the winter months spent training in Nice and playing in a steady sequence of tournaments.

First marriage, on June 7 in Paris, to Lydie Sarazin-Levassor, twenty-five-year-old daughter of an automobile manufacturer. Formal church wedding. Bridal procession filmed by Man Ray. Marriage ends in divorce the following January.

### 1928

Chess continues, with tournaments in Hyères, Paris, The Hague, and Marseilles.

Arranges with Alfred Stieglitz for Picabia exhibition at the Intimate Gallery in New York.

### 1929

Visits Spain with Katherine Dreier.

Chess tournaments in Paris.

Begins work on chess book, detailed exposition of special end-game problems.

### 1930

Chess tournaments in Nice and Paris. Member of French team of the third Chess Olympiad, Hamburg. Duchamp draws with Frank Marshall, the U.S. champion.

*Nude Descending a Staircase* shown for the first time since 1913 in exhibition of Cubism at De Hauke Gallery, New York, in April.

Apparent relaxation of determination not to exhibit. *Belle Haleine, Pharmacy, Monte Carlo Bond,* and two versions of *L.H.O.O.Q.* included in exhibition of collages, "La Peinture au Défi," organized by Louis Aragon at Galerie Goemans, Paris, in March.

Asked by Katherine Dreier to select works in Paris for a Société Anonyme exhibition in New York the following January. The selection includes Max Ernst, Joan Miró, Amédée Ozenfant, and Piet Mondrian.

Criticized by Breton in the *Second Manifesto of Surrealism* for abandoning art for chess.

### 1931

Important chess tournament in Prague. Becomes member of Committee of French Chess Federation and its delegate (until 1937) to the International Chess Federation.

## 1932

With Vitaly Halberstadt, publishes *L'Op-position et les cases conjugées sont réconciliées.* Layout and cover designed by Duchamp.

Chess tournament at La Baule. Plays in radio match against Argentine Chess Club of Buenos Aires. Wins Paris Chess Tournament in August, a high point in his chess career.

Around this time, sees Raymond Roussel playing chess at nearby table at the Café de la Régence, Paris, but they do not meet.

Invents for Alexander Calder's movable constructions the name "mobiles" and encourages their exhibition at the Galerie Vignon in Paris. (Arp then names the static works "stabiles.")

## 1933

Last important international chess tournament, at Folkestone, England.

Translates Eugène Znosko-Borovsky's chess book into French: *Comment il faut commencer une partie d'échecs,* a study of opening moves which neatly counters his own interest in end games.

Sails for New York on October 25 to organize a second Brancusi exhibition at the Brummer Gallery (November 17–January 13, 1934).

## 1934

Returns to Paris in February.

Begins to assemble notes and photographs pertaining to the *Large Glass.* These are reproduced in a painstaking facsimile edition of three hundred, which he publishes in September in Paris: *La Mariée mise à nu par ses célibataires, même* (known as the *Green Box*).

## 1935

Produces a set of six *Rotoreliefs* in an edition of five hundred which he displays at the annual Paris inventors' salon, the Concours Lépine (August 30–October 8), with no commercial success. Refuses to allow Katherine Dreier to charge more than $3 per set since they were so inexpensive to print.

Starts assembling material for the *Box in a Valise,* another special edition which is to include reproductions of all his major works.

Included in "Exposicion Surrealista," Tenerife, Canary Islands.

Serves as captain of French team of First International Chess by Correspondence Olympiad. He is undefeated.

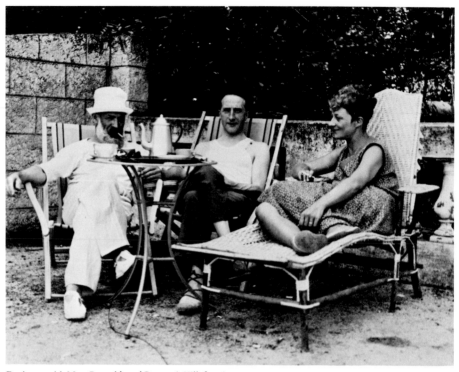

Duchamp with Mary Reynolds and Brancusi, Villefranche, 1929.

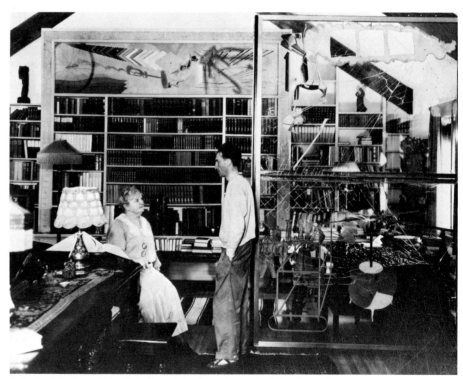

Katherine S. Dreier and Marcel Duchamp in her home in West Redding, Connecticut, 1936.

Designs a binding for Alfred Jarry's *Ubu Roi* which is executed by Mary Reynolds.

Publication of André Breton's "Phare de la Mariée" (Lighthouse of the Bride), in winter issue of *Minotaure* (Paris)—the first comprehensive and illuminating essay on the *Large Glass*.

### 1936

Continues interest in optical phenomena with *Fluttering Hearts,* design for cover of issue of *Cahiers d'Art* (Paris), containing an important article on his work by Gabrielle Buffet.

Readymades including *Why Not Sneeze?* shown at the "Exposition Surréaliste d'Objets" at the apartment of the dealer Charles Ratton, Paris (May 22–29).

Four works included in the vast "International Surrealist Exhibition" in London at the New Burlington Galleries (June 11–July 4).

Sails May 20 on the *Normandie* for New York, to undertake the month-long painstaking restoration of the *Large Glass* at Katherine Dreier's house in West Redding, Connecticut.

In August, travels across the United States by train to San Francisco, and then visits the Arensbergs in Hollywood. Stops on return trip in Cleveland, where *Nude Descending a Staircase* is included in the Cleveland Museum of Art's Twentieth Anniversary Exhibition.

Sails for France on September 2.

Eleven works (largest selection to this date) included in "Fantastic Art, Dada, Surrealism," the first major exhibition of its kind in the United States, organized by Alfred H. Barr, Jr., at The Museum of Modern Art, New York (December 9–January 17, 1937).

### 1937

First one-man show held at the Arts Club of Chicago (February 5–27), while he remains in France. Nine works included. Preface to catalog by Julien Levy.

Designs glass doorway for André Breton's Galerie Gradiva, at 31 Rue de Seine, Paris.

Writes a chess column every Thursday for Paris daily journal *Ce Soir,* edited by Louis Aragon.

Continues work on reproductions for *Box in a Valise.*

Assists Peggy Guggenheim with her London gallery, Guggenheim Jeune. First show planned for Brancusi, then changed to drawings of Jean Cocteau.

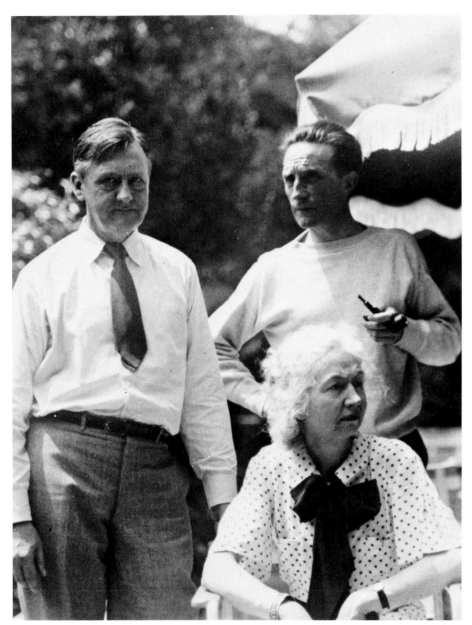

Duchamp with Louise and Walter Arensberg, Hollywood, 1936.

21

## 1938

As "generator-arbitrator," participates in organization of the "Exposition Internationale du Surréalisme," Galerie Beaux-Arts, Paris (January 17–February). Collaborates with Breton, Eluard, Salvador Dali, Ernst, Man Ray, and Wolfgang Paalen. Proposes ideas for elaborate installation, which includes a ceiling of twelve hundred coal sacks. Shows five works including *Rotary Demisphere* and *Nine Malic Molds* of 1914. Contributes mannequin (Rrose Sélavy) dressed only in his own hat and coat to row of artists' mannequins in the "Rue Surréaliste." Leaves for England on the day of the opening. Eight works reproduced in the "Dictionnaire abrégé du surréalisme," a section of the exhibition catalog.

Prepares summer exhibition of contemporary sculpture for Guggenheim Jeune gallery, London. Selection includes Arp, Brancusi, Calder, Duchamp-Villon, Pevsner.

## 1939

Publishes volume of puns, *Rrose Sélavy, oculisme de précision, poils et coups de pieds en tous genres,* in Paris.

*Monte Carlo Bond* given by Duchamp to The Museum of Modern Art, New York (first work in a public collection).

Preoccupied with reproduction of the *Large Glass* on transparent plastic for *Box in a Valise.*

## 1940

Continues work on his *Valise.*

Summer with the Crottis in Arcachon, in the Occupied Zone of France.

Man Ray moves to the United States, settling in California.

Previously unpublished notes included in Breton's *Anthologie de l'humour noir,* which was intended to have a special cover by Duchamp.

## 1941

Official date of first publication of *Box in a Valise.* Individual *Valises* are assembled slowly over the years by Duchamp and various assistants, including Joseph Cornell, Xenia Cage, and Jacqueline Matisse.

As trustee, with Katherine Dreier, of the permanent collection of the Société Anonyme, authorizes its presentation to Yale University Art Gallery, New Haven, Connecticut. *Rotary Glass Plates* of 1920 included in this gift.

Obtains permanent pass for the "free zone"

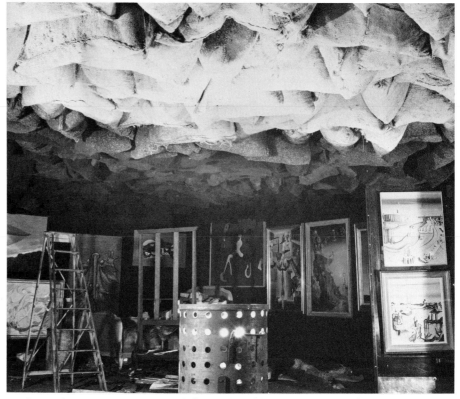

Installation of the "Exposition Internationale du Surréalisme" at the Galerie Beaux-Arts, Paris, January 17–February, 1938. Ceiling of coal sacks by Duchamp.

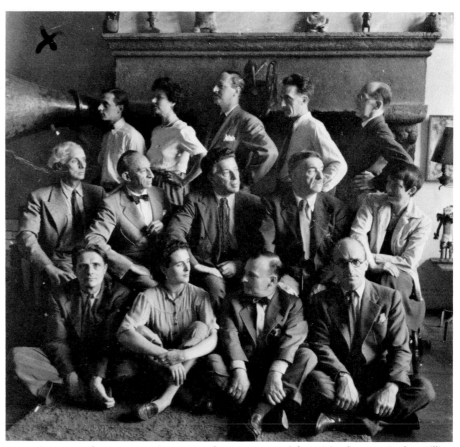

Group photograph of "Artists in Exile," New York, 1942(?). From left to right, first row: Stanley William Hayter, Leonora Carrington, Frederick Kiesler, Kurt Seligmann; second row: Max Ernst, Amédée Ozenfant, André Breton, Fernand Léger, Berenice Abbott; third row: Jimmy Ernst, Peggy Guggenheim, John Ferren, Marcel Duchamp, Piet Mondrian.

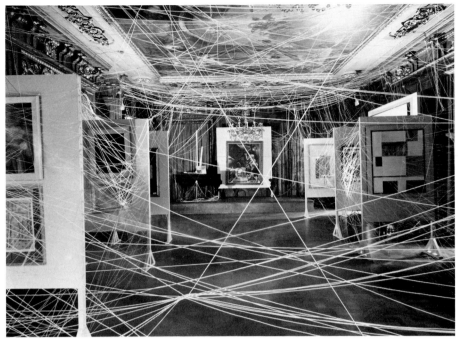

Installation of the "mile of string" for exhibition "First Papers of Surrealism," New York, October 14–November 7, 1942.

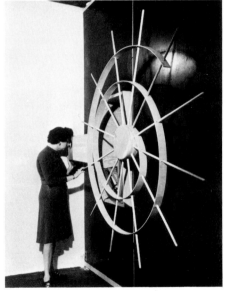

Peggy Guggenheim looking at Duchamp's *Valise* in a special installation by Frederick Kiesler at her gallery, Art of This Century, New York, 1942.

210 West 14th Street, New York, where Duchamp lived from 1943 to 1965 in the top-floor studio.

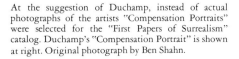

At the suggestion of Duchamp, instead of actual photographs of the artists "Compensation Portraits" were selected for the "First Papers of Surrealism" catalog. Duchamp's "Compensation Portrait" is shown at right. Original photograph by Ben Shahn.

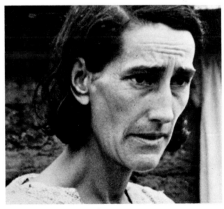

as a cheese dealer from his merchant friend Gustave Candel; travels between Paris and the south of France, moving the contents of the *Valises* to Marseilles, whence they will be sent to New York.

### 1942

Returns to the United States, where he resides for the rest of his life. Sails from Lisbon on the *Serpa Pinto,* arriving in New York on June 25.

Lives briefly in the Ernsts' apartment at 440 East 51st Street, then moves to 56 Seventh Avenue, where he stays with Frederick Kiesler.

Associates with Surrealist group of artists and writers temporarily living in New York during the war, including Breton, Ernst, Matta, André Masson, Wifredo Lam, and Yves Tanguy.

With Breton and Ernst, serves as editorial advisor for several issues of the review *VVV,* founded by David Hare in New York.

Peggy Guggenheim's gallery Art of This Century, which serves as a museum for her private collection and a gallery for temporary exhibitions, opens at 30 West 57th Street in October. Installation by Kiesler includes reproductions from Duchamp's *Valise* seen through holes in a revolving disk which the viewer turns with a wheel.

Collaborates with Breton, Sidney Janis, and R. A. Parker on catalog and exhibition of "First Papers of Surrealism," shown at 451 Madison Avenue, New York (October 14–November 7) and sponsored by the Coordinating Council of French Relief Societies. Designs spectacular and frustrating installation with a mile of string. Encourages Janis children to play energetic games in the gallery during opening (at which he is not present).

Meets John Cage through Peggy Guggenheim.

### 1943

Moves into top-floor studio at 210 West 14th Street which he occupies for about twenty-two years.

With Breton, and Kurt Seligmann, designs show window at Brentano's bookstore on Fifth Avenue for publication of *La Part du diable* by Denis de Rougemont.

Takes part in a sequence of Maya Deren's uncompleted film *The Witch's Cradle.*

His collage *Genre Allegory* rejected by *Vogue* magazine as a design for a George Washington cover.

*Large Glass* placed on extended loan to The Museum of Modern Art, New York, and is part of international exhibition there, "Art in Progress" (first public appearance of the *Glass* since its repair in 1936). Remains on view until it is returned to Katherine Dreier in April 1946.

### 1944

Executes drawing of nude figure, first known sketch for his major last work, *Etant donnés: 1° la chute d'eau, 2° le gaz d'éclairage,* on which he was to work in secret for twenty years.

Describes daily existence to Katherine Dreier: "Chessing, lessoning, starting a few boxes, my usual life."

Hans Richter begins his film *Dreams That Money Can Buy,* including sequence of Duchamp with his *Rotoreliefs.* Other collaborators are Calder, Ernst, Léger, and Man Ray.

Designs catalog for "Imagery of Chess" exhibition at Julien Levy Gallery in December and referees six simultaneous games of blindfold chess between champion George Koltanowski and Alfred Barr, Ernst, Kiesler, Levy, Dorothea Tanning, and Dr. Gregory Zilboorg.

The Société Anonyme publishes *Duchamp's Glass: An Analytical Reflection,* by Katherine Dreier and Matta.

### 1945

March issue of *View* (New York) devoted to Duchamp, providing first important illustrated anthology of writings on his work.

Family group exhibition of "Duchamp, Duchamp-Villon, Villon" at Yale University Art Gallery (February 25–March 25). Ten works shown. An exhibition of Duchamp and Villon organized by the Société Anonyme travels to college art galleries in Virginia, California, Pennsylvania, Minnesota, and Maine during 1945–46.

With Breton installs show window at Brentano's on Fifth Avenue for publication of Breton's *Arcane 17.* After protests from League of Women, installation is moved to Gotham Book Mart at 41 West 47th Street.

With Enrico Donati, installs show window at Brentano's for second edition of Breton's book *Le Surréalisme et la peinture.*

In December The Museum of Modern Art, New York, purchases *The Passage from the Virgin to the Bride* from Walter Pach (first painting to be bought by a museum).

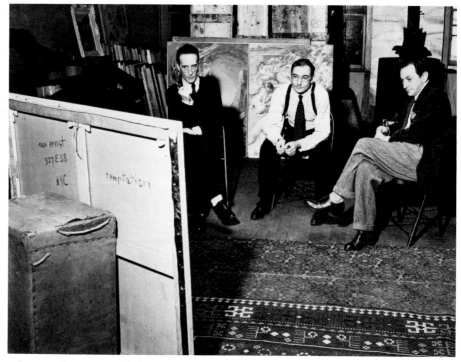

Judges Marcel Duchamp, Alfred H. Barr, Jr., and Sidney Janis with *The Temptation of St. Anthony* by Max Ernst, first-prize winner in the Bel Ami International Competition. The painting was featured in the motion picture *Bel Ami or the History of a Scoundrel,* starring George Sanders, 1946.

"Marcel Duchamp at the Age of Eighty-five." Photograph was taken when he was fifty-eight years old for the March 1945 issue of *View* (New York), which was devoted to Duchamp.

Katherine S. Dreier in the elevator painted by Duchamp to match the wallpaper in her house in Milford, Connecticut, to which she had recently moved (*Bridgeport Post,* June 23, 1946).

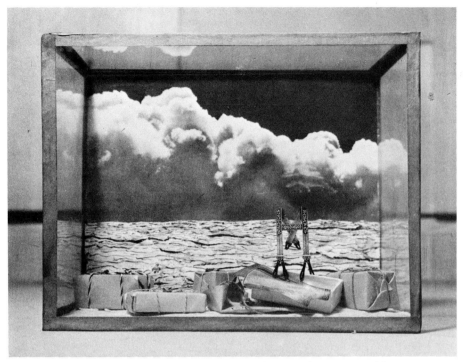

*The Green Ray.* Photo-collage by Frederick Kiesler executed for the exhibition "Le Surréalisme en 1947" on Duchamp's behalf—"art by proxy." Paris, 1947.

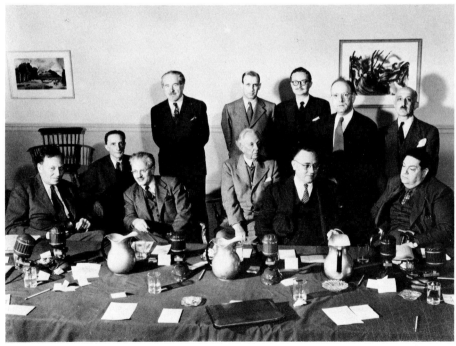

Participants in the Western Round Table on Modern Art, San Francisco, 1949. From left to right, seated: Gregory Bateson, Marcel Duchamp, George Boas, Frank Lloyd Wright, Andrew Ritchie, Darius Milhaud; standing: Mark Tobey, Robert Goldwater, Douglas MacAgy, Kenneth Burke, Alfred Frankenstein.

## 1946

Begins twenty years of work on the tableau-assemblage *Etant donnés* in his 14th Street studio.

Guest director of the Florine Stettheimer exhibition at The Museum of Modern Art, New York (catalog by Henry McBride).

Serves, with Alfred Barr and Sidney Janis, on jury for "Bel Ami International Competition and Exhibition of New Paintings by Eleven American and European Artists" on the theme of the Temptation of St. Anthony. First prize awarded to Max Ernst.

First important extended interview, with James Johnson Sweeney, published in *The Museum of Modern Art Bulletin,* "Eleven European Artists in America."

Helps Katherine Dreier decorate her recently purchased house in Milford, Connecticut. Paints the small elevator installed in the entrance foyer with a *trompe-l'oeil* leaf pattern matching the wallpaper.

Visits Paris in the fall, where he and Breton design and prepare exhibition "Le Surréalisme en 1947" at the Galerie Maeght (July–August 1947). Duchamp's suggestions for the Labyrinth and Rain Room carried out by Kiesler. Returns to New York in December, long before the opening. Kiesler also executes photo-collage *The Green Ray* for the exhibition on Duchamp's behalf—"art by proxy."

## 1947

In collaboration with Enrico Donati in New York, designs catalog cover for *Le Surréalisme en 1947* and hand-colors 999 foam-rubber "falsies," labeled "Prière de Toucher," for the deluxe edition.

Applies for United States citizenship.

## 1948

Executes vellum-and-gesso study for nude figure in *Etant donnés,* which he gives to Maria Martins, the Brazilian sculptress.

Included in group exhibition with Joseph Cornell and Tanguy, "Through the Big End of the Opera Glass," at the Julien Levy Gallery, New York, in December, for which he designs catalog.

## 1949

Participates in three-day session of the Western Round Table on Modern Art, held at the San Francisco Museum of Art, April 8–10. Other panelists are Gregory Bateson, Kenneth Burke, Alfred Frankenstein, Robert Goldwater, Darius Milhaud, Andrew Ritchie, Arnold Schönberg, Mark

Tobey, and Frank Lloyd Wright, with George Boas as moderator; *Nude Descending a Staircase* shown in an exhibition assembled for the event at the museum. Afterward, visits Max Ernst in Sedona, Arizona, for a few days.

Largest group of works (thirty) exhibited to date included in "Twentieth Century Art from the Louise and Walter Arensberg Collection" at The Art Institute of Chicago (October 20–December 18).

Visits Chicago, with Arensbergs, at the time of the exhibition.

### 1950

Contributes thirty-three critical studies of artists (written 1943–49) to catalog of the *Collection of the Société Anonyme*, Yale University Art Gallery.

Takes brief trip in September to Paris, where Mary Reynolds is seriously ill. She dies on September 30.

As a trustee of the Arensbergs' Francis Bacon Foundation, joins in decision to donate the Arensbergs' collection of twentieth-century art and Pre-Columbian sculpture to the Philadelphia Museum of Art.

Appearance of first plaster erotic objects (*Not a Shoe, Female Fig Leaf*).

### 1951

Publication of *Dada Painters and Poets: An Anthology,* edited by Robert Motherwell, New York. Includes contributions by and about Duchamp, who also gave advice and assistance to the editor.

### 1952

Helps to organize "Duchamp Frères et Soeur, Oeuvres d'Art," an exhibition at the Rose Fried Gallery, New York (February 25–March).

Death of Katherine Dreier on March 29.

Collaborates with Hans Richter in the latter's film *8 x 8* based on chess. Sequences filmed in Southbury, Connecticut, with Ernst, Calder, Tanguy, Arp, Kiesler, Dorothea Tanning, Julien Levy, Jacqueline Matisse.

Gives address at banquet of New York State Chess Association on August 30.

Assists in organization of memorial exhibition of Katherine Dreier's own collection at Yale University Art Gallery in December. Writes preface for catalog. Miss Dreier's collection, which includes major works by Duchamp, is bequeathed to several museums including Yale University Art Gallery, The Museum of Modern Art, New York, and the Philadelphia Museum of Art. As an executor of her will, Duchamp plays an important role in the division of the collection.

### 1953

Assists with assembly and installation of the exhibition "Dada 1916–1923" at the Sidney Janis Gallery, New York. Shows twelve works. Designs catalog on single sheet of tissue paper which is crumpled into a ball before being distributed. Extended (unpublished) interview with Harriet, Sidney, and Carroll Janis.

Death of Picabia on November 30.

Death of Louise Arensberg on November 25, followed shortly by the death of Walter Arensberg on January 29, 1954.

Five works included in exhibition "Marcel Duchamp, Francis Picabia" at Rose Fried Gallery (December 7–January 8, 1954).

### 1954

Marries Alexina (Teeny) Sattler, who had previously been married to Pierre Matisse, on January 16 in New York. Duchamp thus acquired a new family of three stepchildren, Paul, Jacqueline, and Peter. Duchamp and his wife live in a fourth-floor walk-up apartment at 327 East 58th Street (formerly occupied by the Max Ernsts) for next five years.

Musée National d'Art Moderne in Paris acquires oil sketch of *Chess Players,* 1911, first work in a French public collection.

Publication in Paris of study by Michel Carrouges on Kafka, Roussel, and Duchamp, *Les Machines célibataires,* which provokes comment and controversy in French literary circles.

Opening of permanent exhibition of the Louise and Walter Arensberg Collection at the Philadelphia Museum of Art, which received this major bequest in 1950. Forty-three works by Duchamp included. Comprehensive catalog published. Installed by Henry Clifford with the assistance of Duchamp.

The *Large Glass,* bequeathed by Katherine Dreier, is permanently installed in the Arensberg galleries.

### 1955

Televised interview with James Johnson Sweeney at the Philadelphia Museum of Art, which is broadcast by NBC in "Wisdom Series" in January 1956.

Becomes a naturalized United States citizen. Alfred Barr, James Johnson Sweeney, and

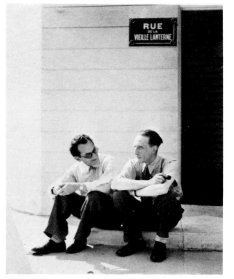

Duchamp with Man Ray, Los Angeles, 1949.

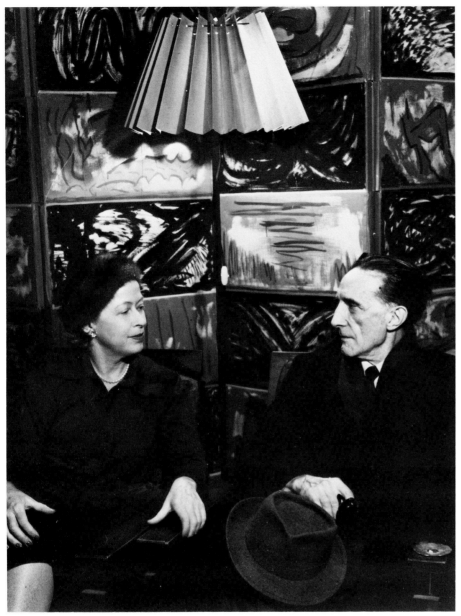

Teeny and Marcel Duchamp, in the apartment of Man Ray, Paris, 1955. Photograph by Man Ray.

Duchamp signing deluxe editions of Robert Lebel's *Sur Marcel Duchamp*, Paris, 1959.

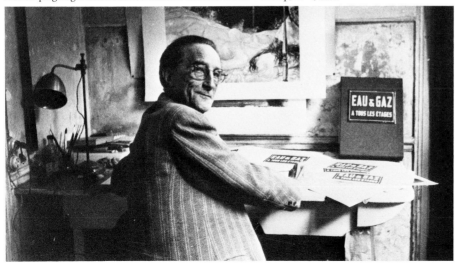

James Thrall Soby are witnesses at the ceremony.

About this time, begins to work on elaborate landscape for *Etant donnés.*

### 1956

Publication of *Surrealism and Its Affinities,* catalog by Hugh Edwards of the Mary Reynolds Collection of rare books, periodicals, and her own bookbindings, at The Art Institute of Chicago. Preface by Duchamp, who also designed the bookplate.

Sends remaining contents of unpublished *Valises* back to Paris, where various assistants continue the slow and painstaking work of their assembly.

### 1957

Major exhibition and catalog of "Jacques Villon, Raymond Duchamp-Villon, Marcel Duchamp" at the Solomon R. Guggenheim Museum, New York (February 19–March 10), prepared by James Johnson Sweeney. Duchamp suggested the idea for the joint exhibition, advised on the selection, and designed the catalog. Exhibition later travels to Houston, Texas.

Delivers important lecture "The Creative Act" at convention (April 3–11) of the American Federation of Arts in Houston.

### 1958

Publication in Paris of *Marchand du Sel, écrits de Marcel Duchamp,* compiled by Michel Sanouillet. The most comprehensive collection to date of Duchamp's writings and statements, with bibliography by Poupard-Lieussou.

Around this time, begins to spend summers in Cadaqués, on the Costa Brava, Spain; visits to Paris often included.

### 1959

Moves to apartment at 28 West 10th Street, New York, where he and his wife live until his death.

Assists in design and publication in Paris of *Sur Marcel Duchamp* by Robert Lebel. (English translation by George Heard Hamilton published in New York.) The most comprehensive and definitive work on Duchamp to that date. Includes a catalogue raisonné with 208 detailed entries and an extensive bibliography. Two new works executed for incorporation in deluxe edition: *Self-Portrait in Profile* and enamel plaque *Eau & gaz à tous les étages.* This publication celebrated in one-man exhibitions at the Sidney Janis Gallery, New

York, Galerie La Hune, Paris, and the Institute of Contemporary Arts, London.

Enters the Collège de 'Pataphysique in France in the year 86 E.P. (Ere 'pataphysique) with the rank of Transcendent Satrap (the highest in this life) and the supplemental honor of being Maître de l'Ordre de la Grande Gidouille. (Note: E.P. in vulgar chronology is based on 1873, the year of Alfred Jarry's birth.)

With Breton, helps arrange the "Exposition Internationale du Surréalisme" at the Galerie Daniel Cordier, Paris (December 15–February 1960). Contributes *Couple of Laundress' Aprons* to *Boîte alerte,* special edition of catalog.

In Cadaqués for the summer, experiments with plaster casting from life (*With My Tongue in My Cheek, Torture-morte*).

### 1960

Publication in London of *The Bride Stripped Bare by Her Bachelors, Even,* first full English translation of the *Green Box,* by George Heard Hamilton with typographic layout by Richard Hamilton.

Exhibition "Dokumentation über Marcel Duchamp," at the Kunstgewerbemuseum, Zurich (June 30–August 28).

Participates in symposium, "Should the Artist Go to College?" at Hofstra College, Hempstead, Long Island, New York, on May 13.

Elected to National Institute of Arts and Letters, New York, on May 25.

Collaborates with André Breton on direction of exhibition "Surrealist Intrusion in the Enchanter's Domain," at the D'Arcy Galleries, New York (November 28–January 14, 1961). Designs catalog cover.

Contributes extended pun to broadside for Jean Tinguely's machine, *Homage to New York,* which destroyed itself in The Museum of Modern Art Sculpture Garden on March 17. Duchamp attends the event.

About this time a number of American artists, including Robert Rauschenberg, Jasper Johns, and Robert Morris, become interested in Duchamp's work and career, through reading Lebel's monograph, the translation of the notes of the *Green Box,* and visits to the Arensberg Collection in Philadelphia. Rauschenberg, for example, dedicates the combine painting *Trophy II,* 1960–61, to Teeny and Marcel Duchamp. Duchamp in turn takes an interest in contemporary manifestations; for example, attends Claes Oldenburg's *Store Days* performances in February–March 1962, and befriends younger artists in New York.

### 1961

Featured in "Art in Motion" exhibition and catalog, organized by Stedelijk Museum, Amsterdam (March 10–April 17), and Moderna Museet, Stockholm (May 17–September 3). Plays (and wins) chess by telegram with a group of students in Amsterdam on the occasion of the exhibition. First replica of *Large Glass* made by Ulf Linde included in exhibition and signed by Duchamp, who visits Stockholm for the occasion.

Participates in panel discussion "Where Do We Go from Here?" at the Philadelphia Museum College of Art on March 20. Other panelists are Larry Day, Louise Nevelson, and Theodoros Stamos, with Katharine Kuh as moderator. Delivers statement including the prophetic words "the great artist of tomorrow will go underground."

Assists with reinstallation of Arensberg Collection at Philadelphia Museum of Art in May.

Interviewed by Katharine Kuh on March 29, and on September 27 by Richard Hamilton for BBC television "Monitor" program.

Featured in "The Art of Assemblage" exhibition and catalog organized by William Seitz at The Museum of Modern Art, New York (October 2–November 12). Exhibition travels to Dallas and San Francisco. Participates in symposium at Museum on October 19, delivering a brief prepared statement "Apropos of Readymades." Other panelists are Roger Shattuck, Robert Rauschenberg, and Richard Huelsenbeck, with Lawrence Alloway as moderator.

Receives honorary degree of Doctor of Humanities from Wayne State University, Detroit, Michigan, on November 29, and delivers an address. Lectured on his work at the Detroit Institute of Arts the previous day.

Dissertation completed by Lawrence D. Steefel, Jr., at Princeton University, New Jersey: *The Position of "La Mariée mise à nu par ses célibataires, même" (1915–1923) in the Stylistic and Iconographic Development of the Art of Marcel Duchamp.*

### 1962

Lectures on his work at Mount Holyoke College, Massachusetts, and at the Norton Gallery, Palm Beach, Florida.

### 1963

Designs poster for "1913 Armory Show 50th Anniversary Exhibition" at Munson-Williams-Proctor Institute, Utica, New York (February 17–March 31), and delivers lecture at the Institute on February 16. The exhibition travels to the Armory in New York (April 6–28).

Delivers lecture on his work, "Apropos of Myself," at Baltimore Museum of Art, Maryland, and Brandeis University, Waltham, Massachusetts.

Death of Jacques Villon, June 9.

Death of Suzanne (Duchamp) Crotti, September 11, whose husband Jean had died in 1958.

One-man exhibition (of replicas made by Ulf Linde) at Galerie Burén, Stockholm, in conjunction with publication of a major monograph, *Marcel Duchamp,* by Linde.

Continues to grant increasing numbers of interviews to critics and journalists.

First major retrospective exhibition, "By or of Marcel Duchamp or Rrose Sélavy," organized by Walter Hopps at the Pasadena Art Museum (October 8–November 3). Duchamp designs poster and catalog cover; 114 works included. Visits California (with a side trip to Las Vegas) on the occasion of the exhibition.

### 1964

Galleria Schwarz, Milan, produces thirteen Readymades in editions of eight signed and numbered copies. One-man exhibition "Omaggio a Marcel Duchamp" at Galleria Schwarz (June 5–September 30) followed by European tour to Bern, Switzerland; London; the Hague and Eindhoven, the Netherlands; and Hannover, West Germany. Catalog includes contributions by Arturo Schwarz, Hopps, and Linde.

Jean-Marie Drot makes a film, *Game of Chess with Marcel Duchamp,* including extensive interview, for French television. Film wins first prize at the International Film Festival at Bergamo, Italy.

Delivers lecture "Apropos of Myself" at the City Art Museum of St. Louis on November 24.

### 1965

Major one-man exhibition, "Not Seen and/or Less Seen of/by Marcel Duchamp/Rrose Sélavy 1904–64," at Cordier & Ekstrom Gallery, New York (January 14–February 13). Includes ninety items from the Mary Sisler Collection, many never exhibited previously. Catalog introduction and notes by Richard Hamilton; cover by Duchamp.

"Profiled" in the *New Yorker* magazine by Calvin Tomkins in February. The *New*

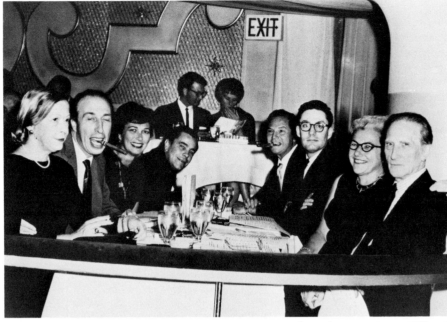

Stardust Hotel, Las Vegas. From left to right: Teeny Duchamp, Richard Hamilton, Betty Factor, William N. Copley, Donald Factor, Walter Hopps, Betty Asher, Marcel Duchamp, 1963.

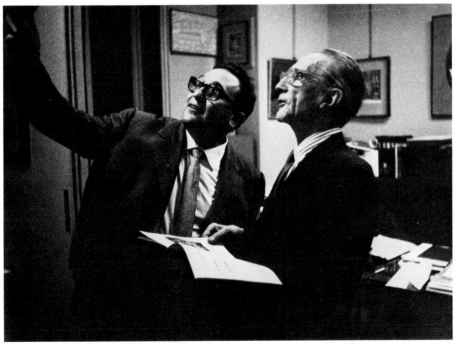

Marcel Duchamp and Arturo Schwarz, Milan, 1964.

*Yorker* article, plus three others (on John Cage, Jean Tinguely, and Robert Rauschenberg), published by Calvin Tomkins as *The Bride and the Bachelors.*

Attends dinner on May 15 in honor of Rrose Sélavy, at Restaurant Victoria in Paris, sponsored by the Association pour l'Etude du Mouvement Dada.

During summer spent in Cadaqués, executes nine etchings of details of the *Large Glass,* which are published by Arturo Schwarz two years later.

In October, paintings representing the murder of Duchamp are shown by artists Aillaud, Arroyo, and Recalcati at the Galerie Creuze, Paris. Duchamp declines to sign a protest.

About this time, forced to vacate the 14th Street studio. Moves the nearly completed *Etant donnés* to a small room in a commercial building at 80 East 11th Street.

1966

Assists organization of "Hommage à Caïssa" exhibition at Cordier & Ekstrom Gallery, New York (February 8–26), to benefit Marcel Duchamp Fund of American Chess Foundation.

*Large Glass* reconstructed, together with studies, by Richard Hamilton at the University of Newcastle-upon-Tyne, England. Exhibited in May as *The Bride Stripped Bare by Her Bachelors, Even, Again,* with photoreportage catalog.

First major European retrospective exhibition, "The Almost Complete Works of Marcel Duchamp," organized by Richard Hamilton for the Arts Council of Great Britain at the Tate Gallery, London (June 18–July 31). Catalog by Richard Hamilton includes 242 items and "Elements of a Descriptive Bibliography" by Arturo Schwarz. Duchamp visits London on the occasion of the exhibition.

Tristram Powell makes a film, *Rebel Readymade,* for BBC television, which is shown on "New Release" on June 23.

Interviewed by William Coldstream, Richard Hamilton, Ronald Kitaj, Robert Melville, and David Sylvester at Richard Hamilton's home in London on June 19 for BBC (unpublished).

Special July issue of *Art and Artists* (London), with cover by Man Ray, devoted to Duchamp.

Publication of *The World of Marcel Duchamp,* by Calvin Tomkins and the Editors of Time-Life, Inc., New York.

Completes and signs last major work, *Etant*

*donnés: 1° la chute d'eau, 2° le gaz d'éclairage,* 1946–66, in the secrecy of room 403, 80 East 11th Street.

Nine works included in the "Dada Austellung" at the Kunsthaus, Zurich (October 8–November 7); the exhibition travels to the Musée National d'Art Moderne, Paris (November 30–January 30, 1967).

## 1967

Writes notes and assembles photographs in New York for book of instructions for dismantling and reassembling of *Etant donnés.*

Publication of important extended interviews by Pierre Cabanne, *Entretiens avec Marcel Duchamp,* in Paris. English translation by Ron Padgett published in New York (in 1971).

Publication by Cordier & Ekstrom Gallery, New York, of *A l'infinitif,* a limited boxed edition of seventy-nine unpublished notes dating from 1912 to 1920, reproduced in facsimile. Accompanied by English translation by Cleve Gray.

Publication in Milan by Arturo Schwarz of *The Large Glass and Related Works* (Volume I), including nine etchings by Duchamp of the *Glass* and its details.

Important family exhibition "Les Duchamps: Jacques Villon, Raymond Duchamp-Villon, Marcel Duchamp, Suzanne Duchamp-Crotti" at the Musée des Beaux-Arts, Rouen (April 15–June 1). Eighty-two works included. Catalog essay on Duchamp by Bernard Dorival.

First major showing in Paris at Musée National d'Art Moderne: "Duchamp-Villon, Marcel Duchamp" (June 6–July 2). Eighty-two works included. Catalog of Rouen exhibition, with alterations.

Exhibition "Editions de et sur Marcel Duchamp," at Galerie Givaudan, Paris (June 8–September 30). Duchamp designs poster.

Begins work on nine etchings on theme of "The Lovers" for future publication by Arturo Schwarz.

One-man exhibition "Marcel Duchamp / Mary Sisler Collection" tours New Zealand and six museums in Australia during 1967–68.

Publication in Paris of monograph by Octavio Paz, *Marcel Duchamp ou le château de la pureté.*

## 1968

Sometime prior to his departure for Europe this summer, takes Bill Copley to see the

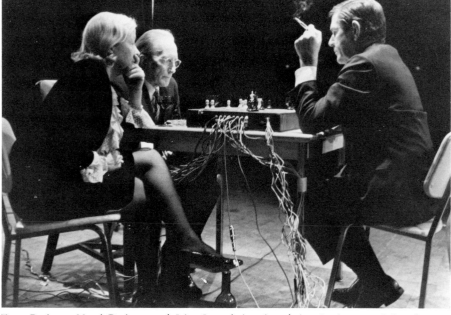

Teeny Duchamp, Marcel Duchamp, and John Cage playing chess during *Reunion,* a musical performance organized by Cage, Toronto, 1968.

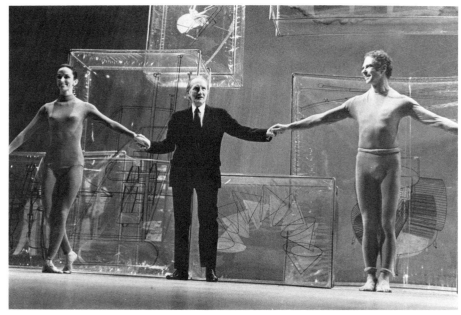

Carolyn Brown, Marcel Duchamp, and Merce Cunningham at premiere performance of Cunningham's *Walkaround Time.* (Decor after Duchamp's *Large Glass,* supervised by Jasper Johns.) Buffalo, New York, 1968.

completed *Etant donnés* in his secret studio and expresses the wish that it join the large group of his works already in the Philadelphia Museum of Art. Copley feels that the Cassandra Foundation, with which he is at that time associated, could assist in making this possible.

Participates in *Reunion,* a musical performance organized by John Cage in Toronto, Canada, on February 5, during which Duchamp, Cage, and Teeny Duchamp play chess on a board electronically wired for sound.

Attends premiere performance (March 10) of Merce Cunningham's *Walkaround Time,* presented during the Second Buffalo Festival of the Arts Today at the State University College at Buffalo, New York. Music, *. . . for nearly an hour . . .,* composed by David Behrman, and played by John Cage, Gordon Mumma, David Tudor, and David Behrman. Decor based on the *Large Glass* supervised by Jasper Johns.

Featured in exhibition and catalog of "Dada, Surrealism, and Their Heritage," organized by William S. Rubin at The Museum of Modern Art, New York (March 27–June 9). Thirteen works included. Duchamp attends opening. Exhibition travels to Los Angeles and Chicago.

Works on handmade anaglyph of the fireplace and chimney which he had had constructed in the Duchamps' summer apartment in Cadaqués.

Orders Spanish bricks for use around door of *Etant donnés* in permanent installation.

Dies on October 2 in Neuilly, during his customary summer and early fall visit to Paris and Cadaqués. Buried with other members of Duchamp family in the Cimetière Monumental at Rouen. At his request, his gravestone bears the inscription "D'ailleurs c'est toujours les autres qui meurent."

<center>*</center>
<center>*  *</center>

Publication of *To and from Rrose Sélavy,* by Shuzo Takiguchi, Tokyo, in a deluxe edition upon which Duchamp had collaborated, as did Jasper Johns, Jean Tinguely, and Shusaku Arakawa.

Featured in exhibition and catalog of "The Machine as Seen at the End of the Mechanical Age," organized by Pontus Hultén for The Museum of Modern Art, New York (November 28–February 9, 1969). Thirteen works included. Exhibition travels to Houston and San Francisco.

## 1969

Publication by Arturo Schwarz in Milan of *The Large Glass and Related Details* (Volume II), including nine etchings by Duchamp on theme of "The Lovers."

As Duchamp had hoped, his last major work, *Etant donnés,* enters the Philadelphia Museum of Art (as a gift from the Cassandra Foundation). The existence of the work remains a secret until it is finally installed in the Museum. It is disassembled by Paul Matisse in collaboration with the Museum staff, following Duchamp's written instructions, and transported in February from New York to Philadelphia. It is reassembled and installed in the small room Duchamp had suggested, at the rear of the galleries containing the Arensberg collection. The room is opened to the public on July 7.

Publication of Arturo Schwarz's major monograph and catalogue raisonné, *The Complete Works of Marcel Duchamp,* accompanied by a volume of *Notes and Projects for the Large Glass,* which includes reproductions and English translations of 144 notes.

Featured in special summer issue of *Art in America,* New York. This section edited by Cleve Grey.

Publication of summer issue of *Philadelphia Museum of Art Bulletin* devoted to *Etant donnés,* "Reflections on a New Work by Marcel Duchamp," by Anne d'Harnoncourt and Walter Hopps. The first extended study of this work.

## 1971

One-man exhibition "Marcel Duchamp, grafica e ready-made" loaned by the Galleria Schwarz, Milan, to the Galleria Civica d'Arte Moderna in Ferrara, Italy (March 19–May 9); 150 items included.

Symposium on Duchamp organized by Barbara Rose with Moira Roth at the University of California at Irvine (November 6–9). Speakers include: David Antin, Susie Bloch, Jack Burnham, Nina Bremer, Willis Domingo, Richard Hamilton, Walter Hopps, Allan Kaprow, Annette Michelson, Barbara Rose, Robert Pincus-Witten. A small exhibition was assembled for the occasion.

## 1972

Fifteen works included in exhibition "Le Surréalisme" organized by Patrick Waldberg for the Haus der Kunst, Munich (March 10–May 7), and the Musée des Arts Décoratifs, Paris (May 26–July 23).

One-man exhibition "Marcel Duchamp:

Drawings, Etchings for the Large Glass, Readymades" at the Israel Museum, Jerusalem (March–May). Catalog introduction by Arturo Schwarz, who lent most of the fifty-seven works included.

Publication in Cologne of a revised and expanded German edition of Lebel's *Marcel Duchamp,* with a new chapter devoted to *Etant donnés.*

Publication in London of John Golding's monograph, *Marcel Duchamp: The Bride Stripped Bare by Her Bachelors, Even.*

One-man exhibition "Marcel Duchamp, 66 Creative Years" at the Galleria Schwarz, Milan (December 13–February 28, 1973); 262 items included, all from the collection of Vera and Arturo Schwarz.

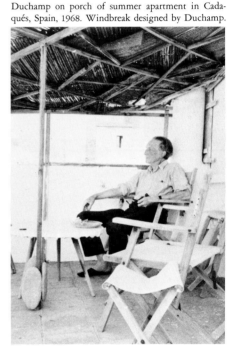

Duchamp on porch of summer apartment in Cadaqués, Spain, 1968. Windbreak designed by Duchamp.

"FOR MARCEL DUCHAMP, the question of art and life, as well as any other question capable of dividing us at the present moment, does not arise."[1] André Breton's words of 1922 have a prophetic ring fifty years later, for rarely has an artist's life appeared to unfold according to the operations of inner laws to such a degree that we are tempted to see the life itself as the artist's invention. Henri-Pierre Roché's tribute to his old friend was equally to the point: "His finest work is his use of time."[2] Duchamp's art, his attitude to "Art," and his long life in the art world present a picture of threads as inextricably intertwined as the mile of string with which he wound the installation of the "First Papers of Surrealism" exhibition in New York in 1942.

Born the son of a notary in a small town in Normandy in 1887, Duchamp spent his life, after the age of twenty, half in Paris, half in New York, and half in art, half in chess, and died a modern legend at the age of eighty-one. The *Nude Descending a Staircase,* which won him widespread notoriety in 1913, has remained his most famous work, although its impact on other artists has been negligible, while the *Large Glass* and an assortment of enigmatic objects and concise gestures have exerted an ever-expanding influence upon successive generations of the avant-garde. His notes for the *Large Glass,* among the most arcane and difficult texts of this century, had been translated into Swedish and Japanese (as well as English, Spanish, Italian, and German) before his death, and his attitude as well as his work had become a touchstone for artists many of whom had never seen so much as a drawing from his hand.

His sequence of moves toward a unique position in the history of modern art was breathtakingly swift, compressed into the space of four crucial years. At the start of 1910 he was producing Fauve-influenced paintings with an eye to Cézanne and Matisse; by the end of 1912 he had passed through experiments with Cubist fragmentation of space and studies of figures in motion to achieve a unique mechanomorphic style in the *Bride.* By 1914, he had executed a quantity of notes and studies for his great project, *The Bride Stripped Bare by Her Bachelors, Even* (the *Large Glass*), he had ceased to paint, in any conventional sense, and he had purchased an ordinary household object from a Paris department store and signed it as if it were a sculpture by his own hand.

From this point on, the development of his work seems less a matter of linear chronological advance than of the gradual filling-in of a total picture, rather like the progress of a jigsaw puzzle. Viewed as a whole, the complex array of paintings and drawings, notes and puns, rotating machines and a movie, Readymades and elaborate constructions offers a bewildering diversity of media and methods. Gertrude Stein put her finger squarely upon the problem that Duchamp was determined to confront in his own career:

*It is awfully hard to go on painting. I often think about this thing. It is awfully hard for anyone to go on doing anything because everybody is troubled by everything.*

*Having done anything you naturally want to do it again and if you do it again then you know you are doing it again and it is not interesting. That is what worries everybody, anybody having done anything naturally does it again, whether it is a crime or a work of art or a daily occupation or anything like eating and sleeping and dancing and war. Well there you are having done it you do it again and knowing you are doing it again . . . spoils its going to be existing. A painter has more trouble about it than any one.*[3]

Duchamp's response to this basic dilemma was a resolution "to put painting once again at the service of the mind."[4] He often expressed his disgust with "retinal" painters, concerned purely with sense impressions, who in his opinion continued to paint the same picture over and over again. Eschewing the painting of the recent past as an influence, Duchamp rapidly arrived at the point (around 1912) where he deliberately chose his own sources. Not Courbet (the father of "retinal" painting) but Mallarmé, not the sensuous, architectonic paint structure of Cézanne but the enigmatic imagery of Odilon Redon,[5] not Picasso and Braque but Alfred Jarry and Raymond Roussel served as *agents provocateurs*. Not painting but language, sometimes literary but often colloquial, not color theory but chronophotography and the concept of a fourth dimension caught his imagination. Despite a small group of major paintings, Duchamp was not a painter but a jack-of-all-trades, and perhaps a poet as well. His contribution was to the broad field of art itself, a field that under his intelligent scrutiny and subversive methods expanded, distorted itself, and occasionally exploded in all directions.

His crucial decision never to repeat himself produced an oeuvre in which infinite opportunity for cross-reference is provided by works widely separated in time and bearing little or no resemblance to each other. As he said to Harriet and Sidney Janis, "I have forced myself to contradict myself in order to avoid conforming to my own taste."[6] The close visual links which we are accustomed to trace from painting to painting in an artist's work are replaced by an underlying thematic interconnection or a common concern which at first may elude detection: "Say it's not a Duchamp," remarked John Cage, "turn it over and it is."[7] Many of the drawings, notes, and objects by Duchamp which survive are not really independent works but preparatory studies, instructions to himself and practical tools for the execution of his plans for two major projects: the *Large Glass,* which occupied his attention from 1915 to 1923, and *Etant donnés: 1° la chute d'eau, 2° le gaz d'éclairage,* which gradually evolved between 1946 and 1966. Even his earliest productions reveal unmistakable signs of interests he was to pursue in those two prolonged projects.

For example, numerous early sketches of men in uniform or engaged in some specific trade (*Knife-Grinder, Funeral Coachman, Gasman*) find their full realization in the ironic, inflated forms of the Nine Malic Molds, the Bachelors in frustrated pursuit of the Bride. Similarly, the little pencil study of a gas lamp done at school around 1904 is undeniably the prototype

of the fixture held aloft by the reclining nude in the tableau of *Etant donnés*, completed some sixty years later. Works as diverse as the *Large Glass, Anémic Cinéma,* and *Etant donnés* can be seen as springing from a fundamental preoccupation with eroticism as a hidden but powerful force: the sexual theme of the *Large Glass* is invisible (revealed only in the notes which accompany it) but all-important. The rhythmic undulation of the spirals and the often lewd content of the puns in the film *Anémic Cinéma* point to an oblique treatment of the same theme, which is most explicit, yet equally mysterious, in the nude woman offered to our gaze in the tableau of *Etant donnés*. Yet the *Glass,* the film, and the tableau (viewed through peepholes) could equally be said to have the phenomena of vision and human perception as a principal theme.

Of all Duchamp's creations, the Readymades most resist classification and incorporation into any thematic whole. They made their sudden, unheralded appearances during the long drawn out period of manual labor on the *Large Glass,* strokes of wit and intellect apparently unrelated to the work in progress. Between 1914 and 1921, two or three objects a year were selected, signed, and occasionally altered by Duchamp, according to his guiding principle of complete indifference. Transferred from a disregarded existence as common manufactured objects into the aesthetic sphere, they acted as an irritant, a mute pressure against the conventional boundaries of that sphere. The Readymades do not simply constitute a gesture of defiance, but rather a venture into unexplored territory. They are a disparate group of works, some left as Duchamp found them (typewriter cover, bottle drying rack, snow shovel), others almost completely fabricated by hand (*With Hidden Noise, Why Not Sneeze?*). The most iconoclastic Readymades like *L.H.O.O.Q.* were not necessarily those that signified the greatest break with artistic convention: the slight alteration and signature of a cheap calendar reproduction (*Pharmacy*) was a more devastating move than the joke at the expense of the Mona Lisa. And yet *Pharmacy* is not only a radical Readymade but a work intimately tied with a theme (landscape enlivened by the presence of water) that first emerges in one of Duchamp's earliest paintings, that is suggested by the water-mill wheel of the *Large Glass,* and that recurs explicitly in the elaborate landscape background and waterfall of *Etant donnés*.

The persistence of certain themes and concerns in Duchamp's work can only be half perceived in the visual evidence he has left behind. A stratum of visible, realized projects floats upon the surface of a sea of ideas, some unrealizable ("l'électricité en large"),[8] others explored in practical detail but only in notes constituting memoranda to himself for future undertakings. Thorough acquaintance with his oeuvre is a matter as much of reading as of looking—the *Large Glass* and the *Green Box* are interdependent works of equal importance, and bear the identical title: *The Bride Stripped Bare by Her Bachelors, Even.* Duchamp's notes, mostly jotted down between 1911 and 1920, collected in the *Box of 1914,* the *Green Box* of 1934 and *A l'infinitif* of 1967, and occasionally published in smaller groupings, constitute one

of his most remarkable contributions to the history of art and thought in this century. They reveal his infinitely stimulating conviction that art can be made out of anything at all, from the most ephemeral or mundane materials (air, shadows, chocolate, shaving soap), and by the most complex processes (physics, photography, perspectival calculations) or the simplest acts ("Buy a pair of ice-tongs as a Rdymade").[9] Some of the notes are pure poetry: "Sculpture musicale. Sons durant et partant de différents points et formant une sculpture sonore qui dure."[10] Many of his proposals appear impossible to execute, yet evoke complex visual ideas in the reader's mind which constitute works of art in themselves:

*Make a painting or sculpture as one winds up a reel of moving picture film. With each turn, on a large reel (several meters in diameter if necessary), a new "shot" continuing the preceding turn and tying it into the next one—This kind of continuity may have nothing in common with moving picture film or even resemble it.*[11]

Equipped with his favorite tools of humor and chance and borrowing techniques from a myriad of nonartistic disciplines, Duchamp constructs an ironic universe by "slightly distending the laws of physics and chemistry."[12] Density "oscillates," symmetry is "subsidized," metals are "emancipated," and human desire is equipped with "love gasoline" and "quite feeble cylinders," like an aging automobile. The glimpse afforded by the notes into Duchamp's alternative system of reality is like the unexpected sight of oneself in a trick mirror—the familiar is distorted just enough to take it beyond the reach of simple recognition by our senses. The concept of the "Possible" rules supreme: "a physical caustic (vitriol type) burning up all aesthetics or callistics."[13]

Duchamp practiced a unique form of aesthetic economy, perhaps partly born of the French notary's love of minute detail. Consistently turning his attention to the slightest or least-regarded of phenomena, he developed the elusive category which he called "Infra-mince" (a rough translation might be "infra-thin") by compiling examples: the faint sound made by velvet trouser legs brushing together, the difference between the space occupied by a clean, pressed shirt and the same shirt, dirty.[14] Infra-mince is explored specifically in a few isolated notes, including the proposal for a "transformer intended to utilize little wasted energies"[15] (like laughter, the fall of tears, the exhalation of tobacco smoke). But it can be said to permeate Duchamp's life and work in the same way that a preoccupation with color and light radiates through the art of Matisse. For example, the pun, one of Duchamp's favorite devices, operates on a principle of infra-mince by containing two or more meanings within one phrase—the thriftiest use of language, based on tiny shifts of sound or spelling. The *Large Glass* is a triumph of infra-mince, since Duchamp employed the most minute physical operations to determine its visual appearance: the deformation of a piece of gauze by a breath of air, the chance fall of a meter-long piece of string, the feeble "shots" of a paint-dipped matchstick from a toy cannon.

Duchamp occasionally expressed dissatisfaction with even the furthest refinements of both the visual arts and language as ultimately inadequate to the precise expression of an idea, accepting this frustrating limitation as a challenge: "Tools that are no good require more skill."[16] With his puns and his whole modus operandi, Duchamp courts ambiguity and open-endedness. The *Large Glass* was deliberately left unfinished, and he described his last major project, *Etant donnés,* as "une approximation démontable."[17]

Questions persist as to the degree to which many of Duchamp's objects, installations, or publications are to be considered works of art. Does the cover of a magazine, executed with infinite care, or the installation of a bookstore window belong in the same grouping as a study for the *Large Glass* or a Readymade? Remembering that the Readymades and the *Glass* themselves seem worlds apart, one finds the same network of interconnecting threads joining the most disparate items in his oeuvre. Duchamp himself included his optical cover design for *Cahiers d'Art* (*Fluttering Hearts*) in his portable one-man museum, the *Box in a Valise,* and there is an important note of 1913 which refers to "the exigency of the shop window."[18] Paradoxically, other works that might find readier acceptance as "art" were deliberately withdrawn by Duchamp from any aesthetic frame of reference when they first appeared, although they were also to be included in the *Valise.* He wrote to Jacques Doucet, who had commissioned the *Rotary Demisphere,* that he did not wish it exhibited: "I would also be sorry if one saw anything other than optics in this globe."[19] He chose to display his *Rotoreliefs* for the first time not in an art gallery but at the annual Paris inventors' salon, where they vied for public attention (in vain) with a vegetable peeler and a garbage compressor. Two Readymades hanging on a wall, ignored by New York visitors (in search of art) to a modern exhibition at the Bourgeois Gallery in 1916, make a neat contrast to the *Rotoreliefs* slowly revolving before an unmindful Parisian public (in search of practical household gadgets) in 1935. Both occasions must have pleased Duchamp profoundly.

He asked perhaps the crucial question of his career in an early note to himself: "Can one make works which are not works of 'art'?"[20] "Art" in the sense of being loaded with conventional strictures as to how it should look, and be looked at. Duchamp's private mission, with its attendant public repercussions, was to strip the word "Art" bare of all its accumulated paraphernalia and return it to one of its etymological meanings—simply, "to make." He protested that the label "anti-art" did not describe his position: "Whether you are 'anti' or 'for' it's the two sides of the same thing."[21] Instead, he sought to eliminate the demand for a definition of art. Anaesthetics: "There is no solution because there is no problem."[22] His own works persistently function in that aesthetic arena which he vastly expanded but did not destroy, and although he preferred to describe himself as a "respirateur," he ultimately admitted to being "nothing else but an artist."[23]

The last statement holds true even for the period of twenty years between the cessation of work on the *Large Glass* and the first studies for *Etant donnés*. During these years Duchamp devoted himself to a series of optical experiments (two machines, *Anémic Cinéma,* the *Rotoreliefs*) and immersed himself in the calculated risks of roulette and the intense mental activity of professional chess. He applied his acute sense of cerebral beauty to the task of breaking the bank at Monte Carlo in what he described as "un esprit mechanisé contre une machine."[24] The resemblance between the roulette wheel and his own rotating machines must have amused him. Apropos of roulette, his remark in a letter of 1924 to Picabia was not purely ironic: "Vous voyez que je n'ai pas cessé d'être peintre, je dessine maintenant sur le hasard."[25] For an artist who had already raised dust, traced shadows of Readymades, and imprisoned 50 cc of Paris air, sketching on a substance as immaterial as chance expressed a continuing aesthetic concern.

Even what is customarily described as Duchamp's decision to abandon art for chess was not (he himself made this clear) a deliberate decision, nor was it a matter of one preoccupation replacing another. Chess had been a frequent and often passionate pastime since childhood, and it also appealed to him as one of the purest forms of artistic and mental activity. "A chess game is very plastic," he once remarked to Truman Capote. "You construct it. It's mechanical sculpture and with chess one creates beautiful problems and that beauty is made with the head and the hands."[26] He must have intrigued members of the New York State Chess Association with the thought that "Beauty in chess does not seem to be a visual experience. Beauty in chess is closer to beauty in poetry . . ."[27]

Chess is undoubtedly one of the most private forms of artistic activity, since the artist's constructions, however beautiful, occur on the invisible plane of thought and could not be said to please a wide audience. One is reminded of Duchamp's remark to Walter Pach when the latter remonstrated with him about his ceasing to produce easel paintings after the *Bride:* "I have not stopped painting. Every picture has to exist in the mind before it is put on canvas, and it always loses something when it is turned into paint. I prefer to see my pictures without that muddying."[28] Yet even in the unmuddied realm of chess Duchamp rendered a group of his thoughts visible, at least to chess initiates, in his treatise on a rare type of end game: *Opposition and Sister Squares Are Reconciled,* published in 1932. This chess book, compiled and illustrated with elaborate care, was one of a series of publications to which Duchamp devoted his energies during the 1930s. Facsimile versions of the notes ("old papers respected and framed in their original shape only")[29] were issued in the *Green Box* of 1934; miniature replicas and ingenious reproductions of his works were assembled over a period of years for the *Box in a Valise.* In his determination to render the invisible visible, to make his ideas as well as his work accessible to the public, Duchamp eludes the charge of esoterism or elitism. Yet his publications are esoteric by their very nature as limited editions, "limited" inevitably by the amount of painstaking handwork involved in their

assembly and therefore, ironically, available to only a small number of his most devoted students and admirers. Duchamp's work and life hover between the private and the public domains, and paradox flourishes.

The Readymades, for example, function as Duchamp's private method of destroying art "for myself, that's all"[30] by replacing good or bad taste in the selection of an object with pure indifference. Yet a snow shovel hanging on a wall next to a painting has obvious implications for any art audience. *L.H.O.O.Q.*, making free with a work of art whose popular fame had reached mythic proportions, was bound to appear provocative. Characteristically, Duchamp's most aggressive works were not insults to the public or to other artists, but rather challenges to the slow reactions and muddy thinking of so-called avant-garde groups. *Fountain* revealed that the jury-free "Independents" exhibition of 1917 had an invisible set of restrictions after all, and his terse telegram PODE BAL in reply to an invitation to join a Dada salon pointed out that even the radical and disruptive Dadaists of 1920 took cooperation in their events for granted.

The reverse of the proverbial philosopher who loved humanity and hated men, Duchamp remarked, "Art doesn't interest me. Artists interest me."[31] He could wage brilliant war on the pretensions and commercialism of the art world while warmly encouraging individual artists and gauging the quality of individual works with a keen and sensitive eye. His repeated attacks on "retinal" painting did not conflict with a profound admiration for Matisse, nor did his disgust with inflated prices and the art market prevent him from assisting Brancusi by purchasing a large group of his sculptures from the Quinn collection in 1926 when a public auction threatened the sculptor's reputation and livelihood. His conviction that the work of art had a "life" of only about fifty years, and that that life and its possible revival at a later date depended heavily upon the spectator, did not discourage him from efforts to preserve his own work in the *Box in a Valise* or in the collections of his friends.

Throughout his life, an intense desire for privacy alternated with active involvement in public events. As early as 1912–13, Duchamp was known to disappear at intervals, presumably to think and work in seclusion; he "took a trip" to his room, as Gabrielle Buffet described it.[32] Richard Hamilton has pointed out that bursts of creative activity coincided with his visits to Munich (1912), Herne Bay (1913), and Buenos Aires (1918–19), where he knew no one and presumably spoke the languages with difficulty, if at all. His studios in Paris and New York were usually remote rooms, at the top of long flights of stairs, with no telephone. There must have been periods when all but one or two of his closest friends lost track of his whereabouts completely. The *Large Glass* was carried out in the relative obscurity of a sequence of dusty rooms in New York over eight years, and *Etant donnés* was kept a complete secret for twenty. Isolated events like the publication of the *Green Box* in 1934 or the appearance of the 1945 issue of *View* devoted to his work must have seemed like rare and significant messages from the underground.

40

And yet his presence, sometimes lively and stimulating, sometimes benevolent but taciturn, was essential to the gatherings of at least five distinct seminal groups in the arts during his lifetime, as he moved inconspicuously between Paris and New York, appearing in each place at the crucial moment. The years 1911–15 saw his involvement with the Cubist circle around his brothers in Puteaux, where theories of simultaneity and the fourth dimension were vigorously discussed. His proto-Dada association with Picabia and Apollinaire dates from the same period. Upon his arrival in New York in 1915 he was instantly lionized, and he was regarded as a catalytic addition to the avant-garde art world until his departure for Argentina in 1918. In the years from 1919 to 1922 he was greeted with considerable reverence by Breton and his Dadaist colleagues whenever he joined them at the Café Certà in Paris. When the expatriate Surrealists gathered in New York during World War II, Duchamp again emerged as a key figure in projects for exhibitions and publications, and in the arbitration of disputes. Finally, his appearance at Happenings and other events and exhibitions in the late 1950s and 1960s and his interest in a new generation of artists in New York and Paris must be considered in any account of recent developments. It should also be noted that, although by nature a loner, he enjoyed the conspiratorial pleasures of collaboration, whether plotting a Dada event with Picabia, filming his optical devices with Man Ray, or preparing 999 hand-colored rubber "falsies" with Enrico Donati for the deluxe edition of a catalog. His circle of friends was wide, and he knew a remarkable number of individual figures whose international importance in the arts paralleled his own, including such diverse personalities as Edgard Varèse, Alfred Stieglitz, Jean Cocteau, Gertrude Stein, and John Cage.

Not only was his presence a stimulus to new ideas and activities on the part of friends and colleagues, but for all his self-promoted reputation as a "respirateur" his participation in important public manifestations of modern art was frequent and effective. He assisted in the planning and organization of a long series of crucial exhibitions. This began with his involvement in the discussions at Puteaux preceding the Cubists' creation of the Salon de la Section d'Or in Paris in October 1912. Four years later, he was chairman of the hanging committee for the first exhibition of the Society of Independent Artists in New York, and proposed that the nonjuried entries be hung in alphabetical order, beginning with a letter to be chosen by lot. When the end of the year 1918 found him in Buenos Aires, he attempted to arrange for an exhibition of Cubist paintings to be sent from New York, a project which collapsed when his New York correspondents did not reply.[33] As a founder, with Katherine Dreier and Man Ray, of the Société Anonyme in 1920, Duchamp committed himself to the aim of putting the most recent art from many countries before the public, and he actively participated in several projects including a one-man show of Eilshemius and the vast International Exhibition of Modern Art at the Brooklyn Museum in 1926. His reluctance to show his own work—

"according to my principles," as he wrote to the Arensbergs[34]—lasted from 1918 to around 1930 but had no effect upon his desire that the work of friends and colleagues like Picabia and Brancusi be widely exhibited and sold. After 1926 he became Brancusi's representative in the United States and organized and installed two exhibitions at the Brummer Gallery in New York. Beginning with the International Surrealist Exhibition in Paris early in 1938, Duchamp produced ideas for a series of elaborate installations which in typically Duchampian fashion became not only projects to assist his colleagues but works of art in themselves. The same phenomenon is observable in a sequence of catalog covers that are both part of the history of the Surrealist movement and items in a catalogue raisonné of Duchamp's oeuvre.

It is impossible to list here all of Duchamp's contributions to the endeavors of his fellow artists, but his statements, puns, and drawings for numerous exhibition or collection catalogs should be mentioned, as well as his participation over a period of years in the awarding of grants to artists as a director of the Cassandra Foundation.[35] Dealers often consulted his opinion about new work, and Julien Levy has remarked that Duchamp's suggestion of an artist whose work might be shown was made casually and with delicacy but was rarely turned down.[36] It is typical of myriad small occasions involving other artists' work that it was Duchamp who suggested that Jackson Pollock's mural commission for Peggy Guggenheim be painted on a vast canvas rather than directly on the wall of her New York apartment, and then came to the rescue during the struggle to hang the finished painting in its destined place.[37]

As *éminence grise* to a number of distinguished collectors and dealers, Duchamp has directly affected what twentieth-century audiences have actually *seen* in galleries and museums. Although he set himself the difficult task of maintaining total visual indifference in the selection of a Readymade in a New York hardware store, few of his contemporaries revealed such sensitivity to the "aesthetic echo," as he preferred to designate the enduring quality, of a wide range of art.[38] It is no accident that the collection of his friends Louise and Walter Arensberg, for whom he acted as scout and mentor, comprises a group of works of remarkable beauty and coherence, with virtually every object a superb example of the particular artist's work and a key piece of its period. For Katherine Dreier, on the other hand, he exercised his love for catholicity and the widest variety: the permanent collection of the Société Anonyme contains 616 items by 169 artists from Alajalov to Zeller. Peggy Guggenheim has written of Duchamp: "I have to thank him for my introduction to the modern art world,"[39] and he must bear some initial responsibility for the exciting quality of the collection on view at the Palazzo Venier dei Leoni as well as for suggesting ideas for exhibitions at her gallery Guggenheim Jeune in London during the late 1930s.

Throughout his life Duchamp was determined that his means of making a living should not depend upon the direct sale of his own work. Walter

Pach gave a clear explanation of his friend's position when he appealed to John Quinn to help Duchamp obtain a job in the French Institute in New York, in the fall of 1915: "He has always made his living at other employment and while neither he or I have any idea that he would grow commercial if he were to rely on his art for a livelihood he would not have the sense of independence he has had thus far,—and it has been of great importance to him."[40]

With the exception of a flurry of sales from early exhibitions (all four works in the Armory Show were sold), his paintings and objects were given away to friends and relatives, or simply kept around the studio and often lost as a result. The *Large Glass* was originally acquired by the Arensbergs in return for paying Duchamp's rent for several years in New York. From his early days in Paris as a librarian at the Bibliothèque Sainte-Geneviève Duchamp found odd jobs which suited him as being sufficiently removed from the business of making art and yet not incompatible with his deeper concerns. A note in *A l'infinitif,* for example, which refers to the "whole section on Perspective" in the catalog of the Bibliothèque Sainte-Geneviève, suggests that Duchamp made full use of his time there.

Duchamp obviously preferred the free-lance to the settled occupation, and his stints at the Paris library and the French Institute were brief. During the years that followed he was content to earn small sums at irregular intervals, with French lessons and translations. A brief experiment with his own business enterprise, a fabric-dyeing establishment which he launched in collaboration with another French expatriate, Leon Hartl, in the early 1920s, produced a bottle-green shirt which pleased him but proved a commercial failure. The opportunity to write a weekly chess column for Louis Aragon's Paris journal *Ce Soir* in 1937 was as welcome for the modest fee provided as for the subject, and the same was true of a series of lectures Duchamp delivered on his work at various museums and universities in the United States during the 1960s.

Duchamp the librarian, the chess player, the French teacher, the Monte Carlo gambler, the art dealer, the "benevolent technician" for Surrealist exhibitions, the book designer, and (with Man Ray) the assistant camera-man—he seems to slip in and out of these identities with the same mixture of sly humor and gravity with which he assumed the name R. Mutt to sign his *Fountain* or created the enigmatic personality of Rrose Sélavy (a work of art in herself) as an alter ego. His intense dislike for the traditional image of the artist "as a sort of superman"—solemn in beret and smock, reeking of oil paints and turpentine—led him to invest his creative ingenuity in a variety of other part-time professions which partly conceal, partly reveal the artist within.

Duchamp accepted his fame, which flared up after the Armory Show and grew steadily during the last two decades of his life, with an air of philosophical detachment and polite amusement. He took pleasure in the fact that for the world at large his own importance was obscured by the celebrity of his works, and described his existence as "in that mist behind

the glass."[41] His simple, almost ascetic living habits changed very little over the years after the brief round of energetic parties and pranks which characterized his life in the Arensbergs' circle between 1915 and 1918. Despite his fame, there were periods when his financial resources must have been very slim indeed. "Living is more a question of what one spends than what one makes," he remarked to Pierre Cabanne.[42] It was a rare moment when he did not have some project quietly afoot, albeit never a lucrative one, whether a magazine layout, participation in a film sequence, or the slow, intermittent progress of one of his major works. His attitude of amiable and idle onlooker, puffing slowly at a pipe in an apparently empty studio, could not have been more misleading if taken for inertia rather than serenity. The principle of infra-mince in operation: a "minimum of action"[43] but ideas and invention in abundance. Those seeking advice or assistance were rarely refused, interviewers rarely turned away. For a man of intense privacy, he remained extraordinarily accessible.

Duchamp's attitude to the sequence of students and scholars bent on cataloging and analyzing his work was one of extreme tolerance, not to say benevolence. His conviction that "it is the SPECTATORS who make the pictures"[44] rendered him an interested and impartial audience for theories about the meaning of his own oeuvre. Issuing, as it were, a free pass to those wishing to explore the enigmatic regions of his creative activity, he often lent a hand in the explorations. His involvement in so many of the projects, books, and exhibitions devoted to his work is deeply missed in this one. One can only hope that the collective efforts and diverse viewpoints of the colleagues, critics, and admirers gathered within this volume will offer a reflected image of the man and his art which he might have found intriguing.

# NOTES

1. André Breton, "Marcel Duchamp," reprinted in *The Dada Painters and Poets*, ed. Robert Motherwell (New York: Wittenborn, Schultz, 1951), p. 211.

2. Henri-Pierre Roché, "Souvenirs of Marcel Duchamp," in Robert Lebel, *Marcel Duchamp*, rev. ed. (New York: Paragraphic Books, 1967), p. 87.

3. Gertrude Stein, *Everybody's Autobiography*, 1937 (New York: Random House, Vintage Books, 1973), p. 28.

4. See Walter Pach, *Queer Thing, Painting* (New York: Harper & Brothers, 1938), p. 163.

5. See "Eleven Europeans in America," ed. James Johnson Sweeney, *The Museum of Modern Art Bulletin* (New York), vol. XIII, nos. 4–5, 1946, p. 19.

6. Quoted in Harriet and Sidney Janis, "Marcel Duchamp: Anti-Artist," reprinted in Motherwell, *The Dada Painters and Poets*, p. 307.

7. One of "26 Statements re Duchamp," in John Cage, *A Year from Monday* (Middletown, Conn.: Wesleyan University Press, 1969), p. 72.

8. A note from the *Box of 1914*, published in *Marchand du Sel, écrits de Marcel Duchamp*, ed. Michel Sanouillet (Paris: Le Terrain Vague, 1958), p. 31. "Electricity widthwise" and "electricity sideways" are two possible translations.

9. A note from the *Green Box*. This and all translated excerpts from the *Green Box* are taken from the typographical version by George Heard Hamilton and Richard Hamilton, *The Bride Stripped Bare by Her Bachelors, Even* (London: Lund, Humphries, 1960), unpaginated.

10. Note from the *Green Box*: "Musical sculpture. Sounds lasting and leaving from different places and forming a sounding sculpture which lasts."

11. A note from *A l'infinitif*, trans. Cleve Gray (New York: Cordier & Ekstrom, 1966).

12. This excerpt and short phrases in the following sentence are parts of the *Green Box* notes.

13. Note titled "Possible," first published in 1958, translated by Arturo Schwarz in *Notes and Projects for the Large Glass* (New York: Abrams, 1969), p. 78.

14. The example of the velvet trousers is given by Duchamp in a quotation in Denis de Rougemont, "Marcel Duchamp, mine de rien," *Preuves*

(Paris), no. 204, February 1968, p. 46. The example of the shirt is from a note, "Physique de bagage," by Duchamp in *Anthologie de l'humour noir* (1940), ed. André Breton (Paris: Jean-Jacques Pauvert, 1972), p. 333.

15. *Anthologie de l'humour noir*, p. 335. Author's translation of "Transformateur destiné à utiliser les petites énergies gaspillées."

16. Cage, *A Year from Monday*, p. 71.

17. Inscription in manuscript book of instructions for assembly of *Etant donnés*: "a dismountable approximation" (author's translation).

18. Part of a note in *A l'infinitif*.

19. Letter dated October 19 (1925?) to Jacques Doucet, in *Marchand du Sel*, p. 190. Author's translation of "Je regretterais aussi qu'on voie dans ce globe autre chose que l'optique."

20. Note in *A l'infinitif*, dated 1913 on reverse.

21. Interview by Richard Hamilton for the British Broadcasting Corporation, September 27, 1961.

22. Quoted by George Heard Hamilton, "Inside the Green Box," an appendix to the typographic translation of *The Bride Stripped Bare by Her Bachelors, Even*.

23. Richard Hamilton BBC interview.

24. Letter dated March 27 (1925?) to Ettie Stettheimer, in the Stettheimer Archive, Yale Collection of American Literature, Beinecke Rare Book and Manuscript Library, Yale University.

25. Letter dated "le jeudi 1924" to Francis Picabia in *Marchand du Sel*, p. 193. "You see that I have not ceased to be a painter, now I sketch on chance" (author's translation).

26. Quoted in Richard Avedon, *Observations* (New York: Simon and Schuster, 1959), p. 55.

27. Arturo Schwarz, *The Complete Works of Marcel Duchamp* (New York: Abrams, 1969), p. 68.

28. Pach, *Queer Thing, Painting*, p. 155.

29. Undated letter to Alfred Stieglitz (probably late 1934), in the Stieglitz Archive, Yale Collection of American Literature, Beinecke Rare Book and Manuscript Library, Yale University.

30. Remark made by Duchamp during the symposium for the exhibition "The Art of Assemblage," held at The Museum of Modern Art, New York, October 19, 1961.

31. Interview by William C. Seitz, "What's

Happened to Art?" *Vogue* (New York), February 15, 1963, p. 129.

32. Gabrielle Buffet, "Some Memories of Pre-Dada: Picabia and Duchamp," reprinted in Motherwell, *Dada Painters and Poets*, p. 256.

33. Duchamp refers to his attempts to organize a Cubist exhibition in letters to Louise and Walter Arensberg from Buenos Aires dated November 8, 1918, January 7, 1919, and "fin mars" 1919, in the Francis Bacon Library, Claremont, California. His New York correspondents were Gleizes, Henri-Martin Barzun, and Marius de Zayas.

34. Letter dated November 8, 1918, in the Francis Bacon Library.

35. Formerly the William and Noma Copley Foundation.

36. In conversation with the author.

37. See Peggy Guggenheim, *Confessions of an Art Addict* (New York: Macmillan, 1960), pp. 106–7.

38. See Duchamp's remarks in "The Western Round Table on Modern Art," in *Modern Artists in America*, ed. Robert Motherwell and Ad Reinhardt (New York: Wittenborn, Schultz, 1952), p. 27.

39. Peggy Guggenheim, *Confessions of an Art Addict*, p. 47.

40. Letter dated October 10, 1915, from Walter Pach to John Quinn, in the John Quinn Papers, Manuscript and Archives Division, The New York Public Library, Astor, Lenox and Tilden Foundations.

41. Letter dated October 4, 1954, to André Breton, in *Marchand du Sel*, p. 164. Author's translation of "dans cette brume derrière le verre."

42. Pierre Cabanne, *Dialogues with Marcel Duchamp*, trans. Ron Padgett (New York: Viking, 1971), p. 83.

43. In a letter dated September 11, 1929, to Katherine Dreier, Duchamp remarks that "I am trying for a minimum of action, gradually." Dreier Archive, Yale Collection of American Literature, Beinecke Rare Book and Manuscript Library, Yale University.

44. Interview by Jean Schuster, "Marcel Duchamp, vite," *Le Surréalisme, Même* (Paris), no. 2, Spring 1957, p. 144. Author's translation of "Ce sont les REGARDEURS qui font les tableaux."

# MARCEL DUCHAMP
# AND THE
# FRENCH
# INTELLECTUAL
# TRADITION

Michel Sanouillet

NO ONE was more typically French than Marcel Duchamp. It seems that everything in his life converged to make of him an epitome of the French tradition and that, at the very outset, impish sprites gathered at his cradle to give this prince of revolt the most banal family name imaginable. Duchamp (*champ* = field), like Dupont, or like Smith in England, smacks of the soil and evokes generations of hard-working middle-class villagers and anonymous laborers living close to the land. There is nothing exotic or abnormal about it; nothing is less Duchampian than the name Duchamp.

There was also nothing less eccentric than his family upbringing. This revolutionary in art was born to a family of provincial notables presided over by the artist's father, a good-natured and liberal patriarch immortalized in one of Duchamp's first paintings (1910), who was a notary—a respectable profession if there ever was one— in the small town of Blainville.

If at least young Marcel had felt uncomfortable in these cozy surroundings, if he like Rimbaud had hated families and dreamed of "drunken boats" . . . But, on the contrary, the strongest of emotional bonds united the six brothers and sisters and their parents, bonds which for nearly a century were never to loosen. Even if one does not follow Arturo Schwarz in his incestuous interpretation of that situation, one has to admit that there is something mysterious here, for never has so much steadiness and apparent happiness engendered such an upheaval in the emotional and intellectual character of two generations.

The product of a social class which still displayed very definite characteristics at the end of the nineteenth century, Duchamp long retained its traits and peculiarities. Some of these traits were never to leave him: discretion, prudence, honesty, rigor of judgment, concern for efficiency, subordination of passion to logic and down-to-earth good sense, controlled and sly humor, horror of spectacular excesses, resourcefulness, love of puttering, and, above all, methodical doubt.

All these traits characterize both his behavior and his work. Psychologically situated at the opposite pole from his friend and accomplice Francis Picabia, who was extremely Spanish, Duchamp

brought to the expression of his revolt a moderation which would be astonishing if it weren't accompanied by a formidable singleness of purpose. Sparing of gesture and of word, miserly as one can be only in that Normandy where the Bovarys haven't yet supplanted the Grandets, Duchamp meticulously calculated the value of his acts, trivial as well as important. In this respect the short text entitled "Transformateur destiné à utiliser les petites énergies gaspillées" (Transformer Designed for the Utilization of Small Wasted Energies), which appeared in André Breton's *Anthologie de l'humour noir,*[1] is singularly revealing.

Duchamp brought to the management of his intellectual heritage the same careful attention his father had applied to the care of the family fortune. Time has proved him right, for never has an oeuvre of such slender proportions produced such impressive dividends.

Those eminently French characteristics that Pascal identified in his countrymen, the bent for precision and the bent for clarity, are to be discerned in Duchamp, even in his physical appearance, with that direct and disarmingly ironic gaze, the free and easy bearing, the clarity and subtlety of his remarks, and his rejection of lyricism and grandiloquence.

It is especially his sense of underplayed humor, exploding at times into sardonic laughter, and his taste for practical jokes that appear in his works and attest to the persistence of that "sense of trickery" which stems from a long French intellectual tradition. A descendant of Voltaire and of Beaumarchais, Duchamp has an innate gift for resourcefulness—what the French call *le système D,* or *débrouillage,* a genius for getting around difficulties, for converting leftovers, for tinkering, and an automatic revulsion in the face of any prodigality.

On the other hand, his obvious scorn of money distinguishes him from his compatriots. The Frenchman, especially the small wage-earner, is traditionally grasping—a trait explained by a long history of exploitation, pillaging, and devaluations. Above all he values stability, surrounding himself with guarantees—often illusory—and insurances, staking everything on security. In contrast to this attitude, Duchamp always lived in a state of frugality that

at times approached destitution, and he never appeared to be affected by it. Moreover, he never hesitated, for fear of scandal, to burn bridges behind him, notably when in 1915 he sailed off for America.

There is no doubt that from then on he adapted himself quickly and smoothly to another style of life and to a different intellectual climate. But it was too late in his own life (he was twenty-eight at the time) for mental patterns and habits acquired during his childhood and early manhood to be fundamentally altered. Even when he expressed himself in English before a receptive English-speaking audience, he thought in French, and it was the Cartesian dialectic that structured his thoughts and acts.

## THE MIND'S DOMINION

FROM HIS earliest childhood, Duchamp seemed to those around him an intellectual, that is to say, an individual passionately interested in the adventures of the mind, in the cerebral play of thought and the delights of pure intellect. Without declaring that he went astray in following his brothers into a career in the plastic arts, we must point out that his visual works owe their full germinal force to their mental content. The notes he wrote leave no doubt in this respect. Duchamp insisted on explaining each of his themes, first defining for himself their ins and outs, the approaches to them, and with a sometimes frightening lucidity evaluating their eddies and undercurrents.

In his remarks on art Duchamp never tired of repeating his determination to reinject some gray matter into easel painting and to abolish the differences between painting and writing. For him the two were analogous forms of optical perception involving not simply the aggregate retinal understanding of a play of form and color, but the rigorous deciphering of a new semiological code made up of signs which are equally significant whether they be letters, lines, or colors.

At the same time, while praising the dominion of the intellect to painters, Duchamp openly displayed his distrust of literature. This was initially a visceral reaction against the verbiage of the writers rotating around Apollinaire, Max Jacob, and Cocteau who were intoxicated with the sound of their own

words. Refusing to compete with these princes of the Parisian literary world and very little attracted to the quarrels of the salons, Duchamp withdrew into an ascetic and laconic world where words would be rare but packed with meaning. We find the same stripping down, the same rejection of lyricism, in both his writing and his "objets-dard."

It would be difficult to explain this double calling of the artist, at one and the same time toward an intellectualization of painting and toward a demystification of literature, if it were not pointed out that, because of his personality as well as his situation in time, Duchamp stands at the crossroads of two typically French traditions. The first is a literary tradition perpetuated through schooling and the conventional social structures. The second, and certainly the more ancient, is the tradition of popular culture, popular and even common, which has come down to us orally from the earliest days of the French nation.

### THE WRITTEN TRADITION

SCHOLARS have argued over the exact breadth of Marcel Duchamp's literary culture. The fact is, as he himself declared, he read very little. Intellectual, even cerebral, he certainly couldn't escape the literary culture of his period. But the few literary references that have come from his pen are not to classic authors or to writers fashionable at the time. He mentions neither Molière nor Proust, but rather a few "literary Impressionists" like Mallarmé or Rimbaud, counterparts of Seurat, whom he admired for reasons that had to do hardly with content, but rather with questions of form, sonority, handling of language: "It isn't simply the structure of his poems or the depth of his thought that attract me."[2]

He appreciates Mallarmé for the very characteristics that put off a number of readers, and notably for his hermeticism. Duchamp finds him "simple"; "in a sense he's simpler than Rimbaud."[3] For Duchamp, poetry is born of the denaturation of words. He does not understand what the Parnassian school calls Art; he readily identifies it as artifice. However, he is pleased to see "the words of the tribe" distorted, torn out of their semantic field, and given a significance in themselves, outside of any logical norm. This play with words requires no reference to literary baggage. It has its validity for any reader, whatever his cultural background.

Later, Duchamp undoubtedly broadened his literary knowledge, particularly after he moved to Paris. His stint in 1913 at the Bibliothèque Sainte-Geneviève gave him easy access to the world of books, and it wasn't a pure coincidence that it was around this time that he started the drafting and elaboration of the notes of the *Green Box*. Influenced undoubtedly by the authors encountered in his eclectic reading, he discovered the virtues of a certain form of verbal expression and

Title page of the 1919 edition of the *Vermot Almanac*. The year 1919 marked the beginning of Duchamp's most intense punning period, when he contributed aphorisms and *contrepèteries* to several Dada periodicals.

decided to use its explanatory and contrapuntal value in conjunction with his great symbolic work.

Who were these authors? In his interviews, writings, letters, and personal conversations, Duchamp has enlightened us somewhat as to the influences which, around the turn of the century, worked on him and in a sense determined the direction of his intellectual career and the form of its plastic expression. The artist's biographers have lingered over these influences, but the matter requires some clarification. Let us simply note beforehand that the influences listed by the researchers were not necessarily the most decisive ones, even if they were acknowledged by Duchamp himself.

To be sure, in a society and at a time when a young artist prided himself on being "stupid as a painter" and where any true exchange between the world of letters and that of art was still far from being a reality, Duchamp differed from his Montmartre and Montparnasse contemporaries in his knowledge of the authors of the time. The reason for this lies in his family background. Notary Duchamp in Blainville was a well-informed man who made a point of being "in the know"; his library contained the most representative works of the preceding literary generation. It was and still is considered good form in the provinces to show a familiarity with current literature.

Moreover, although we know very little about Marcel's elementary and secondary studies, he seems to have had a precocious taste for the Symbolist poets. But, as we shall see, it would be rash to extrapolate and to venture any further into gratuitous hypotheses.

At best we can be certain that his literary culture never approached in scope or depth that of certain Surrealists, notably the encyclopedic André Breton. From the beginning, Duchamp focused on authors of a certain kind, marginal writers who had openly disdained the conventional status of artist and poet and whose life style was very different from that of their contemporaries, those who had attacked the very structures of their society by various original means: the proto-Dadaist gesture of scorn and anger, the vocation of failure, the championing of doubt, the use of new language made up of vulgar words, neologisms, aberrant figures of speech, abstruse rhetorical usages, or quite simply syntactical structures unintelligible to most ordinary mortals.

All or some of these criteria can be applied to a half-dozen writers who composed the literary microcosm of Marcel Duchamp: Joris-Karl Huysmans, Lautréamont, Jules Laforgue, Arthur Rimbaud, Alfred Jarry, Raymond Roussel, Jean-Pierre Brisset, Stéphane Mallarmé—the first apostles of a counterculture that was to reach its apogee in the middle of the twentieth century.

Thus Duchamp is linked to French Symbolism, but to the eccentric branch of the movement that Jules Laforgue

called the Decadent School, which took shape after 1880. It is in a novel by Huysmans, *A rebours* (1884), that Jean des Esseintes, archetype of the antihero of modern literature, makes his appearance. Outside the mainstream of French letters, which was still following the traditional psychological vein, the Decadents preached the abolition of social structures, exalted philosophy over literature, and worked to reduce the opposition between art and life. They challenged the Romantic myths, especially that of the woman-muse, whom they deliberately reduced to the rank of pleasure object. Contrary to the orthodox Symbolists, who rose up against Naturalism, the Decadents espoused the anarchist, antisocial, positivist, and irreligious sentiments of Emile Zola. Most of the Decadent authors gave proof of a chronic pessimism and took refuge in a disillusioned irony. This behavior is expressed in their works by a concerted action against linguistic constraints; they create a profusion of new words and joyously violate grammar. "Huysmans' style," writes Breton, ". . . is the product of a fraudulent misuse of many vocabularies whose combination in itself provokes spasmodic laughter while the circumstances of the plot least justify it."[4]

Duchamp's early interest in Jules Laforgue is evidenced by the series of sketches he executed to illustrate some ten poems by the author of *Complaintes*. Three of these drawings are known to have survived: *Encore à cet astre,* considered to be the first rough sketch of *Nu descendant un escalier; Sieste éternelle;* and *Médiocrité*. Duchamp again and again evoked the early fascination that the baroque and lunar sensibility of Laforgue held for him, and in particular the character of his Hamlet in the *Moralités légendaires,* a new, strange, and disturbing des Esseintes, a caricatural and minor-key counterpart of Shakespeare's hero.

Of themselves the drawings in question would not merit any special consideration if it weren't for the fact that Duchamp was so sparing in his allusions to his sources, and if their execution were not situated at a crucial time in Duchamp's life and work, that is to say late in 1911, when the artist's style began to change radically and when he conceived the model of chronophotographic analysis which is represented without ambiguity for the first time in

The *Vermot Almanac* page for Friday, March 28, 1919. A typical sample of the almanac's contents. Here "L'admiration ou la demi-ration" (Admiration or Half-Ration) recalls some of Duchamp's verbal exercises, such as "Moustiques domistiques (demi-stock)."

the painting *Jeune Homme triste dans un train*. Duchamp had originally entitled that work *Pauvre Jeune Homme M*, which is precisely the name of one of Laforgue's *Complaintes*. We know that what attracted Duchamp to Laforgue was "less his poetry than his titles."[5] Aren't we then justified in thinking that the idea for that painting has its origin in a sketch which is lost today and which belonged to the 1911 series?

One can conclude that underneath their technical and impassive appearance, the chronophotographic paintings of Duchamp hold a secret emotional content, as Duchamp's biographers long suspected. Thus we should be talking not about the "literary" influence of Laforgue on Duchamp, but about an identification with intimate personal behavior at a time when Marcel, like Hamlet, bends thoughtfully over the skull of the person

The *Vermot Almanac* page for Thursday, April 10, 1919. The piece entitled "Bizarreries de la langue française" lists a few syntactic puns (such as "Les idées noires font passer des nuits blanches") quite close to Duchamp's.

he was and the person he will become. Behind the enigmatic visage which Man Ray, in his 1923 painting, proposed for the Duchamp legend, behind those attitudes of a modern dandy, sovereignly detached, is silhouetted a mysterious personage whose faults and desires have been glimpsed by only a few privileged individuals.

The same observation holds for Duchamp's debt to Alfred Jarry. There also appearances are misleading. It is true that Duchamp agreed, late in his life, to be a mamamouchi, a satrap, or whatever in the College of Pataphysics, that Parisian band of zealots devoted to perpetuating (and often distorting) Jarry's philosophical pranks. But his acceptance of the post appeared to be a jest in keeping with the systematic "Why not?" of Duchampian philosophy rather than a formal adherence to Jarry's basic outlook on life as fossilized by latter-day college boys. Here again

only a comparative behavioral study could throw some light on the strange attachment on the part of the elitist and reserved Father of the Bride for the eccentric, baroque, and exuberant pronouncements of Ubu's Daddy. Jarry and Duchamp showed an identical dryness of mind so far as popular romantic feelings went. Jarry gleefully presents a mass "debraining" ceremony, and Duchamp's *Large Glass* clinically comments on the Bride's "deflowering." Both hate the concept of taste, be it good or bad. However, Jarry's influence on Duchamp should not be overstressed. Even the similarities in the use of linguistic inventions that are often offered as evidence by modern critics are not a deciding factor, for in that respect Duchamp had more potent and convincing experiments to look to for inspiration. One was the work of Jean-Pierre Brisset.

"Looked at from the point of view of humor, the work of Jean-Pierre Brisset owes its importance to its unique situation, dominating the line that links Alfred Jarry's *pataphysics* . . . to Salvador Dali. It is striking to note that the work of Raymond Roussel and the literary work of Marcel Duchamp were produced, with or without their knowledge, in close connection with that of Brisset, whose empire can be extended up to the most recent attempts at poetic dislocation of language."[6] In this introduction to the selections of Brisset's work published in his *Anthologie de l'humour noir*, Breton was the first to point out the bond linking the preoccupations of Duchamp, Jarry, Brisset, and Roussel. A new tradition, born of the multiform experiments of Symbolism in the domain of poetics, arose spontaneously in France at the beginning of the twentieth century. This new movement sprang from a sudden shift in the intellectual orientation of certain men of letters, and the growing sense that a radical alteration in the nature of the creative act was taking place. No longer interested in the connotative function of language, in the emotive effects to be achieved by manipulating verse forms, in the triumphs already achieved by the Romantics, the Parnassians, and the Symbolists, writers now began concentrating on verbal cells in their pure, denotative function, then on the anarchic development of these cells in the presence of certain catalytic agents, and finally on the rupture of the conjunctive tissue

that had united them ever since language had come into being.

This cancerous process, with its inevitable metastases, can be observed in its classic form in the famous *merdre* of Jarry, where the addition of a single malignant letter to an obscene word provokes a tumor that brings on the functional denaturation of the original word. Duchamp systematically used this archetype as inspiration and, Einstein-like, formulated the equation for linguistic relativity: Art/Arrhe = Merde/Merdre.[7] From this equation, the $E = MC^2$ of contemporary art, every imaginable linguistic theory can be constructed.

Of course, critics have not failed to point out that Duchamp takes his place in a long line of language innovators going all the way back to the Middle Ages. But it would be wrong to see his gesture as only the latest in the perennial transmutations imposed on the poetry of the past. The Duchampian alchemy is different—in its nature, in its origin, and especially in its objectives, which are of a systematic and didactic order. Like Brisset's *Grammaire logique,* Duchamp's notes on language aim at the exemplary rigor and universality of a manual on correct diction. Beginning with simple rules (polysemy, methodological alteration, etc.), Duchamp proposed the use of a new phonetics, a new morphology, and a new syntax which, to start off at least, would adopt the methods and the categories of traditional grammar, but with the single purpose of attacking it and finally demonstrating its shakiness and inadequacy. From Brisset he borrowed inflexible reasoning founded on the obstinate exploitation of variant stereotypes and semantic confusions occasioned by phonetic identities which in the end open up onto vast and strange domains where words can play freely.

Going much further than Breton, who constantly demanded respect for syntax, Duchamp glaringly violated every rule and spurned the prescribed constructions for phrases and sentences. He fled anything that could bring to mind high culture, the picturesque, local color, sentimentality—in a word, *style.*

In 1912, at the Théâtre Antoine, Marcel Duchamp, in the company of Apollinaire and the Picabias, attended the production of Raymond Roussel's *Impressions d'Afrique.* He enjoyed the play enormously—the production in fact

Catalog of the Manufacture Française d'Armes et Cycles de Saint-Etienne, 1913, page 206. The graphic demonstration gives concrete meaning to abstract statistics as it shows "What Our Swallow Bicycles Can Take."

more than the text, which oddly enough Duchamp declared he "didn't remember very well," not having listened carefully as he watched this mad carnival of frenzied action and delirious language.

It is remarkable that Duchamp, who attached more importance to people than to works, never made the necessary effort to meet Roussel personally. As for the writing process that Roussel was to explain in *Comment j'ai écrit certains de mes livres,* it is obvious that

Duchamp could not have known of it until very late (it was published in 1935), at a time when his own theories had long been written down in his notes. If there is a kinship between the word games of Roussel and those of Duchamp it can only be coincidental. Hearing and seeing *Impressions d'Afrique* probably did no more than confirm the creator of the *Large Glass* in convictions already established with respect to primary words, the nonsignificant, and the mathematics of lin-

## VÊTEMENTS DE SPORTS

## PANTALONS, CULOTTES, COSTUMES DE GYMNASTIQUE

Catalog of the Manufacture Française d'Armes et Cycles de Saint-Etienne, 1913, page 448. The sportswear presentation on invisible dummies lends these objects an eerie appearance akin to that of Duchamp's *Cemetery of Uniforms and Liveries.*

way above the melee, is the fact that early in his career he was led to move in a particular milieu, among the journalists, cartoonists, and artisans of Paris more than among the fashionable painters and men of letters. Thus he kept close to a French oral tradition that manifests itself in a thousand different ways in the life of the average Parisian: argot, vulgar words, "in" jokes, puns, the language of pamphlets, ads, almanacs, etc.

It is worth considering the almanacs in particular because they represent the surviving expression of a social phenomenon which began at the end of the sixteenth century and which attained its height toward the middle of the nineteenth century, when more than four million copies of various almanacs were circulated throughout the French countryside and to the less cultivated classes of the big cities.

One of them, the *Vermot Almanac,* a "little museum of French popular humor and traditions," which was founded in the 1880s and still has a printing of tens of thousands of copies, recaptures an old Rabelaisian vein which was in eclipse, at least in literary form, for several centuries. Since its first publication intellectuals have looked with sovereign contempt on this collection of vulgarities, elementary puns, spoonerisms, punning riddles, jokes that approach the obscene, all mixed in with horoscopes, weather forecasts, kitchen recipes, popular remedies, proverbs, gardening hints, etc.

An examination (benefiting from a perspective stretching over nearly a century) of seventy-three issues of the *Vermot Almanac,* which constituted the only library for millions of households, permits us to appreciate the capital importance for the history of French contemporary ideas represented by the crystallization in printed form of an "underground" linguistic tradition that thrusts its roots deep in the collective unconscious of a people.

This is what Marcel Duchamp—and perhaps Duchamp alone in his time and in his milieu—was able to grasp, and this when it was considered good form in the Proustian salons of the Faubourg Saint-Germain to affect a preciosity of language far removed from popular culture. Apollinaire, who also had his ties with the street, early noted Duchamp's instinctive communion with a certain vernacular style, and this provides the

guistic subversion. Moreover, Duchamp never pushed his linguistic research as far as Roussel, nor did he show the same quasi-pathological and systematizing obstinacy—an exercise little in keeping with the ironic detachment he conferred upon everything he touched.

### POPULAR TRADITION

WITHOUT minimizing the diverse literary influences that could have worked on Marcel Duchamp during his first

Parisian period (1906–15), I feel they do not suffice to explain the artist's basic originality or his specific contribution to the history of contemporary ideas. If he had merely read Rimbaud, Mallarmé, or Laforgue, like so many of his contemporaries, he would doubtless have developed an allegiance, like the other Surrealists, to a group of aesthetic rules, and he would have integrated himself into the major literary current of the twentieth century.

What sets Duchamp apart, and in a

sense we should apply to the frequently misinterpreted prophecy by the author of *Calligrammes,* that it will be given to Marcel Duchamp "to reconcile art and the people."[8] Apollinaire was not mistaken and hadn't, as Duchamp himself thought, just written "whatever came into his head."[9] Adding a moustache to the Mona Lisa and calling the work *L.H.O.O.Q.* is certainly an iconoclastic act, but it is above all a gesture that bypasses the normal circuits of culture, going over the heads of the mandarins and litterateurs to meet the common people on their own ground, those precisely who buy the *Vermot Almanac* and devour it without sneering.

What was the *Vermot Almanac* publishing when Duchamp began reading it? Exactly the kind of linguistic games to be found in his writings and his paintings. In fact one should note that the Duchampian diversions belong not to the "noble" domain of wit, but to the most directly communicable and understandable kind of humor. Most of the verbal twists of *Rrose Sélavy* can be understood without any excessive mental effort. So also the elementary verbal mechanisms brought into play in the puns of the *Vermot Almanac* have their source in the jokes exchanged on the benches of French schools where nearly the entire population has worn out the seat of its pants. Witness the universally played game which consists in forming a verbal chain by using as the first syllable of a word the last of the preceding, aside from any consideration of semantic link: "Comment vas-tu-yau de poêle." Roussel and Brisset based their expression on the same mechanisms—which simply proves that the underlying current had finally gained enough force to assert itself explicitly in avant-garde thought.

It is of course next to impossible to translate or even explain in any other language the approximations, paradigmatic variations and warpings of stereotyped collective data. These stereotypes are products of the tribal unconscious, special instruments of communication for a social class that remained in a cultural limbo for centuries; and these commonplaces, which Baudelaire had already understood as containing the essence of the human

spirit, offer a privileged point of departure for individual as well as collective imagination. We are closer than one might think to the procedure of Surrealist automatic writing, in that the stimulus is provided arbitrarily, aside from any semantic intention. The proverb, the saying, in short the "public" word, serves as a catalytic agent, then as a "generator" (Chomsky), or "incipit" (Aragon). With Duchamp, as in the case of most of the Surrealists who engaged in some form of creative automatism, the strictly mechanical part is limited to the start of the exercises. Consciousness then intervenes and embellishes, starting from a determined cultural base which is characteristic of each individual and grist for the "ideatic" mill. The initial syllable suffices to initiate a process whose development requires only a set of elementary cultural references that adapt themselves without major problems to the fundamental patterns of proletarian thought, which has no other means for attaining an awareness of its own identity.

There isn't the shadow of a doubt in the mind of those who spoke with him about these problems that Duchamp knew what he was doing in using this unwonted and reputedly vulgar mode of literary and artistic creation. While drawing readily on the literary domain mentioned previously, Duchamp used all the other sources of information which his unfailing curiosity revealed to him. He never tired of repeating that he was above all an artisan, a tinkerer. I remember spending long hours in his company going through old catalogs of the Saint-Etienne Gun and Cycle Factory, which have been reaching modest country homes and French working-class suburbs for about as long as the *Vermot Almanac.* It's there no doubt that Duchamp got the idea of the notes for the *Large Glass* (the "boxes" of 1914, 1934, *A l'infinitif,* and other documents which have been lost or discarded by their author): in the definitions which were exact, neutral, technical, impassive, however fantastic the object represented.

I reexperienced that sense of marvel recently with Michel Butor, a great Duchamp admirer, as we looked through one of the latest Manufrance catalogs devoted to artificial eyes for

stuffed animals—eyes "created individually and by hand with choice enamels by artisans whose skill is a guarantee of a perfect imitation bearing no relation to industrially fabricated eyes which are devoid of all expression." In the midst of that profusion of eyeballs for mammals, birds, and fish, each differing in form and color, from the orange eye of the vulture to the greenish-yellow eye of the tiger cat, we were at the heart of a new poetic microcosm where magisterial objects, stripped of any contextual significance, assumed a role at once enigmatic, symbolic, and esoteric. It is easy to understand the fascination that illustrations in didactic works exercised on Max Ernst and the other Dada and Surrealist collagists, whose work thus parallels Duchamp's.

It is here, in this documentary material neglected up to now by the literary world, that we should seek, if not the source, at least the resurgence of an antiartistic current which attains its full force in the Readymades and then in each of the "objet-dards," where object and commentary are allied in an endless contrapuntal play of syllables.

The view that Marcel Duchamp took of the world and the way in which he translated that vision into words or into plastic signs appear at first to be radically new. His originality is such in all realms that one is tempted to see in his appearance at the turn of the century an accident of history, a break in continuity of the intellectual evolution of humanity—in a way, the birth of a "man born without a father."

That would be a superficial analysis. Actually, there is nothing of the "man from Mars" about Duchamp. He belongs firmly to his country and to his time in history. But instead of being perfectly integrated into a strongly determined sociocultural milieu that produced homogeneous and evolutive art, he unites in his person several modes of expression which previously remained separate, in hermetically sealed compartments. This is the explanation for the disruptive character of his works and the general uneasiness they still provoke. There are, of course, successful marriages that the in-laws persist in calling mismatches.

—*Translated from the French by Elmer Peterson*

## NOTES

1. André Breton, *Anthologie de l'humour noir* (Paris: Editions du Sagittaire, 1940), p. 225.

2. Pierre Cabanne, *Dialogues with Marcel Duchamp,* trans. Ron Padgett (New York: Viking, 1971), p. 105.

3. Ibid.

4. Breton, *Anthologie de l'humour noir,* p. 110.

5. Interview with James Johnson Sweeney in "Eleven Europeans in America," *Museum of Modern Art Bulletin* (New York), vol. XIII, nos. 4-5 (1946), p. 19.

6. Breton, *Anthologie de l'humour noir,* p. 146.

7. *Boîte de 1914,* in *Marchand du Sel,* ed. Michel Sanouillet (Paris: Le Terrain Vague, 1958), p. 33.

8. Guillaume Apollinaire, "Marcel Duchamp," in *Les Peintres cubistes: Méditations esthétiques* (Paris: Figuière, 1913), trans. Lionel Abel (New York: Wittenborn, Schultz, 1949), p. 48.

9. Cabanne, *Dialogues with Marcel Duchamp,* p. 30.

# THE LARGE GLASS

Richard Hamilton

*La Mariée mise à nu par ses célibataires, même* (the *Large Glass*) is most of Duchamp; earlier paintings feed its voracious capacity, and half a century later the saga of the stripped bride was painstakingly pressed into new molds to build another astonishing perception, *Etant donnés*. Duchamp's incomparable mind disdained the role assigned it by Parisian art; he saw through every sham, subjecting his own talent to no less fierce a distrust. This aggressive humility (it might be mistaken for arrogance) nourished the little inventor. If he could conceive of something, then he could try to give that thought form; insisting that "art, etymologically speaking, is to make," his occupation was to tinker. An artisan's approach to fabrication freed his mind to soar way out of sight while the constructs remain gloriously unpretentious. Discussion of the *Large Glass* will involve a good deal of description of techniques and methods; though its prefiguration—a leap of the imagination that is, in some minds, the ultimate heroic feat of Modern Art—was accomplished in some few months, twice as many years were to be devoted to laborious detailing and execution.

There is a well-marked starting point. The drawing made soon after Duchamp reached Munich for a visit in July–August 1912, on which was written "Première recherche pour: La mariée mise à nu par les célibataires," nearly the title given to both the *Large Glass* and to the boxed annotations that are an integral part of the total work, can be seen as an illustration of its legend. It shows a central female figure attacked at either side by two rampant males. Ulf Linde first observed that the drawing bears a resemblance to an illustration in a treatise by Solidonius—an insight which proliferated into the fashionable notion that alchemy provides a key to the iconography of the *Glass*. Ingenious and amusing as later cross-referencing with esoteric texts and images may be, it must be said that Duchamp gave this no credence. An inspiration (frequently mentioned by the artist) was his enthusiasm for the work of Raymond Roussel, whose play *Impressions d'Afrique* he attended in the company of Apollinaire, Gabrielle Buffet, and her husband Francis Picabia during its run in May–June 1912—an excitement carried fresh to Munich. But the *Large Glass* is born of Duchamp's perversity. It springs from the intensity of his will to seek only within himself the rules of a game of his own devising. Unquestionably the Munich drawing coincides with the purpose and the graphic language of the works that immediately precede it (*King and Queen Traversed by Swift Nudes*, for example), which owe something, in both intention and style, to the *Nude Descending a Staircase*. Two subsequent drawings, both called *Virgin*, lead to the small painting *The Passage from the Virgin to the Bride*, which in turn acts as prompter to the climactic Munich painting, *Bride*. The chronology is plain, and that sequence is vital to an understanding of the creative mystery of those fecund weeks in Germany. The logic of Duchamp's purposeful progression, his persistent questioning of these products of his own fantasy, offers the best clue to the genesis of the *Glass*.

In Munich, his interest in chronophotographic representation of movement, most rigorously applied in the descending nude, went beyond the brisk graphic style of the intervening works to engage in a new inquiry. If the subject is time and space, in what way, he asks, can such a subject be pictured as a formal entity? And then, what attributes, what functions, what desires and psychological peculiarities does that time-generated structure possess? The crisis occurs with *The Passage from the Virgin to the Bride*. Its figurative language stresses spatial movement; yet the transposition from virgin to bride cannot be a displacement from here to there, nor is it an illustration of deflora-

tion. The subject undergoes a metaphysical change, and a search for the identity of that change is the motivation of the *Bride* painting. The *Passage* configurations are here crystallized into well-defined forms, indications of transference are firmed into volumes, kineticism gives birth to a new formal state.

Returning home in August 1912, he was very sure that, for him, painting was over; the extremity of effort, the conclusiveness of the *Bride* were traumatic. Paris provided a convalescence from the fervor of Munich and relief from his isolation there. A key event followed: he made a weekend trip to the Jura mountains, arranged by Gabrielle Buffet, with Picabia and Apollinaire (the group that had attended *Impressions d'Afrique* together). Duchamp was moved by the fast car ride across France to produce a prose fantasy. A machine, with an animal component, is described as absorbing the long, straight, empty road, with its cometlike headlights beaming out in front toward a seeming infinity. The text turns to a speculation on the graphic means by which to express this mechanomorphic object in a limitless one-dimensional space; only at the end does it become evident that a painting is being proposed, one that will require detailed planning.

Although resolved that painting, per se, was untenable, he was nevertheless stuck, for the moment, with the pictorial modes he so firmly rejected. His Jura-Paris text was full of vague notions about the possibility of using materials other than artist's pigments, but another painting was made in January 1913. It portrayed a chocolate grinder he had seen displayed in the window of a well-known confectioner in his hometown, Rouen. *Bride* was the first canvas for several years in which physical motion was not illustrated, though movement is its rationale. *Chocolate Grinder, No. 1*, a literal picture of an odd object, stands three-square on a tabletop; its formal existence is so totally dependent on function that motion is implied without explicit representation.

The stay in Munich had been a period of separation from friends, and isolation was the more complete for Duchamp because he spoke little German. Another period of similar containment followed with a visit to Herne Bay, on the south coast of England, in the summer of 1913, ostensibly as chaperon to his sister Suzanne. It was here that *The Bride Stripped Bare by Her Bachelors* began to take shape in written notes which establish the chemistry and mechanical performance of the complex apparatus to be depicted. These notes, together with others made over the next few years—none more than a single sheet of paper, often a torn scrap—were to be published in 1934 as facsimiles of the originals in a green box. Though a sequence for the notes was never prescribed by their author, it is fair to assume that among the first was the longest and most ambitious. It is headed "the Bride stripped bare by the bachelors" and begins:

*2 principal elements: 1. Bride*
                              *2. Bachelors*

*Graphic arrangement*
*a long canvas, upright*
*Bride above—*
*Bachelors below.*

There follow detailed descriptions of the two elements as machines. They have interrelationships, but the Bride's domain is strictly separated from that of the Bachelors by a "cooler." Above the earthbound, "fat and lubricious" Bachelors hangs the Bride, "an apotheosis of virginity" who has reached the "goal of her desire" and emits a "cinematic blossoming . . . the sum total of her splendid vibrations . . . the orgasm which may (might) bring about her fall." A thumbnail sketch indicates the composition with its three glass

fins which forever divide MARiée from CELibataires. Quotation from the notes unfortunately distorts their quality; intimacy with all the texts and diagrams of the *Green Box* is the best, indeed the only, way to achieve true understanding and enjoyment of the *Glass*.

The annotations for the upper half of the *Large Glass* begin with a consideration of the Munich *Bride*. They are an after-the-fact determination of a possible physical nature and operation, justifying the fortuitous disposition of forms which would be abstract if they did not give a strong illusion of existence and if some alien causality could not be read into them. Duchamp crosses into this other reality, reducing its fantastic character by playing it very straight with descriptions as precise as those of a patent engineer. Each constituent is named, and its function and interactions with the whole are stated with inexorable logic. The Bride in the Munich canvas floats vacuously in her mesh of paint—in the new work she will hang free on the glass. "The *Pendu femelle* is the form in *ordinary perspective* of a *Pendu femelle* for which one could perhaps try to discover the true form." In spite of his precision, or maybe because of it, Duchamp sees any configuration as arbitrary—it is one fixed state in a flux of time and space. The images of the *Glass* are a "Delay in glass . . . not so much in the different meanings in which delay can be taken, but rather in their indecisive reunion."

As the *Bride* canvas gives birth to the upper half of the *Glass*, so the only pure painting to follow it, *Chocolate Grinder, No. 1*, is the starting point of the Bachelor Apparatus. Duchamp thought always in terms of oppositions, so the Bride's irregular organic shapes and hinged, flexing relationships are contrasted with the Bachelor's predetermined, mensurated, rectilinear planning and simple mechanical movements. The *Bride*, painted with the artist's fingers directly, a perfect tactile communion with *matière*, had induced a disgust with sensual aspects of painting. The Bachelor Machine, conceived after the Bride, would be drafted with measured care, its members plotted to a millimeter, the hand distanced from the surface with instruments. The most remarkable aspect of the arrangement of the lower part of the *Glass* is that it was not *composed* in perspective. The Bachelor features were conceived from above, for the first drawing of the whole Bachelor Apparatus is evidently the "plan" included in the *Green Box*. The circular platform of the Chocolate Grinder occupies a central position; its stem is the core from which all other dimensions are generated. Parallel with the plan is, of course, an "elevation" which carries all vertical information to complete a three-dimensional record of the apparatus. With these figures at hand, two-dimensional composition consisted of positioning the central vanishing point (nicely judged at 11.8 cms left of the grinder's center, roughly the viewpoint of the original grinder painting), which locates the spectator relative to the objects depicted, projecting the perspective, and then deciding where to place the edges of the glass. No perspective treatments were necessary for the Bride panel.

The next two years were spent in consolidation and refinement. With the aid of the "General plan—perspective," the elements of the Bachelor Apparatus could be treated separately. Duchamp returned to the grinder and made a new painting, redrawn to marry it perfectly with the general plan. *Chocolate Grinder, No. 1* was visualized as an object standing on a surface with a fixed point of illumination, a classic perspective exercise; indeed, shadow cast by curved forms on curved surfaces is pure textbook study. *Chocolate Grinder, No. 2* takes the image to another realm, where it becomes a philosophic statement concerning the nature of two-dimensional representation. The subject is no longer illuminated from a point source, color is applied flat and

unmodulated, additional lines made with thread sewn through the canvas radiate from the centers of the rollers and turn across their slightly tapered sides—no longer a likeness but an object flattened, re-created in two dimensions on a background painted in the flat blue tint he used to symbolize a neutral, vacant ground. By this time (winter 1913–14) the perspective of the whole Bachelor Apparatus had reached full size, drawn on a plastered wall in his studio. Thread is very helpful in making a perspective drawing of this size. Since the vanishing points are a considerable distance from the image, a ruler would have to be long—and therefore clumsy. The simplest method is a nail driven into a vanishing point; from the nail a thread can be pulled taut to the position required for any particular line. The technique of drawing with the thread itself on the *Chocolate Grinder* canvas is an invention more plausible than its concurrent use to make *Three Standard Stoppages.*

Einstein's theory of relativity was just then being discussed at a superficial level in the popular press, and Duchamp gave an ironic twirl to the notion of the standard meter being modified by movement through time and space. "A horizontal thread one meter in length falls from a height of one meter onto a horizontal plane while twisting as it pleases and creates a new image of the unit of length." This process was repeated three times with the thread falling on a canvas painted blue (the Prussian blue of the *Grinder* background), and drops of varnish were gently applied to fix the curve as it lay. Each canvas was cut into a strip, and these were glued individually to long pieces of glass. The three curves were then inscribed on wooden slats so that a profile of the curve could be cut to make three templates, boxed as a set of tools.

To the left of the Chocolate Grinder, attached via the Scissors which pivot on the central stem, or Bayonet, of the grinder, is the Chariot, Sleigh, or Glider. This element received separate treatment as a study on glass (the first work on this unforgiving material and the only one to remain unbroken). The technique derives in part from Duchamp's use of plate glass as a palette in the studio. The reverse of the palette showed flat brilliant colors, and it occurred to him that the problem of impermanence of oil pigments could be solved by using glass as a support. Paint seen through glass would be isolated from contact with the air, so that oxidization, the main factor in deterioration, would be prevented. Another virtue was that he would be freed from the "demeaning" task of actually applying color to an area coincidental to the form—a negative activity he disliked. Finally, and most important, the background would be provided by chance, by whatever environment the picture happened to be in.

Work on the semicircular *Glider* began with an unsuccessful attempt to etch the drawing with hydrofluoric acid. A long period of dangerous discomfort from fumes produced a barely visible line. At that time in Paris it was customary to keep a supply of lead fuse wire at hand, in various sizes for different amperages. It is a malleable, strangely sculptural material that may be shaped to follow a laterally reversed drawing placed underneath the glass. The wire, precisely positioned, might then be fixed to the glass with mastic varnish, another handy commodity in the studio, already successfully used to fasten the threads of the *Standard Stoppages.* The technique worked well and was slow enough to satisfy Duchamp's painstaking deliberation. Once the wire was fixed in place, the glass could be painted within the wire boundaries and a sealing layer of lead foil pressed to the wet paint—a final optimistic protection of the pigment, sealing it in an envelope of glass and lead. The *Large Glass* and its studies have undergone a dramatic change, for Duchamp's

contriving of permanence was thwarted by two factors: an unexpected chemical interaction takes place when lead foil is in contact with the lead pigments used (white lead as a base and pure red for the Malic Molds); and the glass, though chemically resistant, is very liable to fracture. Chance has run with unwitting abandon through the fabric of these works.

A study on glass was also made of the *Nine Malic Molds*. Originally eight molds (the ninth had been added before the glass study), they are hollow shells each representing a different professional uniform, surmounted by an appropriate hat—Priest, Delivery Boy, Gendarme, Cuirassier, Policeman, Undertaker, Flunky, Busboy, Stationmaster. Their function is to mold Illuminating Gas. (Duchamp liked to turn to account readily available utilities, so what more natural than to resort to the water and gas supplied to all floors of Parisian apartment houses of the time, proudly advertised as having *Eau & gaz à tous les étages,* for the two "given" requirements of his Bachelor Apparatus?) The molds endow the gas with a particular character—rather as clothes make the man. A strange feature of the Malic Molds is that the figures do not stand on a surface; Duchamp's perspective is never less than cunning. The common denominator linking them is the "horizontal plane of sex"—the crotch of each mold is at the same level, while head and feet vary in extension above and below that plane.

Illuminating Gas, given a particular character by confinement in the livery molds, seeps along Capillary Tubes joined to the hat of each mold. A large canvas was at hand, the unfinished *Spring* painting discarded in 1911, on which had been superimposed a pencil-drawn enlargement of the "General plan" to half the full size. Overlying these earlier uses, the positions, in plan, of the Nine Malic Molds were located full-size with the center of vision of the *Large Glass* perspective carefully noted. Each template of the *Standard Stoppages* was used three times to trace the network of Capillary Tubes so that all paths meet at their termination on the right. This painted map derives from an idea to place the canvas at such an angle relative to a camera that a photograph would provide a perspective projection of the lines to fit accurately into the existing master perspective. Camera lenses proved inadequate to the task, so a conventional method of drawn projection was used. All the elements of the Bachelor Apparatus would have to be in reverse, so that the wire on the back of the glass would be seen right way round from the front. The only reversed drawing that survives is that for the Malic Molds, which shows the "network" in perspective.

In its passage through the Capillary Tubes, the Illuminating Gas solidifies. When it reaches the opening, extruded by pressure from the mold, it breaks into short "needles" which will ascend (since coal gas is lighter than air) through the Sieves (seven cones in a semicircular arc behind the Grinder). Duchamp's conceptual subtlety, as recorded in the notes, could hardly be matched by execution; such elegance and refinement of thought made impossible demands on the technical resources then available—which meant that a great many ideas got no further than words. The *Sieves* drawing carries a text which describes how the disposition in plan of the Malic Molds, as seen in the "network," could be marked on a thin rubber disk. If the membrane were pushed at its center to make a cone, the cone might be photographed for each of the Sieves so that the original relationship of the fragments of solidified gas would be maintained throughout their 180° disorientation in the Sieves—in other words, the distribution in plan would be inverted; the scheme was abandoned, however. During their circumnavigation the "spangles" of solidified gas are converted into a "liquid scattered

suspension" sucked out, in its later stages, by a "butterfly pump." From the pump, the liquid spirals down to create a great "flow" to the orgasmic splash.

Another cycle of activity takes place simultaneously at a purely mechanical level. The Chariot, Sleigh, or Glider slides back and forth on its "runners," powered by the Waterfall through the Water Mill. The right-hand side of the Chariot's box frame has extensions up to the Scissors so that sliding connections allow the arms to open and close in unison with the movements of the Chariot, while the opposite ends are said to "affect the splash." There were problems in converting the rotary motion of the Water Mill to the reciprocations of the Chariot. Springs (a "Sandow") were finally assisted by an ironic solution—a weight of oscillating density (in the form of a bottle of Bénédictine) adds its impetus.

In 1915 Duchamp left France for America, arriving there as something of a celebrity. The *Nude Descending a Staircase* had been illustrated in the Armory Show press. He had contacts, through Walter Pach, with the organizers of the show and with the poet and collector Walter Arensberg, who became a lifelong friend. Nobody in the United States, and hardly anyone in Paris, had knowledge of Duchamp's extraordinary new project. The whole work had been elaborately studied in notes, a perspective of the lower half was fully prepared, technical solutions were developed for the fabrication of the image on glass, and trials made of three main features of the Bachelor Machine, but as yet work on the *Large Glass* itself had not been started. Soon after Duchamp's arrival in New York, plate-glass panels were bought and work began. There were limits to the amount of material Duchamp could transport across the Atlantic in 1915; he could carry his notes, but the large glass study of the Chariot remained in France, as did the *Bride* painting, which he had given to Picabia. The full-size perspective on plaster had to stay where it was; but the full-size details of most of the Bachelor Apparatus existed on paper, so that execution of the lower glass presented the least problems. Duchamp began to grapple with the unresolved upper panel—the Bride's domain.

We know that the *Pendu femelle* of the *Large Glass* derives from the Munich *Bride* painting. In fact, those organs of the bride to which Duchamp had been able to ascribe a function reappear unchanged except in color. It is possible to isolate the *Pendu femelle* by cutting her silhouette from a photograph of the Munich *Bride*. A remarkable note on the "blossoming" proposes that the glass be prepared with a silver bromide emulsion; indeed the technique was tried in an unsuccessful attempt to print the *Pendu femelle* by projecting a negative of the *Bride* directly onto the glass from a photographic enlarger. Only a thin, elusive image was produced, so the wire-drawing procedure was put to use again; but instead of filling in with flat color, as in the lower glass, Duchamp painted the *Pendu femelle* in black-and-white gradations simulating a photograph of the *Bride*.

Though manipulation of paint had become repugnant, the "halo of the Bride" is given due lyricism in its handling—"this cinematic blossoming is the most important part of the painting (graphically as a surface)." The treatment, however, is no less conceptual than the flat pigments used as substance in other parts of the *Glass*. As the color of the Grinder is chocolate, so the hue of the blossoming is flesh, rich, sumptuous, Renoiresque: the rose pinks and pale peach tinged with emerald green of the classic female nude. Buried in glass and lead, the color has an actuality richer than its appearance from the front, modified by the overall *eau de Nil* tinge that plate glass adds.

Within the blossoming are three rectangular openings, Draft Pistons or Nets,

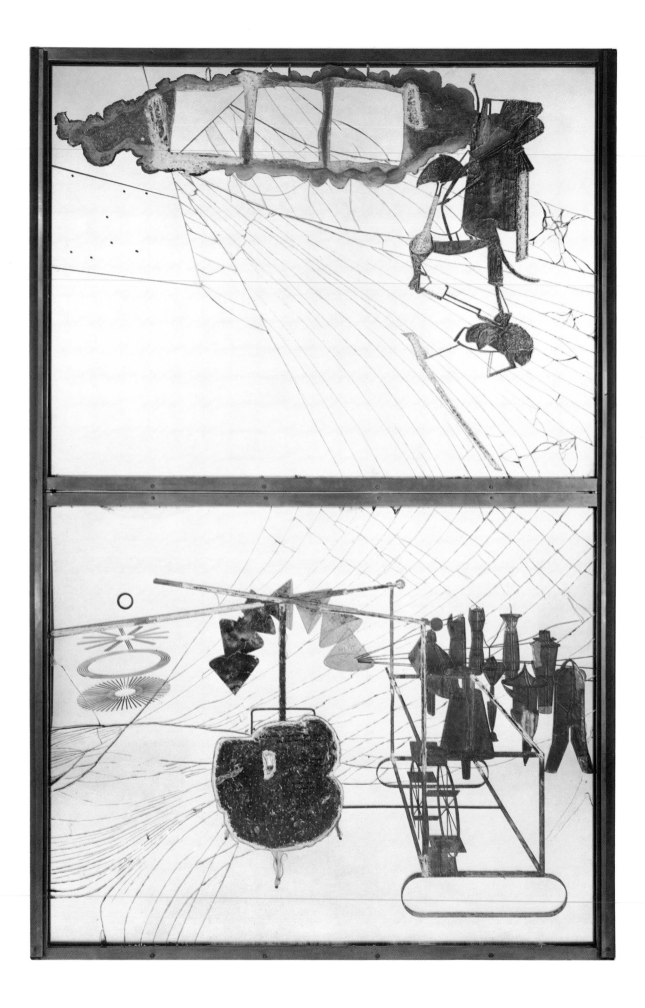

a Triple Cipher, titles that explain their role in the allegory and that also stress the importance of method in the *Glass*. Duchamp used the number three throughout his work, so much so that one might be tempted to suppose that he ascribed to it some magic property. But his mind is Cartesian and the predilection for three is rational. One is unity, two's a pair, three is number (n). To make three of a thing is to mass-produce it. Triplication deprives the art object of a factor he found deplorable—that reverence given to a unique work for no other reason than its singularity. There is another, equally important application of number in the *Large Glass*; the number three is "taken as a refrain in duration," so that it binds the elements of the composition together in a repeating rhythm. Three rollers grind chocolate, Three Standard Stoppages, each used three times, form the Capillary Tubes coming from the Nine Malic Molds, and they fix, "preserve," or "can" a chance-modified line. The three Draft Pistons apply the principle to a plane, while the Shots (to be discussed later) are a three-times-three chance distribution of points. Point, line, and plane are all submitted to systematized hazard—a triple use of triple chance.

Draft Pistons (planes moved by air pressure) were fabricated by hanging a one-meter-square Net (net curtain or veiling) above a radiator. Rising currents of warm air disturbed the material, so that three photographs of it produced three different profiles for the plane. Since the Net had spots distributed at regular intervals, the photographs record not only the contour but the topology of the entire surface. Naturally the Pistons have their function: they are to determine the terms of the Top Inscription which will run over the blossoming like news flashed across Times Square in letters of light. A text must have its "alphabetic units" readily available, so a "letter box" is situated at the junction of the *Pendu femelle* and her blossoming from which the Draft Pistons sort the ciphered messages. This Moving Inscription crosses toward the Shots, a group of nine holes drilled in the top right.

Duchamp's manipulation of chance always has a profound philosophical content which finds expression in play (Von Neumann's mathematical treatise on chance is, after all, devoted to "Theory of Games"). For the Shots he takes a toy cannon, with a match dipped in paint as a projectile. A carefully aimed shot is fired at a "target" point—the target is missed but a mark is made by the paint. Two more shots from the same position produce spots at varying distances around the target, since neither his skill nor the instrument is unerring. This process repeated from two other positions gives nine points. The target is, according to Duchamp, "demultiplied"—a phenomenon then developed metaphysically. If the nine spots are joined in sequence, in the manner of a numbers drawing, the result is a jagged plane. If lines are drawn vertically below the points of this plane we get a fluted column. Therefore the one-dimensional target is said to embody "the schema of any object whatever," in much the way that a single living cell carries within it the potential of complex organic development. This is just one elegant demonstration of a major obsession of the *Glass*, dimensionality. The question continually posed is: If the *Large Glass* is a representation of a three-dimensional world on a two-dimensional surface, then could a three-dimensional representation be a conventional projection of a four-dimensional world? One is tempted to continue this speculation and to ask: Is *Etant donnés* (the recapitulation of the saga of the Stripped Bride that occupied the last twenty years of Duchamp's life) the three-dimensional construction forming the center of a trilogy awaiting the final unimagined, probably unimaginable, restatement, the four-dimensional Bride?

Back view of *The Bride Stripped Bare by Her Bachelors, Even (the Large Glass)*. 1915–23.

We must stay with the *Glass* and turn, as Duchamp did, to the lower panel. Four of the Bachelor features presented no problems. Chocolate Grinder, Glider, Malic Molds, and Capillary Tubes required only the patient labor of remaking them as grouped on the glass and linked by the Scissors, following the methods used in the studies. In the way that it is applied, the paint on the lower panel is quite different from that on the upper. The Bride presents the appearance of a three-dimensional object attached to the top edge of the glass with *trompe-l'oeil* loops and hooks. Another intention prevails in the Bachelor Apparatus: pigment is used to create an "apparition of an appearance." By this Duchamp seems to mean that the color we see is not a semblance of something; it is not a *color* decision, nor is it a skin of paint on the surface of an object. A two-dimensional layer of pigment does not merely represent the metal frame of the Glider, but is the substance itself; oxides of lead and cadmium actually compose the metal framework of the Chariot. An arbitrary color choice for the Malic Molds is avoided by the application of an undercoat of "provisional color." They wait, primed with red lead "like croquet mallets," for each to be allocated its final coat.

A full-size drawing of the Sieves was done in Paris, but there were no trials of an idea for their execution. Since the Sieves permit the passage of Illuminating Gas, they must be permeable. The fabric is to be a "reverse image of porosity" so dust might be allowed to settle for a period of three months (Man Ray's famous photograph shows the "dust breeding" process) to be finally fixed with varnish. This "breeding of colors" takes us closest to his ideal—the *Glass* seen as a "greenhouse" in which transparent colors, as ephemeral as perfumes, will emerge, flourish, ripen, and decay like flowers and fruits.

By 1917 all of the developed aspects of the *Green Box* notes, the 1913 conceptualization, were completed. Two proposed components had been abandoned: a Boxing Match attached by Rams to the top right of the lower panel and above that a Juggler of Gravity at bottom right of the upper panel. Duchamp was bored by the need to cover the same ground repeatedly. He had also perfected another art, that of the Readymade, which removed the need for manual skill altogether. Life was exciting, and the *Glass* must have appeared an overworked private obsession to the man who presented a urinal to the Independents' exhibition, New York, 1917, with the title *Fountain*.

A third significant opportunity for isolated introspection occurred in 1918, when Duchamp went to Argentina. As the Bride appeared secretly in a Munich *pension*, as the intricacies of the great *Glass* were figured out in a seaside boarding house in Herne Bay, England, so the conclusive effort was made in a Buenos Aires apartment, where a new contribution (the Oculist Witnesses) was added to the original scheme. From the Sieves the Illuminating Gas, converted to a fog of "spangles," is sucked down by a "butterfly pump" which ejects it through a "chute" to make a great splash, the orgasm of the Bachelors ("a liquid elemental scattering"), which makes such a "din." The splash ascends above the "planes of flow" and finally relates to the Shots; thus the issue of the Nine Malic Molds is "regularized by the 9 holes" which terminate the Bride.

The 1918 supplement to the project was a witness to the events of the glass—a Peeping Tom. A *témoin oculiste* is, in French law, an eye witness. But it is also a chart used by opticians for eye testing. Duchamp, exploring as always the ambiguous character of any one *reality,* the fortuitous nature of any one existence, was intrigued by devices that play visual tricks. He enjoyed optical illusions as he loved verbal puns, which question the validity

of language. In Buenos Aires a new glass study was made—*To Be Looked at with One Eye, Close to, for Almost an Hour*. It is a direct study for the *Large Glass* (the Scissors, at their free ends, enter from the side of the small panel), though not all of its new material was used. The relevant part of the image is a series of reflecting lines, in mirror silver, which radiate from the vertical axis of the splash. This is a standard, readymade oculist's chart placed horizontally in a precise relationship to the scissor arms and the central vanishing point of the *Large Glass*.

On his return to New York Duchamp took this element and multiplied it. Of course it had to be three charts, so two other designs were chosen, to be placed one above the other, as a column of shimmering disks surmounted by a vertical ring at a central position between the terminations of the Scissors, a place occupied by a magnifying lens on the *To Be Looked at* glass. Projection of the perspective was, in itself, a most demanding task, no less difficult than that of transferring it to the back of the Bachelor panel, now silvered on the right-hand side. To work in negative, scraping away the surplus silver, was a long and difficult process.

Walter Arensberg owned the unfinished glass in 1918. When he moved to California in 1921, ownership was transferred to Katherine Dreier, for the piece was rightly thought too fragile to travel. By 1923 Duchamp had decided that no further work would be done, and *The Bride Stripped Bare by Her Bachelors, Even* was publicly exhibited for the first time in 1926 at the International Exhibition of Modern Art in the Brooklyn Museum. Returning to the Dreier home in a truck, the two sheets of glass, lying face to face in a crate, bounced and shattered in great symmetrical arcs—a disaster hidden until the box was opened some years later. Duchamp, undismayed by this unplanned intervention of chance, reassembled the fragments in 1936, aided by the lead wire and varnish which had helped to hold the pieces together.

With the publication of the notes in their *Green Box* in 1934, the story seemed at an end, until another batch of notes, covering roughly the same period and almost equaling their number, emerged in 1964. Duchamp's involvement with words is extensive—as unique in itself as it is uniquely integrated into his art. In much the way that he defeated pomposity of pictorial expression, he attacked explicit formal language. *La Mariée mise à nu par ses célibataires* was a sentence with too clear a meaning; *même* made nonsense of its grammatical structure. Why a green box when he detested the color green as much as he disliked the name Rose? Perhaps, in pursuance of his creed to make determinations other than aesthetic ones, a *Boîte verte* should accompany a *Grand Verre*. Duchamp's writings equate in spareness with his images and have all their concentrated power; together they are an experience unmatched in art. One sheet in the *Green Box* is headed ''General notes for a Hilarious picture'': this says more about Duchamp and the *Glass* than twenty pages of criticism or explanation. The stripping is hilarious because if it were solemn it would be laughable. His keenest tool is irony, ''ironism of affirmation: differences from negative ironism which depends solely on laughter.'' He doesn't avoid decision—''always or nearly always give reasons for the choice between 2 or more solutions (by ironical causality).'' What he does is to devise systems by means of which choice is no longer an expression of ego. Everything he attempted is accomplished meticulously, with ''precision and the beauty of indifference,'' for Duchamp saw detachment as the greatest human virtue. As the Bride hangs stripped yet inviolate in her glass cage while the Bachelors grind their chocolate below, so Duchamp is remote and alone with his high art that he held to be artless.

# MARCEL DUCHAMP
# AND
# THE MACHINE

Lawrence D. Steefel, Jr.

*To insist on purity is to baptize in-stinct, to humanize art, and to deify personality.*
*Artists are above all men who want to become inhuman.*
—Guillaume Apollinaire, 1913

*Mallarmé was a great figure. This is the direction in which art should turn: to an intellectual expression rather than to an animal expression. I am sick of the expression "bête comme un peintre"—stupid as a painter.*
—Marcel Duchamp, 1946

MARCEL DUCHAMP'S interest in the machine and the mechanistic is best understood as a consequence of his pursuit of a poetic of impersonality in which there will be a positive separation for the artist between "the man who suffers and the mind that creates."[1] Seeking to distance himself from his own fantasies, Duchamp sought a means of converting pathos into pleasure and emotion into thought. His mechanism of conversion was a strange one, but essentially it consisted of inventing a "displacement game" that would project conflicts and distill excitements into surrogate objects and constructs without whose existence his mental equilibrium might not have been sustained. Using personalized though expressively impersonal conventions drawn from what Elizabeth Sewell has called "the field of nonsense," Duchamp disciplined the artistic products of his excited fantasy by a progressive mechanization of their aesthetic valence. By using the machine as an increasingly distinct and rigid counter against the turbulent vastness of unchanneled association and unfiltered dream, Duchamp created an art of nonsense that "hygienically" freed his mind from all those capsizing factors which had previously haunted him as a Laforguian "sad young man."[2]

Framing the oppositions and conjugations of his fantasy into the provocative perplexes of a hallucinogenic art, Duchamp, "like a mediumistic being, who, from the labyrinth beyond time and space, seeks his way out to a clearing," manages to work his way out to a position where the "blankness of dada" and the power of invention paradoxically coincide.[3] Viewed as problematic outcomes of Duchamp's struggle against obsessional impulses and fantasies in himself, the mechanomorphic works of 1911–12 and the machine works after that, as compared to his earlier productions, seem both tamer and more dangerous. Like appanages or autonomous dependencies subject to the sovereignty though not the full possession of Duchamp's conscious self, these works are full of aggressive irrationality beneath their apparent nonchalance.

Leading us, the viewers, back toward the condition from which Duchamp had originally worked himself out, images like Nude Descending a Stair-case, The Passage from the Virgin to the Bride, and Readymades like the Bicycle Wheel, With Hidden Noise, or In Advance of the Broken Arm frustrate our good intentions and insult our common sense. Framed as they are by a superficially logical set of titles to be correlated with what ought to, but does not, make sense, Duchamp's visual puzzles lead us to expect that with sufficient effort and technical intelligence we can integrate his problems by sheer persistency of task. If we can only transcend his inconsistencies by extrapolating his consistencies, or so we fondly think, we can master the situation and find ourselves at rest. For most if not all viewers, however, this is a deceptive and irrational hope, for the ultimate heuristic thrust of Duchamp's dissembling work is to lead us continually to a brink of consummatory expectation only to "short-circuit" our cognitive grasp.[4]

By demonically distributing complex clues of representational deception and an abstract pattern that is never quite "abstract," Duchamp makes sure that his refractory productions frustrate their own illusions of integrity by being neither true nor false except to their own rationale of divisive anamorphism and self-reflexive plot. As counters in the Duchamp game, which is a displacement game par excellence, his works are both too consistent to be wholly inconsistent and too inconsistent to be wholly consistent, leaving us, the viewers, either the uncomfortable option of endlessly inventing new rules for the game as we pursue its play or the bewildering option of lapsing into delighted (or not so delighted) indifference as to what it is we play. Since most viewers will be oriented, as Duchamp originally was, to dominance in the Duchamp game, one can only persist in seeking devices for short-circuiting difficulty, or adopt (as Duchamp did) what he called a posture of "meta-irony," an affirmative indifference to irresolution and difficulty which accepts ambiguity as normative and the problematical as "nonsense."[5] But here we are at the heart of the matter!

It is only in Duchamp's first machine image, the Coffee Mill of 1911, that an achievable possibility of perceptually short-circuiting the built-in contradictions of the imagery surely exists for us. In all subsequent cases, the men-

Marcel Duchamp, New York, 1916.

70

*talité* of meta-irony, with its "nonsense" strategy of playfully accepting what one cannot otherwise outplay, seems the only alternative to being blocked or else "debrained" by Duchamp's cruel *cervellités*.[6] In the *Coffee Mill* we see an object of passive manipulation transformed into a mechanism apparently operating under its own power. Something potentially autonomous is thus derived from a culinary banality. Painted ostensibly as a wedding gift for his brother Raymond Duchamp-Villon ("Every kitchen needs a coffee grinder, so here is one from me"), this small panel is a kind of premonitory manifesto of what Duchamp himself turned out to be: a freewheeling operative of elusive inconsistency whose motion in space and time was centered on himself in an effort to transcend his origins as a provincial bourgeois *notaire*'s son and the existential burden of what he called physicality. By physicality he meant the whole mess of contingent interests and necessities one suffers by having a body and being part of society. If one could escape being acted upon by forces beyond one's own powers of self-motivation and self-mastery, as the little machine seems to have done, then one could, like the machine, focus on one's "head" and blossom into "pure operation" of blissful motility. Significantly, one can construct such a blossoming in the handle complex of the *Coffee Mill* only by mastering a technique of looking "beyond" the thrashing handle positions to the orbit of perfect enclosure that is imperfectly rendered by Duchamp. This orbit, formed of a circle of dots culminating in a curved arrow of directed constancy, must be converted by the viewer into a field of virtual motion and spatialized lubricity; if this can be done, the machine becomes a glimpse of freedom as pure mentality. This mentality is an apparitional presence of sheer immediacy which is visual insofar as we see it spatially but is intuitive insofar as we appreciate it as a resolution of a perceptual difficulty encountered in scanning the image syntactically and semantically.[7]

Painted in a polyglot style of Cubist and quasi-Futurist elements with just enough "realism" to tempt us toward believing the image is of a real machine, Duchamp's panel combines static and dynamic patterns in a subtle and devious way, so that we are both attracted by the lack of inertial "frictions" and bothered by what we see. What bothers us is lack of purposefulness in an image of such intricacy, and we may also be distracted by the confusion of handle positions within the orbit that contains their sweep. These multiple handle options do not behave consistently. Some are horizontal, some are vertical, and some wobble crazily. Out of this turbulence one seeks a resolution of representational or postural consistency, but it is only by "going beyond" their thrashing that one can find perceptual serenity.[8]

In this image one can, I believe, go beyond physical impediments to imaginative consistency, but this is the only image in Duchamp's oeuvre where one can "go beyond" literally. In all his other images, even those like the *Large Glass,* where there is a perspective system with a vanishing point at infinity, "going into depth" is ultimately a fruitless effort if one is to find serenity. Only by accepting the necessity of a "blocked depth" or an internal *échec* in trying to "see through" Duchamp's work can one achieve the *ataraxia* of detachment from his problems (that is, from both Duchamp's and ours). One must either welcome the hypnotizing of our attention that Duchamp's paradoxes evoke or force oneself to become detached from them as Duchamp gradually did.

The method of detachment involved an increasing reliance on the machine as a target for his interest in letting himself be free from troubling obsessions (whatever their nature) and personal passions (whatever those might be). As Duchamp once said to me, "I did not really love the machine," adding, "It was better to do it to machines than to people, or doing it to me."[9] By letting machines and mechanisms suffer outrageously, Duchamp could muster his energies for survival and the pursuit of poetry. Duchamp's poetic was basically Mallarméan, with a strong dose of irony; hence it was a poetic of mental freedom and creative autonomy.[10] He willingly called himself *un aspirateur* once he gave up painting consistently (a wonderful pun combining the sense of *aspirateur* as "vacuum cleaner" and also as "free breather" of personal autonomy), and the idea of breath is linked to both "inspiration" and "coming to life" be-

yond the limits of mechanization or the bounds of determinacy.[11] One can see the process of detachment beginning to operate in *Nude Descending a Staircase,* internally within the image as well as externally in the necessity of becoming free from the hope of resolving the image into pure motility.[12]

In *Nude Descending a Staircase,* 1912, Duchamp reverses the feeling of passivity conveyed by his first image of a robot person, *Sad Young Man in a Train,* 1911. The *Sad Young Man,* which Duchamp has identified as an image of himself in a gloomy mood on a train trip home from Paris, is a sensitive and rather mysterious image of reverberative fantasy. Without stressing its probably sexual overtones, one can believe that Duchamp painted it in a "state of anesthesia." There is something ominous in the work—muted by the subtle color and tonal play, but there nonetheless—as if the artist were submitting himself to a suspension of will as he passes through time. Whether or not one actually perceives a vague but threatening figure behind the serially eclipsed "patient," a phantom who seems to be striking a blow at the "young man's" head, there is still an inescapable sense of fatality and violence in this poignant work that cannot be allayed.[13]

In *Nude Descending a Staircase,* the persona of the nude actively descends the stairs. Using the stroboscopic effect of chronophotography, especially that developed many years before by E.-J. Marey in the hope of finding a universal language of graphic recordings for movements that are too rapid or too subtle for the unaided eye to catch, Duchamp suffuses a mechanistic shell of postural positions with a fleshy glow of android life.[14] Evoking not only a traversal of space but also a finesse of locomotion that provokes a sense of body image half-purposeful, half-somnambulistic, Duchamp dialectically interplays a precision of mechanism with a strangely unpredictable sense of events.[15]

Descending out of a multiple reverberation of swinging phantom states, the nude careens and coalesces in a complex, jostling sweep toward an unknown step we cannot see. Whether the nude will collapse or continue is uncertain. We know of two previous studies of the nude: *Once More to This Star* (*Encore à cet astre*), a strangely symptomatic drawing of November 1911; and *Nude Descending a Staircase, No. 1,* a lumpy, nucleated oil of December 1911. In comparison, the definitive version is more serene in its aspects of passage and flow, and more pointed in its malaise (note the depressed carapace head just as it is about to pass the ball-headed newel post at the lower right-hand margin of the frame). While attending to the dynamic enigma of the descent and, perhaps, to the presence or nonpresence of the nude as "nude," we can hardly fail to feel a sense of destiny, however obscure, in the work.[16] As we scan the bewildering profusion of elisions and interruptions, dissolutions and materializations, fragmentations and integrations out of which Duchamp has evolved his "nude descending," this intricacy, which is both the nude and its descent, becomes the ground of a haunting invitation to lose ourselves in the intimate life of the forms. Following this invitation, we are then rebuffed by inconsistencies and refractory elements in the flow and, more importantly, by the nude's coldness and distanced "absence" à la Roussel or Mallarmé.[17]

The "intimacy" of the nude is its most closely guarded secret. Its labyrinthine mystery involves more than the mere recording of space traversal or a game of *cherchez la femme,* neither of which was of really visceral importance to Duchamp. Rather, this image intimates both a rush of desperation and an ecstasy of hope refracted through a web of glazed impersonality, as if Duchamp had hypostatized his struggles with solipsism into a mechanism of oneiric un-self-consciousness that turns inward to itself.[18] More subtle than a mere projection of feeling into a surrogate persona, yet less articulate than a truly personal expressive form, the *Nude,* as a total experience, seems both impotent and powerful—impotent in its jeering aspects of mechanized awkwardness and powerful in its freedom of accelerative poise. Since we cannot wholly reduce this image either to pure fantasy or to pure fact, the motivational ambiguity of Duchamp's art becomes an enigma whose symptomology of practice and intent evades our grasp just as the nude as "nude" does.[19]

The *Nude,* in most ways, was also a mystery to Duchamp. He considered it

E.-J. Marey. "Jump from a height with stiffened legs." From his book *Movement,* translated by Eric Pritchard (London: William Heinemann, 1895).

the unpredictable product of a process which, beginning with a specific technical intent, became something more than what the artist planned. "Between the unexpressed but intended and the unintentionally expressed" is a coefficient of displacement and "objective chance." ("My chance is different from your chance," said Duchamp.)[20] This differential, which may be "good" chance or "bad" chance, is one of Duchamp's metaphors for both opportunity and fate, a force he denied but with which he was incessantly engaged in a battle of inputs and outcomes one feels was the true locus of his work.[21]

If the machine as "order" was a factor in balancing out personal ineptness, whether of the mind or of the flesh, it was an ambivalent order with overtones of determinism and distress at the same time that it was a way of articulating and displacing that distress.[22] Walking a delicate line between pessimism and hope, Duchamp's *Nude* seeks an equilibrium, however precarious, that will reconcile destructive and constructive forces, or at least hold them in suspension. Working, in the creative process, through a "series of efforts, pains, satisfactions, refusals, decisions which . . . cannot and must not be fully self-conscious, at least on the aesthetic plane," the artist pursues an image testifying to a separation between "the man who suffers and the mind that creates." But he will accept, as he must, a provisional limitation to total separation (which for him would be total success). He permits an interplay, at this point in his career, of dream-sense and non-sense with aesthetic finesse—an amalgam of components he would, after 1912, try to reject.[23] If Duchamp's images as expressive compounds behave like thematic apperception tests that do not "appercept," "continuously collapsing into unknown intentions" that frustrate and bother us,[24] Duchamp's mechanization of their "actions" numbs the rawness of their impact by masking and distributing the brute energies of their semantic substrate into and through mechanisms and mechanistic forms that are objectifying and arbitrary if not really "abstract."

In the mechanomorphic period which follows Duchamp's first introjection of mechanical and machinelike "substances" into the "body" of his art, we find a significant intensification of formal concentration matched by a growing sense of distance between our emotional reactions to the forms and to what the imagery is presumably "about." To a crucial extent, for the viewer who becomes involved with Duchamp's imagery of 1912, which mechanizes the body more strictly as it becomes more visceral and abstract, the problem of what the machine means to Duchamp becomes of less immediate interest than the problem of coping with the perceptual and conceptual paradoxes of "seeing" the art. Duchamp's "perplexes" of the year 1912 are pervaded by mechanization and machine forms (mostly armored turret forms and thrashing rotor mechanisms in *The King and Queen Surrounded by Swift Nudes,* anatomized filaments and robotoids in *The Passage from the Virgin to the Bride,* and crucible-like distillery apparatus in the *Bride*). It is the labyrinthine elaboration of these mechanisms, more than their "actions," that compels our attention and dazzles our minds.[25] Closer in potential affect to the language labyrinths of Jean-Pierre Brisset, with their elaboration of animal cries into human language, than to any other non-Duchampian verbal or pictorial form,[26] Duchamp's "putting to the question" of parental authority (*The King and Queen*), the loss of virginity (*The Passage*) and the matrix (literally "womb") of desire (the *Bride*) combines an aggressive and regressive obsession with the complexity of primal energies and relationships and a ruthless distancing of interest about these most intimate affairs.[27]

Insofar as "putting to the question" implies both a form of judicial torture and a kind of scientific experiment, Duchamp subjects these intimate concerns to a tortuous discipline of brilliantly composed and succinctly articulated pictorial illusions, full of salient entanglements and provocative interactions and elusive relationships. Condensing hostility into an intricate panoply of esoteric metastatic form, Duchamp makes the human body "humanoid" without resorting to the banal robot structures of conventional science fiction. Thanks largely to his pictorial imagination (a quality he would convert into a mechanic's ingenuity at the end of 1912), Duchamp evolved a strategy of converting Cubist dislocations, detachments, interpenetrations,

and figural eclipses into an ambiguous imagery of tactical finesse.[28] Combining illusions of tangible filaments and flaps, foldings and convolutions, platings and scraps with a fluid density of suspended shadowings, as if light and shade were quasi-substantial sponginess transmuted into hovering effluents, Duchamp moves from penetration and "revolution" ("revolving") in *The King and Queen* (May 1912) to "passage" as tumescent numbness in *The Passage from the Virgin to the Bride* (July–August 1912) to generation as "stillness" in the *Bride* (August 1912), a distillery of torture and alchemic instruments welded into a configural splendor of finely wrought contempt.

If one's rhetoric tends to become florescent (one is tempted to say fluorescent) in response to these works, it is because Duchamp, at this time, seems closest to the intensity of the flesh and its primal palpitations while metaphoring that "flesh" into structures of art. These art structures are hardly nonobjective, nor are they figurative in any easy sense. Rather they are constructs suffused with a quality of excitement that is distanced and displaced, absorbing pornographic potentials in the smoothness of paint cuisine (Duchamp kneaded the pigment with his fingers to "extra smoothness") and in the strangeness of their elaborateness. If there is little of orgasmic delight to grasp in these images, they are, we can hardly fail to suspect, Machiavellian in their sculptural aplomb and erotic in their depths. Their eroticism is a "black" eroticism rather like Sade's, but an eroticism that has been refined, distilled, and literally transfigured into a mechanism of distraction from the burden of rankling sex. If we foolishly seek to plumb the imagery's mysterious depths, making a human penetration into problems that Duchamp has consciously "walled off," we are checked by the resolute impenetrability of the quasi-sculptural intervening "sets," which have both presence and elusiveness as intellectual invitations and toughness and cunning as perceptual barriers to our heuristic thrusts.[29]

These images, in which Duchamp becomes Dada's "Poussin," are impersonal plumbings of a mind that "digests" the passions which are its materials and, in this case, its substrate. The sentience of the flesh as a kind of instinct substance needs the operation of the mind (what Duchamp called "gray matter") to trick the body into however grudging a respect for its rights and privileges of superiority.[30] By converting the body into an "almost" mechanized substance, the mind makes it into a web of anamorphic forms acting as a counterforce to the "contained" activities within and behind the works, activities hinted at, glimpsed, suspected, and suspect, which could, one feels, erupt at any moment out of the formal control of the image if it were not for the astringent finesse of the artist who has locked them into place.[31]

It is at this point that we really begin to understand the ruthlessness of Duchamp's need to control emotion through the metaphor of form. He does not want so much to "think things through" as to think *against* "thinking them through"; hence the impenetrability of his articulations and the toughness of his art. By this decision to create paintings whose contents will not move beyond his controlling censorship, Duchamp can now, it seems, make "subjective" pictures that will not let their subjects "out." In this, the tactic of mechanization of his subjects and of his subjectivity is crucial in the overall strategy of what Duchamp and his paintings are all about, namely the containment of eros and the transmutation of pathos into a welcome absence of feeling, which for him was a victory of intelligence over the Caliban in himself. As repressors of instinct, Duchamp's images are a kind of infernal machine, but they regulate their own "meta-forces" in so cunning a way that we are tempted to call them mechanisms of affirmation as much as monsters at play.[32] They appear to be autonomous worlds of irrational thought, but their autonomy, however much it seems a function of pervasive forces within the works, is finally threatening only if one becomes involved in it personally. Only by assuming that it is one's business to enter into subjective traffic with the imagery, rather than merely to observe how it works, will our indifference be threatened by Duchamp's mechanomorphs.

It may not be easy to be so indifferent to images and objects as provocative as those of Duchamp. *Peinture de précision, beauté d'indifférence* was a Duchampian goal he himself had to struggle to attain. While a meta-irony

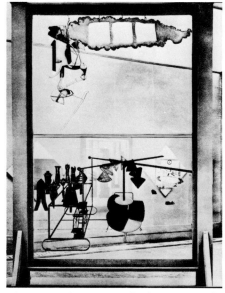

The *Large Glass* in its unbroken state at the "International Exhibition" at the Brooklyn Museum, November 19, 1926–January 9, 1927.

of indifference is the appropriate affirmation Duchamp tells us to adopt, his own efforts to fully master such a "set" led him, after the mechanomorphs, to an even more ruthless suppression of what, in contrast to what followed, seemed his previous "expressiveness." Only with his embarkation on the great project of *The Bride Stripped Bare by Her Bachelors, Even* (1915–23), an enormous glass panel of autistic intercourse,[33] ancillary works such as *Glider Containing a Water Mill in Neighboring Metals* (1913), *Chocolate Grinder, No. 1* and *No. 2* (1913 and 1914), and various Readymades, such as bottle-drying racks, combs, bicycle wheels on stools, and other bric-a-brac, did Duchamp make a final commitment to full suppression of all "human" affect in his work.

Whether it be the tortured and tortuous "bride and bachelors," the ball of twine that is the "guts" of a Readymade called *Hidden Noise,* or the geometry book, called *Unhappy Readymade,* hung out to disintegrate into its "natural roots," each "subject" is clamped into a mechanical format or "nonsensized" beyond possible return to any original identity it may once have had. Each becomes a part of what may be called Duchamp's "field of nonsense," and a counter in a game that is both cruel and *amusant*.[34] Duchamp plays his game with a potential spectator (friend or enemy), of course, and it is this game that has attracted most attention from students of Duchamp's art. It is so complex and "open-ended" a game, involving extrapolations and decipherings, open interpretations and closed forms, reductions and expansions, inversions and reversals, additions and subtractions, divisions and multiplications, shocks and buffetings, foolishness and sense, that it can be only partially anatomized here. Each image after 1912, beginning with the wholly mechanistic drawing *The Bride Stripped Bare by the Bachelors* of July–August 1912, which targets a central "bride machine" between two allogamous "bachelors," encodes some cunning rendezvous with an alerted idea which has not yet become knowledge and, therefore, carries with it the potential of further thought ascending through larger and larger dimensions of precipitous flight, with the viewer forced to follow in hot pursuit, as if the geometric ratio of Duchamp's *cervel-*

*lités* was always one step beyond the horizon of the viewer no matter how "fast he runs."[35]

If the works are n − 1 dimensional projects of an n dimensional realm, their output over input ratio of fantastic motivational ramification is $n/(n-1)$. It is not just because these works are mechanistic that this output is achieved, though the mechanization of the work is a crucial step in allowing such an output, as we shall see. Rather it is because Duchamp now uses nothing but machines and machine forms, which are "like thematic apperception tests which discourage self-projection,"[36] in a strictly scaled game of nonsense arrayed against the vastness of a dreamlike transparency, creating a labyrinth of perceptual and conceptual gamesmanship in the mind of the viewer which ascends, by its own fictions of gratuitous effort, toward self-reflexive ecstasy. If the game of fictionalizing what, at its lowest level, is Duchamp's creative residue becomes a form of infinite Dada delight in "going too far" and succeeding in that excess of delirious play, this overreaching of logical interpretive extension is an intellectual game we are able to play because Duchamp has presented us with an infinitely ambiguous set of relationships open to the wildest Brissetian or Rousselian orders of incongruous fantasy. Learning something, no doubt, from those linguistic madmen, but essentially inventing his own forms of countersense out of his own psychic need, Duchamp releases both himself and us, his audience, from the burden of logical necessity, enabling us to play freely and madly, with whatever fervor we please, a game of "delirium metaphor" to a historically unprecedented degree.[37]

The words "nonsense" and "field of nonsense" used above are employed by Elizabeth Sewell in a more specific sense that provides an unexpected insight into Duchamp's syntactical methods after 1912. For Sewell and for Duchamp, nonsense is a game played with fixed counters against the boundlessness of "dream"—dream taken both in its literal sense and as the intuition of infinite analogy possible in a world "beyond the looking glass," as in Alice's adventures, where the farthest reaches of fantasy escape the bounds of language, reason, restraint, or "reality" of any kind other than that which

is "dreamlike" and, hence, imaginative infinity.[38] Nonsense in Duchamp's case involves juxtaposition and super-imposition of mechanisms and machine forms of a specific configuration (after 1912) and discrete separateness of placement[39] (however much "tied together" by mechanical connections or rigid links). The nonsense game involves, as other highly developed games do, "the active manipulation . . . of a certain object or class of objects, concrete or mental, within a limited field of space and time and according to fixed rules of play, with the aim of producing a given result despite the opposition of chance or opponents."[40]

This definition of a game is "Dada-ized" by Duchamp, who takes the limited space to be the translucency of a glass panel or the emptiness of a room where we find a Readymade, while the limited time may be a minute, an hour, or a whole life. The objects and counters in the Duchamp game are, of course, the paraphernalia of machines and mechanisms, but they are also forms and systems, illusions and mirrorings (literal or figurative), titles and imports—all of which are the counter personae and presences of Duchamp's "works." The field of play is not only the "perspective" of the images (and the perspectives we bring to them), but the ambience of the works in relation to the perceptual and conceptual rapports of the viewers of these works. According to the "fixed" rules, which always seem to be asking to be changed as we play the game, we begin by taking seriously what we see, trying to make sense of the relationships we are faced with—and then abandon that seriousness in favor of Dada hilarity. The operation of chance is, on the whole, the opposition we face: chance as distraction and lack of sense. But our opponent is also the imagery itself (we must "take" the chance), which must be mastered by going beyond the plausible. In this respect Duchamp's nonsense is a set of strict relationships and a matter of flexibility, a paradox to reason but a new and very twentieth-century poetic of converting the given and the banal into apparitional potency.[41]

The scale of conversion from the givens of grinders and dummies, of cylinders and scissors, of hatracks and typewriter covers to the freedom of unimpeded hyperbolic thought is so

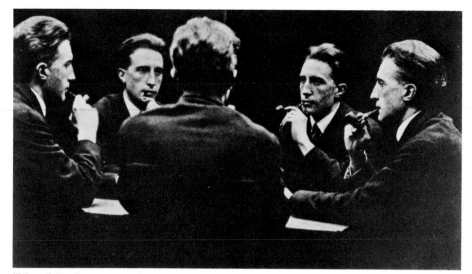

"Marcel Duchamp around a Table." New York, 1917.

great that only a kind of "short circuit" of intelligibility can lead us from the pathos to the ethos of the *Large Glass* and the Readymades, happy or unhappy, which are its offspring or counterparts. This short circuit of our normal ways of using visual imagery is grounded in a logic of mental relations subject to its own laws, limited and controlled by reason and will, set within and against a suppressed power of cogent irrationality. Dedicated basically to "balance and safety," this logic of mental relations, which is "nonsense" instead of "sanity," postpones the effect of climax which is orgasmic irrationality.[42]

With the strictness of machinery applied to the fantasy of seduction and masturbation, Duchamp breaks the indices of that fantasy into small units set side by side. Counting on the deflection of intention by a concrete and fastidious arrangement of schematic objects as "nonconvertible currency" in a game of sexual exchange, Duchamp uses his translations of affect into intellect as a nonsense order to limit multiplicity, to sterilize action, and to convert impulse into "an order" of a "nonconvertible" kind.[43] For nonsense is a nonconvertible currency unless it is converted into dream. Being "nothing but itself," nonsense, with its careful selectivity of juxtaposed unintelligibilities, is a multiverse that is never more than the sum of its parts. Dream, on the other hand, is a universe that is always more than the sum of its parts because its contents are organically (and not mechanically) compre-

hended by its infinite interrelatedness. Combining nonsense and calculation with poetic invitations to Surrealist ecstasy (as he combines linear perspective with visual indeterminacy), Duchamp plays a short-circuit game with himself and the "beauty of indifference," which becomes an equation of existential pathos and creative purity.

If we as viewers can use his art as a vehicle for self-transcendence into a kind of dream work that is a "moral holiday" (to use William James's suggestive term), we see how, for Duchamp himself, the achievement of "seeming to be one's own cousin and yet still being oneself" was the product of working out a curious mixture of exhaustion and emptiness and an almost machinelike indifference to existential consequence. The elaborate mechanism of the *Large Glass,* the "stupidity" of the simpler Readymades, the geometrics of *Tu m',* the unachieved projects of the Notes—these and the whole strategy of calculated outrages against the expectations of "normalcy" were essential steps in Duchamp's freeing himself from contingency by a calculated contempt for "future shock" and "present shortcomings" articulated through Dada, which became a form of art. For Duchamp's work, strange as it is, *is* art, albeit of a very special kind; an art of living as well as an art of mechanisms and a nonsense of machines.[44] By mechanizing the contingent into a field of nonsense, Duchamp devalues its depreciative power on his essential self-esteem; by the conversion of psychic pressure into tautology, he transfigured it into absurdity, an absurdity he could deride. By thus projecting exigency into nonsense he could provide a model, in concrete instances, of how to achieve a sophisticated neutrality of interested indifference to all existential events. In this way Duchamp could be both master of his destiny and never out of touch with what "really mattered" to him, as long as what mattered was filtered through *his* nonsense and *his* pride.

Wishing to become essentially a relationless entity centered on himself, Duchamp found the machine, a willing instrument of his passion, to be truly passionless. As an intangible presence in every one of his works, Duchamp could resemble the godlike artificer of Flaubert and Joyce paring his finger-

nails while his mechanisms "did their work." The *échec* (block or check) in the imagery, which we have called nonsense, is the contradictory banished to the realm of language and its infinite artifice. What is caught in this trap is both contingency (the limiting action of the world and time) and the aspect of Duchamp himself that is an excess of complexity which he really wants to "check." By catching and exhibiting this complexity (one is tempted to say not "complexity" but "complex"), Duchamp can stand above and beyond himself without quite losing touch with what exercises his fantasy and "touches his heart." Like the phrase "definitions, by definition, define," which, when repeated once, then twice, then three times, becomes a redundancy that at first seems clear and then opaque and finally a numbingly translucent nonsense of eulalic, ritual delight, Duchamp through his art converts himself and us into labyrinths of pure mentality contemplating our own contents. If that nonsense is more than a matter of playing with anxious artifice, the result may be poetic fulfillment somewhere between Mallarmé and Lautréamont. Its formula of conversion is $1/0 = \infty$; it is as simple and as nonsensical and as complex as that!

Feed into this formula equal amounts of involvement and indifference on our own and Duchamp's part, and one will understand, as far as it can be understood by ordinary people, the meaning of his art. As a component of that meaning, the machine was always a means and never an end, but it was a target for Duchamp's hostility and an instrument of his release from the servitude of having to be himself without the advantage of transcending his involvements with matters beyond himself. If the image of Duchamp as a "relationless entity" centered on himself is a fiction we are hypnotized into believing in spite of rational doubts, that only goes to prove that art is illusion, even in the hands of Duchamp. Such illusions, however, are psychological facts, and even if we can arbitrarily resolve the whole thing into nothing, that resolving into nothing is "where Duchamp is at"—for the nothing that is *his* cipher is a divisor and not a quotient. Between unity and nothingness is the infinity of Duchamp. As he said in a note on conditions of a language, "the search for prime

Marcel Duchamp, 1953. Photograph by Victor Obsatz.

words divisible only by themselves and by unity" was a basic enterprise to which he dedicated his life. If a prime word is, in essence, self-reflexive, it is also autonomous, even if the mechanism of its autonomy is pure fiction, a contentless nothingness.

Mallarméan as he was, Duchamp was willing to become a fiction of his own idea of himself.[45] In this self-transformation, the machine was both a motor force and a catalyst, crucial for his personal and untraditional alchemy of achieving "fool's gold" out of what would have been others' "dross." What was dross was his Kierkegaardian humanity, but, to him, that was what he needed to abolish! Like his *Anémic Cinéma,* in which self-transforming spirals and punning disks rotate elliptically without ultimate gain or loss, Duchamp became the "negation of his own negation," a kind of dialectical *néant,* which told him, with "the blankness of dada," that he was not as "blank" as he had thought. If Duchamp was hardly an angel (unless we think of Lucifer as one), he was also not a machine; that is why he converted the mechanism of nonsense into the alphabet of dreams. What others could make out about this alphabet was a matter of general unconcern to Duchamp, though on the "art level" he admitted that the spectator qualified and "completed" the work. What *he* made out of it, his oeuvre, is more than a matter of machines, although some interest in the machine is a prerequisite for dealing with Duchamp on any level and to any significant degree.

What is more important is that the viewer, whoever he may be, have an extraordinary capacity to understand and enjoy nonsense, in itself and extensively, as a mode of redefining an appropriate measure of order between pathos and ecstasy. If he can do that, he will be at the heart of the matter, which is located about 180 degrees from where most people see nonsense as standing—that is, not on the other side of reason, but on this side of dreams. Accept that and the machine will begin to detach itself—without wholly losing touch with Duchamp's own capacity for pathos and ecstasy—from the humanity of the artist, which is of less importance to us now than the efficacy of his manner of transcending his own limitations through an art that made him free.

1. See Marcel Duchamp, "The Creative Act," in Robert Lebel, *Marcel Duchamp* (New York: Grove Press, 1959), p. 77.

2. Elizabeth Sewell, *The Field of Nonsense* (London: Chatto & Windus, 1952). See also Roger Shattuck, *The Banquet Years: The Arts in France, 1885–1918* (New York: Harcourt, Brace, 1958), p. 258. For Duchamp's mood and a characterization of him as a "sad young man," see Gabrielle Buffet-Picabia, "Some Memories of Pre-Dada: Duchamp and Picabia," in *The Dada Painters and Poets,* ed. Robert Motherwell (New York: Wittenborn, Schultz, 1951), pp. 255–58. "Hygienic" was a favorite word of Duchamp, and Laforgue's *Hamlet* was an early *locus classicus* for his baffling discontents.

3. For "mediumistic being," see note 1. For "blankness of dada," which taught Duchamp that he was not as blank as he had thought, see "Eleven Europeans in America," ed. James Johnson Sweeney, *Museum of Modern Art Bulletin* (New York), vol. XIII, nos. 4–5, 1946, pp. 19–21.

4. The notion of "short-circuit" is derived from Duchamp's notes for the *Large Glass* and the "blossoming of the bride."

5. "Irony is a playful way of accepting something. Mine is an irony of indifference. It is a 'meta-irony.'" See Harriet and Sidney Janis, "Marcel Duchamp: Anti-Artist," in Motherwell, *Dada Painters and Poets,* pp. 306–15.

6. "Debrained" is a Jarryesque term, a favorite of Duchamp, and *cervellités* is a Duchampian neologism for thought products—or "brain facts."

7. A useful pragmatic aid in achieving this climactic effect, which is a consequence of great perceptual effort in looking at the *Coffee Mill,* is provided (without reference to Duchamp) by Anton Ehrenzweig, "The Pictorial Space of Bridget Riley," *Art International* (Lugano), vol. IX, February 1965, pp. 20–24. By imagining Riley's *Blaze I,* 1962 (p. 20), surmounting *Twist,* 1963 (p. 24), as "accelerations" of Duchamp's *Coffee Mill,* one can more easily achieve the transformation of the *Coffee Mill* from pattern to "presence" just noted.

8. For possible semantic extensions of this perceptual process, see Steefel, *The Position of "La Mariée mise à nu par ses célibataires, même" (1915–1923) in the Stylistic and Iconographic Development of the Art of Marcel Duchamp,* Mic. 61-2004 (Ann Arbor: University Microfilms, 1960), pp. 113–27; for the mill as mandala, see Lebel, *Marcel Duchamp,* p. 74; and for the key role of the mill in Duchamp's artistic development, see Janis, "Duchamp: Anti-Artist," pp. 309–11.

9. Interview, 1956. For a related comment on "science," see Pierre Cabanne, *Dialogues with Marcel Duchamp,* trans. Ron Padgett (New York: Viking, 1971), p. 39.

10. See Duchamp's comment on Mallarmé in James Johnson Sweeney, "Eleven Europeans in America," p. 21. See also Cabanne, *Dialogues with Marcel Duchamp,* pp. 30, 40, 105. For the most "Duchampian" of Mallarmé's creations, conceived as early as 1866, worked on mostly after 1894, and left *inachevé* at his death, see Jacques Scherer's *Le "Livre" de Mallarmé* (Paris: Gallimard, 1957), pp. 155–380, which presents the text of a set of notes for a *théâtre imaginaire* in which time is suppressed and mastered.

11. Interview with Steefel, 1956. See also Cabanne, *Dialogues with Marcel Duchamp,* p. 72.

12. There has been much debate as to whether the "nude" moves. Duchamp said he did not want "cinematic effects" but admitted that everyone, including himself, saw motion in the image. Interview with Steefel, 1956. See also Cabanne, *Dialogues with Marcel Duchamp,* p. 30.

13. For further analysis of this image, see Steefel, *Position of "La Mariée,"* pp. 107–113.

14. For Marey, see Aaron Scharf, *Art and Photography* (Baltimore: Penguin, 1969), pp. 199–210, and Siegfried Giedion, *Mechanization Takes Command* (New York: Oxford University Press, 1948), pp. 17–28.

15. For "body image," see the penetrating discussion of body perception in Paul Schilder, *The Image and Appearance of the Human Body* (New York: International Universities Press, 1950). For the body as instrument, subject, and presence, see Matthew Lipman, *What Happens in Art* (New York: Appleton, Century, Crofts, 1967), pp. 67–80.

16. See Lebel, *Marcel Duchamp,* p. 9.

17. This "coldness" is perfected as "the beauty of indifference" in what may be the finest version of the image, the Philadelphia Museum's "Blue Nude," produced on the format of the 1912 painting, photographed and "assisted" by Duchamp in 1916.

18. For "turning inward," see Duchamp in Sweeney, "Eleven Europeans in America," p. 20. For the context of desperation and hope, see Janis, "Duchamp: Anti-Artist," pp. 311–12.

19. If Duchamp had simply transposed a Marey schematic image as a procedure for his *Nude,* there would have been no "unabsorbed difficulty" for the viewer to face. It is hard to believe that such a borrowing would have been too radical a step for Duchamp to make. Rather, one feels it would have been too easy for him—which, if true, points to his concern with ego in making his own *Nude* in a more personal way than he would have chosen to do after 1912, and also to the process of "disincarnation" and "decomposing" his work was undergoing at this time.

20. Interview with Steefel, 1956. For the creative process, see note 1, above. For "chance" and Duchamp, see Cabanne, *Dialogues with Marcel Duchamp,* pp. 95–97. For "the mind" and "aleatory order," see Frank Kermode, "Modernisms Again," *Encounter* (London), no. 26 (April 1966), pp. 65–74.

21. See Janis, "Duchamp: Anti-Artist," pp. 311–12; Arturo Schwarz, *Complete Works of Marcel Duchamp,* passim; and Lebel, *Marcel Duchamp,* pp. 74–75.

22. "Before he had, so to speak, purged himself of it, Duchamp had let us feel, through the sarcastic atmosphere in which he enveloped it, that the universe of his works was for him the anti-world. . . . It is the intolerable world of reality which he 'brushes aside' as one would wave away a nightmare, by fixing it in the *Glass* [and other works]." Lebel, *Marcel Duchamp,* p. 72.

23. For the rejection of aesthetic finesse, see Sweeney, "Eleven Europeans in America," pp. 20–21.

24. Max Kozloff, "Duchamp," *The Nation* (New York), vol. 200, February 1, 1965, pp. 123–24.

25. For these images, see Lebel, *Marcel Duchamp,* pp. 10–15; Schwarz, *Complete Works of Marcel Duchamp* (New York: Abrams, 1969), pp. 103–20; and Steefel, *Position of "La Mariée,"* pp. 133–50.

26. See Michel Foucault, "*7 Propos sur le 7e ange,*" in Jean-Pierre Brisset, *La Grammaire logique* (Paris: Tchou, 1970), pp. vii–xix, and Brisset's own text.

27. The most compelling frame of reference for *l'état brut* of Duchamp's obsessional matrix is Georges Bataille's *Death and Sensuality: A Study of Eroticism and the Taboo* (New York: Ballantine, 1969), pp. 5–19 and passim.

28. For a detailed analysis of one image in this suite, *The Passage from the Virgin to the Bride,* see L. D. Steefel, Jr., "The Art of Marcel Duchamp," *Art Journal* (New York), vol. XVII, no. 2 (Winter 1962–63), pp. 72–80.

29. "Problems are nonsensical. They are human inventions." Duchamp, interview with Steefel, 1956.

30. Duchamp may have been aware of the Greek root of "machine": *mēchanē,* trick or ruse.

31. For a detailed study of this complex point, see Steefel, "The Art of Marcel Duchamp," pp. 73–74.

32. "A human body that functions as if it were a machine and a machine which duplicates human functions are equally fascinating and frightening. Perhaps they are so uncanny because they remind us that the human body can operate without a human spirit, that body can exist without soul." Bruno Bettelheim, "Joey: A 'Mechanical Boy,'" *Scientific American* (New York), vol. 200, no. 3 (March 1959), p. 117.

33. For a responsible discussion of the ambiguous issue of Duchamp's "autisms," see Lebel, *Marcel Duchamp,* pp. 70–75.

34. See Cabanne, *Dialogues with Marcel Duchamp,* p. 40.

35. For the geometric ratio of Duchamp's

"speculative intrigue" as played into the evolution of the *Large Glass*, see Cabanne, *Dialogues with Marcel Duchamp*, pp. 39–40. For more on Duchamp and the "fourth dimension," see L. D. Henderson, "A New Facet of Cubism: The Fourth Dimension and Non-Euclidean Geometry Reinterpreted," *Art Quarterly* (New York), vol. 34, no. 4 (Winter 1971), pp. 410–33. For a fascinating parallel to the oneiric articulation of Duchamp's dimensionality, see Lewis Carroll, "Through the Looking Glass," *The Complete Works of Lewis Carroll*, Modern Library (New York: Random House, n.d.), pp. 162–67.

36. Kozloff, "Duchamp," p. 124.

37. See André Breton, "Lighthouse of the Bride," in Lebel, *Marcel Duchamp*, pp. 88–94. Cf. Duchamp's interview with Steefel, 1956: "You can do anything you want with these," said Duchamp, referring to the works.

38. Sewell, *The Field of Nonsense*, pp. 1–6, 25–26, 41–43, and especially 44.

39. Ibid., pp. 44–54.

40. Ibid., p. 27.

41. Ibid., pp. 55–80, 115–29.

42. Duchamp spoke, in the early stages of his thought about the *Large Glass*, of *un retard en verre*, or "a glass delay." The postponement of climax may be the meaning of that phrase which has remained otherwise unexplained.

43. For distinctions between "in order," "an order," and "order," see Kermode, "Modernisms Again."

44. "If today the elaboration and execution of the *Glass* can simultaneously suggest asceticism and the Great Work of the alchemists, or some apparently trifling exercises in Zen Buddhism, Duchamp's experience remains nonetheless unique, empirical and inconclusive as it is. Confronted with the crises of modern times which he had first to live through, and in the face of all formulae, all illusions, all doctrines, he has raised his enigmatic monument to the free disposition of one's self, and in addition he has restored a reason for existence to the work of art he meant to abolish." Lebel, *Marcel Duchamp*, p. 75.

45. "To strive to make oneself the most irreplaceable of individuals is, for all practical purposes, to strive never to resemble one's fellow men, and for some, at least, not even to resemble oneself. This is a singularly attractive undertaking. A kind of underground spirit drives man to experiment with the extremist possibilities of self-metamorphosis. The question is whether it is possible to enrich one's nature and achieve a new awareness of one's total being by overruling the resistance of reason and habit, by forcing one's imagination to leap into the unknown, beyond any beaten track. This implies a readiness to destroy the traditional concept of man, and, first of all, to destroy one's personal being, to let it be absorbed and lost in a *selva oscura*. . . . More than that: this very activity, this mental proteanism, this way of living and constantly renewing one's life is poetry." Marcel Raymond, *From Baudelaire to Surrealism* (New York: Wittenborn, Schultz, 1950), pp. 220–21.

*Coffee Mill.* 1911. Oil on cardboard, 13 x 4$^{15}/_{16}$ in. Collection Mrs. Robin Jones, Rio de Janeiro. Cat. 69.

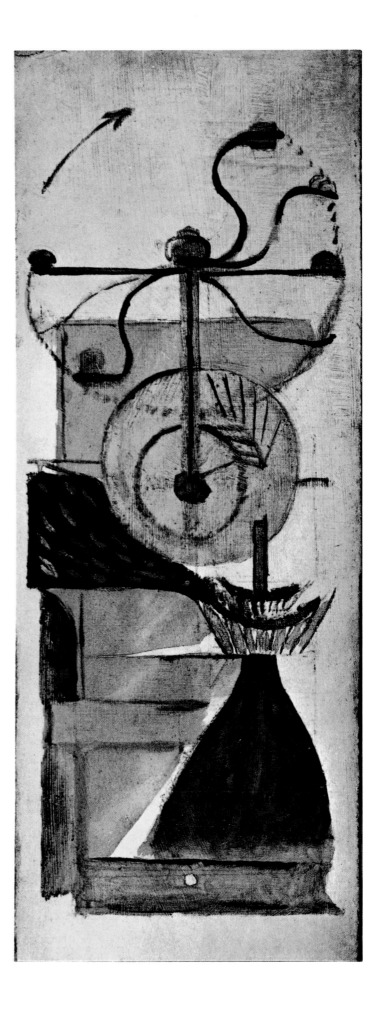

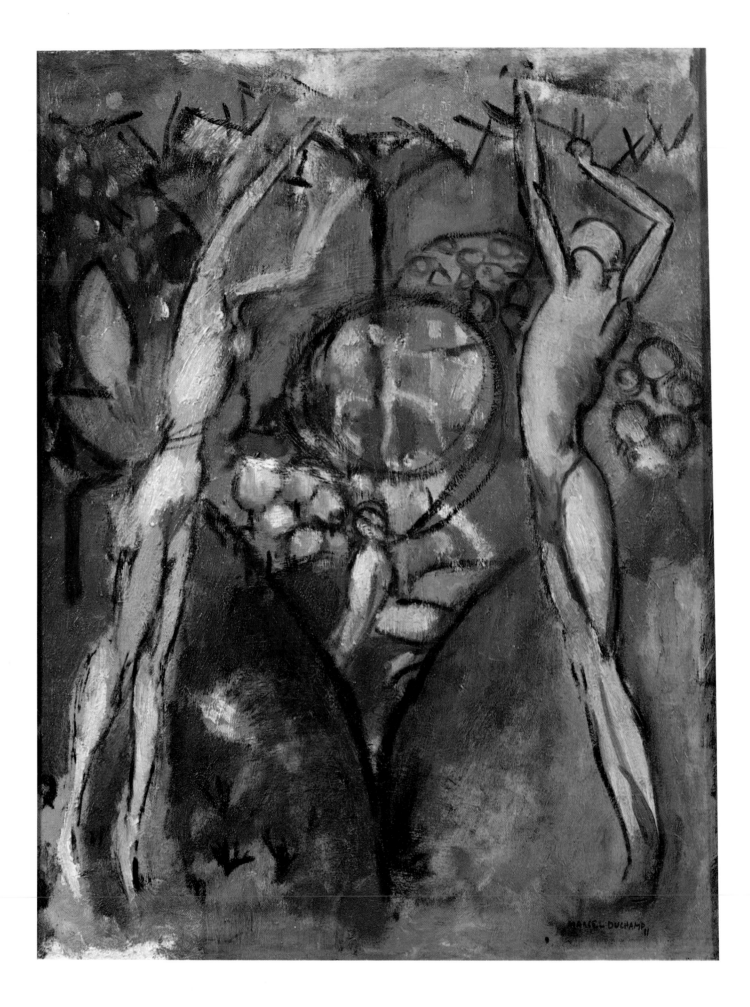

# THE ALCHEMIST
# STRIPPED BARE
# IN THE BACHELOR,
# EVEN

Arturo Schwarz

*If I have ever practiced alchemy, it was in the only way it can be done now, that is to say, without knowing it.*[1]—Marcel Duchamp

*The Philosopher's stone is nothing more or less than that which was to enable man's imagination to take a stunning revenge on all things.*[2]—André Breton

*Young Man and Girl in Spring.* 1911. Oil on canvas, $25\frac{7}{8}$ x $19\frac{3}{4}$ in. Collection Vera and Arturo Schwarz, Milan. Cat. 54.

ALCHEMY is a word that contains several notions, of which only the most common—and least important—is usually remembered. Most dictionaries encourage our laziness. For instance, the unabridged edition of the Random House Dictionary of the English Language defines alchemy as "an art practiced in the Middle Ages and the Renaissance concerned principally with discovering methods for transmuting baser metals into gold and with finding a universal solvent and an elixir of life."

Alchemy is one of the oldest arts of mankind. Its beginning coincides with the dawn of civilization. Egypt, India, and China were the most important centers of alchemical thought and practice in the ancient world. The Royal Art then spread to the Occident through Hellenistic Egypt—one of the earliest treatises on alchemy was written in Alexandria—at the beginning of the Christian era. However, we find records of what might very well be alchemical operations in Egyptian papyri that date back to at least a thousand years earlier.

Alchemy is an esoteric and exoteric adventure; it is a symbolic operation. The transmutation of metal into gold is only the top of the iceberg. The superficial observers who see only this part of the iceberg make their appearance in history at the same time as alchemy itself. An ancient Chinese text denounces such people: "They believe that [alchemy] means to transform stones into gold: isn't that crazy?"[3]

The material liberation of philosophic gold from vulgar metal is a metaphor for the psychological processes concerned with the liberation of man from life's basic contradictions. Jung points out that "from its earliest days alchemy had a double face: on the one hand the practical chemical work in the laboratory, on the other a psychological process, in part consciously psychic, in part unconsciously projected and seen in the various transformations of matter."[4] Elsewhere he draws our attention to the parallel between "the transmutation of metals and the simultaneous psychic transformation of the artifex."[5]

These contradictions spring from a dualistic view of the universe that postulates the conflicting polarity of all natural phenomena; liberating man from these contradictions thus entails a monistic interpretation of nature. Such an interpretation takes the opposite stand and requires the conciliation, on a higher, transcending plane, of the contradictions that man encounters on the way toward higher self-development: in alchemical terms, on the way toward achieving the status of the *homo maior* endowed with eternal youth.

But, for the adept to achieve higher consciousness means, in the first place, acquiring "golden understanding" (*aurea apprehensio*) of his own microcosm and of the macrocosm in which it fits. It is in the course of his pursuit of the Philosopher's Stone that he acquires this new awareness. Thus the quest is more important than its reward; as a matter of fact, the quest *is* the reward. Alchemy is nothing other than an instrument of knowledge—of the total knowledge that aims to open the way toward total liberation.

Only by acquiring this "golden understanding" will the adept succeed in achieving the higher consciousness that is the first stage toward the reconstitution, at a higher level, of the unity of his divided self. Jung terms this psychological process "individuation," and he defines it as "the centralizing processes in the unconscious that go to form the personality." He then comments: "I hold the view that the alchemist's hope of conjuring out of matter the philosophical gold, or the panacea,

or the wonderful stone, was only in part an illusion, an effect of projection; for the rest it corresponded to certain psychic facts that are of great importance in the psychology of the unconscious. As is shown by the texts and their symbolism, the alchemist projected what I would call the process of individuation into the phenomena of chemical change."[6]

Individuation, in the alchemical sense, entails abolishing the conflicting male-female duality within the integrated personality of the reconstituted Gnostic Anthropos, i.e., the original androgyne—the Homo Maior of mythical times, the Rebis (the double thing) of the alchemist. André Breton had already singled out the importance of this aspect of alchemical thought when he wrote: "It is essential, here more than anywhere else, to undertake the reconstruction of the *primordial Androgyne* that all traditions tell us of, and its supremely desirable, and *tangible,* incarnation within ourselves."[7]

The myth of the androgyne runs through our literature from Plato's *Symposium* to Balzac's *Séraphita.* The concept that everything having shape, quality, and individuation originated from an undifferentiated principle, superior and at the same time anterior to the opposition between Me and not-Me, the physical and the spiritual, inside and outside, not only contains the doctrinal premise of transmutation—creation—but also refers to the sacredness of the Rebis. Bisexuality has always been an attribute of divinity.

Absolute freedom is one of man's oldest aspirations, and Eliade has pointed out that "to be no longer conditioned by a pair of opposites results in absolute freedom."[8] But to be able to enjoy this freedom man must first attain integration, become a self. "Only a unified personality can experience life, not that personality which is split up into partial aspects, that bundle of odds and ends which also calls itself 'man.'"[9]

For the alchemist the Rebis was the fruit of the "chymical nuptials" between mercury (the female, lunar principle) and sulphur (the male, solar principle). These "chymical nuptials" are of a basically incestuous nature. What was divided on a lower level will reappear, united, on a higher one.

For Jung the chymical nuptials are a metaphor for the reconstitution of the integrity of the split personality through the unification of the *anima* (female principle in man) with the *animus* (male principle in woman). This integration is achieved through the reconciliation of opposites (*coincidentia oppositorum*), the prerequisite for individuation.

The main prototype of the alchemical marriage is the Brother-Sister incest, where "the Brother-Sister pair stands allegorically for the whole conception of opposites."[10] Their union symbolizes "the return to a primordial unity, and this is why the *artifex* who seeks to realize this union is often helped by his *soror mystica*."[11] Curious relationships between androgyny and incest between siblings are also to be found in many myths.[12] The themes of the androgyne and the Brother-Sister incest have more in common than might at first be expected. The richness of their symbolism gives an esoteric dimension of universal significance to some of the basic patterns underlying Duchamp's oeuvre, and helps us to understand the importance of Duchamp's lack of dogmatism as expressed in his often-avowed preference for the suspension of judgment. The undifferentiated psychic and physical pattern

of the androgyne is the mythical model for Duchamp's ethics and aesthetics as seen at work in the *Large Glass* and in the Readymades. This pattern also throws a new light on works such as the bearded Mona Lisa of *L.H.O.O.Q.* and the *Door: 11, rue Larrey,* 1927, which contradicts the saying that a door must be either open or closed.

But more fundamentally still, bisexuality is the archetypal quality of the creator, while the alchemical incest is the ideal mythical model for the state in which, after all contradictions have been resolved, individuation is achieved and creation becomes possible.

In *The Complete Works of Marcel Duchamp*[13] I have maintained that the *Large Glass* is the mythical account of an unrealizable love affair between siblings. The work is understood as an esoteric projection of an unconscious, exoteric, train of thoughts—Marcel Duchamp's love for his sister Suzanne. Even the unconscious thought of the sexual consummation of the relationship is sufficient to bring about the most drastic of reprisals, death, and thus the *Large Glass* also reveals the undisguised pattern of one of the world's oldest and most widespread taboos—the taboo against incest.

It is necessary, however, to understand that the term "incest" is, as Korzybski would say, a typically over/under-defined term, and that it is to be understood "symbolically, not concretistically and sexually. Wherever the incest motif appears, it is always a prefiguration of the *hieros gamos,* of the sacred marriage consummation which attains its true form only with the hero."[14]

It should therefore be clear that these patterns were entirely unconscious. The extraordinarily poetic quality of the *Large Glass* resides precisely in the fact that its creator was led by forces and drives of which he was ignorant. In a lecture he delivered in 1957 on "The Creative Act," Duchamp declared, "We must then deny him [the artist] the state of consciousness on the aesthetic plane about what he is doing or why he is doing it."[15] And Jung confirms that "one can paint very complicated pictures without having the least idea of their real meaning."[16] Jung also observes that the alchemist's quest is again a "psychological projection at the unconscious level." Discussing the Gnostic philosophy of Zosimos, the Greek alchemist, Jung points out that his philosophy is the outcome of "an unconscious process that works only so long as it stays unconscious."[17]

If any single painting were to be pointed out in Duchamp's oeuvre as the one in which the manifest and latent alchemical connotations are most strikingly evident, the choice would no doubt fall upon *Young Man and Girl in Spring,* painted in 1911. It can only be mentioned here that this pivotal work was immediately preceded by a trilogy of allegorical portraits which suggest a sequence of mythic themes: *The Bush* (the presentation of the neophyte), *Baptism* (rites of initiation), and *Draft on the Japanese Apple Tree* (the attainment of enlightenment).

A discussion of the details of *Young Man and Girl in Spring* will lead to the realization that in complexity of theme this painting is second only to the *Large Glass;* but this is not surprising, since the painting is an anticipation of the *Glass.*

It might be helpful, before starting a detailed analysis, to point out that this theme is hinted at both in the double sense of the title—two young people in the "spring" of their life—and in the attitude that the

Albert the Great points to the hermetic androgyne holding a Y (symbol of immortality). Michael Maier. *Symbola aurea.* Frankfort: Luc Jenn, 1617.

Hero-Virgin pair have assumed in the painting—the two youngsters are sexually attracted to each other. We might see in this attraction a sign of the psychological maturation that favors the development of the individuation process. This individuation process is enriched by the peculiar type of relationship between them as the real relationship of the Brother-Sister pair gradually replaces the mythical relationship of the Hero-Virgin pair. Incest is envisaged here as a means of resolving the contradictions of the male-female duality within the reconstituted androgynous unity of the primordial being, endowed with eternal youth and immortality. In this respect, the basic theme of *Young Man and Girl in Spring* is a metaphor of the struggle to produce the Philosopher's Stone.

In *Young Man and Girl in Spring* the Young Man (Marcel, the future Bachelor of the *Large Glass*) and the Young Girl (Suzanne, the future Bride) are barely differentiated sexually, and both have their arms lifted to the sky in a Y-shaped figure, a position indicative of their common aspiration—immortality—and of their basic androgynous psychic patterns—an aspiration and a pattern that are closely interdependent. Eliade tells us that when the shaman takes a similar position during rituals he exclaims, "I have reached the sky, I am immortal."[18] In the Hyperborean and North Atlantic traditions the Y-sign stands for the Cosmic-Man-with-Uplifted-Arms, and again it embodies the concept of immortality through resurrection as well as the concept of the "double" androgynous personality. (In Egyptian, the hieroglyph Kha, which stands for the "double," is drawn in the Y-form of two uplifted arms,[19] and in alchemy the Y-sign is again the symbol of the androgyne, as may be seen, for instance, in an illustration of Michael Maier's *Symbola aurea,* where Albert the Great points to an androgyne holding a Y.)[20] In esoteric writings the Cosmic Man is androgynous since he also stands for the primordial man (the Gnostic Anthropos) who gives birth through a dichotomy to the duality of male and female.

The two young people stand on two separate worlds, implied by the two semicircles from which they strive toward each other. The semicircle on which the Young Man stands radiates a yellowish light: it may well symbolize the Sun. The semicircle on which the Young Girl stands is darker and has a patch of silver-white: the Moon. Similarly, in the alchemical tradition the incestuous Brother-Sister pair is symbolized by the Sun-Moon pair. Their union (*coniunctio oppositorum*) reconstitutes the original unity of the primordial being, the immortal Hermetic Androgyne (the Rebis). The Young Girl's head, painted from an unusual angle, disappears behind her uplifted arms; her body looks headless. The dislocation of the head anticipates the position of the head in the *Pendu femelle* hanging in the upper part of the *Large Glass.* The term *Pendu femelle,* i.e., the Female Hanged Body, is used repeatedly by Duchamp to indicate the Bride in the *Large Glass.*

Duchamp has also said that the theme of the Bride was suggested to him "by those booths at the fairs, which were so numerous then, where dummies, often representing the characters of a wedding, offered themselves for decapitation thanks to the skill of the ball-throwers."[21] The thrown-back head of the Young Girl is reminiscent of these dummies. A headless body is not only a symbol of castration; in the esoteric and alchemical tradition, it also stands for the concept of order in the creation of the cosmos as opposed to the disorder of chaos. Neu-

The incestuous union between Gabricus and his sister Beya. Notice the familiar King/Queen and Sun/Moon archetypal characterization of the couple (Gabricus and Beya are crowned; the sun and moon are at their feet). *Rosarium philosophorum.* Frankfort, 1550.

mann points out that "Mutilation—a theme which also occurs in alchemy—is the condition of all creation."[22]

Furthermore, the meeting of the two young people appears to be both hindered and furthered by a tree whose branches grow between them. The tree both divides and unites them; they reach for its branches and enter thus into indirect contact. The tree as symbol conveys a great variety of meanings.[23]

Basically, the tree is a symbol of the drive toward cosmic totality, of the totality of the cosmos in its genesis and its becoming. It is also the prototype of the hermaphrodite, the synthesis of both sexes; and as the *axis mundi*, it may act as a mediator between Earth (woman) and the Sky (man). It suggests the prolongation of human life.[24] The tree may also stand for the Adamic Tree, the Tree of Knowledge, which embodies the conflicting but complementary notions of the Tree of Life (or Green Tree) sinking its roots into the sky and the Tree of Death (or Dry Tree) that sinks its roots into the red *terra adamica*.

In this painting these two aspects of the tree interchange freely. In the alchemical tradition, the Tree of Life is the source of the Sun (on which the Bachelor stands and with which he is identified) and its fruit is the Living Water, the Fount of Youth. Even though the branches of the tree in the painting are utterly dry (suggesting the Tree of Death), they are also enveloped by a green cloud (suggesting the foliage of the Tree of Life).

The tree in this painting grows from a circle, or rather from a transparent glass sphere in which we might be tempted to recognize an alembic, the alchemical vessel, also called the spherical house of glass (comparable to the *Large Glass*, which houses the Bride and Bachelor), or again the Prison of the King. In this painting the sealed vessel of Hermes imprisons a sexless personage who closely resembles the Mercurius that is often present in the alembic. Mercurius stood for "the hermaphrodite that was in the beginning, that splits into the traditional Brother-Sister duality and is reunited in the *coniunctio*, to appear once again at the end in the radiant form of the *lumen novum*, the stone. He is metallic yet liquid, matter yet spirit, cold yet fiery, poison and yet healing draught—a symbol uniting all opposites."[25] Here Mercurius assumes a typical offering attitude, kneeling and tendering a piece of cloth to the naked Young Man.

To understand the meaning of this offering one must consider the symbolic significance of cloth. According to Durand, woven material is what "opposes itself to discontinuity, to tearing as well as to breaking . . . it is that which 'fastens' two parts which are separated, that which 'repairs' a hiatus."[26] We recall that in this painting the Young Man and Girl are separated by the tree. And this separation is emotional as well as physical. Remarking that the cloth offered by the androgynous personage is pink—a typical color for female garments—we may recall that at Cos the husband wears women's garments to receive the bride, while at Argos the bride wears a false beard the first night of marriage.[27] (In quite a few photos Duchamp is seen wearing women's clothes; the best-known example is the photo on the label of the perfume bottle, *Belle Haleine, Eau de Voilette*, of 1921. And the Mona Lisa of *L.H.O.O.Q.*, 1919, is given a beard by Duchamp.)

The exchange of garments, however, is also often associated with an exploit—conquering a woman's heart, for instance.[28] The invitation

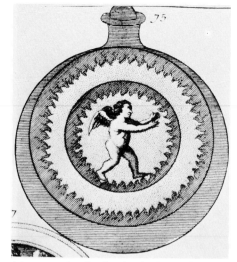

Mercurius in the bottle. J. C. Barckhausen. *Elementa chemiae*. Leyden, 1718.

of Mercurius could not be more welcome to the Bachelor, who is separated from his Bride. Obviously, the disguise also symbolizes bisexuality, which, in turn, is linked with the human aspiration toward eternity.[29] Durand emphasizes this aspect of the cloth's totalizing symbolism, standing as it does for the necessary fusion of the cosmic polarities,[30] which takes us back to the solution envisaged to repair this hiatus—the alchemical incest. This *coniunctio oppositorum*—the union of the Brother-Sister pair—takes place in the alchemical vessel, and the fruit of the union is not only Mercurius but also the androgynous original man (the Gnostic Anthropos).

Finally, the circular shape of the "alchemical vessel" in the painting (such vessels are usually an irregular oval) again emphasizes the aspiration to reconstitute the original unity; the alchemical ideogram for the "One and All" is a circle—a line or movement that has in itself its beginning and end. In the hermetic tradition it designates both the Universe and the Great Work.[31]

I have mentioned that the tree grows from this circle, and when the Tree of Death was discussed it was observed that the circle was the schematic representation of its branches. Since the androgynous figure appears in the midst of these branches, it may be identified as the tree's fruit; we remember, in fact, that the Fount of Youth is the fruit of the Tree of Life and that it is also synonymous with the Great Work (the *Opus*). The function of the Tree of Life, which is to reanimate the Tree of Death, is thus seen to be fulfilled as, again, Eros defeats Thanatos.

Directly below the central transparent glass sphere, with eyes turned toward the personage it contains, there is another figure, who rests on both the Bachelor's (Sun) world and the Bride's (Moon) world. This figure participates in both and mediates between them, reconciling in itself their contradictions. The character is kneeling—halfway between Earth (woman) and Sky (man).

This central personage epitomizes the meaning of this painting, which is the accomplishment, on the artistic level, of three primordial and only apparently contradictory aspirations that find gratification within the frame of the alchemical incest: the urge to reconstitute the original unity, the drive toward individuation, and the wish for immortality. In fact, the *coniunctio oppositorum* of the Brother-Sister pair aims, here again, at resolving the contradictions of the male-female principle in the hermaphroditic, primordial entity which is endowed with eternal youth and immortality.

Let us consider the extraordinary similarities between *Young Man and Girl in Spring* and its mythical model—the traditional representation of the philosophical androgyne (the Rebis or *Compositam de compositis*) as may be seen, for instance, in one of the illustrations of Michael Maier's *Auriferae artes* (Basel, 1572), where the incestuous Brother-Sister pair again stand on the Sun and the Moon.

In Maier's illustration the Brother and Sister are united into the Philosophical Marriage by the Universal Spirit that descends upon them under the appearance of a Dove. Each of the three figures in the illustration (the King-Sun-Bachelor, the Queen-Moon-Bride, and the Dove) holds a rose. The roses occupy in the illustration the same position occupied in Duchamp's painting by the rose-colored garment offered by the Young Man to the Girl. The stems of the three roses cross to form an X-shaped figure that symbolizes the Fire of the Philos-

Union of Luna-Sol. Michael Maier. *Auriferae artes.* Basel, 1572.

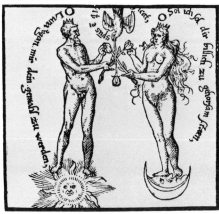

ophers or the Fire of Love. We have recognized in the pink garment the same allegorical reference to the force of love. Finally, the Universal Spirit (the Dove) finds its allegorical representation in the green cloud that suggests the foliage of the Tree of Life. In the configuration of the tree's V-shaped diverging branches we can find a trace of the outlines of the Dove's wings (again both details occupy the same position in the painting and the illustration). Let us also note that, in the alchemical tradition, the Universal Spirit is the Living Water, i.e., the green cloud "dispenser of the beneficent dew" that crowns, in the painting, the Tree of Life, and that it also stands for the *aurea apprehensio.*

Quite fittingly, 1911, the year that witnessed the realization of the trilogy of allegorical portraits and of *Young Man and Girl in Spring,* ends with the painting of a grinder, which is a typical alchemical instrument. *Coffee Mill* is the first of a series of grinding machines; it was followed by *Chocolate Grinder, No. 1,* 1913, *Chocolate Grinder, No. 2,* 1914, and *Glider Containing a Water Mill in Neighboring Metals,* 1913–15.

A typical alchemic distilling apparatus, the alembic, is to be found in the glass sphere at the center of *Young Man and Girl in Spring,* and in the *Coffee Mill* we meet another typical alchemic instrument, the grinding mill. We may see in this the continuity of Duchamp's thought and the unitary organization of his symbols. "The mill and the apparatus of distillation are associated in hermetic thought with transformation symbolism in the tradition of alchemy, both as a physical quest for gold and in the psychic dimension of introversion and spiritual rebirth."[32] Both instruments are refining instruments—the alembic acting chemically, the mill physically. They transmute raw materials into their sublimated form just as Duchamp sublimates his sexual drives into artistic drives.

A detail common to the two paintings executed during the summer of 1912 in Munich, *The Passage from the Virgin to the Bride* and *Bride,* reveals one of the most beautiful correspondences between Duchamp's and alchemical iconography. At the center of both these paintings we can recognize an alembic—the classical androgynous symbol in alchemy. The androgynous nature of the Bride is further confirmed by another fact; Duchamp writes that the spinal column of the Bride is arbor-type, and we may recall again that the tree is a typical symbol of bisexuality. The Bride in this painting thus embodies the realization of the wishes of the protagonists of *Young Man and Girl in Spring.* Another detail of this painting may lend even further support to this hypothesis: we may notice that a streamlet of liquid is entering the opening of the alembic. In the alchemic tradition, this operation stands for the alchemical marriage—the union of the Brother-Sister pair. The alchemical marriage is similarly represented in traditional alchemical iconography. For instance, in Hieronymus Bosch's famous painting *The Garden of Earthly Delights,* we may note, in a detail, a "hooded crow pouring out from a little phial in its beak a glimmering fluid that flows down into the ovary." Fränger comments that this is "a process that in Bosch's metaphorical language indicates the celebration of an alchemical marriage."[33]

The *Bicycle Wheel* of 1913 is the first Readymade, and it introduces another aspect of Duchamp's relation to the art of the alchemist. What is of interest in this context is the correspondence between Duchamp's attitude concerning the Readymades in general, and the kernel of

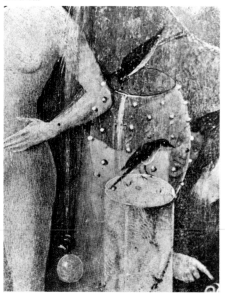

Detail of lower right-hand corner of central panel of the triptych *The Garden of Earthly Delights* by Hieronymus Bosch. 1503–4. The Prado, Madrid.

alchemical thought concerning the work of art *par excellence*, the Philosopher's Stone. For the alchemist, the Stone "is familiar to all men, both young and old, is found in the country, in the village, in the town, in all things created by God; yet it is despised by all. Rich and poor handle it every day. It is cast into the street by servant maids. Children play with it. Yet no one prizes it."[34]

Similarly for Duchamp, art is to be found everywhere, in the most common objects. We only have to open our eyes and our minds to the beauty that surrounds us. Maybe it is this that Duchamp had in mind when, speaking of the Readymades, he declared that any manufactured object can be raised to the dignity of a work of art through the mere choice of the artist. Duchamp entirely rejects the traditional concept of a work of art. "A point that I want very much to establish is that the choice of these Readymades was never dictated by aesthetic delectation. The choice was based on a reaction of *visual indifference* with a total absence of good or bad taste."[35]

The difference between artist and layman thus ceases to exist. Lautréamont had already declared that poetry is not to be written only by "poets" but by everybody; and social thinkers have envisaged a golden age in which man will have resolved the problems of social and ideological alienation and in which he will be free to devote himself to ideological and artistic activities with the same proficiency that he will have in productive activities. Marx and Engels saw the advent of such an era as the result of the disappearance of the division of labor.

To fulfill Duchamp's vision of the disappearance of the distinction between the artist and the layman implies, naturally, a degree of freedom that is not even imaginable today—a kind of freedom that is both a prerequisite for and a consequence of the notion that all men are capable of creating art, a kind of freedom that can only exist in a situation in which there is a future completely open to unlimited adventures, and the creation of such a future is precisely the aspiration of the narcissistic-unitary drive and of the alchemist.

In this context, Duchamp's adventure with the Readymades heralds the nonalienated man of the future and the new dimensions that artistic activity will encompass. In alchemical terms, it epitomizes the end result of the successful quest for the Philosopher's Stone.

*The Bride Stripped Bare by Her Bachelors, Even*, 1915–23, known for short as the *Large Glass*, together with *Given: 1. The Waterfall, 2. The Illuminating Gas*, 1946–66, are Marcel Duchamp's two major works. The latter is in fact the figurative projection in space and time of the former. When one recalls that the *Large Glass* is the focal point of his oeuvre, the point at which all his more significant earlier works converge, and from which his outstanding later works diverge, one would expect to find in the *Large Glass*, as well as in its projection, *Given: 1. The Waterfall . . .*, the greatest number of alchemical references. This is indeed the case. One would like to point out the numerous correspondences between classical alchemical iconography and the iconographical structure not only of both these works taken as a whole, but also of all the details that compose them. Here, however, we must content ourselves with an analysis of the underlying theme of the *Large Glass*.

André Breton defined the *Large Glass* as "a kind of great modern legend."[36] On the secular plane, the theme of the *Large Glass* is the

unrealizable and unrealized love affair between a half-willing but inaccessible Bride (Suzanne, Duchamp's sister) and an anxious Bachelor (Marcel). The French title of this work, *La Mariée mise à nu par ses célibataires, même,* contains a pun in which the whole theme of the work is hidden. One has only to substitute for *même* the homophone *m'aime,* and the title reads: The Bride stripped bare by her bachelors is in love with me.

The subtitle of the *Glass* that describes it as an "agricultural machine" is equally revealing, the reference clearly having to do with the mythical concept of agriculture as a symbolic wedding of Earth and Sky, and plowing being associated with semination and the sexual act.

Duchamp provided us with another clue to the meaning of the *Glass* when he drew our attention to the fact that it is "a world in yellow."[37] In the esoteric and alchemical tradition, yellow symbolizes both gold and the Sun; the Sun, in turn, is symbolic of Revelation. And in general, when Revelation is involved, gold and yellow characterize the state of the initiate—Buddhist priests wear robes of saffron. And, as is the nature of symbols, the significance of yellow is ambivalent. Sulphur is associated with both guilt and the devil. This is the color of both marriage and cuckoldry, wisdom and betrayal, the ambivalent couple and the hermaphrodite.

More important still, the notion of color in the alchemist's system is of cardinal significance—transmutation of one metal into another often boiled down to finding a "tincture" that could change the original color of the baser metal into the yellow color of gold.

When Duchamp called the *Large Glass* "a world in yellow," he unconsciously repeated a classical alchemical operation. However, in keeping with his philosophy of an art more mental than physical, instead of a chemical tincture he uses a mental tincture to transmute the transparent, neutral color of glass into the yellow color of the philosophical gold. Thus, the Bachelor is caught red-handed while using a standard alchemical technique!

The use of the pun in the title of the *Large Glass* is indicative not only of its theme, but also of its basically mythical nature. And, like all myths, this one too involves the use of an allegorical and symbolic language in which puns and metaphors disguise its real content, accessible only to the initiate. Duchamp emphasized another characteristic that it has in common with myth—its existence within a dual reality and its resulting ambivalence: "In general, the picture is the apparition of an appearance."[38]

When the painting *Young Man and Girl in Spring* was discussed, the full alchemical implications of the brother-sister incest were mentioned. We may now add that the basic pattern of the story that the *Large Glass* unravels is again a metaphor of the struggle to produce the Philosopher's Stone. Let us briefly outline this story before seeking the correspondence with the alchemical archetype.

In the Bride's domain (the upper half of the *Glass*) three main orders of events are described. First there is the stripping of the Bride, which culminates in a blossoming. This blossoming is "the last state of this nude Bride before the orgasm which may (might) bring about her fall."[39] Then comes the transmission of the Bride's desires (also termed love gasoline by Duchamp) to the Bachelor through an extremely complex mechanism which involves the use of a "triple cipher"[40] that

permits the messages to pass through the vigilant censorship of three Nets (also called Draft Pistons: squarish apertures seen in the Top Inscription or Milky Way).

Finally there is the unrealized meeting of the Bride's and the Bachelor's desires in an area of the Bride's domain delimited by the chance configuration obtained by firing nine shots at the *Glass*.

The complex mechanism of the long-awaited meeting of the Bride and Bachelor ensures that no contact will take place between the Bride and the Bachelor—even though only their psychic expressions confront each other here.

In the Bachelor's domain (the lower half of the *Glass*) a symmetrical pattern of three orders of events takes place. First the birth of the Bachelor's desires—the Illuminating Gas—in the Nine Malic Molds that Duchamp appropriately calls Eros's matrix. Then the long and tormented journey of the Bachelor's desires on their way to the meeting with the Bride's. In the case of the Bachelor's the obstacles are even more formidable. His desires will first have to pass through the narrow nine Capillary Tubes, where they will lose their sexual identity—they will be castrated ("cut in bits").[41] Then they will be stopped by the seven Sieves, who have a dual conflicting role: on the one hand they filter, censor, and "straighten out"[42] the Bachelor's desires; on the other, after performing this first role, the Sieves help these desires to reacquire their sexual identity. But the Bachelor's vicissitudes are still not over. His desires will be channeled into the Toboggan, crash (die) three times at its base before resurrecting and being allowed to rise triumphantly toward the Bride's domain through the three Oculist Witnesses.

In the course of this journey the Bachelor's desires will be constantly threatened by two imposing castrating machines that symbolize the Bachelor's onanistic activity: the Water Mill, whose seesaw movement controls the aperture of the castrating Scissors, and the Chocolate Grinder, whose gyratory movement produces "milk chocolate."[43] Let us notice that the Scissors rest on the tip of the sharp Bayonet that rises threateningly from the heart of the Chocolate Grinder.

A beautiful poetical metaphor concludes the account of this perilous voyage. The mirror reflections of the Bachelor's desires "coming from below" will harmoniously organize themselves "like some jets of water which weave forms in their transparency"[44] to form the Picture of Cast Shadows in the upper half of the *Glass*. It is this immaterial work of art—which epitomizes the Bachelor's longings as well as the very significance of his life—that our timid lover offers to the contemplation of the Bride.

True to its mythical character, and to the fact that the *Large Glass* exists within a dual reality, the saga has a dual ending. The unhappy end in the *Large Glass* is countered by the happy end that Duchamp envisaged for this story in his *Notes and Projects for the Large Glass*, where the expression of the Bride's and of the Bachelor's desires finally do meet.

Now that the story unraveled by the *Large Glass* has been outlined, we may verify the correspondences with its alchemical model.

The very layout of the *Glass* is revealing. The *Glass* is divided into two halves. The upper half, the Bride's domain, is clearly identified with the Sky: the whole top of the Bride's domain is occupied by a cloudlike formation known as the Top Inscription or Milky Way. The

lower half, the Bachelor Apparatus, is clearly identified with Earth—in Duchamp's own words it "rests on firm ground."[45]

In the alchemical pansexual tradition, the Sky and the Earth are the "vertical" alchemical couple corresponding to the "horizontal" Brother-Sister couple. Sky and Earth are linked by the same love principle, and the alchemist's task is again to provoke the *coniunctio oppositorum* in the alchemical microcosm.[46] In the words of the eighteenth-century alchemist Le Breton, this is achieved "by the union of two sperms, fixed and volatile, in which the two spirits are enclosed . . . the Sky becomes earth and the earth becomes sky, and the energies of one and the other are reunited. . . . This operation is called the reconciliation of contrary principles, the conversion of the elements, the regeneration of the mixture, and the manifestation of clarity and efficiency; or the real and perfect sublimation from the center to the circumference, the marriage of Sky and Earth, the nuptial couch of the Sun and the Moon, of Beya and of Gabertin, whence the Royal Child of the Philosophers [i.e., the Philosopher's Stone] will issue."[47]

The opening phrases of this quotation help us to understand the poetical metaphor through which Duchamp, in his Notes, describes the concluding event in the *Large Glass*. The Bride's desires, the "love gasoline, a secretion of the Bride's sexual glands"[48] (which calls to mind the "astral sperm" or *Spiritus mundi* of the alchemical tradition), will mingle with the Bachelor's desires, the volatile sperm, the "Illuminating Gas"[49] (similarly formed in the Bachelor's sexual glands—the "Eros matrix"),[50] to form a "physical compound . . . unanalysable by logic."[51] This poetical metaphor for the union of the Bride and Bachelor is a transparent allusion to the alchemical *coniunctio oppositorum* that Le Breton, in the above quotation, described as the "union of two sperms, fixed and volatile."

We have seen how the Bride's "love gasoline" and the Bachelor's "Illuminating Gas" must overcome all sorts of obstacles before reaching the region where they will finally confront each other. Their long and tormented journey[52] is again a metaphor of the quest for the Philosopher's Stone. "The road is arduous, fraught with perils, because it is, in fact, a rite of the passage from the profane to the sacred, from the ephemeral and illusory to reality and eternity, from death to life, from man to the divinity."[53]

Nor should it surprise us that the psyche's odyssey to reconquer its unity is so tortuous if we remember that "the right way to wholeness . . . is a *longissima via* not straight but snakelike, a path that unites the opposites,"[54] since "individuation, or becoming whole, is neither a *summum bonum* nor a *summum desideratum*, but the painful experience of the union of opposites."[55]

The goal of this union is the same as the alchemist's: the reconstruction of the splintered personality. And the way Duchamp succeeds in graphically expressing this goal is indeed remarkable. Duchamp uses for the last element represented in the Bachelor's domain one of the oldest esoterical symbols of humanity: the Dotted Circle. This Dotted Circle admirably epitomizes the twin psychological and alchemical concepts of the fundamental unitary drive of the Psyche and the quest for the Stone. In his studies concerning Mandala symbolism, Jung remarks that in the Tantric doctrine, Lamaism, and Chinese alchemy, the circle stands for "the union of all opposites . . . the state of ever-

Allegory of alchemy in a bas-relief of the central porch of Notre Dame Cathedral, Paris. Notice the head crowned by clouds—exactly like the Bride's in the *Large Glass*.

lasting balance and immutable duration."[56] From the psychologist's standpoint, the periphery contains "everything that belongs to the self—the paired opposites that make up the total personality."[57] Jung, however, adds a new dimension to the circle symbolism when he ascribes a therapeutic effect to it. "The protective circle then guards against possible disruption due to the tension of opposites,"[58] and the circle thus expresses "the idea of a safe refuge, of inner reconciliation and wholeness."[59]

On the other hand, the Dotted Circle is also the alchemical symbol for both the Stone (or Philosopher's Gold)[60] and the King (the active principle who possesses the power to fertilize the waters and form the Philosopher's Stone).[61]

The three steps of the Bachelor's individuation process find an exact parallel in the three main stages of the alchemical process for the production of the Philosopher's Stone (*lapis philosophorum*).

This process can be expressed in the lapidary formula *solve et coagula*, corresponding, on the physical plane, to separation and reunion; on the physiological plane to catabolism and anabolism; on the psychological plane to analysis (*meditatio*) and transcendental synthesis (*imaginatio*). This operation is to be repeated as many times as may be necessary to achieve the desired result. The energy required to carry out the second part of this proposition is to be released by executing its first part.

This dual operation involves three main stages. The first stage, *calcinatio* or *melanosis* (calcination or blackening), sees the apparent death of the adept. It involves a complete loss of his identity; the adept returns to a state of primordial unconsciousness, of *agnosía*. "We notice a total and hallucinating scattering of the intellectual faculties, the unbridled psyche having lost all its points of contact invades the intellect. I am no longer 'I.' And I am also nothing else."[62]

Duchamp describes in almost identical terms the first stage of the Bachelor's individuation process. The Bachelor's desires are "hallucinated rather onanistically";[63] they take the scattered "form of a fog of solid spangles"[64] . . . "each spangle retaining in its smallest parts the malic tint"[65] [malic tint: sexual identity]. The spangles are then "dazed . . . they lose their awareness . . . . They can no longer retain their individuality."[66] Finally "the spangles dissolve . . . into a liquid elemental scattering, seeking no direction, a scattered suspension."[67]

This "elemental scattering" irresistibly evokes the primordial elemental state into which the alchemist's *prima materia* has been broken down during the first stage of the process for producing the Philosopher's Stone. This state derives its model from the original chaotic state of the cosmos before the beginning of the differentiating processes. The first stage of the *prima materia* is the empirical equivalent of the adept's state of *agnosía*.

Jung remarks that the alchemical description of this first stage "corresponds psychologically to a primitive consciousness which is constantly liable to break up into individual affective processes—to fall apart, as it were."[68]

If the adept is to achieve the considerable increase of self-knowledge that is implied by the third stage—a prerequisite for the *unio mentalis*, the interior oneness that Jung calls individuation—it is necessary to reach a psychic equilibration of opposites. These opposites—in this case

mind and body—have to be separated if they are to be reunited at a higher level; Jung points out that this separation is equivalent to voluntary death.

*The aim of this separation was to free the mind from the influence of the "bodily appetites and the heart's affections," and to establish a spiritual position which is supraordinate to the turbulent sphere of the body. This leads at first to a dissociation of the personality and a violation of the merely natural man. . . . The separation means withdrawing the soul and her projections from the bodily sphere and from all environmental conditions relating to the body. In modern terms it would be a turning away from sensuous reality . . . it means introversion, introspection, meditation, and the careful investigation of desires and their motives. Since, as Dorn says, the soul "stands between good and evil," the disciple will have every opportunity to discover the dark side of his personality, his inferior wishes and motives, childish fantasies and resentments, etc.; in short, all those traits he habitually hides from himself. He will be confronted with his shadow, but more rarely with the good qualities, of which he is accustomed to make a show anyway.*[69]

Before proceeding to the second stage, I would like to mention that our discussion does not constitute a digression, since the discovery of the alchemical patterns of the Bachelor's motivation helps us grasp the fascinating complexity of his psyche. The mundane meaning of the Bachelor's love affair acquires in this context an archetypal dimension of universal significance.

The second stage, *leukosis* or *albedo* (whitening), sees the reacquisition, on a higher plane, of the adept's identity. A sifting of the scattered elements takes place. These elements are washed (*ablutio* or *baptisma*) and undergo a whole series of operations with a view to transforming the adept into the Alchemical King. "It is the silver or moon condition, which still has to be raised to the sun condition. The *albedo* is, so to speak, the daybreak, but not till the *rubedo* is it sunrise."[70] Again, Duchamp's description of the processes that lead to the Bachelor's reacquired identity are strikingly similar. The spangles who have lost their identity—"provisionally, they will find it again later"[71]—are washed "in the operation of the liquefaction of the gas,"[72] and sifted in passing through "the holes of the Sieve with élan."[73] It then becomes possible for the spangles to "improve" and become "the apprentice in the sun."[74]

The reacquisition of the adept's identity is achieved in the second stage by reuniting, on a higher level, what has been separated in the first stage—spirit and body.

*For this procedure there were many symbols. One of the most important was the chymical marriage, which took place in the retort. The older alchemists were still so unconscious of the psychological implications of the opus that they understood their own symbols as mere allegories. . . . Later this was to change, and already in the fourteenth century it began to dawn on them that the lapis was more than a chemical compound. . . . The second stage of conjunction, the reuniting of the* unio mentalis *with the body, is particularly important, as only from here can the complete conjunction be attained—union with the* unus mundus. *The reuniting of the spiritual position with the body obviously means that the insights gained should be made real. An insight might just as well remain in abeyance if it is simply not used. The second stage of conjunction therefore consists*

*in making a reality of the man who has acquired some knowledge of his para-
doxical wholeness. The great difficulty here, however, is that no one knows how
the paradoxical wholeness of man can ever be realized . . . because the realization
of the wholeness that has been made conscious is an apparently insoluble task.*[75]

These last words of Jung's comment may provide an additional ex-
planation for the fact that the *Large Glass* was abandoned by Duchamp
in a state of incompletion. Since it was impossible for the unconscious
drives to find a satisfactory graphic materialization, Duchamp lost all
interest in pursuing an "insoluble task."

The third stage, *iosis* or *rubedo* (reddening), sees the celebration of
the nuptials between the (red, solar) King and the (white, lunar) Queen.
The King stands for the adept who, in this second stage, has achieved
individuation through the *unio mentalis* just described. The Queen stands
for the original *unus mundus*—the potential world still at the stage of
the undifferentiated cosmos, the *res simplex* (the simple thing), literally
the "one world." Jung explains:

*. . . the idea of the* unus mundus *is founded on the assumption that the
multiplicity of the empirical world rests on an underlying unity, and that not
two or more fundamentally different worlds exist side by side or are mingled
with one another. Rather, everything divided and different belongs to one and
the same world, which is not the world of sense but a postulate whose probabil-
ity is vouched for by the fact that until now no one has been able to discover
a world in which the known laws of nature are invalid. That even the psychic
world, which is so extraordinarily different from the physical world, does not
have its roots outside the one cosmos is evident from the undeniable fact that
causal connections exist between the psyche and the body which point to their
underlying unitary nature.*[76]

The monistic outlook of the alchemist reflects itself in the strictly
holistic nature of the partners in this marriage. Their union, the *con-
iunctio oppositorum*, finds its model in the *hieros gamos*, the sacred wedding
feast, whose original incestuous nature is decisive.

For the alchemist, man's salvation is the outcome of the union or
relationship of the adept's reconquered unified self with the primordial
world. In psychological terms, it is the transcendental merging of the
conscious with the unconscious.

Commenting on this aspect of alchemical thought as expressed by
Gerhard Dorn, Jung writes:

*The thought Dorn expresses by the third degree of conjunction is universal: it
is the relation or identity of the personal with the suprapersonal atman, and
of the individual tao with the universal tao. To the Westerner this view appears
not at all realistic and all too mystic; above all he cannot see why a self should
become a reality when it enters into relationship with the world of the first day
of creation. He has no knowledge of any world other than the empirical one.
Strictly speaking, his puzzlement does not begin here; it began already with the
production of the* caelum, *the inner unity. . . . The psychological interpretation
(foreshadowed by the alchemists) points to the concept of human wholeness. This
concept has primarily a therapeutic significance in that it attempts to portray
the psychic state which results from bridging over a dissociation between conscious
and unconscious. The alchemical compensation corresponds to the integration of
the unconscious with consciousness, whereby both are altered.*[77]

It is this complex psychic process that Duchamp expresses in the *Large Glass* when he implies that the Bride's domain (the upper half of the *Glass*, the Sky, the unconscious) is the "mirrorical return" of the Bachelor domain (the lower half of the *Glass*, the Earth, the conscious). In so doing Duchamp actually bridges the gap between conscious and unconscious. He draws our attention to the fundamental monistic structure of the *Glass*; the duality that derives from the physical division of the *Glass* in two halves, each of which bears a different name, is abolished.

Let us return to Duchamp's description of the third stage of the Bachelor's odyssey. We remember that the Bachelor "coming from below" (Earth) finally meets the Bride "coming from above" (Sky) in the upper half of the *Large Glass*. The Bachelor-King, at the end of his long journey, has conquered the *unio mentalis*; he is therefore ready to meet the Bride-Queen who symbolizes the *unus mundus*.

We may now notice another beautiful correspondence. Duchamp's projection of the horizontal Bride/Bachelor couple into the vertical Earth/Sky couple finds its isomorphic equivalent in the alchemical projection of the horizontal King-Queen couple into the vertical Earth-Sky couple that has been mentioned before. Duchamp gives graphic expression to this projection from the horizontal to the vertical plane when he shows us, in the sketches that accompany Notes 82 and 83 for instance, the projection of the Bride's and the Bachelor's desires, respectively, from the horizontal level to the vertical one. It is expressed in words when he describes the mechanism that governs this projection. In the case of the Bride, her desires will be deviated from one plane to the other through the orientation of the three nets (Note 81); in the case of the Bachelor, through the prisms that were to have been "stuck behind the glass" (Note 119).

This identification of the Bride/Bachelor couple with the Earth/Sky couple extinguishes the motivations for the moral conflict that derives from the unconscious incestuous trend and bridges over the apparently irremediable Bride/Bachelor separation.

The basic goal of alchemy is not different. Jung observes:

*It was a work of reconciliation between apparently incompatible opposites, which, characteristically, were understood not merely as the natural hostility of the physical elements but at the same time as a moral conflict. Since the object of this endeavor was seen outside as well as inside, as both physical and psychic, the work extended as it were through the whole of nature, and its goal consisted in a symbol which had an empirical and at the same time a transcendental aspect.*[78]

One last remark: we may have noticed the constant recurrence of the number three in the processes described by Duchamp. This is not astonishing if we remember that, in the alchemical tradition, this number is the symbol of Hermes, who, in turn, is the prototype of the Son, the hermaphrodite, the radiant *lumen novum*.

Duchamp's mythopoeic ability, which finds its highest achievement in the *Glass*, has given us one of the most useful works of Occidental thought. "We like to imagine that something which we do not understand does not help us in any way," observes Jung, "but that is not always so. . . . Because of its numinosity the myth has a direct effect on the unconscious, no matter whether it is understood or not."[79]

I still have in my ears the sound of Bachelard's voice when, years ago, he explained that "alchemy is a science only for men, for bachelors, for men without women, for initiates isolated from the community, working in favor of a masculine society,"[80] and I remember that I immediately thought of Duchamp. When I read Jung's remark that "'true' alchemy was never a business or a career, but a genuine *opus* to be achieved by quiet, self-sacrificing work,"[81] I could not help thinking again about Duchamp. In a world as rationalist, prosaic, and fragmented as ours, only Duchamp had attempted an irrational, poetic, and humanistic adventure of alchemical dimensions. No work but the *Large Glass* has embodied the unattainable transparency of the Philosopher's Stone. The story of the quest of the Philosopher's Stone is a story of failures. But the men who bravely fail teach us more than those who briefly succeed.

## NOTES

1. Marcel Duchamp, quoted by Robert Lebel in *L'Art magique,* ed. André Breton and Gérard Legrand (Paris: Club Français de l'Art, 1957), p. 98.

2. André Breton, *Second Manifesto of Surrealism* (1930), in *Manifestoes of Surrealism,* trans. Richard Seaver and Helen R. Lane (Ann Arbor: University of Michigan Press, 1969), p. 174.

3. Quoted by Pierre Prigent in *Dictionnaire des symboles* (Paris: R. Laffont, 1969), p. 18.

4. Carl Gustav Jung, *Psychology and Alchemy* (1944), "The Collected Works of C. G. Jung," Bollingen Series XX, vol. XII, ed. Sir Herbert Read, Michael Fordham, Gerhard Adler, trans. R. F. C. Hull (New York: Pantheon; London: Routledge & Kegan Paul; 1953), p. 258.

5. C. G. Jung, *Alchemical Studies,* "The Collected Works . . . ," Bollingen Series XX, vol. XIII, ed. Sir Herbert Read, Michael Fordham, Gerhard Adler, William McGuire, trans. R. F. C. Hull (Princeton: Princeton University Press, 1967), p. 159.

6. Jung, *Psychology and Alchemy,* p. 462.

7. Breton, *Prolegomena to a Third Surrealist Manifesto or Not* (1942), in *Manifestoes of Surrealism,* pp. 301–2.

8. Mircea Eliade, *Méphistophélès et l'Androgyne* (Paris: Gallimard, 1962), p. 150.

9. Jung, *Psychology and Alchemy,* pp. 78–79.

10. Ibid., p. 317.

11. Marie Delcourt, *Hermaphrodite: Mythes et rites de la bisexualité dans l'antiquité classique* (Paris: Presses Universitaires de France, 1958), p. 124.

12. Ibid., p. 10.

13. *Complete . . .* (New York: Abrams, 1970).

14. Erich Neumann, *The Origins and History of Consciousness* (1949), trans. R. F. C. Hull (New York: Harper & Brothers, 1962), vol. I, pp. 16–17.

15. Marcel Duchamp, "The Creative Act," *Art News* (New York), vol. LVI, no. 4 (Summer 1957, contents incorrectly dated Summer 1956), p. 28.

16. C. G. Jung, "A Study in the Process of Individuation" (1950), *The Archetypes and the Collective Unconscious,* p. 352. "The Collected Works . . . ," vol. IX, part I; for publishers, see note 4.

17. Jung, *Psychology and Alchemy,* p. 288.

18. M. Eliade, *Shamanism: Archaic Techniques of Ecstasy* (1951), Bollingen Series LXXVI, trans. Willard R. Trask (New York: Pantheon, 1964), p. 404.

19. Julius Evola, *La tradizione ermetica nei suoi simboli, nella sua dottrina e nella sua "Arte Regia"* (Bari: Laterza, 1931), p. 102.

20. Michael Maier, *Symbola aurea* (Frankfort: Luc Jenn, 1617).

21. Duchamp interviewed by Jean Schuster in "Marcel Duchamp, vite," *Le Surréalisme, Même* (Paris), no. 2 (Spring 1957), p. 143.

22. Neumann, *The Origins and History of Consciousness,* vol. I, p. 121.

23. M. Eliade, *Patterns in Comparative Religion,* trans. Rosemary Sheed (Cleveland and New York: World, 1963), pp. 265–330; and Gilbert Durand, *Les Structures anthropologiques de l'imaginaire* (Paris: Presses Universitaires de France, 1963), pp. 365–72.

24. Durand, ibid., pp. 367–69.

25. Jung, *Psychology and Alchemy,* pp. 281–82.

26. Durand, *Les Structures anthropologiques de l'imaginaire,* p. 347.

27. Plutarch, *The Greek Question* (58th) and the *Virtues of Women;* quoted by Delcourt, *Hermaphrodite,* p. 7.

28. Delcourt, ibid., p. 14.

29. Ibid., p. 64.

30. Durand, *Les Structures anthropologiques de l'imaginaire,* p. 348.

31. Evola, *La tradizione ermetica . . . ,* p. 32.

32. Lawrence D. Steefel, Jr., *The Position of "La Mariée mise à nu par ses célibataires, même"* (1915 –1923) in the Stylistic and Iconographic Development of the Art of Marcel Duchamp, Ph.D. dissertation (Princeton University, 1960), p. 38.

33. Wilhelm Fränger, *The Millennium of Hieronymus Bosch: Outlines of a New Interpretation*, trans. Eithne Wilkins and Ernst Kaiser (London: Faber and Faber, 1952), p. 138.

34. Barcius, *Gloria mundi, alias Paradysi tabula*, in *Musaeum hermeticum*, Part. VI (Frankfort, 1678).

35. The first draft of this talk has been published in Marcel Duchamp, "Apropos of Readymades," *Art and Artists* (London), vol. I, no. 4 (July 1966), p. 47. My quotations are taken from the final, unpublished text given to me by Duchamp.

36. André Breton, "Phare de *La Mariée*," *Minotaure* (Paris), no. 6 (Winter 1935), pp. 45–49. English translation published in *View* (New York), Marcel Duchamp Number, series V, no. 1 (March 1945), p. 9.

37. *Notes and Projects for the Large Glass*, ed. Arturo Schwarz (New York: Abrams, 1969), Notes 9 and 10.

38. Ibid., Note 36.

39. Ibid., Note 1.

40. Ibid., Note 81.

41. Ibid., Note 100.

42. Ibid., Note 100.

43. Ibid., Note 140.

44. Ibid., Note 85.

45. Ibid., Note 1.

46. Elie-Charles Flamand, *Erotique de l'alchimie* (Paris: Pierre Belfond, 1970), p. 16.

47. Le Breton, *Clefs de la philosophie spagyrique* (Paris: C. Joubert, 1722), quoted by Flamand, *Erotique de l'alchimie*, p. 16 and pp. 38–39. See also Jean d'Espagnet, *Enchiridion physicae restitutae* (1623), who also greatly emphasizes the pansexualist aspect of hermetic cosmogony.

48. *Notes and Projects*, Note 1.

49. Ibid., Note 92.

50. Ibid.

51. *Notes and Projects*, Note 1.

52. Described in my *Complete Works*, pp. 151–62 and 165–89.

53. M. Eliade, *Cosmos and History: The Myth of the Eternal Return* (1949), trans. Willard R. Trask (New York and Evanston: Harper & Row, 1959), p. 18.

54. Jung, *Psychology and Alchemy*, p. 6.

55. Jung, "Concerning Mandala Symbolism" (1950), *The Archetypes and the Collective Unconscious*, p. 382.

56. Ibid., p. 358.

57. Ibid., p. 357.

58. Ibid., p. 367.

59. Ibid., p. 384.

60. Hervé Masson, "Symboles alchimiques et spagyriques," in *Dictionnaire initiatique* (Paris: Pierre Belfond, 1970), p. 365.

61. Bernard of Treviso, *Natural Philosophy of Metals*, quoted by H. Masson, *Dictionnaire initiatique*, p. 125.

62. H. Masson, *Dictionnaire initiatique*, p. 127.

63. *Notes and Projects*, Note 92.

64. Ibid., Note 98.

65. Ibid., Note 100.

66. Ibid.

67. *Notes and Projects*, Note 101.

68. C. G. Jung, *Mysterium Coniunctionis*, "The Collected Works . . . ," vol. XIV, ed. Sir Herbert Read, Michael Fordham, Gerhard Adler, trans. R. F. C. Hull (London: Routledge & Kegan Paul, 1963), p. 459.

69. Ibid., pp. 471, 472–73.

70. Jung, *Psychology and Alchemy*, p. 221.

71. *Notes and Projects*, Note 100.

72. Ibid., Note 98.

73. Ibid.

74. *Notes and Projects*, Note 110.

75. Jung, *Mysterium Coniunctionis*, pp. 475–76.

76. Ibid., pp. 537–38.

77. Ibid., pp. 535, 546.

78. Ibid., p. 554.

79. Jung, "On the Psychology of the Trickster Figure," in *The Trickster*, by Paul Radin (New York: Bell Publishing Company, 1956), p. 207.

80. Gaston Bachelard, *La Psychanalyse du feu*, 1949 (Paris: Gallimard, 1965), p. 90.

81. Jung, *Psychology and Alchemy*, p. 301.

davidantin

# duchamp and

# language

thats the question      and i think its an interesting
question that anyone would want to talk about duchamps
relation to language[1]      if duchamp as an artist seems oc-
casionally to be obsessed with language      which doesnt
appear in the works      in any obvious way      in any way
that appears directly      he's interested in things that
he writes down and the writings get placed somewhere      and
then the question becomes are the writings the works or are
the works related to the writings      in effect what im in-
terested in in duchamp is something that seems very important
now      namely where is the art work taking place      because
if we can find it we may be able to find out what it is
that is      im not interested in whether its an art work
or not      allan kaprow and i have a long argument going on
about that whether we should use the word art      whether
some things are art work or not      but i dont want to talk
about that now      i would rather talk about chess      since
we're talking about duchamp its only right that we should
talk about chess      chessboards define the action in chess
the action is usually on the board      similarly if you
use the word art you use a board as a perimeter and some-
where within the perimeter is the site of an action      at
least it would appear so to someone who knew how to play
chess      which is an action of a different sort for someone
who knows how to play chess than it is for someone who doesnt
know how to play chess      for if two people      two chess
masters      are playing a game and somebody watches that game
and he gasps      ostensibly this is an act of little signifi-
cance      a man pushes a little piece of wood and moves it
over here say and the other man gasps      the watcher      the
man next to him doesnt know why he's gasping      the first
man is gasping because the player whose move it was has just
moved the bishop to a particular position on the board from
which will ensue 15 alternative possibilities      all of
which are not very good      the man who doesnt gasp      the
other watcher      hasnt seen anything but the bishop moving
to another square      now this cant all be happening on the
board      bobby fischer once was a typical manipulator of
daring sacrifices      he used to be before he started winning
all the time      he used to give up bishops or rooks or
queens in what looked like uncomfortable positions and
then demonstrate that the queen having been lost he could
still recoup because the pressure he could apply      the
tempo he would gain      would be so devastating      that even
if the real strategic position he would be in was a little
foolish      that the other player would not be able to find
the right sequence of responses      under the time pressure
to equalize the position and neutralize the threat
now for fischer this was a way of going on      now the
people who gasp when they watch fischer play are different
from the people who do not gasp when they watch fischer play
they are chess players not mere onlookers      and as a
matter of fact i cant imagine anything less interesting to a

general population than duchamps "chess moves"      on the
face of it they seem to be of no consequence whatever      they
are gambits in the art domain      on the art board      and if
they arent gambits they arent anything      that is a way of
looking at duchamp that has made people gasp      art people
      because there is a kind of war about art that enters
in with duchamp      and the war is a peculiar one      one
wonders what the war is really about      he was a terrible
painter      so you couldnt say that he was involved in a war
about painting because he really was indifferent to painting
      nor was he exactly what you thought of when you thought
of a sculptor      though as a sculptor      considered as a
sculptor he was interesting      especially if you thought of
sculpture in a kind of traditional way      you know how a
sculpture is about taking something away from something it
once belonged with      like consider clemenceau as a possible
sculpture      as an object of possible sculpture      theres
a piece of stone and you remove what isnt clemenceau      as
the story goes      and you call it clemenceau      with duchamp
it may very well be that what you remove you put in a box and
call that clemenceau      it may be that duchamps moves have
      something to do with this kind of removal of what wasnt
clemenceau boxing it and challenging everyone to say that it
isnt clemenceau      but whatever the war      duchamps relation
to art has been an endless series of stratagems      stratagems
involving complete systems that he puts into some degree of
disarray      now what do i mean by that      let me give you
an example      a characteristic passage      a note to be
found in the notes on the glass      and this is one on dic-
tionary      a <u>dictionary</u> <u>of</u> <u>a</u> <u>language</u> <u>in</u> <u>which</u> <u>each</u> <u>word</u> <u>is</u>
<u>to</u> <u>be</u> <u>translated</u> <u>into</u> <u>french</u>      <u>when</u> <u>necessary</u> <u>by</u> <u>a</u> <u>whole</u>
<u>sentence</u>      <u>of</u> <u>a</u> <u>language</u> <u>which</u> <u>one</u> <u>could</u> <u>translate</u> <u>in</u> <u>its</u>
<u>elements</u> <u>into</u> <u>known</u> <u>languages</u> <u>but</u> <u>which</u> <u>would</u> <u>not</u> <u>reciprocally</u>
<u>express</u> <u>the</u> <u>translation</u> <u>of</u> <u>french</u> <u>words</u> <u>or</u> <u>of</u> <u>french</u> <u>sentences</u>
      this may sound rather complicated but its not very in-
teresting from a language point of view      because any inter-
lingual dictionary will behave like this      that is to say if
you take the great french-english and english-french dictionary
its two volumes will not translate into each other      the one
most obvious thing about these two volumes is that they are
not reciprocally arranged so that the pages of the french
convert into pages of the english and the pages of the english
into pages of the french      entry for entry      the french
translates into the english      in that part of the dictionary
      in such a way that if you got a fluent bilingual french
and english speaker and handed him the english and asked him
to translate the english entries      he would wind up with a
set of french entries that did not correspond to the original
french entries in any very regular fashion and his entries
would not be wrong at all      now this is a typical and not
especially profound fact that may be stated about languages
      that languages are not symmetrical systems      one lan-
guage does not abut on another language in such a manner that
you can plug one into the other and theyll go back and forth
      and the way you can prove this is by the amount of money
thats been wasted in mechanical translation systems      in
fact i hear that one of the great mechanical translation
theoreticians at harvard      oettinger      decided they should
junk the whole thing      but at one time there was a great
expectation there      back in the fifties      by which they
proposed initially      and everybody thought it was a great
idea      "we'll get a couple of grammars      an english grammar

and a russian grammar and we'll program them into a computer
along with the rules for converting the russian grammar into
the english grammar and the english grammer into the russian
grammar and wow we'll put in the text whether its english or
    russian and the russian will come out in english and the
english will come out in russian and we'll save ourselves a
lot of money that weve up to now wasted on difficult human
translators who are anyway not so good or regular as the ones
    we can hire to define the rules for our computer"     and
since they had thought up this idea it seemed to them that it
was an excellent idea and it was funded with government money
and they went to work      and a lot of linguists and computer
scientists got fed a lot of money until they came to the as-
tonishing conclusion that neither did they know enough about
    english nor did they know enough about russian      nor did
    they know enough about grammar      to arrange a situation
where one language would plug into the other language with
any degree of reason over a system of words that made any
difference      that is to say      for a very trivial set of
words it is quite possible for you to mechanically plug in
    one language and have it come out the other      but this
expectation      this grand expectation of plug in is not an ex-
pectation that i believe duchamp would have shared      he was as
a matter of fact counting on the inability to make such a plug in
to begin his operation      for in talking about this dictionary
he is ostensibly discussing a project for the big glass      i'll
get back to the relation it has to the glass      the dictionary
    but when he talks about a dictionary      everyone knows that
a dictionary is not a linguistic entity      dictionaries are
    not natural parts of language activity among human beings
        dictionary-making is special metalinguistic activity
    the people who made dictionaries arrived at the brilliant
conception that language is a string of words      and you can
find a word      everybody knows what a word is except a lin-
guist      its very hard for a linguist to define a word but
its not at all hard for persons      a word is the result of
a kind of human analysis of the language they speak into its
    smallest reasonable part      so to speak      and you stack
    them up      those words      in the dictionary      and you
stack them into people that havent been brought up right
        or dont know what certain words mean      in the 17th
century when they were very busy teaching manners to people
who hadnt been fortunate enough to have been born into fami-
    lies exercising them dictionaries became very important
particularly latin dictionaries      or dictionaries of "hard
words"      so that people who were ignorant of latin or greek
could learn certain prestigious words that were either latin
or greek or manufactured from them      and there were also
other problems      also of manners      people thought or began
to think that words should be spelled in one particular way
    the correct way      but the people who thought that words
should be spelled in one particular way were seldom certain
what particular way that was and it was handy to have an
authority to go to to tell them the particular way      what
youll find in a dictionary is a certain kind of tradition
    a social tradition of the language      and a certain
series of entries intended to codify that tradition      these
entries      usually in the same language      will be limited
in number and theyll be specific to certain approved types of
    language use and the kinds of definition that take place
in dictionaries      which is really very haphazard but useful
for certain limited purposes      now this idea of a dictionary

Buy a dictionary
and cross out the words
to be crossed out.
Sign: revised and corrected

From A l'infinitif, translated by
Cleve Gray, by permission of Cordier
& Ekstrom, New York.

is a very curious mechanical idea in relation to language
          because language is a very elaborate system      and a
language does not consist of words      a language consists of
     utterances      people talk all the time but they never say
words      they say sentences or meaningful phrases      people
arrive at their idea of a word only from breaking down what
other people are saying into parts      there is no such thing
     as a word      when children first learn to speak they dont
     utter words      though people generally think so      they
learn full utterances with full intonation contours      youve
all heard some mother say "my child just today learned the
     word 'ball'"      but he did no such thing      my own little
boy's first utterance or one of his first ones was something
     like the word "ball"      he didnt say "ball" he said "ba"
          which was a statement that referred to a ball      when
he said "ba!" it usually meant something like "wow! what
a terrific idea! throw me the ball! now!"      and after a
     while the utterance "ba!" took on a much bolder general
character      children are very bold intellectual and philo-
     sophical theorists      especially when they are about 9
months old      they make grand theoretical generalizations
that suffer only from a terrible lack of facts      anyway my
child generalized his sentence "ba!" to include reference to
planes cars anything moving that attracted his interest and
     that he thought should be called to your attention      his
word "ba" divided the world into two parts      as utterances
usually do      the part that youre talking about and the part
that youre not talking about      the word "ba"      not a word
but really an utterance      meant "for godsake look theres
something interesting over there and its worth articulating
because its moving or its big or important and i like it
     its a figure as opposed to the ground      the ground is
a drag      this is what im talking about and you really ought to
pay attention to it"      and all of this was signaled through
the intonation contour and stress and duration of the utter-
ance      if you stripped away the word and left only its pitch
content you would have found that the pitch content generated
an urgency that no single lexical entry ever carries      and at
other times you would have found that this same utterance
     could be turned into a question "ba?"      which might at
     times have meant "are we going to be dealing with ba" or
"why dont you throw me the ba" and so on      now this is a
rather different kind of entity than a word because a word is
what youre left with when you strip away all the functional
possibilities of context and imagine a neutral and common
semantic core      you take part of the utterance and say cut
it here and maybe you say its an alphabetic string that always
has that common semantic core      thats not so very different
     from the malevolent computer scientist      computer
scientists are always malevolent unless they are dealing
with the sentimentalities of science      and you say
poems consist of a string of letters      you can make such
an analysis and you will be confirmed      up to a point
     every time you look at the text of a poem you will
find that it consists of a string of letters derived from
some alphabet      say the english alphabet      being then a
computer scientist      or maybe a concrete poet      you can
say that all poems consist of alphabetically derived letters
disposed in conformity with some set of rules like you cant
follow a q with anything but a u      and you call this the
syntax      to this you add the one clarifying rule that any
space between letters is also a letter called space      then

103

youre ready to start making poems     i suppose you will all
agree with me that there are more nonlinguistic poems that
will be the outcome of this approach than linguistic ones
       that is there will be many more poems that will look
something like alphabet soup and there would be a few that
would occasionally look like something     like _french_ _window_
    lets say or _fresh_ _widow_     and those would be relatively
improbable poems to be derived from this mad computer program
       now you can reach for slightly less mad computer pro-
grams     you can put in words from a dictionary     put in
words and say that a poem consists of a string of words with
another kind of word called a word-space     that is there is
always a word called the zero-word     and you can now say
that a poem is a string of these words     and youll now come
up with a great number of poems     some of which are lin-
guistically plausible and some of which are not linguistically
plausible     few of them will be linguistically plausible
     now all this sounds very mechanical you say "why duchamp"
     well let me say that duchamp in some ways approaches
this malevolent mechanical analysis of language     lan-
guage is a full-blown and articulated system of a very high
and different order     its the kind of system that allows
us to sit here and understand what we mean when we talk
     it is not a trivial system     it is the basis of thought
     and you say take this system and you say     look-
ing at the words _french_ _window_ which you have in front of
you     not the object french window     and you say "my
god what if i delete the _n_ from both parts of it     i do
an _n_ deletion"     there is no relation between a french
window and a fresh widow is there     well you build this
relationship then     you build this "thing"     you get a
french window and replace its panes with black leather     thats
sort of fun     you color it in color it black     color it
widowlike     you color it widowlike and what you wind up
with is an art work that has become a sort of pressure re-
sponsive mechanism     it is what stands between two poems
     you might say the construction is a kind of diaphragm
between two poems     _fresh_ _widow_ = poem 1 and _french_ _window_
= poem 2     on the pedestal of the window you see the words
_fresh_ _widow_ and when you look at the construction and realize
that it was a french window before its widowfication     the
two verbal constructions i am calling poems     two linguistic
constructions which have no semantic relation to each other
     are thrown one against the other as in a tongue twister
     "fresh widow/french window/fresh widow/french window/fresh
widow/french window"     like "shesells/seashells/shesells/
seashells/shesells/seashells at the seashore"     now there
is nothing meaningful about this     it is conceptual not
meaningful     it isnt going in any particular direction
     you have a mechanism for translating one poem into another
poem     they are poems because as we agreed im calling a
poem a string of words     and by referring to two word
strings that are different only in the absence of a single
letter or phoneme from the one poem that are present in the
second poem i have regressed to the theory that a poem is a
string of letters     the relation between _fresh_ _widow_ and
_french_ _window_ is not a relation of meaning but a relation of
phonology or spelling and the only other relation that these
words     poems     seem to have to each other is that they
both belong to are meaningful entities in the english lan-
guage     and the work we come back to that     what is it
     it is an intermedial piece consisting of a physical con-

struction locked between two linguistic ones       and
when you read this physical construction as an image       as a
representation of the class of things of which it is a member
       the class of french windows       it oscillates something
like a pendulum caught in a magnetic field       it oscillates
between the two divergent semantic poles       fresh widow/
french window/fresh widow/french window       so that the actual
physical construction is more of an aide memoire than a simple
physical construction       which once decoded sets the con-
ceptual pendulum in oscillation between the two poles that
have just been electrified or actuated       i would say that
what duchamp does as an artist is to create a series of
kinetic art works in which a language field defines the
action of something thats put in the middle       now why would
he want to do this       probably because what he was confronted
by on all sides       at the time       appeared to him to be
without an agitating motor       now there was very little
motivation behind certain kinds of art as it existed       then
as now       now i dont think it is impossible to make a case
for many kinds of art that coexisted with duchamp       i think
you can make a very interesting case for an agitating motor
underlying cubism       that is       central cubism       i find it
harder but you could probably produce a kind of agitating
motor underlying abstraction       though by duchamps time
it was probably nearly dead       abstract art had begun in the
1880s and should have been dead a long time       though it
seems to have been resurrected       anyway by abstract art i
dont mean cubism       though some of the practitioners of
abstraction assumed some of the external features of cubism
around 1912 or so       by abstract art i mean the kind of
kandinskylike color psychologism or gestural drawing-generated
psychologism out of art nouveau       that produced abstraction
in general       but regardless of the agitating motor under-
lying cubism or its possible assimilation to abstraction there
was another tradition for reading cubism as a form of im-
pressionism       this was a view held by mondrian       when
mondrian was painting what are called his cubist paintings
mondrian said of them later "i was still an impressionist"
and i think i know what he means       i think he regarded
cubism as a kind of retinal painting nevertheless and duchamp
seems to have shared this feeling or came to share it       which
led him to conclude that along with other painting of the
time it had cut itself off from the kind of linguistic signi-
ficance that made art what it was       why do i say "linguistic
significance"       because there is no other kind of signi-
ficance       language is the matrix of significance itself
we wouldnt be sitting here       and you wouldnt do anything
human without language       without the matrix of language there
is no such thing as human behavior       there is no such thing as
nonlinguisitic humanity       human behavior is linguistic or
protolinguistic from its very beginning       the ability to
categorize things into "that which im talking about" and
"that which im not talking about" or "that which im kicking"
or "that which im not kicking" constitutes linguistic be-
havior       it is a derivation of two fundamental categories
"figure" and "ground"       the idea that art could divorce
itself from that and come to occupy a kind of neutral space
between thoughts was an aspiration arising from the sense of
a linguistic trap in which art had always been enmeshed
       the idea that art could free itself from language was
based on a desire to test a limit       and artists had been
moving consistently toward this kind of fantasized self-tran-

scendence for a long time     and for good reason     partly
because of the trivial grasp of the nature of language that
was available but mainly because the linguistic background of
  a work of art had a tendency to congeal into literature
theres a difference between linguistics and literature     be-
tween language and literature     a literary program for an
art work very quickly leaves the art work or used to do so
very quickly     goes on its own allegorical trip     which
may never rejoin the art work again     and this might not
have been so bad     to have these two disjunctive systems
pulling at your mind     art work and allegory     but thats
    not quite the way it was     the sort of allegories that
underlay salon painting say     were quite expectable     they
could be read out instantaneously     in fact they scarcely
needed reading at all     merely a glance and you knew the
game     allegory as it was commonly encountered you read it
and were off into your own head     never to look at anything
in the world again     you were off in the relatively obvious
world of literature and the more or less fixed literary and
cultural connections of a kind of decadent renaissance style
       now duchamp at various points referred to himself     re-
ferred to works of his as allegorical painting     but the kind of
ideas that he had were rather different from the kind of com-
monplace allegory that you would expect to underlie works of
say the french salon or the kind of allegorical substructure
that french painting had at about the time of diderot     that
kind of allegory was derived from a commonplace set or shared
group of ideas and literary preconceptions     you could re-
duce it to a set of sentences very quickly     or even if you
    couldnt nobody would feel obliged to complain if you did
       now with duchamp can you by examining many of his works
arrive at an explicit associated sentence or group of sentences
       after all duchamp manipulates language structure and he
manipulates it mechanically     he manipulates it mechanically
because it is precisely that sort of system that is not available
for mechanical actuation     that is     he chooses to invent a
mechanism with which to move about language parts and he pulls
    its levers     when he pulls its levers what happens
    does language come to his aid     is language there to back
up what he has to say     thats a question i'd like to raise
in relation to another duchamp quote     duchamp talking about
dictionaries     he likes dictionaries because they are
mechanical treatments of language

dictionary =
  with films, taken close up, of parts
  of very large objects, obtain
  photographic records which no longer
  look like photographs of
  something--with these
  semimicroscopies
  constitute a dictionary of which each
  film would be the representation of a
  group of words in a sentence or separated
  so that this film would assume a
  new significance or rather that
  the concentration on this film of the
  sentences or words chosen would give
  a form of meaning to this film
  and that once learned, this
  relation between film and meaning
  translated into words would be striking
  and would serve as a basis for a kind

106

        of writing which no longer has an
          alphabet or words but
            signs (films) already freed
            from the "baby talk" of all
          ordinary languages.
              --Find a means of
              filing all these films in such order
              that one could refer to them
              as in a dictionary

now wait a minute        this sounds as absurd as minor whites
photographs        at least thats what it sounds like at first
        but consider what he has to say in detail        he suggests
treating each of these detail photographs as a word and pro-
poses constructing a film of sequences of such words or details
   so that each sequence would then become a kind of disjoined
   syntactical unit        like a phrase        and you would store
   these arbitrary film phrases in the storage bin that youre
   calling a dictionary        according to duchamp a "writing
system" constructed in this manner        by concatenating natural
(iconic) signs        would be able to sidestep all the tedious
constructional characteristics of the natural language        ac-
   cording to duchamp the "'baby talk' of ordinary languages"
        now this is an utterly idiotic idea or would be if it
were merely a serious utopian proposition for a future more
"concrete" and shorthand language        but duchamp had some-
thing particular in mind        he was considering this possi-
bility in relation to "the glass"        he intended to use this
arbitrary partitioning to create a kind of syntactical unit
that has no clearly anticipated semantic consequence        that
   is to say        the denotation of the detail shots would not
be determinable in any clear way        so that the signification
of the phrases would have to be constructed out of the inter-
   relations between and among the ambiguous details        syn-
   tactical relations would then override any initial semantic
   possibilities and it would be nearly impossible to form any
   semantic reading until a phrase ensemble had been created
        since the phrase ensembles are not intended to "point
to anything" that already existed in the external world they
   would be "rigorous"        that is they would be entirely (at
least in theory) reflexive        pointing only to the unity of
   their own ensemble constitution        if this is the effect
that such phrases would have it is certainly rigorous in this
   sense        no film would mean anything other than the film
that it was because being constituted of unrecognizable parts
   there would be nothing in the external world with which it
could be associated        so it has no significance other than
itself as a kind of unit        it would represent itself as a
   member of a class of similarly constructed units        and
these units would have various tonal (connotative) properties
        because people are used to having/finding in various
light/dark arrangements various imageries        that is to say
   vision is really a very uninteresting sense        treated
   seriously in isolation        except that vision linked with
   haptic sensibilities and memory has largely kept us from
walking under cars        one of the things about the mechanism
of vision is that it keeps us out of trouble        we have sur-
vived a long time by avoiding cars        avoiding other animals
also        animals of our kind have used vision a great deal in
connection with other senses to create a kind of artificial
   construction        frequently called visual space        its not
a visual space        its a conceptual space        in which vision
   is a prop        you learn the distances between things        im

standing here and youre sitting there      the way i know that
   is not by the way you look but by the way you look and my
   remembrances of how long it took me to get to a place that
   looked like that which someone was occupying in the manner
that you are and looking like that      there would be no way of
my knowing it otherwise      because purely visual information
is relatively minimal      there are an awful lot of bits com-
ing in on light and dark      and an awful lot of bits coming
in about motion      but until i put it together with the experi-
ences ive had before i cant build this space      now this whole
   emphasis on visualization      i come from a department of
visual arts      which is a ghastly name for an art department
      this emphasis on the visual in art frequently led people
to assume that there was a kind of separate area called vision
   that artists exploited      and that that had a meaning in-
   trinsic to itself      thats an idea without any foundation
         though attempts at a kind of foundation could be found
among various sentimental gestalt psychologists like arnheim
      on the whole this notion of vision began to take over
art      vision didnt dominate the field of art from the begin-
ning      nobody made visual art in the beginning      for ex-
ample in a discussion of cave art      cave art cant possibly
be visual art      think about it for a minute      think about
   these things on the walls of caves      they arent even pic-
   tures of things      the idea that these things are pictures
would lead to the question of what kind of pictures they were
      is this a naturalist picture or is it not a naturalist
picture      im thinking of arnold hauser and finding it rather
comical      a comical disquisition on whether this is paleo-
lithic naturalism      let me propose      rashly      what these
pictures were      these pictures were movies      the only way
you could see those pictures was to go in there with torches
of some sort or other      torches flicker      the damn things
   move      they move and you have a movie going      film fes-
   tivals declined in the neolithic and that took care of the
   whole thing      ever since then nobody knew what the pic-
   tures were about      because as pictures they looked funny
         but the reason they looked funny      had extra spots
   and things or missing parts      was that nobody was sup-
   posed to be looking at them standing still      and when
   they were moving they didnt look so funny      they looked
scary or exciting      now looking scary or exciting is not
a "visual" property      in this case it was a cinematic
property and nobody would assume cinema was visual      with
   the exception of certain underground filmmakers who have
   treated us to endless exhibitions of "visual" properties
      color shows and the like      but this aside      i want
   to get back to duchamp facing this cul-de-sac of visual
art      the possibility that there is a visual entity that
stands for itself      for no reason      at the other extreme
there is the possibility of a "literary" world that stands
   for itself      it is a world of total intention or nearly
total      literary worlds are notoriously intentional in the
sense that their "intent"      their "pointedness" is relatively
clear      they tend to explain everything about themselves
and they occupy instantaneous space      in this way you have
an idea of say "motivation" or "meaning" or "sequence"      every-
thing in a traditional narration      you wrap it up and every-
thing is signified but nothing is there      one may say that
"literature" has the characteristic weakness of not occupy-
   ing any space and that "visual art" has the characteristic
weakness of not occupying any mind      and duchamp was in the

position of exploiting this        that there are two systems
        there is the visual-haptic system or whatever you want
to call it        it is a hybrid system        it is what one might
call the representational system for human beings        and
there is another system        the conceptual system of language
        and duchamp is interested in these particularly mis-
matched though related areas        he likes the mismatch he's
a troublemaker        as barbara rose said duchamp was a man who
produced sensations        though probably not in a way that
barbara imagines        he produces sensation by going up to a
system and proposing to treat it in a plausible way        plau-
sible but not reasonable        he writes about what he would do
with a larousse dictionary        a larousse dictionary is very
interesting        the whole world is in a larousse dictionary
        as everybody knows frenchmen are in fact walking ex-
amples of the knowledge of larousse dictionaries and it has
been fairly evident that the larousse dictionary has been one
of the prevailing elements in the destruction of french cul-
ture        all of meaning is packed into larousse in such a
manner that it seems entirely intelligible        this has
led to a great deal of the so-called irrationalism in france
        because anybody who has been confronted with larousse
dictionaries feels that he has to break with them        duchamp
takes the larousse and says copy out all the so-called abstract
words        what is an abstract word?        "continuity"?        "dif-
ferential"?        "color"?        presumably those are all abstract
words because they have no direct semantic reference        this no-
tion goes back to an old idea about language        that if you say
"apple" that word is not abstract at all        after all there is an
apple out there and you can grab it        but when you say
"apple" you dont say what kind of apple        whether its green
or red        whether its a lousy apple        ever since saint
augustine everybody thinks that when you say "apple" you
really mean something specific and youre putting a tag on it
        augustine has a long passage on how he learned language
in terms of objects        there were objects out there and he
pinpointed them with tags and then he had this strange view
of language as a pile of tags        and duchamp is relying in
part upon such a notion when he asks for the "abstract" words
        the words that may be tags but you cant find anything to
tie them to        "these have no concrete reference" he says
        also "compose a schematic sign designating each of these
words        this sign could be composed with the standard stops"
        im not sure what he thinks he means by this but he says
take each of these words and make a sign for it        the ade-
quacy of any sign for such a purpose would depend upon the
structure within which you would distribute these signs        he's
saying "give a schematic image of it"        to make a schematic
image of "continuity" you have to make a map        that is "con-
tinuity" is defined as a relation between other elements
        what he seems to be suggesting is setting up some kind
of logical skeletal structure for human language using a series
of dots and dashes or whatever you have on a typewriter
        now whether this is entirely plausible im not sure        i
dont know what sort of coding system he had in mind        and
he doesnt go on to say        but he says "this sign can be com-
posed with the standard stops"        and he goes on "these
signs must be thought of as the letters of a new alphabet"
        and what he is proposing here is a repertory of con-
stituent elements        an alphabet        and he is proposing to
accumulate these elements in a dictionary        an alphabet of
schematics        and this alphabet of schematics will be memo-

Prendre un dict. Larousse et copier tous les mots dits "abstraits", c.à.d. qui n'aient pas de référence concrète.

Composer un signe schématique désignant pour chacun de ces mots. (ce signe peut être composé avec les arrêts établis)

Les signes doivent être considérés comme les lettres du nouvel alphabet.

Un groupement de plusieurs signes déterminera

[utiliser les couleurs — pour différencier ce qui correspondrait dans cette littérature] à substantif, verbe, adverbe déclinaisons, conjugaisons etc)

Nécessité de la continuité idéale. c.à.d. chaque groupement sera relié aux autres groupements par une signification rigoureuse (sorte de grammaire, n'exigeant plus une construction de la phrase. mais, laissant de côté les différences de langages, et les "tournures" propres à chaque langage — pèse et mesure des abstractions de substantifs, de négations, de rapports de sujet à verbe etc, au moyen des signes étalons. (représentant ces nouvelles relations : conjugaisons, déclinaisons, pluriel et singulier, adjectivation inexprimables par les formes alphabétiques concrètes des langues vivantes présentes et à venir.)

Cet alphabet ne convient qu'à l'écriture de ce tableau très probablement.

---

Take a Larousse dictionary and copy all the so-called "abstract" words. i.e. those which have no concrete reference.

Compose a schematic sign designating each of these words. (this sign can be composed with the standard-stops)

These signs must be thought of as the letters of the new alphabet.

A grouping of several signs will determine

(utilize colors—in order to differentiate what would correspond in this [literature] to the substantive, verb, adverb declensions, conjugations etc.)

Necessity for _ideal_ _continuity_. i.e.: each grouping will be connected with the other groupings by a _strict_ _meaning_ (a sort of grammar, no longer requiring a [pedagogical] sentence construction. But, apart from the differences of languages, and the "figures of speech" peculiar to each language—; weighs and measures some _abstractions_ of _substantives, of negatives, of_ relations of subject to verb etc, by means of standard-signs. (representing these new relations: conjugations, declensions, plural and singular, adjectivation inexpressible by the _concrete alphabetic_ forms of languages living now and to come.).

This alphabet very probably is only suitable for the description of this picture.

From the _Green Box_, translated by George Heard Hamilton.

rized       learned as a coding system with dots or what have
you      a grouping of several signs will determine syntactical
units      and groupings of these groupings will be devised
in accordance with <u>strict</u> <u>meaning</u>      what he is proposing in
a somewhat confused and slightly whimsical way is an under-
lying logical substructure for language or perhaps even mind
      i say whimsical or confused because he makes a big thing
of assigning colors to differentiate "the substantive verb
adverb declensions conjugations etc"      and it would be fully
evident to anyone who had thought about language for any
reasonable length of time that in many instances these form
classes as they are called carry redundant or very minimal
signals      whats more i dont think it makes the least dif-
ference when you draw the map of "differential" whether you
specify that it belongs to the form class "adjective" unless
you want to use it in a syntactical grouping and want to pre-
vent it from being distributed as an adverb say      "they
treated frogs and mice differentially"      if you want to pre-
vent it from being used as an adverb you color it "adjective"
      or you color it "noun" if you want to speak about the
"differential" and so on      he talks about this notation but
he doesnt give any indication of the use to which he
intends to put it      which is why it is not at all clear
whether or to what degree it is an adequate notation or for
what it might be adequate      it seems he intends to use
it somewhere      but as you read the note you begin to come
to the conclusion that this is essentially a scenario for
making something like a picture      which is sort of disap-
pointing      you mean that all thats going to come out of
this after all is that he's going to make a design on a piece
of glass      after going through all of language setting up
a whole dictionary and all he's going to come out with is
yellow red and blue      thats really rather draggy if you
think about it      language has so many capacities and all
he's going to do is make a picture with it?      if not      what
is he going to do with it      he's not going to present you
with it as a poem      or is he?[2]      isnt it typical of duchamp
to present you with something on the order of a poem in all
of his "sculptures"      after all duchamp is not exactly a
constructional sculptor      what is usually involved in the
readymades say      is an object and its name      the object
may be some simple recognizable utensil      a urinal      a
shovel      or a construction of a sort      like a cage with
small pieces of marble in it and a thermometer      and its
"name" or the verbal text associated with it      its motto
so to speak      or poem      maybe "fountain" or "in advance
of a broken arm" or "why not sneeze?"      you have the object
over here and the poem over there      with a wide gulf between
them      which is a kind of enigma      that is to say      in
some way the words affect the object and the object affects
the words      this is even true of the "big glass"      even
if all you know of it is the poem that is its name      "the
bride stripped bare by her bachelors even"      you may dis-
miss the name      you may look at it and say its pretty or
its not pretty      i dont know anyone who has ever had a non-
pleasant aesthetic experience with it      ever since i was a
child i thought the "big glass" looked attractive      nobody
told me what it meant i always wondered what in the world it
was      i thought it was terrific      i said "but gee what is
it?"      now if i knew what it was      a little bride up there
looking very charmingly disrobed      or in the act of disrob-
ing      and all those weak little bachelors down there with

little pants or something     i would have said "what a drag"
or maybe not     maybe i would have said a different kind of
thing     there were these little bachelors and theres this
plump little bride looking like a caterpillar     and there
is about it a kind of marvelous ambiguity     after youve
read all the entries regarding the bride     and the bachelors
     youre faced with a bizarre situation     youre faced with
duchamp colliding with another system i wanted to talk about
     youre faced with duchamp colliding with the system of
science     there is a sense in which science is one system
although in another sense it is a family of related systems
     but in the sense i want to talk about it is one system
     theyre all out there building the pyramids     it is a
single paradigm     and all of these pyramid builders belong
to a club     called the science club     and nobody counts
who doesnt have a membership in the science club     for
example if you were to go up to pasadena to cal tech lets say
     and talk to richard feynman and say to him "you know thats
very funny to have invented the electron hole     it has no
mass     it moves and furthermore youre going to tell me how
fast it moves     thats ridiculous"     and lets say he thought
for a moment it was absurd     it wouldnt bother him at all
anyway     because at no point would the american society of
physics give a damn about what you had said     on the other
hand if the american society of physics said the very same
thing it could prove very distressing to feynman     in a
very real sense science is its own enterprise     its such
a closed world that enterprise that it is of no consequence
what whimsical interventions anyone else might make into it
     now duchamp takes fragments of science     his relation
to science is that of a scavenger     you reach in and you
say "what a nice pretty set of wires" and you pull them out
     and if you survive you say "now doesnt that look great"
     duchamp takes all sorts of mechanical imagery and puts
together a series of physical laws     they are physical
laws in the sense that they are phrased like such laws     this
does this in such and such a way     the feeble cylinders
actuate the desire motor     love gasoline     you really
dont know what he's talking about     it seems like a kind of
scrambled version of the description of the physics of an engine
     it has the grammar of such descriptions     it is a deliberate
sort of double talk     this nonmachinery machinery     which
is then used as a mapping system     as a sort of syntax to
work out the map that the "big glass" finally gives you     now
all thats working in the "big glass" is your own mind and the
     ultimate gag     the one that depends upon the peculiarly
     situated adverb     <u>même</u>     one of the odd things about
french as about many languages     is that the rules obeyed
     by native french speakers in the placement of adverbs are
very subtle     some linguist has written an entire thesis on
the rules governing the placement of adverbs in english and it
barely sketches in an outline of the subject     in french i
dont think theyve written it yet     but where does duchamp
place the adverb <u>même</u>     in the damndest place     if youre
translating it you say "the bride stripped bare <u>by her bache-
lors</u> yet"?     "the bride stripped <u>bare</u> yet by her bachelors"
     what does it mean     by which you mean what phrase is
it intended to emphasize     think of the places you could put
  it in natural french     "the bride stripped stark naked
 really"     "la mariée même mise à nu"     you could put it
there couldnt you     or "même par ses célibataires"     "by
her bachelors in fact"     but at the end it seems amazingly

Make a <u>list of</u>
<u>surnames</u>––French
or English (or other language)
or mixed––
   with Christian names
   (alphabetical order
   or not)––etc.
From <u>A</u> <u>l'infinitif,</u> translated by
Cleve Gray.

awkward    then why did duchamp put it at the end    you hold your head    you walk around several times and you say "no    what an awful joke"    you take <u>même</u> and change it to <u>m'aime</u>    you say "no    he didnt really"    you say "yes really"    "the bride stripped bare by the bachelors loves me"    now thats a terrible joke but on the other hand its very much like duchamp    here are all these little art bachelors running around after "art" and theyre all trying to take off her clothes and shes all this time in love with duchamp    how about that?    well its so low its almost convincing    you know that the placement of <u>même</u> is there for no other reason than to provide you with another analysis of the title    it is typical of duchamp that he should put that dandyish quip on the glass    after all this work    the bride loves me    after all this time these busy little peo- ple have been working and ive been playing chess all this time and the bride has been loving me all the while    its terribly convincing    mainly because of the adverb    it even sounds silly in english translation    no reasonable frenchman would put it there    <u>if</u> <u>the</u> <u>title</u> <u>was</u> <u>a</u> <u>complete</u> <u>sentence</u>    which alas it may not have been because it could also have been an abruptly interrupted beginning to a sub- ordinate clause that had been cavalierly deleted    for ex- ample    "the bride stripped bare by her bachelors even" (if they could not consummate the union)    i'd like to use one more example of duchamp and the language situation    because its a very peculiar one    im sure there are a lot of inter- pretations of this one    by that i mean concurrent inter- pretations    because there is nothing to interpret in any final sense    everyone knows the window piece thats called "the brawl at austerlitz"    i used to wonder why it was called "the brawl at austerlitz"    why "brawl"    for that matter why "austerlitz"    everybody says its a pun but what pun?    what is the "brawl at austerlitz"    there are a lot of versions of it i grant you    but if you look at the ob- ject youll notice that on the large lower panes of the window there are two scrawled marks that look like the letter <u>s</u>    suppose you delete the pronounced <u>ss</u> from "austerlitz"    it is then transformed to "oteli" because of the rules of french graphemics    that is to say <u>austerlitz</u> becomes <u>ôter</u> <u>lits</u> and <u>la</u> <u>bagarre</u> <u>d'austerlitz</u> becomes <u>la</u> <u>bagarre</u> <u>d'ôter</u> <u>lits</u>    "the racket of moving beds" or "the scuffle of changing beds"    thats a little different    it is not a magnificent pun[3]    no better say than the one used by leonard bloomfield to exemplify the nature of juncture in english    which can change "catch it" to "cat shit"    ul- timately the use of a pun is low    it leads to a low enter- tainment    duchamps punning which most people like always winds up in a low joke    "she was only the stablemans daughter but all the horse manure" (horsemen knew her)    its a minor scandal    this is typical of duchamp pun- ning    there is no relation between the two sentences    be- tween the horsemen knowing her and that which horses produce    there is merely a string of letters or of sounds if you prefer that can be mapped into two entirely divergent meanings and what happens is that you realize that you have no strong motivation for preferring one reading to another so that you wind up with a pendulum again    you oscillate between this reading and the other    and i think that duchamps manipulation of these two systems of interpretations (readings) is such that you will be driven between the two alternatives without being allowed to come to rest    not always perhaps and not

equally all the time      there are cases where one reading is
more likely or interesting than the other      in the glass say
      one pole may be stronger than the other      the glass
may produce "she loves me" more vividly than it produces any-
thing else      but its a very opaque pun      its very hard to
decode it      and it seems unlikely to me that he would take
what he supposed to be the correct reading and bury it in that
way as in a time capsule      i dont really suppose that the
pendulum of decoding effort is intended to come to rest there
      the only thing that leads to this conclusion is a pos-
sibly greater degree of satisfaction resulting from this
reading than from any of the others      if the title of the
big glass is taken as a notation for the voice      and if that
voiced utterance is supposed to be the real title of the glass
      i think whether you hear "loves me" (m'aime) or "even"
(même) depends upon whether your voice supplies a period
after m'aime. or an ellipsis after même . . .      you pay
your money and take your choice      but the title of the big
glass is a perpetual pendulum that keeps swinging back and
forth between alternative readings      and this is typical of
duchamp      it is typical of him not to let go of a work
      he has a sort of compulsion (attraction) for all of the
things he is interested in even when they are in contradiction
to each other      which is why he rehearses his career for-
ever      the criminal forever returning to the scene of the
crime      he goes back again and again to the same material
      modifying and remodifying it      he is always redoing the
same works so he seems to have a limited repertory of ideas
      very seldom do these ideas go beyond a certain point
      they are all interesting ideas or at least most of them
are interesting in that they are all kinetic ideas      they
are all ideas of action      in a sense what he wants is an
actuating motor for a perpetual motion machine      any reading
for a duchamp work is too stable for it      the readings that
are associated with his works are not "correct"      they are
plausible      if any reading were so plausible that it anni-
hilated the other plausible readings associated with the work
      the work would break down      disappear into the litera-
ture of its meaning      i dont think there is any reason to
suppose that duchamp was interested in real allegory      if he
was he could have been much more obvious with his meanings
and the meanings would not have been quite so trivial or
indifferent      perhaps casual is a better word for it
      im certain duchamp was aware of almost all the possible
readings that could be obtained from any piece he put forward
      and im also certain that he enjoyed all the defects in
each reading      that it was silly or depended upon bad french
or so on      and this defectiveness is what reduces the probabil-
ity of "correctness"      the satisfaction derived from any given
reading      by building defectiveness into any reading duchamp
ensured the instability of it      so that the pendulum of atten-
tion would keep moving      the defects drive his machine      and
now it seems clear that his relation to language is fundamental to
all of his work      language is a system of great coherence and
elegance which he violates for its potential energy      he "rips
it off"      tapping the energy of one system and feeding it into
another      it is not the only system he could use but it is his
favorite system and it is the most profoundly human system he
could have found      in this sense the role of language in his
      work is profound      not profound as language      but
it is a profoundly human actuating principle that drives all
of his art

# notes

1. "duchamp and language" is the
notation of an improvised talk
given 12 april 1972 on the occasion
of the duchamp festival at uc
irvine arranged by moira roth

2. since giving this talk i have
had the occasion to reconsider the
relation of duchamps language specu-
lations to his "sculpture" in an
essay in october 1972 <u>art</u> <u>news</u>
    "duchamp: the meal and the
remainder"    i am now quite con-
vinced what he was interested in
was a complete underlying logical
calculus of language or mind in
spite of his own and everyone elses
insufficient competence to carry
it out

3. thinking about this piece again
somewhat later i discovered an-
other and perhaps slightly less
defective pun in <u>la</u> <u>bagarre</u>
<u>d'austerlitz</u> / <u>la</u> <u>bague,</u> <u>garde</u>
<u>d'austères</u> <u>lits</u> and offered it as
an alternative reading in my essay
in october 1972 <u>art</u> <u>news</u>      but
i do not think that goodness of
fit is a terribly significant issue
for an artist who liked punning
sequences as defective as "my niece
is cold" / "my knees are cold"
    it is merely that the better
alternative has more semantic
energy and drives the duchamp
machine more effectively

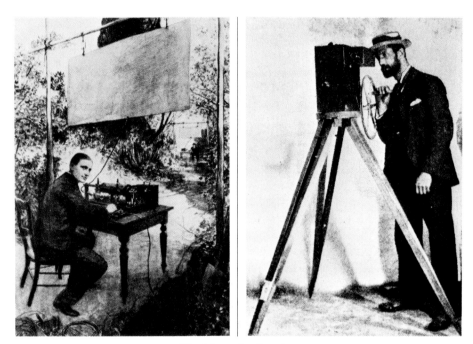

*The Adversative Rotarian*

# THE ROMANTIC ADVENTURES
## OF AN
### ADVERSATIVE ROTARIAN

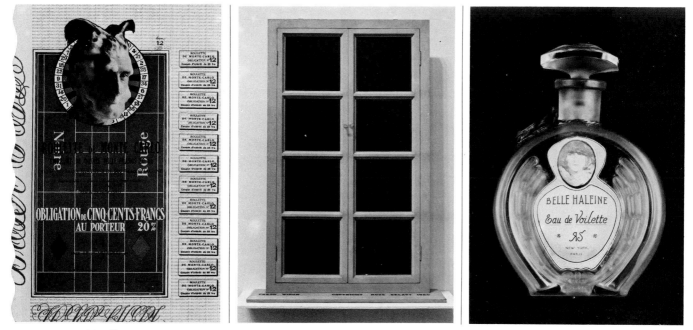

Mr. Chance        The French Widow        Bel Alain

# OR
# ALLREADYMADESOMUCHOFF

Collated by Lucy R. Lippard

## CHAPTER I

"He had the advantage of seeing the beautiful mechanism in Mr. Chance's works, and that which struck him most was the cross-stroke in the polishing; when there was a ring lens to be made, the cross-curvature was not given by grinding[1] in a bowl, but by the cross work of the polisher; and by some small adjustment of the mechanism, which Mr. Chance had arranged, there was a power of altering the degrees of curvature which would be given by that cross-stroke. Upon that everything depended, and he looked upon it as the critical point in the construction of these lighthouses. He arrived at that conclusion because, when the light diverged from a lamp and fell upon the prisms, the intention was that it should emerge in parallel beams with reference to the vertical plane.

"During the Exhibition of 1851, he had an occulting light placed on the roof of his own house, with a view to experiment upon its adaptability for telegraphic communication; and subsequently he received a communication from America, requesting him to visit that country to establish that system there. He thought he might be permitted there to state a curious fact relating to the effect of these very rapid occultations so quickly succeeding each other that he was aware of their being double occultations before he was enabled to put into mental language the expression of that fact."[2]

On his arrival, he met, of course, Mr. Chance himself, who tut-tutted in kingly fashion, "If your idea of a bicycle is one of these balloon tired, heavy frame, unwieldly jobs that kids ride, you ought to

*"If your idea of a bicycle is one of these balloon tired, heavy frame, unwieldy jobs that kids ride . . ."*

drop by a bicycle shop and see what *real* bikes are like. You can pick one up with one hand and hoist it on your shoulder, so you can easily carry it up steps, onto stools, into buildings, and so on."[3]

"Should the rear wheel run crooked," his new friend joined in with enthusiasm, "it can be adjusted by screwing up the nuts until it is straight, or in alignment, as it is called."[4]

At this point, Mr. Chance's flowing scarf was temporarily caught in the spokes of his monocycle, through which he saw as he chose, and as he extricated himself he suggested ruefully that the wheel might be "a symbolic synthesis of the activity of cosmic forces and the passage of time. The allusion is, in the last resort, to the splitting up of the world-order into two essentially different factors: rotary movement and immobility—or the perimeter of the wheel and its still center, an image of the Aristotelian 'unmoved mover.' This becomes an obsessive theme in mythic thinking, and in alchemy it takes the form of the contrast between the volatile (moving, and therefore transitory) and the fixed."[5]

Rolling this around in his mind, Mr. Chance's new acquaintance absentmindedly tweaked a thread loose from his waistcoat (a plaid one of which he was very proud; it had once had five buttons spelling the initials of his first five mistresses—L.H.O.O.Q.—but with the loss of the H, the Q, and an O, only a cheery greeting remained). No sooner had he pulled this one thread than another appeared, and that one, breaking, produced a third, which occultation he took as a sign: "The mass production of machinery by modern manufacturing methods is possible only because of strict standards of measurement. Varying degrees of accuracy in measurement are required for different purposes. It should always be kept in mind that inaccurate and careless measurements are worthless, and may often cause waste of time and materials."[6]

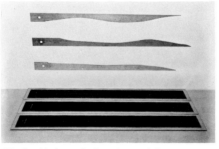

*"It should always be kept in mind that inaccurate and careless measurements are worthless, and may often cause waste of time and materials."*

Here they were briefly interrupted by a French widow whom Mr. Chance had met when they both befriended a blind man taking the wrong, wrong passage from New York to Zurich, via Barcelona. Once introductions had been made, the conversation resumed.

"The process of measurement itself alters the very thing we are measuring and there is nothing to be done about it on account of the quantized nature of radiation, and since position and motion cannot be resolved into simpler terms."[7]

The visitor fielded this in fine fashion: "A third type of 'uncertainty' lies in the limitations of perception. At first signs this might seem to be no more than an instrumental inefficiency, comparable with the inaccuracies of our wooden ruler. This is not really the case, however, since we can go on improving the accuracy of our measuring rods whereas we cannot very greatly improve the acuity of our senses."[8]

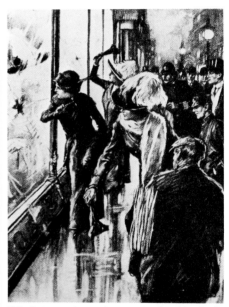

*"To their surprise, and even pain, the widow broke in afresh . . ."*

*". . . with a new, new and extremely feminine theory of random networks, cagily attributed to Zachariasen, who was being lionized at the time."*

To their surprise, and even pain, the widow broke in afresh with a new, new and extremely feminine theory of random networks, cagily attributed to Zachariasen, who was being lionized at the time: "The atomic or molecular arrangement in the glasslike state is an extended network which lacks symmetry and periodicity . . . oxides forming the basis of a glass are known as *network formers* and those which are soluble in the network are termed *network modifiers*. Some oxides cannot easily be glassified in this way and are termed *intermediates*."

"Nonsense!" ofchorused both men. "If the structure of glass lacked symmetry and periodicity in contrast with the crystalline state, then a new surface created by fracture would possess in its outer layer a statistical distribution of the constituent atoms."[9]

Meanwhile, Rrose, undisturbed by their vehemence, "watching the great white flakes falling over bare woods and gray lake, looking neither to port nor to starboard, felt the benediction of its quiet.

*"Meanwhile Rrose, undisturbed by their vehemence, 'watching the great white flakes falling over bare woods and gray lake, looking neither to port nor to starboard . . .'"*

She had come, after weeks of turmoil, into a peace which was not happiness but which was at least a working basis for living. She had actually, she felt, prayed herself into acceptance of life as it stretched before her. Perhaps, in time, she might comprehend the triumph of sacrifice."[10]

By then, Mr. Chance's friend, tortured by her wintry gaze, was hopelessly enameled. "When the victim was securely fixed on the rack, the questions to which answers were desired were put to him. Failure to reply satisfactorily was the signal

for the two executioners to commence operating the levers. The result was the stretching of the victim's limbs and body."[11] "Courage," he muttered to himself. "The witness, however, is never questioned, in *modern* practice, as to his religious belief. It is not allowed, even after he has been sworn. Not because it is a question of tending to disgrace him; but because it would be a personal scrutiny into the state of his faith and conscience foreign to the spirit of our institutions. . . . The law, in such cases, does not know that he is an atheist."[12]

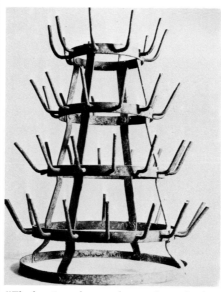

*"The law, in such cases, does not know that he is an atheist."*

Thus reassured, he turned black to the widow and, braving another cold shudder, realized with relief that "nearly every business enterprise is in some way dependent upon the removal of snow. Unremoved snow may become a real menace to the health of the community because of the inability to remove garbage and refuse. Unhealthful conditions are almost certain to result when garbage is not collected for several days and there are many accidents due to icy, slippery streets."[13]

He folded in his arms in advance, but when she left, his mind, etc., was already made-up. Hidden in his green box, making a curious sound when rattled, was an unspeakable object, attached to his secrets by the ball of twine which so resembled the hair of his beloved. He realized this could be the source of a new and immeasurable standard of measurement. Whatever Mr. Chance advised, there was no stopping now.

## CHAPTER II

"On reaching home, [Apolinère enam-

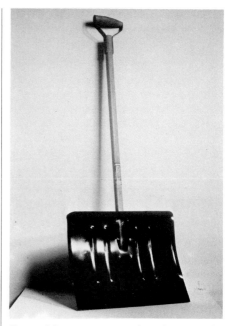

*". . . and there are many accidents due to icy, slippery streets."*

ored] would feel ashamed of what had taken place; but the wish to possess hair, always accompanied by great sexual pleasure, became more and more powerful in him. He wondered that previously, even in the most intimate intercourse with women, he had experienced no such feeling."[14] Could it be that "since the comb is the attribute of some fabulous female

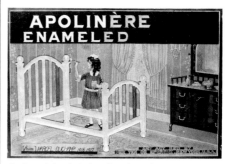

*Left to right: hair brusher, hair dresser.*

beings, such as lamias and sirens, there is in consequence a relationship between it and the fleshless tail of the fish in turn signifying burials (or the symbolism of sacrificial remains)"?[15] Actually, he made this connection only some years later when his fancy was struck by the sweet lines of a cuttlefish bone that made his temperature rise alarmingly.[16]

Feeling himself in need of being pulled together, it was with relief that Mr. Chance's friend closeted himself with a chessboard at hand. But his thoughts continued to follow a sad train. He recalled an early trip to Germany: "The formation of waterfalls is due to a variety of causes.

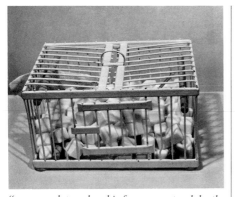

*". . . years later when his fancy was struck by the sweet lines of a cuttlefish bone that made his temperature rise alarmingly."*

For instance, cascade falls are due to the fact that Nature is constantly at work wearing away the surface of the earth by swift denudation. In Europe the finest falls are those of the Rhine below Schaffhausen, where the water plunges over a succession of ledges of hard Jura limestone."[17] "All lip urinals," he mused, particularly Queens', "should be of the flushing rim type. The flushing rim allows the entire surface of the interior to be thoroughly cleaned at each flush. The lip urinal may be flushed with the flush under direct pressure and operated by means of a urinal cock attaching to the top of the urinal. Owing to the conditions surrounding the use of the urinal, the known carelessness of many people using it, and the character of the waste entering it, the partitions, backs, and flooring should never be of wood or any material which may corrode. One form of urinal is the waste-preventive urinal, which works in a manner similar to that of the waste-preventive slop-hopper. The fixture is of such sensitive action that the entrance of urine into the trap acts to form a vacuum which produces Independent syphonage and the immediate operation of the flush."[18]

*"He links it also with the 'land of infancy . . .'"*

Mr. Chance's interpretation of this cleansing dream was as follows: "Jung has devoted much time to the study of fountain-symbolism, specially insofar as it concerns alchemy, and, in view of how much lies behind it, he is inclined to the conclusion that it is an image of the soul as the source of inner life and of spiritual energy. He links it also with the 'land of infancy,' the recipient of the precepts of the unconscious, pointing out that the need for this fount arises principally when the individual's life is inhibited and dried up."[19] This can be remedied by a rapid infusion from Walter.

No longer racked by conscience, though still a bit limp from the ordeal covered, our lover acted upon a deviled ham under wood (then didn't know quite what to think of this slip over glass), ap-

*". . . our lover acted upon a deviled ham under wood . . ."*

plied his corkscrew to a good rosé, and wondered if the widow was really his type. Her name he found affected, her shape less than curvilinear, her surface slick. Since meeting her, he had been a shadow of his former self, but now A. Klang of the inner bell brought him to his senses. He couldn't think why he had found himself hanging on her every word, why she had so tripped his imagination. After all, "decorative racks for various purposes are found in *many* styles, and possess charm and interest for collectors typical of such minor furniture. A conscientious observance of considerations of utility[20] in equipping a room or a house is one of the surest means of attaining the fourfold desirable result of *individuality,*

*Une utilité très bougée.*

*restraint, comfort,* and *economy,* qualities which even the most uncompromising utilitarian will unreservedly recommend. It is well to remember that a single piece of *good furniture,* well chosen, is better than six pieces of *poor furniture* ill chosen."[21]

### CHAPTER III

"The value of photography to mankind depends almost entirely upon the truthful records which it gives of different subjects as the eye sees them. Leaving out of these considerations the question of photographic manipulation for artistic or impressional effects, it will be evident that the ordinary flat photograph *does not* depict the subject as the eyes perceive it but only as one eye does. In the case of solid geometry, the stereoscopic method will be found most valuable. Nothing is more disconcerting to the student than a mass of intersecting lines, intended to represent planes with different inclinations, when studying rectilinear solid geometry. In the stereoscope method, however, the various planes stand out in their natural positions, exactly as if they were made of thin glass sheets with wire framings. The stereoscopic model has the advantage over actual models that everything can be seen at once, and objects can be shown suspended in space, with their reference, or co-ordinate planes in the back or side-ground."[22] "Still better instances of the power I refer to," he continued to his transparent witnesses, "because they are more analogous to cases to be explained, are furnished by the attraction existing between glass and air, so well known to barometer and thermometer makers, for here the adhesion or attraction is exerted between a solid and gases, bodies having different physical conditions, having no power of combination with each other, and each retaining during the time of action, its physical state unchanged."[23] All of which reminded him, once again, of the open windows out of which he stared while humming a familiar lay, or air, he had heard on the wireless. ("I love Paris in the springtime, I love Paris in the fall, I love Paris, why oh why do I love Paris . . ., etc.") Dragging himself back to the present, he scribbled dutifully on a slip of paper: "With reference to (2), it will be seen that the tests dealt with the total transmission through the combination of the following successive regions, glass, glass-air contact, air, air-glass contact, and glass, with the addition of the two water-

*"I love Paris in the springtime . . ."*

glass contacts in the experimental procedure (which replaced only two of the air-glass contacts found in practical conditions)."[24]

Suddenly he was distracted by the arrival, in the teeth of the gale, of Mr. Chance himself, who stopped for a moment to check his attire (he was dressed to the nines, except for the four pins which held

*"He was dressed to the nines . . ."*

an extra pocket to his broad chest, a peculiarity he had affected since a Czechoslovakian childhood). "I have in this day, seen, professionally," he announced regally, "Josephine Boisdechêne, and, in relation to the legal question referred to me, hereby certify that although she has beard and whiskers, large, profuse, and

strictly masculine, on those parts of the face occupied by the beard and whiskers in men, and, although on her limbs and back she has even more hair than is usually found on men, she is without malformation. Her breasts are large and fair, and strictly characteristic of the female."[25]

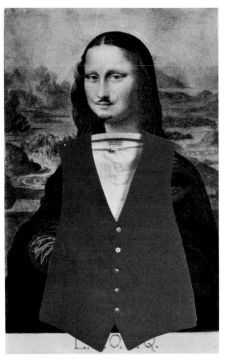

*". . . she is without malformation."*

Aghast with pleasure at the news proffered by his jocund friend, the unhappy reader maintained a silence misinterpreted by the other, who virtually threw the book at him: "Caution! This need not be the same as $[(x_o, \ldots x_n) A]^*$, i.e.,* and A need not commute! Be careful when deciding whether or not the collineation * leaves a point $P = [x_o, x, \ldots x_n]$ fixed. There is always one set of homogenous coordinates of $P$ left fixed by the semi-linear map *, but not all sets of homogenous coordinates are left fixed if * is nontrivial."[26] "I can recommend a fine polish for leather. Dissolve enough beeswax in turpentine until it is about as thick as the cream you get if you live in New York, that is thin cream, and you will have a polish for leather upholstery that can't be whipped."[27]

"One would expect that the easiest way of producing a clean glass surface would be to fracture a piece of glass," observed the other, somewhat recovered from these unexpected solutions. "A simple method of removing superficial dirt from glass is to rub on the surface with cotton wool dipped in a mixture of precipitated chalk and alcohol or ammonia."[28]

*". . . until it is about as thick as the cream you get in New York . . . and you will have a polish for leather upholstery that can't be whipped."*

*"A simple method of removing superficial dirt from glass is to rub on the surface with cotton wool . . ."*

Mr. Chance now became impatient at his acquaintance's inability to see through the lady in question. "No, no. Sometimes you are stupid as a painter, unnecessarily opaque. Sometimes you have the breeding of a dirty young man." But then he repented and invited the expert out to dinner with himself and his nephew Alain.

## CHAPTER IV

As they neared the battlefield on which the restaurant was located, the two cronies carried on a witty barrage of allusions to the landscape and to their mode of transportation: "You know about the Arrangement of Exciters in a Station, do you not?" said Mr. C. "Attempts have been made to build self-exciting alternators, but they have been failures, as evidenced by the fact that there are practically none in

*A little restaurant near the battlefield.*

*"If the exciters are driven by motors obtaining their power from the alternators, their motors cannot be started until the alternators are excited."*

service, except an occasional machine of very small capacity."[29] "An intersex develops completely as one sex for a period of time and then changes and develops as the other. If the turning-point of intersexuality occurs early enough, it will bring about a total sex reversal: a conversion of potential males to normal females, or the reverse."[30]

"But sometimes," the other followed handily, "sometimes each alternator is furnished with its own exciter (either belted or direct-connected, the exciter in the latter case is often built into the core of the alternator), but in large stations there is generally a set of exciter bus-bars on the switchboard, and two or more exciters (each equipped with its own driver) furnish power to these buses. In all stations at least one of the exciters is driven by a steam turbine or engine, or by a separate water turbine, to insure excitation for the alternators if the entire station has shut down because of an accident. If the exciters are driven by motors obtaining their power from the alternators, their motors cannot be started until the alternators are excited."[31]

Dinner was lively, with the bel Alain demonstrating his own wares and discoursing on his trade: "To an increasing extent the sale of fabrics for dresses is being supplanted by the sale of ready-made dresses. The shift in purchasing habits in this matter is indicated by the fact that while thirty or forty years ago

the ready-made trade was negligible, in 1921 there was placed on the market more than 167 million dresses representing a wide range in quality of fabric and workmanship, as well as character of design."[32]

"I'll bet," said Mr. Chance with a veiled glance at his friend, "you can't name the manufacturers of the following perfumes: Sinner, Blue Grass, Mais Oui, Nuit de Noël, No. 5, Breathless, Tapestry, Danger, Emeraude, Tabu, White Shoulders, Aphrodisia. Tweed, Duchess of York, Shocking."[33] Alain's score was perfect: "Adrian, Elizabeth Arden, Bourjois, Caron, Chanel, Charbert, Mary Chess, Ciro, Coty, Dana, Evyan, Fabergé, Lenthéric, Matchabelli, Schiaparelli, Polly Perruque."[34]

*Left to right: Adrian, Elizabeth Arden, Mary Chess, two unidentified bourgeois gentlemen, Polly Perruque.*

But in the midst of all this gaiety, Mr. Chance's friend's pain became increasingly visible, and spirits sank.[35] For across the room swept the widow herself in the attentive company of an infamous bachelor.

"The false French seam is so-called because it somewhat resembles a French seam," whispered Mr. C. consolingly. "It is used as a finish for a plain seam in thin

or medium-weight material, for the armhole finish, for silk garments, and as a finish for the lapped seam."[36]

"I know," said the younger man ruefully as they walked out into the street. "Some of the sinkers currently in use for any water are the Bank lead (these have holes at one end to fasten the line) and the Pyramid lead (these are solid lead sinkers equipped with a ring on the top for the purpose of fastening the line to the sinker)."[37]

"Maybe she doesn't know she's Wanted," suggested Alain, sensibly.

*"Maybe she doesn't know . . ."*

"I'll have her by hook or by crook. There are four positions for the eye of a hook: Ringed or straight Eye; Flat Eye; Turned-up Eye; Turned-down Eye. And then there's the line Dreier, a device constructed with open spokes on which a fishing line may be quickly run off to dry it."[38]

"Nevertheless," put in Mr. Chance fortuitously, "there are gamblers who are convinced that they can devise 'systems' to beat the roulette wheel. The manner in which reasoning may become corrupted by gambling is well known. In trying 'systems' which they hope will outwit the bank, players ignore the fact that the prediction of roulette sequences is beyond skill. One and the same probability, if it relates to success, is subjectively overrated, and if to failure, underrated. Thus, a 1 in 7,000 chance of winning a prize would be thought by many people to be favorable, whilst these same people would regard as negligible the chance of being killed in an accident on the roads, though the probability is about the same."[39]

At this, our hero said farewell to his companions and set out for home, grinding his own teeth (which needed a checkup), looking at the single star above, and thinking of his close shave. As he turned into Larrey Street, a veiled figure appeared out of the cold mist to his left, saying, "Sometimes a sticking door can be made to work by rubbing *French chalk* on the places where it strikes the frame."[40]

His heart fluttering, he locked her in his arms and, before the door opened and the spooning began, somewhat ambiguously described to her his intentions: "Being assured that there will be sufficient depth of sand over the pattern, sand is sifted on the pattern as it lies on the mold-board by means of the riddle until the pattern is completely covered. The molder then tucks the sand around the edges of the pattern with his fingers, but does not press it down on top of the pattern unless there is some special reason for so doing. The drag is next shoveled full of sand and heaped high. The sand is then rammed around inside of the flask with the peen, or sharp end of the rammer. The rammer is held at this time with the butt inclining toward the center and the flask, so that the blow is somewhat outward in direction, compressing the sand at the edges of the mold. After placing the bottom-board, the drag is rolled over, so as to bring the pattern, and also the joint, to the top. When there are a number of molds to be made from a pattern, it is frequently advisable to use a molding machine for this purpose. Molding machines are made in a number of varieties, each designed for some specific purpose. Thus we have the power squeezer and the hand squeezer, the split-pattern squeezer, the jarring machine, also known as a jolt-rammer, and the roll-over machines. Each machine has its particular field in which it will do better work than any of the other types."[41]

The widow, never at a loss, looked him straight in the eye and replied: "On every pattern there is a balance line. This line is always marked on the pattern part and should be looked for and found before attempting to use the pattern. If the pattern needs altering, pay special attention to the balance lines so that their position is not moved when making the alterations. The size of the pattern must be tested, and any necessary alterations made before the lay is attempted. Study the lays given on the instruction sheet of the bought pattern and mark the one

provided for your particular size of pattern and width of fabric. A vest should always be worn next to the skin to absorb perspiration. Winter vests are absorbent and not bulky if they are made from fine wool, a fine wool mixture, or a spun yarn of one of the new synthetic fibers."[42]

Mr. Chance's friend "had no criticism to offer on the subject; but he thought this beautiful apparatus was capable of being rendered of still greater utility. Most lighthouses were upon the revolving principle, some revolving with more, and some with less velocity; and others had temporary eclipses; but there were circumstances which were greatly influenced by the state of the weather . . ."[43]

*"Thus we have the power squeezer . . . the jarring machine, also known as a jolt-rammer, and the roll-over machines."*

## NOTES

1. The bachelor grinds his own lenses.

2. James T. Chance, *On Optical Apparatus Used in Lighthouses,* including "an abstract of the discussion upon the paper" (London: William Clowes & Sons, 1867). The research for the following essay has been carried out at the New York Public Library with Duchamp the librarian in mind at all times, as well as his mistrust of books.

"As soon as we start putting our thoughts into words and sentences, everything gets distorted. Language is just no damn good; I use it because I have to, but I don't put any trust in it. We never understand each other. Only the fact directly perceived by the senses has any meaning. The minute you get beyond that, into abstractions, you're lost" (Duchamp). The Readymades in this text are almost without exception unassisted.

3. Ernest Callenbach, *Living Poor with Style* (New York: Bantam Books, 1972). "Style is just what the French must get away from and the Americans cease to strive after; for style means following tradition and is bound up with good manners and a standard of behavior, all completely outside the scope of art. Under such conditions, no new norm can be reached" (Duchamp).

4. A. Frederick Collins, *The Home Handy Book* (New York: Appleton, 1917).

5. J. E. Cirlot, *A Dictionary of Symbols* (New York: Philosophical Library, 1962). "René Guénon says in relation to Taoist doctrine, that the chosen one, the sage, invisible at the center of the wheel, moves it without himself participating in the movement, and without having to bestir himself in any way."

"Use *delay* instead of 'picture' or 'painting'" (Duchamp). "This sentence gives us a glimpse into the meaning of his activity; painting is a criticism of movement but movement is the criticism of painting" (Octavio Paz).

6. Wendell H. Cornetet, Head, Dept. of Vocational Science, Huntington East High Trades School, Huntington, W.Va., *Methods of Measurement* (Bloomington, Ill.: McKnight, c. 1942).

123

7. G. W. Scott Blair, *Measurements of Mind and Matter* (London: Dennis Dobson, 1950).

8. Ibid.

9. L. Holland, *The Property of Glass Surfaces* (London: Chapman and Hall, 1964).

10. Mary Synon, *Copper Country* (New York: P. J. Kenedy & Sons, 1931). "I've decided that art is a habit-forming drug" (Duchamp).

11. George Ryley Scott, *The History of Torture Throughout the Ages* (London: Laurie, 1941).

12. S. G. Weeks, *Remarks on the Exclusion of Atheists as Witnesses* (Boston: Jordan & Co., 1839). "As a drug [art] is probably very useful for a number of people—very sedative—but as religion it's not even as good as God" (Marcel Duchamp, M.D.).

13. *Snow Removal from Streets and Highways* (New York: American Automobile Association, Winter 1926–27).

14. Richard von Krafft-Ebing, *Psychopathia Sexualis: A Medico-Forensic Study,* rev. trans. by F. J. Rebman (New York: Pioneer Publications, 1947).

15. Cirlot, *A Dictionary of Symbols.* Trois ou quatre gouts d'auteur n'ont rien à voir avec la ssovacherie.

16. Soon after which he would find himself on his knees (Latvanna Greene).

17. Ellison Hawks, *The Book of Air and Water Wonders* (London: George G. Harrap & Co., 1933).

18. R. M. Starbuck (used juddiciously), *Modern Plumbing Illustrated* (New York: Henley, 1915). "It is a fixture that you see every day in plumbers' show windows. Whether Mr. Mutt with his own hands made the fountain or not has no importance. He CHOSE it. He took an ordinary article of life, placed it so that its useful significance disappeared under the new title and point of view—created a new thought for that object. As for plumbing, that is absurd. The only works of art America has given are her plumbing and her bridges" (*The Blind Man*).

19. Cirlot, *A Dictionary of Symbols.*

20. In the case of Duchamp, *une utilité très bougée.*

21. Henry W. Frohne, ed., *Home Interiors* (Grand Rapids, Mich.: Good Furniture Magazine, 1917).

22. Arthur W. Judge, *Stereoscopic Photography* (London: Chapman & Hall, 1935). "I would like to see [photography] make people despise painting until something else will make photography unbearable" (Duchamp).

23. Holland, *The Property of Glass Surfaces.*

24. A. Norman Shaw, *Transmission of Heat Through Single-Frame Double Windows,* McGill University Publications (Montreal), Series X (Physics), no. 18, 1923.

25. *The Biography of Madame Fortune Clofullia, the Bearded Lady* (New York: Baker, Godwin & Co., 1854). (New York Public Library card for Alfred Canel, *Histoire de la barbe et des cheveux en Normandie* [Rouen: 1959]: "pp. 65–86 mutiliated.")

26. Paul B. Yale, *Geometry and Symmetry* (San Francisco: Holden-Day, 1968). "[If] *linear perspective* is a good means of *representing equalities in a variety of ways,* [then in perspective symmetry] the equivalent, the similar (homothetic), and the equal get blended" (Duchamp).

27. Collins, *The Home Handy Book.*

28. Holland, *The Property of Glass Surfaces.*

29. John H. Morecraft and Frederick W. Hehre, *Electrical Circuits and Machinery, vol. II, Alternating Currents* (New York: John Wiley & Sons, 1926).

30. E. B. Ford, *Moths* (London: Collins, 1955).

31. Morecraft and Hehre, *Alternating Currents.* "The work of art is always positioned between the two poles of maker and onlooker, and the spark that comes from this bi-polar action gives birth to something, like electricity" (Duchamp).

32. Alpha Latzke and Beth Quinlan, *Clothing* (Chicago: Lippincott, 1935). "In Paris, in the early days, there were seventeen persons who understood the 'readymades'—the very rare readymades by Marcel Duchamp. Nowadays there are seventeen million who understand them, and that one day, when all objects that exist are considered readymades, there will be no readymades at all. Then Originality will become the artistic Work, produced convulsively by the artist *by hand*" (Salvador Dali).

33. John V. Cooper and Raymond J. Healy, *The Fireside Quiz Book* (New York: Simon & Schuster, 1948). Because a rose by any other name smells like quite something else: "Women found wit in Duchamp's conversation, elegance in his manner and masculinity in his gray eyes, reddish blond hair, sharply defined features and trim build" (*New York Times* obituary, October 3, 1968).

34. Ibid.

35. See Louis Napoleon Filon and H. T. Jessop, "On the Stress-Optical Effect in Transparent Solids Strained beyond the Elastic Limit," Royal Society of London, *Philosophical Transactions* (London), Series A, v. 223, 1922.

36. Latzke and Quinlan, *Clothing.*

37. *The Wise Fisherman's Encyclopedia* (New York: Wise, 1951).

38. Ibid.

39. John Cohen, *Chance, Skill and Luck* (London: Penguin Books, 1960). "The museums are run, more or less, by the dealers. In New York, the Museum of Modern Art is completely in the hands of the dealers. Obviously this is a manner of speaking, but it's like that. The museum advisers are dealers. A project has to attain a certain monetary value for them to decide to do something. As far as I'm concerned, I have nothing to say, I don't hold much for having shows; I don't give a damn" (Duchamp). "I've forced myself to contradict myself in order to avoid conforming to my own taste" (Duchamp).

40. Collins, *The Home Handy Book.*

41. R. H. Palmer, *Foundry Practice, A Text Book for Molders, Students and Apprentices* (New York: Wiley, 1926).

42. Margaret G. Butler, *Clothes, Their Choosing, Making and Care* (London: B. T. Batsford, 1958).

43. Chance, *On Optical Apparatus Used in Lighthouses.*

# LA VIE EN RROSE

*Kynaston McShine*

In learning a man should be an amateur at as many points as possible, privately at any rate, for the increase of his own knowledge and the enrichment of his vision . . . The amateur, because he loves things, may find points at which to dig deep in the course of his life.
—*Jakob Burckhardt,* Reflections on History

GROWING UP *in a well-educated family with two artists as older brothers, caught up in discussions on mathematics, physics, aesthetics, music, and literature, Marcel Duchamp early came to associate art with an active play of intelligence rather than a passive filtering of experience. He resented the expression* bête comme un peintre[1] (*"dumb like a painter"*) *but recognized a justification for it if painting was regarded as solely "retinal," involving nothing beyond visual impressions. Painting in this sense could not satisfy him, and so he probed, experimented, invented—"tinkered." A* métier *was not for him.*

*Duchamp refused to be categorized as painter, sculptor, or what you will, and he decided not to "repeat himself" or fall into any routine. Plunging into whatever was most appropriate for him at a given moment—poetry, linguistics, optics, film, theater, music, bookmaking—and delighting in the use of diverse and unorthodox materials—dust, silver, talcum powder, marzipan, and his own head—he assumed extraordinary dimensions. The conventional role of painter or sculptor would have been stifling and would have given too little significance to living and "breathing." He was to fulfill a vocation more radical and more important than the artist's as usually conceived.*

*This ambition seemed to blossom after his arrival in New York in 1915. The handsome young Frenchman, with his extraordinary charm, wit, but equal reticence, apparently was creating his own legend. He would disappear from sight at times, but whenever he appeared he was the center of attraction, at the Arensbergs' salon or at an artists' ball.[2] It was as if Duchamp had arrived in New York to collect the fame that the* Nude Descending a Staircase *had already earned for him.*

*His public image gave no hint of the meticulous work he was doing on the* Large Glass *in a modest studio. Duchamp's posture of seeming not to work lasted all his life. He was thought to have given up art for chess, and*

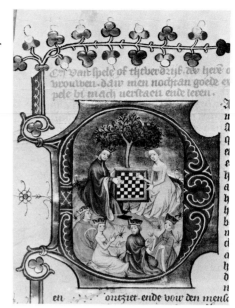

*"A Royal Game of Chess," from an illuminated manuscript* Table of the Christian Faith, *by Dirck van Delft. Dutch, c. 1405. The Pierpont Morgan Library, New York.*

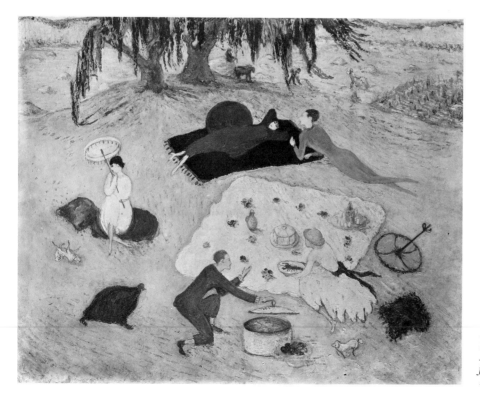

*Florine Stettheimer.* Picnic at Bedford Hills. *1918. Oil on canvas, 40 x 50 in. Pennsylvania Academy of Fine Arts, Philadelphia. Clockwise, from left: The artist, Ettie Stettheimer, Elie Nadelman, Carrie Stettheimer, Marcel Duchamp.*

in later years he appeared as the grand old man at avant-garde events and performances—while he was working on Etant donnés.

The image that Duchamp projects is that of the dandy, elegant, revealing an aristocratic superiority of mind and creating his own originality true to Baudelairean definition: "an institution beyond the laws . . . they all partake of that characteristic quality of opposition and revolt . . . of combating and destroying triviality. . . . The distinguishing characteristic of the dandy's beauty consists above all in an air of coldness which comes from an unshakable determination not to be moved; you might call it a latent fire which hints at itself, but chooses not to burst into flame."[3]

Duchamp's dandy concealed the complex artist striving for a higher freedom, questioning the very purpose of art—the ultimate in artistic ambition.

True to this mission of changing sensibility, Duchamp had opened himself to a force that he felt was more revolutionary than the visual arts—literature, and specifically the writings of recent French antecedents and contemporaries which he felt embodied modern man's sensibility.

Although he had great admiration for Baudelaire and Rimbaud, Duchamp did not seem attracted to their personal rebellion and romantic excesses. He was much more drawn to Laforgue and Raymond Roussel. Seeing in them a commitment to human adventure and exploration which he felt larger than that of contemporary painters and sculptors, he applied their "teachings" to his art. At the same time Duchamp did not completely stop looking at other artists; he could even admire and respect other endeavors and could enjoy absorbing the lessons of artisans and mathematicians.

A roving curiosity governed Duchamp. He looked at everything with new eyes and made extraordinary connections. Léger has reminisced: "Before the World War, I went with Marcel Duchamp and Brancusi to the Salon de l'Aviation. Marcel, who was a dry type with something inscrutable about him, walked around the motors and propellers without saying a word. Suddenly

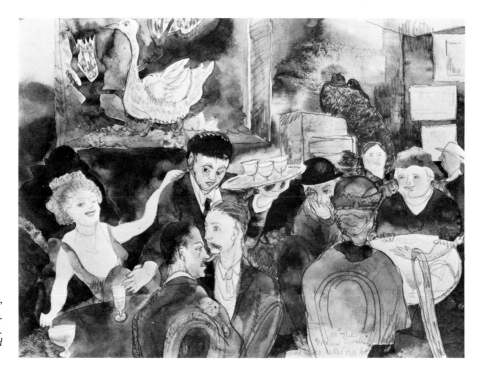

*Charles Demuth.* At the "Golden Swan" sometimes called "Hell Hole." *1919. Watercolor, 8¼ x 10¾ in. Collection Robert E. Locher, Lancaster, Pennsylvania. Duchamp third from left.*

127

he turned to Brancusi: '*Painting is finished. Who can do anything better than this propeller? Can you?*'"[4]

"*Le Poète est celui qui regarde. Et que voit-il?—Le Paradis.*"[5] *With Paradise everywhere in this world and yet beyond it, the poet transcends time and space. Paradise accepts tradition but also innovation. There is room for contradiction, and in this realm the concept of "taste" becomes impossible. Freedom and surprise rule supreme; categories are abolished. Paradise gives the license "to play," "to make," "to be a true individual." It allows the Poet to be a man of ideas and one who can live ideas intensely.*

*Inhabiting the realm of Paradise, Adam needs an Eve, the poet a muse, the Bachelor a Bride, Marcel a Rrose. "Voici le domaine de Rrose Sélavy / Comme il est aride—comme il est fertile / Comme il est joyeux—comme il est triste" is the caption for the first publication in 1922 of the photograph* Dust Breeding *in* Littérature.[6] *The theme of the landscape (from* Landscape at Blainville *to* Etant donnés*) runs through Duchamp's work, and it is not a mere coincidence. "Votre âme est un paysage," wrote Verlaine. Rrose Sélavy's landscape/soul embraces everything—Paradise.*

*In retrospect, the invention of this alter ego, this persona, seems inevitable for the mythopoetic aesthetic Duchamp proposes. The creation of Rrose may arise partly from conscious or unconscious use of sources in alchemy, but she also seems closely related to the persona of Lautréamont's* Maldoror, *Laforgue's* Hamlet, *Jarry's* Ubu, *and Mallarmé's* Hérodiade. *She has read Baudelaire's* Mon Coeur mis à nu *and Rimbaud's* Illuminations, *and perhaps even Edgar Allan Poe's* To Helen:

Lo! in yon brilliant window niche
How statue-like I see thee stand,
The agate lamp within thy hand!
Ah, Psyche, from the regions which
Are Holy-Land!

*For Rrose is not only Belle Haleine but also Dulcinea, the Bride, the Statue of Liberty, the mannequin in Marcel Duchamp's clothes on the Rue Surréaliste and in the Gotham Book Mart window with a faucet on her thigh; she is also recumbent with lamp in hand in the* Etant donnés—L.H.O.O.Q! *For those versed in Dada and Surrealism, her fame parallels the* Mona Lisa's.

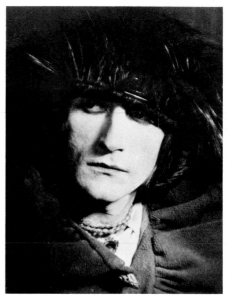

*Rrose Sélavy. New York. 1921. Photograph by Man Ray.*

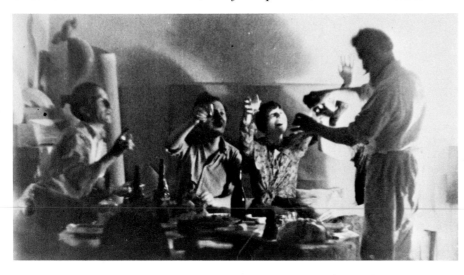

*Marcel Duchamp, Brancusi, and others in Brancusi's studio, Paris, c. 1923–24.*

*L.H.O.O.Q. 1919. Rectified Readymade: pencil on a reproduction, 7³/₄ x 4⁷/₈ in. Private collection, Paris. Cat. 131.*

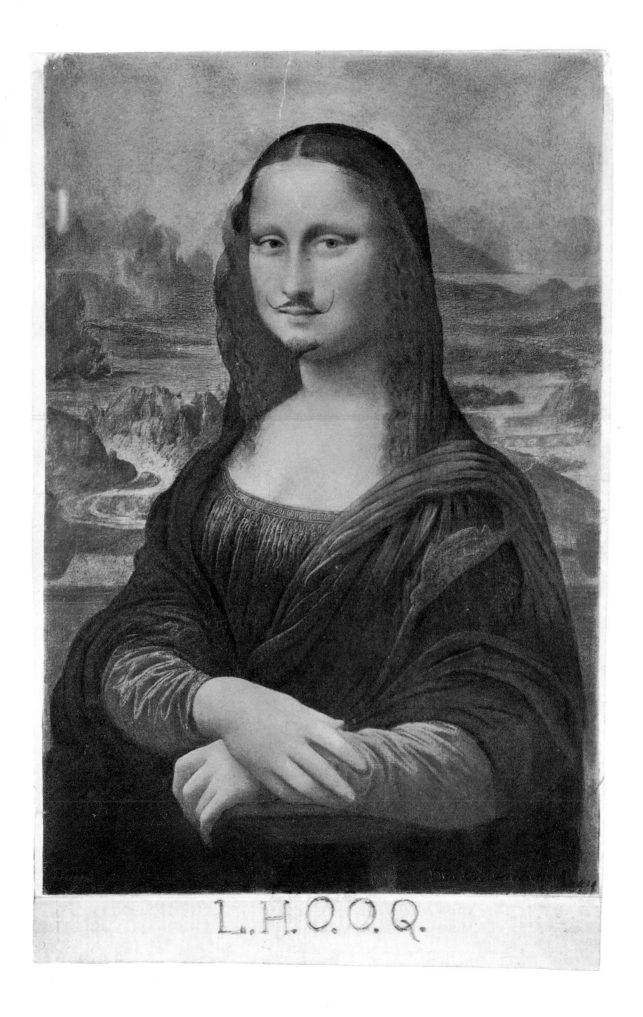

L.H.O.O.Q.

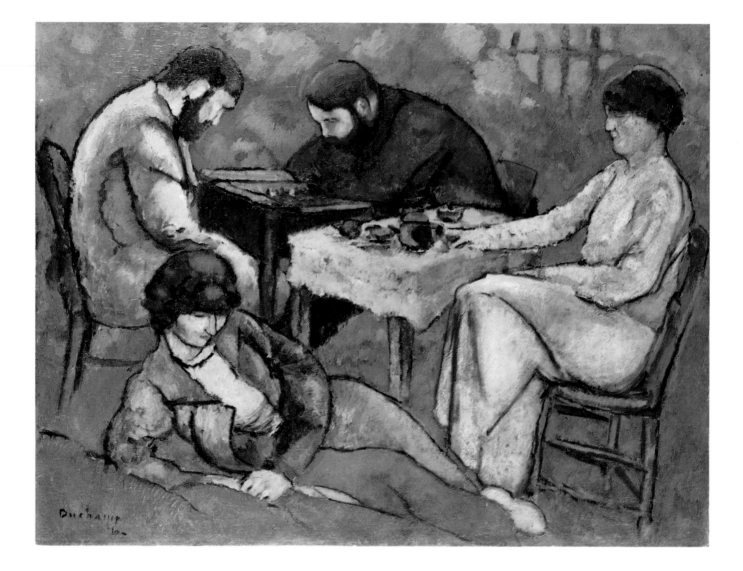

In the formulation of an aesthetic that has its obvious dangers, particularly that of turning oneself into a myth, the need for Rrose Sélavy is clear. She allows Duchamp to be himself, gives him a freedom in which to operate in any way he likes.

Duchamp's is an extraordinary strategy; it proposes the life of chance, and it changes life into art and art into life. It provides no competition for anyone else, and allows Duchamp to be not of art history, but of Art. It makes no distinction between artist and artisan or artist and poet. Autobiography and dilettantism are sanctioned, even sanctified.

"Toute Pensée émet un Coup de Dés" (Every Thought gives off a Throw of the Dice). This last line of Mallarmé's great poem Un Coup de dés might be one of Duchamp's mottoes. Thought, given its freedom of expression, can be the game of risk and of mystery. The throw of the dice allows combinations of thoughts that create works seemingly sprung from other regions and other times. The work becomes an approximation of ideals, chance is converted into power, and the early dictum of Mallarmé, "peindre non la chose, mais l'effet qu'elle produit" (paint not the thing but the effect that it produces), becomes law.

Duchamp's oeuvre therefore is not meant to teach us anything. Unparaphrasable and untranslatable, it can be contemplated, described, theorized upon, but not explained. It is self-contained and possesses a life of its own. In creating his own language and laws, constantly destroying convention, being in perpetual warfare with himself, and renouncing the facile, Duchamp led himself and us toward a new perception of the world, or at least one Orphic fragment of it.

Essentially a man of ideas living his ideas, Duchamp leaves little room for criticism since he attempts to transcend the usual rules. His philosophy emphasizes man as a true individual and allows Duchamp to say "yes" to everything if he so chooses. But, as he is anxious to point out, his rules are solely for himself and no one else: every man must make his own.

In seeking the ideal work, like Mallarmé's Le Livre, with the patience of an alchemist, Duchamp led a consecrated life. In an early essay Mallarmé wrote: "Everything sacred is enveloped in mystery. Art has secrets it must protect. The artist must remain an aristocrat." Duchamp repudiates "the stupidity of the painter" and reminds us that an ancient nobility accompanies art, that art ultimately is not rational but mystical. What art is for Duchamp is difficult to define (there is always a contradiction); it is easier to say what it is not. But at least it is a mode of thought.

This aristocratic attitude naturally places a distance between the spectator and the artist, as Duchamp consistently emphasized.[7] Like the Bachelors who never really meet the Bride face to face, the spectator is constantly set apart, "delayed." Duchamp almost forces us to be voyeurs. The windows and doors (Fresh Widow, Bagarre d'Austerlitz, 11 rue Larrey, and Etant donnés) reinforce the idea that we can only look at his work, not enter it. We can only imagine the object in With Hidden Noise, and we must avoid falling over Trébuchet. Even the windows for the Gotham Book Mart and the string installation for the "First Papers of Surrealism" exhibition present remote, enclosed worlds, which we look into but cannot penetrate. Duchamp described this basic frustration as early as 1913 in a note on "the question of shop

The Chess Game. 1910. Oil on canvas, 44⅞ x 57½ in. Philadelphia Museum of Art, The Louise and Walter Arensberg Collection. Cat. 44.

129

*windows" recently published in* A l'infinitif: *where consummation occurs "through a glass pane," regret must inevitably follow.[8] Only Alice can go through the glass unharmed and penetrate the wonderland of mysteries beyond. Only the Bride and Rrose Sélavy inhabit the* terra incognita, *isolated, unknown, probably forbidden, that is Paradise.*

*The voyeur then has no choice but to be both exalted and melancholy (Sad Young Man in a Train). For him there is both voluptuousness and sadness, desire and frustration. Art becomes a liturgical kind of mystery with a beauty which causes despair—despair that disillusions but enlightens. This art of self-reflection and silence where even the shadows are given life (as in Tu m') has an extraordinary elusiveness. Visibility and invisibility coincide (something that Duchamp insisted upon both in his art and in his life).*

*It is a game in which at least if you cannot win you cannot lose. Again Duchamp provided the clue by spending several months working out a system to break even at roulette.[9] Duchamp's lifelong involvement with chess was yet another form of self-expression which enhanced both his aesthetic and style. Duchamp asserted that for the liberation of an artist one of the most important responsibilities was "the education of the intellect, even though, professionally, the intellect is not the basis of the formation of the artistic genius."[10]*

*Arthur Koestler defines chess as a paradigm or symbol of the working of the human mind, showing both its glory and its bloodiness: "On the one hand an exercise in pure imagination happily married to logic, staged as a ballet of symbolic figures on a mosaic of sixty-four squares, on the other hand, a deadly gladiatorial contest."[11] And Goethe referred to chess as the touchstone of the intellect, the gymnasium of the mind.*

*Chess owes its beauty and elegance to imagination and creativity as much as to the exercise of intelligence. Duchamp asserts that beauty in chess is close to "beauty in poetry; the chess pieces are the block alphabet which shapes thoughts; and these thoughts, although making a visual design on the chessboard, express their beauty abstractly, like a poem . . . Actually I believe that every chess player experiences a mixture of two aesthetic pleasures, first the abstract image akin to the poetic idea in writing, second the sensuous*

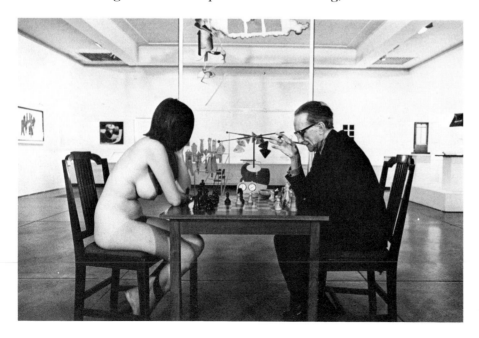

*A chess game at the Pasadena Art Museum during Duchamp's first major retrospective exhibition, 1963. Photograph by Julian Wasser.*

*pleasure of the ideographic execution of that image on the chessboards . . . I have come to the personal conclusion that while all artists are not chess players, all chess players are artists."*[12]

*Duchamp's involvement in chess lasted all his life, but its possibilities for invention, speculation, and artistic interest became almost a total preoccupation for many years. "I am completely ready to become the chess maniac—everything around me takes the form of a knight or a queen and the external world has no other interest for me than its transposition into winning or losing positions."*[13] *Duchamp became fascinated with playing chess by cable, using a complicated code to play two games simultaneously. The chessboard was paradise, "the landscape of the soul," and the universe.*

*Chess problems, with their compositional economy and absoluteness, give both the composer and solver delight in the pure and flawless fulfillment of idea in construction. It is no surprise that Duchamp's book* Opposition and Sister Squares Are Reconciled *of 1932 should be devoted to an end-game problem that occurs perhaps once in a thousand times—when, because of blocked pawns, the only means of winning is by the kings' moves.*[14] *It is a book that interests only the most dedicated or esoteric chess players.*

*Is this book (half geometry and half chess) for the artist or for the chess savant? Like so many of his works, it is a mechanism that provides another facet of mental expression just different enough from what is expected, avoiding categorization yet plausibly adding to the body of his life and art.*[15]

*Throughout his life Duchamp kept notebooks in which he analyzed positions, recorded and studied games. He concentrated on those masters who seemed to epitomize modernity and unorthodoxy, and particularly on the end games of Capablanca and Nimzovich, whose books* Hypermodern Chess *and* Chess Praxis *seem to have influenced him. Edward Lasker described Duchamp as "a very strong player . . . a master among amateurs and a marvelous opponent. He would always take risks in order to play a beautiful game, rather than be cautious and brutal to win."*[16]

*The strictness and logical beauty of the abstract thinking demanded by chess serve Duchamp as the antithesis of chance, and as a check to self-indulgence*

*Marcel Duchamp, Washington Square, New York, 1965. Photograph by Ugo Mulas.*

and facility. In playing chess seriously, "strategy" is developed to meet challenges; one has to gain insight into the total situation, grasp things at "a glance," and shift position subtly. Duchamp transferred all he learned from chess to art and very specifically reminded us that art is "play" and "game" (and vice versa) in the truest sense of those words. When Walter Arensberg pointed out that Duchamp's works resembled successive moves in a game of chess, Duchamp replied: "Your comparison between the chronological order of the paintings and a game of chess is absolutely right . . . But when will I administer checkmate—or will I be mated?"[17]

The "game" becomes an intellectual liberation. It upholds no taste; it is a conceptual domain operating according to its own rules. Therefore it is not a win-or-lose proposition, but derives from a fascination with the conflict rather than with its resolution.

Duchamp is proposing an attitude of mind, an intelligence which has the capacity to grasp complex relations, to see the sense in non-sense and the nonsense in sense. One can readily appreciate his love of puns, jeux de mots, his admiration for Roussel's elaborate games with sentence structure, and his affinity to the pseudo-linguistic science of Brisset and the fake mathematics of Princet. The spectator has to play the game with Duchamp. This of course means that the spectator must become an artist—and, perhaps more important, a thinker. It is this revolutionary challenge to his audience that has made Duchamp the embodiment of the truly avant-garde figure and a symbol of modernism.

What was it like to buy a snow shovel as a work of art? The complicated emotion of displacing oneself in one's own time, attempting to look at a contemporary object as an archaeological artifact, has its inverted counterpart in the response the transistor radio must have evoked when it first appeared deep in the Congo, or the Polaroid when it arrived in New Guinea.

In seeking an art based on indifference and doubt[18] it was essential for Duchamp to introduce humor, to particularize, to move toward the individual and specific choice as in the Readymades. "Whether Mr. Mutt made the fountain or not has no importance. He CHOSE it. He took an ordinary article of life, placed it so that its useful significance disappeared under the new title and point of view—created a new thought for that object."[19]

Transformation is crucial to Duchamp's "breathing." Art becomes life and life is art. The myth is the man and the man the myth. Rrose Sélavy, R. Mutt, and Belle Haleine are salvation from the ennui of modern life.

Although restoring some of the magic and mystery essential to the meaning of art he has also extended that meaning—but only through maintaining his individuality and guarding his secrets.

Duchamp repeatedly warns of the paradoxes and risks implicit in his aesthetic. In creating an extraordinary network of ideas, Duchamp allows for the delirium of the imagination and the madness of the unexpected. He produced a body of work that contains infinite proposals and suggestions, and true to his intelligence he insisted on the individuality of the creative act, the creative choice.

The Readymades might be very different if chosen today. Duchamp was aware of being trapped by his own time. Was the bottlerack chosen to be a domestic Tour Eiffel? Would today's Readymades be so small? What would

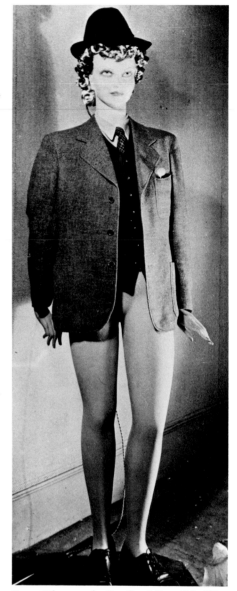

*Rrose Sélavy on the Rue Surréaliste of the "Exposition Internationale du Surréalisme" at the Galerie Beaux-Arts, Paris, January 1938. She wears Duchamp's hat and coat and has a red light bulb in her pocket.*

*the* rendezvous *be in 1973? What do you exhibit in a museum or gallery to shock in the way that* Fountain *did in 1917? Nevertheless, Duchamp succeeded in moving beyond time, propelled by wit and irony but not without gravity. A game at least drawn.*

*Marcel Duchamp—dandy, amateur, inventor, aristocrat, generator, breather—throwing the dice and surrounded by swift nudes, triumphantly reigns over the dominion of Rrose Sélavy breeding . . .*

## NOTES

1. *Interview in "Eleven Europeans in America,"* ed. James Johnson Sweeney, The Museum of Modern Art Bulletin (*New York*), *vol. XIII, nos. 4–5, 1946, pp. 19–21.*

2. *"Duchamp was becoming less and less mistrustful of cocktails. He began to drink too much. One night during an artists' ball in Webster Hall, he determined to climb to the end of the main flagpole. It was extremely slippery and inclined at a 45° angle over the dance floor. He obstinately refused to give up and on several occasions almost fell on the dancers below. When he finally succeeded everybody sighed in relief. The last I saw of him that night, he and a girl were balancing themselves unsteadily on the edge of the Elevated." H.-P. Roché, "Souvenirs of Marcel Duchamp," reprinted in Robert Lebel,* Marcel Duchamp, *trans. George Heard Hamilton (New York: Grove Press, 1959), p. 80.*

3. *Charles Baudelaire,* The Painter of Modern Life and Other Essays, *trans. and ed. Jonathan Mayne (London: Phaidon Press, 1964), pp. 26–29.*

4. *"La Vie dans l'oeuvre de Fernand Léger," interview with Dora Vallier,* Cahiers d'Art (*Paris*), *vol. 29, no. 2, 1954, p. 140 (author's translation).*

5. *"The Poet is the one who looks. And what does he see? Paradise" (author's translation). From André Gide,* Le Traité du Narcisse (Théorie du symbole), *in "Oeuvres complètes d'André Gide," ed. L. Martin-Chauffier (Paris: Gallimard, 1933–39), vol. 1, p. 216.*

6. *"Here is the realm of Rrose Sélavy / How arid it is—How fertile it is / How joyous it is—How sad it is" (author's translation). From* Littérature (*Paris*), *no. 5, October 1922, p. 8.*

7. *"To all appearances, the artist acts like a mediumistic being who, from the labyrinth beyond time and space, seeks his way out to a clearing. If we give the attributes of a medium to the artist, we must then deny him the state of consciousness on the esthetic plane about what he is doing or why he is doing it. All his decisions in the artistic execution of the work rest with pure intuition and cannot be translated into a self-analysis, spoken or written, or even thought out. . . . The result of this struggle is a difference between the intention and its realization, a differ-ence which the artist is not aware of. Consequently, in the chain of reactions accompanying the creative act, a link is missing. This gap, representing the inability of the artist to express fully his intention, this difference between what he intended to realize and did realize, is the personal "art coefficient" contained in the work. . . . All in all, the creative act is not performed by the artist alone; the spectator brings the work in contact with the external world by deciphering and interpreting its inner qualifications and thus adds his contribution to the creative act. This becomes even more obvious when posterity gives its final verdict and sometimes rehabilitates forgotten artists." From "The Creative Act," an address delivered by Duchamp at the convention of the American Federation of Arts, Houston, Texas, April 1957.*

8. *Note from* A l'infinitif, *trans. Cleve Gray (New York: Cordier & Ekstrom, 1966), p. 5:*

> The question of shop windows ∴
> To undergo the interrogation of shop windows ∴
> The exigency of the shop window ∴
> The shop window proof of the existence of the outside world ∴
> When one undergoes the examination of the shop window, one also pronounces one's own sentence. In fact, one's choice is "round trip." From the demands of the shop windows, from the inevitable response to shop windows, my choice is determined. No obstinacy, ad absurdum, of hiding the coition through a glass pane with one or many objects of the shop window. The penalty consists in cutting the pane and in feeling regret as soon as possession is consummated. Q.E.D.                    Neuilly, 1913

9. *"Here we come across another, very positive feature of play: it creates order, is order. Into an imperfect world and into the confusion of life it brings a temporary, a limited perfection. Play demands order absolute and supreme. . . . The profound affinity between play and order is perhaps the reason why play, as we noted in passing, seems to lie to such a large extent in the field of aesthetics. Play has a tendency to be beautiful. It may be that this aesthetic factor is identical with the impulse to create orderly form, which animates*

play in all its aspects. The words we use to denote the elements of play belong for the most part to aesthetics, terms with which we try to describe the effects of beauty: tension, poise, balance, contrast, variation, solution, resolution, etc. Play casts a spell over us; it is 'enchanting,' 'captivating.' It is invested with the noblest qualities we are capable of perceiving in things: rhythm and harmony." J. Huizinga, Homo Ludens: A Study of the Play-Element in Culture (*Boston: Beacon Press, 1955*), p. 10.

10. *Marcel Duchamp, paper delivered at symposium, "Should the Artist Go to College?" Hofstra College, Hempstead, Long Island, New York, May 13, 1960.*

11. *Arthur Koestler, "The Chess Match of the Century,"* The Sunday Times (*London*), *July 2, 1972.*

12. *Marcel Duchamp, address at banquet of the New York State Chess Association, August 30, 1952.*

13. *From a letter to Walter Arensberg (author's translation) written in Buenos Aires, June 15, 1919; in the Francis Bacon Library, Claremont, California.*

14. "*There comes a time toward the end of the game when there is almost nothing left on the board, and when the outcome depends on the fact that the king can or cannot occupy a certain square opposite to, and at a given distance from, the opposing king. Only sometimes the king has a choice between two moves and may act in such a way as to suggest he has completely lost interest in winning the game. Then the other king, if he too is a true sovereign, can give the appearance of being even less interested, and so on. Thus the two monarchs can waltz carelessly one by one across the board as though they weren't at all engaged in mortal combat. However, there are rules governing each step they take and the slightest mistake is instantly fatal. One must provoke the other to commit that blunder and keep his own head at all times.*

"*These are the rules that Duchamp brought to light (the free and forbidden squares) all to amplify this haughty junket of the kings.*" *H.-P. Roché, "Souvenirs of Marcel Duchamp," reprinted in Lebel,* Marcel Duchamp, *p. 83.*

15. "*Both chess and music are visual arts coupled to mechanics. Both are arts of movement. The beauty of a chess position is that it is not static. The beauty is in the arrangement and the inherent possibilities.*" *Interview with Duchamp by Harold C. Schonberg,* New York Times, *April 12, 1963.*

16. *Calvin Tomkins,* The Bride and the Bachelors: The Heretical Courtship in Modern Art (*New York: Viking, 1965*), p. 5.

17. *Letter from Marcel Duchamp to Louise and Walter Arensberg, July 22, 1951; in the Francis Bacon Library, Claremont, California.*

18. "*What's Happened to Art?*" *interview with Marcel Duchamp by William Seitz,* Vogue (*New York*), *vol. 141, February 15, 1963, p. 113:*

"W.S.: *Your kind of revolutionary activity apparently was never political. What adjective would you use to describe it? 'Aesthetic'? 'Philosophical'?*

"M.D.: *No. No. 'Metaphysical,' if any. And even that is a dubious term. Anything is dubious. It's pushing the idea of doubt of Descartes, you see, to a much further point than they ever did in the School of Cartesianism: doubt in myself, doubt in everything. In the first place never believing in truth. In the end it comes to doubt 'to be.' Not doubt to say 'to be or not to be'—that has nothing to do with it. There won't be any difference between when I'm dead and now, because I won't know it. You see the famous 'to be' is consciousness, and when you sleep you 'are' no more. That's what I mean—a state of sleepingness; because consciousness is a formulation, a very gratuitous formulation of something, but nothing else. And I go farther by saying that words such as truth, art, veracity, or anything are stupid in themselves. Of course it's difficult to formulate, so I insist* every word I am telling you now is stupid and wrong."

19. "*The Richard Mutt Case,*" *editorial in* The Blind Man (*New York*), *no. 2, May 1917, p. 5.*

# MARCEL DUCHAMP
## AND
## ANDRE BRETON

Robert Lebel

It was an extraordinary experience to be and to remain a friend of both Marcel Duchamp and André Breton for thirty years, but it could also be a strain. Undoubtedly the two men had a great deal in common, but in some respects their ideas and their behavior were almost incompatible.

Their relationship cannot be properly understood if we fail to realize that they did not belong to the same intellectual generation. Duchamp was only nine years older than Breton but had already reached a sort of scandalous fame at the Armory Show of 1913. At that time Breton had not yet begun his medical studies in Paris, and he was just discovering Symbolist poetry under the guidance of Paul Valéry, who was his senior by twenty-five years and still an unknown writer outside a small literary circle.

Nevertheless, young Breton's passage through Symbolist and Mallarméan poetry created his first link with Duchamp at a time when they were not yet aware of each other. As soon as he had given up "retinal" painting, Duchamp sought to develop a system of expression in which language played the leading part. Most of his casual writings, such as his notes in the *Green Box* and, of course, his puns, were so closely connected with his plastic works that it was difficult to decide whether the words explained the works or the works elucidated the words; whether, taken together, they turned into a subversive chess game, a kind of engineering, or enigmatic poetry.

Although his language was apparently prose, it was clearly written under the Mallarméan spell and was curiously akin to Breton's early poems, except that it remained strictly concise and deliberately apoetical. Duchamp had rapidly drawn away from lyricism, and while he was very appreciative of Raymond Roussel's dispassionate narration, the poet he preferred most was Jules Laforgue, who had tried to change the splenetic tune of Symbolist poetry into an ironical free

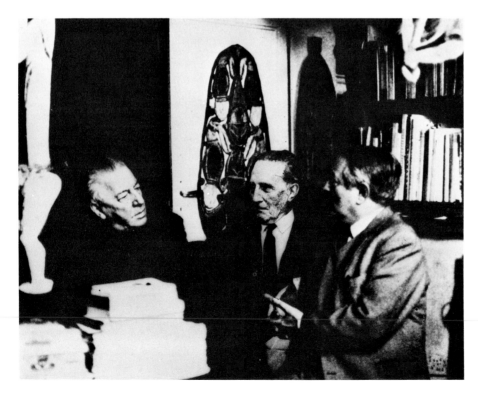

André Breton, Marcel Duchamp, and Robert Lebel in Breton's studio, Paris, 1965.

verse beyond the frontiers of conventional meaning. Incidentally, Breton could not stand Laforgue, but it is obvious that his first interest in Duchamp arose from the discovery of the latter's language, which had at once struck him as absolutely new.

It has often been said that Guillaume Apollinaire "bequeathed" Giorgio de Chirico and Pablo Picasso to Breton. The same remark applies to Duchamp, whom Breton did not meet personally until 1921, but of whose importance he was aware, through Apollinaire, as early as 1917. For Breton, Duchamp was a legendary figure of the Cubist and pre-Dada era. Only at the end of 1918, when he established contact with Francis Picabia, who had returned to Paris, did Breton learn, in minute detail, of Duchamp's more recent activities in New York. Marcel appeared in Paris briefly in 1919, when he left *L.H.O.O.Q.* as a visiting card, but it was during his second sojourn in 1921 that he really mixed with the Parisian Dada group of which Breton was a leader.

Breton has left an enthusiastic report of their first encounter.[1] He had felt strongly drawn to Duchamp, and he found in him a providential substitute for his recently deceased friend and hero Jacques Vaché. Did his effervescent overtures meet with a warm response, or did Duchamp greet him with his usual aloofness? All we know is that the contrasting attitudes of the two men always contributed to a degree of misunderstanding between them. Breton could not help feeling a touch of bitterness at times, although he had enough insight to recognize that Duchamp's cool detachment was an indispensable part of his character.

It is not that Duchamp was completely immune to inner drama, but his dramatic period seemed terminated once and for all at the very time when Breton was stepping into his never-ending ordeal. Here probably lies the root of the recurrent variance between them.

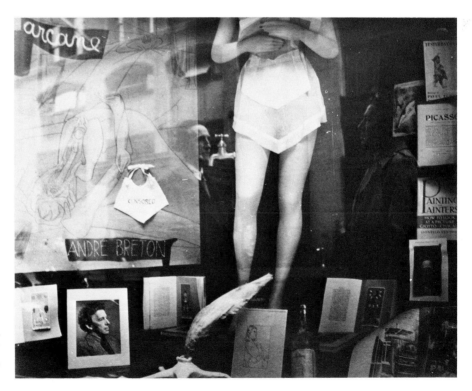

Window installation by Marcel Duchamp and André Breton for publication of Breton's *Arcane 17*, at Gotham Book Mart, New York, 1945. Duchamp and Breton can be seen reflected in the glass.

137

From then on, Duchamp's main concern would be to maintain his self-restraint, while Breton would always remain a tragic figure.

In his lecture at the Barcelona Ateneo on November 17, 1922, Breton ventured to establish a list of the most advanced artists of the time, and he chose Picasso, Picabia, Duchamp, Giorgio de Chirico, Max Ernst, Man Ray. Today this list of six names seems highly prophetic and should be recalled to those who are always eager to deprecate Breton's judgment. Yet, in Duchamp's case, how many of his major plastic works had Breton actually seen when he included him in the list? None, very likely, as most of them were in America. Again, in 1934, when he published "Lighthouse of the Bride," the first inspired analysis of the *Large Glass*, he knew it only from the notes and the few sketches assembled in the *Green Box*.

André Breton in front of his art gallery, Gradiva, Paris, 1937. The glass door was designed by Duchamp.

Therefore he built his opinion of Duchamp much less on the works themselves than on the words that accompanied them. Six puns were included in *Littérature*, no. 5, and their impact on the Parisian pre-Surrealist circles was unforgettable. "They were, to my mind, the most remarkable thing produced in poetry for a long time," wrote Breton in the same issue of *Littérature*. Indeed they exploded like fireworks, and they were soon echoed by Robert Desnos's no less extraordinary responses dictated under hypnosis. "Words are making love," added Breton to his description of this experience. He felt that this was in accord with his own "automatic writing," on the border line of verbal expression and leading toward the destruction of and the liberation from rational language—the goal he and Duchamp were seeking.

There is evidence that although in America Duchamp was recognized from the start as a legitimate artist, his influence in France remained mainly intellectual. Even his earliest French supporters, such as Breton himself, who was well aware of his artistic accomplishments and who, in time, became the owner of several of his works, including a painting of the *Bride*, preferred to see him as an oracle who merely used art as he used language or gestures, to convey laconically the essence of his thoughts.

The famous telegram POD E BAL (a pun on the derisive expression *Peau de balle*), with which Duchamp replied to an invitation to participate in the Dada Salon of 1921, did more to increase his prestige in Paris than all the reports of his success in America at the Armory Show and after. Perhaps the lack of physical contact with his plastic works could be responsible for his countrymen's peculiar view of his personality. On the other hand, it is also probable that very few of his American friends were ever in a position to grasp entirely the unique quality of his language and its intricate substance. Although it is difficult to conceive a better translation than the typographic version of *The Bride Stripped Bare* which we owe to Richard Hamilton and George Heard Hamilton, it must be admitted that their version yields barely a part of the French original. It is possibly from this gap that the hypothesis of alchemy has emerged as a substitute for the missing significance. In any case, the nonchalant and witty Duchamp, who was a renowned figure in America, and the distant, inscrutable Duchamp, who in France remained a property of the "happy few," were not one and the same person. The nearest to the real Duchamp would have been a combination of both.

Cover and jacket designed by Marcel Duchamp for André Breton's *Young Cherry Trees Secured against Hares*, 1946.

Reverting to his impact on the Parisian avant-garde, one can now add to the proof of Robert Desnos's telepathic communication with Rrose Sélavy the testimony of some Surrealist dreams recently analyzed by Sarane Alexandrian.[2] It is well enough known, but not always conceded, that the Surrealists had completely discarded the romantic conception of dream as a poetical or mystical experience. For them dreams gave access to the knowledge of hidden reality and of unconscious desire, and dreams became the subject of a systematic investigation, based chiefly on Freudian methods, despite the fact that Breton was not entirely in agreement with Freud, as their continued correspondence clearly shows.

Documents were assembled, and many were published in *La Révolution Surréaliste*, from its first issue of December 1924 onward. They include accounts of dreams and automatist material contributed by de Chirico, Breton, Antonin Artaud, Desnos, Paul Eluard, Louis Aragon, Max Ernst, and others. Needless to say, Duchamp did not participate in this collective research, but his presence was felt all the same, playing a prevailing part in Breton's dreams, as Alexandrian points out. Quoting one of these, which he proposes to call a "program dream," inasmuch as it attempts to solve problems involving the Surrealist group and its tactics, he uncovers Breton's concern over the possibilities and difficulties of enlisting Duchamp in his camp. This interpretation intimates that Breton considered Duchamp's help indispensable to the Surrealist cause, but also that he feared such help was not easy to get or to keep.

This assessment of Breton's attitude toward Duchamp in the twenties applies to the following decades as well. Often Breton's books, and even more so his poems, expressed with great intensity a state of expectation, a poignant longing which must have been the counterpart of Duchamp's evasiveness—although if he had been trapped in the "Bachelor Machine" it could hardly be against Duchamp's will or consent. Their ambiguous tie resembled an everlasting courtship, with Duchamp in the guise of the Bride who was never caught stripped bare. It remains to be seen who was trying to catch whom.

Breton, of course, had been seduced, and he knew it. In his first description of Duchamp, he did not omit the physical appearance, the good looks, "the admirable beauty of the face." Despite both men's unquestionable heterosexual taste, the situation could have been awkward. Each time Breton wished to get hold of Duchamp for some important enterprise, such as the organization of a Surrealist event, Marcel never refused; he did splendidly the work he was asked to do, but always managed to slip away before the final "splash" occurred. This happened repeatedly, in 1938, in 1942, in 1947, in 1959. The last Surrealist show, in 1965, was the only one from which Marcel was entirely absent, but Breton, for once, had not invited him. This was after four young painters in Paris had exhibited a series of works representing Duchamp's murder and Breton had resented his refusal to sign a protest prepared by the Surrealist group. Duchamp felt his symbolic assassination was a rather funny and personal affair, and he did not see the need of a group to protect or to avenge him.

These slight oscillations in Duchamp's feelings toward Breton were particularly perceptible in New York, where they were both stranded

between 1942 and 1945. We used to see Breton daily, but Duchamp could never be depended upon for regular discussions. He came and went as he pleased, although he was always ready to give his ideas away most generously for *VVV*, the Surrealist magazine for which he had accepted the office of coeditor with Breton and Max Ernst.

After all, Breton was a considerable presence—not only an overwhelming poet whose style never once deviated from the grand manner, but also a charismatic leader, a relentless agitator, a dedicated fighter for a great many causes. Yet he remained a vulnerable person, often buffeted by crises, exile, disappointments, and insults. I recall the attention his bearing commanded as we watched him strolling along the streets of New York in despair—still, after several years, unable or reluctant to utter a single word in English. At times his tragic stance could be too much for Duchamp to share or even to bear. Marcel felt free from any "thesis" or allegiance. He thought his existence in the world was completely his own and that he owed nothing to anyone but himself. However, even this allegiance ceases to be certain if we take into account his self-denials. When he was urged by Breton to come nearer, to participate more, he would instinctively avoid any move that could lead to closer involvement. He would not be a victim of relationship.

At this point one can guess how his "Bachelor Machine" had once and for all set the pattern of his contacts with others. Starting from his conception of the human being, including himself, as a machine, he had blended man and woman in a single machine, though separated into two parts, and put it to work for his own use. The sheer idea, let alone its materialization in the *Large Glass*, was an astounding and revolutionary masterpiece of mock psychology, mock technology, mock sociology, and mock economics. We can now see that it also anticipated the most serious and ferocious of the "desiring machines" which some recent analysts have located in the schizophrenic area. Of course in their petulant treatise Gilles Deleuze and Félix Guattari see the "Bachelor Machine" as a somewhat different device.[3] Its "production," in contrast with the "desiring machine's" rather painful output, is essentially an autoerotic pleasure that can result in a new birth, a dazzling ecstasy. As far as Duchamp's machine is concerned this description seems rewarding enough, and it accounts for the glittering radiance evident to everyone who encountered him.

What he really thought, on the other side of the glass, about his friends, he never cared to confide, and Breton had reasons to feel insecure. Only after Breton's death in 1966 did Duchamp suddenly speak up, and his answers to André Parinaud, a shrewd newspaperman who had interviewed Breton years before, sounded amazing. He went so far as to pronounce the word "love" in earnest. "I have never known a man who had a greater capacity for love," he said of Breton, "a greater power for loving the greatness of life, and you don't understand anything about his hatreds if you don't realize that he acted in this way to protect the very quality of his love for life, for the marvelous in life." "Breton loved like a heart beats. He was the lover of love in a world that believes in prostitution." "And what of Surrealism?" asked Parinaud. "For me," Duchamp replied, "it was the incarnation of the most beautiful youthful dream of a moment in the world."[4]

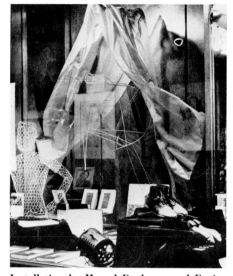

Installation by Marcel Duchamp and Enrico Donati for second edition of André Breton's *Le Surréalisme et la peinture*, at Brentano's, New York, 1945.

140

After such a statement, one might wonder what had happened to the sarcastic, cynical, and sometimes merciless Duchamp we had known. Yet there were always in him traces of tenderness that he could not suppress or conceal. I observed him at Breton's funeral. He had the same dismayed and piercing look the last time I saw him, one hour before his own death. I believe the change had nothing to do with any sentimental weakening in old age. The vicinity of death can bring about in the strongest mind a transformation in awareness, a clearheadedness that lays the defensive barriers wide open. "Bachelor Machines" suddenly become useless. This is my tentative vindication of Duchamp's belated and unexpected surrender to his feelings. It could also perhaps explain his need for a "Last Piece"—which should then be interpreted as an "Anti-Bachelor Machine," opposing to the abstract and ascetic rigidity of the earlier *Bride* a realistic exposure of emotions stripped bare.

Now that they both are dead and have become the prey of historians, Duchamp and Breton appear to us closer to one another than they ever were during their lifetime. If Breton in his dreams saw Duchamp as indispensable to the cause of Surrealism, Duchamp at the end disclosed how important to him were Breton's support and stimulation. Since their death the situation of course has changed again. They endure the same promiscuous recognition and face the same exploitative curiosity; but the spirit of unrest that brought them together is increasingly radicalized, and their works or their words are taking on new meanings. Although there is a general tendency to take the Readymade or the Surrealist rebellion for granted, their most subversive consequences are yet to come. The indictment of discursive language is very much under way. It has been confirmed that the real function of rational discourse is to imprint the master's orders in his subordinate's mind, and there can be no posthumous compromise, either in Duchamp's or in Breton's name, with the domineering culture they both endeavored to overturn.

Why then, at least for Duchamp, this public celebration, this scholarly worship, this comprehensive exhibition, and this knowledgeable book? Perhaps the most illuminating and paradoxical result of such extraordinary recognition will be to focus our attention on Duchamp's and Breton's gestures, rather than on their works or their words, and to keep them both visible through the idiomatic wall, as Breton wrote, like twin Lighthouses of the Bride, "luminously erect, to guide future ships on a civilization which is ending."[5]

NOTES

1. André Breton, "Marcel Duchamp," *Littérature* (Paris), Nouvelle Série, no. 5 (October 1922), pp. 7–10. Later published in *Les Pas perdus* (Paris: Gallimard, 1924).

2. Sarane Alexandrian, "Le Rêve dans le surréalisme," in "L'Espace du rêve," *Nouvelle Revue de Psychanalyse* (Paris), vol. I, no. 5 (Spring 1972), pp. 27–50.

3. Gilles Deleuze and Félix Guattari, *L'Anti-Oedipe* (Paris: Les Editions de Minuit, 1972), pp. 24–25.

4. "André Breton," *Arts-Loisirs* (Paris), no. 54 (October 5–11, 1966), pp. 5–7. In this interview, Duchamp hints for the first time that he had seen and singled out Breton as early as 1919, before they had formally met. The passage quoted was translated by Henry Martin.

5. André Breton, "Phare de *La Mariée*," *Minotaure* (Paris), no. 6 (Winter 1935), pp. 45–49. English translation by George Heard Hamilton, *View* (New York), ser. 5, no. 1 (March 1945), pp. 6–9, 13.

# * water writes always in * plural

Octavio Paz

Given  1.  the waterfall

   2.  the illuminating gas,

one will determine
we shall determine the conditions

for the instantaneous State of Rest (or allegorical appearance)  ?

of a succession [of a group] of various facts

seeming to necessitate each other

under certain laws, in order to isolate the sign
   the
of accordance between, on the one hand,
   all the      (?)
this State of Rest (capable of innumerable eccentricities)

and, on the other, a choice of Possibilities

authorized by these laws and also

determining them.[1]

WE ARE indebted to Apollinaire for three judgments on Marcel Duchamp, incompatible with one another, and all three true. In one of them he allotted his friend a mission: "to reconcile art and the people." In another he claimed that the young painter (Duchamp was about twenty-five when Apollinaire wrote this) was one of the few artists unafraid of "being criticized as esoteric or unintelligible." The third judgment was no less peremptory nor, apparently, less arbitrary and contradictory: "Duchamp is the only painter of the modern school who today (autumn, 1912) concerns himself with the nude."[2]

The first claim, surprising at the time of its formulation, seems less so today. The Readymades evicted the "art object," replacing it with the anonymous "thing" which belongs to us all and to no one. Though they do not exactly represent the union of art and the people, they acted subversively against the fastidious privileges of artistic taste. And *The Bride Stripped Bare by Her Bachelors, Even* does indeed bring about the union that Apollinaire predicted. It does so twice over: it not only adopts the highly publicity-conscious form of illustrations from catalogs of industrial machinery, but it was conceived by Duchamp as a monument whose theme is at once popular and traditional—the apotheosis of the Bride as she is being denuded.

Despite its twofold public character—graphic description of the workings of a machine and representation of an erotic ritual—the *Large Glass* is a secret work. Its composition is the projection of an object that we cannot perceive with our senses; what we see—outlines, mechanisms, diagrams—is only one of its manifestations in the mechanic-ironic mode. The painting is an enigma and, like all enigmas, is something not to be contemplated but deciphered. The visual aspect is only a starting point. Furthermore, there is another element that radically modifies the innocuous act of seeing a painting and turns it into a kind of initiation rite: the riddle is presented to us by a virgin who is also a machine. It is surely not necessary to recall the ancient and fateful connection between virgins and riddles. There is yet another similarity between the myth and the painting: like the heroes and the knights of old, we confront the enigma with only the innocence which is left to us and with a sure but hermetic guide—the notes of the *Green Box*. The public monument to the Bride is transformed into a sexual and mental labyrinth: the Bride is a body made of reflections, allusions, and transparencies. Her clarity dazzles us, and I am afraid that beside her this text will seem like the gas lamp held by the naked woman in the assemblage in the Philadelphia Museum.

At once a scientific description, a monument to a virgin, and an enigma made up of fearful clarities, *The Bride Stripped Bare by Her Bachelors, Even* is a nude. And so it confirms Apollinaire's third assertion. Except that, once again, it is an assertion which belies itself even as we affirm it: the nude is a skeleton. Erotic myth and negation of the myth by the machine, public monument and secret creation, nude that is a skeleton, and skeleton that is a motor, the *Large Glass* opens out before us like the image of contradiction. But the contradiction is apparent rather than real: what we see are only moments and states of an invisible object, stages in the process of manifestation and concealment of a phenomenon. With that lucidity which is no less unique in him because it is constant, Duchamp alludes to the duplicity of his attempt in one of the first notes in the *Green Box:* "Perhaps make a *hinge picture*" (*tableau de charnière*). This expression, applicable to all his work, is particularly apt in the case of the *Large Glass:* we are facing a hinge picture, which, as it opens out or folds back, physically and/or mentally, shows us other vistas, other apparitions of the same elusive object.

The *hinge* appears frequently in Duchamp. Thanks to the literal and

Door of *Given: 1. The Waterfall, 2. The Illuminating Gas.* 1946–66. Mixed-media assemblage, approximately 95½ in. high, 70 in. wide, including: an old wooden door, bricks, velvet, wood, leather stretched over an armature of metal and other material, twigs, aluminum, iron, glass, plexiglass, linoleum, cotton, electric lights, gas lamp (Bec Auer type), motor, etc. Philadelphia Museum of Art, Gift of the Cassandra Foundation. Cat. 186.

144

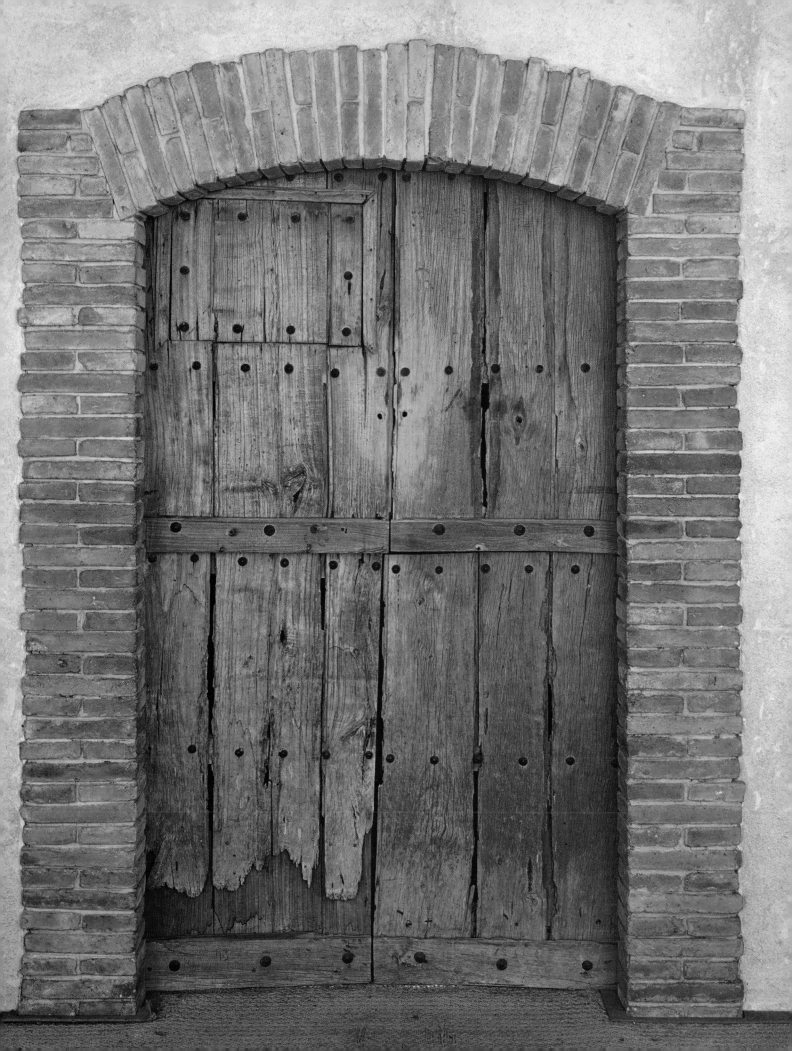

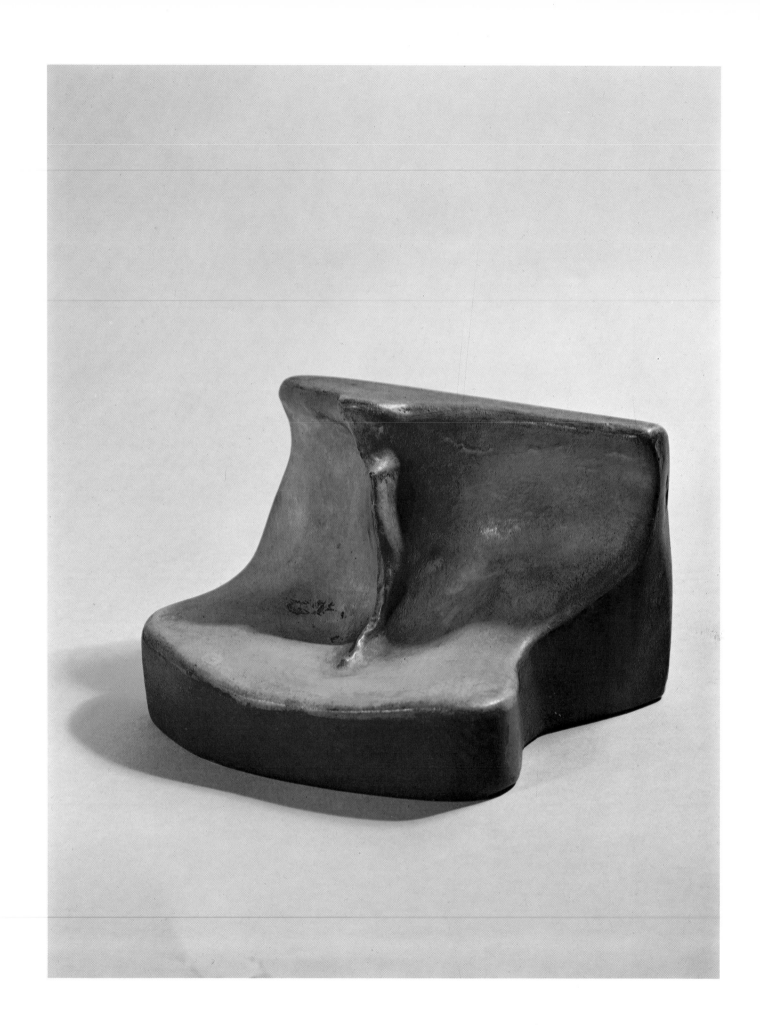

paradoxical use of the idea of the hinge, Duchamp's doors and ideas open while remaining closed, and vice versa. If we have recourse to the same procedure, the expression "hinge picture," opening out (closing) on itself, reveals to us another expression that also appears in one of the early notes of the *Green Box:* "delay in glass" (*retard en verre*). Duchamp explains that this refers to a "sort of subtitle." Always explicit, even within his extreme succinctness, he adds that we must understand the word "delay" in the "indecisive reunion" of its different meanings. According to the Petit Littré dictionary, the meanings of *retard* are three in number: "What is or what happens too late; the delay of a watch, a clock, part of the movement which serves to slow it down or move it ahead; in harmony, the momentary delay when one starts to play one of the notes of a chord, but prolongs for a few moments the note of the preceding chord, a note which needs for its resolution the one which is delayed."[3] As it swings on its hinge, the "delay in glass" leads us on to another composition that is its *resolution,* as much in the musical sense as in any other. This composition, the final chord, is the "assemblage" in the Philadelphia Museum. To see it is to hear the note held in abeyance in the *Large Glass.* Is the resolution the solution? Not exactly. It is rather the realization, the incarnation: the naked Bride.

Although it has been described several times—in the noteworthy study by Anne d'Harnoncourt and Walter Hopps,[4] for example—I think it will serve some purpose here to give an idea of the work, since a photographic reproduction is not possible. As everyone knows, it is located in the Philadelphia Museum beyond the large gallery where much of Duchamp's work is collected and where the *Large Glass* occupies the central spot. The visitor goes through a low doorway, into a room somewhat on the small side, completely empty. No painting on the plastered walls. There are no windows. In the far wall, embedded in a brick portal topped by an arch, there is an old wooden door, worm-eaten, patched, and closed by a rough crossbar made of wood and nailed on with heavy spikes. In the top left-hand corner there is a little window that has also been closed up. The door sets its material doorness in the visitor's way with a sort of aplomb: dead end. The opposite of the hinges and their paradoxes. But if the visitor ventures nearer, he finds two small holes at eye level. If he goes even closer and dares to peep, he will see a scene he is not likely to forget. First of all, a brick wall with a slit in it, and through the slit, a wide open space, luminous and seemingly bewitched. Very near the beholder—but also very far away, on the "other side"—a naked girl, stretched on a kind of bed or pyre of branches and leaves, her face almost completely covered by the blond mass of her hair, her legs open and slightly bent, the pubes strangely smooth in contrast to the splendid abundance of her hair, her right arm out of the line of vision, her left slightly raised, the hand grasping a small gas lamp made of metal and glass. The little lamp glows in the brilliant three-o'clock-in-the-afternoon light of this motionless, end-of-summer day. Fascinated by this challenge to our common sense—what is there less clear than light?—our glance wanders over the landscape: in the background, wooded hills, green and reddish; lower down, a small lake and a light mist on the lake. An inevitably blue sky. Two or three little clouds, also inevitably white. On the far right, among some rocks, a waterfall catches the light. Stillness: a portion of time held motionless. The immobility of the naked woman and of the landscape contrasts with the movement of the waterfall. The silence is absolute. All is real and verges on banality; all is unreal and verges—on what?

The viewer draws back from the door feeling that mixture of joy and guilt

*Female Fig Leaf.* 1950. Painted plaster, 3⁹⁄₁₆ x 5½ x 4¹⁵⁄₁₆ in. Collection Mme Marcel Duchamp, Villiers-sous-Grez. Cf. cat. 168.

145

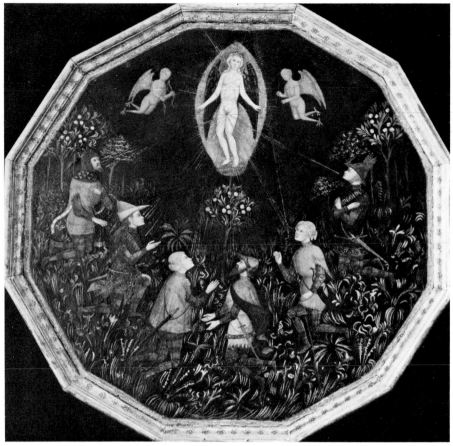

of one who has unearthed a secret. But what is the secret? What, in fact, has he seen? The scene that takes place without taking place behind the door is no less enigmatic than the outlines and strokes of the *Large Glass*. Seeking a sign to orient him in his perplexity, the visitor finds the title of the assemblage affixed to the wall: *Etant donnés: 1° la chute d'eau, 2° le gaz d'éclairage. (1946–1966)*. The contradictory relationship between public and secret art, monument and initiation rite, is repeated: the assemblage leads us to its title, the title to the Preface of the *Green Box*, which begins with precisely the same pseudoscientific formula: *Etant donnés. . . .* The formula leads us to the *Large Glass* and the *Large Glass* to our own image, which, as we gaze at the *Large Glass*, blends with the painted forms and the reflections of the outside world. The play of correspondences and reflections between the assemblage and the *Large Glass* is upsetting, and it presents itself on the visual plane as well as the textual—the notes of the *Green Box* are the verbal bridge between the two works. In both cases, the mere act of looking at a painting or an assemblage is turned into the act of viewing-through. In one case, through the obstacle of the door, which finally becomes the line of vision leading us to the landscape with the woman and the waterfall; in the other, through the glass on which the composition is painted and which, by reason of its very transparency, becomes an obstacle to our vision. Reversibility: seeing through opaqueness, not-seeing through transparency. The wooden door and the glass door: two opposite facets of the same idea. This opposition is resolved in an identity: in both cases we look at ourselves looking. Hinge procedure. The question "What do we see?" confronts us with ourselves.

Twenty-three years separate the date when the *Large Glass* was finally unfinished and the date when the *Etant donnés* was begun. This long period of retirement gave rise to the idea that Duchamp had given up painting. The truth is that after 1913, with only a few exceptions like the *Tu m'* of 1918, his work not only abandoned strictly pictorial procedures but, without ceasing to be visual, turned into the negation of what we have called painting for more than two centuries. Duchamp's attitude toward the pictorial tradition is also governed by the hinge principle: the negation of painting-painting, which is the basic concept of the modern tradition since Delacroix, implies negation of the avant-garde. This is a unique position in the art of our era: Duchamp is at one and the same time the artist who carries avant-garde trends to their final consequences, and the artist who, in consummating them, turns them back on themselves and so inverts them. Negation of "retinal" painting breaks with the modern tradition and unexpectedly renews the bond with the central current of the West, anathematized by Baudelaire and his twentienth-century descendants: the painting of ideas.[5] A procedure analogous to that of the "delay in glass," though in the diametrically opposite direction, the acceleration of the modern ends in its devaluation. In 1957 Duchamp was asked, "Do you believe in a forthcoming explosion of the modern spirit?" He replied, "Yes, but it is the word *modern* which has run itself out. Look at the *new* art from the beginning of the century . . ."[6]

The general system governing Duchamp's work is the same as that which inspires the so-called Wilson-Lincoln effect—in those portraits that represent Wilson when seen from the left and Lincoln from the right. The Wilson-Lincoln effect is a variant of the hinge principle: the pivot converted into the material and spiritual axis of the universe. Generalized reversibility, circularity of phenomena and ideas. Circularity includes the spectator, also: the Bride is enclosed in our glance, but we are enclosed in the *Large Glass* and included in the *Etant donnés*. We are part of both works. Thus there comes about a radical inversion of the position of the terms that intervene in creation and artistic contemplation and that, to a certain extent, constitute it: the artist's subjectivity (or the viewer's) and the work. A certain kind of relationship initiated by Romanticism ends with Duchamp.

The art and poetry of our time come into being precisely when the artist inserts subjectivity into the order of objectivity. This procedure sensitizes Nature and the work, but, at the same time, it makes them relative. Romantic irony has been the nourishment-poison of Western art and literature for almost two centuries. Nourishment, because it is the leavening of "modern beauty," as Baudelaire defined it: the bizarre, the unique. Or rather: objectivity torn apart by ironic subjectivity, which is always an awareness of human contingency, awareness of death. Poison, because "modern beauty," contrary to that of the ancients, is condemned to destroy itself; in order to exist, to affirm its modernity, it needs to negate what was modern scarcely as long ago as yesterday. It needs to negate itself. Modern beauty is bizarre because it is different from yesterday's, and for that very reason it is historical. It is change, it is perishable: historicity is mortality.

Duchamp's youth coincides with the explosion of the avant-garde movements; that is to say, with the last and most violent manifestation of the modern tradition ushered in by Romanticism. Duchamp has recalled more than once his youthful interest in Jules Laforgue, a poet thought little of in France but who has had a profound influence on Anglo-American poetry and on Latin American as well. In Laforgue, modern subjectivity turns in on itself: he is a Symbolist poet who uses irony to gnaw away at the Symbolist aesthetic.

It was natural that Laforgue should inspire Duchamp, as Mallarmé did later. Apart from the influences that he has revealed himself, others can be quoted. For example, this title of a Laforgue poem could be a phrase from the litany of the Chariot: "Célibat, célibat, tout n'est que célibat." Another poem is called "Complainte de crépuscules célibataires." Human history, says Laforgue, is the "histoire d'*un* célibataire." Schopenhauer revised and corrected: the world is the representation of a bachelor *I*.

Duchamp submits Laforgue's irony to the disorienting action of the Wilson-Lincoln system and in this way changes it, literally turning it inside out. Modern irony, from Romanticism onward, is the action of the bite of subjectivity into the work; in the *Large Glass* and the *Etant donnés*, it is not the I that takes over the object, but the contrary: we see ourselves seeing through the opaqueness of the door of the assemblage or the transparency of the *Large Glass*. The Wilson-Lincoln principle is revealed as a meta-irony, that is, as an "irony of affirmation," as opposed to the Romantic negation. Irony and subjectivity have become the axis of modern art. Duchamp makes this axis spin on itself, and he overturns the relationship between subject and object: his "laughing picture" laughs at us. The very notion of modernity is demolished. While continuing to be peculiar and different from yesterday's—continuing to be polemical and historical, i.e., modern—Duchamp's art undertakes the criticism of modernity, and exchanges nods of recognition with the art of the past.

The negation of painting-painting was far from being a renunciation of art; the twenty-three years separating the *Large Glass* from *Etant donnés* were not empty. The surprising thing is precisely the persistence of Duchamp's underground work, his patience and his coherence. Like Saint-Pol-Roux, who used to hang the inscription "The poet is working" from his door while he slept, Duchamp used to say that he was not doing anything except breathing— and when he was breathing he was working. His obsessions and his myths were working him: inaction is the condition of inner activity. On various occasions Duchamp denounced the publicity surrounding modern art and maintained that artists should go underground. Here the hinge principle reappears: the man who drew a moustache on the Mona Lisa is the same man who, for twenty years, carried out work in secret. Contrary and complementary forms of his rupture with the world: public profanation and the descent to the catacombs, the slap in the face and silence.

Helped by Teeny, his wife and confidant, in assembling this clandestine production, Duchamp worked more or less continuously from 1946 to 1966, first in his study on Fourteenth Street, and later in modest premises in a commercial building on Eleventh Street. Early in 1969, three months after his death, Anne d'Harnoncourt and Paul Matisse dismounted the assemblage, took the pieces to Philadelphia and put them together again in the museum there. They used as a guide a notebook prepared by Duchamp and made up of precise instructions, diagrams, and more than a hundred photographs. An exceedingly difficult task, which was carried out with great skill and sensitivity.

The *Etant donnés* is a combination of materials, techniques, and different artistic forms. As for the former, some have been brought to the work with no modification—the twigs on which the nude is lying, the old door brought from Spain, the gas lamp, the bricks—and others have been modified by the artist. Equally varied are the techniques and forms of artistic expression: the artificial lighting and the theatrical illusion of the scene; the action of the invisible electric motor, which reminds us of the techniques of clockwork

toy-making; photography, painting, properly speaking, and even window dressing. All these techniques and forms draw together Duchamp's earlier experiences, for example, the window display at the Gotham Book Mart in New York in 1945, advertising Breton's *Arcane 17*, where a half-nude dummy was used. However, there is a difference between Duchamp's earlier works and the *Etant donnés*. In the former, he is trying to show what is behind or beyond appearance—the decomposition of movement in the *Nude Descending a Staircase*, a passional game of chess in *The King and Queen Traversed by Swift Nudes*, the symbolic functioning of an erotic machine in the *Large Glass*—while in the latter the artist seems to aim at the appearance. In the *Large Glass*, the spectator must imagine the scene of the bride's delight at being stripped; in *Etant donnés* he sees her in the actual moment of fulfillment. The symbolic description of the phenomenon is followed by the phenomenon itself: the machine of the *Large Glass* is the representation of an enigma; the nude of *Etant donnés* is the enigma in person, its incarnation.

The bridge between the *Large Glass* and *Etant donnés* is a drawing from 1959: *Bedridden Passes* [*Cols alités*], *Project for the 1959 Model of The Bride Stripped Bare by Her Bachelors, Even*. The drawing reproduces the *Large Glass*, but in the central region it adds a sketch of hills, with very fine, hardly visible lines. Furthermore, on the far right, after the Chocolate Grinder and as if it were a prolongation of one of the blades of the Scissors, Duchamp drew an electric pole with its wires and insulators. One of the notes in the *Green Box* indicates that the communication between the Bride and the Bachelors is electric, and in the 1959 drawing this idea—which refers rather to a metaphor: the electricity of thought, of the glance, or of desire—is expressed in the most direct and material form: a pole and its wires. And so we have two images of electricity: physical energy and psychic energy. By the title of the drawing, Duchamp hints that the mountainous landscape is made up of passes (*cols*) but that these passageways are bedridden, ailing (*alités*). As a result, they are scarcely passable, and communication between the realm of the Bachelors and that of the Bride is difficult. In *Etant donnés* communication is even more difficult, in spite of the fact that the landscape of wooded hills possesses an almost tactile reality—or perhaps for this very reason: we are dealing with the deceptive reality of *trompe-l'oeil*. Lastly, the title alludes also to the law that governs the conception of the *Large Glass*, and of *Etant donnés:* ironic causality. *Causalité/Cols alités:* a slight distension of the sounds takes us from the ailing passes of the hills to a universe in which chance and necessity exchange nods. Knowledge is a disease of language.

The road from the *Large Glass* to *Etant donnés* is made up of reflections. It is a spiral that begins where it ends and in which over there is here. Identity emerges from itself in search of itself, and every time it is about to meet itself, it bifurcates. But the echoes and correspondences between one and the other can be applied to all of Duchamp's work. We are facing a true constellation in which each painting, each Readymade, and each word-play is joined to the others like the sentences of a discourse. A discourse ruled by rational syntax and delirious semantics. A system of forms and signs moved by their own laws. The landscape of *Etant donnés*, implicit in the *Large Glass*, is an echo or a rhyme of three other pictures in which the same combination of trees, sky, and water appears. One represents the landscape of his birthplace (Blainville) and dates from 1902; another is the well-known Readymade of 1914, *Pharmacy*; the last is the 1953 *Moonlight on the Bay at Basswood*. The gas motif goes back to his adolescence: there is a drawing from 1903 that shows

a gas lamp with the brand name Bec Auer. The water/gas pair appears constantly in Duchamp's works, word games, and conversations, from the years when he was preparing the *Large Glass* until the year of his death. *Eau & gaz à tous les étages* (Water and Gas on Every Floor) was an inscription found on the doors of new buildings in the Paris of his youth, which he used for the title page of the deluxe edition of Robert Lebel's monograph. Other correspondences could be quoted, but it might be better to concentrate on the water/gas duality: they are the two *authors* of the *Large Glass* and the *Etant donnés*, and their writing is in the plural.[7]

In the note to the *Green Box* that serves as epigraph to this text and that gives its title to the assemblage, it is clearly stated that the Waterfall and the Illuminating Gas literally produce the Bride. Water and gas are human and cosmic elements, physical and psychic. Eroticism and ironic causality at the same time, they come together and separate according to rigorous and eccentric laws. In the *Large Glass* they are invisible forces, and if it were not for the notes of the *Green Box*, we would not know that it is their action which sets the complicated and tragicomic mechanism running. Water and gas, says the *Green Box*, work in the *darkness* and in the *darkness* will emerge the "allegorical appearance," the Bride, like an "extra-rapid exposure."

Because they are elements pregnant with sexuality, erotic signs, it is not strange that one of the most assiduous exegetes of Duchamp's work has identified gas as a masculine and water as a feminine symbol. Two reasons prevent me from accepting this oversimplified interpretation. The first is the discredit into which the Jungian archetypes have fallen. Not because they are false but because people want to explain everything with them—and so nothing is explained. For that reason I prefer to call the Waterfall and the Illuminating Gas signs and not symbols. Symbols have lost their meaning by virtue of having so many contradictory meanings. On the other hand, signs are less ambitious and more agile: they are not emblems of a "conception of the world" but movable pieces of a syntax. The second reason: signs (and symbols) change their meaning and gender according to the context in which they are placed. They mean nothing by themselves: they are elements in a relationship. The laws that govern phonology and syntax are perfectly applicable in this sphere. No symbol has an immutable meaning: the meaning depends on the relation. We generally think of water as a feminine symbol (the womb), but as soon as it becomes running water—waterfall, river, stream, rain—it takes on a masculine tonality: it penetrates into the soil, or it gushes out of it. The same thing happens with air, although it is the masculine principle *par excellence*, from the Aztec Quetzalcoatl to the Christian Holy Ghost, the air that comes out of the orifices (the genitals, the mouth) of the archetypes of the great Jungian mother is feminine: the all-containing vessel. Air becomes feminine in the sylph and in the "cloud-damsels" of the Sirigiya frescoes. The cloud, image of indetermination, undecided between water and air, admirably expresses the ambivalent nature of signs and symbols. And why not mention fire, which is both Zeus's bolt and the feminine oven, the womb where men are cooked, according to the Nahuatl myth? The meaning of signs changes as their position in context changes. The best thing will be to follow the path of water and gas in the context of reflections that the *Large Glass* and the *Etant donnés* interchange between themselves.

In the *Large Glass* gas appears as the determining element of the Bachelors. Not only does it inspire (inflate) them, but they expire it, in the double meaning of the word. They send it through the Capillary Tubes to the Sieves, where it undergoes an operation, in the surgical sense, emerging as an explosive

liquid (semen = liquid fire?), to be immediately cut off and atomized by the Scissors; falling into the region of the Splashes, it ascends once more and, sublimated by the Oculist Witnesses who transform it into an image, is thrown into the Bride's domain, turned into a reflection of reflections. Despite all these adventures and misadventures, gas is invisible. In *Etant donnés* gas appears—and appears in its most direct and commonplace manifestation: in the form of a phallic gas lamp clutched by a naked girl. In the *Large Glass*, the Illuminating Gas is identified with the Bachelors: it is their desire; in the assemblage the Bachelors disappear—or, rather, are reabsorbed by the gas lamp. Onanism, leitmotif of the litanies of the Chariot, passes from the Bachelors to the Bride. But was the same thing not happening in the *Large Glass*? The *Etant donnés* not only confirms the imaginary nature of the operation—emphasized more than once by Duchamp—but also the nonexistence of the Bachelors: they are a projection, an invention of the Bride.[8] In her turn the Bride is an epiphany of another invisible reality, the projection in two or three dimensions of a four-dimensional entity. And so the world is the representation not of a bachelor, as Laforgue said, but of a reality that we do not see and that appears sometimes as the rather sinister machine of the *Large Glass*, sometimes as a naked girl in her culminating moment of ecstasy.

In describing the physiology of the Bride, the *Green Box* mentions a substance that is not water, though it is a liquid and possesses certain affinities with gas: petrol, the erotic gasoline that lubricates her organs and makes orgasm possible. The Bride is a "wasp" who secretes by osmosis the essence (gasoline) of love. The "wasp" draws the necessary doses from her liquid deposit. The deposit is an "oscillating tub" that provides for the Bride's hygiene, or, as Duchamp says somewhat cruelly, for her diet. In the *Etant donnés*, ideas become images, and the irony disappears: the tub is turned into the lake, and the "wasp-motor" into the naked girl, creature of the waters. But the best example of these changes—from the liquid state to the gaseous or vice versa, equivalent to mutations of gender—is the Milky Way of the *Large Glass*, manifestation of the Bride in the moment when, as she is being stripped, she reaches the fullness of delight. The Milky Way is a cloud, a gaseous form that has been and will again be water. The cloud is desire before its crystallization: it is not the body but its ghost, the *idée fixe* that has ceased to be an idea and is not yet perceptible reality. Our erotic imagination ceaselessly produces clouds, phantoms. The cloud is the veil that reveals more than it hides, the place where forms are dissipated and born anew. It is the metamorphosis, and for this reason, in the *Large Glass*, it is the manifestation of the threefold joy of the Bride as she is stripped bare: ultrarapid instantaneous communication between the machine state and that of the Milky Way.

This digression on gasoline and clouds should not make us forget that Duchamp does not talk about gas and water in general, but very precisely as Illuminating Gas and Waterfall. In the *Large Glass*, the Waterfall is not in the Bride's realm but in the Bachelors'. Though it does not actually appear in the composition, we know its form and location from the *Green Box*: "a jet of water coming from a distance in a semicircle, from above the Malic Molds." The Waterfall is masculine, as much because it is in the domain of the Bachelors as because it is running water: "Flowing and moving waters," says Erich Neumann, "are bisexual and male and are worshipped as fructifers and movers."[9] However, it is a masculinity dependent on the feminine sign: waterfalls and streams although "looked upon as masculine . . . have the significance of a son." In the *Large Glass* the Waterfall feeds the Bride's

imagination and purposes, is part of the seduction mechanism of the Bachelors and cause of their ultimate failure. Moreover, it serves as a "cooler" between them and the Bride.

In the *Large Glass* the Waterfall is invisible, a force we do not see but which produces the movement of the Water Mill; in the *Etant donnés*, the Water Mill disappears and the Waterfall is a visible presence. And who sees these apparitions and disappearances? The Oculist Witnesses, who are *inside* the *Large Glass*—and we ourselves who, by spying through the cracks in the Spanish door, incarnate the Witnesses as the nude incarnates the Bride. They (we) are the only ones who can tell us something (tell themselves) about the syntax of the Waterfall and the Illuminating Gas and about the text traced out in the conjunctions and metamorphoses.

In the *Large Glass*, the Oculist Witnesses occupy the extreme right of the Bachelors' domain. A little above the third witness there is a circle that represents the hole in the lock through which the voyeur peeps. The positioning of the Oculist Witnesses more or less corresponds to that of the holes in the door of the assemblage. The spectator, like the Oculist Witnesses, is a voyeur; also, like them, he is an ocular witness, as much in the legal sense of being present in the case as in the religious sense of attesting to a passion or a martyrdom. We are reminded of the "Four Master Analysts of Ireland" in *Finnegans Wake*, with whom the Witnesses share more than one affinity. This is not the only analogy, moreover, between Joyce and Duchamp: the *Large Glass* and *Etant donnés* can be considered the visual equivalents of the Letter of Anna Livia Plurabelle, another "untitled mamafesta memoralizing the Mosthighst" (the invisible object, the fourth dimension—Rrose Sélavy). The Oculist Witnesses are part of the *Large Glass*; the spectator of the *Etant donnés*, by his very act of peeking, shares in the dual rite of voyeurism and aesthetic contemplation. Without him the rite would not be fulfilled. It is not the first time that an artist includes in his painting those who look at it, and in my earlier study on Duchamp I recalled Velázquez and his *Meninas*. But what is representation in *Las Meninas* and in the *Large Glass* is an act in *Etant donnés*; we are really turned into voyeurs and also into ocular witnesses. Our testimony is part of the work.

The function of the Oculist Witnesses, despite their marginal position, is central: they receive the Splashes from the Illuminating Gas, now converted into a sculpture of drops, and transform it into a mirrorlike image that they throw into the Bride's domain, in the zone of the Shots. The Oculist Witnesses refine (sublimate) the Illuminating Gas turned Splash of explosive drops: they change the drops into a look—that is, into the most immediate manifestation of desire. The look passes through the obstructed passages (*cols alités*) of the Bride and reaches her. It arrives thus far not as reality, but as the image of desire. The vision of her nudity produces in the Bride the first bloom, before orgasm. It is, as Duchamp emphasizes, an electric flowering.[10] The function of the Oculist Witnesses is the sublimation of the Illuminating Gas into a visual image, which they transport in a look capable of passing through obstacles. Desire is the "electricity at large" that the *Green Box* mentions. In *Etant donnés* electricity is literally everywhere: behind the backdrop (in the motor) and outside as the brilliant light that bathes the landscape and the naked figure.

Who are the Witnesses? Duchamp the artist (not the man) and ourselves, the spectators. There is often a tendency to see the Bride as a projection of Duchamp and, consequently, of the viewer. The contrary is also true: we are her projection. She sees her naked image in our desiring gaze, which is

*Diana Lucifera.* Roman, stone. Farnese Collection, Museo Nazionale, Naples.

born from her and returns to her. Once again, the theme is viewing-through. We see the erotic object *through* the obstacle, be it door or glass, and this is voyeurism; the Bride sees herself naked in our gaze, and this is exhibitionism. Both are the same, as Schwarz has pointed out. But they are united not in Duchamp or in the viewer, but in the Bride. The circular operation starts from her and returns to her. The world is her representation.

The complementary opposite of voyeurism is clairvoyance. The Oculist Witnesses of the *Large Glass* and the beholder of *Etant donnés* are clairvoyants; their gaze passes through material obstacles. The relationship is circular, once again: if desire is second sight, clairvoyance is voyeurism transformed by the imagination; desire made knowledge. Eroticism is the condition of second sight. The erotic vision is creation as well as knowledge. Our gaze changes the erotic object: what we see is the image of our desire. "It is the spectators who make the picture."[11] But the object also sees us; more precisely, our gaze is included in the object. My looking makes the painting only on condition that I accept becoming a part of the painting. I look at the painting, but I look at it looking at what I look at—looking at myself. The person peeping through the holes in the Spanish door is not outside the assemblage: he is part of the spectacle. *Etant donnés* is realized by means of his look: it is a spectacle in which someone sees himself seeing something. And what does he really see? What do the Oculist Witnesses see? *They don't see:* it is the Bride who sees herself. The vision of herself excites her: she sees herself and strips herself bare in the look that looks at her. Reversibility: we look at ourselves looking at her, and she looks at herself in our look that looks at her naked. It is the moment of the discharge—we disappear from her sight.

The dialectic of the look that looks at nudity and nudity that looks at itself in this look irresistibly evokes one of the great myths of pagan antiquity: Diana's bath and Actaeon's downfall. It is strange that to date no one has explored the disturbing similarities between this mythological episode and Duchamp's two great works. The subject matter is the same: the circularity of the look. Actaeon moves from hunter to hunted, from looking to being looked at. But the correspondences, echoes, and rhymes are more numerous and precise than this comparison indicates. I will begin where the scene takes place: Ovid describes Diana's sanctuary as a valley wooded with pines and cypresses, surrounded by mountains. A waterfall tumbles down a rock, into a small lake, hardly more than a pool.[12] Ovid's description seems to anticipate the scene in *Etant donnés.*

Diana and the Bride: both are virgins, and Ovid uses a curious expression to describe the goddess's clothing: she is "the scarcely clad one." The Bride's virginity in no way implies frigidity or asexuality. The same is true of Diana: "In spite of the fact that she must be considered a virgin," says Dumézil, "in the excavations of the sanctuary at Aricia, near Rome, votive offerings were found in the form of masculine and feminine organs, and images of women clothed, but with their robes open in front."[13] Who corresponds to Actaeon in the *Large Glass* and the *Etant donnés?* Not the Bachelors, since, apart from the fact that they do not exist in their own right, *they cannot see,* but the Oculist Witnesses. The similarity is more remarkable if we are aware that in both cases the visual violation is preceded by disorientation. According to Ovid, the young hunter reaches the sacred confine "wandering and with uncertain steps," that is to say, lost; before turning into the look of the Oculist Witnesses, the Illuminating Gas comes out of the Sieves unable to distinguish left from right; the visitor who goes up to the two holes in the door in the

Philadelphia Museum invariably does it after a moment of hesitation and disorientation.

The first study for the Bride (Munich, 1912) had as subtitle "Modesty Mechanism." Time and again Duchamp has emphasized the ambiguous nature of the Bride's modesty, a veil which uncovers her as it hides her, prohibition tinged with provocation. Warm, not cold modesty, and with a "touch of malice." Diana's attitude seems more resolutely and more fiercely chaste. Ovid expressly says that Actaeon's offense was an error, not a crime: it was not desire but destiny that led him to witness the goddess's bath. Nor is Diana an accomplice: her surprise and anger at the sight of Actaeon are genuine. But Pierre Klossowski in a splendid essay suggests that the goddess desires to see herself, a desire that implies being seen by someone else. For this reason, "Diana becomes the object of Actaeon's imagination."[14] This operation is identical to that of the Bride, who sends herself her own nude image through the medium of the Oculist Witnesses, as Diana does through Actaeon. Klossowski indicates that the look stains, and that the virgin goddess *wishes* to be stained; for his part, Duchamp says that the Bride "warmly rejects (not chastely)" the Bachelors' offering. Lastly, as Diana throws water over Actaeon and transforms him into a deer, the Bride puts a cooler between the Bachelors and herself—the Waterfall.

In both cases we witness not the violation of the two virgins but its homologue: visual violation. But our look really does pass through the material obstacle—the door of the assemblage, the boughs and leaves of the goddess's sanctuary—and so the transgression is as much psychic as material. Actaeon's punishment is to be turned into a deer—he who stared is stared at—torn to pieces by his own dogs. "Seeing prohibited" is a motif that Duchamp expresses in many ways, especially in his two windows: *Fresh Widow* (French Window) and *The Brawl at Austerlitz*. Both prevent us from seeing; they are windows not to see out of. In the title of the former, there is, furthermore, an allusion to the guillotine—the Widow, in popular French jargon—which immediately recalls the fate of the Illuminating Gas cut to pieces by the Scissors, and of Actaeon by his dogs.

But, according to a note from *A l'infinitif*, the real punishment consists of possession: "No obstinacy, ad absurdum, of hiding the coition through a glass pane with one or many objects of the shop window. The penalty consists in cutting the pane and in feeling regret as soon as possession is consummated. Q.E.D."[15] Except that voyeurism is not a solution either: if the punishment is eluded, the torture becomes greater. Nonconsummation, desiring without touching what is desired, is no less cruel a penalty than the punishment that follows possession. The solution is the conversion of voyeurism into contemplation—into knowledge.

The same note from *A l'infinitif* contains another curious confession, which is at the same time a lucid description of the circularity of the visual operation: "When one undergoes the examination of the shop window, one also pronounces one's own sentence. In fact, one's choice is round-trip." I have already pointed out the resemblance of the Actaeon myth and Duchamp's two works: the gazer is gazed at, the hunter hunted, the virgin strips herself in the look of him who looks at her. The "round-trip" that Duchamp refers to exactly corresponds to the internal structure as much of the myth as of his two works. Actaeon depends on Diana; he is the instrument of her desire to see herself. The same thing happens with the Oculist Witnesses: as they look at themselves looking at her, they give the Bride back her image. It is all a round-trip. Duchamp has said several times that the Bride is an apparition,

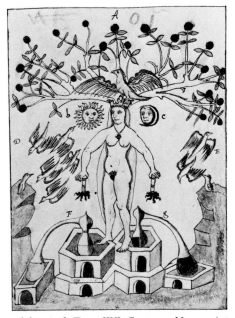

*Alchemical Tree.* XVI Century. Manuscript (perhaps a draft of Hieronymus Reusner, *Pandora*, Basel, 1582). Universitäts-Bibliothek, Basel.

the projection of an invisible reality. The Bride is an "instantaneous State of Rest," an "allegorical appearance." Klossowski indicates that Diana's essential body is also invisible: what Actaeon sees is an appearance, a momentary incarnation. In the theophanies of Diana and the Bride, Actaeon and the Oculist Witnesses are included. The manifestations of Diana and the Bride demand that someone look at them. The subject is a dimension of the object: its reflexive dimensions, its glance.

There are other similarities worth mentioning. In the *Green Box* the Bride is often called Hanged Woman (*Pendu femelle*). The machine outlined by Duchamp is literally suspended, hanging in space like a dead beast on a butcher's hook or a hanged man on a scaffold. The theme of the hanged man appears in many myths, but the sacrificial victim is invariably a god. There is, however, an exception: in the Peloponnesus, where the cult of Artemis was very popular, an effigy of the divinity was hung from a tree and was called Apanchomene (the Hanged Woman). One of the notes in the *Green Box* says that the Bride is an "agricultural machine"; further on, she is a "plowing tool." The plow is predominantly masculine—which is why Ceres was three times plowed. But there is another exception: in the festivals of Artemis Orthia, a plow was dedicated to the virgin goddess. There was also a flagellation of young men, and a torch procession. (I will return to the latter detail.) In all these ceremonies, there were reminiscences of human sacrifice.

In order to label the Bride's axis, Duchamp uses the expression "arbor-type" (*arbre-type*). Diana is an arboreal divinity and was originally a dryad, like the *yakshis* of Hindu mythology. The tree that spreads its leaves to the heavens is a feminine tree, and its image, says Neumann, has fascinated all men: "It shades and shelters all living things and feeds them with its fruit which hang on like stars . . ."[16] The sky in which the tree-goddess stretches out its branches is not the day but the night sky—which is why leaves, branches, fruits, and birds are seen as stars. For his part, Dumézil observes that the name of Diana originally meant "the expanse of the heavens."[17] Referring to the blossoming (*épanouissement*) of the Bride, Duchamp indicates that in the arbor-type the bloom is *grafted on*, and is the Bride's aureole and the conjunction of her "splendid vibrations." This aureole or crown is none other than the Milky Way: the cloud that preserves in its bosom the lightning (Illuminating Gas) and the rain (Waterfall), the cloud that is the halfway point between the incarnation and the dissipation of the feminine form. The movable cipher of desire. Very significantly Ovid says that when Diana sees herself touched by Actaeon's gaze, she blushes like a cloud shot through by the sun. Finally, if Diana's tree is a figure of the mythical imagination, the alchemists saw it in the crystallization obtained by dissolving silver and mercury in nitric acid. It is the spirit of sal ammoniac. Duchamp would have liked this definition.

All the elements of the *Green Box* and the *Large Glass*—the Illuminating Gas, the tree-type, the cloud or Milky Way, the Waterfall—appear in the *Etant donnés* converted into visual semblances. The vision of the landscape and the waterfall, with the naked woman (Milky Way) stretched on a bed of branches (the tree), would be a pacifying metaphor if it were not for the glow of the gas lamp lit in broad daylight. An incongruity that winks at us roguishly and destroys our idea of what an idyll should be. Torches appear in the ceremonies in honor of Diana, but nobody knows for sure why and for what purpose. The experts agree on only one point: they are not epithalamial torches. On the Ides of August, Dumézil says, processions of women would go to Aricia carrying torches. One of Propertius's loveliest elegies (II, 32)

mentions these processions:

*Hoc utinam spatiere loco, quodcumque vacabis,*
*Cynthia! sed tibi me credere turba vetat,*
*cum videt accensis devotam currere taedis*
*in nemus et Triviae lumina ferre deae.*[18]

The relation between torch and goddess is clear in the case of divinities like Demeter and Persephone; it almost always symbolizes the union of the virgin mother and her son, as we see in Phosphora, "bearer of the torch." Flame is the fruit of the torch, light is the fruit of the tree of night. In all these images the idea of fertility appears. At any rate, there is an impressive co-incidence between the darkness which, according to the *Green Box,* is required by the extra-rapid exposure—the momentary and allegorical apparition of the Bride—and the darkness which, in the Eleusinian mysteries, preceded *heuresis:* "Amid the total darkness the gong is struck, summoning Koré from the underworld . . . suddenly the torches create a sea of light and fire and the cry is heard: Brimo has borne Brimos!"[19] But this Greek rite concerns the birth of a god, while the Bride's torch evokes not the slightest notion of maternity or procreation. The Bride and Diana begin and end in themselves.

I have still to point out the relationship between Diana and Janus, the two-faced god, divinity of doors. His name, Dumézil says, marks him as a "passageway." Spatially speaking, he is inside doors and presides as *janitor* over entrances and exits; in the temporal sense he is the beginning: *Januarius,* the first month, between the year that is ending and the one beginning, is his month. He faces in two directions because every passage implies two places, two states, the one left behind and the one being approached. Janus is a hinge, a pivot. Though Dumézil says nothing about the relationship between one and the other, we know that the Romans saw Diana as Janus's double. There is an evident affinity between two patterns: on the one hand, the Bride, the doors, and, in short, the hinge system that rules Duchamp's universe; on the other, Janus and Diana, divinities who are circular and twofold, and in whom the end is the beginning, obverse and reverse are one and the same. Divinities who ceaselessly unfold and reflect themselves, reflexive gods who go from themselves to themselves, Janus and Diana embody the circularity of desire, and also that of thought, that bifurcating unity, that duality which pursues unity only to bifurcate once again. In them Eros becomes speculative.

The correspondence of Duchamp's Bride with the images of the goddess has yet another disturbing aspect. The oneness of the Bride and her landscape, explicit in the *Large Glass* and implicit in *Etant donnés,* repeats itself in the mythic conception: the sacred place *is* the goddess. For this reason, according to Jean Przyluski, it is a complete landscape: water, trees, and hills.[20] The forces of Nature are concentrated in the divine presence, and this presence in its turn is diffused throughout the physical surroundings. Imperceptibly the sacred place moves from being merely a magnetic and generally secluded spot where ceremonies are held, to being the center of the world. It then becomes detached from earthly space and is transformed into an ideal place: Eden, Paradise. The center of the world coincides with the goddess: the holy tree becomes a column and the column the axis of the cosmos. The four cardinal points are born and annulled in this center. As it revolves upon itself, like the stereoscope that fascinated Duchamp, this side and that side, left and right disappear.

Duchamp did not hide his admiration for the art works of the past that were incarnations of an Idea, usually religious in nature. The *Large Glass*

is an attempt to renew that tradition within a radically different context, a-religious and ironic. But since the seventeenth century our world does not have Ideas in the sense in which Christianity had them in the age of its apogee. What we have, especially from Kant onward, is Criticism. Even contemporary "ideologies," despite their pretensions to incarnate truth, and the pseudo-religious fanaticisms which they have engendered, present themselves as *methods*. Marxism itself does not claim to be anything other than a theoretico-practical method in which *praxis* is inseparable from *criticism*. Duchamp's art is public because he sets out to renew the tradition of art "at the service of the Mind"; it is hermetic because it is critical. Like the tree-goddess who is the center of the universe where distinctions between this side and that side disappear, the Bride in the *Large Glass* is the axis in which movement and immobility are fused together into a moment at once full and empty. But unlike the goddess, the Bride is not a presence but an Idea. Except that she is an Idea continually destroyed by herself: each of her manifestations, by realizing her, denies her. For this reason I have dared to say, in my earlier work on Duchamp, that the Bride is the (involuntary) representation of the only Idea-Myth of the Western world in the modern era: Criticism.

Like Mallarmé's *Un Coup de dés*, the *Large Glass* and *Etant donnés* not only contain their negation, but this negation is their motor, their animating principle. As happens in *Finnegans Wake*, in Duchamp's two great works the moment of the apparition of the feminine presence coincides with that of her vanishing. Diana: pivot of the world, appearance that dissolves and appears again. The appearance is the momentary form of the apparition. The appearance is the form that we apprehend with our senses. The apparition is not a form but a conjunction of forces, a knot: the knot of desire. Between the appearance and the apparition there is a third term: the presence. The essential difference between the *Large Glass* and *Etant donnés* lies in the fact that the Bride is presented in the former as an appearance to be deciphered, while in the latter she is a presence offered for our contemplation. There is no solution, said Duchamp, because there is no problem. It would be more exact to say: the problem is resolved in the presence, the Idea incarnate in a naked girl.

The *Etant donnés* is the moment of Duchamp's reconciliation with the world and himself. But there is no abdication or renunciation: negation, criticism, and meta-irony do not disappear. They are the gas lamp burning in the sunlight: its feeble little flame makes us doubt the reality of what we see. The lamp produces the *darkness* that Duchamp demanded for the extra-rapid exposure: it is the reflexive element that makes the work enigmatic. The enigma lets us glimpse the other side of the presence, the single and dual image: the void, death, the destruction of the appearance, and, simultaneously, the momentary plenitude, vivacity in repose. Feminine presence: true Water-fall in which is revealed what is hidden, what is inside the folds of the world. The enigma is the glass, which is separation/union: we pass from voyeurism to clairvoyance. No longer condemned to see, we become free to contemplate.

—Translated from the Spanish by Rachel Phillips

1. Marcel Duchamp, opening paragraph of the preface to the *Green Box*, translation by George Heard Hamilton, typography by Richard Hamilton, from *The Bride Stripped Bare by Her Bachelors, Even* (London: Lund, Humphries; New York: Wittenborn; 1960).

2. All three quotations, Guillaume Apollinaire, *Les Peintres cubistes: Méditations esthétiques* (Paris: Figuière, 1913). English translation by Lionel Abel, *The Cubist Painters: Aesthetic Meditations* (New York: Wittenborn, Schultz, 1949), pp. 47–48.

3. In English the third meaning is not apparent.

4. "Etant donnés: 1° la chute d'eau, 2° le gaz d'éclairage," *Philadelphia Museum of Art Bulletin*, nos. 299–300 (April–June and July–September 1969).

5. "The retinal shudder! Before, painting had other functions: it could be religious, philosophical, moral. . . . Our whole century is completely retinal, except for the Surrealists, who tried to go outside it somewhat. And still, they didn't go so far!" Duchamp quoted by Pierre Cabanne, *Dialogues with Marcel Duchamp*, trans. Ron Padgett (New York: Viking, 1971), p. 43.

6. Jean Schuster, "Marcel Duchamp, vite," *Le Surréalisme, Même* (Paris), no. 2 (Spring 1957), p. 148.

7. This expression appears in *The*, Marcel Duchamp's first text in English, composed in New York in 1915. The article "the" was systematically replaced by an asterisk and gives the fragment its title.

8. Cf. my essay *Marcel Duchamp o el castillo de la pureza* (Mexico City: Era, 1968). English translation, *Marcel Duchamp or the Castle of Purity* (London: Cape Golliard; New York: Grossman; 1970).

9. Erich Neumann, *The Great Mother*, Bollingen Series XLVII (Princeton: Princeton University Press, 1963), p. 48.

10. The second is the denuding voluntarily imagined by the Bride, and the third is the conjunction of the first two: the crown-bloom in the form of a cloud or the Milky Way, which "cannot be analyzed by logic."

11. Jean Schuster, "Marcel Duchamp, vite," *Le Surréalisme, Même* (Paris), no. 2 (Spring 1957), p. 143.

12. Ovid, *Metamorphoses*, Book III, Loeb Classical Library (London: Heinemann; Cambridge, Mass.: Harvard University Press; 1916), vol. 1, p. 134.

13. Georges Dumézil, *La Religion romaine archaïque* (Paris: Payot, 1966), p. 397.

14. Pierre Klossowski, *Le Bain de Diane* (Paris: Pauvert, 1956), p. 55.

15. Duchamp, *A l'infinitif* [the *White Box*, notes from 1912 to 1920] (New York: Cordier & Ekstrom, 1966), p. 5.

16. Neumann, *The Great Mother*, p. 245.

17. Dumézil, *La Religion romaine archaique*, p. 396.

18. "Ah that thou wouldst walk here in all thine hours of leisure! but the world forbids me trust thee, when it beholds thee hurry in frenzy with kindled torches to the Arician grove, and bear lights in honour of the goddess Trivia." *Elegies*, II, 32, trans. H. E. Butler, Loeb Classical Library (London: Heinemann; Cambridge, Mass.: Harvard University Press; 1912), p. 159.

19. Neumann, *The Great Mother*, p. 318.

20. Jean Przyluski, *La Grande Déesse* (Paris: Payot, 1950), p. 60.

# THE INFLUENCE OF MARCEL DUCHAMP

John Tancock

LIKE A LAW of his own "amusing physics," Marcel Duchamp's role in the development of twentieth-century art reversed the normal succession of events attendant upon the creation of a significant body of work. In general an artist has the most influence on the art of his contemporaries and immediate successors, the power of his own work to stimulate younger artists getting progressively weaker as it recedes further into history. For example, the various phases of Picasso's art affected entire generations of artists in the decades from 1910 to 1950, although since the latter date he can hardly be said to have figured prominently in the awareness of the more advanced, younger artists. With Duchamp, however, the sequence of events has been very different. From relatively small beginnings, that is to say from a direct but limited influence on the work of a small number of close associates, his immensely varied lifework has continued to grow in importance for other artists until his presence affects multiple facets of the art of the 1960s and 1970s. There is nothing that is not paradoxical about Duchamp's life and work—paradox was an approach he adopted deliberately, and was perhaps the key to his whole personality—yet the greatest paradox of all may be this very fact of his expanding influence. "Oscillating gravity" was a fancy of his, but the "expanding influence" of his work is a fact, and one that can be examined in terms of disciplines more conventional than his playful physics.

Even before his arrival in New York in the summer of 1915, when he became a celebrity and a central figure in the circle of artists, writers, and musicians who gathered in the apartment of Walter and Louise Arensberg, Duchamp's power to attract and influence artists of diverse persuasions had become apparent. *The Passage from the Virgin to the Bride,* painted in July–August 1912, and *Bride,* painted in August 1912, were not exhibited but were, needless to say, well known to his family and his friends. Certainly the fusion of mechanical and organic forms in these two paintings, so different in intent from the works of the preceding months, provided important points of departure for both Raymond Duchamp-Villon (Duchamp's brother) in his single most important work and

Raymond Duchamp-Villon. *The Horse.* 1914. Bronze, 40 x 39½ x 22⅝ in. The Museum of Modern Art, New York, Van Gogh Purchase Fund.

Man Ray. *The Rope Dancer Accompanies Herself with Her Shadows.* 1916. Oil on canvas, 52 x 73⅜ in. The Museum of Modern Art, New York, Gift of G. David Thompson.

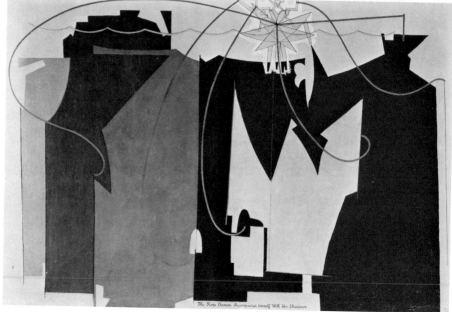

Francis Picabia, Duchamp's closest friend of the early period. Before the *Large Horse* of 1914, Duchamp-Villon's sculpture had been austerely classical in feeling, imposing if rather dry. In the first studies of a horse and rider, the transformation of the forms was entirely mechanical, but in the final version, certain elements—notably the protrusion with a knob at the end—recall the fleshy pink forms of the *Bride.* Yet the end product could not be more different. Lacking the eroticism and the devilish complexity of the *Bride,* the *Large Horse* reveals a sensibility that is diametrically opposed to Duchamp's insofar as it celebrates strength and dynamism for their own sake. Yet the formal language is very similar; so is the approach to the subject matter, bypassing analysis of given forms altogether.

With Picabia, on the other hand, the erotic atmosphere of the paintings is what made the most lasting impression. There was no trace of this liberating element in two of his most successful "Cubist" paintings of 1912, *Dances at the Spring* and *Procession, Seville.* By 1913, however, with paintings such as *Udnie (Young American Girl)* and *Edtaonisl (Ecclesiastical),* the formal language had been greatly expanded in keeping with the more personal nature of the theme—Picabia's voyage to the United States aboard the same ship as the dancer Mlle Napierkowska and a Dominican priest who was fascinated by her. Finally in *I See Again in Memory My Dear Udnie,* c. 1914, the erotic implications of the two previous paintings became fully explicit. Reliving in memory the series of events on board ship, Picabia relied even more heavily on the Duchamp of 1912. His reverie on the "star-dancer" is expressed in sequences of forms that range from the geometrical to the biomorphic, from the totally abstract to the almost specific (in forms that resemble electrical appliances). Yet, when compared to its major source, the display of passion in the painting is much more public, altogether less hermetic, than the transformation taking place within Duchamp's *Bride.* Picabia's bolder, more flamboyant forms enact events on an erotic plane, but as spectacle rather than as mysterious event.

Duchamp arrived in New York from Paris in the summer of 1915 and for

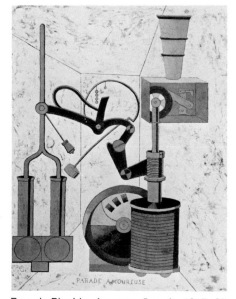

Francis Picabia. *Amorous Parade.* 1917. Oil on canvas, 38 x 29 in. Collection Mr. and Mrs. Morton G. Neumann, Chicago.

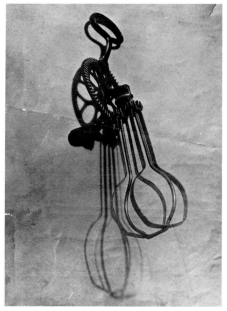

Man Ray. *Man.* 1918. Photograph, 20 x 15⅛ in. Galleria Schwarz, Milan.

the first time was very much at the center of action. He immediately encountered Walter and Louise Arensberg and became the focal point of a group that included at various times Picabia and Man Ray, Albert Gleizes, Jean Crotti, H.-P. Roché, Marsden Hartley, Charles Demuth, John Covert, Katherine Dreier, Arthur Dove, Walter Pach, John Sloan, George Bellows, Isadora Duncan, William Carlos Williams, and Edgard Varèse. Henceforth it was no longer Duchamp the painter who provided the stimulus. Instead it was Duchamp the iconoclast, the creator of mechanical forms and the exponent of mechanical techniques, the provider of Readymades and wit. Not surprisingly, Picabia was the first to succumb to the mechanical side of Duchamp. In 1915 his style underwent an abrupt change. *Amorous Parade,* one of the first machine pictures, deals with the same area of experience as the *Large Glass* but in a much more explicit and prosaic manner, comparing the act of human coupling to the purely automatic functioning of machine parts.

More profoundly affected by this aspect of Duchamp's art was Man Ray, who, until he met Duchamp in 1915, had contented himself with the traditional media and had painted in a style that was considerably influenced by Cubism. He became extremely close to Duchamp and was readier than any of his contemporaries to put Duchamp's principles into practice. "I want something where the eye and hand count for nothing," Duchamp had said to Walter Pach in 1914.[1] Pach could not accept the total rejection of painterly faculties, but Man Ray, who had been trained as an architectural draftsman, understood exactly what Duchamp meant. Anxious to free himself from painting and its "aesthetic implications,"[2] he turned immediately to collage (a technique that enabled him to achieve striking effects without the apparent intrusion of the artist's hand) and, in one major painting, *The Rope Dancer Accompanies Herself with Her Shadows,* to pseudo-collage.[3]

Man Ray's objects clearly owed a great deal to Duchamp's Readymades, especially the more complicated examples, yet in their inventiveness and abundance they reveal the entirely different bent of his character. From *Man* of 1918, a photograph of an

161

eggbeater, by way of *Main Ray* of 1935 to his most recent "exuberances," his sense of humor, which tends toward the essentially American tradition of the wisecrack rather than to wit or irony, has produced a uniquely personal range of three-dimensional jokes. For Duchamp, the significance of Readymades lay in the fact that their number was severely limited, although once chosen they could be duplicated. Man Ray, on the other hand, saw no reason to be so sparing with his talents and regarded his objects as yet another way of making a point.

Even to such essentially minor talents as those of his sister Suzanne and her future husband, Jean Crotti, Duchamp's total independence of convention proved to be a liberating force. Crotti's *Portrait of Marcel Duchamp,* 1915, consisted of a wire framework on which was mounted a mass of wire hair and optician's false eyes, foreshadowing Alexander Calder's wire portraits of the 1920s, while Duchamp's wedding present to his sister on the occasion of her marriage to Crotti, a geometry book which she was instructed to hang out of the window, inspired her to paint one of her best works, *Marcel's Unhappy Readymade.*

In view of the puritanical background of most American painters, it is hardly surprising that they gravitated toward the mechanical forms of the "Bachelors'" domain rather than to the sensuous world of the "Bride." Certainly the pair of works that exercised the most influence on American painters of this generation—John Covert, Charles Demuth, Charles Sheeler, and indirectly the whole of the Precisionist movement—were the two paintings of the *Chocolate Grinder,* both in the collection of Walter Arensberg by about 1918. The titles of three works of 1919 by John Covert (Arensberg's cousin)—*Vocalization, Brass Band,* and *Time*—indicate Covert's interest in themes of an elusive, not to say philosophical, nature, quite opposed to the concreteness of *Chocolate Grinder, No. 2* or the personal mythology of the *Large Glass.* Yet the techniques Covert employed—wooden dowels nailed to composition board in *Vocalization,* heavy cords attached to composition board in *Brass Band,* and the use of upholstery tacks in *Time*—show his desire to bypass painterly facility. In *Brass Band,* Covert devel-

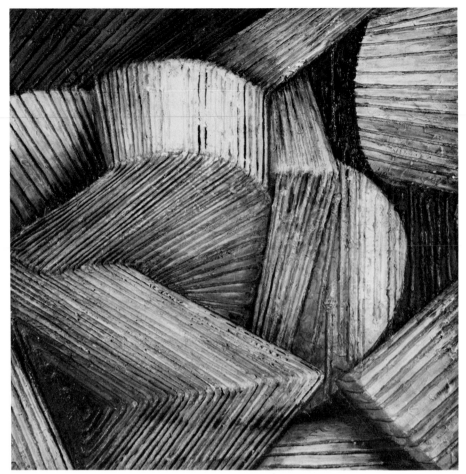

John Covert. *Brass Band.* 1919. Oil and string on composition board, 26 x 24 in. Yale University Art Gallery, Gift of the Collection Société Anonyme.

oped the method Duchamp used in *Chocolate Grinder, No. 2,* but in using it to activate the entire picture plane rather than to delineate a specific object, he achieved a mysterious sense of depth that anticipates the later work of Antoine Pevsner.

Although less immediately apparent, Duchamp's role in the formation of Precisionism, a dominant avant-garde American art style of the 1920s, was vitally important. It was through Duchamp and, in particular, works like the *Chocolate Grinders* that Charles Demuth turned increasingly to mechanistic forms. Certainly by 1923, he could say that Duchamp had been "his strongest influence in recent years," and he wrote to Alfred Stieglitz that "Marcel is stronger than any of us . . . and that's writing a lot! But a great painter. The big glass thing, I think, is still the great picture of our time."[4] Through his experience as an illustrator Demuth was fully aware that the title was a way of adding a further dimension to the visual image, of "putting painting at the service of the mind." His views of industrial landscapes frequently bear ironical titles that have been likened to those of Duchamp and Picabia. Thus he calls a view of a smokestack and a water tower *Aucassin and Nicolette* and a cluster of factory chimneys *End of the Parade.* With the Immaculates, however, this was not a primary concern; the study of mechanical forms became an end in itself.

Joseph Stella had already developed a fully mature manner when he encountered Duchamp, but for a brief period he experimented with painting on glass. An untitled work of about 1919[5] and *Chinatown,* in the Philadelphia Museum of Art, are typical examples of the transference of forms from his canvases onto glass, but this was not a direction he was to pursue.

Other artists found inspiration in the Readymade aspect of Duchamp's art. Morton Schamberg's *God* of c. 1918 differs considerably from the rest of his work in its use of a battered piece of pipe and in its desecration of hallowed values (not to mention God: Duchamp is reported to have said that America's greatest works of art were its bridges and its plumbing). For Stuart Davis, the notorious *Fountain* acted like a "time bomb." "Duchamp's suggestion worked slowly. Unesthetic material,

non-arty material—ten years later I could take a worthless eggbeater, and the change to a new association would inspire me."[6]

Even within the restricted circle of artists who constituted New York Dada, the power of Duchamp's oeuvre to stimulate and provoke had become apparent. Individual works, reflections of just one aspect of his dialectic, were capable of affecting entire movements, deflecting them from their course or even creating them (the *Chocolate Grinder* leading to Precisionism). The coherence of this scheme came to an end in 1921, when Duchamp left for Paris and as the myth began to take over from reality. Henceforth he acted like a master criminal, sure enough of his superiority to the forces of law and order to leave his signature behind at the scene of the crime. Disdaining the lack of imagination that leads to a personal style on the part of the "criminal," Duchamp left totally dissimilar clues—one year it might be a set of *Rotoreliefs,* the next the installation of an exhibition—yet they were always unmistakably his.

In retrospect it now seems as if two generations of artists did not fully succeed in deducing the identity of the "criminal." In the appreciation of his work, it was the period, one might say, of Dr. Watson rather than of Sherlock Holmes. During the 1920s and 1930s, in spite of his omnipresence, he exerted surprisingly little influence on the development of Surrealist painting and sculpture. His role as a pioneer was accepted, but his art was too ironic, too lacking in the element of the marvelous, to provide a very direct stimulus. Numerous artists paid their homage—among them Yves Tanguy and Joseph Cornell[7]—but, one might surmise, to the man and the myth rather than to the artist. About 1940, however, certain figures began to focus on particular aspects of Duchamp's art as, partly through the *Boîte en valise,* the scope of his achievement became more widely known.

Matta Echaurren approached Duchamp in the most traditional way, that is to say through his paintings. Matta discovered *The Passage from the Virgin to the Bride* in the mid-1930s and in 1944, together with Katherine Dreier, published an "Analytical Reflection" on the *Large Glass.*[8] At the

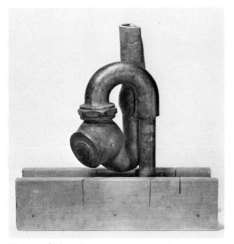

Morton Schamberg. *God.* c. 1918. Miter box and plumbing trap, 10½ in. high. Philadelphia Museum of Art, The Louise and Walter Arensberg Collection.

same time that he was reflecting on the oeuvre of Duchamp, his own work was undergoing a considerable change. In certain paintings of 1944, for example *The Vertigo of Eros,* a highly complex linear network was superimposed on the vaguer effects of linear space achieved by painterly means. James Thrall Soby was the first to point out the analogy between Matta's treatment of space and the labyrinth of white twine, linking the most disparate objects, that Duchamp concocted for the 1942 Surrealist exhibition in New York.[9] From the dizzy perspectives of these cosmic scenes, sinister semi-mechanical personages soon began to emerge, their analogy with Duchamp's creations of 1912–15 being finally confirmed in 1943 by the reappearance of the Bachelors in *The Bachelors Twenty Years After.* Matta admired Duchamp because he "attacked a whole new problem in art, and solved it—to paint the moment of change, change itself. I have devoted myself to that same problem ever since."[10] In spite of his philosophical and formal indebtedness to Duchamp, however, Matta lost none of his individuality. His relationship to Duchamp is not unlike that of the Futurists to the Cubists. Cubism provided the formal language needed by the Futurists to express their dynamic ideas just as Duchamp, more than any other artist, enabled Matta to give definite form to the dramas of transmogrification that infested his imagination.

While Matta was mining Duchamp's oeuvre as a source of fantastic images, John Cage began to discover an altogether different aspect of Duchamp, one that, in terms of recent art history, was to exert far greater influence. Duchamp returned to New York in 1942, the same year as Cage's arrival. It is clear that Duchamp, among visual artists, was a source of particular fascination to Cage. They met, but Cage kept at a "worshipful distance."[11] About 1944, he contributed a work to an exhibition devoted to Duchamp's interest in chess, held at the Julien Levy Gallery in New York. This consisted of a sheet of musical notation printed in alternate squares of black and white, thereby constituting a chess board. Three years later he composed *Music for Marcel Duchamp,* a work for prepared piano, used for Duchamp's section in Hans Richter's film *Dreams*

Matta (Echaurren). *The Bachelors Twenty Years After.* 1943. Oil on canvas, 38 x 50 in. Private collection, Massachusetts.

John Cage. *Chess Pieces.* c. 1944. Gouache, black and white ink, 19 x 19 in. Collection Rue W. Shaw, Chicago.

*That Money Can Buy.* In Duchamp, Cage found an artist whose ideas on a wide variety of topics corresponded with his own, although they were generally arrived at in a diametrically opposed manner. Like Duchamp, Cage rejected the notion of the artist as an inspired creator who dictated the correct approach to the spectators or the auditors. He adopted chance as a method of eliminating traces of the artist's personality (compare Duchamp's *Three Standard Stoppages*) and referred to the *Large Glass* and its fusion with the environment through its transparency as a paradigmatic example of the manner in which works of art ought to exist in the second half of the twentieth century.[12] His distrust of value judgments was at least as strong as Duchamp's. Cage would not have arrived at this position without his exposure to Zen, but he found in Duchamp an artist who had arrived there instinctively.

Another Duchamp, then, began to surface in the 1950s. To a considerable extent this was because of John Cage and his friendship with a group of younger artists, although individuals in Europe also began to follow suit, intuitively sensing in Duchamp the antithesis of everything that constituted the prevailing style.

Among the major artists of the twentieth century, he seemed to offer the most viable alternatives to the emphasis on self-expression through the handling of paint that culminated in Abstract Expressionism in the United States and the various manifestations of the same tendency in Europe. Duchamp had broken through all the categories—physical, technical, and aesthetic—that had hitherto stratified the art world. "I do not believe at all in the physical purity of painting," he said.[13] He had no messianic pretensions, summarizing his attitude as "Doubt in myself, doubt in everything. In the first place, never believing in truth."[14] His career offered to younger artists not a model to be followed, but an example of perfect freedom from which to develop their own particular form of expression.

Exposure to Duchamp's work led to art and attitudes of the most diverse kinds. On the one hand, there was art of considerable intellectual tension and complexity and, on the other, an immersion in the simplest kinds of

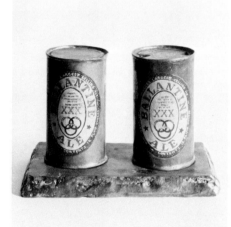

Jasper Johns. *Painted Bronze.* 1964. Painted bronze, 5½ x 8 x 4½ in. Collection of the artist.

events and activities, deprived of all intentional ambiguities. Jasper Johns, Robert Rauschenberg, and Richard Hamilton, the first of the younger generation of artists to look hard at Duchamp, clearly belong to the first category. Both Johns and Rauschenberg were friends and admirers of John Cage. Duchamp must thus have figured as a general presence in the background of the two artists, but only insofar as Duchamp's precepts coincided with Cage's. Their strong inclination to remove all traces of personality and self-expression from their painting was as Cagean as it was Duchampian. Although they were surely familiar with Robert Motherwell's important anthology, *The Dada Painters and Poets,* published in 1951, it was not until 1959 and the appearance of Robert Lebel's monograph on Duchamp that a specifically Duchampian coloring or awareness began to be apparent in their instinctive Dadaism. Ambiguity was the keynote of Johns's emblematic paintings of the 1950s. In the more painterly works that followed, a number of Duchampian motifs began to appear as alien presences or modifying factors in fluid situations.[15] Measurement, both of distance and temperature, and structured relationships (the color scale) obsessed Johns as much as they did Duchamp. For Johns, however, this was not part of a general strategy to "stretch things a little," as was the case with his mentor. He introduced these apparently authoritative and unquestionable systems of measurement into a painterly context, opposing the measurable to the immeasurable and hierarchy to chaos. A work like *Painting with Ruler and "Gray"* of 1960, in which the ruler was dragged through the paint to create a chance pattern, employed a unit of measurement as an implement to wipe out part of the pattern of brushstrokes created by the artist. Notions of order and chaos exist in suspension. The three-dimensional objects—the two *Painted Bronzes*—are equally problematic. Appearing to be Readymades, they are in fact the reverse, painstaking and even loving re-creations of mundane objects. In both cases the handcrafted element is just sufficiently evident to make it apparent that complex processes of casting lie between the models and their simulacra.

Johns's indebtedness to Duchamp does not stop at the level of specific references to various motifs. His description of Duchamp's field of action as one where "language, thought and vision act upon one another" applies equally to his own.[16] The speculative, ruminative side of his personality frequently expresses itself in cryptic messages and instructions to himself that resemble the notes in the *Green Box.* Some of these were published in the periodical *Art and Literature* in 1965 and are almost as important to a full understanding of the group of paintings consisting of *Souvenir, Watchman,* and *According to What* as Duchamp's notes are for the elucidation of the *Large Glass.*[17] Certainly without them the relationship between the personae of the three paintings, the "spy" and the "watchman," is not immediately apparent, nor is it fully so when the notes are digested, although highly suggestive clues are given. *According to What,* 1964, is the most complete statement of Johns's Duchampian preoccupations and, in its enumeration of these within the confines of one painting, it occupies a position in his career comparable to that of *Tu m'* in Duchamp's. Abstract passages of freely applied and highly colored paint coexist with verbal but, by virtue of their hinged existence, highly unstable evocations of the primary colors, a visual color chart, and a bold statement of tonal progression from white to black. The various motifs—the cast, the shadow of a coat hanger—coexist but do not comment on or form any meaningful relationship with each other. On the hinged section is a depiction of Marcel Duchamp's profile, still recognizable although conceived originally as a negative form torn from a piece of paper and here reversed in the process of transposition. It is not "open" and "closed" that are compounded but left and right.

In the context of British art, Richard Hamilton's adoption of Duchampian methods comes as more of a surprise, since there was almost no awareness of Duchamp in England in the 1950s. From the very beginning, however, Hamilton's response to works of art was primarily intellectual, and with hindsight it seems inevitable that he should have focused consciously on Duchamp. Even his earliest surviving works show a fascination with sub-

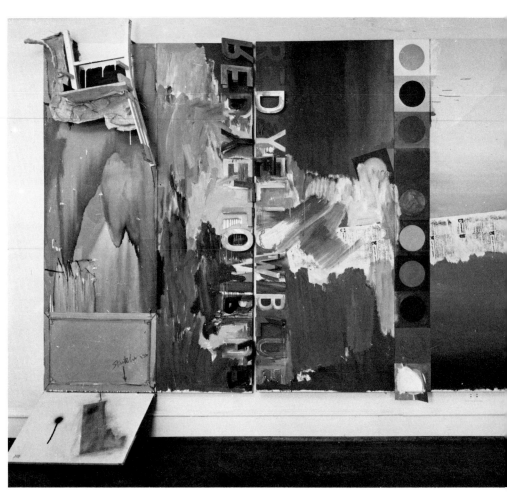

Jasper Johns. *According to What.* 1964. Oil on canvas with objects, 88 x 192 in. Collection Edwin Janss, Los Angeles.

Richard Hamilton. *Hommage à Chrysler Corp.* 1957. Oil, metal foil, and collage on panel, 48 x 32 in. Private collection, London.

jects—movement, perspective—that had preoccupied his predecessor.[18]

Specific references to Duchamp first became apparent in 1956, in the installation of the exhibition "This Is Tomorrow," which incorporated several *Rotoreliefs* at the end of an illusionistically treated corridor.[19] In the following year he worked on *Hommage à Chrysler Corp.,* the first of a series of works in which he turned his attention to eroticism. The mechanical and the erotic were ultimately the twin poles of Duchamp's universe, but he had not foreseen the situation, savored by Hamilton, whereby the erotic was used to enhance the salability of machines in a consumer society. In a highly elliptical manner the painting shows a girl in a car showroom caressing an automobile. In one of the studies, the Blossoming from the *Large Glass* hovers over a disembodied mouth, a visual clue (later abandoned) to the nature of Hamilton's preoccupations.[20] In this group of paintings—*Hommage à Chrysler Corp., Hers Is a Lush Situation, $he, Pin-up,* and *Glorious Techniculture*—the mechanomorphic eroticism of Picabia that owed so much to Duchamp was reborn but in a considerably more sophisticated form.

Among all the artists who have been drawn to Duchamp, Hamilton occupies a unique position. His intimate involvement with every aspect of Duchamp's oeuvre[21] resulted not in pastiche or in occasional references, but in a personal strategy that closely resembled his mentor's. Duchamp once painted with a chisel to defy his familiarity with the paintbrush. Likewise Hamilton distrusted his own facility and supreme elegance as a craftsman. Aware of the seductive simplicity of doing and repeating ad infinitum what comes most easily, Hamilton deliberately changed his course when he saw the danger signals. From the iconographic and formal complexities of the various versions of *Towards a Definitive Statement on the Coming Trends in Men's Wear and Accessories,* he turned in 1963 to the abstract investigations of *Five Tyres Abandoned,* an attempted perspectival treatment of an advertisement that dealt with the development of the car tire by presenting five different types in chronological sequence (like the *Large Glass,* this project was abandoned when the formal problems became too complex—although it was

Richard Hamilton. *Five Tyres Abandoned.* 1963. Screenprint, 23 x 36 in. Collection of the artist.

later completed, in 1972, with the aid of a computer). From the graphic precision of *Five Tyres Abandoned,* he turned to the bold, unadorned statement of *Epiphany*—an enlargement, forty-eight inches across, of a lapel button ("Slip It to Me") which he purchased on a visit to America in 1964 and which, like the Readymades, required no formal intervention, only enlargement. At the opposite end of the spectrum from Hamilton's interest in formal systems is his involvement with chance effects in the more recent series of works based on photographic processes.

Rauschenberg's response to Duchamp was much less intellectual than that of Johns or Hamilton. Like Johns he absorbed certain Duchampian attitudes through his friendship with Cage, but it is in the realm of gesture rather than specific works that he made further contributions to Duchamp's commentary on the status of the artist and his creations. Earliest and most notorious of these was his erasure of a drawing by de Kooning in 1953, where the parallel is clearly with the moustache and goatee that Duchamp added to the Mona Lisa, although the implications are very different. This was not so much a gesture of irreverence as a neat way of symbolizing a break with the past by a young artist who, in the series of white-and-black paintings executed between 1949 and 1952, had attempted to relinquish all traces of self-indulgence in the handling of paint and the expression of emotion. Some years later, when he was asked to do a portrait of the Parisian dealer Iris Clert, he complied by sending a telegram that read: "This is a portrait of Iris Clert if I say so." Duchamp's famous telegram PODE BAL established a precedent for the event, as did Duchampian reflections on the artist's ability to create a work of art by a mere act of will. Still, Rauschenberg continued to produce silkscreen paintings and works in assorted media that owe very little to Duchampian aesthetics. In the telegram, however, Rauschenberg was demonstrating what is only implicit in the works themselves, namely that the artist creates his own terms of reference. As was the case for Johns, the publication of Robert Lebel's monograph in 1959 was an important event, but it did not bring about any changes

Robert Rauschenberg. *Trophy II (for Teeny and Marcel Duchamp).* 1960–61. "Combine-painting," 90 x 118 in. Collection of the artist.

Arman (Fernandez). *Poubelle Papier* (*Wastepaper Basket*). 1964. Torn papers in plexiglass box, 23⅝ x 15⅝ in. Galerie Der Spiegel, Cologne.

in Rauschenberg's work. On the other hand, it did reveal to him that the freedom he had claimed for himself had been more clearly glimpsed by Duchamp than by anybody else, and he proceeded to buy a replica of the *Bottlerack* and to devote the second of his series of homages to friends, *Trophy II,* to Duchamp and his wife, Teeny.

Johns, Rauschenberg, and Hamilton found in Duchamp a mentor who more effectively than anyone else provided an antidote to the painterly aesthetic of the 1950s. Simultaneously, a much wider group turned to him not for intellectual stimulation, but for confirmation of their satisfaction with activities that were more mundane than those savored by the Abstract Expressionists. Increasingly Duchamp was valued for the doorway he opened to the banal. In focusing on the world around them, the Nouveaux Réalistes saw Duchamp (in his Readymade aspect) as their immediate antecedent, although the degree to which his art may be said to have exerted any influence varies greatly from case to case.

In their second manifesto, *A Quarante Degrés au dessus de dada,* published in May 1961, the Nouveaux Réalistes recognized the role of the Readymade in shaping their approach to the world, but "in the present context, the readymades . . . take on a new meaning. They indicate a right to expression of a whole organic sector of modern activity, that of the city, the street, the factory, of mass production." What in Duchamp's hands had been a negative gesture became for the Nouveaux Réalistes "the basic element of a new expressive repertory."[22]

The work of the Nouveaux Réalistes was characterized by its direct appropriation of fragments from the real world that were "endowed with universal significance."[23] Arman, for example, produced a piece consisting of three months of *Pierre Restany's Mail* in 1962 and two years later devoted his attention to the wastepaper basket— one day's contents constituting the subject matter and its enclosure in a plexiglass box the form of the work.[24] Daniel Spoerri produced a considerable number of "snare pictures," works consisting of assemblages of objects found in chance positions, on tables, in drawers, and so on, that were fixed in place and offered as evidence

of precise moments in time. *Marcel Duchamp's Dinner,* 1964, is the most familiar of these and also the most instructive insofar as it offers evidence of Duchamp's importance for the entire movement. Yet another object with Duchampian associations was appropriated by Jean Tinguely when he equipped Marcel Duchamp's old icebox with a red light in its interior and a siren that emitted a loud wail when the door was opened by an unsuspecting visitor to the "New Realists" exhibition at the Sidney Janis Gallery in 1961. In *Homage to New York,* 1960, however, Tinguely's first self-destroying machine, the reference to Duchamp had gone beyond the use of a specific object. In the preliminary drawings the close relationship to Duchamp's mechanomorphic imagery is immediately apparent, although it was not until the dramatic night of March 17, 1960, when the huge construction failed to perform as anticipated in the sculpture garden of The Museum of Modern Art in New York, that Tinguely's thoroughly Duchampian irony and humor were revealed to the public at large.

For the Nouveaux Réalistes, Duchamp's Readymades were the cornerstone of their entire doctrine, while for the Pop artists (with certain exceptions) Readymades existed as rather distant progenitors of their deliberate espousal of the lowest common denominator of contemporary culture. With the possible exception of Andy Warhol and to a lesser extent Jim Dine, Duchamp's role was that of a highly respected but seldom regarded grandfather, admired for his achievements in the past but having little to contribute to the solution of painterly problems. Tom Wesselmann, for example, incorporated fragments of the real world in his works (telephones, radios, radiator grilles, and so on), and Roy Lichtenstein dealt with "Readymade" material in his use of comic strips, but these were simply employed as component parts of an aesthetic entity.

In his total, uncritical acceptance of the world around him, Andy Warhol can be seen as a logical though perverse heir of Duchamp, who selected a limited number of objects and only implied that anything could be elevated to the status of a work of art. For Warhol, Pop art was "liking things," and he drew no distinction between

Daniel Spoerri. *Marcel Duchamp's Dinner.* 1964. Assemblage, 24⅞ x 21⅛ in. Collection Arman, Nice.

170

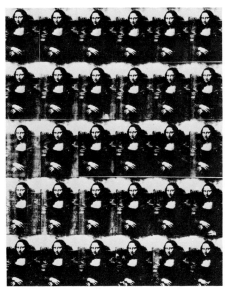

Andy Warhol. *Thirty Are Better than One.* 1963. Synthetic polymer paint and silkscreen on canvas, 110¼ x 82¼ in. Collection Mr. and Mrs. Peter Brandt, Greenwich, Connecticut.

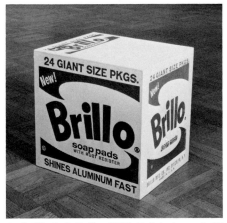

Andy Warhol. *Brillo.* 1964. Painted wood, 17 x 17 x 14 in. Leo Castelli Gallery, New York.

Jean Tinguely. *Homage to New York.* A self-constructing and self-destroying assemblage, March 17, 1960, in the Sculpture Garden, The Museum of Modern Art, New York, 27 ft. high x 23 ft. long.

do-it-yourself paintings and the Mona Lisa as the subject matter of his work. His use of the Mona Lisa (for example, *Thirty Are Better than One,* 1963) provides a direct point of contact with Duchamp, while the numerous versions of Campbell soup cans and Brillo boxes, paintings in the one case and three-dimensional replicas in the other, develop the Duchampian dialectic through their specificity of reference. Duchamp modified the wording in the advertisement for Sapolin enamel, whereas Warhol left his advertisements intact. More than any other artist associated with Pop, Warhol perceived the importance of Duchamp's recognition of the fact that the significance of a work of art need not reside in the object itself. Urinals and soup cans are equally devoid of ''artistic'' richness, but when presented as works of art they can serve as stimuli to the widest possible range of speculations.

The Nouveaux Réalistes and the Pop artists represented only one aspect of an exceedingly complex situation. In spite of the fact that they were generally thought at the time to have made a fatal pact with vulgarity, they continued to produce objects that departed in no way from the traditional status of works of art. Their paintings and sculptures were the result of a complex of vital decisions on the part of the artist and, as unique embodiments of individual perceptions, they could be handled comfortably by the dealer-collector-museum network that had grown in the previous century. This was decidedly not true for the exponents of Happenings and the members of the Fluxus group, who likewise claimed Duchamp as their favorite ancestor.

John Cage's classes at the New School for Social Research in New York brought together a number of people, among them Allan Kaprow, who devoted much energy to the organization of ephemeral works of art. Besides Hans Hofmann, Jackson Pollock, and Kurt Schwitters, Kaprow pointed to Duchamp as his most important influence ''because of what he didn't do. After the big glass piece, he deliberately stopped making art objects in favor of little (ready-made) hints to the effect that you could pick up art anywhere if that's what you wanted. In other words, he implied that the whole business of art is quite arbitrary.''[25] For

Kaprow, the chief theorist of the Happenings movement, Duchamp was a philosopher more than an artist and it was his fiat that prepared the way rather than any specific works or acts; although his installations of the Surrealist exhibitions are strikingly similar, both in motivation and construction, to the environment of certain Happenings.[26] Duchamp was certainly very much in sympathy with Happenings and was an assiduous spectator-participant from the very beginnning. He favored them because they were ''diametrically opposed to easel painting''[27] and because they recognized the participatory role of the onlooker in the work of art.

Duchamp was even more important for Fluxus than he was for the development of Happenings. Originated by George Maciunas in collaboration with Wolf Vostell and Nam June Paik in Wiesbaden in 1962, and manifested most notably in international festivals throughout Europe and America during the next few years, Fluxus proceeded even further than Duchamp with the demythologizing of the artist and the work of art. George Brecht placed ''Fluxus art-amusement'' in direct opposition to the present situation in which art must appear to be ''complex, pretentious, profound, serious, intellectual, inspired, skilful, significant, theatrical''[28] in order to be valuable as a commodity. The Fluxus artist should be ''dispensable'' and ''must demonstrate that anything can be art and anyone can do art. Therefore, art-amusement must be simple, amusing, unpretentious, concerned with insignificance, require no skill or countless rehearsals, have no commodity or institutional value. The value of art-amusement must be lowered by making it unlimited, mass produced, obtainable by all.''[29] In summary, he described the new art as ''the fusion of Spike Jones, Vaudeville, gag, children's games and Duchamp.''[30] In particular, it was the Readymades that the Fluxus artists singled out for attention. In the planometric diagram of the development of various ''expanded performing arts'' published by Fluxus,[31] Duchamp and the Readymades were listed as conspicuous influences (via Ben Vautier and George Brecht) on the development of Events and the neo-Haiku theater that in turn led to Fluxus, with its festivals, mass-produced ob-

jects, films, publications, and events. In addition to the Fluxyearboxes,[32] which contained collections of objects, a wide variety of solo objects and publications were distributed, among which may be mentioned Ayo's finger tactile boxes, Per Kirkeby's *Finger Sweater, Boxed,* and Robert Watts's stick-on tattoos, ribbons, nipples, and navels.

The activities of Ben Vautier were particularly prominent in the international festivals and very much indebted to Duchamp for their basic concepts. At the "Festival of Misfits, Gallery One," 1962, Ben sat in the gallery window as a living work of art. "I am a living, moving sculpture in all my moments and all my gestures, for sale: $250. Everything I touch and look at is a work of art."[33] Departing from Duchamp's demonstration that anything could be art, Ben set out to sign the entire universe, including himself. At the "Fluxus of Total Art" held at Nice in 1963, Ben, described as "créateur de l'art total," signed the city as "Oeuvre d'art ouverte," the Promenade des Anglais as "Musée de Sculptures Vivantes," and, in preparation for the event, swam across the harbor "en tant qu'oeuvre d'art." When not signing things and transforming Duchamp's discreet interventions into an absurd, all-embracing activity, Ben produced large quantities of statements, written in bold copperplate on black panels, that dealt in a lighthearted way with a wide variety of aesthetic propositions.

Ben utilized Duchamp as an excuse for an extended joke. George Brecht, on the other hand, regarded Duchamp as one of the major "research artists"[34] and found in him moral support for his own immersion in mundane "events," the term he later used to describe all his activities, whether or not they involved physical activity. Brecht began by studying musical composition with John Cage, but he soon felt that the visual element in his work was at least as important as the aural; from the brief instructions of his events —for example, *Exit,* 1961, and *Two Vehicle Events: Start Stop,* 1961—he turned increasingly to the world of objects. In 1964, he began work on *The Book of the Tumbler on Fire,* the first "pages" of which consisted of groups of objects assembled in cotton-filled specimen boxes. He then turned to larger objects and groups of objects. At the Wadsworth Atheneum in 1964,

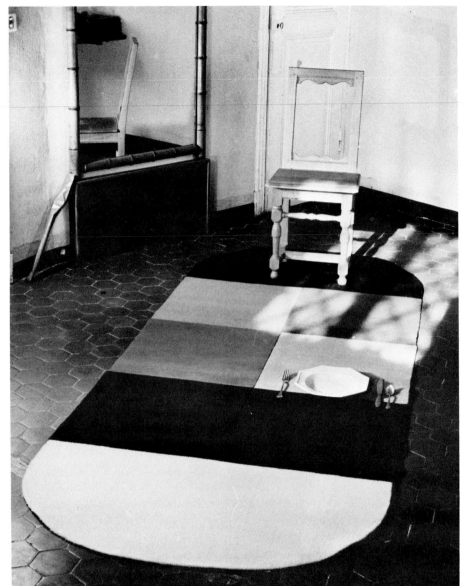

George Brecht. *Chapter III: Hopscotch.* 1966. Assemblage with chair, plate, knife, fork, and spoon. Galleria Schwarz, Milan.

he exhibited *Table and Chair Event,* which consisted of a white kitchen table at either end of which was placed a kitchen chair; on top of the table were a white plate, a knife, a fork and spoon, a clear wine glass, and a copy of the *Daily News. Chapter III: Hopscotch* consists of a checkered rug with a chair and a table setting. Having reduced the role of the artist in the creation of the work of choice, Brecht made no attempt to *change* the meaning of his objects. He described them as "just simple things, to see how life goes or how it could go."[35] In the same conversation he did not dismiss the idea that his activities could be paralleled with those of Duchamp and his attempt to "put painting at the service of the mind," but Brecht admitted to their different intellectual ambitions when he said, "One difference between Duchamp and me is that he plays chess and I prefer pick-up sticks."[36]

Brecht chose not to go beyond the quiddity of his objects. They were chosen not for their representative quality, as was the case with the Nouveaux Réalistes, or for their vulgar typicality, the main interest of the Pop artists, but because they existed and could be easily overlooked. Ray Johnson, on the other hand, looked at objects and images and saw not what was physically before his eyes, but only their relationships and analogies with other objects and images. He organized the New York Correspondance School to propagate his ideas. Although less specifically involved with Duchamp than Brecht was, insofar as his collages depend extensively on the poetic interplay of fragmentary images, Johnson looked to Duchamp as a benevolent force whose lifework, like his own, followed its own logic and set of rules. Johnson's exhibition at the Willard Gallery in 1967 consisted of a series of reliefs composed of small rectangular plaques grouped around various motifs, among which was Duchamp's *Comb* of 1916. By 1972, Duchamp had entered the pantheon of folk heroes that included Jayne Mansfield, Marilyn Monroe, and Batman's Mother and was the subject of a portrait in an exhibition at the Galleria Schwarz, Milan.

The ever-growing fame and prestige of Duchamp's work in the 1960s served to encourage a new kind of freedom. It was no longer a question of what to express in certain given media, but of how art might be newly defined. William T. Wiley, who paid specific homage to Duchamp (rather than to Leonardo) in *Mona Lisa Wipe Out or "Three Wishes,"* 1967, recognized Duchamp's unique position in the 1960s when he wrote, "What we can learn from Marcel Duchamp is the same message from any artist who has made his presence manifest in the form of personal achievement: is essentially that we do not have to follow his example. Yet should we find in his example a path that interests us we should trust ourselves enough to follow that path as long as it is possible without an overabundance of human misery."[37]

To many artists who continued on the path of formalist reduction, Duchamp was anathema. For those, on the other hand, whose interest lay in the cross-fertilizing of the various media, he became the most conspicuous touchstone. The early work of Robert Morris, Bruce Nauman, and, to a lesser extent, Walter de Maria, is virtually a commentary on certain issues raised by Duchamp (frequently by way of Jasper Johns), but in each case it is strongly personal. In their dissatisfaction with the painterly style of the 1950s, they began producing objects that, unlike the straight appropriations of George Brecht, enmeshed visual and verbal information in the most curious manner.

Morris's *I Box* of 1962, like numerous works by Duchamp (*Belle Haleine,* for example), utilizes an image of the artist as the focus of inquiry. An I-shaped door in a blank-looking wooden box opens to reveal a photograph of the artist, naked and grinning. In representing the letter "I," Morris fuses the first person singular and its physical embodiment only to reveal their mutual discontinuity. *Three Rulers,* 1963, is likewise concerned with verbal and visual discontinuities, conceived in terms of an examination of the inexorable demands of measurement (the parallel here is obviously with Duchamp's *Three Standard Stoppages*). Three yardsticks are suspended from adjacent hooks, but they are all of different lengths. Measurement of these rulers with a "real" yard ruler would perhaps identify the impostors, but doubt has nonetheless been

Ray Johnson. *Marcel Duchamp, 1887–1968.* 1972. Collage, 12¼ x 12¼ in. Galleria Schwarz, Milan.

thrown on the unquestioned prestige of measuring devices. *Card File,* 1962, which consists of a series of alphabetically arranged and cross-indexed cards describing the construction of the piece, may be considered as a further development of Duchamp's decision to regard the notes made in preparation for the *Large Glass* as a work in its own right. *Litanies,* 1963, a relief of a bunch of keys, makes overt reference to Duchamp, for inscribed on each key are individual words from the *Green Box* notes for "litanies of the Chariot." This piece reverses Duchamp's position with regard to the artist's ability to confer the status of an art work on an ordinary object by including a sworn affidavit withdrawing from it all aesthetic content.

For Morris, these thoroughly Duchampian but visually distinctive objects were a prelude to other activities. Such was also the case with Bruce Nauman, who from 1966 to 1968 produced a series of visual and verbal jokes that bear the same kind of relationship to Morris's objects as Man Ray's did to Duchamp's, insofar as their humor is broader and more outgoing. Although he has stressed that his knowledge of Duchamp was of the most general kind (Duchamp was simply "in the air"),[38] the affinities between Nauman and Duchamp are frequently striking. About 1966, Nauman had begun to feel dissatisfied with his deliberately unassuming and often unprepossessing sculptures because they seemed to have too much to do with sculpture and not enough to do with his own thought processes.[39] As a result he began using wax and neon as media to produce objects in which the title was at least as important as the form. The pun was as dear to him as it was to Duchamp. A wax relief of the artist's back with arms tied bears the title *Henry Moore Bound to Fail.* A cast of his mouth and right arm in pea-green wax and plaster is called *From Hand to Mouth,* and a photograph of the artist spewing water from his mouth is titled *Portrait of the Artist as a Fountain.* The delight in puns and verbal games was, however, only the most conspicuous aspect of a more profound similarity of temperament. Like Duchamp, who made deliberate efforts not to follow his own taste, Nauman frequently chose to work in areas that were unfamiliar to him. In *Flour Arrangements,* for example, he investigated the effects of chance in a series of photographs of flour spilled on the floor and brought to mind Duchamp's hobby as a breeder of dust.

Walter de Maria's early work was even more enigmatic than that of Morris and Nauman, the Duchampian element being more effectively concealed within his hieratic forms. In certain works, however, de Maria permitted himself to be more explicit. *Statue of John Cage,* 1961, for example, was a tall, narrow cage (85 by 14 by 14 inches) of eight evenly spaced wooden dowels. In 1965, he made a second version in stainless steel and changed the title simply to *Cage.* The pun is Duchampian, but the severely abstract forms leave the humor rather bleak. *70" of Tape,* 1967, is at the opposite end of the formal spectrum and provides a further gloss on the Duchampian theme of measurement. The tape, which was cut at irregular intervals, is hung limply from two nails, the mathematical and geometrical principles it embodies having been deprived of their rigidity, as was the case with Duchamp's *Unhappy Readymade.*

Duchamp firmly believed that language was "just no damn good"[40] for the precise conveyance of ideas, although it was a source of major fascination to him throughout his career. To many artists of the 1960s, language was likewise the subject of intense scrutiny, and in this area Duchamp moved even closer to the foreground of their awareness. With Baruchello and Arakawa an involvement with language was couched in terms that were still recognizably pictorial. Baruchello's random scatterings of heterogeneous marks, images, words, and fragments of words are purely verbal in inspiration,[41] although they are further complicated and diversified by chance "doses" of other images that occur to him while working, inspired by radio or television.[42] In his adoption of chance as a vital element, he has admitted to being the heir of Duchamp and Cage and has referred specifically to Duchamp in several pieces—*Oui, oui, Marcel,* 1964, and *Se Servir d'un Rembrandt,* 1970.

Arakawa has moved steadily closer to the essence of Duchampian thought, although his early work with its silhouettes of diverse objects transferred to the canvas by means of the airbrush

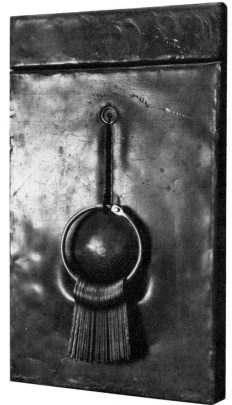

Robert Morris. *Litanies.* 1963. Lead over wood with steel ring, 27 keys, and brass lock, 12 x 7⅛ x 2½ in. The Museum of Modern Art, New York, Gift of Philip Johnson.

Robert Morris. *Statement of Esthetic Withdrawal* from *Document,* two-part work. 1963. Typed and notarized statement on paper. The Museum of Modern Art, New York, Gift of Philip Johnson.

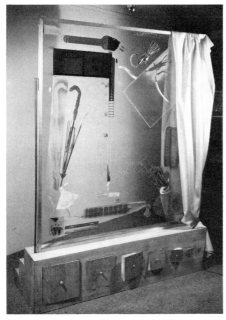

Shusaku Arakawa. *Diagram with Duchamp's Glass as a Minor Detail.* 1963–64. Mixed media sculpture, 90 x 66 x 22 in. Collection Frits and Agnes Becht, Amsterdam.

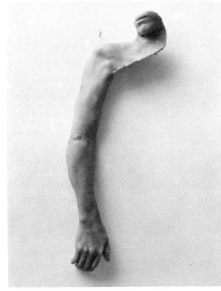

Bruce Nauman. *From Hand to Mouth.* 1967. Wax over cloth, 30 x 10 x 4 in. Collection Mr. and Mrs. Joseph Helman, Rome.

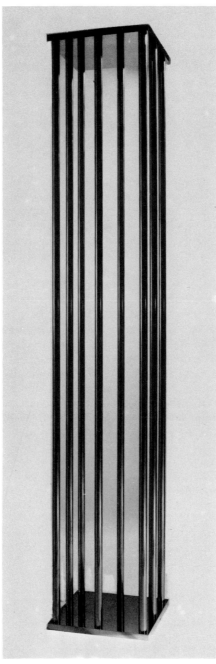

Walter de Maria. *Cage.* 1962–65. Stainless steel, 85 x 14½ x 14½ in. Collection Mr. and Mrs. Robert C. Scull, New York.

was the direct descendant of Duchamp's *Tu m'.* In one work, *Diagram with Duchamp's Glass as a Minor Detail,* 1963–64, Arakawa employed the whole barrage of Duchampian techniques, going so far as to treat the most elaborately prepared work in Duchamp's entire oeuvre as a Readymade, although altering its dynamics by placing the two sections side by side. It is in *The Mechanism of Meaning,* however, the comprehensive work begun systematically in collaboration with Madeleine Gins in 1968, that Arakawa fulfilled Duchamp's aim to reveal the naked philosophy of painting, without being indebted to him on a purely formal or technical level. *From Degrees of Meaning,* 1972, a recent version of a more diagrammatic treatment of the theme, is a perfect example of Arakawa's ability to render abstract ideas palatable through the extreme sophistication and refinement of his presentation. Arakawa is now so confident of his ambitions that he feels able to indulge in dazzling displays of painterly bravura without compromising the philosophical core at the heart of his work.

To the most rigorous conceptual artists, a work's visual appeal is ultimately irrelevant. Duchamp had glimpsed just such a prospect—a totally disembodied art. When Walter Pach asked him why he had stopped painting, he replied that he had not. "Every picture has to exist in the mind before it is put on canvas, and it always loses something when it is turned into paint. I prefer to see my pictures without that muddying."[43] Of course, he continued to produce objects from time to time, but the idea always took precedence over purely formal qualities. For Joseph Kosuth, one of the leading theorists of conceptual art, "All art (after Duchamp) is conceptual (in Nature) because art only exists conceptually."[44] "The event that made conceivable the realization that it was possible to 'speak another language' and still make sense in art was Marcel Duchamp's first unassisted Readymade. With the unassisted Readymade, art changed its focus from the form of the language to what was being said. Which means that it changed from a question of morphology to a question of function."[45] Discounting altogether formalist criticism's "morphological" definition of art, Kosuth proposed a situation where

art is valuable only insofar as it questions art's nature. Kosuth's dictionary definitions represent the most austere and disembodied aspect of conceptual art, departing from Duchamp but totally lacking his sense of humor.

The British Art-Language group is also not noted for its levity, although in elaborating on aspects of the Readymade, they have created situations that border on the absurd. In 1966, for example, David Bainbridge built a crane in response to a commission from Camden Borough Council, North London, to build a functional plaything. Bainbridge used this as a pretext to investigate the changes of status possible within one object. It was sometimes a member of the class "art-object" and sometimes a functional crane, depending on the location and attributed function. From March to April 1967, Terry Atkinson and Michael Baldwin conducted the *Declaration Series,* a series of declarations applied to locations and situations rather than to objects (Readymades). They chose Oxfordshire since there was no possibility of its being moved into an art ambience (gallery or museum). Temporal rather than spatial considerations defined the nature of the enterprise/experiment, just as they did in the final event of the *Declaration Series—The Monday Show.*

To the degree that Duchamp embodied conflicting possibilities, that he was a "one man movement but a movement for each person and open to everybody,"[46] he succeeded in influencing artists of the most diverse persuasions and no more so than at the present time. For while Art-Language was engaged in abstruse and frequently tedious philosophical investigations based to a considerable extent on themes established by Duchamp, other artists responded to the fatal appeal of Rrose Sélavy. What the Mona Lisa was for Walter Pater, Rrose Sélavy is for Vettor Pisani and Vito Acconci. The androgyne is as much a problem of definition as any of the topics that concern the members of Art-Language, but it is rooted in human

personality rather than philosophy. Pisani in 1970 and 1971 devoted a series of works to the subject—"Maschile, femminile e androgino: Incesto e cannibalismo in Marcel Duchamp." Acconci has admitted to a parallel with Marcel Duchamp/Rrose Sélavy in his *Conversions* of 1971 in which he is shown pulling at and burning hair from his chest, as well as hiding his penis between his legs in an effort to transform himself into a female.[47] The bizarre not to say psychopathic nature of Acconci's activities, which frequently suggest the context of Krafft-Ebing rather than of an art gallery, are upsetting because they are deadly serious, unlike Duchamp's ironic female disguises. In certain of his sexually oriented works, Acconci has given a completely literal translation of Duchampian ideas, turning ambiguous humor into didactic exercise.

For Joseph Beuys, on the other hand, Duchamp is an artist whose detachment and ironic stance vis-à-vis life and art are at the opposite pole from Beuys's own deep involvement with the revolutionary possibilities of art, both for the individual and for society. *The Silence of Marcel Duchamp Is Overrated* is the title of an action performed in 1964, indicating Beuys's attitude toward withdrawal most clearly. For Beuys, art means not contemplation but action and, if necessary, political action. In his view, drawings, objects produced in the course of actions, and even the actions themselves are secondary to the awakening of a revolutionary consciousness by means of provocation. Duchamp was singled out for comment as being the most insidiously inviting example of an artist whose career was based on indifference. By concentrating on him, however, Beuys showed that Duchamp's power was such that he could be rejected but not overlooked. Almost fifty years after the period of Duchamp's greatest productivity, the issues raised by his work still make him an inescapable point of reference. The beam of the lighthouse has not dimmed.

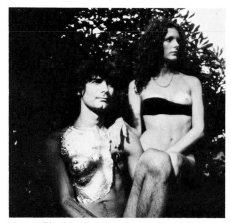

Vettor Pisani. *Carne umana e oro (Human Flesh and Gold).* 1971. Photograph courtesy Claudio Abate.

Joseph Beuys. *Das Schweigen von Marcel Duchamp wird überbewertet (The Silence of Marcel Duchamp Is Overrated).* 1964. Collage with chocolate, felt, paper, brown oil pigment, 62⅛ x 70⅛ x ¾ in. Collection Hans van der Grinten, Mönchengladbach, Germany.

1. Walter Pach, *Queer Thing, Painting: Forty Years in the World of Art* (New York: Harper and Brothers, 1938), p. 162.

2. Man Ray, *Self Portrait* (Boston: Little, Brown, 1963), p. 82.

3. Before beginning the painting, Man Ray worked on a collage version of the same subject in which the scraps of paper left over from the operation of cutting out the dancer in her various positions were used as the shadows. Following Duchamp, Man Ray evolved a constructive technique that departed from all previous artistic conventions. From collage he turned to airbrush painting, photography, and the rayograph.

With the aerographs and the rayographs he discovered additional ways of eliminating the personal touch. Using a spraygun and stencils of various shapes, he showed in *Untitled,* 1919, that a Cubist painting could be created using entirely mechanical means, the end product lacking nothing in sensitivity when compared to a carefully handcrafted painting. "It was thrilling," he said, "to paint a picture hardly touching the surface—a purely cerebral act, as it were." (*Self Portrait*, pp. 72–73.)

4. As quoted in John I. H. Baur, *Revolution and Tradition in Modern American Art* (Cambridge, Mass.: Harvard University Press, 1951), p. 59, and Emily Farnham, *Charles Demuth Behind a Laughing Mask* (Norman, Okla.: University of Oklahoma Press, 1971), p. 12.

5. Illustrated in Irma B. Jaffe, *Joseph Stella* (Cambridge, Mass.: Harvard University Press, 1970), plate 60.

6. As quoted in William Agee, "New York Dada, 1919–30," in *The Avant-Garde,* Art News Annual XXXIV (New York: Macmillan, 1968), p. 112.

7. For a reproduction of Joseph Cornell's *A Watchcase for Marcel Duchamp,* see below, p. 192.

8. Katherine S. Dreier and Matta Echaurren, *Duchamp's Glass: La Mariée mise à nu par ses célibataires, même. An Analytical Reflection* (New York: Société Anonyme, Inc., 1944).

9. James Thrall Soby, *Contemporary Painters* (New York: Museum of Modern Art, 1948; reprint ed., Arno Press, 1966), p. 65.

10. As quoted in Calvin Tomkins, *The Bride and the Bachelors* (New York: Viking Press, 1965), p. 23.

11. John Cage, *A Year from Monday* (Middletown, Conn.: Wesleyan University Press, 1969), p. 23,

12. See John Cage, "The Arts in Dialogue," in *John Cage,* ed. Richard Kostelanetz (New York: Praeger, 1970), p. 149.

13. Alain Jouffroy, *Une Révolution du regard* (Paris: Gallimard, 1964), p. 14.

14. William Seitz, "What's Happened to Art? An Interview with Marcel Duchamp on Present Consequences of New York's 1913 Armory Show," *Vogue* (New York), February 15, 1963, p. 113.

15. For a full account of these see Max Kozloff, "Johns and Duchamp," *Art International* (Lugano), vol. VIII, no. 2 (March 1964), pp. 42–45.

16. Jasper Johns, "Marcel Duchamp (1887–1968)," *Artforum* (New York), vol. VII, no. 3 (November 1968), p. 6.

17. In John Russell and Suzi Gablik, *Pop Art Redefined* (New York: Praeger, 1969), pp. 84–85.

18. "Anything that I respect in art is for its idea rather than its handling or any other quality; . . . this is an obsession I've had ever since I was a student." Interview conducted by Andrew Forge for the British Broadcasting Corporation on November 3, 1964, as quoted in Richard Morphet, *Richard Hamilton* (London: The Tate Gallery, 1970), p. 8.

Movement was one of the first themes that Hamilton explored systematically. *Still-life?* and *re Nude*, both 1954, explored spectator movement in relation to a static object, while in the series of four *Trainsitions* he turned his attention to the relationship between the moving spectator (in a train) and the moving subject (the view through the train window). There is no stylistic relationship between Duchamp's *Sad Young Man on a Train* and Hamilton's train paintings, but the similarity of interests is striking. The same holds true for *d'Orientation,* 1952, and *Sketch for Super-Ex-Position,* 1953, both highly sophisticated examinations of problems of perspective, likewise a topic on which Duchamp lavished considerable attention in his studies for the *Large Glass.*

19. For a reproduction of the collage study, see Morphet, *Richard Hamilton,* p. 29, no. 22.

20. Reproduced in Morphet, *Richard Hamilton,* p. 32, no. 24.

21. Richard Hamilton collaborated with George Heard Hamilton on the typographic version of the notes from the *Green Box,* went to Pasadena in 1963 specifically to see the Duchamp retrospective organized by Walter Hopps, and in 1966 organized the Duchamp retrospective at the Tate Gallery.

In his re-creation of the *Large Glass,* entitled *The Bride Stripped Bare by Her Bachelors, Even, Again,* which extended over a period of thirteen months (1965–66) and paralleled the course of his own work, he went back to the original notes, attempting to reconstruct procedures rather than imitate the effects of action.

22. *A Quarante Degrés au-dessus de dada,* May 1961, second manifesto, reprinted in Pierre Restany, *Les Nouveaux Réalistes* (Paris: Editions Planète, 1968), p. 41.

23. Ibid. "Les nouveaux réalistes considèrent le monde comme un tableau, la grande oeuvre fondamentale dont ils s'approprient des fragments dotés d'universelle significance."

24. One hundred of these were produced in series by the Galerie der Spiegel, Cologne, in 1964.

25. Interview with Allan Kaprow, catalog *Allan Kaprow* (Pasadena Art Museum, 1967).

26. "Exposition Internationale du Surréalisme," Galerie Beaux-Arts, Paris, 1938; "First Papers of Surrealism," New York, 1942. Photographs of these installations became readily available with the publication of Robert Lebel's monograph, *Marcel Duchamp* (New York: Grove Press, 1959).

27. Pierre Cabanne, *Dialogues with Marcel Duchamp,* trans. Ron Padgett (New York: Viking, 1971), p. 99.

28. George Brecht, "Something about Fluxus," May 1964, reprinted in *Happening & Fluxus* (Cologne: Kölnischer Kunstverein, 1970), unpaged.

29. Ibid.

30. Ibid.

31. Reprinted in *Happening & Fluxus.*

32. Fluxyearbox I, 1962–64; Fluxyearbox II, May 1968.

33. Reprinted in *Happening & Fluxus.* Author's translation.

34. See Henry Martin, "An Interview with George Brecht," *Art International* (Lugano), vol. XI, no. 9 (November 1967), p. 23.

35. Compare Duchamp's description of the

*Bicycle Wheel* as "a pleasure, something to have in any room the way you have a fire, or a pencil sharpener" (Tomkins, *The Bride and the Bachelors,* p. 26).

36. Martin, "An Interview with George Brecht," p. 23.

37. William T. Wiley, "Thoughts on Marcel Duchamp," in Brenda Richardson, *Wizdumb: William T. Wiley* (Berkeley: University Art Museum, 1971), p. 42.

38. See Jane Livingston and Marcia Tucker, *Bruce Nauman: Work from 1965 to 1972* (Los Angeles, Calif.: Los Angeles County Museum of Art, 1972), p. 10.

39. See Willoughby Sharp, "Nauman Interview," *Arts Magazine* (New York), March 1970.

40. See Tomkins, *The Bride and the Bachelors,* p. 31.

41. See exhibition catalog *Baruchello* (Milan: Galleria Schwarz, 1970), p. 13. ". . . these paintings have nothing at all to do with reality since they are not painted *après-nature* and I didn't—how can I put it—I don't have to pick up a pair of pliers or play with a woman's breast in order to paint them. This pair of pliers is above all the *word* pliers, which is to say that from a linguistic point of view we've got the phenomenon that these things have only been thought, only imagined, have never been *seen.* Let's put it then that I give body to a Devonian fish, but it's a section of the fish that I have never seen anywhere in reality. In short I'm never stimulated by images; I'm stimulated by words and ideas."

42. *Baruchello,* p. 14.

43. Pach, *Queer Thing, Painting,* p. 155.

44. Joseph Kosuth, "Art after Philosophy," *Studio International* (London), vol. 178, no. 915 (October 1969), p. 161.

45. Ibid., p. 135.

46. Willem de Kooning described Duchamp in these terms in "What Abstract Art Means to Me," *The Museum of Modern Art Bulletin* (New York), vol. XVIII, no. 3 (June 1951), p. 7.

47. Robert Pincus-Witten, "Vito Acconci and the Conceptual Performance," *Artforum* (New York), vol. 10, no. 8 (April 1972), p. 49. "Did this film record a process parallel to the multivalence between Marcel Duchamp and Rrose Sélavy?" "Yes."

An equally startling event was the artist's *Seedbed* of 1971. Concealed within a wedge-shaped ramp that occupied a large portion of the gallery space, the artist spent two afternoons a week engaged in "private sexual activity," fantasizing about the visitors to the gallery who walked over the ramp. The artist's manual exertions and groans of satisfaction could be heard over a loudspeaker system in the gallery. The fusion of a severely abstract, minimal form, which Pincus-Witten likened to Duchamp's *Wedge of Chastity,* with the intimate sounds placed the viewers in a highly ambivalent situation in which every step contributed to the excitement of the artist (instead of the artist's striving to excite the spectator, as is the case in pornography). The Duchampian pun of the title served only to emphasize the sterility of the event.

A

COLLECTIVE

PORTRAIT

GUILLAUME APOLLINAIRE
ARAKAWA
ARMAN
RICHARD BOIX
GEORGE BRECHT
ANDRÉ BRETON
GABRIELLE BUFFET-PICABIA
JOHN CAGE
ALEXANDER CALDER
HENRI CARTIER-BRESSON
WILLIAM COPLEY
JOSEPH CORNELL
JEAN CROTTI
MERCE CUNNINGHAM
SALVADOR DALI
WILLEM DE KOONING
WALTER DE MARIA
JAN DIBBETS
ENRICO DONATI
KATHERINE S. DREIER
MAX ERNST
RAFAEL FERRER
DAN FLAVIN
ELSA BARONESS FREYTAG-LORINGHOVEN
GEORGE HEARD HAMILTON
DAVID HARE
SIDNEY JANIS
MARCEL JEAN
JASPER JOHNS
ALLAN KAPROW
FREDERICK KIESLER
JULIEN LEVY
MAN RAY
MATTA
E. L. T. MESENS
JOAN MIRÓ
REUBEN NAKIAN
BRUCE NAUMAN
FRANK O'HARA
GEORGIA O'KEEFFE
ALFRED STIEGLITZ
CLAES OLDENBURG
YOKO ONO
ANTOINE PEVSNER
FRANCIS PICABIA
ROBERT RAUSCHENBERG
CARL FREDERIK REUTERSWARD
HANS RICHTER
DANIEL SPOERRI
EDWARD STEICHEN
GERTRUDE STEIN
JOSEPH STELLA
FLORINE STETTHEIMER
SHUZO TAKIGUCHI
JEAN TINGUELY
LOUISE VARÈSE
JACQUES VILLON
ANDY WARHOL
LAWRENCE WEINER
WILLIAM T. WILEY
GEORGES DE ZAYAS

OF

MARCEL

DUCHAMP

Marcel Duchamp's pictures are still too few in number, and differ too much from one another, for one to generalize their qualities, or judge the real talents of their creator. Like most of the new painters, Marcel Duchamp has abandoned the cult of appearances. (It seems it was Gauguin who first renounced what has been for so long the religion of painters.)

In the beginning Marcel Duchamp was influenced by Braque (the pictures exhibited at the *Salon d'Automne,* 1911, and at the *Gallery Rue Tronchet,* 1911), and by *The Tower* by Delaunay (*A Melancholy Young Man on a Train*).

To free his art from all perceptions which might become notions, Duchamp writes the title on the picture itself. Thus literature, which so few painters have been able to avoid, disappears from his art, but not poetry. He uses forms and colors, not to render appearances, but to penetrate the essential nature of forms and formal colors, which drive painters to such despair that they would like to dispense with them, and try to do so whenever possible.

To the concrete composition of his picture, Marcel Duchamp opposes an extremely intellectual title. He goes the limit, and is not afraid of being criticized as esoteric or unintelligible.

All men, all the beings that have passed near us, have left some imprints on our memory, and these imprints of lives have a reality, the details of which can be studied and copied. These traces all take on a character whose plastic traits can be indicated by a purely intellectual operation.

Traces of these beings appear in the pictures of Marcel Duchamp. Let me add—the fact is not without importance—that Duchamp is the only painter of the modern school who today (autumn, 1912) concerns himself with the nude: *King and Queen Surrounded by Swift Nudes; King and Queen Swept by Swift Nudes; Nude Descending a Staircase.*

This art which strives to aestheticize such musical perceptions of nature, forbids itself the caprices and unexpressive arabesque of music.

An art directed to wresting from nature, not intellectual generalizations, but collective forms and colors, the perception of which has not yet become knowledge, is certainly conceivable, and a painter like Marcel Duchamp is very likely to realize such an art. . . .

Just as Cimabue's pictures were paraded through the streets, our century has seen the airplane of Blériot, laden with the efforts humanity made for the past thousand years, escorted in glory to the [Academy of] Arts and Sciences. Perhaps it will be the task of an artist as detached from aesthetic preoccupations, and as intent on the energetic as Marcel Duchamp, to reconcile art and the people.—*Paris, 1912*

From *The Cubist Painters: Aesthetic Meditations,* translated by Lionel Abel (New York: Wittenborn, Schultz, 1949), pp. 47–48, by permission of George Wittenborn, Inc., New York.

29. 11. 1972.

Dear Rrose ~~Selavy~~, Don Marcel.

_Even so, a line is a crack._

Who comes to visit once the possibility of recognizing _two and a half_ similar objects has been lost ??

Where would (does) the possibility of recognizing two and a half similar objects go?

What are the Etats - Unis of Paris air?
Where is Rrose Selavy's falcon?
The other?
What other colors?

I meant to ask you if you like these expressions: OH!! and AH!! etc . . . .

When "always and not" signifies something, "The signified or if" belongs to the Zero set. Have we met before ??...

love ARAKAWA.

P.S. What good news about Willy Brandt's re-election in 1972.

_—New York, 1972_

181

ARMAND P. ARMAN
CORRESPONDENT AT REJAYORK FOR THE DAILY MOMA

WORLD CHAMPIONSHIP OF SWIFT - CHESS
FINAL BETWEEN MARCEL DUCHAMP AND ROSE SELAVY

MARCEL DUCHAMP ARRIVED TEN MINUTES BEFORE THE OFFICIAL TIME AND
CALMLY STARTED TO SMOKE A CIGAR. ROSE SELAVY ARRIVED ON TIME, TALL,
SLIM AND SILENT . . . SHAKED HANDS WITH MARCEL DUCHAMP. THEY SAT
AT THE TABLE AND DUCHAMP ASKED SELAVY IF THE CIGAR WAS BOTHERING
HIM. SELAVY REPLIED, "NO," AND ADDED THAT HE WOULD LIKE TO SMOKE
A CIGAR HIMSELF.

WHITE          BLACK
1) P—K4 . . . P—K4
2) P—KB4   DUCHAMP GIVES A NEW TURN TO THE SCENE QUITE
DETACHED FROM THE CONSECRATED FORM OF EXPRESSION.
. . . P x P   ADVENTUROUS, CONTRE GAMBIT IS MORE IN FAVOR, BUT THE
YOUNG MAN IS IN THE SPRING.
3) N—KB3   THE KNIGHT GOES DOWN LIKE THE NUDE DESCENDING
STAIRCASE, RIGHT AT HIS PLACE COVERING ALREADY A GOOD SPACE IN THE
CENTER OF THE HISTORY OF ART.
. . . P—KN4   DEFENDING THE PAWN BUT STANDING LIKE A SAD YOUNG
MAN IN A TRAIN.
4) P—KR4   TRYING TO GRIND THIS DEFENSE IN A COFFEE MILL.
. . . P—N5   THE PAWN TRAVERSES THE GRINDER LIKE A NUDE AT HIGH
SPEED.
5) N—K5   THE KNIGHT ESCAPES STILL MENACING STANDING STRONG
AND SWIFT.
. . . N—KB3   BRINGING OUT THE PIECE DEFENDING PN5 CAREFREE AS A
BACHELOR.
6) P—Q4   BIG OPENING IN THE CENTER, THE VIRGIN IS READY AND THE
QUEEN'S MALIC MOLD GOT HIS DIAGONAL.
. . . P—Q3   THE BACHELOR'S APPARATUS PICKS ON THE STRONG AND
SWIFT.
7) N—Q3   WHICH GOES BACK IN THE CENTER OF THE BRIDE AIMING AT
THE YOUNG MAN.
. . . N x P   THE KNIGHT ERASES THE BEGINNING'S PAWN WITH THE
DESIRE TO ABANDON A MODE OF EXPRESSION WHICH SEEMED VITIATED TO
HIM.
8) B x P   THE QUEEN'S MALIC MOLD GOES ON THE GLISSIERE, THE
STRIPPING STARTED.
. . . B—N2   THE OTHER MALIC MOLD ON THE OTHER RAIL, THE
TRANSFORMATION WILL BE REALIZED.
9) N—B3   ON THE WHEEL OF THE WATER MILL THREATENING THE
BLACK KNIGHT.
. . . N x N   TO SAVE TIME AND DOUBLING A WHITE PAWN, THE VIRGIN IS
STRIPPED BARE.
10) P x N   A STOPPAGE TAKES PLACE.

. . . P—QB4   THE OCULIST WITNESSES ARE SUPERPOSED.

11) B—K2   THAT THE LOUIS XV FOOT OF THE CHOCOLATE GRINDER DIRECTED AT THE SAD YOUNG MAN IN THE TRAIN.

. . . P x P   THE RED LIGHT IN THE PHARMACY.

12) O—O   THE BOTTLE DRYER TAKES REFUGE IN THE CASTLE.

. . . N—B3 !   IN ADVANCE OF THE BROKEN ARM, CREATING A HEAVY PRESSION.

13) B x NP   THE PHARMACY LOST THE GREEN BOTTLE AND THIS IS GOOD FOR THE KING'S SIDE.

. . . O—O   THE OTHER SIDE OF THE GLASS.

14) B x B   GIVES MORE ROOM TO THE QUEEN, THE GAME IS PULLED AT FOUR PINS.

. . . R x B   TAKING AN OPEN LINE, NOW THE GAME IS TO BE LOOKED AT (FROM THE OTHER SIDE OF THE GLASS) WITH ONE EYE CLOSED FOR ALMOST AN HOUR.

15) Q—N4   PINNING THE MALIC MOLD ON THE DUST BREEDING, AND TAKING OPTION IN WHITE'S LINES.

. . . P—B4   WITH A HIDDEN NOISE, THE PAWN REPULSES THE QUEEN.

16) Q—N3   STILL THERE, BUT L.H.O.O.Q.

. . . P x P   STOPPING THE TENSION, TARTAKOVER SAID, "THE THREAT IS MIGHTIER THAN THE EXECUTION" ON A SHAPE OF AN UNHAPPY READYMADE.

17) QR—K1   GOOD MOVE. NOW THE CENTER LOOKS LIKE THE FOUNTAIN.

. . . K—R1   UNPINNING THE MALIC MOLD AND BRINGING SOME AIR OF PARIS IN THE GAME.

18) K—R1   TO AVOID ANY SURPRISES, BECAUSE "2 OU 3 GOUTTES DE HAUTER N'ONT RIEN A FAIRE AVEC LA SAUVAGERIE."

. . . R—KN1   REGROUPING THE PIECES AGAINST THE BOTTLE DRYER.

19) B x P   BUILDING THE "TRAP."

. . . B—B1   THE HAT RACK'S HANGING ABOVE THE WHITE SIDE.

20) B—K5ch   TAKES THIS DIAGONAL AND UNTANGLES THE SCULPTURE FOR TRAVELING.

. . . N x B   AN OBLIGATION, TO SIGN A BLANK, TZANCK CHECK.

21) Q x Nch   LA BAGGARE D'AUSTERLITZ IS OPEN.

. . . R—N2   BEAUTIFUL MOVE, BEAUTIFUL BREATH, BETTER THAN B—N3.

22) R x P   POWERFUL GROUP WORTH AT LEAST $2,000 REWARD.

. . . Q x Pch   THE FRESH WIDOW IN BLACK SHINY LEATHER CAME TO PAY HER RESPECTS TO THE KING.

23) K—N1   ESCAPING AT THE SPEED OF A ROTARY DEMISPHERE.

. . . Q—KN5   HEAVY AS TWELVE HUNDRED COAL BAGS.

24) R—B2   NONCHALANT, LAZY HARDWARE WORKS.

. . . B—K2   THE OBJECT DARD GIVES ROOM TO THE OTHER ROOK.

25) R—K4   FORCING THE WEDGE OF CHASTITY IN.

. . . Q—N4   THE FRESH WIDOW PUTS BACK THE JACKET.

26) Q x Q   THE BRAWL AT AUSTERLITZ AT HIS PEAK AND FRESH WIDOW DISAPPEARS IN A DRAFT WHEN THE DOOR OF 11 RUE LARREY IS OPEN.

. . . B x Q   THE ONLY WAY. THE LAST MALIC MOLD DISPOSES OF THE JOCUND L.H.O.O.Q. RASEE (SHAVED).

27) N—K5   Why not sneeze Rose Selavy? Different obvious objectives.

. . . K—N1   To avoid check, this is not an anemic cinema move.

28) N—QB4   As Lawrence said, "The Turkish army was more an accident than a goal," and this draft piston has more than one.

. . . P—N3   This Monte Carlo bond is safer.

29) RB2—K2   Doubling on the glider.

. . . RN2—QB2   Doubling the two laundresses' aprons full of surprises on QB line.

30) R—K8ch   Starting the Tu m' . . .

. . . R x R   Tu m' . . . goes on.

31) R x Rch   Tu m' . . . always; everything in place for a still torture.

. . . K—B2   Maybe in the way of the check, but going close in the jacket.

[If 31. . . . K—N2, 32. R—K4 . . . B—B3 (not B—Q7 because R—Q4) 33. N—Q6, and one of the almost satisfactory answers, 33. . . . R—K2 leads to 34. R x R . . . B x R and 35. N—N5! leaving Black with a difficult Knight to fight.]

32) R—QB8!   With his tongue in his check, the goal was not indeed the Turkish army, but always the QB Pawn.

. . . R x R   Going for simplifications in the manner of Delvaux.

33) N—Q6ch   A check in genre allegory George Washington style.

. . . K—K3   Not K2. K3 more in the center and out of reach from the Knight in the waistcoat.

34) N x R   Marcel dechiravit R2 and N3 in danger.

. . . B—K6ch   The last malic mold coming from sixteen miles of string to save the situation.

35) K—B1   Coming in view, March 1945.

. . . KRP—R4   In form of female fig leaf.

36) K—K2   With the desire of priere de toucher.

. . . B—Q5   Fluttering hearts escape.

37) K—Q3   Last touch of apolinere enameled.

. . . K—K4   Obliged (not K—Q4 because of Knight) but not rongwrong.

38) N—K7   In the green box.

. . . K—K3   That become a total in a box in a valise, because it is impossible to stay, N—QB6ch is lethal.

39) K x B   Chess is in a pocket.

. . . K x N   Not a shoe.

40) K x P   Closing the door with the locking spoon.

. . . K—Q3   We now reach the state of a still sculpture in the milky way.

Given 1. The water fall 2. The illuminating gas—Marcel gracefully offers to Rose Selavy a draw. . . . Rose Selavy knowing the strength of Marcel Duchamp in the endgame (opposition and sister squares are reconciled) happily accepts. After tomorrow, there is a possibility of the championship resuming.—*New York, 1972*

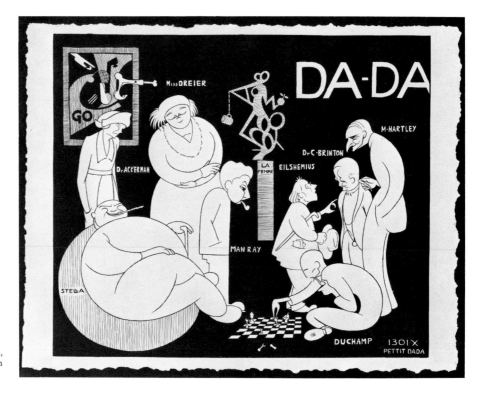

Richard Boix. *New York Dada Group.* c. 1921. Brush, pen and ink, 10½ x 12½ in. The Museum of Modern Art, New York, Katherine S. Dreier Bequest.

GEORGE BRECHT

NOTES ON THE INEVITABLE RELATIONSHIP (GB⟩⟨MD)
(IF THERE IS ONE)

I used to have a kind of guru complex. That is, there always seemed to be someone who especially turned me on. (For example, at 12 it was either Tchaikovsky or jerking-off.)

At the end of the 50s I found I had breathed all of Duchamp's water and gas at every level period.

Nevertheless, in the middle 60s it occurred to me that "Marcel Duchamp plays chess, and I play pick-up-sticks."

A little later I found myself making a note on D's Brasserie de l'Opera note.

The closest I ever got to meeting Duchamp in the flesh as they say was one time when I was living in Rome. Arturo Schwarz told me there was to be an exhibition of D's things and MD was going to be there. Arturo gave me the address and details. The show was to be in some furniture store, if I remember rightly. I prepared the last copy I had at the time of Water Yam by inscribing a few notes on some of the cards (in India ink) and tying the top onto the box with linen cord joined with a sailor's knot. After walking for quite a while under the sun (high at the time in Italian air-space), the box under my arm, I found the street and the number, but nothing remotely resembling what Arturo had described as the site of the great occasion.

No regrets.

I read somewhere, quite a while ago, that an interviewer asked: "How does it feel now, Mr. Duchamp, that everyone knows your name?" And Duchamp answered, "My grocer doesn't."

Al Hansen and I once cooked up a "Blues for Marcel Duchamp." Some of the parts were: spraying a bit of the tree outside MD's door on W. 10th St. with blue paint; leaving (within an hour of its appearance) a blue-dyed copy of the *New York Times* (impeccably ironed and refolded) in an empty milk bottle on his doorstep; playing a few bars of "Sunflower Blues" outside the windows of the house, and so forth. I think we came up with about fifty or so things to do, and actually put a notice in the *Voice* for the occasion, but beyond that I don't recall the thing going much further than leaving a blue trace on that tree.—*Cologne, 1972*

### ANDRÉ BRETON

*Marcel Duchamp.* It is by rallying around this name, a veritable oasis for those who are still *seeking,* that we might most acutely carry on the struggle to liberate the modern consciousness from that terrible fixation mania which we never cease to denounce. The famous intellectual crab-apple tree which in half a century has borne the fruits called symbolism, impressionism, cubism, futurism, dadaism, demands only to be felled. The case of Marcel Duchamp offers us a precious line of demarcation between the two spirits that will tend to oppose one another more and more in the very heart of the "modern spirit," depending on whether or not this spirit lays claim to the possession of the truth that is rightly represented as an ideal nude woman, who emerges from the well only to turn around and drown herself in her mirror.

The admirable beauty of the face imposes itself through no striking detail, and likewise, anything one can say to the man is shattered against a polished plaque that discloses nothing of what takes place in the depths; and those laughing eyes, without irony, without indulgence, that dispel the slightest shadow of concentration and reveal the solicitude of the man to preserve a perfectly amiable exterior; elegance in its most fatal quality, that goes beyond elegance, a truly supreme *ease:* thus Marcel Duchamp appeared to me in the course of his last stay in Paris; I had not seen him before, and, because of certain strokes of his intelligence that had reached me, I had expected something marvelous.

First of all let us observe that the situation of Marcel Duchamp in relation to the contemporary movement is unique in that the most recent groupings invoke the authority of his name, although it is impossible to say up to what point he has ever given them his consent, and although we see him turning with perfect freedom away from the complex of ideas whose originality was in large part due to him, before it took the systematic turn that alienates certain others as well. Can it be that Marcel Duchamp arrives more quickly than anyone else at the *critical point* of an idea? . . .

For Marcel Duchamp the question of art and life, as well as any other question capable of dividing us at the present moment, does not arise.

—*Paris, 1922*

From "Marcel Duchamp," translated by Ralph Manheim, in *The Dada Painters and Poets,* edited by Robert Motherwell (New York: Wittenborn, Schultz, 1951), pp. 209 and 211, by permission of George Wittenborn, Inc., New York.

We had found Marcel Duchamp perfectly adapted to the violent rhythm of New York. He was the hero of the artists and intellectuals, and of the young ladies who frequented these circles. Leaving his almost monastic isolation, he flung himself into orgies of drunkenness and every other excess. But in a life of license as of asceticism, he preserved his consciousness of purpose: extravagant as his gestures sometimes seemed, they were perfectly adequate to his experimental study of a personality disengaged from the normal contingencies of human life. He later recognized, in an interview with James Johnson Sweeney, that in this fabrication of his personality he was very much influenced by the manner of Jacques Vaché, whom he had met through Apollinaire. In art he was interested only in finding new formulas with which to assault the tradition of the picture and of painting; despite the pitiless pessimism of his mind, he was personally delightful with his gay ironies. The attitude of abdicating everything, even himself, which he charmingly displayed between two drinks, his elaborate puns, his contempt for all values, even the sentimental, were not the least reason for the curiosity he aroused, and the attraction he exerted on men and women alike. Utterly logical, he soon declared his intention of renouncing all artistic production. And if he continued to busy himself with his great work in glass, *The Bride Stripped Bare by Her Bachelors, Even,* to which for two years he had been devoting such meticulous care, it was because it had been purchased prior to completion. He was almost happy when it was cracked in moving. As to painting, he kept his word, he never again touched a brush. But at long intervals he did work on certain strange objects or machines, strictly useless and anti-aesthetic, which one of his historians very aptly named "wolf traps" (he should have added: "for the mind"). He drugged himself on chess, playing night and day like a professional. And when asked to participate in artistic events, he consented only for the sake of the scandal that might be provoked. At the New York Independents exhibition, for example, he exhibited a urinal entitled *Fountain,* which was of course disqualified. Yet a kind of occult prescience of men and things gave him an extraordinary influence on all the innovating artists of his generation, particularly the Surrealist, for whom he became a kind of symbol. Although he has to his credit only a very limited number of painted works or invented objects, his contribution is considerable, and, because of his sure judgment, he later came to be consulted as an authority, even in official circles.—*1949*

From "Some Memories of Pre-Dada: Picabia and Duchamp," translated by Ralph Manheim, in *The Dada Painters and Poets,* edited by Robert Motherwell (New York: Wittenborn, Schultz, 1951), pp. 260–61, by permission of George Wittenborn, Inc., New York.

## 26 Statements re Duchamp

### History

The danger remains that he'll get out of the valise we put him in. So long as he remains locked up—

The rest of them were artists. Duchamp collects dust.

The check. The string he dropped. The Mona Lisa. The musical notes taken out of a hat. The glass. The toy shotgun painting. The things he found. Therefore, everything seen—every object, that is, plus the process of looking at it—is a Duchamp.

### Duchamp Mallarmé?

There are two versions of the ox-herding pictures. One concludes with the image of nothingness, the other with the image of a fat man, smiling, returning to the village bearing gifts. Nowadays we have only the second version. They call it neo-Dada. When I talked with M.D. two years ago he said he had been fifty years ahead of his time.

Duchamp showed the usefulness of addition (moustache). Rauschenberg showed the function of subtraction (de Kooning). Well, we look forward to multiplication and division. It is safe to assume that someone will learn trigonometry. Johns.

### Ichiyanagi Wolff

We have no further use for the functional, the beautiful, or for whether or not something is true. We have only time for conversation. The Lord help us to say something in reply that doesn't simply echo what our ears took in. Of course we can go off as we do in our corners and talk to ourselves.

There he is rocking away in that chair, smoking his pipe, waiting for me to stop weeping. I still can't hear what he said then. Years later I saw him on Macdougal Street in the Village. He made a gesture I took to mean O.K.

"Tools that are no good require more skill."

### A Duchamp

Seems Pollock tried to do it—paint on glass. It was in a movie. There was an admission of failure. That wasn't the way to proceed. It's not a question of doing again what Duchamp already did. We must nowadays nevertheless be able to look through to what's beyond—as though we were in it looking out. What's more boring than Marcel Duchamp? I ask you. (I've books about his work but never bother to read them.) Busy as bees with nothing to do.

He requires that we know that being an artist isn't child's play: equivalent in difficulty—surely—to playing chess. Furthermore a work of our art is not ours alone but belongs also to the opponent who's there to the end.

Anarchy?

He simply found that object, gave it his name. What then did he do? He found that object, gave it his name. Identification. What then shall we do? Shall we call it by his name or by its name? It's not a question of names.

*The Air*

We hesitate to ask the question because we do not want to hear the answer. Going about in silence.

One way to write music: study Duchamp.

Say it's not a Duchamp. Turn it over and it is.

Now that there's nothing to do, he does whatever anyone requires him to do: a magazine cover, an exhibition, a movie sequence, etc., ad infinitum. What did she tell me about him? That he gave himself except for two days a week (always the same days, Thursdays, Sundays)? That he's emotional? That he formed three important art collections? The phonograph.

Theatre.                                                                    —*1964*

From *Art and Literature* (Paris), no. 3, Autumn–Winter 1964, pp. 9–10, by permission of *Art and Literature*.

let Me

hAve

youR baggage;

I will Carry it for you.

no nEed:

i'm wearing aLl of it.

—*1971*

Saché 37
NOV. 13/72

Dear Anne, dear Kynaston,
We, Louisa & I,
first met Marcel Duchamp
in 1930-31. I had met
Mary Reynolds in 1930, in
Villefranche (A.M.), and that
was before (or after) I had
met Mary, with whom Mary
Butts (English writer) had
left some photographs of mine.
This is rather confused, but
I met Marcel through Mary Reynolds.
At that time we had

2/ a modest house in the
rue de la Colonie — now
demolished, and they came
to see us now & then.
The object, which I have
since tried to reproduce,
was in my atelier — the
same house, 3rd floor.

something
like this

This was the moment that
I was preparing for the show
at the Galerie Vignon,
(Mme. Marie Cuttoli) which Maratier
proposed to me.

3/ Marcel said to call
my objects "mobiles" —
and said "Calder,
Ses
Mobiles"
serait la bonne annonce.
— avec un dessin (un peu
mechanique)
So, in 1932 I had my
first show of "mobiles"
As I had had an abstract
show at Galerie Percier.
Hans Arp said — what were
those objects of last year? —
it must have been des
"stabiles" — which I was glad to keep

4/ Much later, during the
war, in New York, it was decided to
make a surrealist book,
which was issued in a box
twice the thickness of the text.
The excess space was to be
occupied by a "falsie" (a rubber
breast pad) — I called
on Marcel in W. 14 St.
The place was infested
by these rubber devices, and
Marcel was busy adding a
bit of color, purple, or green,
(mostly), to the nipples
I was always very fond
of Marcel, he was very clever
at keeping his weight down

5/ which I admire, but do
not emulate

Cordially yours
Sandy Calder

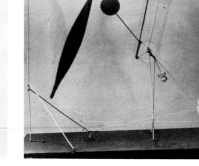

Alexander Calder, *The Motorized Mobile That Duchamp Liked*. 1932 (reassembled by the artist, 1968). Wood, wire, cord, and metal, approx. 42 in. high. Collection of the artist.

*—Saché, France, 1972*

190

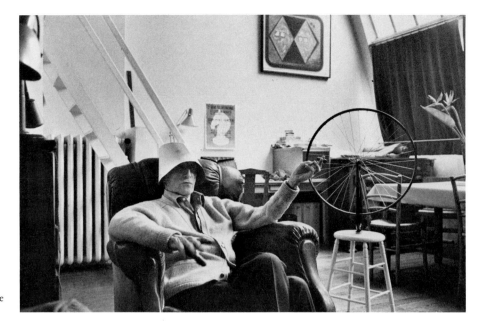

Henri Cartier-Bresson. *Marcel Duchamp* (at 5 Rue Parmentier, Neuilly-sur-Seine). 1951.

## WILLIAM COPLEY

Forgive me if I speak of Marcel Duchamp as a saint. He was for me. A saint is merely a wise man. Marcel was vitally aware of the simple truths that are under all our noses, truths that are just now inspiring demonstrations, sit-ins, etc.

"There is no solution because there is no problem." And now we have the pill and the morning after—or, as he once said, "a little curettage." A constitutional amendment is being worked on to make women legally more franchised. We seem to be deciding not to slay our fellow creatures under the cloak of jurisprudence.

All this Marcel predicted without talking about it. He liked what was sensible. He liked America and its gadgets. He had little patience with politics or the discussions of it since the problems never existed. "Yes and chess."

Marcel beat me in chess one time (he always beat me so I'm a lousy player) by simply advancing every pawn. It was a ludicrous situation for me since all my pieces were standing on each other's feet. Marcel, I think, was not so interested in winning as seeing how his pattern looked.

The word "yes" was almost his entire vocabulary. "Yes" can be said without emotional expenditure. Saying "no" reddens the face.

He did not malign people. He avoided them when he had to.

Concerning the work of artists, I never heard him say the words "better than." The positive only existed for him.

It was either the second or third time I met him I (as a provincial) took him to lunch at Lüchow's. I must have been twenty-seven or twenty-eight at the time (I blush). I remember he had to borrow a waiter's tie and white jacket before they'd let him sit down. There was a Dutch painting of a sinking ship on the wall between us. Wishing to impress him I said, "What a

piece of shit that is." The luncheon was taken up by his kindly and patiently explaining to me what was good about the painting.

Marcel was my best friend not to infer that I was his best friend. But we do have a right to choose. I used to call it charging my batteries. I had to see him three or four times a year, or else I might stop believing in myself, red-faced and sweating with the word "no."

Obviously I am out to canonize him. St. Marcel of the Fields. Would you believe it, I once heard somebody say that. Given time a flock of chimpanzees statistically will write *War and Peace* and all the plays of Shakespeare. Well, the saints are marching through the doors that Marcel opened.

I am avoiding talking about Marcel as an artist. That's another kettle of fish. But what went on between Marcel's ears means that a blind man can be a painter any time he wants to.

A final sentimental anecdote. Now I think it was the second time I met him. Yes, the first time I had to send him a telegram. I got a postcard back telling me what bar to meet him in. A lot of feet on the rail and twice as many eyes glued on television.

We had agreed this time to meet in the lobby of the Hotel Biltmore. It seems that the Hotel Biltmore has lots of lobbies.

I found him after a frantic hour and was groveling with apologies. He was unruffled and incredibly not annoyed. "I often come here just to ride the elevators," he said.—*New York, 1973*

JOSEPH CORNELL

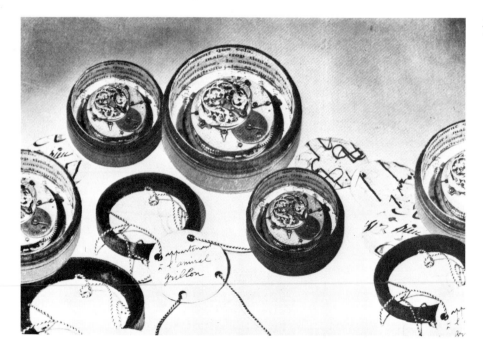

Joseph Cornell. ¾ *Bird's Eye View of a Watchcase for Marcel Duchamp.* 1944. Present whereabouts unknown.

192

Jean Crotti. *Marcel Duchamp.* 1915. Pencil on paper,
21½ x 13½ in. The Museum of Modern Art, New York,
Purchase, 1970.

Festival of the Arts Today
State University College of Buffalo
Buffalo, New York
March 10, 1968

I remember seeing Marcel Duchamp at the end of that first performance on the stairs, coming up to the stage, eyes bright, head up, none of that looking down at the steps. He walked to the center and, standing between Carolyn and me, held our hands, bowed and smiled as though he were greeting guests. He was a born trouper. A photograph by Oscar Bailey, taken from the wings, shows him between us, turned toward Carolyn, his stance slightly oblique, with that look he often gave me of having made another choice about how to balance.—*New York, 1973* [*See Chronology, pages 30, 31.*]

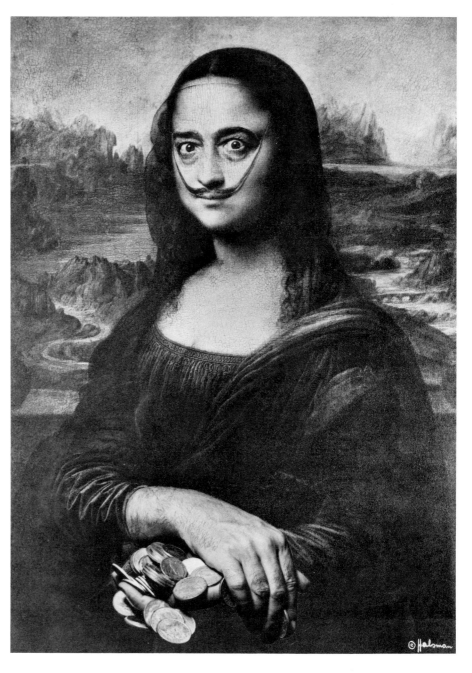

Salvador Dali. *Self-Portrait as Mona Lisa.* 1954. Photograph by Philippe Halsman.

## WILLEM DE KOONING

And then there is that one-man movement, Marcel Duchamp—for me a truly modern movement because it implies that each artist can do what he thinks he ought to—a movement for each person and open for everybody.—*1951*

From "What Abstract Art Means to Me," *The Museum of Modern Art Bulletin* (New York), vol. XVIII, no. 3 (June 1951), p. 7.

## WALTER DE MARIA

From Herman Melville's novel of 1857, *The Confidence Man*:

"Ah, now," deprecating with his pipe, "irony is so unjust; never could abide irony; something Satanic about irony. God defend me from Irony, and Satire, his bosom friend."

—*New York, 1972*

## JAN DIBBETS

```
IPMTINC NYK
2-142277E044 02/13/73
ICS IPMMIZZ   CSP
 2122884820 TDMT NEW YORK NY 17 02-13 0818P EST
PMS KYNASTON MCSHINE CURATOR, DLR
MUSEUM OF MODERN ART 11 WEST 53RD ST
NEW YORK NY 10019
AMSTERDAM 28 NOV 1972
MY FINAL STATEMENT ON DUCHAMP:
ALL STOP READY STOP MADE STOP
JAN DIBBETS.
 UNSIGNED

2022 EST

IPMTINC NYK
```

...NATI

# BookFinder.com

Search Results

Search Author, Title or ISBN [Go]

**Search | About | Preferences | Feedback | Help**

Searching for books where
Author is **Anne D'Harnoncourt e Kynaston McShine**
Title is **Marcel Duchamp**
Book is written in **Italian**
Publisher is **museum of modern art**

**Prices INCLUDE standard shipping to United States**
Show prices without shipping • Change shipping destination/currency
Shipping prices may be approximate. Please verify cost before checkout.

Our site contains affiliate links. When you buy through our links, we earn a commission.
Revise search — New search

**Used books: 1 - 1 of 1**

| # | Bookseller | Notes | Price |
|---|---|---|---|
| 1. | Antonio Pennasilico via AbeBooks Italy | Publisher: Museum of Modern Art, New York, 1973
Used. Testo inglese, brossura, formato 22x28, pagine 360, con 429 illustrazioni in nero e 12 a colori, ottime condizioni - 4734 | **$92.92** |

( All matching books shown )

Revise search    New search

*Flowers to Marcel*    *Souvenir d'un souvenir Enrico*

—*New York, 1973*

197

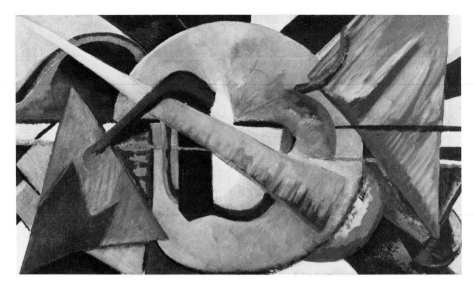

Katherine S. Dreier. *Abstract Portrait of Marcel Duchamp.* 1918. Oil on canvas, 18 x 32 in. The Museum of Modern Art, New York, Abby Aldrich Rockefeller Fund, 1949.

Max Ernst. *Le Marchand d'Ucel (c'est la vie).* 1931. Present whereabouts unknown.

## MAX ERNST

Faithful to the Dada spirit, he has eluded all discussion. When he signed his Readymades in 1913 or 1914 he was the only one to allow himself this liberty. And it is this fact which gave so much value to his gesture. When we learned not long ago that Marcel had given permission to a Milan art dealer to multiply his "Readymades" (to use them to make commercial "multiples") I was frankly intrigued. The value of the gesture which established the great beauty of the Readymade seemed compromised. The challenge which had scandalized the New York art world, at the same time loosing storms of enthusiasm in the European capitals of Dada, was threatened with defeat. Later I asked myself if it was not simply another gesture to irritate public opinion, to trouble minds, to baffle his admirers, encourage his imitators to follow his naughty example, etc. When I asked Marcel he replied, laughing, "Yes, it's a little of all that."—*Paris, 1969*

Translated from an interview with Robert Lebel, 1969, in *Ecritures* (Paris: Gallimard, 1970), p. 433, by permission of Editions Gallimard.

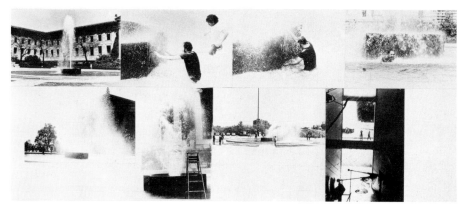

Rafael Ferrer. *Deflected Fountain 1970, for Marcel Duchamp.* 1970. 8 photographs, overall 23 x 54½ in. The Museum of Modern Art, New York, Gift of M.E. Thelen Gallery.

## DAN FLAVIN

I would happily comply with your request for a statement about Marcel Duchamp and his arts if I could, but I can't. I have no particular information or special opinion of interest. I've never deliberately studied the man and his arts. And I'm unable to accept the myth of Marcel the most profound magician presiding over just about any art possible since New York 1913 which so many enchanted and beguiled promotional American art critics and historians have been compounding confounding during the past fifteen years or so. (Certainly, M. Duchamp did not neglect his export myth.) Certainly, I have admired and do so still certain mentalisms of the man against, with and in arts. And accordingly, my own art, at present, is of as much ironic "readymade" (and thereafter) as not. But then, the dubious historical game of influential attributions never climaxes—so permit me to guess that I've abused Piet Mondrian and his paintings and post-painterly promise, too. And so forth and so what.

Marcel Duchamp credited favorably by letter my first summary release of "some light" in March 1964, while persuading a much-needed financial award for me and mine from the foundation of his friends, Noma and Bill Copley. Later, he wrote a futile (because there was, and probably still is, too much abusive, non-competitive elite-istic pre-judgment) recommendation for a Guggenheim fellowship all the way from Neuilly-sur-Seine, I presume. When I happened to meet Duchamp a few years later during an opening of his in Cordier-Ekstrom, I waited until he was alone and thanked him again for what he had done previously. Evidently, he was so shy that he was "put off" by my sincere, direct and quiet attention and strode off apparently embarrassedly waving away my few words. I did not want to disturb the old man and never did again.

Noma Copley had told me that Duchamp would have welcomed my friendship if I had played chess with him, but I didn't believe that, for that type of so deliberately stylized notion was of the standard myth which put me off. Just suppose I was a *better* chess player than he was. (At least, I'm somewhat gamy, too.) Well, anyhow, suppose it, for there is so much of "let's pretend" toward in the grand grandiose Duchampian myth. Do you folks really require this sort of stuff? So be it.—*New York, 1972*

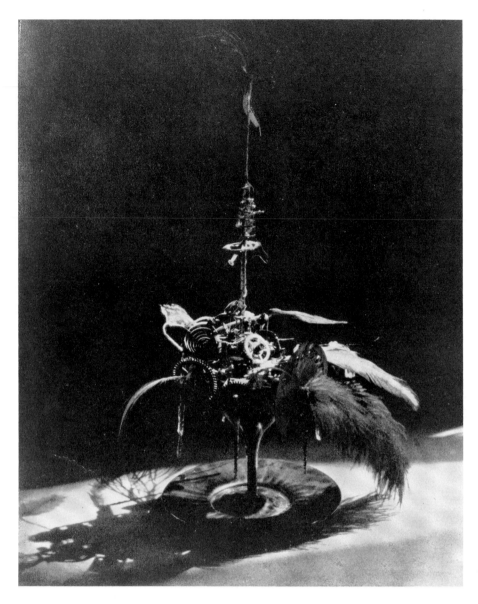

Elsa Baroness Freytag-Loringhoven. *Portrait of Marcel Duchamp*. Assemblage with feathers. Photograph by Charles Sheeler for *The Little Review*, Winter, 1922. Present whereabouts of assemblage unknown.

GEORGE HEARD HAMILTON

REMEMBERING MARCEL

When our new Dalmatian puppy tumbled into the living room one evening
he said, "So you have the positive! What do you suppose the negative looks
like?"—*Williamstown, Massachusetts, 1973*

DAVID HARE

FOR M.D.

He fell grasping stars not to fall forever between
   between forever
   so as not to ever fall
Perhaps more I wouldn't know
   I live here

People say tree frogs say
   "Rivet Rivet Rivet"
So does the machine
Meant to say a *fly* a *beauty* where *in the ointment*
Meant to say butterfly ointment

He set beauty a-fly
   in the ointment
Then fell
   clean through
And quickly shuddered out of sight

*—New York, 1973*

## A RECOLLECTION OF THE DADA SHOW

Marcel Duchamp, always the giver, but in giving he received. His expertise in giving has been documented in part by his role as executor of the estates of Mary Reynolds and later Katherine Dreier, whose collections he so equitably distributed. In other ways his generosity had a way of coming back to him in multiplied form, an instance of which I witnessed at the time of the Dada show held at Marcel's suggestion at the gallery in 1953. A most difficult show to do since collectors were hesitant to risk invaluable loans, but Marcel's frequent intercession smoothly resolved these problems; still it took a year of intensive work to assemble it. Marcel designed the setting, including a transparent ceiling—an inverted showcase—covered with Dada manifestos and posters. The gallery itself was subdivided by plexiglass walls creating an ambiguous atmosphere which, when the show was hung, resembled a huge Merz construction.

Prior to the hanging, two Dada artists then living in New York brought in their work and in my absence expropriated the most prominent walls, whereas the plan of the show was to center upon Duchamp. Marcel, confronted by the new situation, was indifferent to having lost his space and casually suggested instead the back room as suitable enough. My dissent from this was not quite as casual. Marcel's suggestion, however, was sufficient for the two artists to agree to move their contributions to less conspicuous walls, leaving the way clear for placement of significant examples by Duchamp, Picabia, Schwitters, and Arp, so as to exert maximum initial impact upon the viewer.

It was inevitable for some to believe that Marcel's modesty was merely a ploy to gain what he really wanted, but this argument has been contradicted by so many self-effacing acts I have witnessed throughout a long acquaintanceship with the artist. For example, the Dada poster-catalog designed by Duchamp, a highly complex typographical affair containing various prefaces laid out in descending staircase form and guided step by step by the artist, contained 212 catalog items and was printed on tissue-thin parchment paper. When finally completed, Marcel crushed the poster into a ball for mailing. Some clients, complaining that they had not received theirs, upon checking found that their secretaries, taking the gesture literally, discarded the catalog as waste. At the gallery, as if in anticipation, Marcel filled a huge wastebasket with crushed catalogs to be retrieved by visitors to the exhibition.

*—New York, 1972*

## MARCEL JEAN

I met Marcel Duchamp in 1938 at the Paris Surrealist Exhibition, inside that strange grotto he had created as an environment for the show, a materialized metaphor which evoked a gallery in a coal mine as well as a clearing in a deep forest, and at the same time a bedroom suggesting also a café terrace . . . Twenty years later we met again in New York. I was writing the last chapters of my *History of Surrealist Painting,* and my wife and I were his guests for two weeks at his home on East 58th Street. We went together to the Museum of Art in Philadelphia where I took with an old camera a photo of the *Mariée mise à nu* . . . Duchamp thought it was the best photo ever made of the big *Glass:* it is reproduced in my *History* and Marcel insisted it should appear as a frontispiece to *Marchand du Sel,* his collected writings published in 1958 at Eric Losfeld's [Le Terrain Vague]. During the journey on the train returning from Philadelphia to New York, we talked of everything and of nothing in particular, neither of us feeling boredom, embarrassment—or any special exaltation. For Duchamp's *gentillesse* was one of his most enjoyable aspects: cleverness and kind attention subtly but naturally blended with detachment. His mind seemed always ahead of his interlocutors' thoughts, yet it followed them with a perfect simplicity. When I last saw him in Paris, a few weeks before his unexpected death, the striking portrait André Breton had drawn of him in *Les Pas perdus* as early as 1922, was still a good likeness.

"Go underground, don't let anyone know that you are working," said Marcel Duchamp to artists asking if there was any avant-garde action open to them. Nowadays, on the art stage and in life itself, violent enjoyment, spectacular jokes, theories, and tragedies are brought unceasingly into the limelight. Duchamp showed an interest for that turmoil, without taking part in it, apparently. But we know now that he kept active all the time— underground.—*Paris, 1972*

## JASPER JOHNS

The self attempts balance, descends. Perfume—the air was to stink of artists' egos. Himself, quickly torn to pieces. His tongue in his cheek.

Marcel Duchamp, one of this century's pioneer artists, moved his work through the retinal boundaries which had been established with Impressionism into a field where language, thought and vision act upon one another. There it changed form through a complex interplay of new mental and physical materials, heralding many of the technical, mental and visual details to be found in more recent art.

He said that he was ahead of his time. One guesses at a certain loneliness there. Wittgenstein said that "'time has only one direction' must be a piece of nonsense."

In the 1920s Duchamp gave up, quit painting. He allowed, perhaps encouraged, the attendant mythology. One thought of his decision, his willing this stopping. Yet on one occasion, he said it was not like that. He spoke of breaking a leg. "You don't mean to do it," he said.

The *Large Glass*. A greenhouse for his intuition. Erotic machinery, the Bride, held in a see-through cage—"a Hilarious picture." Its cross references of sight and thought, the changing focus of the eyes and mind, give fresh sense to the time and space we occupy, negate any concern with art as transportation. No end is in view in this fragment of a new perspective. "In the end you lose interest, so I didn't feel the necessity to finish it."

He declared that he wanted to kill art ("for myself") but his persistent attempts to destroy frames of reference altered our thinking, established new units of thought, "a new thought for that object."

The art community feels Duchamp's presence and his absence. He has changed the condition of being here.—*New York, 1968.*

From "Marcel Duchamp (1887–1968): An Appreciation," *Artforum* (New York), vol. VII, no. 3 (November 1968), p. 6, by permission of *Artforum*.

Allan Kaprow

## Doctor MD

What good is history? Marcel Duchamp's legacy contains a small but influential body of quasi-art, often bordering on philosophy. A carefully styled dialectic is at work, in which linked visual and verbal puns are couched in narrative fictions, operational processes, common objects, and words meant not so much to be seen as read. He was opposed to the taste of his time for optical means in painting; he questioned whether modern art had its own language, doubted that such a "dumb" affair which addressed itself to the eyes could be intelligent. Above all, he wanted art to be intelligent. Today, thanks to him, critical discourse is inseparable from whatever other stuff art is made of. Conceptualism, for example, is "inconceivable" without Duchamp.

It followed that his position equally questioned the possibility of purely verbal intelligence. Professional philosophy, bound up as it was with words alone, was as fruitless as pure painting. That's the barb contained in his puns: human aspiration that until recently sought understanding through specialization was both futile and absurdly amusing. Multimedia experiments of the 60s were not caused by Duchamp alone, but he clarified the critical setting for their emergence.

Hence, his verbal-visual play, perhaps born of mixed skepticism and dandyism, confronted a romantic tradition of high, often tragic, seriousness in art-making. Humor was superficial. Even humor as arch as his was overcast by the dreamwork of Surrealism and the existential struggles of Abstract Expressionism. But since Pop art (itself indebted to him), artists are quite funny and still avant-garde! The Fluxus movement, many body workers, Conceptualists, and Happeners are evidence of the permission he gave to wit. Wit, from the Duchamp perspective, is the condition and consequence of keen thought. If you see things clearly, *really* clearly, you've got to laugh because nothing's been accomplished. There's a Zen story about one of the

great patriarchs who was asked what it felt like to be enlightened. His answer was, "I found out that I was just as miserable as ever."

Considering Duchamp's work specifically, the big *Glass,* though a major piece of art and a summary of his early interests as a painter, is nevertheless not particularly helpful for the present. It is a late Symbolist conceit over which academics hover, seeking linguistic riddles and cabalistic import (all of which is there, including the latest racing poop sheet). But it remains a hermetic exercise, a *picture,* in the old sense, of a world contained within itself. The best part of the *Glass* is that it is a windowpane to look through; its actual configurations are forced into accord with the visible environment beyond them, for instance, a chocolate grinder diagram superimposed on a kid picking his nose.

His Readymades, however, are radically useful contributions to the current scene. If a snow shovel becomes a work of art by simply calling it that, so is all of New York City, so is the Vietnam war, and so is a pedantic article on Marcel Duchamp. All the environmental pieces, activities, slice-of-life video works, Information pieces, and Art-Tech shows we've become accustomed to owe their existence to Duchamp's idea about a snow shovel.

Conversely, since any non-art can be art after making the appropriate ceremonial announcement, any art, theoretically, can be de-arted ("Use a Rembrandt for an ironing board"—Duchamp). This, it turns out, is a bit difficult. Duchamp's gesture in this direction, his *L.H.O.O.Q.,* didn't alter the Mona Lisa, it simply added one more painting to the museums. Replacing the meaning and function of the history of the arts with some other criteria seems to interest us much less than discovering art where art wasn't.

Beyond these identity games, the implication that life can be beautiful is rather salutary, if overwhelming. In the process, the word "art" ceases to refer to specific things or human events so much as it is a device for getting the attention of key people, who, having been gotten to, realize that the world is a work of art. Art as such, as it used to be, is reduced to a vestigial specialization on its way out; only the title remains, like the military epaulets on a doorman's uniform.

As an addition to the history of thought, the Readymade is a paradigm of the way humans make and unmake culture. Better than "straight" philosophy and social science, a good Readymade can "embody" the ironic limits of the traditional theory that says reality is nothing but a projection of a mind or minds. Duchamp, a cool subscriber to that tradition, knew, I suspect, that metaphysics, theology, science, and art were "useful fictions" (Hans Vaihinger's phrase). The intellectual or artist merely needs a persuasive consensus to launch an idea into the world. "All in all, the creative act is not performed by the artist alone," he said in a speech in 1957. Otherwise, the fiction will be useless, only a fiction and not a reality. The Readymade is thus both exposure meter and confidence game.

According to some of my friends, the freeways of Los Angeles are great theater, modern theater, with no beginning or end, full of chance excitements and plenty of the sort of boredom we all love. I pass that observation on here. Their future as Readymade art depends on the reader. That is, I am engaging in gossip. Duchamp's generous reminder to his posterity is how fragile public relations are.—*Pasadena, 1972*

Frederick Kiesler. *Marcel Duchamp*. 1947. Pencil on paper in 8 sections, (1–7) 14⅜ x 10⅞ in., (8) 10⅞ x 14⅜ in. The Museum of Modern Art, New York, Gift of the S. S. & R. H. Gottesman Foundation.

## Julien Levy

### Marcel/D . . . artiste-inventeur

I first met Marcel when I was twenty and he was twice that, and found that he could teach me, teach us, how to exist—somewhere between the bonds of irony and the illusive liberty of chance.

Through the years with his hand on my shoulder I felt bold to make random interpretations of his meaning. He never corrected me. Of his own works he has said, "This is purely my idea and I don't care if it is true or not."

In a magazine article I once remarked how certain notes in the *Green Box* resembled pages from the notebooks of Leonardo da Vinci.

To raise dust
    for 4 months. 6 months which you
close up afterwards
hermetically.—Transparency
—Difference. To be worked out [Duchamp]
Concerning the local movements of flexible dry
    things such as dust and the like
I say that when a table is struck
    in different places the dust
that is upon it is reduced to various shapes
    of mounds and tiny hillocks. [Leonardo]

I conclude that perhaps it was no coincidence that each abandoned painting and made inventions, no coincidence that in 1919 Marcel added the *Gioconda* to a moustache. He once signed himself "Marcel/D artiste-inventeur."

It saddens me deeply that Duchamp is no longer at my shoulder. But I cannot feel that he is really gone away, leaving only his "museum." I like to believe that during the third game of the Fischer-Spassky chess tournament I heard him laughing—a distant *ricanement*. Will he also giggle when someone adds a moustache to his "Bride," signs and exhibits it as a "Readymade"?—*Bridgewater, Connecticut, 1972*

## Man Ray

### Bilingual Biography

"Rrose Selavy et moi esquivons les ecchymoses des esquimaux aux mots exquis."

et AVIS AUX EXHIBITIONISTES: If you cannot show us your anatomy, it is of no avail to show us that you know your anatomy.

1915, Yes and Love; Notre première rencontre au tennis (sans filet), en deux mots, nous parlons mal mais nous tenons la balle aux temoins oculistes.

West 67th Street; La Mariée mise à nu par ses célibataires, même. While the bride lay on her face, decked out in her bridal finery of dust and debris, I exposed her to my sixteen-candle-camera. Within one patient hour was fixed once for all the Domaine de Duchamp. Elevage de poussières; didn't we raise the dust, though, old boy!

West 71st Street; Rotative plaques de verre, le seul attentat heureux de ma

vie; comme j'aimais le danger, et comme nous aimons le verre, et comme vous les cassez, comme les Russes. Yes, and chess.

Grand Central; The very independent Richard Mutt robbed the vestals of their vespasienne in broad daylight and called it another day. Yes, and chess.

West 8th Street; Stereoscopic streptococci in pretechnicolor, prelude to Anémic Cinéma. Yes, and chess.

Dada New York; La vieille Belle Helene veille sur notre jeunesse.

Société Anonyme Incorporated; Fair, cold but warmer, as indicated by my special device, Catherine Barometer, very reliable. Now you have almost unfinished the only authentic portrait of Lautréamont's god, jumping hair of cones in a bordel.

On nous a traité d'hommes finis. Parceque nous ne finissons jamais? Dites plutôt, des hommes in-finis.

Rendez-vous à la Rue La Condamine, et puis, je reçois à l'Hotel Meublé tous les critiques si bien disposés envers moi. Je te remercie, mon vieux, je te dois beaucoup. Seulement je n'ai pas su profiter. Comme dit notre cher André, "I have always been drawn only to what is not a sure bet."

Puteaux; In the gardens of Jacques Villon (I am still not speaking French), you return to your spiral monocycle embellished with delicious pornographic anagrams. Final vindication and prototype of the ideal obscenema. Yes, and chess.

31 Rue Campagne-Première; The demi-spheres aux mots exquis continue to rotate. But you never told me about the Broyeuse de Chocolat. I had to find out for myself. It was a pleasure, a much greater pleasure to find out by myself. Would it be an indiscretion on my part to relate that, walking down the streets of Rouen with my back to the lopsided steeples of the cathedral, I was overcome by a most delicious odor of chocolate which grew stronger as I advanced? And then, there they were, in a window, those beautifully polished steel drums churning around in the soft brown yielding mass of exquisite aroma? Later when questioned, you admitted your pure school-boy love. Ton amour-propre. I translate freely.

Monte Carlo; Pendant que j'étais pris entre les courses d'autos et les courses de toros, tu courais aprés la roue aux chiffres.

"Mots fait de chiffres

Appel de chiffres clameur d'or" Paul a dit.

Yes, and chess.

Aux Belles Japonaises; J'ai perdu mon chapeau, mais, toi tu n'avais toujours ni temps ni argent à perdre.

Arcachon; you write, "J'éspère que tu n'as pas tenté de rentrer à Paris." We both came back, at different times, and we both left at different times without seeing each other.

Hollywood; merci, cher vieux, I received your valise. Those who say you do not work any more are crazy. I know you do not like to repeat yourself, but only a real cheater can repeat himself with impunity. The most insignificant thing you do is a thousand times more interesting and fruitful than the best that can be said or done by your detractors. Strange how those most suspicious of your pulling their legs haven't any to stand on.

1945, New York; yes, and chess. Au revoir!

From *View* (New York), ser. 5, no. 1 (March 1945), pp. 32 and 51, by permission of Man Ray.

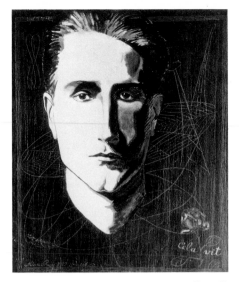

Man Ray. *Rrose Sélavy.* 1923. Oil on canvas, 23¼ x 19½ in. Private collection.

CORRECTION: I'll try, I have tried to add something to what has been said about Duchamp. But I think that everything has already been said.

—*Paris, 1973*

E. L. T. MESENS

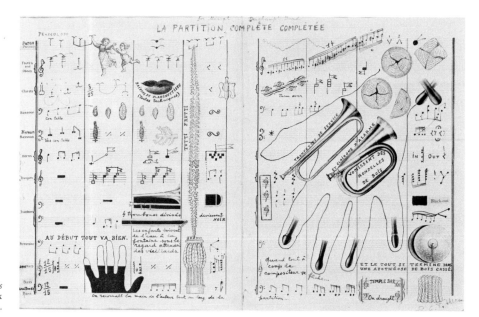

E. L. T. Mesens. *The Complete Score for Marcel Duchamp's Band Completed.* 1945. Ink and collage on paper, 11¾ x 18⅛ in. Musée des Beaux-Arts de Belgique, Brussels.

Joan Miró. *Nude Descending a Staircase.* 1924. Pencil and chalk drawing on paper with collaged stamp, 23⅝ x 18⅛ in. Collection Carl Frederik Reutersward, Lausanne, Switzerland.

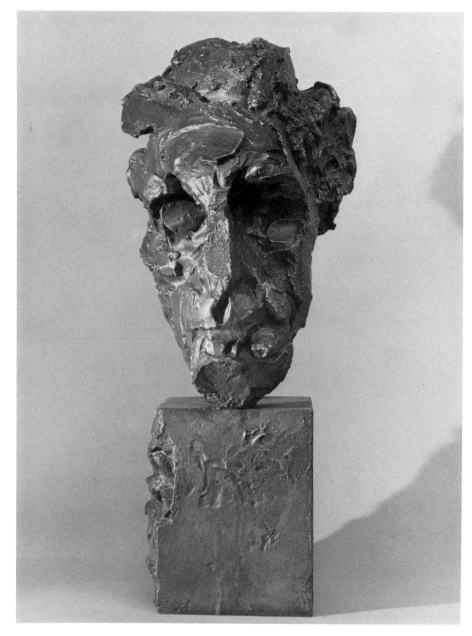

Reuben Nakian. *Head of Marcel Duchamp.* 1943. Bronze, 21¾ in. high. The Hirshhorn Museum and Sculpture Garden, Smithsonian Institution, Washington, D. C.

BRUCE NAUMAN

He leads to everybody and nobody.  —*California, 1970*

211

FRANK O'HARA

HOMAGE TO RROSE SÉLAVY

Towards you like amphibious airplanes
peacocks and pigeons seem to scoot!

First thing in the morning your two eyes
are shining with all night's funny stories

and every time you sit down during the day
someone drops a bunch of rubies in your lap.

When I see you in a drugstore or bar I
gape as if you were a champagne fountain

and when you tell me how your days and nights
seem to you you are my own stupid Semiramis.

Listen, you are really too beautiful to be true
you egg-beater and the next time I see you

clattering down a flight of stairs like a
ferris wheel jingling your earrings and feathers

a subway of smiling girls a regular fireworks
display! I'll beat you and carry you to Venice!

— *Cambridge, Massachusetts, 1949*

GEORGIA O'KEEFFE

It was probably in the early twenties that I first saw Duchamp. Florine Stettheimer made very large paintings for the time, and when a painting was finished she had an afternoon party for twenty or twenty-five people who were particularly interested to see what she had been painting. I probably went with Stieglitz because I'm sure I wouldn't have gone alone.

I had looked at the painting and sat down in a chair at the side of a table a little behind the painting. Someone else was sitting at the other side of the table and Duchamp was sitting in front of me. I don't remember seeing anyone else at the party, but Duchamp was there and there was conversation. I was drinking tea. When I finished he rose from his chair, took my teacup and put it down at the side with a grace that I had never seen in anyone before and have seldom seen since. I don't remember anything else about the party. I don't remember who was there or anything else that happened or was said.

The next time I saw him was at my first large show in 1923 on the top floor of the Anderson Galleries. The show had started. There were not very

many people there when Duchamp came in in a raccoon coat that he had got when he was out in Chicago. He was very proud of the raccoon coat and wore it on every possible occasion. He came in, walking briskly around the room. It was a very large room and I saw him walking around. He came up to me quickly and said, "But where is your self-portrait? Everyone has a self-portrait in his first show." Well, I didn't have a self-portrait and we laughed about it and that's all I remember about that.

The next time I saw Duchamp was when Stieglitz and I went to a studio that he had over on 79th or someplace on the West Side. It was a few flights up in a dismal, drafty building. It was a very large room—again. It was the room where he made the glass paintings and he evidently lived there while he was making them. The room looked as though it had never been swept—not even when he first moved in. There was a single bed with a chess pattern on the wall above it to the left. Nearby was a makeshift chair. There was a big nail in the side of it that you had to be very careful of when you got up or you'd tear your clothes or yourself.

On the other side of the room was a bicycle up on the back wheel with a mirror stuck in the top wheel. There was a bathtub in the corner that he said he had put in himself. Duchamp's two large glass creations that are now in the Philadelphia Museum were standing against the wall not far from the

ALFRED STIEGLITZ

Alfred Stieglitz. *Marcel Duchamp.* c. 1923. Photograph, 8 x 7½ in. The National Gallery of Art, Washington, Alfred Stieglitz Collection.

tub, and the scraps of the pieces of metal he had cut to make the patterns on the glass were right on the floor where they had fallen when he cut them.

There was a bureau with the bottom drawer out. The drawer had a good many ties in it, and some were pulled out and hanging over the edge as though he hadn't decided which one he was going to wear. I don't remember much else, but it seems there was a lot of something else in the middle of the room and the dust everywhere was so thick that it was hard to believe. I was so upset over the dusty place that the next day I wanted to go over and clean it up. But Stieglitz told me that he didn't think Duchamp would be very pleased. He thought he probably liked to be just as he was. I remember that I was sick with a cold. I just seemed to be sick from having seen this unpleasantly dusty place. I don't remember seeing Duchamp there. I only remember the things I saw as I walked around the room.

I was in a hall at the Museum of Modern Art one day near the big windows when Duchamp came careening in, saying quickly, "Have you seen my glass paintings?" I was surprised and said I hadn't. "Where are they?" He said he didn't know but they were nailed into the partitions somewhere and where did I think they could be. We walked up and down looking at the thickness of the partitions. There was room for the glass to be in between the boards, but as they were covered and nailed in you couldn't possibly tell where they were. And we both went on our way not knowing.

I think Duchamp came with Demuth when Demuth came to Stieglitz and was photographed. Two shots were made of Duchamp and several of Demuth. Demuth was on his way to the hospital to take insulin and was the thinnest man I've ever seen. Stieglitz's photograph is a different side of Duchamp than was usually seen.—*Abiquiu, New Mexico, 1973*

CLAES OLDENBURG

The artist disappears
No one knows where he went
He leaves his signs here and there
He is seen in this part of town and, the next moment,
    miraculously, on the other side of town.
One senses him rather than sees him—
A lounger, a drunkard, a tennis-player, a bicycle rider,
Always violently denying that he did it.
Everyone gives a different description of the criminal.

*—1961*

From *Guises of Ray Gun,* an unpublished notebook.

YOKO ONO

drink an orange juice laced with
sunshine and spring and you'll see Duchamp

*—1972*

ANTOINE PEVSNER

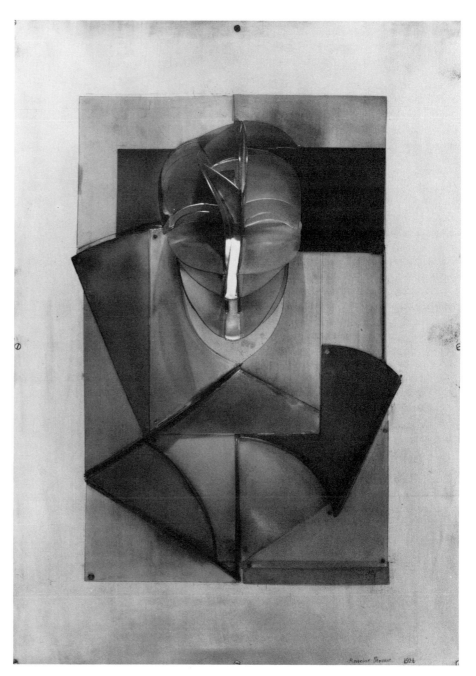

Antoine Pevsner. *Portrait of Marcel Duchamp.* 1926.
High relief construction, celluloid on copper (formerly
zinc), 25¾ x 37 in. Yale University Art Gallery, Gift of
Collection Société Anonyme.

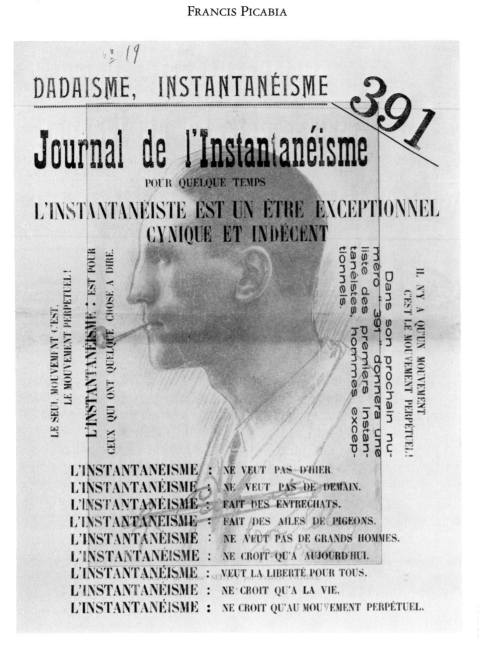

Francis Picabia. *Portrait of Rrose Sélavy.* c. 1924. Cover for *391*, no. XIX, October 1924, Paris. Composed from photograph of the boxer Georges Carpentier.

Marcel Duchamp is all but impossible to write about. Anything you may say about him is at the same time untrue, but when I think of him I get a sweet taste in my body.—*Florida, 1973*

CARL FREDERIK REUTERSWÄRD

THROUGH THE GLASS

The *Large Glass* replica by Ulf Linde, Moderna Museet, Stockholm, 1961.

I am not entirely convinced that it is Marcel Duchamp one observes when looking through the *Large Glass*. In Philadelphia one detects the presence of somebody, camouflaged as an indoor palm tree, permanently installed behind the *Glass*. Tactically—somewhat to the right—like an extra Oculist Witness.

Even on most photographs of the *Glass* this flaccid but enduring representative of the jungle has always contrived to establish its position.

One way to attain clarity about this impression "d'Afrique"—and especially the identity of the palm tree in relation to the *Glass*—is of course to fabricate a *Glass* oneself.

Therefore I decide to enlist myself as Ulf Linde's assistant in his kindred project, an interpretation of the *Glass*. At long last during the summer of 1961 Linde's *Glass* is finished. Without the palm! In spite of comprehensive analyses of Marcel Duchamp's texts and original *Glass* in Philadelphia, Ulf does not succeed in correlating any form of vegetation for his *Glass*. A small birch tree in Moderna Museet's garden thrives ingratiatingly but has difficulties in liberating itself from its northern bonds.

This same summer Teeny and Marcel come to Stockholm. Marcel and Ulf discuss certain technical solutions of the Bride's clothes on the *Glass*. For one second I manage to see into Marcel's eyes—*through* the *Glass*. And I assure you, in them is no glimpse of—gardening.

Marcel signs the *Glass*: "Certifié pour copie conforme/Marcel Duchamp/Stockholm 1961." He paints the words on the lead folio which covers the backside of one of the Bachelors—the Undertaker.

Ulf and I say good-bye to Teeny and Marcel at Stockholm's terminal and return to Moderna Museet. Then! In the entrance to the museum we meet the attendant NL. And what is he not dragging after him, if it isn't a little wheeled wagon upon which an enormous palm tree is swaying! He does not delay in asking us which side of the *Glass* this emblem of victory shall be placed.

"Palma Rei," Heraclitus would have said.—*Lausanne, 1972*

Marcel Duchampion.

marcel played for me his roto-reliefs in Paris. Ten years later they moved in my film "Dreams that money can buy", together with several me can descending a stair= ma co-vered with an cite. ba rel has his eyes is the m c nl. ds and his hands essmen and the en in his eyes. That is why I had ke "8×8", a about chess ✝oly game. ing an affe= marcel my eyes hands, my on the chessmen chessmen in my "8×8 is dedicated marcel as much as am. He was and is the white King who ruled and inspired

Hans Richter 73.

Fra in on chess And to ma= film the X of be= cionnddo, made in my hands and the eyes. Lo y

*—Locarno, Switzerland*

—*Meilen, Switzerland, 1973*

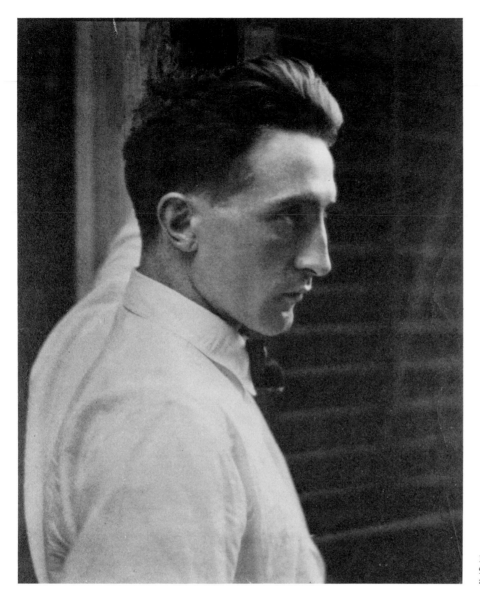

Edward Steichen. *Marcel Duchamp*. 1917. Photograph, $9^{11}/_{16}$ x $7^{1}/_{2}$ in. Philadelphia Museum of Art, The Louise and Walter Arensberg Collection.

GERTRUDE STEIN

### NEXT: LIFE AND LETTERS OF MARCEL DUCHAMP

A family likeness pleases when there is a cessation of resemblances. This is to say that points of remarkable resemblance are those which make Henry leading. Henry leading actually smothers Emil. Emil is pointed. He does not overdo examples. He even hesitates.

But am I sensible. Am I not rather efficient in sympathy or common feeling.

I was looking to see if I could make Marcel out of it but I can't.

Not a doctor to me not a debtor to me not a d to me but a c to me a credit to me. To interlace a story with glass and with rope with color and roam.

How many people roam.

Dark people roam.

Can dark people come from the north. Are they dark then. Do they begin to be dark when they have come from there.

Any question leads away from me. Grave a boy grave.

What I do recollect is this. I collect black and white. From the standpoint of white all color is color. From the standpoint of black. Black is white. White is black. Black is black. White is black. White and black is black and white. What I recollect when I am there is that words are not birds. How easily I feel thin. Birds do not. So I replace birds with tin-foil. Silver is thin.

Life and letters of Marcel Duchamp.

Quickly return the unabridged restraint and mention letters.

My dear Fourth.

Confess to me in a quick saying. The vote is taken.

The lucky strike works well and difficultly. It rounds, it sounds round. I cannot conceal attrition. Let me think. I repeat the fullness of bread. In a way not bread. Delight me. I delight a lamb in birth.—*1922*

From *Geography and Plays* (New York: Something Else Press, 1968).

## JOSEPH STELLA

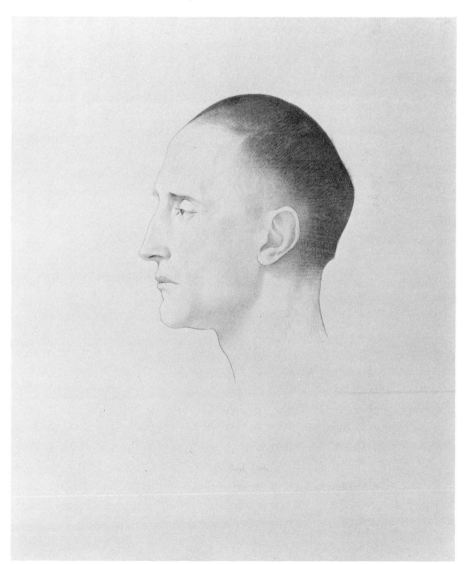

Joseph Stella. *Marcel Duchamp.* c. 1920. Silverpoint drawing, 27¼ x 21 in. The Museum of Modern Art, New York, Katherine S. Dreier Bequest.

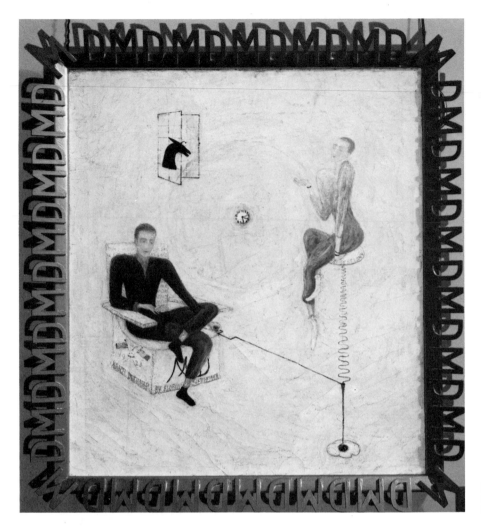

Florine Stettheimer. *Portrait of Marcel Duchamp.* 1923. Oil on canvas, 30 x 26 in. Collection Virgil Thomson, New York.

## SHUZO TAKIGUCHI

I saw Marcel Duchamp only once in my life. It happened to be quite an unexpected and brief encounter at Dali's, as I was just leaving Port Lligat and the taxi was waiting impatiently for me: August 1958.

I first learned the impenetrable myth existing between the *Large Glass* and the notes, thanks to André Breton's initiative article "Phare de la Mariée," and I tried to retell it after Breton in 1936. Far later, I translated some words chiefly from the *Green Box* and *A l'infinitif* in my book *To and from Rrose Sélavy,* privately published in 1968. For all that, I have never *seen* the work itself!

Duchamp was so kind and witty as to baptize my imaginary shop of *objects,* destined possibly to be nowhere, as "Rrose Sélavy." I made also a double-image plastic plate, incorporating his young portrait in profile by Man Ray and Rrose Sélavy's autograph repeated four times, "Rrose Sélavy in the Wilson-Lincoln System" as its title, which I meant for a sort of sign-plaque, to be contained in the book above mentioned, and he OK'ed and signed some copies of it. Duchamp never visited Japan but left his signature there.

How strange and familiar a person he was!

He once wrote to me, "In principle I do not write and I am sending you here a book of my 'writings'!" (*Marchand du Sel*)

He was a "benevolent" writer too, and even a poet, which he should have never thought of: I mean, an unprecedented seer of Time and Space in continuum, not exactly of a physicist's sequence, but in his genuine principle of life, the *c'est la vie* (exactly, the *Sélavy*) manner of his own invention.

The incarnation of great paradox, in spite of himself.

Why not blossoming? The man between. He was and he is, even.

—*Tokyo, 1972*

JEAN TINGUELY

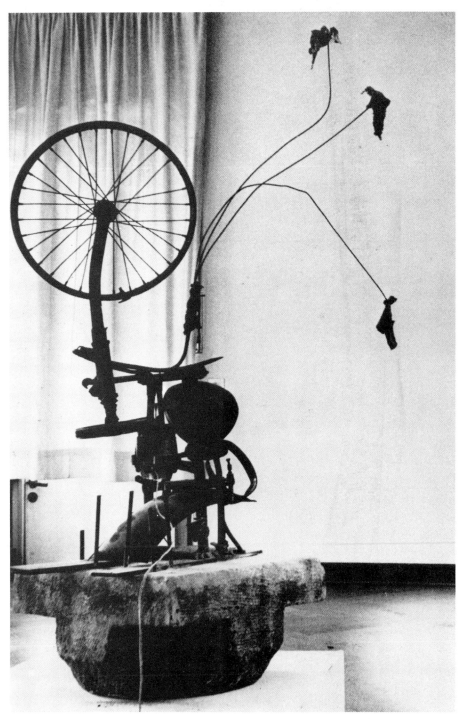

Jean Tinguely. *Hommage à Marcel Duchamp.* c. 1960. Assemblage with bicycle wheel, stone, and motor. Collection of the artist, Soissy-sur-Ecole, France.

## MARCEL DUCHAMP AT PLAY

I met Marcel Duchamp at Walter Arensberg's in the late spring of 1915 soon after he arrived in New York. Having spent innumerable evenings in Walter Arensberg's large hospitable apartment, where every inch of wall space was covered with Cézannes, Picabias, Picassos, Gleizes, Duchamps and many many others, I was familiar with modern art, but only in the way you are familiar with the people you pass every day in your neighborhood; and though I was out of New York during the Armory Show, I had read all the jests and gibes in the papers aimed at the *Nude Descending a Staircase* (one art critic called it "an explosion in a shingle factory," his humor to be matched many years later by a music critic's description of one of Varèse's compositions as "a catastrophe in a boiler factory"). But I was not roused to serious attentiveness until Marcel took me to the gallery at 291 Fifth Avenue and introduced me to Alfred Stieglitz, a great photographer and the John the Baptist in the American desert of modern art. Stieglitz had something of the Ancient Mariner as well. He was a tireless talker, propagandist, and pedagogue and whetted my appetite by all he poured into my virgin ears, while Marcel, wandering around the gallery, would turn to look at me now and then with his crooked smile; he knew Stieglitz well and was amused at the rape of the innocent. My education continued in Marcel's studio, not verbally but by osmosis, receiving quite a fillip from the Readymades, though I hardly appreciated their paradoxical multiplicity of intent. Marcel was only didactic about the French language and taught me all the expressions no lady needs to know, which made Albert Gleizes warn me: "Madame Norton, if you speak like that all the doors of Paris will be closed to you." That tickled Marcel.

To his complete surprise, Marcel on arriving found himself a celebrity, which was, he himself explained, due entirely to the title of his Armory nude; people, being accustomed to nudes lying down or standing, were startled by nudes walking down a staircase. He was soon lionized by *tout New York* and courted by most of the female population. He learned to like our very bibulous American ways and to emulate them; he was keen on parties and the public balls of those days.

I remember one morning after a Webster Hall ball, at the milkman's hour, ending up in my apartment with Marcel and other friends. Famished after a night of carousing, Marcel made straight for my icebox, where he found a superb leg of lamb almost intact. It was not mine but belonged to the Gleizeses, who had no icebox in their apartment on the floor above and sometimes on Saturday night stored food for Sunday in mine. I weakly protested, but Marcel had already started to carve and with his mouth full said I had no sense of humor. After we had eaten it bare, the bone became a Readymade on which Marcel in Dada style expressed thanks, and left it with a couple of bills in front of the Gleizeses' door. We all thought it hilariously funny. Only Juliette and Albert did not laugh when they discovered that hooligans downstairs had eaten their Sunday dinner. Marcel spent the morning scouting around for replacements.

Variations being the fate of legends as they pass through more and more

remote mouths, a very different version of the anecdote is given by Marcel's friend H.-P. Roché in Robert Lebel's book *Marcel Duchamp*. According to Roché, Marcel with his prankish friend Picabia "one Christmas night broke into Gleizes' cellar [nonexistent] and ate a big leg of lamb."

Sometimes we would go to the Café-in-the-Park for breakfast. There remains in my memory a picture of one precociously warm spring morning. Four of us are sitting outside on the terrace. The forsythia is in bloom and Marcel—very anti-nature at that time—has firmly turned his back to the bushes, gloriously yellow against the drab winter background, and looking down at his hands examines them gravely; then holding them up for our inspection says, with his half-muted chuckle, "Drink fingers."

To the amazed disgust of organizers of Duchamp Readymade exhibitions and to my regret, I have allowed to vanish a Readymade he gave me. It was a chimney pot or chimney vane made of ordinary mottled gray tin on which Marcel had written, "pulled at four pins," a designation, like all his others, aimed to be as Alice-in-Wonderland nonsensical as possible. I have, however, one of his beautiful drawings of chess players that I have not allowed to vanish. Noticing that I used to stop to look at it whenever I came to his studio, Marcel had it framed and gave it to me. It has hung on all my numerous walls ever since, finally settling down on my last one at Sullivan Street.

*—New York, 1972*

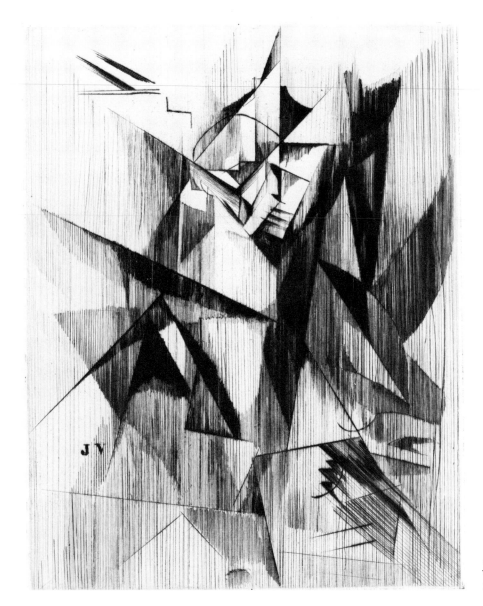

Jacques Villon. *Monsieur D. lisant*. 1913. Etching, 15⅜ x 11⅝ in. The Art Institute of Chicago, Gift of Mr. and Mrs. William O. Hunt.

For Rrose Sélavy and Belle Haleine   —*New York, 1973*

LAWRENCE WEINER

PERHAPS THE SOLE OR AGAIN THE MOST IMPORTANCE ONE CAN ATTRIBUTE TO DUCHAMP IS THE REMARKABLE NUMBER OF POINTS OF REFERENCE HE WAS CAPABLE OF ESTABLISHING WITHOUT RELINQUISHING WHAT AMOUNTS TO A BLIND FAITH IN ART.

IT DOES, ONE MUST ADMIT, BESPEAK A MARVELOUS DEGREE OF CULTURAL MASOCHISM.   —*New York, 1972*

William T. Wiley. *To Marcel Duchamp, 1887–1968, Tool and Die Maker.* 1968. Stainless steel, pyramid 6 x 6 x 7 ft., sphere 28¾ in. diameter, chain 6 ft. long. Collection Mr. and Mrs. Edwin Sabol, Villanova, Pennsylvania.

228

Georges de Zayas. *Marcel Duchamp.* 1919. Lithograph printed in brown, 18⅛ x 12⅛ in. (sheet). The Museum of Modern Art, New York, Gift of the artist, 1949.

# THE WORKS
## OF
## MARCEL DUCHAMP:
## A CATALOG

THE FOLLOWING is offered not as a complete catalogue raisonné of the works of Marcel Duchamp, but as a comprehensive selection intended to give a thorough survey of his career. Invaluable sources for much of the information given here are the oeuvre catalogs of Robert Lebel (bibl. 51) and Arturo Schwarz (bibl. 53), both of whom worked closely with Duchamp. The immense debt owed to their research is gratefully acknowledged. For many of the items listed, those two volumes provide additional information and extensive descriptions. Any differences that are evident here are due to new information that has been made available. Previously uncataloged material is so identified.

The twenty-eight quotations printed in SMALL CAPITALS are taken from previously unpublished notes by Duchamp for a slide lecture, "Apropos of Myself," delivered at the City Art Museum of St. Louis, Missouri, on November 24, 1964. Duchamp gave a series of similar talks at several universities and museums in the United States around that time. The quotations appear here through the courtesy of Mme Marcel Duchamp.

For those works which Duchamp titled in French, the French title is given first and, when possible, an English translation follows. Dimensions are given in inches and centimeters, height preceding width. The place name in parentheses after the title and date of a work is the town (indicated when known) in which the work was executed. Frequent small discrepancies between the date assigned to a work and that inscribed upon it are due to Duchamp's habit of inscribing works some time after they were done (often at the time when he gave them to a friend). Since the history of individual pieces throws considerable light upon Duchamp's career, previous owners of a number of works are listed (when known) and the first public showings of many of the most important early works are also indicated. The numbers preceded by the letter L or S refer to entries in the Lebel or Schwarz catalog. For all unique works listed here, unless otherwise stated the present owner and location are noted. —A.d'H. and K.McS.

1

3

2

1. LANDSCAPE AT BLAINVILLE, 1902
Oil on canvas, 24 x 19$\frac{11}{16}$ in. (61 x 50 cm)
Inscribed lower right: *M Duchamp/02* (initials form a monogram)
Cat: L 209, S 5
Ex coll: Marcel Lefrançois, Blainville; Cordier & Ekstrom, Inc., New York

Collection Vera and Arturo Schwarz, Milan

One of Duchamp's first known paintings, this landscape of water and woods finds curious echoes in much later works. Despite his boredom with filling in the background of a picture (one of the reasons which led him to work on glass), an interest in landscape recurs in the Readymade *Pharmacy* of 1914, the little mixed-media study *Moonlight on the Bay at Basswood* of 1954, and in the elaborate photo-collage background of *Etant donnés*.

2. CHURCH AT BLAINVILLE, 1902
Oil on canvas, 24 x 16$\frac{3}{4}$ in. (61 x 42.5 cm)
Inscribed lower right: *M Duchamp/02*
Cat: L 1, S 6
Ex coll: Louise and Walter Arensberg, Hollywood, acquired through the artist in 1950

Philadelphia Museum of Art, The Louise and Walter Arensberg Collection

"BLAINVILLE IS A VILLAGE IN NORMANDY WHERE I WAS BORN, AND THIS PAINTING WAS DONE IN 1902, WHEN I WAS ONLY FIFTEEN YEARS OLD.

"I WAS STILL ATTENDING SCHOOL IN ROUEN AT THE LYCÉE AND TWO OF MY CLASSMATES WERE ALSO STARTING TO PAINT. WE EXCHANGED VIEWS ON IMPRESSIONISM, WHICH WAS THE ART REVOLUTION OF THE MOMENT AND STILL ANATHEMA IN OFFICIAL ART SCHOOLS. HOWEVER, MY CONTACT WITH IMPRESSIONISM AT THAT EARLY DATE WAS ONLY BY WAY OF REPRODUCTIONS AND BOOKS, SINCE THERE WERE NO SHOWS OF IMPRESSIONIST PAINTERS IN ROUEN UNTIL MUCH LATER.

"EVEN THOUGH ONE MIGHT CALL THIS PAINTING 'IMPRESSIONISTIC' IT REALLY SHOWS ONLY A VERY REMOTE INFLUENCE OF MONET, MY PET IMPRESSIONIST AT THAT MOMENT."

3. SUZANNE DUCHAMP SEATED, 1903 (Blainville)
Colored pencils on paper, 19$\frac{1}{2}$ x 12$\frac{5}{8}$ in. (49.5 x 32 cm)
Inscribed lower left, in red pencil: *M Duchamp/Août 03* (initials form monogram)
Cat: L 5i, S 16
Ex coll: Mme Suzanne Crotti, Neuilly

Collection Mme Marcel Duchamp, Villiers-sous-Grez, France

4. HANGING GAS LAMP (BEC AUER),
1903–4 (Rouen)

Charcoal on paper, $8\frac{13}{16}$ x $6\frac{3}{4}$ in.
(22.4 x 17.2 cm)

Inscribed lower left, in pencil: *Ecole
Bossuet/MD.;* inscribed lower center in
pencil: *circa 1902*

Cat: L 4b, S 19

Ex coll: Mme Suzanne Crotti, Neuilly

Collection Mme Marcel Duchamp, Villiers-
sous-Grez

A prophetic work from Duchamp's school-
days. The Bec Auer gas lamp was to appear
again sixty years later, clasped in the hand of
the reclining nude figure in *Etant donnés*.
Posters for the Bec Auer company, fre-
quently showing gas lamps held aloft by
decorative women, were probably a fre-
quent sight in Rouen and Paris during
Duchamp's youth, and may have given him
one visual cue for the ideas later elaborated
in that tableau.

5. PORTRAIT OF MARCEL LEFRANÇOIS, 1904
(Blainville)

Oil on canvas, $25\frac{1}{2}$ x $23\frac{7}{8}$ in. (64.8 x 60.7
cm)

Inscribed verso, upper right, in ink: *Portrait
de Marcel/Lefrançois/Marcel Duchamp/
1904/Signé en 1950*

Cat: L 8, S 22

Ex coll: Louise and Walter Arensberg,
Hollywood, acquired through the artist
in 1950

Philadelphia Museum of Art, The Louise
and Walter Arensberg Collection

"PAINTED . . . AROUND 1904, THIS POR-
TRAIT OF A YOUNG FRIEND OF MINE WAS
ALREADY A REACTION AGAINST THE IM-
PRESSIONIST INFLUENCE.

"IN THIS PAINTING I WANTED TO TRY
OUT A TECHNIQUE OF THE RENAISSANCE
PAINTERS CONSISTING IN PAINTING FIRST
A VERY PRECISE BLACK AND WHITE OIL AND
THEN, AFTER IT WAS THOROUGHLY DRY,
ADDING THIN LAYERS OF TRANSPARENT
COLORS.

"THIS TECHNIQUE OF PRECISION WAS DE-
LIBERATELY IN CONTRAST WITH MY FIRST
ATTEMPTS AT OIL PAINTING AND IT HELPED
ME TO KEEP MY FREEDOM OF DEVELOPMENT
INSTEAD OF STICKING TO ONE FORMULA.

"NEVERTHELESS, I ABANDONED IT VERY
SOON TO DIRECT MY RESEARCH TOWARDS
ALL SORTS OF UNSUCCESSFUL TRIES MARKED
BY INDECISION AND FINALLY DISCOVERED
THE IMPORTANCE OF CÉZANNE."

G. M. Mataloni. *Bec Auer Gas Mantles*. 1895. Poster.

4

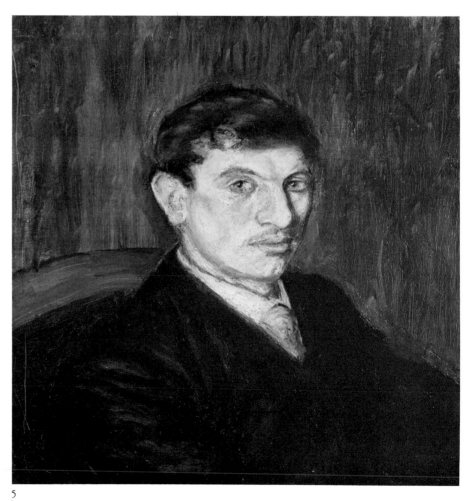

5

6

7

8

9

6. PORTRAIT OF JACQUES VILLON, 1904–5 (Paris)
Charcoal on double sheet of paper, 12³⁄₁₆ x 7¹⁵⁄₁₆ in. (31 x 20.2 cm)
Inscribed lower center, in pencil: *Portrait de Villon/MD.*
Cat: L 4f, S 23
Ex coll: Mme Suzanne Crotti, Neuilly

Collection Dr. Robert Jullien, Paris

During his first year in Paris, Duchamp shared a studio on the Rue Caulaincourt with Villon, who was already an accomplished draftsman. The influence of Villon's style, in both quick sketches and more elaborate etchings, is evident in the early work of his younger brother.

7. RAYMOND DUCHAMP-VILLON, 1904–5 (Paris)
Conté pencil on paper, 8¹⁄₄ x 5¹⁄₈ in. (21 x 13 cm)
Inscribed lower right, in pencil: *Marcel Duchamp*
Cat: L 9, S 29
Ex coll: Henri-Pierre Roché, Paris, sketchbook acquired from the artist, c. 1940; Cordier & Ekstrom, Inc., New York; The Mary Sisler Collection, New York; Carl Solway Gallery, Cincinnati, Ohio

Collection Charles Koch, Cincinnati, Ohio

8. POLICEMAN, BACK VIEW, 1904–5 (Paris)
Conté pencil on paper, 8¹⁄₄ x 5¹⁄₈ in. (21 x 13 cm)
Inscribed lower right, in pencil: *M.D.*
Cat: L 9, S 41
Ex coll: Henri-Pierre Roché, Paris, sketchbook acquired from the artist, c. 1940

Galleria Schwarz, Milan

One of a series of early sketchbook studies of men wearing uniforms or engaged in specific trades. The policeman is recognizable by the outline of his uniform (clothes make the man) and prefigures Duchamp's preoccupation with external appearances in the *Nine Malic Molds.*

9. THE KNIFE-GRINDER, 1904–5 (Paris)
Pencil and india ink on paper, 8¹⁄₄ x 5¹⁄₈ in. (21 x 13 cm)
Inscribed lower right, in pencil: *Marcel Duchamp*
Cat: L 9, S 42
Ex coll: Henri-Pierre Roché, Paris, sketchbook acquired from the artist, c. 1940

Collection Mme Marcel Duchamp, Villiers-sous-Grez

Perhaps the first appearance of a rotating machine in Duchamp's work.

235

10. GASMAN, 1904–5 (Paris)
Pencil and wash on paper, $6^{13}/_{16}$ x $4^{3}/_{16}$ in. (17.3 x 10.7 cm)
Inscribed lower center in pencil: *Employé du gaz;* inscribed lower left, in pencil: *Marcel Duchamp*
Cat: L 9, S 43
Ex coll: Henri-Pierre Roché, Paris, sketch-book acquired from the artist, c. 1940; Cordier & Ekstrom, Inc., New York; The Mary Sisler Collection, New York; Carl Solway Gallery, Cincinnati, Ohio

Collection John J. Sullivan, Cincinnati, Ohio

11. VEGETABLE PEDDLER, 1904–5 (Paris)
Pencil and wash on paper, $6^{13}/_{16}$ x $4^{3}/_{16}$ in. (17.3 x 10.7 cm)
Inscribed lower right, in pencil: *Marcel Duchamp*
Cat: L 9, S 44
Ex coll: Henri-Pierre Roché, Paris, sketch-book acquired from the artist, c. 1940; Cordier & Ekstrom, Inc., New York; The Mary Sisler Collection, New York; Carl Solway Gallery, Cincinnati, Ohio

The Pollock Gallery, Toronto

12. FUNERAL COACHMAN, 1904–5 (Paris)
Conté pencil on paper, $8^{1}/_{4}$ x $5^{1}/_{8}$ in. (21 x 13 cm)
Inscribed lower right, in pencil: *Marcel Duchamp*
Cat: L 9, S 48
Ex coll: Henri-Pierre Roché, Paris, sketch-book acquired from the artist, c. 1940; Cordier & Ekstrom, Inc., New York; The Mary Sisler Collection, New York; Carl Solway Gallery, Cincinnati, Ohio

Collection Timothy Baum, New York

13. COACHMAN ON BOX, 1904–5 (Paris)
Pencil and watercolor on paper, $8^{5}/_{8}$ x $5^{1}/_{2}$ in. (22 x 14 cm)
Inscribed lower center, in pencil: *Marcel Duchamp*
Cat: S 51
Ex coll: Henri-Pierre Roché, Paris, acquired from the artist, c. 1940

Galleria Schwarz, Milan

10

11

12

13

14

17

15

16

14. BIG WOMAN AND BABY, 1904–5 (Paris)
Pencil and wash on paper, $6^{13}/_{16}$ x $4^3/_{16}$ in.
(17.3 x 10.7 cm)
Inscribed lower center, in pencil: *Marcel Duchamp*
Cat: L 9, S 52
Ex coll: Henri-Pierre Roché, Paris, sketch-book acquired from the artist, c. 1940; Cordier & Ekstrom, Inc., New York; The Mary Sisler Collection, New York; Carl Solway Gallery, Cincinnati, Ohio

Collection Mr. and Mrs. Alan L. Katz, Troy, Michigan

15. KNEELING PEASANT, BACK VIEW, 1904–5 (Paris)
Watercolor on paper, $6^{13}/_{16}$ x $4^3/_{16}$ in.
(17.3 x 10.7 cm)
Inscribed lower right, in pencil: *Marcel Duchamp*
Cat: L 9, S 65
Ex coll: Henri-Pierre Roché, Paris, sketch-book acquired from the artist, c. 1940; Cordier & Ekstrom, Inc., New York; The Mary Sisler Collection, New York; Carl Solway Gallery, Cincinnati, Ohio

Collection Dr. and Mrs. Richard Glins, Hamilton, Ohio

16. THE SACRÉ-COEUR, 1904–5 (Paris)
Pencil on paper, $4^1/_2$ x $4^1/_8$ in. (11.5 x 10.5 cm)
Inscribed lower right, in pencil: *M.D.*
Cat: S 73
Ex coll: Henri-Pierre Roché, Paris, acquired from the artist, c. 1940

Galleria Schwarz, Milan

17. MOULIN DE LA GALETTE, 1904–5 (Paris)
Pencil and wash on paper, $6^{13}/_{16}$ x $4^3/_{16}$ in.
(17.3 x 10.7 cm)
Inscribed lower right, in pencil: *Marcel Duchamp*
Cat: L 9, S 72
Ex coll: Henri-Pierre Roché, Paris, sketch-book acquired from the artist, c. 1940; Cordier & Ekstrom, Inc., New York; The Mary Sisler Collection, New York; Carl Solway Gallery, Cincinnati, Ohio

The Pollock Gallery, Toronto

18. MAGDELEINE DUCHAMP WEARING A RED HOOD, 1905 (Rouen)
Watercolor on paper, $18^{15}/_{16}$ x $12^3/_{16}$ in.
(48 x 31 cm)
Inscribed lower right, in pencil: *M D 21 Mars 05/retrouvé en 1964/Marcel Duchamp* (initials form a monogram)
Cat: L 10a, S 74

Collection Magdeleine Duchamp, Neuilly

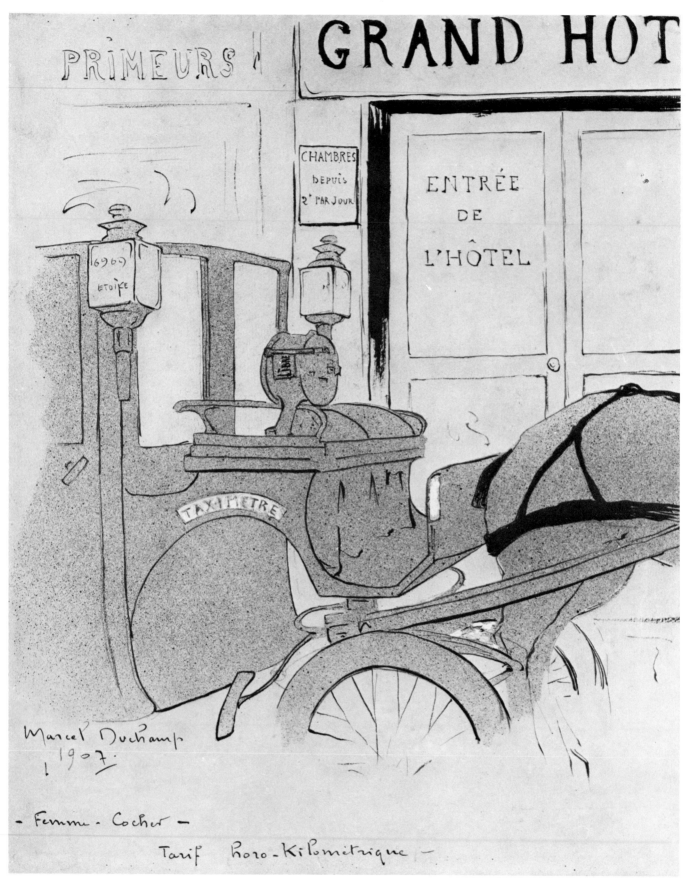

19

19. FEMME-COCHER (WOMAN HACK DRIVER), 1907 (Paris)
Brush and ink, pencil and "splatter" on paper, 12½ x 9⅝ in. (31.7 x 24.5 cm)
Inscribed lower left, in ink: *Marcel Duchamp/1907*
Caption: *Femme-Cocher-/Tarif horo-Kilométrique-*
Cat: L 17, S 79
Ex coll: Henri-Pierre Roché, Paris; Cordier & Ekstrom, Inc., New York

The Mary Sisler Collection, courtesy Fourcade, Droll, Inc., New York

One of the cartoons Duchamp produced for the Paris journals *Le Rire* and *Le Courrier Français* during this period. The themes of such cartoons were often slightly ribald jokes, suiting Duchamp's taste for visual and verbal puns. The inference is that the woman taxi driver (a Paris innovation at the time) is plying two trades at once. She has disappeared into the hotel with her patron, leaving the meter running.

20. FLIRT, 1907 (Paris)
Ink, wash and blue pencil on paper, 12⅜ x 17¹¹⁄₁₆ in. (31.5 x 45 cm)
Inscribed lower right: *Marcel Duchamp / 07-*
Caption: — *Flirt* — / *Elle — Voulez vous que je joue "Sur les Flots Bleus"; Vous verrez comme ce piano rend bien l'impression qui se dégage du titre? / Lui (spirituel) — Ca n'a rien d'étonnant Mademoiselle, c'est un piano . . . aqueux.* (Flirtation / She — Would you like me to play "On the Blue Waters"; You'll see how well this piano renders the impression suggested by the title? / He (wittily) — There's nothing strange about that, it's a watery piano.)
Cat: L 18, S 80
Ex coll: Private collection, Paris

Galleria Schwarz, Milan

A pun on the French term for grand piano (*piano à queue*). The inscription in the lower right-hand corner is an instruction to the printer.

21. MAN SEATED BY A WINDOW, 1907 (Yport)
Oil on canvas, 21⅞ x 15¼ in. (55.6 x 38.7 cm)
Inscribed lower left: *Marcel Duchamp*
Cat: L 14, S 84
Ex coll: Henri-Pierre Roché, Paris; Cordier & Ekstrom, Inc., New York

The Mary Sisler Collection, courtesy Fourcade, Droll, Inc., New York

The model was Felix Barré, the actor, a friend of the Duchamp brothers. Several portraits

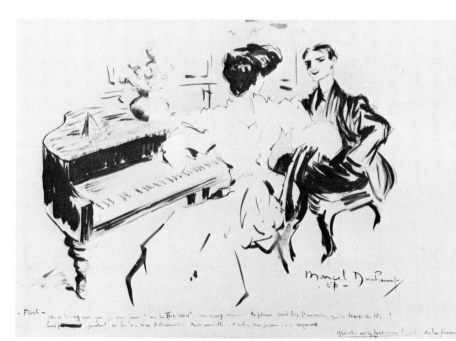

20

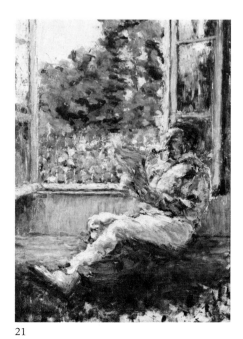

21

of him were also done at this time by Jacques Villon. The painting reveals an interest in effects of light, and the brushwork is lively and loosely handled.

22. Menu de Reveillon (Christmas Eve Menu), 1907 (Paris)
Drypoint, $9\frac{5}{8}$ x $6\frac{1}{8}$ in. (24.5 x 15.5 cm)
Inscribed lower left: *M.D./Déc. 1907*
Cat: L 22, S 86
Ex coll: Mme Ferdinand Tribout, Rouen

Musées de Rouen

This item has been previously recorded but was thought to be lost or destroyed. It marked the occasion of an extremely lively party at Duchamp's Montmartre studio. The style is very close to that of Villon at this time.

23. Two Nudes on a Ladder, 1907–8 (Puteaux)
Pencil on paper, $11\frac{5}{8}$ x $17\frac{1}{8}$ in. (29.5 x 43.5 cm)
Inscribed lower right and lower left in pencil: *MD*
Cat: S 87
Ex coll: Mme Suzanne Crotti, Neuilly

Collection Mlle Magdeleine Duchamp, Neuilly

This sheet is now divided in two. The study on the right belongs to Mme Marcel Duchamp.

24. Information, 1908 (Paris)
India ink on paper, $12\frac{15}{16}$ x $19\frac{7}{8}$ in. (32.8 x 50.5 cm)
Inscribed lower left, in ink: *M. Duchamp 08*
Cat: L 25a, S 89
Ex coll: Private collection, Paris

Galleria Schwarz, Milan

In the style of Boutet de Monvel, an artist Duchamp found extremely boring. A closely related drawing, titled *News,* is in the collection of Robert Lebel, Paris.

25. Peonies in a Vase, 1908 (Rouen)
Oil on canvas, $21\frac{5}{8}$ x $17\frac{1}{8}$ in. (55 x 43.5 cm)
Inscribed lower right: *M. Duchamp/08*
Cat: L 26, S 91
Ex coll: Gustave Candel, Paris; Cordier & Ekstrom, Inc., New York; The Mary Sisler Collection, New York

Galleria Schwarz, Milan

22

24

27

240

23

25

26

28

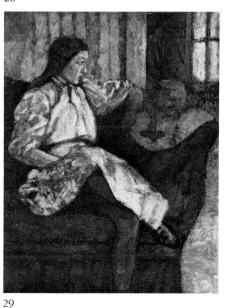

29

26. RED HOUSE AMONG APPLE TREES, 1908 (Puteaux)
Oil on canvas, 21⅝ x 16¹⁵⁄₁₆ in. (55 x 43 cm)
Inscribed lower left: *M Duchamp/08*
Cat: L 27, S 92
Ex coll: Gustave Candel, Paris; Cordier & Ekstrom, Inc., New York; The Mary Sisler Collection, New York

Galleria Schwarz, Milan

The house belonged to the painter Frank Kupka, a neighbor of Villon and Duchamp-Villon at Puteaux. Kupka's studies of figures in motion, done around 1910–11, may have had some influence on the evolution of the *Nude Descending a Staircase.*

27. FOR THE MENU OF SIMONE DELACOUR'S FIRST COMMUNION DINNER, 1909 (Neuilly)
Watercolor and etching on paper, 8⁷⁄₁₆ x 9¹³⁄₁₆ in. (21.5 x 25 cm)
Etched in the plate, lower right: *à Simone/ Delacour/affectueusement/Marcel Duchamp/ 6 Juin 09*
Cat: L 4a, S 101
Ex coll: Mme Suzanne Crotti, Neuilly

Collection Mme Marcel Duchamp, Villiers-sous-Grez

Like so many apparently incidental works, done by Duchamp to please a friend, this etching reveals a serious theme: the girl in her communion dress and veil (like a bride?) watches a procession of toys and dolls who wave goodbye. Is she bidding farewell to her childhood?

28. SAINT SEBASTIAN, 1909 (Veules-les-Roses)
Oil on canvas, 24⅛ x 18¼ in. (61.3 x 46.4 cm)
Inscribed lower right: *Duchamp 09*
Cat: L 31, S 102
Ex coll: Gustave Candel, Paris; Cordier & Ekstrom, Inc., New York

The Mary Sisler Collection, courtesy Fourcade, Droll, Inc., New York

A study of a sculpture in the church of Veules-les-Roses, a coastal town near Rouen.

29. PORTRAIT OF YVONNE DUCHAMP, 1909 (Veules-les-Roses)
Oil on canvas, 34¹⁄₁₆ x 26½ in. (86.5 x 67.3 cm)
Inscribed lower left: *Duchamp*
Cat: L 23, S 103
Ex coll: Gustave Candel, Paris; Cordier & Ekstrom, Inc., New York

The Mary Sisler Collection, courtesy Fourcade, Droll, Inc., New York

Probably painted during a summer holiday, this somewhat mysterious portrait of a younger sister is no longer Impressionist in feeling, but concerned with outlines of forms and the evocation of a mood more than with surface effects of color and light.

30

30. Mi-Carême (Mid-Lent), 1909 (Neuilly)
Conté pencil, ink and "splatter" on paper, 24 x 19⅛ in. (61 x 48.6 cm)
Inscribed lower left, in pencil: *Duchamp/09*
Caption: — Mi-Carême — / — *Naturellement qu'on va sans chapeau au bal* —
( — Mid-Lent — / — Naturally one goes to a ball without a hat — )
Cat: L 34, S 106
Ex coll: Henri-Pierre Roché, Paris; Cordier & Ekstrom, Inc., New York

The Mary Sisler Collection, courtesy Fourcade, Droll, Inc., New York

31. At the Palais de Glace, 1909 (Paris)
Brush and ink with "splatter" on paper, 17 x 12 in. (43.2 x 30.5 cm)
Inscribed center right, in ink: *A Madame et à Monsieur Candel / Respectueusement; / Duchamp 09*
Caption: — *tu vois, on porte beaucoup le tricorne cette année* — / *Lui* — *Oh! tu sais, à une corne près, c'est toujours la mode* —
( — you see how many people are wearing tricorns this year — / He — Oh! you know, a horn or two is always in fashion — )
Cat: L 33, S 107
Ex coll: Gustave Candel, Paris; Cordier & Ekstrom, Inc., New York

The Mary Sisler Collection, courtesy Fourcade, Droll, Inc., New York

32. Dimanches (Sundays), 1909 (Neuilly)
Conté pencil, brush and 'splatter' on paper, 23¾ x 19⅛ in. (60.3 x 48.6 cm)
Inscribed lower center: *Duchamp/09*
Caption: —*Dimanches*—
Cat: L 35, S 108
Ex coll: Henri-Pierre Roché, Paris; Cordier & Ekstrom, Inc., New York

The Mary Sisler Collection, courtesy Fourcade, Droll, Inc., New York

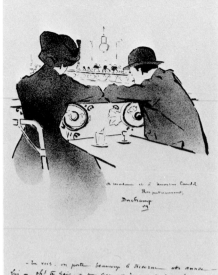

31

34

32                                                33

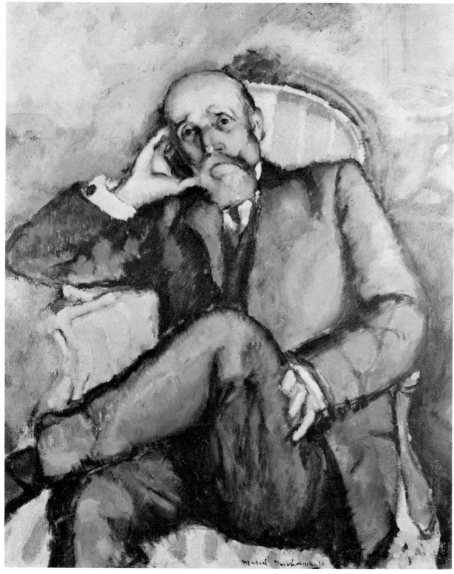

35

33. TUTU, 1909 (Neuilly)
Brush and ink on paper, 13⅛ x 8⅞ in.
(33.3 x 22.5 cm)
Inscribed lower right, in ink: *a Gustave
Candel/Amicalement. ./Duchamp/09*
Cat: L 41a, S 112
Ex coll: Gustave Candel, Paris

Collection Mrs. Arne Horlin Ekstrom, New
York

34. YOUNG MAN STANDING, 1909–10
(Neuilly)
India ink on paper, 16¹⁵⁄₁₆ x 11 in. (43 x
28 cm)
Inscribed lower right, in ink: *Sur com-
mande/de ce vieux Léo./Bien cordialement/
Duchamp.*
Cat: S 119
Ex coll: Mme Ferdinand Tribout, Rouen

Collection Mme Babette Babou, Dinard

Léo Tribout is the wife of one of Duchamp's
oldest friends in Rouen.

35. PORTRAIT OF THE ARTIST'S FATHER,
1910 (Rouen)
Oil on canvas, 36¼ x 28¾ in. (92 x 73 cm)
Inscribed lower center: *Marcel Duchamp 10*
Cat: L 54, S 130
Ex coll: Jean Crotti, Neuilly; Louise and
Walter Arensberg, Hollywood, acquired
through the artist in 1936

Philadelphia Museum of Art, The Louise
and Walter Arensberg Collection

Exh: Rouen, Société Normande de Peinture
Moderne, 1911

"AFTER COMPLETING MY STUDIES AT THE
LYCÉE IN ROUEN, I WENT TO PARIS TO LIVE
FOR A WHILE WITH MY BROTHER, JACQUES
VILLON, AND ENTERED THE ACADÉMIE
JULIAN, A FREE-LANCE ART SCHOOL WHERE I
ONLY LEARNED TO DESPISE ALL ACADEMIC
TRAINING.

"1909 AND 1910 WERE THE YEARS OF MY
DISCOVERY OF CÉZANNE, WHO WAS THEN
ACCLAIMED ONLY BY A MINORITY. THIS POR-
TRAIT OF MY FATHER WAS DONE IN 1910
AND IS A TYPICAL ILLUSTRATION OF MY CULT
FOR CÉZANNE MIXED UP WITH FILIAL LOVE.

"THANKS TO . . . CONSISTENT FINANCIAL
HELP FROM MY FATHER, I WAS ABLE TO CON-
CENTRATE FREELY ON THIS INFLUENCE OF
CÉZANNE WHICH LASTED ABOUT TWO YEARS
AND OPENED NEW VISTAS FOR MY GENERAL
DEVELOPMENT."

36. TWO STANDING NUDES, 1907–10
(Neuilly)
Ink on paper, 19⅞ x 18¹¹⁄₁₆ in. (50.5 x 47.5
cm)
Inscribed under each nude, in pencil: *M D (?)*
Cat: L 11d, S 116
Ex coll: Mme Suzanne Crotti, Neuilly

Collection Mlle Magdeleine Duchamp,
Neuilly

37. NUDE WITH BLACK STOCKINGS, 1910
(Rouen)
Oil on canvas, 45¹¹⁄₁₆ x 35¹⁄₁₆ in. (116 x 89
cm)
Inscribed lower left: *Duchamp/10 —*
Cat: L 46, S 132
Ex coll: Henri-Pierre Roché, Paris

Private collection, New York

In a series of finished paintings and studies
of nudes, done from professional models
during the years 1910–11, Duchamp came as
close as he ever would to current modes of
painting in Paris. The subjects (allegorical
themes or intimate scenes of women bathing
and dressing) were popular among the
Post-Impressionists and the Fauves, and the
style was relatively conventional.

38. TWO NUDES, 1910 (Neuilly)
Oil on canvas, 39 x 31¹¹⁄₁₆ in. (99 x 80.5 cm)
Inscribed lower left: *Marcel Duchamp/vers
1910.*
Cat: L 44, S 135
Ex coll: Henri-Pierre Roché, Paris; Cordier
& Ekstrom, Inc., New York

The Mary Sisler Collection, courtesy Four-
cade, Droll, Inc., New York

39. STANDING NUDE, 1910 (Neuilly)
Gouache on cardboard, 23⅝ x 14¹⁵⁄₁₆ in.
(60 x 38 cm)
Inscribed lower right: *à ce cher vieux Tri-
bout/bien cordialement/Duchamp/10*
Cat: L 47, S 136
Ex coll: Mme Ferdinand Tribout, Rouen

Musées de Rouen

A closely related nude study, with the same
curious white outline around the figure, be-
longs to Cordier & Ekstrom, Inc., New
York.

36

38

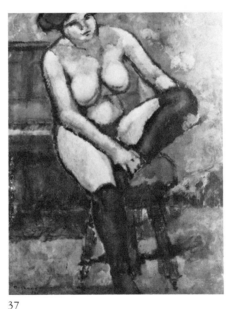

37

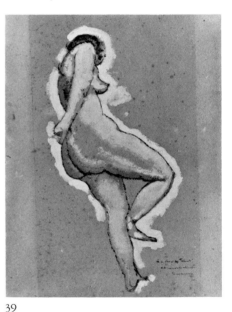

39

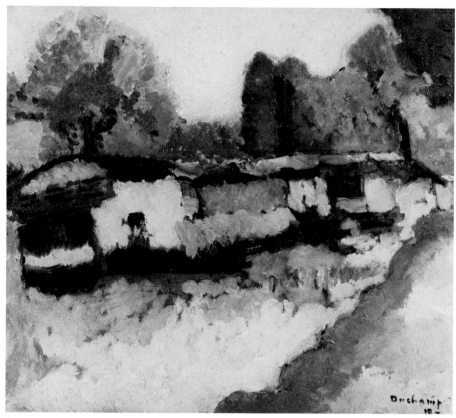

40

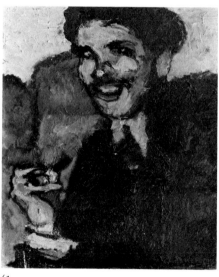

41

40. BATEAU LAVOIR (LAUNDRY BARGE), 1910 (Neuilly)
Oil on cardboard, 26 x 29⅛ in. (66 x 74 cm)
Inscribed lower right: *Duchamp/10 —*
Cat: L 49, S 138
Ex coll: Gustave Candel, Paris; Cordier & Ekstrom, Inc., New York

The Mary Sisler Collection, courtesy Fourcade, Droll, Inc., New York

A study in pure Fauve color.

41. PORTRAIT OF DR. FERDINAND TRIBOUT, 1910
Oil on cardboard, 21⅝ x 17¾ in. (55 x 45 cm)
Inscribed lower right: *Duchamp/—10*
Cat: L 50, S 139
Ex coll: Mme Ferdinand Tribout, Rouen

Musées de Rouen

Dr. Tribout and Dr. Dumouchel were schoolfriends of Duchamp.

42. PORTRAIT OF DR. DUMOUCHEL, 1910 (Neuilly)
Oil on canvas, 39⅜ x 25⁹⁄₁₆ in. (100 x 65 cm)
Inscribed lower left: *Duchamp/10;* inscribed verso, upper right, in ink: *à propos de ta "figure"/mon cher Dumouchel/Bien cordialement/Duchamp.*
Exh: Rouen, Société Normande de Peinture Moderne, 1910
Cat: L 52, S 141
Ex coll: Dr. R. Dumouchel; Louise and Walter Arensberg, Hollywood, purchased July 1951

Philadelphia Museum of Art, The Louise and Walter Arensberg Collection

"IT WAS AROUND 1910 THAT I MADE THE ACQUAINTANCE OF THE 'WILD MEN,' THE FAUVES, AFTER HAVING EXHAUSTED THE RESOURCES OF MY LESSON FROM CÉZANNE. AT THAT TIME, 1905–1910, MATISSE, DERAIN, BRAQUE, AND VAN DONGEN WERE THE WILD BEASTS IN THE ZOO OF PAINTING.

"HERE WE HAVE THE PORTRAIT OF A MEDICAL STUDENT FRIEND OF MINE, DR. DUMOUCHEL, SHOWING MY INTEREST IN THE FAUVES IN 1910. IT REMINDS ONE OF VAN DONGEN'S VIOLENT COLORING AND AT THE SAME TIME, DETAILS, LIKE THE HALOED HAND, INDICATE MY DEFINITE INTENTION TO ADD A TOUCH OF DELIBERATE DISTORTION.

"THE COMPOSITION IS COMPLETELY FREE FROM A SERVILE COPY OF THE MODEL AND BECOMES ALMOST A CARICATURE."

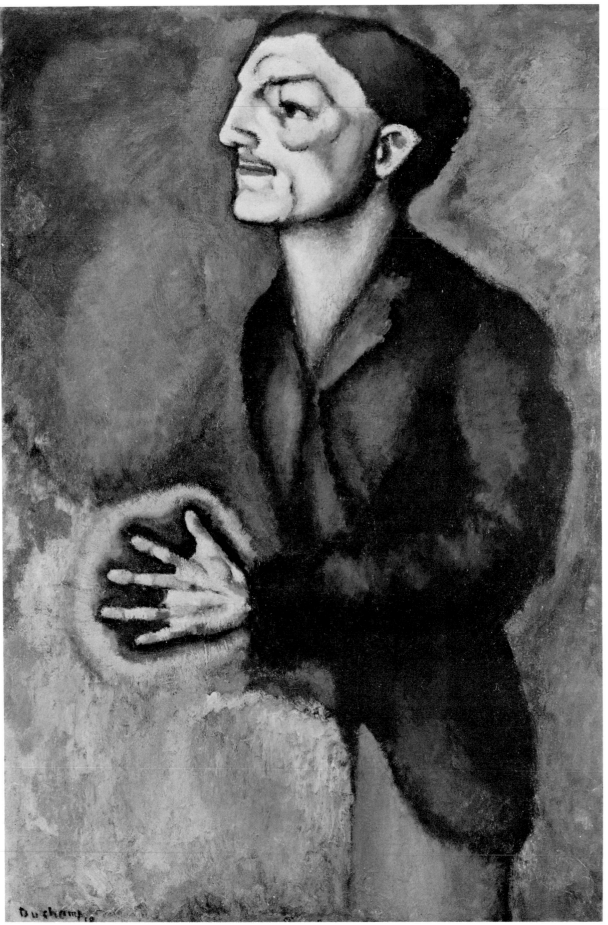

42

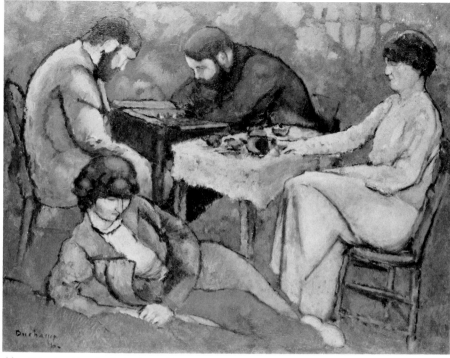

44   *Reproduced in color facing page 129.*

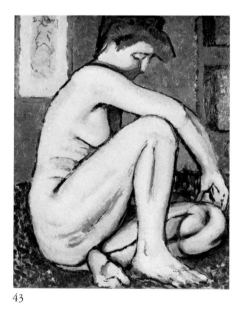

43

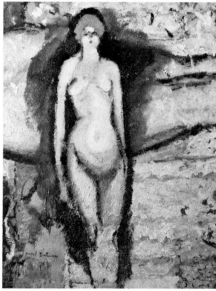

45

43. RED NUDE, 1910 (Neuilly)
Oil on canvas, 36¼ x 28¾ in. (92 x 73 cm)
Inscribed upper left: *Duchamp/10*
Cat: L 55, S 143
Ex coll: Mme Suzanne Crotti, Neuilly;
Cordier & Ekstrom, Inc., New York; The
Mary Sisler Collection, New York

The National Gallery of Canada, Ottawa

44. LA PARTIE D'ÉCHECS (THE CHESS
GAME), August 1910 (Puteaux)
Oil on canvas, 44⅞ x 57½ in. (114 x 146
cm)
Inscribed lower left: *Duchamp/10* —
Exh: Paris, Salon d'Automne, October 1–
November 8, 1910, cat. no. 346; New
York, Carroll Galleries, "Third Exhibition
of Contemporary French Art," March 8–
April 3, 1915, cat. no. 18
Cat: L 56, S 144
Ex coll: John Quinn (purchased from
Carroll Galleries in 1915); The artist (pur-
chased prior to Quinn sales in 1926); H. M.
Tovell, 1926; Walter Pach, New York;
Louise and Walter Arensberg, Hollywood,
acquired through the artist in 1950

Philadelphia Museum of Art, The Louise
and Walter Arensberg Collection

"ANOTHER EXAMPLE OF THE INFLUENCE OF
CÉZANNE IS THIS GAME OF CHESS, BETWEEN
MY TWO BROTHERS.
  "PAINTED IN THE SUMMER OF 1910 IN THE
GARDEN OF PUTEAUX, WHERE THEY LIVED,
IT WAS SHOWN AT THE SALON D'AUTOMNE
IN OCTOBER OF THE SAME YEAR.
  "THE JURY OF THE SALON AWARDED ME THE
TITLE OF 'SOCIÉTAIRE' WHICH GAVE ME,
FROM THEN ON, THE PRIVILEGE TO EXHIBIT
WITHOUT PASSING THROUGH THE JURY.
CURIOUSLY ENOUGH I NEVER TOOK ADVAN-
TAGE OF THIS DISTINCTION, AND NEVER
SHOWED AGAIN AT THE SALON D'AUTOMNE.
  "IN FRONT OF MY TWO BROTHERS PLAYING
CHESS YOU SEE MY TWO SISTERS-IN-LAW
HAVING TEA."

45. NUDE ON NUDE, 1910–11 (?)
Oil on board, 25⁹⁄₁₆ x 19¹¹⁄₁₆ in. (65 x 50
cm)
Inscribed lower left: *Marcel Duchamp*
Inscribed verso (in 1960): (*1910 ou 9?*)
Cat: L 39, S 98
Ex coll: Henri-Pierre Roché, Paris

Collection Arnold D. Fawcus, Paris

Duchamp could not remember precisely
when this study was done, but in color and
subject it seems to fall with the work done
in the winter of 1910–11.

46. STUDY OF KNEELING NUDE, 1910 (Neuilly)

India ink and pencil on paper, 20¼ x 11⅝ in. (51.5 x 29.5 cm)

Inscribed lower right, in ink: *à ce cher Hervieu/affectueusement/Duchamp. 10*

Cat: L 59a, S 153

Ex coll: Mme Gustave Hervieu, Paris; Charles Feingarten Galleries, Los Angeles

Collection Mr. and Mrs. Harry W. Anderson, Atherton, California

47. LANDSCAPE, 1911 (Neuilly)

Oil on canvas, 18¼ x 24⅛ in. (46.3 x 61.3 cm)

Inscribed lower left (two signatures, one almost obliterated):
*MARCEL DUCHAMP/11*

Cat: L 65, S 159

Ex coll: Dr. Nagel, New York (gift of the artist in return for medical services); Katherine S. Dreier, West Redding, Connecticut

The Museum of Modern Art, New York, Katherine S. Dreier Bequest, 1953

Possibly a study for the landscape in the upper left background of the painting *Paradise.* It seems probable that both works were executed during the winter of 1910–11.

48. PARADISE, 1910–11 (Neuilly)

Oil on canvas, 45 1/16 x 50 9/16 in. (114.5 x 128.5 cm)

Inscribed lower left (probably around 1950):
*MARCEL DUCHAMP/(PAINTED 1910).*

Cat: L 94, S 142

Ex coll: Arthur Jerome Eddy, Chicago, acquired in 1913

Philadelphia Museum of Art, The Louise and Walter Arensberg Collection

The model for Adam was Duchamp's friend, Dr. Dumouchel, while a professional model posed for Eve. Picabia was to paint a version of the same subject a year later. In 1912 Duchamp used the back of this canvas to paint *King and Queen Surrounded by Swift Nudes* (see no. 78).

47

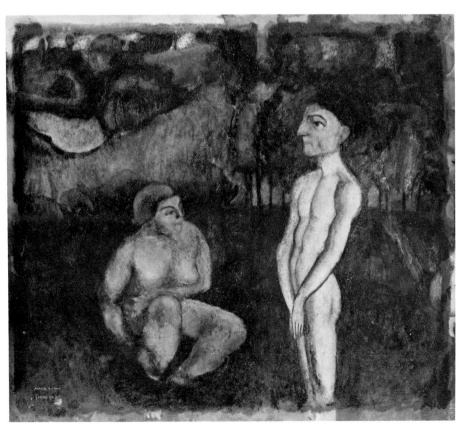

48

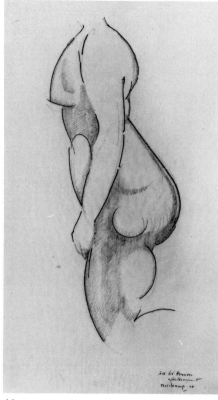

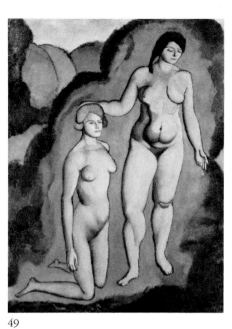

46

49

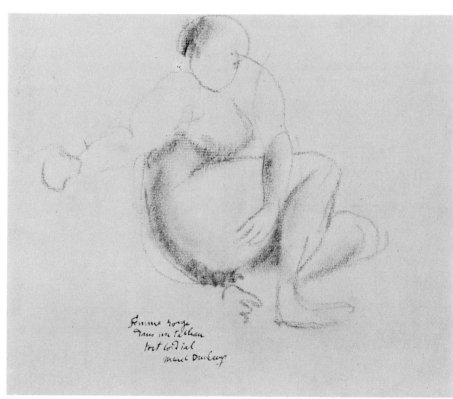

50

49. Le Buisson (The Bush), 1910–11 (Neuilly)
Oil on canvas, 50 x 36¼ in. (127 x 92 cm)
Inscribed lower right: *MARCEL DUCHAMP/11*
Exh: Paris, Salon des Indépendants, April 21–June 13, 1911, cat. no. 1958
Cat: L 62, S 156
Ex coll: Dr. R. Dumouchel, Neuilly; Louise and Walter Arensberg, Hollywood, acquired in 1938

Philadelphia Museum of Art, The Louise and Walter Arensberg Collection

"FAUVISM AS A SCHOOL WAS CHARACTERIZED BY THE FREE USE OF DISTORTION WHICH CÉZANNE AND THE IMPRESSIONISTS HAD INITIATED.

"THIS PAINTING, CALLED THE BUSH, SHOWS A TURN TOWARD ANOTHER FORM OF FAUVISM NOT BASED ON DISTORTION ALONE. THE FIGURES ARE STYLIZED IN THEIR DESIGN, AND THE COLORS ARE CONTRASTED AND BLENDED AT THE SAME TIME.

"THE PRESENCE OF A NON-DESCRIPTIVE TITLE IS SHOWN HERE FOR THE FIRST TIME. IN FACT, FROM THEN ON, I ALWAYS GAVE AN IMPORTANT ROLE TO THE TITLE WHICH I ADDED AND TREATED LIKE AN INVISIBLE COLOR."

Duchamp also stated, in a letter of 1951 to Miss Mary Ann Adler, the Arensbergs' restorer in California:

". . . without a definite 'plot,' I was looking for some 'raison d'être' in a painting *otherwise* than the *visual* experience—The Bush and the 2 nudes in relation to one another seemed at that time to satisfy the desire I had to introduce some anecdote without being 'anecdotal'. ——In other words I did not, in that painting, illustrate a definite theme, but the disposition of the three elements evoked for me the possibility to invent a theme for it, *afterwards.*" (Arensberg Archive, Philadelphia Museum of Art.)

50. Femme rouge dans un tableau (Red Woman in a Painting), 1910–11
Pencil on paper, 7½ x 9⅜ in. (19 x 23.8 cm)
Inscribed lower left, in india ink: *Femme rouge/dans un tableau/tout cordial/Marcel Duchamp*
Cat: L 60, S 155
Ex coll: Gustave Hervieu, Paris; Charles Feingarten Galleries, Los Angeles; Lee Ault & Co., New York; Royal Marks Gallery, New York

Collection Mr. and Mrs. Jack Sonnenblick, New York

A study for the right-hand figure in *Baptism*.

51. BAPTÊME (BAPTISM), 1911 (Neuilly)
Oil on canvas, 36⅛ x 28⅝ in. (91.7 x 72.7 cm)
Inscribed lower right: *MARCEL DU-CHAMP/11:* inscribed on reverse (now covered by relining): *Au cher Tribout Carabin/j'offre ce "Baptême": M.D.*
Cat: L 64, S 158
Ex coll: Dr. Ferdinand Tribout, Rouen, gift of the artist; Louise and Walter Arensberg, Hollywood, acquired in 1937

Philadelphia Museum of Art, The Louise and Walter Arensberg Collection

52. COURANT D'AIR SUR LE POMMIER DU JAPON (DRAFT ON THE JAPANESE APPLE TREE), 1911 (Puteaux)
Oil on canvas, 24 x 19¹¹⁄₁₆ in. (61 x 50 cm)
Inscribed lower left: *pour Gaby/Marcel Duchamp/vers 1911*
Cat: L 66, S 160
Ex coll: Mme Jacques Villon, Puteaux

Collection Dr. S. H. Jurmand, Paris

53. STANDING NUDE, 1911 (Neuilly)
India ink and charcoal on paper, 24⅝ x 18¹³⁄₁₆ in. (62.5 x 47.8 cm)
Inscribed lower center, in pencil: *M D/ Marcel Duchamp/1911*
Cat: L 67, S 161
Ex coll: Mme Suzanne Crotti, Neuilly

Collection Vera and Arturo Schwarz, Milan

A study for the left-hand figure of the leaping girl in *Young Man and Girl in Spring.*

54. YOUNG MAN AND GIRL IN SPRING, 1911 (Neuilly)
Oil on canvas, 25⅞ x 19¾ in. (65.7 x 50.2 cm)
Inscribed lower right: *MARCEL DU-CHAMP/11;* inscribed verso: *A toi ma chère Suzanne Marcel*
Exh: Paris, Salon d'Automne, October 1–November 8, 1911, cat. no. 401
Cat: L 68, S 162
Ex coll: Mme Suzanne Crotti, Neuilly, gift of the artist, 1911; Cordier & Ekstrom, Inc., New York; The Mary Sisler Collection, New York

Collection Vera and Arturo Schwarz, Milan

A study for the large painting, never completed, which became the bottom layer of the later composition *Network of Stoppages.* One of Duchamp's most provocative early works, the allegorical subject of this painting has received extensive critical analysis. For one interpretation, see the essay by Arturo Schwarz in this volume.

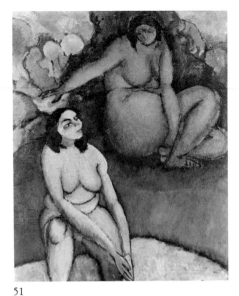

51

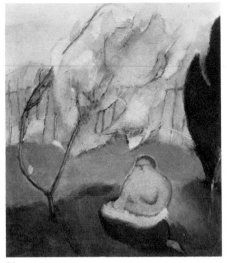

52

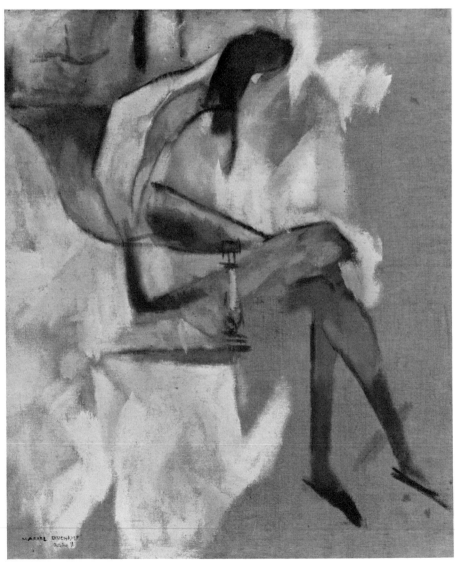

55

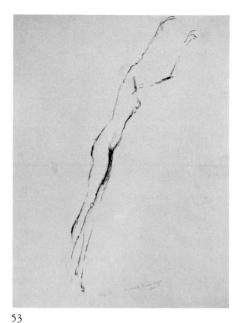

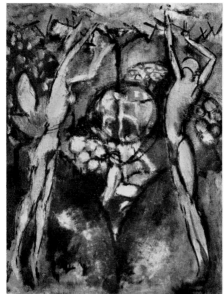

53

54 *Reproduced in color facing page 81.*

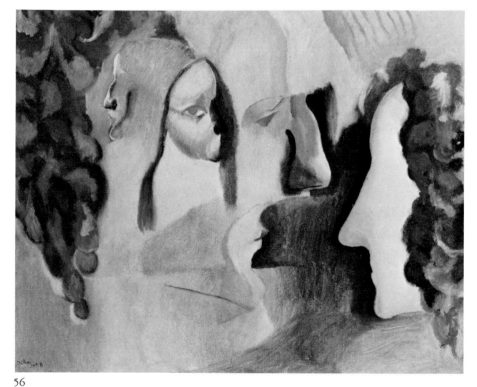

56

55. A PROPOS DE JEUNE SOEUR (APROPOS OF LITTLE SISTER), 1911 (Rouen)
Oil on canvas, 28¾ x 23⅝ in. (73 x 60 cm)
Inscribed lower left: *MARCEL DUCHAMP/ Octobre 11;* inscribed verso: *Une étude de femme/Merde*
Exh: New York, Carroll Galleries, "Third Exhibition of Contemporary French Art," March 8–April 3, 1915, cat. no. 19
Cat: L 74, S 164
Ex coll: John Quinn, New York, acquired in 1915; Henri-Pierre Roché and the artist, bought back from Quinn estate in 1925; Cordier & Ekstrom, Inc., New York; The Mary Sisler Collection, New York

The Solomon R. Guggenheim Museum, New York

A study of Magdeleine Duchamp, apparently seated reading or working by the light of a candle at her side.

56. YVONNE ET MAGDELEINE DÉCHIQUE-TÉES (YVONNE AND MAGDELEINE TORN IN TATTERS), 1911 (Veules-les-Roses)
Oil on canvas, 23⅝ x 28¾ in. (60 x 73 cm)
Inscribed lower left: *Dchp/Sept. 11;* inscribed verso: *Marcel Duchamp/Yvonne et Magdeleine/déchiquetées 1911*
Exh: New York, Montross Galleries, "Exhibition of Pictures by Jean Crotti, Marcel Duchamp, Albert Gleizes, Jean Metzinger," April 4–22, 1916, cat. no. 24
Cat: L 73, S 163
Ex coll: Louise and Walter Arensberg, New York, as early as 1918

Philadelphia Museum of Art, The Louise and Walter Arensberg Collection

"YVONNE AND MAGDELEINE WERE AND STILL ARE MY TWO YOUNGER SISTERS. IN-TRODUCING HUMOR FOR THE FIRST TIME IN MY PAINTINGS I, SO TO SPEAK, TORE UP THEIR PROFILES AND PLACED THEM AT RAN-DOM ON THE CANVAS. YOU CAN SEE FOUR PROFILES FLOATING IN MID-AIR.

"THERE AGAIN WE HAVE A VERY LOOSE INTERPRETATION OF THE CUBIST THEORIES— TWO PROFILES OF EACH SISTER OF A DIFFER-ENT SCALE AND SCATTERED ABOUT THE CAN-VAS; IN OTHER WORDS, I WAS TRYING VERY HARD TO GET AWAY FROM ANY TRADI-TIONAL OR EVEN CUBISTIC COMPOSITION."

57. SONATE (SONATA), 1911 (Rouen, Neuilly)

Oil on canvas, 57 1/16 x 44 1/2 in. (145 x 113 cm)

Inscribed lower left: *MARCEL DU-CHAMP/11;* inscribed verso: *Sonate/MARCEL DUCHAMP/11*

Exh: Paris, Galerie d'Art Ancien et d'Art Contemporain, "Exposition d'Art Contemporain," November 20–December 16, 1911, cat. no. 9

Cat: L 71, S 171

Ex coll: Louise and Walter Arensberg, New York, as early as 1918

Philadelphia Museum of Art, The Louise and Walter Arensberg Collection

". . . THIS FAMILY SCENE, MY MOTHER AND MY THREE SISTERS, WAS PAINTED IN 1911, WHEN I BEGAN TO USE A TECHNIQUE CLOSER TO CUBISM.

"THE PALE AND TENDER TONALITIES OF THIS PICTURE, IN WHICH THE ANGULAR CONTOURS ARE BATHED IN AN EVANESCENT ATMOSPHERE, MAKE IT A DEFINITE TURNING POINT IN MY EVOLUTION.

"CUBISM WAS STILL IN ITS CHILDHOOD IN 1911, AND THE THEORY OF CUBISM ATTRACTED ME BY ITS INTELLECTUAL APPROACH. THIS PAINTING WAS MY FIRST ATTEMPT TO EXTERIORIZE MY CONCEPTION OF CUBISM AT THAT TIME. THIS CONCEPTION WAS FORTUNATELY QUITE DIFFERENT FROM THE ALREADY EXISTING EXPERIMENTS. I SAY 'FORTUNATELY' BECAUSE ON ACCOUNT OF MY INTEREST IN CUBISM, I WANTED TO INVENT OR FIND MY OWN WAY INSTEAD OF BEING THE PLAIN INTERPRETER OF A THEORY."

Mme Duchamp stands behind her daughters, Suzanne is in foreground, Yvonne plays the piano, Magdeleine the violin.

58. PORTRAIT (DULCINÉE) (PORTRAIT [DULCINEA]), 1911 (Neuilly)

Oil on canvas, 57 1/2 x 44 7/8 in. (146 x 114 cm)

Inscribed lower left: *MARCEL DUCHAMP/11;* inscribed verso: *Duchamp Marcel/Portrait*

Exh: Paris, Salon d'Automne, October 1–November 8, 1911, cat. no. 402

Cat: L 72, S 172

Ex coll: Louise and Walter Arensberg, New York, as early as 1918

Philadelphia Museum of Art, The Louise and Walter Arensberg Collection

This portrait was of an anonymous woman Duchamp occasionally saw walking her dog in Neuilly. As she progresses across the canvas in five successive images she is gradually divested of her clothing.

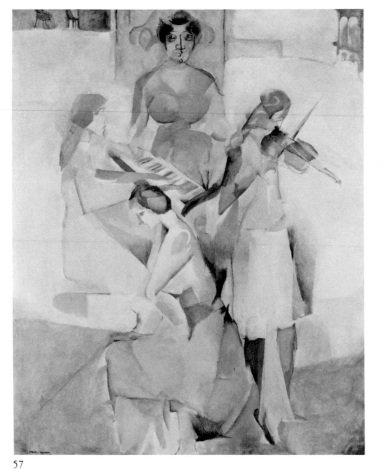

57

58

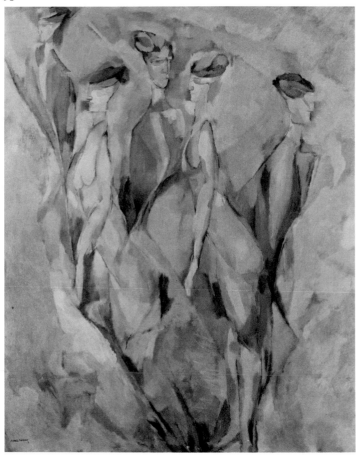

59

60

61

62

63

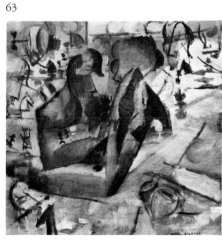

64

59. STUDY FOR "PORTRAIT OF CHESS PLAYERS," 1911 (Neuilly)

Charcoal on paper, 17 x 23 in. (43.1 x 58.4 cm)

Inscribed lower right, in ink: *Marcel Duchamp/11;* inscribed below, in ink: *pour Jackie, la fée Parmentière/Marcel 1964*

Cat: L 75, S 166

Ex coll: Mme Suzanne Crotti, Neuilly

Collection Jacqueline Monnier, Paris

The most naturalistic of a group of studies for the *Portrait of Chess Players,* a complex Cubist painting of his brothers Villon and Duchamp-Villon absorbed in their game.

60. STUDY FOR "PORTRAIT OF CHESS PLAYERS," 1911 (Neuilly)

Charcoal and ink on paper, 13 x 15⅜ in. (33 x 39 cm)

Inscribed lower right, in pencil: *Marcel Duchamp 11*

Cat: L 76, S 165

Ex coll: Louise and Walter Arensberg, New York, as early as 1918

Philadelphia Museum of Art, The Louise and Walter Arensberg Collection

61. POUR UNE PARTIE D'ÉCHECS (FOR A GAME OF CHESS), 1911 (Neuilly)

Ink and watercolor on paper, 6½ x 6⅛ in. (16.5 x 15.6 cm)

Inscribed lower center, in ink: *pour une partie d'échecs. M. Dchp 11*

Cat: L 79, S 167

Ex coll: Katherine S. Dreier, West Redding, Connecticut, gift of estate to The Solomon R. Guggenheim Museum, 1953

The Solomon R. Guggenheim Museum, New York

62. STUDY FOR PORTRAIT OF CHESS PLAYERS, 1911 (Neuilly)

Charcoal on paper, 19½ x 19⅞ in. (49.5 x 50.5 cm)

Inscribed lower right, in pencil: *Marcel Duchamp/11*

Cat: L 78, S 168

Collection Louise Varèse, New York

63. POUR UNE PARTIE D'ÉCHECS (FOR A GAME OF CHESS), 1911 (Neuilly)

Charcoal and india ink on paper, 17¹¹⁄₁₆ x 24³⁄₁₆ in. (45 x 61.5 cm)

Inscribed lower left, in ink: *Pour une partie d'échecs/Marcel Duchamp 1911*

Cat: L 77, S 170

Ex coll: Mme Suzanne Crotti, Neuilly

Collection Mme Marcel Duchamp, Villiers-sous-Grez

64. LES JOUEURS D'ÉCHECS (THE CHESS PLAYERS), 1911 (Neuilly)
Oil on canvas, 19$^{11}\!/_{16}$ x 24 in. (50 x 61 cm)
Inscribed lower right: *Marcel Duchamp/déc. 11;* inscribed verso upper right: *Marcel Duchamp/Les Joueurs d'Echecs/1911*
Cat: L 80, S 176
Ex coll: Jacques Villon, Puteaux; purchased by the Musées Nationaux in 1955

Musée National d'Art Moderne, Paris

The final oil study for *Portrait of Chess Players.*

65. PORTRAIT DE JOUEURS D'ÉCHECS (PORTRAIT OF CHESS PLAYERS), 1911 (Neuilly)
Oil on canvas, 42$^{1}\!/_{2}$ x 39$^{3}\!/_{4}$ in. (108 x 101 cm)
Inscribed lower left: *MARCEL DU-CHAMP/11;* inscribed verso: *Marcel Duchamp/Portrait de joueurs d'échecs*
Exh: Paris, Galerie de la Boétie, Salon de la Section d'Or, October 10–30, 1912; Armory Show, 1913: New York cat. no. 240, Chicago cat. no. 106
Cat: L 81, S 177
Ex coll: Arthur Jerome Eddy, Chicago, purchased from the Armory Show, 1913; Louise and Walter Arensberg, Hollywood, acquired in 1930

Philadelphia Museum of Art, The Louise and Walter Arensberg Collection

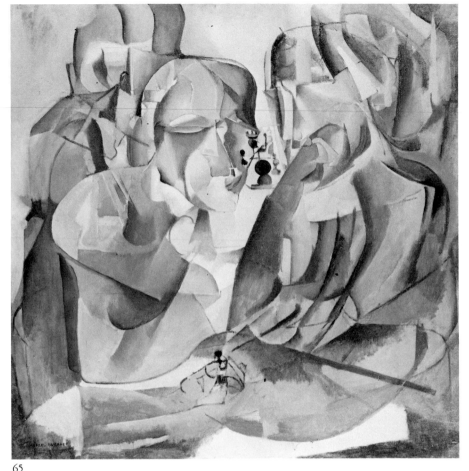

65

"USING AGAIN THE TECHNIQUE OF DEMULTIPLICATION IN MY INTERPRETATION OF THE CUBIST THEORY, I PAINTED THE HEADS OF MY TWO BROTHERS PLAYING CHESS, NOT IN A GARDEN THIS TIME, BUT IN INDEFINITE SPACE.

"ON THE RIGHT JACQUES VILLON, ON THE LEFT RAYMOND DUCHAMP-VILLON, THE SCULPTOR, EACH HEAD INDICATED BY SEVERAL SUCCESSIVE PROFILES. IN THE CENTER OF THE CANVAS, A FEW SIMPLIFIED FORMS OF CHESS PIECES PLACED AT RANDOM. ANOTHER CHARACTERISTIC OF THIS PAINTING IS THE GRAY TONALITY OF THE ENSEMBLE.

"GENERALLY SPEAKING, THE FIRST REACTION OF CUBISM AGAINST FAUVISM WAS TO ABANDON VIOLENT COLOR AND REPLACE IT BY SUBDUED TONES. THIS PARTICULAR CANVAS WAS PAINTED BY GASLIGHT TO OBTAIN THE SUBDUED EFFECT, WHEN YOU LOOK AT IT AGAIN BY DAYLIGHT."

66. MÉDIOCRITÉ (MEDIOCRITY), 1911 (Neuilly)
Pencil on paper, 6$^{1}\!/_{2}$ x 7$^{7}\!/_{8}$ in. (16.5 x 20 cm)
Inscribed lower left, in pencil: *Marcel Duchamp/12;* inscribed lower right, in pencil: *Médiocrité/(Jules Laforgue)*
Cat: L 82, S 173
Ex coll: André Breton, Paris

66

67

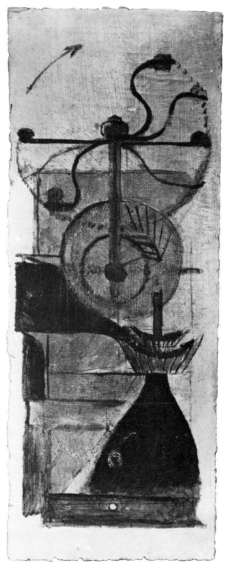

68

Private collection, Paris

This and the two drawings that follow were among a number of sketches suggested by the poems of Jules Laforgue. They reveal Duchamp's interest in other than purely visual sources for his work.

67. SIESTE ÉTERNELLE (ETERNAL SIESTA), 1911 (Neuilly)
Pencil and watercolor on paper, 9$\frac{15}{16}$ x 6$\frac{7}{16}$ in. (25.2 x 16.3 cm)
Inscribed center left, in pencil: *Marcel Duchamp/12;* inscribed center right, in pencil: *Sieste éternelle/(Jules Laforgue)*
Cat: L 83, S 174
Ex coll: Marie Sterner, New York; Katherine S. Dreier, West Redding, Connecticut

Private collection, Williamstown, Massachusetts

68. ENCORE À CET ASTRE (ONCE MORE TO THIS STAR), 1911 (Neuilly)
Pencil on paper, 9$\frac{13}{16}$ x 6$\frac{1}{2}$ in. (25 x 16.5 cm)
Inscribed lower left, in pencil: *Marcel Duchamp/12/a Monsieur F. C. Torrey/très cordialement,/Marcel Duchamp./13.* Inscribed lower right, in pencil: *Encore à cet astre/(Jules Laforgue* [sic]
Cat: L 84, S 175
Ex coll: Frederic C. Torrey, San Francisco, gift of the artist in 1913; Louise and Walter Arensberg, Hollywood, acquired after 1930

Philadelphia Museum of Art, The Louise and Walter Arensberg Collection

This drawing anticipates the theme of the *Nude Descending a Staircase,* although the figure in this case is ascending. Duchamp accidentally misdated the sketch when he gave it to Torrey, who had purchased the *Nude Descending* from the Armory Show.

69. MOULIN À CAFÉ (COFFEE MILL), 1911 (Neuilly)
Oil on cardboard, 13 x 4$\frac{15}{16}$ in. (33 x 12.5 cm)
Cat: L 85, S 178
Ex coll: Raymond Duchamp-Villon, Paris, until his death in 1918; Mme Raymond Duchamp-Villon (later Mme Yvonne Lignières), Paris; Mme Maria Martins, Rio de Janeiro

Collection Mrs. Robin Jones, Rio de Janeiro

"TOWARDS THE END OF 1911, MY BROTHER RAYMOND DUCHAMP-VILLON HAD THE IDEA OF DECORATING HIS KITCHEN WITH OIL PAINTINGS. HE ASKED ABOUT SIX OR SEVEN OF HIS FRIENDS: GLEIZES, METZINGER, DE LA

69  *Reproduced in color facing page 80.*

255

FRESNAYE AND OTHERS TO GIVE HIM A SMALL PAINTING.

"I MADE THIS OLD-FASHIONED COFFEE MILL FOR HIM. IT SHOWS THE DIFFERENT FACETS OF THE COFFEE GRINDING OPERATION AND THE HANDLE ON TOP IS SEEN SIMULTANEOUSLY IN SEVERAL POSITIONS AS IT REVOLVES. YOU CAN SEE THE GROUND COFFEE IN A HEAP UNDER THE COG WHEELS OF THE CENTRAL SHAFT WHICH TURNS IN THE DIRECTION OF THE ARROW ON TOP."

This is the first painting to reveal Duchamp's interest in the appearance and operations of the machine. Simultaneously, he was exploring the depiction of the human figure in motion. The two interests were soon to fuse in his preparatory work for the *Large Glass,* a static diagram of the erratic mechanism of human desire.

70. JEUNE HOMME TRISTE DANS UN TRAIN (SAD YOUNG MAN IN A TRAIN), December 1911 (Neuilly)
Oil on canvas, mounted on board, 39³⁄₈ x 28³⁄₄ in. (100 x 73 cm)
Inscribed lower left: *MARCEL DUCHAMP 12;* inscribed verso: *Marcel Duchamp nu (esquisse) Jeune homme triste dans un train/ Marcel Duchamp*
Exh: Armory Show, 1913: New York cat. no. 242, Chicago cat. no. 108, Boston cat. no. 40
Cat: L 86, S 179
Ex coll: Manierre Dawson, New York, purchased from Armory Show, 1913; Walter Pach, New York; Peggy Guggenheim, New York, acquired in 1942

Peggy Guggenheim Foundation, Venice

A self-portrait (with pipe), on a train journey between Paris and Rouen.

71. NU DESCENDANT UN ESCALIER (NUDE DESCENDING A STAIRCASE [No. 1]), December 1911 (Neuilly)
Oil on cardboard, 38¹⁄₁₆ x 23¹³⁄₁₆ in. (96.7 x 60.5 cm)
Inscribed lower left: *MARCEL DUCHAMP/ 11/NU DESCENDANT UN ESCALIER*
Cat: L 87, S 180
Ex coll: John Quinn, New York, acquired in 1915 through Walter Pach; Earl Horter, Philadelphia; Galka Scheyer, Pasadena; Louise and Walter Arensberg, Hollywood, acquired in 1935

Philadelphia Museum of Art, The Louise and Walter Arensberg Collection

"VERY MUCH ATTRACTED BY THE PROBLEM OF MOTION IN PAINTING, I MADE SEVERAL SKETCHES ON THAT THEME.

"THIS ONE IS THE FIRST STUDY FOR THE NUDE DESCENDING A STAIRCASE.

YOU CAN SEE A NUMBER OF ANATOMICAL PARTS OF THE NUDE WHICH ARE REPEATED IN SEVERAL STATIC POSITIONS OF THE MOVING BODY. COMPARED WITH THE FINAL VERSION . . . THIS IS ONLY A ROUGH SKETCH IN MY SEARCH FOR A TECHNIQUE TO TREAT THE SUBJECT OF MOTION.

"IT WAS DONE IN THE LAST MONTHS OF 1911 AT THE SAME TIME WHEN I WAS PAINTING THE CUBIST CHESS PLAYERS . . . ; AND USING THE METHOD OF DEMULTIPLICATION OF THE MOVEMENT WHICH WAS TO BE MY MAIN PREOCCUPATION DURING THE FIRST PART OF 1912."

72. NU DESCENDANT UN ESCALIER (NUDE DESCENDING A STAIRCASE [No. 2]), January 1912 (Neuilly)
Oil on canvas, 57¹⁄₂ x 35¹⁄₁₆ in. (146 x 89 cm)
Inscribed lower center: *MARCEL DUCHAMP 12;* inscribed lower left: *NU DESCENDANT UN ESCALIER;* inscribed verso: *Marcel Duchamp 12*
Exh: Paris, Salon des Indépendants, March–April, 1912, cat. no. 1001 (withdrawn); Barcelona, Dalmau Gallery, Cubist Exhibition, May, 1912; Paris, Galerie de la Boétie, Salon de la Section d'Or, October 10–30, 1912; Armory Show, 1913: New York cat. no. 241, Chicago cat. no. 107, Boston cat. no. 39; Portland, Oregon, Portland Art Museum, Post-Impressionist Exhibition, November–December, 1913
Cat: L 88, S 181
Ex coll: Frederic C. Torrey, San Francisco, 1913; Claus Spreckels, Los Angeles, until 1927; Walter Pach, New York; Louise and Walter Arensberg, Hollywood, acquired by 1930

Philadelphia Museum of Art, The Louise and Walter Arensberg Collection

"THIS FINAL VERSION OF THE NUDE DESCENDING A STAIRCASE, PAINTED IN JANUARY 1912, WAS THE CONVERGENCE IN MY MIND OF VARIOUS INTERESTS AMONG WHICH THE CINEMA, STILL IN ITS INFANCY, AND THE SEPARATION OF STATIC POSITIONS IN THE PHOTOCHRONOGRAPHS OF MAREY IN FRANCE, EAKINS AND MUYBRIDGE IN AMERICA.

"PAINTED, AS IT IS, IN SEVERE WOOD COLORS, THE ANATOMICAL NUDE DOES NOT EXIST, OR AT LEAST CANNOT BE SEEN, SINCE I DISCARDED COMPLETELY THE NATURALISTIC APPEARANCE OF A NUDE, KEEPING ONLY THE ABSTRACT LINES OF SOME TWENTY DIFFERENT STATIC POSITIONS IN THE SUCCESSIVE ACTION OF DESCENDING.

"BEFORE IT WAS SHOWN AT THE ARMORY SHOW IN NEW YORK, IN 1913, I HAD SENT

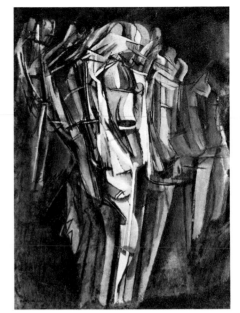

70

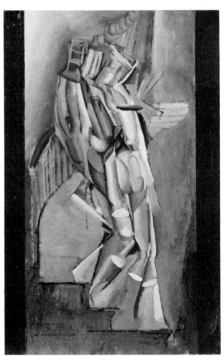

71

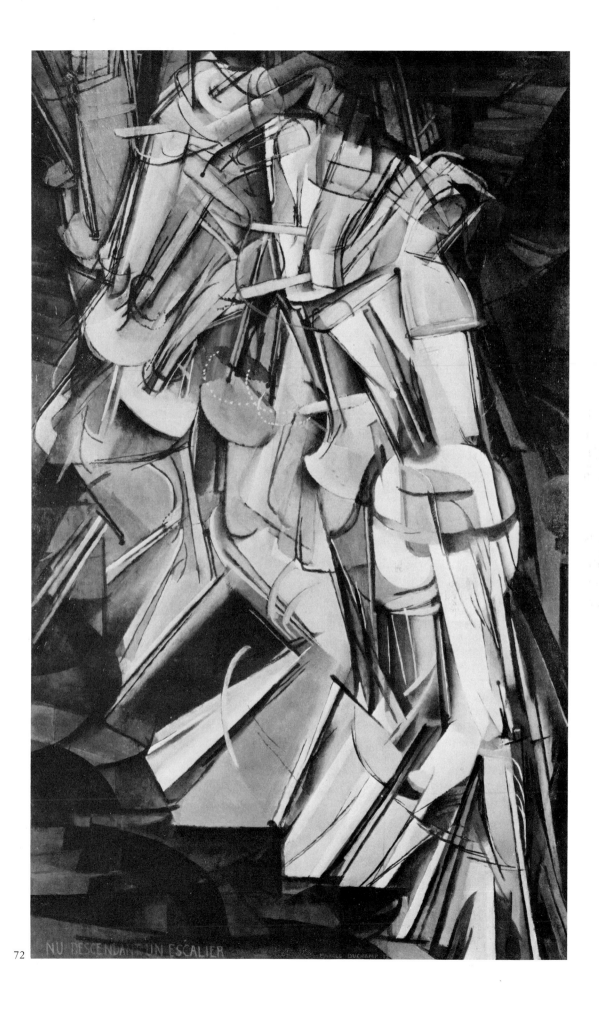

NU DESCENDANT UN ESCALIER

72

IT TO THE PARIS INDEPENDENTS IN FEBRU-
ARY 1912. BUT MY FELLOW CUBISTS DID NOT
LIKE IT AND ASKED ME TO, AT LEAST,
CHANGE THE TITLE. INSTEAD OF CHANGING
ANYTHING, I WITHDREW IT AND SHOWED IT
IN OCTOBER OF THE SAME YEAR AT THE
SALON OF THE SECTION D'OR, WITHOUT ANY
OPPOSITION THIS TIME.

"THE FUTURISTS ALSO WERE INTERESTED IN
THE PROBLEM OF MOVEMENT AT THAT TIME
AND WHEN THEY EXHIBITED FOR THE FIRST
TIME IN PARIS IN JANUARY 1912, IT WAS
QUITE EXCITING FOR ME TO SEE THE PAINT-
ING DOG ON A LEASH BY BALLA, SHOW-
ING ALSO THE SUCCESSIVE STATIC POSITIONS
OF THE DOG'S LEGS AND LEASH.

"NEVERTHELESS, I FELT MORE LIKE A CUBIST
THAN A FUTURIST IN THIS ABSTRACTION OF
A NUDE DESCENDING A STAIRCASE: THE
GENERAL APPEARANCE AND THE BROWNISH
COLORING OF THE PAINTING ARE CLEARLY
CUBISTIC EVEN THOUGH THE TREATMENT OF
THE MOVEMENT HAS SOME FUTURISTIC OVER-
TONES."

73. PORTRAIT OF GUSTAVE CANDEL'S
   MOTHER, 1911–12 (Neuilly)
Oil on canvas, 24 x 17⅛ in. (61 x 43.5 cm)
Inscribed lower left: *à Madame Candel/
Hommage très affectueux/Marcel Du-
champ/13*
Cat: L 70, S 183

Collection Gustave Candel, Paris

Perhaps the only direct evidence offered by
Duchamp's work of the influence of Odilon
Redon, an artist he greatly admired. Gustave
Candel was a close friend from Duchamp's
early years in Paris, and owned a large collec-
tion of his work. Duchamp painted both of
Candel's parents, but the portrait of M. Can-
del was a straightforward, naturalistic por-
trayal.

74. 2 PERSONNAGES ET UNE AUTO (ÉTUDE)
   (2 PERSONAGES AND A CAR [STUDY]),
   1912 (Neuilly)
Charcoal on paper, 13¾ x 11⁷⁄₁₆ in.
(35 x 29 cm)
Inscribed lower right, in pencil: *2 personnages
et une auto (étude)/Marcel Duchamp/12*
Cat: S 185

Collection Mme Marcel Duchamp, Villiers-
   sous-Grez

Incorporated in no. XIV/XX of the *Box in
a Valise*. One of Duchamp's rare signs of in-
terest in a typically "modern" machine, as
opposed to the old-fashioned mechanisms of
the bicycle wheel, chocolate grinder, and
coffee mill.

73

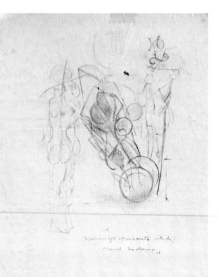

74

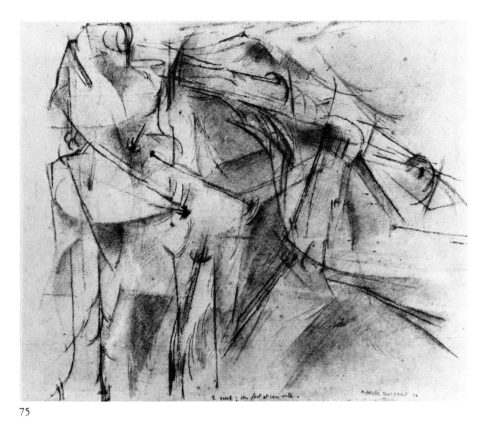

75

76

75. 2 NUS: UN FORT ET UN VITE (2 NUDES: ONE STRONG AND ONE SWIFT), March 1912 (Neuilly)

Pencil on paper, 11¹³⁄₁₆ x 14³⁄₁₆ in. (30 x 36 cm)

Inscribed lower right, in pencil: *MARCEL DUCHAMP 12;* inscribed lower center, in pencil: *2 nus: un fort et un vite*

Cat: L 91, S 186

Ex coll: Gabrielle Buffet-Picabia, Paris; Edmond Bomsel, Paris

Collection Dr. Emile-Jean Bomsel, Paris

The first of a group of drawings leading up to the painting *King and Queen Surrounded by Swift Nudes,* which combine Duchamp's interest in depicting motion with an allegorical theme of confrontation drawn from chess imagery.

76. LE ROI ET LA REINE TRAVERSÉS PAR DES NUS VITES (THE KING AND QUEEN TRAVERSED BY SWIFT NUDES), April 1912 (Neuilly)

Pencil on paper, 10³⁄₄ x 15³⁄₈ in. (27.3 x 39 cm)

Inscribed lower right, in pencil: *Le Roi et la Reine traversés par des nus vites/Marcel Duchamp/1912*

Exh: New York, Arden Gallery, "The Evolution of French Art," April 29–May 24, 1919, cat. no. 228

Cat: L 93, S 188

Ex coll: Louise and Walter Arensberg, New York, acquired c. 1919

Philadelphia Museum of Art, The Louise and Walter Arensberg Collection

77. LE ROI ET LA REINE TRAVERSÉS PAR DES NUS EN VITESSE (THE KING AND QUEEN TRAVERSED BY SWIFT NUDES AT HIGH SPEED), April 1912 (Neuilly)

Watercolor and gouache on paper, 19¹⁄₄ x 23¹⁄₄ in. (48.9 x 59.1 cm)

Inscribed lower right, in ink: *Le roi et la reine traversés par des nus en vitesse./Marcel Duchamp 12*

Exh: Paris, Galerie de la Boétie, Salon de la Section d'Or, October 10–30, 1912

Cat: L 92, S 187

Ex coll: Man Ray, Paris; Louise and Walter Arensberg, Hollywood, acquired through the artist in 1938

Philadelphia Museum of Art, The Louise and Walter Arensberg Collection

259

78. Le Roi et la reine entourés de nus vites (The King and Queen Surrounded by Swift Nudes), May 1912 (Neuilly)

Oil on canvas, $45\frac{1}{16}$ x $50\frac{9}{16}$ in. (114.5 x 128.5 cm)

Inscribed lower left: *LE ROI ET LA REINE/ENTOURÉS DE NUS VITES;* inscribed lower center right: *MARCEL DUCHAMP 12*

Exh: Paris, Galerie de la Boétie, Salon de la Section d'Or, October 10–30, 1912; Armory Show, 1913: New York cat. no. 239, Chicago cat. no. 105

Cat: L 94, S 189

Ex coll: Arthur Jerome Eddy, Chicago, purchased from the Armory Show, 1913; Louise and Walter Arensberg, Hollywood, as early as 1935

Philadelphia Museum of Art, The Louise and Walter Arensberg Collection

"DONE IMMEDIATELY AFTER THE NUDE DESCENDING A STAIRCASE IN THE SPRING OF 1912, THIS OIL PAINTING CALLED KING AND QUEEN SURROUNDED BY SWIFT NUDES IS A DEVELOPMENT OF THE SAME IDEA.

"THE TITLE 'KING AND QUEEN' WAS ONCE AGAIN TAKEN FROM CHESS BUT THE PLAYERS OF 1911 (MY TWO BROTHERS) HAVE BEEN ELIMINATED AND REPLACED BY THE CHESS FIGURES OF THE KING AND QUEEN. THE SWIFT NUDES ARE A FLIGHT OF IMAGINATION INTRODUCED TO SATISFY MY PREOCCUPATION OF MOVEMENT STILL PRESENT IN THIS PAINTING.

"UNFORTUNATELY THIS PICTURE HAS NOT STOOD TIME AS WELL AS MY OTHER PAINTINGS, AND IS FULL OF CRACKS. . . . IT IS A THEME OF MOTION IN A FRAME OF STATIC ENTITIES. IN OTHER WORDS THE STATIC ENTITIES ARE REPRESENTED BY THE KING AND THE QUEEN, WHILE THE SWIFT NUDES ARE BASED ON THE THEME OF MOTION."

Painted on the reverse of *Paradise*, 1910–11 (see no. 48).

79. La Mariée mise à nu par les célibataires (The Bride Stripped Bare by the Bachelors), July–August 1912 (Munich)

Pencil and wash on paper, $9\frac{3}{8}$ x $12\frac{5}{8}$ in. (23.8 x 32.1 cm)

Inscribed lower left, in ink: *Marcel Duchamp./Juli 1912;* inscribed below, in ink: *Première recherche pour: La mariée mise à nu par les célibataires—*; inscribed lower center, in pencil: *Mécanisme de la pudeur/ Pudeur mécanique* (Mechanism of chastity/ Mechanical chastity)

Cat: L 99, S 190

Ex coll: Gustave Candel, Paris

Cordier & Ekstrom, Inc., New York

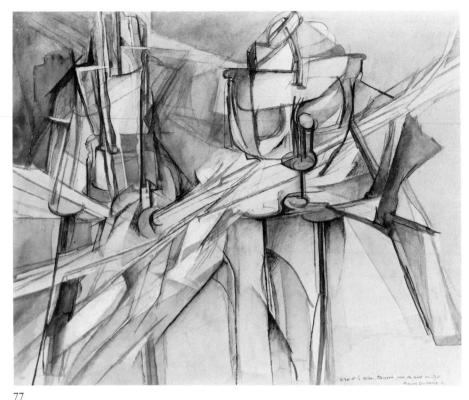

77

78

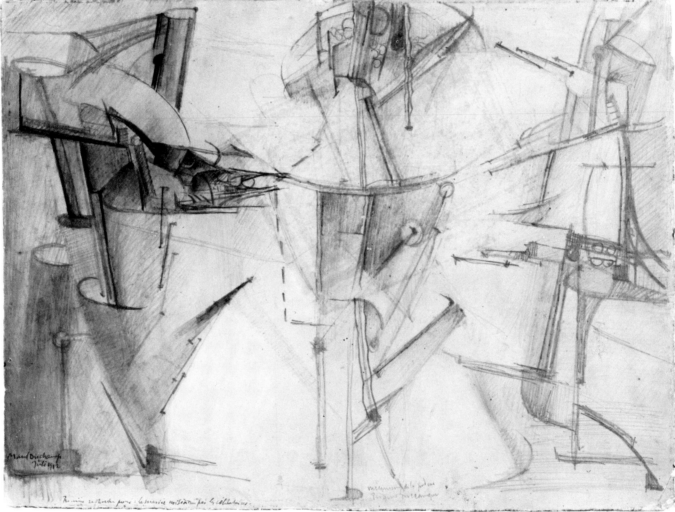

79

The first drawing on the theme of the *Large Glass,* and the only study which shows a direct confrontation between the protagonists: the mechanical figure of the Bride appears between the menacing forms of the two Bachelors. This drawing and the following group of works on the theme of the Virgin and the Bride were produced during a two-month visit to Munich in the summer of 1912, a period of the most intense creativity for Duchamp.

80. VIERGE (VIRGIN [No. 1]), July 1912 (Munich)
Pencil on paper, 13¼ x 9¹⁵⁄₁₆ in. (33.6 x 25.2 cm)
Inscribed lower left in pencil: *VIERGE. MARCEL DUCHAMP/12*
Exh: Paris, Salon d'Automne, October 1–November 8, 1912, cat. no. 506; New York, Carroll Galleries, "First Exhibition of Works by Contemporary French Artists," December 1914–January 2, 1915, cat. no. 44; New York, Montross Gallery, "Exhibition of Pictures by Jean Crotti, Marcel Duchamp, Albert Gleizes, Jean Metzinger," April 4–22, 1916, cat. no. 25
Cat: L 95, S 191
Ex coll: Jacques Villon, Puteaux; Albert E. Gallatin, New York, acquired in 1935

Philadelphia Museum of Art, A. E. Gallatin Collection

81. VIERGE (VIRGIN [No. 2]), July 1912 (Munich)
Watercolor and pencil on paper, 15¾ x 10⅛ in. (40 x 25.7 cm)
Inscribed lower left, in india ink: *VIERGE/ MARCEL DUCHAMP/12*
Cat: L 96, S 192
Ex coll: Bernard Poissonnier, Paris; Louise and Walter Arensberg, Hollywood, acquired in 1939

Philadelphia Museum of Art, The Louise and Walter Arensberg Collection

82. LE PASSAGE DE LA VIERGE À LA MARIÉE (THE PASSAGE FROM VIRGIN TO BRIDE), July–August 1912 (Munich)
Oil on canvas, 23⅜ x 21¼ in. (59.4 x 54 cm)
Inscribed lower left: *LE PASSAGE de la vierge à la mariée/MARCEL DU-CHAMP/12;* inscribed verso, in ink: *Marcel Duchamp/12;* in blue crayon: *1912*
Cat: L 97, S 193
Ex coll: Walter Pach, New York, gift of the artist

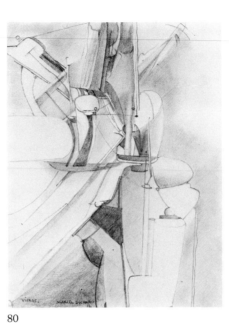

80

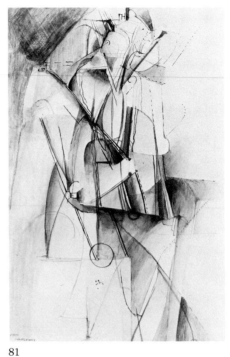

81

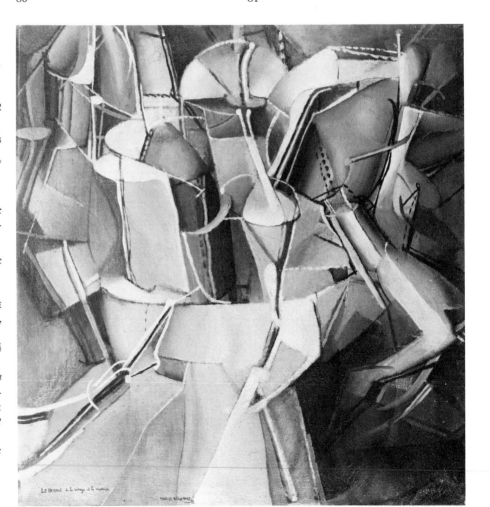

82

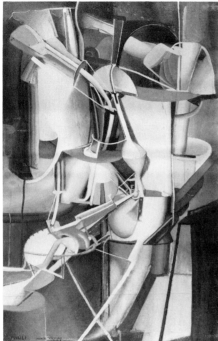

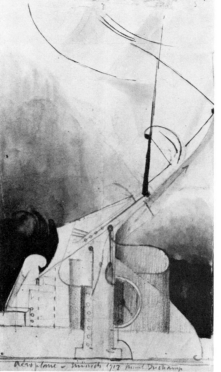

83  *Reproduced in color facing page 272.*    84

Unlike the physical motion represented in
the *Nude Descending a Staircase,* the "passage"
here indicates a change in metaphysical state.

83. MARIÉE   (BRIDE),   August   1912
(Munich)
Oil on canvas, $35\frac{1}{4}$ x $21\frac{5}{8}$ in. (89.5 x 55
cm)
Inscribed lower left: *MARIÉE MARCEL
DUCHAMP/aŭgŭst 12*
Cat: L 98, S 194
Ex coll: Francis Picabia, Paris, gift of the art-
ist in 1912; Paul Eluard, Paris; André
Breton, Paris; Julien Levy, New York, ac-
quired in 1936; Louise and Walter Arens-
berg, Hollywood, acquired in 1937

Philadelphia Museum of Art, The Louise
and Walter Arensberg Collection

"ABANDONING   MY   ASSOCIATION   WITH
CUBISM AND HAVING EXHAUSTED MY INTER-
EST IN KINETIC PAINTING, I FOUND MYSELF
TURNING TOWARDS A FORM OF EXPRESSION
COMPLETELY   DIVORCED   FROM   STRAIGHT
REALISM.
"THIS PAINTING BELONGS TO A SERIES OF
STUDIES, THE LARGE GLASS . . .
[WHICH] I BEGAN THREE YEARS LATER IN
NEW YORK. REPLACING THE FREE HAND BY
A VERY PRECISE TECHNIQUE, I EMBARKED ON
AN ADVENTURE WHICH WAS NO MORE TRIB-
UTARY OF ALREADY EXISTING SCHOOLS.
"THIS   IS   NOT   THE   REALISTIC   INTER-
PRETATION OF A BRIDE BUT MY CONCEPT OF
A BRIDE EXPRESSED BY THE JUXTAPOSITION
OF MECHANICAL ELEMENTS AND VISCERAL
FORMS.
"MY STAY IN MUNICH WAS THE SCENE OF
MY COMPLETE LIBERATION, WHEN I ESTAB-
LISHED THE GENERAL PLAN OF A LARGE-SIZE
WORK WHICH WOULD OCCUPY ME FOR A
LONG TIME ON ACCOUNT OF ALL SORTS OF
NEW TECHNICAL PROBLEMS TO BE WORKED
OUT."
Duchamp originally intended to transfer
the image of the *Bride* from this canvas to
the *Large Glass* by photographic means. This
proved impractical, so he copied one section
of the picture onto the *Glass* in black and
white tones.

84. AÉROPLANE, August–September 1912
(Munich)
Wash on paper, 9 x 5 in. (22.9 x 12.7 cm)
Inscribed along lower edge, in pencil:
*Aéroplane—Münich 1912 Marcel Duchamp*
Cat: L 100, S 195

Collection Beatrice Wood, Ojai, California

**85.** Erratum musical (Musical Erratum), 1913 (Rouen)

Ink on double sheet of music paper, 12½ x 19 in. (32 x 48 cm)

Inscribed top center of right half, in pencil: *Erratum Musical*

Cat: L 107, S 196

Collection Mme Marcel Duchamp, Villiers-sous-Grez

A score for three voices (Duchamp and his sisters Yvonne and Magdeleine) derived from the chance arrangement of musical notes picked out of a hat. The text is a dictionary definition of the verb "to print": *Faire une empreinte marquer des traits une figure sur une surface imprimer un sceau sur cire* (To make an imprint mark with lines a figure on a surface impress a seal on wax).

**86.** La Mariée mise à nu par ses célibataires même. Erratum musical (The Bride Stripped Bare by Her Bachelors, Even. Musical Erratum), 1913

Ink, colored pencils, and pencil on two double sheets of music paper, each 13¾ x 21¼ in. (35 x 54 cm)

Ex coll: the artist; John Cage, New York

Foundation for Contemporary Performance Arts, New York

A previously uncataloged musical composition, bearing the same title as the *Large Glass,* and proposing an elaborate use of chance in the creation of a "new musical alphabet." The inscription and a translation are given here in full:

*Chq no. indique une note; un piano ordinaire contient environ 89 notes; chaque no. est le no. d'ordre en partant de la gauche*

*Inachevable; pour instrument de musique précis ( piano mécanique, orgues mécaniques, ou autres instruments nouveaux pour lesquels l'intermédiare virtuose est supprimé); l'ordre de succession est (au gré) interchangeable; le temps qui sépare chaque chiffre romain sera probablement constant (?) mais il pourra varier d'une exécution à l'autre; exécution bien inutile d'ailleurs;*

*appareil enregistrant automatique[1] les périodes musicales fragmentées*

*Vase contenant les 89 notes (ou plus: ¼ de ton). figures parmi no. sur chaque boule*

*ouverture A laissant tomber les boules dans une suite de wagonnets B,C,D,E,F, etc.*

*Wagonnets B,C,D,E,F, allant à une vitesse variable recevant chacun 1 ou plusieurs boules*

*Quand le vase est vide: la période en 89 notes (tant de) wagonnets est inscrite et peut être exécutée par un instrument précis*

*un autre vase = une autre période = il resulte de l'équivalence des périodes et de leur comparaison une sorte d'alphabet musical nouveau. permettant des descriptions modèles. (à développer).*

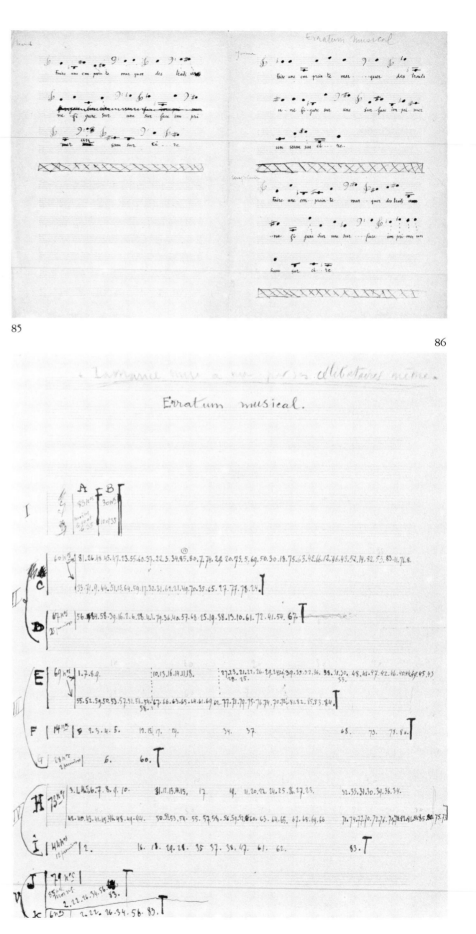

85

86

87

86

Each number indicates a note; an ordinary piano contains about 89 notes; each note is the number in order starting from the left

Unfinishable; for a designated musical instrument (player piano, mechanical organs or other new instruments for which the virtuoso intermediary is suppressed); the order of succession is (to taste) interchangeable; the time which separates each Roman numeral will probably be constant (?) but it may vary from one performance to another; a very useless performance in any case.

An apparatus automatically recording fragmented musical periods. Vase containing the 89 notes (or more: $\frac{1}{4}$ tone). figures among number on each ball Opening A letting the balls drop into a series of little wagons B, C, D, E, F, etc. Wagons B, C, D, E, F, going at a variable speed, each one receiving one or several balls When the vase is empty: *the period* in 89 notes (so many) wagons is inscribed and can be performed by a designated instrument another vase = another period = there results from the equivalence of the periods and their comparison a kind of new musical alphabet allowing *model descriptions*. (to be developed).

87. BROYEUSE DE CHOCOLAT (CHOCOLATE
   GRINDER [No. 1]), 1913 (Neuilly)
Oil on canvas, 24⅜ x 25⁹⁄₁₆ in. (62 x 65 cm)
Printed in gold on piece of leather glued in
   upper right: *BROYEUSE DE CHOCO-
   LAT—1913;* inscribed verso, in ink:
   *Broyeuse de Chocolat 1913 / appartenant à
   Marcel Duchamp*
Exh: New York, Carroll Galleries, "Third
   Exhibition of Contemporary French Art,"
   March 8–April 3, 1915, cat. no. 16; New
   York, Bourgeois Galleries, "Exhibition of
   Modern Art," April 3–29, 1916, cat. no. 7
Cat: L 106, S 197
Ex coll: Louise and Walter Arensberg, New
   York, as early as 1918

Philadelphia Museum of Art, The Louise
   and Walter Arensberg Collection

The first study for one of the principal elements of the "Bachelor Apparatus" in the lower section of the *Large Glass.* The motion of the machine is not represented pictorially, as in the *Coffee Mill,* but rather implied.

88. Machine célibataire 1° en plan et 2° en élévation (Bachelor Apparatus, 1. Plan and 2. Elevation), 1913 (Neuilly)
Red, blue, black ink and pencil on paper, cut into 2 pieces and later rejoined, 10½ x 13⅞ in. (26.6 x 35.2 cm)
Inscribed lower right, in pencil: *Machine Célibataire 1° en plan/et 2° en élévation*; inscribed below, in pencil: *Echelle =* 1/10/1913
Cat: L 102, S 198

Collection Mme Marcel Duchamp, Villiers-sous-Grez

Plan and elevation for the lower half of the *Large Glass,* drawn to scale with specific measurements noted. Duchamp later made precise copies of both sections of this drawing for inclusion in the *Green Box.*

89. La Mariée mise à nu par ses célibataires, même (The Bride Stripped Bare by Her Bachelors, Even), 1913 (Neuilly)
Pencil on tracing cloth, 12⅛ x 10 in. (30.5 x 25 cm)
Inscribed lower right, in pencil: *Marcel Duchamp 1913*; inscribed upper right, in pencil: *9 trous/compris dans/le rectangle pointillé* (9 holes included in the dotted rectangle); inscribed upper left, in pencil: *Echelle 1/10*
Cat: L 104, S 199
Ex coll: Mme Jeanne Reynal, New York

Collection Jacqueline Monnier, Paris

First complete perspective layout of the *Large Glass* to scale. Duchamp drew the full-size perspective on the plaster wall of his studio at 23 Rue Saint Hippolyte.

90. Combat de boxe (Boxing Match), 1913 (Neuilly)
Pencil and crayon on paper, 16½ x 12³⁄₁₆ in. (42 x 31 cm)
Inscribed lower left, in pencil: *Marcel Duchamp, 1913*
Exh: New York, Bourgeois Gallery, "Exhibition of Modern Art," April 3–29, 1916, cat. no. 52a; New York, Arden Gallery, "The Evolution of French Art," April 29–May 24, 1919, cat. no. 227
Cat: L 103, S 200
Ex coll: Louise and Walter Arensberg, Hollywood, acquired from the artist, 1936

Philadelphia Museum of Art, The Louise and Walter Arensberg Collection

A study (later abandoned) for a small section of the *Large Glass.* Duchamp's 1965 etching *The Large Glass Completed* (see p. 64) shows its intended position. The drawing is accompanied by typed transcriptions of the notes.

88

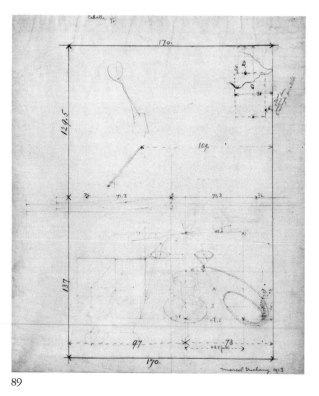

89

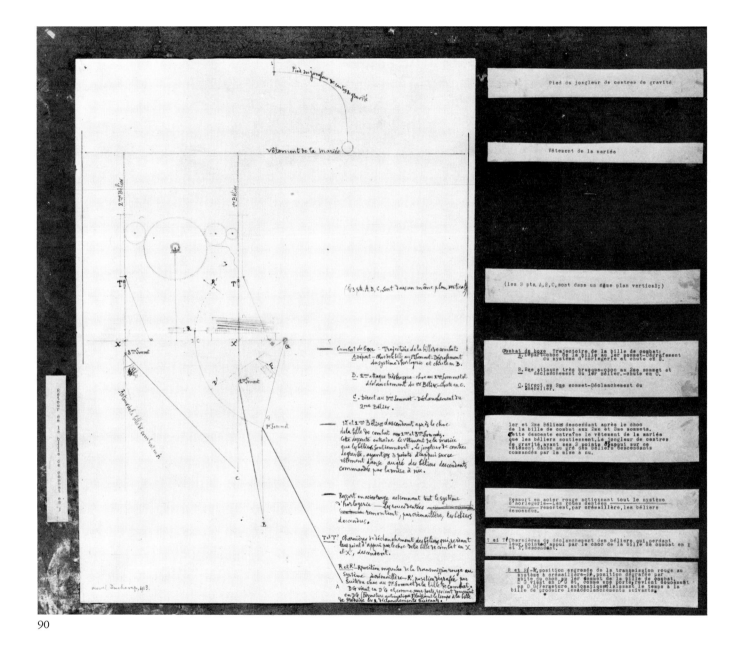

90

## 91. STUDIES FOR THE BACHELORS, 1913

Double-sided drawing, pencil on paper, $8\frac{3}{8}$ x $6\frac{1}{2}$ in. (21.3 x 16.5 cm)

Inscribed lower right, in ink: *1913/affectueusement pour/Hartl N.Y. 1936/Marcel Duchamp;* inscribed verso, lower left, in pencil: *Marcel Duchamp/1913;* inscribed verso, lower right, in pencil: *chef de gare*

Ex coll: Leon Hartl, New York, gift of the artist, 1936

Cordier & Ekstrom, Inc., New York

These previously uncataloged sketches show the Bachelors in an early stage of their evolution toward the depersonalized forms of the Nine Malic Molds.

## 92. PERSPECTIVE DRAWING FOR THE WATER MILL WHEEL, 1913

Pencil on paper, 12 x $7\frac{3}{4}$ in. (30.5 x 19.7 cm)

Inscribed lower right, in ink: *1913/a mon cher Hartl/affectueusement/1936./Marcel Duchamp;* inscribed lower center, in pencil: *Profondeur du plleppede [?] = 12 cm./Roue trop petite (pour fournir force suffisante)*

Depth of parallelepiped [?] = 12 cm./ Wheel too small (to provide sufficient force)

Ex coll: Leon Hartl, New York, gift of the artist, 1936

Cordier & Ekstrom, Inc., New York

A previously uncataloged sketch for the Water Mill Wheel in the Glider.

## 93. CIMETIÈRE DES UNIFORMES ET LIVRÉES (CEMETERY OF UNIFORMS AND LIVERIES [No. 1]), 1913 (Neuilly)

Pencil on paper, $12\frac{5}{8}$ x $15\frac{15}{16}$ in. (32 x 40.5 cm)

Inscribed lower right, in pencil: *Marcel Duchamp/13;* inscribed lower center, in pencil: *1ère esquisse du: Cimetière des uniformes et livrées*

Cat: L 112, S 201

Ex coll: Mme Suzanne Crotti, Neuilly; Louise and Walter Arensberg, Hollywood, acquired through the artist in 1937

Philadelphia Museum of Art, The Louise and Walter Arensberg Collection

Only eight Malic Molds appear in this study for the Bachelor Apparatus: Priest, Department Store Delivery Boy, Gendarme, Cuirassier, Policeman, Undertaker, Flunky, and Busboy. The ninth Mold, a Stationmaster, was added to the group later.

91 91

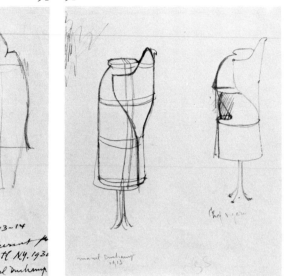

92

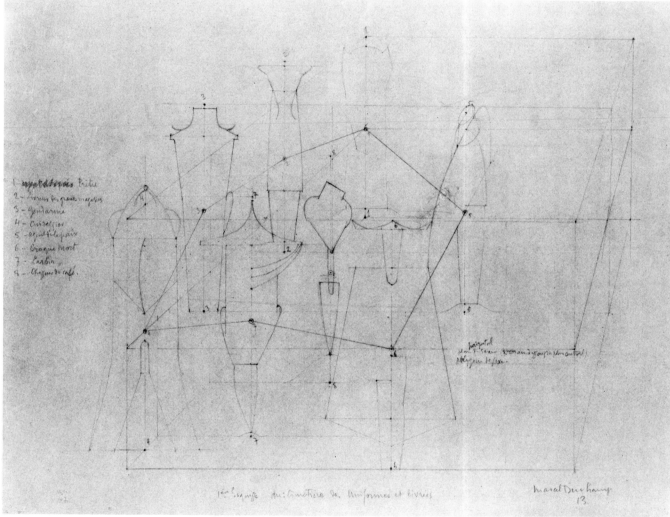

94. BICYCLE WHEEL, 1913 (Paris)
Original lost; 2nd version: the artist, New
   York, 1916 (lost); 3rd version: Sidney Janis,
   New York, 1951; 4th version: Ulf Linde,
   Stockholm, 1961; 5th version: Richard
   Hamilton, London, 1963; 6th version:
   Galleria Schwarz, Milan, edition of 8 signed
   and numbered replicas, 1964
Cat: L 110, S 205
Replica of 1951 after lost original
Bicycle wheel, 25½ in. (64.8 cm) diameter,
   mounted on painted wooden stool, 23¾ in.
   (60.2 cm) high
Formerly inscribed on the wheel in green
   paint: *Marcel Duchamp 1913–1959*
Ex coll: Sidney Janis, New York, given to
   The Museum of Modern Art, 1967

The Museum of Modern Art, New York,
The Sidney and Harriet Janis Collection

The original Bicycle Wheel was left behind
in Paris when Duchamp sailed to New
York in 1915. He made a replica for his
New York studio around 1916, which later
also disappeared.
Duchamp described this work in an in-
terview with Pierre Cabanne:
". . . when I put a bicycle wheel on a stool,
the fork down, there was no idea of a
'readymade,' or anything else. It was just
a distraction. I didn't have any special rea-
son to do it, or any intention of showing
it, or describing anything." (See bibl. 54,
p. 47.)
And he remarked to Arturo Schwarz:
"To see that wheel turning was very sooth-
ing, very comforting, a sort of opening of
avenues on other things than material life
of every day. I liked the idea of having a
bicycle wheel in my studio. I enjoyed look-
ing at it, just as I enjoy looking at the
flames dancing in a fireplace." (See bibl. 53,
p. 442.)

95. PHARMACIE (PHARMACY), January 1914
(Rouen)
Rectified Readymade: gouache on a com-
   mercial print, 10⁵⁄₁₆ x 7⁹⁄₁₆ in. (26.2 x 19.2
   cm)
Inscribed lower right, in india ink: *PHAR-
   MACIE. MARCEL DUCHAMP/1914.*
Exh: New York, Montross Gallery, "Exhi-
   bition of Pictures by Jean Crotti, Marcel
   Duchamp, Albert Gleizes, Jean Met-
   zinger," April 4–22, 1916, cat. no. 27
Cat: L 113, S 208
Ex coll: Man Ray, Paris

Private collection, New York

This Readymade was produced in an edition
of three, two of which have been lost. The
two small red and green marks added by

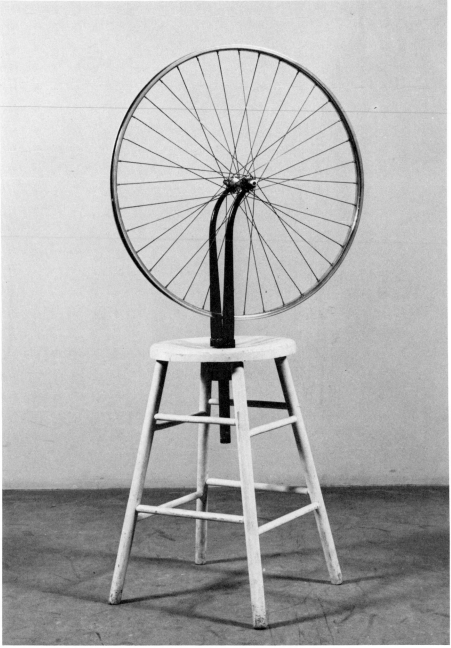

94

95  96

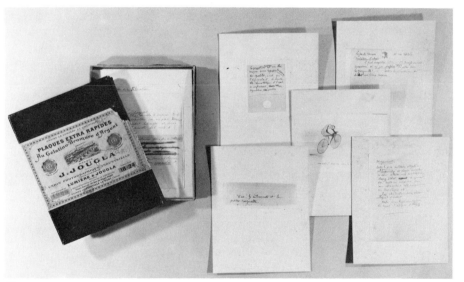

97

Duchamp to the print of a winter landscape are a reference to the bottles of colored liquid which were a common sight in pharmacy windows at that time.

96. AVOIR L'APPRENTI DANS LE SOLEIL (TO HAVE THE APPRENTICE IN THE SUN), January 1914 (Rouen)
India ink and pencil on music paper, 10¾ x 6¾ in. (27.3 x 17.2 cm)
Inscribed lower center, in ink: —*avoir l'apprenti dans le soleil.*—; inscribed lower left, in pencil: *Marcel Duchamp. 1914.*
Cat: L 109, S 207
Ex coll: Louise and Walter Arensberg, New York, probably acquired by 1921

Philadelphia Museum of Art, The Louise and Walter Arensberg Collection

The image was perhaps suggested by a prose poem in Alfred Jarry's *Spéculations:* "La Passion considérée comme course de côte" ("The Passion Considered as an Uphill Bicycle Race"). This drawing was incorporated in the Box of 1914.

97. THE BOX OF 1914, 1913–14 (Paris)
Facsimiles of 16 manuscript notes and a drawing, mounted on 15 matboards, each 9¹³⁄₁₆ x 7¼ in. (25 x 18.5 cm), contained in a cardboard box
Cat: L 109, S 210

Collection Mme Marcel Duchamp, Villiers-sous-Grez

One of an edition of three facsimile reproductions of a group of early notes and the drawing *Avoir l'apprenti dans le soleil.* Each copy is contained in a cardboard box for photographic plates. This is Duchamp's first venture in assembling and "publishing" his notes. The original notes were given to Louise and Walter Arensberg and are now in the Philadelphia Museum of Art.

98. STUDY FOR THE "CHOCOLATE GRINDER, No. 2," 1914 (Paris)
Oil, colored pencils, and ink on irregular canvas fragment, 22⅛ x 15⅝ in. (56 x 39.5 cm)
Inscribed lower center in ink: *Marcel Duchamp/1914*
Ex coll: Joseph Stella Estate, New York; Harold Diamond, New York, acquired 1972; Alain Tarica, Paris

Staatsgalerie, Stuttgart

A previously uncataloged study, with color notes.

271

99. STUDY FOR THE "CHOCOLATE GRINDER,
No. 2," 1914 (Paris)
Oil and pencil on canvas, 28³⁄₄ x 23⁵⁄₈ in.
(73 x 60 cm)
Ex coll: Joseph Stella Estate, New York;
Harold Diamond, New York, acquired
1972; Alain Tarica, Paris

Kunstsammlung        Nordrhein-Westfalen,
Düsseldorf

A previously uncataloged work, showing the
"Bayonet" and three rollers of the Chocolate
Grinder, before the addition of the "Louis
XV chassis" on which the machine rests.

100. BROYEUSE DE CHOCOLAT (CHOCOLATE
GRINDER [No. 2]), February 1914 (Paris)
Oil and thread on canvas, 25⁹⁄₁₆ x 21¹⁄₄ in.
(65 x 54 cm)
Printed in gold letters on leather label in
lower left: *BROYEUSE DE CHOCOLAT
—1914*
Exh: New York, Carroll Galleries, "Third
Exhibition of Contemporary French Art,"
March 8–April 3, 1915, cat. no. 17; New
York, Bourgeois Galleries, "Exhibition of
Modern Art," April 3–29, 1916, cat. no. 8
Cat: L 117, S 213
Ex coll: Louise and Walter Arensberg, New
York, as early as 1918

Philadelphia Museum of Art, The Louise
and Walter Arensberg Collection

"FROM 1913 ON, I CONCENTRATED ALL MY
ACTIVITIES ON THE PLANNING OF THE LARGE
GLASS AND MADE A STUDY OF EVERY DETAIL,
LIKE THIS OIL PAINTING WHICH IS CALLED
CHOCOLATE GRINDER, 1914. IT WAS
ACTUALLY SUGGESTED BY A CHOCOLATE
GRINDING MACHINE I SAW IN THE WINDOW
OF A CONFECTIONERY SHOP IN ROUEN.
"THROUGH    THE    INTRODUCTION    OF
STRAIGHT PERSPECTIVE AND A VERY GEO-
METRICAL DESIGN OF A DEFINITE GRINDING
MACHINE LIKE THIS ONE, I FELT DEFINITELY
OUT OF THE CUBIST STRAIGHTJACKET.
"THE LINES OF THE THREE ROLLERS ARE
MADE OF THREADS SEWN INTO THE CANVAS.
THE GENERAL EFFECT IS LIKE AN ARCHITEC-
TURAL, DRY RENDERING OF THE CHOCOLATE
GRINDING MACHINE PURIFIED OF ALL PAST
INFLUENCES.
"IT WAS TO BE PLACED IN THE CENTER OF
A LARGE COMPOSITION AND WAS TO BE COP-
IED AND TRANSFERRED FROM THIS CANVAS
ONTO THE LARGE GLASS."

98

*Bride.* 1912. Oil on canvas, 35¹⁄₄ x 21⁵⁄₈ in. Philadelphia
Museum of Art, The Louise and Walter Arensberg Col-
lection. Cat. 83.

99

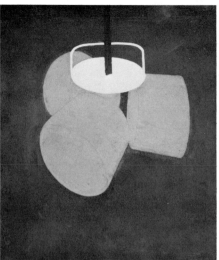

100

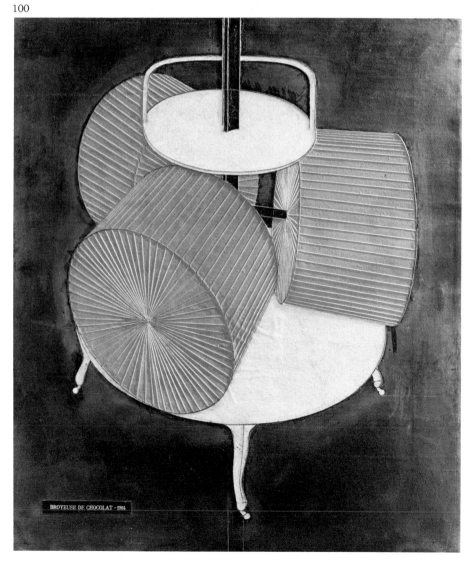

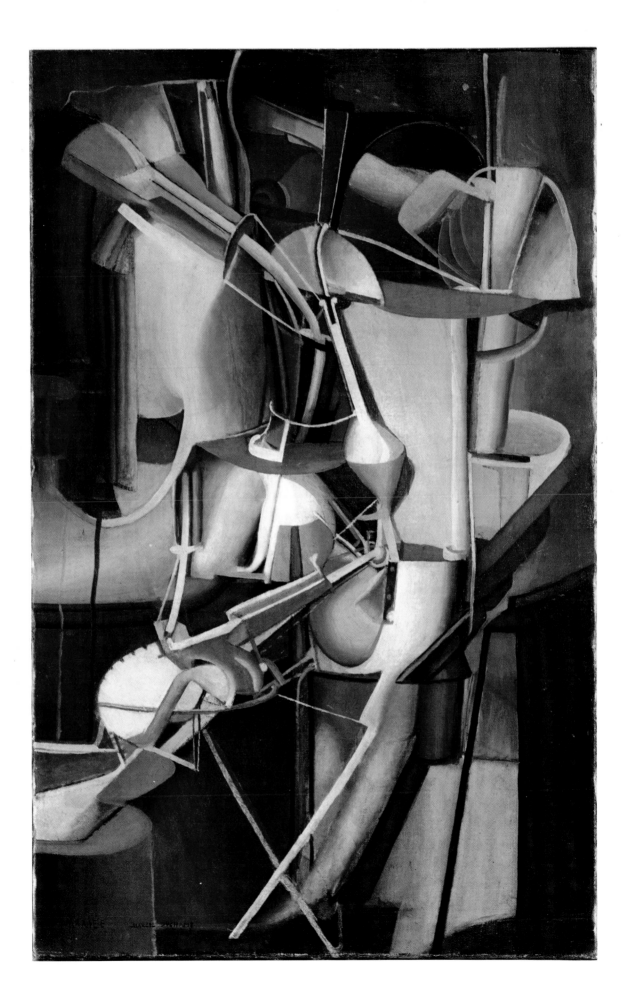

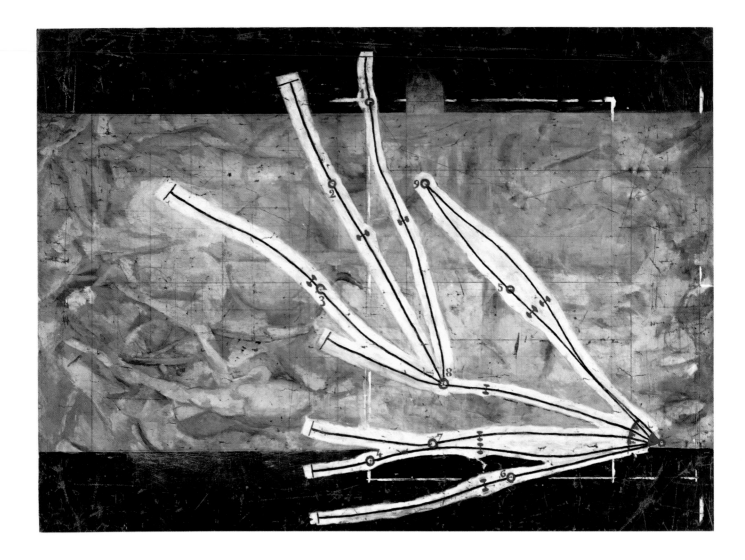

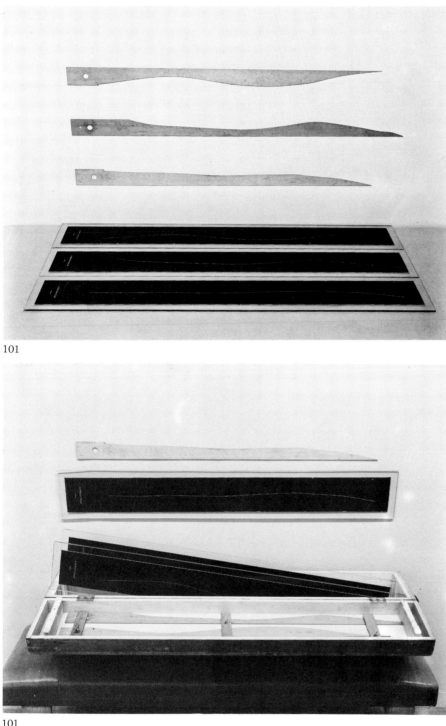

101

101

*Network of Stoppages.* 1914. Oil and pencil on canvas, 58⅛ x 77⅝ in. The Museum of Modern Art, New York, Abby Aldrich Rockefeller Fund and Gift of Mrs. William Sisler. Cat. 102.

101. 3 STOPPAGES ÉTALON (3 STANDARD STOPPAGES), 1913–14 (Paris)

2nd version: Ulf Linde, Stockholm, 1963; 3rd version: David Hayes, Pasadena, 1963; 4th version: Galleria Schwarz, Milan, edition of 8 signed and numbered replicas, 1964

Assemblage: three threads glued to three painted canvas strips, each 5¼ x 47¼ in. (13.3 x 120 cm), each mounted on a glass panel, 7¼ x 49⅜ in. (18.4 x 125.4 cm); three wood slats averaging 2½ x 44½ in. (6.2 x 113 cm) shaped along one edge to match the curves of the threads. The whole fitted in a wooden box, 11⅛ in. h. x 50⅞ in. l. x 9 in. d. (28.2 x 129.2 x 22.7 cm) Printed in gold letters on leather labels, 2¹/₁₆ x 3¼ in. (5.3 x 8.2 cm) glued at the end of each canvas strip: *3 STOPPAGES ETALON/1913–14*

Inscribed verso, on canvas strips, seen through the glass: *Un mètre de fil droit, horizontal, tombé d'un mètre de haut. (3 Stoppages étalon; appartenant à Marcel Duchamp./ 1913–14)*

Also included in the box are two wooden meter sticks marked "1 METRE," which were added at Duchamp's suggestion when the piece was shown as part of the Katherine S. Dreier Bequest to The Museum of Modern Art in 1953.

Cat: L 105, S 206

Ex coll: Katherine S. Dreier, West Redding, Connecticut

The Museum of Modern Art, New York, Katherine S. Dreier Bequest, 1953

". . . THIS IS NOT A PAINTING. THE THREE NARROW STRIPS ARE CALLED THREE STANDARD STOPPAGES FROM THE FRENCH 3 STOPPAGES-ETALON.

"THEY SHOULD BE SEEN HORIZONTALLY INSTEAD OF VERTICALLY BECAUSE EACH STRIP SHOWS A CURVED LINE MADE OF SEWING THREAD, ONE METER LONG, AFTER IT HAD BEEN DROPPED FROM A HEIGHT OF 1 METER, WITHOUT CONTROLLING THE DISTORTION OF THE THREAD DURING THE FALL. THE SHAPE THUS OBTAINED WAS FIXED ONTO THE CANVAS BY DROPS OF VARNISH. . . . THREE RULERS . . . REPRODUCE THE THREE DIFFERENT SHAPES OBTAINED BY THE FALL OF THE THREAD AND CAN BE USED TO TRACE THOSE SHAPES WITH A PENCIL ON PAPER.

"THIS EXPERIMENT WAS MADE IN 1913 TO IMPRISON AND PRESERVE FORMS OBTAINED THROUGH CHANCE, THROUGH MY CHANCE. AT THE SAME TIME, THE UNIT OF LENGTH: ONE METER WAS CHANGED FROM A STRAIGHT LINE TO A CURVED LINE WITHOUT ACTUALLY LOSING ITS IDENTITY [AS] THE METER, AND YET CASTING A PATAPHYSICAL DOUBT ON THE CONCEPT OF A STRAIGHT

LINE AS BEING THE SHORTEST ROUTE FROM
ONE POINT TO ANOTHER."

102   *Reproduced in color facing page 273.*

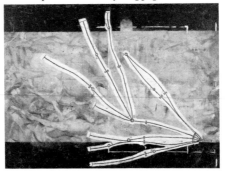

102. RÉSEAUX DES STOPPAGES (NETWORK
 OF STOPPAGES), 1914 (Paris)
Oil and pencil on canvas, $58\frac{1}{8}$ x $77\frac{5}{8}$ in.
 (148.9 x 197.7 cm)
Cat: L 115, S 214
Ex coll: Joseph Stella, New York; Pierre
 Matisse, New York; Cordier & Ekstrom,
 Inc., New York; The Mary Sisler Col-
 lection, New York

The Museum of Modern Art, New York,
 Abby Aldrich Rockefeller Fund and Gift of
 Mrs. William Sisler, 1970

Three compositions are superimposed upon
this canvas. The bottom layer is an unfin-
ished, enlarged version of *Young Man and
Girl in Spring,* probably executed in 1911.
Duchamp later (late 1913?) painted black
borders at each side of the canvas to reduce
it to the proportions of the *Large Glass* and
drew a half-scale layout for the *Glass* over the
earlier composition. The uppermost layer is
a view in plan of the nine "Capillary Tubes"
with numbered circles indicating the posi-
tion of the Nine Malic Molds. The nine
curved lines were drawn using each template
of the 3 *Standard Stoppages* three times.

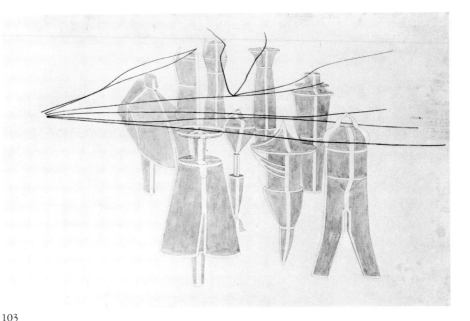

103. CIMETIÈRE DES UNIFORMES ET LIVRÉES
 (CEMETERY OF UNIFORMS AND LIVERIES
 [No. 2]), 1914 (Paris)
Pencil, ink, and watercolor on paper, 26 x
 $39\frac{3}{8}$ in. (66 x 100 cm)
Inscribed lower right, in pencil: *Marcel
 Duchamp/1914 M.D 1914*
Cat: L 114, S 215
Ex coll: Katherine S. Dreier, West Redding,
 Connecticut

103

Yale University Art Gallery, New Haven,
 Connecticut, Gift of Katherine S. Dreier
 for the Collection Société Anonyme, 1948

A full-size working drawing for the Nine
Malic Molds (reversed for transfer onto the
back of the *Glass*). The lines leading to the
top of each Mold are the "Capillary Tubes"
from the *Network of Stoppages,* seen in per-
spectival projection.

104. TAMIS (SIEVES), summer 1914 (Yport)
Colored pencil, pencil, and ink on paper,
 $27\frac{7}{8}$ x $20\frac{7}{8}$ in. (70.8 x 53 cm)
Inscribed lower right, in ink: *Marcel
 Duchamp/1914*
Cat: L 118b, S 217
Ex coll: Walter Pach, New York; Pierre
 Matisse, New York; Cordier & Ekstrom,
 Inc., New York; The Mary Sisler Col-
 lection, New York

104

105

A full-scale working drawing for the *Large Glass,* ready to be traced, reversed, and used as a guide to the lead-wire outlines of the Sieves on the back of the *Glass* itself.

105. PISTON DE COURANT D'AIR (DRAFT PISTON), 1914 (Paris)
Photograph, $23\frac{1}{8}$ x $19\frac{11}{16}$ in. (58.8 x 50 cm)
Inscribed lower left, in ink: *Marcel Duchamp / 1914;* inscribed lower center, in ink: *Piston / de Courant d' air*
Cat: L 120, S 220
Ex coll: Mme Suzanne Crotti, Neuilly

Collection Mme Marcel Duchamp, Villiers-sous-Grez

A study for the upper section of the *Large Glass,* following instructions from a *Green Box* note for "3 photos of a piece of white cloth . . . cloth accepted and rejected by the draft." The Draft Pistons were used to determine the shapes of the three irregular transparent squares on the painted cloud or "Blossoming" at the top of the *Glass.* They were to serve as a kind of communication mechanism, transmitting the "commands" of the Bride.

106. BOTTLERACK (BOTTLE DRYER), 1914
Original lost; 2nd version: the artist, Paris, c. 1921 (inscribed "Antique"), collection Robert Lebel, Paris; 3rd version: Man Ray, Paris, 1961; 4th version: Robert Rauschenberg, New York, 1961; 5th version: Ulf Linde, Stockholm, 1963; 6th version: Galleria Schwarz, Milan, edition of 8 signed and numbered copies, 1964
Readymade: galvanized-iron bottle dryer
Cat: L 119, S 219

The original *Bottle Dryer* was purchased from the Bazar de l'Hôtel de Ville in Paris and inscribed with a phrase or title which Duchamp later could not remember. This photograph was taken by Man Ray for the *Box in a Valise.*
This functional, manufactured object (a common sight in French households at the time Duchamp chose it as his first Readymade) was selected on the basis of pure visual indifference. As he remarked in an unpublished interview with Harriet, Sidney, and Carroll Janis in 1953, the act of choosing a Readymade allowed him to "reduce the idea of aesthetic consideration to the choice of the mind, not to the ability or cleverness of the hand which I objected to in many paintings of my generation . . ." He added that he was not concerned by the functional aspect of the Readymade: "that functionalism was

106

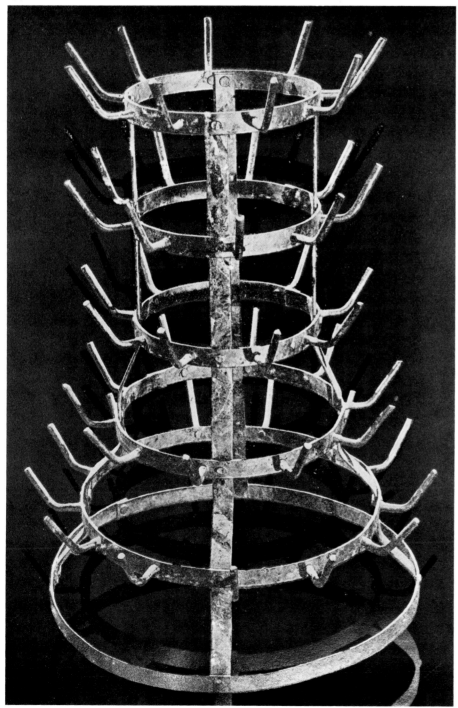

already obliterated by the fact that I took it out of the earth and onto the planet of aesthetics."

107. GLISSIÈRE CONTENANT UN MOULIN À EAU EN MÉTAUX VOISINS (GLIDER CONTAINING A WATER MILL IN NEIGHBORING METALS), 1913–15 (Paris)
Oil and lead wire on glass, mounted between 2 glass plates, $57\frac{7}{8}$ x $31\frac{1}{8}$ in. (147 x 79 cm)
Inscribed verso: *GLISSIERE/contenant/un MOULIN à Eau/(en métaux voisins)/ appartenant à/Marcel Duchamp/—1913- 14-15—*
Cat: L 111, S 230
Ex coll: Raymond Duchamp-Villon, Paris; Jacques Doucet, Paris; Louise and Walter Arensberg, Hollywood, acquired c. 1936

Philadelphia Museum of Art, The Louise and Walter Arensberg Collection

"THIS IS THE SECOND MOTIF [FOR THE LARGE GLASS] WORKED OUT ON A HALF CIRCULAR GLASS PANE AND IT IS MY FIRST PAINTING ON GLASS.

"THIS GLIDER IS ALSO A MACHINE SLIDING ON ITS TWO RUNNERS. THE WHEEL WHICH YOU SEE INSIDE IS SUPPOSED TO BE ACTIVATED BY A WATERFALL WHICH I DID NOT CARE TO REPRESENT TO AVOID THE TRAP OF BEING A LANDSCAPE PAINTER AGAIN."

In Duchamp's scheme for the Bachelor Apparatus of the *Large Glass,* the Glider (or Sleigh, or Chariot, as it is variously called in the *Green Box* notes) is designed to slide back and forth "at a jerky pace," activated by the erratic fall of a bottle of Benedictine. During its journey, the melancholy Litanies of the Chariot are to be recited: "Slow life. Vicious circle. Onanism. Horizontal. Round trip for the Buffer. Junk of life. Cheap construction . . ." For all its elegance of design, the Glider is not just an oddly simplified machine, but a paradigm of frustrated, pointless activity.

108. 9 MOULES MALIC (9 MALIC MOLDS), 1914–15 (Paris)
Oil, lead wire, and sheet lead on glass (cracked, 1916), mounted between 2 glass plates, 26 x $39\frac{13}{16}$ in. (66 x 101.2 cm)
Inscribed on reverse: *1913-14-15/9 Moules Malic,* and on the back of each figure from left to right: *Cuirassier, Gendarme, Larbin, Livreur, Chasseur, Prêtre, Croquemort, Policeman, Chef de Gare*
Cat: L 121, S 231
Ex coll: Henri-Pierre Roché, Paris, acquired in 1916 and sold back to the artist in 1956

Collection Mme Marcel Duchamp, Villiers-sous-Grez

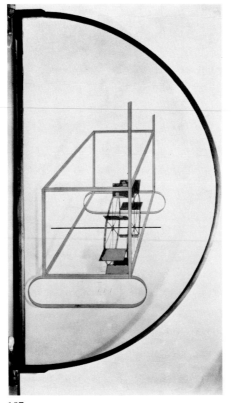

107

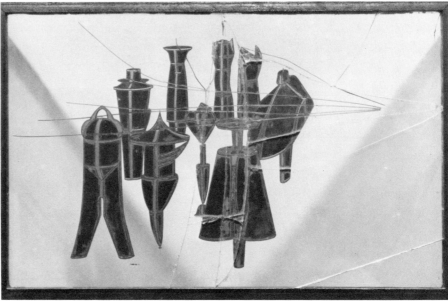

108

276

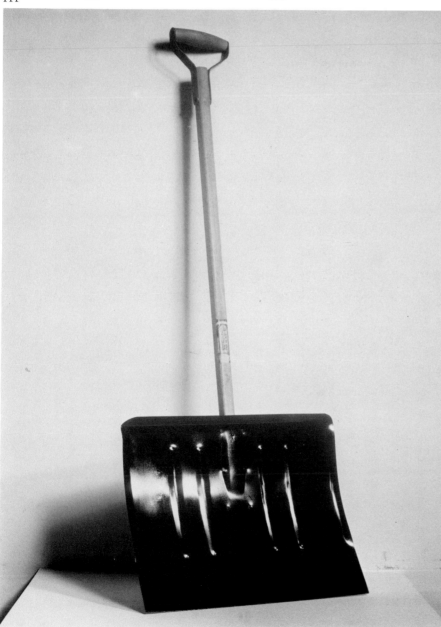

111    109                    110

"ANOTHER STUDY FOR A BIG SECTION OF THE LARGE GLASS. PAINTED DIRECTLY ON ONE SIDE OF THE GLASS, AND TO BE SEEN FROM THE OTHER SIDE, IT IS CALLED THE CEMETERY OF UNIFORMS AND LIVERIES. IT REPRESENTS NINE MOULDS OR NINE EXTERNAL CONTAINERS OF THE MOULDINGS OF NINE DIFFERENT UNIFORMS OR LIVERIES. IN OTHER WORDS YOU CAN'T SEE THE ACTUAL FORM OF THE POLICEMAN OR THE BELLBOY OR THE UNDERTAKER BECAUSE EACH ONE OF THESE PRECISE FORMS OF UNIFORMS IS INSIDE ITS PARTICULAR MOULD.

"DONE IN PARIS IN 1914–1915, THE DESIGN IS MADE WITH LEAD WIRES FIXED ONTO THE GLASS BY DROPS OF VARNISH AND THE COLORS ARE REGULAR OIL PAINTS.

"THE BREAK THAT OCCURRED IN 1916 DID NOT DISTURB THE DESIGN AND IT IS NOW FRAMED BETWEEN TWO PLATE GLASS PANES."

109. SUZANNE DUCHAMP AS A NURSE, 1915 (Paris)
Pen, pencil, and colored crayons on paper, 9 x 5⅜ in. (22.8 x 13.7 cm)
Inscribed center left, in pen: *M.D. 15.;* inscribed lower left, in red ink: *Marcel Duchamp*
Cat: L 124b, S 227
Ex coll: Paul François, Paris

Collection Arnold D. Fawcus, Paris

This and the following drawing were done while Duchamp's sister was serving in a military hospital at the start of World War I.

110. THE PHARMACIST, 1915 (Paris)
Pen and pencil on paper, 8³⁄₁₆ x 5⅜ in. (20.8 x 13.7 cm)
Inscribed lower right, in ink: *M.D. 15;* inscribed lower left, in ink: *Marcel Duchamp*
Cat: L 124d, S 228
Ex coll: Paul François, Paris

Collection Arnold D. Fawcus, Paris

111. IN ADVANCE OF THE BROKEN ARM, 1915 (New York)
Original lost; 2nd version obtained by Duchamp for Katherine S. Dreier, 1945; 3rd version Ulf Linde, Stockholm, 1963; 4th version Galleria Schwarz, Milan, edition of 8 signed and numbered replicas, 1964
Readymade: wood and galvanized-iron snow shovel, 47¾ in. h. (121.3 cm)
Inscribed on reverse of lower edge, in white paint: *IN ADVANCE OF THE BROKEN ARM MARCEL DUCHAMP* [1915] *replica 1945*
Cat: L 125, S 233
Ex coll: Katherine S. Dreier, West Redding, Connecticut, acquired in 1945

Yale University Art Gallery, New Haven, Connecticut, Gift of Katherine S. Dreier for the Collection Société Anonyme, 1946

Purchased by Duchamp in a New York hardware store, the snow shovel was the first Readymade to be called by that name.

112. "THE," 1915 (New York)
Ink on paper, $8\frac{3}{4}$ x $5\frac{5}{8}$ in. (22.2 x 14.3 cm)
Cat: L 126, S 234
Ex coll: Louise and Walter Arensberg, New York, probably acquired c. 1915

Philadelphia Museum of Art, The Louise and Walter Arensberg Collection

Possibly Duchamp's first manuscript text in English, in which an asterisk replaces the article "the" every time it occurs. This text was published in the October 1916 issue of *Rogue* (New York) as "THE, Eye Test, Not a 'Nude Descending a Staircase.' "

113. FANIA (PROFILE), 1916 (New York)
Ink and wash with typescript on typing paper, 11 x $8\frac{1}{2}$ in. (28 x 21.5 cm)
Inscribed lower right, in ink; *Fania (. Profil )/Marcel Duchamp/presque 1916*
Cat: L 213, S 235
Ex coll: Louise and Walter Arensberg, Hollywood

Philadelphia Museum of Art, The Louise and Walter Arensberg Collection

A portrait provoked by the acquisition of an Underwood typewriter. Fania Marinoff was the wife of Carl Van Vechten.

114. RENDEZ-VOUS DU DIMANCHE 6 FÉVRIER 1916 . . . (RENDEZVOUS OF SUNDAY, FEBRUARY 6, 1916), 1916 (New York)
Typewritten text on four postcards, taped together, $11\frac{1}{4}$ x $5\frac{11}{16}$ in. (28.4 x 14.4 cm)
Inscribed in black ink on lower left postcard in space for address: *Rendez vous* [sic] *du Dimanche 6 Février 1916/à 1 h. $\frac{3}{4}$ après midi*
Cat: L 127, S 236
Ex coll: Louise and Walter Arensberg, New York, acquired in 1916

Philadelphia Museum of Art, The Louise and Walter Arensberg Collection

Duchamp described his intention in composing this French text in an interview with Arturo Schwarz:
". . . there would be a verb, a subject, a complement, adverbs, and everything perfectly correct, as such, as words, but meaning in these sentences was a thing I had to avoid . . . the verb was meant to be an abstract word acting on a subject that is a material object, in this way the verb would make the

112

113

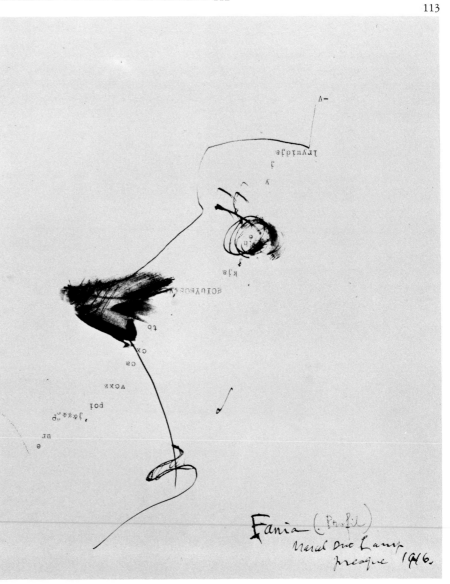

-toir. On manquera, à la fois, de
moins qu'avant cinq élections et
aussi quelque accointance avec q-
-uatre petites bêtes; il faut oc-
-cuper ce délice afin d'en décli-
-ner toute responsabilité. Après
douze photos, notre hésitation de-
-vant vingt fibres était compréh-
-ensible; même le pire accrochage
demande coins porte-bonheur sans
compter interdiction aux lins: C-
-omment ne pas épouser son moind-
-re opticien plutôt que supporter
leurs mèches? Non, décidément, der-
-rière ta canne se cachent marbr-
-ures puis tire-bouchon. "Cepend-
-ant, avouèrent-ils, pourquoi viss-
-er, indisposer? Les autres ont p-
-ris démangeaisons pour construi-
-re, par douzaines, ses lacements.
Dieu sait si nous avons besoin, q-
-uoique nombreux mangeurs, dans un
défalquage." Défense donc au tri-
-ple, quand j'ourlerai, dis je, pr-

-este pour les profits, devant le-
-squels et, par précaution à prop-
-os, elle défonce desserts, même c-
-eux qu'il est défendu de nouer.
Ensuite, sept ou huit poteaux boi-
-vent quelques conséquences main-
-tenant appointées; ne pas oubli-
-er, entre parenthèses, que sans l'
-économat, puis avec mainte sembl-
-able occasion, reviennent quatre
fois leurs énormes lines; quoi!
alors, si la férocité débouche de-
-rrière son propre tapis. Dès dem-
-ain j'aurai enfin mis exactemen-
-t des piles là où plusieurs fen-
-dent, acceptent quoique mandant
le pourtour. D'abord, piquait on
ligues sur bouteilles, malgré le-
-ur importance dans cent séréni-
-tés? Une liquide algarade, après
semaines dénonciatrices, va en y
détester ta valise car un bord
suffit. Nous sommes actuellement
assez essuyés, voyez quel désarroi

114

-onent, après avoir fini votre gê-
-ne. N'empêche que le fait d'éte-
-indre six boutons l'un ses autr-
-es paraît (sauf si, lui, tourne a-
-utour) faire culbuter les bouto-
-nnières. Reste à choisir: de lo-
-ngues, fortes, extensibles défect-
-ions trouées par trois filets u-
-sés, ou bien, la seule enveloppe
pour étendre. Avez vous accepté
des manches? Pouvais tu prendre
sa file? Peut-être devons nous a-
-ttendre mon pilotis, en même tem-
-ps ma difficulté; avec ces chos-
-es là, impossible ajouter une hu-
-itième laisse. Sur trente misé-
-rables postes deux actuels veul-
-ent errer, remboursés civiquement,
refusent toute compensation hors
leur sphère. Pendant combien, pou-
-rquoi comment, limitera-t-on min-
-ce étiage? autrement dit: clous
refroidissent lorsque beaucoup p-
-lissent enfin derrière, contenant

porte, dès maintenant par grande
quantité, pourront faire valoir l-
-e clan oblong qui, sans ôter auc-
-un traversin ni contourner moin-
-s de grelots, va remettre. Deux
fois seulement, tout élève voudra-
-it traire, quand il facilite la
bascule disséminée; mais, comme q-
-uelqu'un démonte puis avale des
déchirements nains nombreux, soi
compris, on est obligé d'entamer
plusieurs grandes horloges pour
obtenir un tiroir à bas âge. Co-
-nclusion: après maints efforts
en vue du peigne, quel dommage!
tous les fourreurs sont partis e-
-t signifient riz. Aucune deman-
-de ne nettoie l'ignorant ou sc-
-ié teneur; toutefois, étant don-
-nées quelques cages, c'eut une
profonde émotion qu'exécutent t-
-outes colles alitées. Tenues, v-
-ous auriez manqué si s'était t-
-rouvée là quelque prononciation

sentence look abstract. The construction was very painful in a way, because the minute I *did* think of a verb to add to the subject, I would very often see a meaning and immediately I saw a meaning I would cross out the verb and change it, until, working for quite a number of hours, the text finally read without any echo of the physical world . . . That was the main point of it." (See bibl. 53, p. 457.)

115. COMB, February 1916 (New York)
2nd version: Ulf Linde, Stockholm, 1963;
3rd version: Galleria Schwarz, Milan, edition of 8 signed and numbered copies, 1964
Readymade: steel comb, 6½ x 1³⁄₁₆ in. (16.6 x 3.2 cm)
Inscribed along the edge in white: *3 OU 4 GOUTTES DE HAUTEUR N'ONT RIEN A FAIRE AVEC LA SAUVAGERIE;* inscribed lower right, end of edge, reading from base: *M.D.;* inscribed lower left, end of edge, reading from base: *FEB. 17 1916 11 A.M.*
Cat: L 128, S 237
Ex coll: Louise and Walter Arensberg, New York, as early as 1918

Philadelphia Museum of Art, The Louise and Walter Arensberg Collection

". . . AN ORDINARY METAL DOG COMB ON WHICH I INSCRIBED A NONSENSICAL PHRASE: TROIS OU QUATRE GOUTTES DE HAUTEUR N'ONT RIEN À VOIR AVEC LA SAUVAGERIE WHICH MIGHT BE TRANSLATED AS FOLLOWS: THREE OF FOUR DROPS OF HEIGHT HAVE NOTHING TO DO WITH SAVAGERY.

"DURING THE 48 YEARS SINCE IT WAS CHOSEN AS A READYMADE THIS LITTLE IRON COMB HAS KEPT THE CHARACTERISTICS OF A TRUE READYMADE: NO BEAUTY, NO UGLINESS, NOTHING PARTICULARLY ESTHETIC ABOUT IT . . . IT WAS NOT EVEN STOLEN IN ALL THESE 48 YEARS!"

The precise date and hour inscribed on this Readymade follow Duchamp's prescription in a *Green Box* note:
"Specifications for 'Readymades.' by planning for a moment to come (on such a day, such a date such a minute), 'to *inscribe* a readymade'.—The readymade can later be looked for. (*with* all kinds of delays)
"The important thing then is just this matter of timing, this snapshot effect, like a speech delivered on no matter what occasion but at *such and such an hour*. It is a kind of rendezvous.
"—Naturally inscribe that date, hour, minute, on the readymade as information."

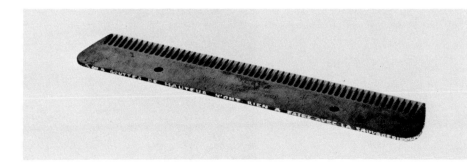

115

116. A BRUIT SECRET (WITH HIDDEN NOISE), Easter 1916 (New York)

2nd version: Ulf Linde, Stockholm, 1963; 3rd version: Galleria Schwarz, Milan, edition of 8 signed and numbered replicas, 1964

Assisted Readymade: ball of twine between 2 brass plates, joined by 4 long screws, containing a small unknown object added by Walter Arensberg, $5\frac{1}{16}$ x $5\frac{1}{8}$ x $4\frac{1}{2}$ in. (12.9 x 13 x 11.4 cm)

Inscribed on top of upper plate, in white paint:
*P.G. .ECIDES DEBARRASSE.*
*LE D.SERT. F.URNIS.ENT*
*AS HOW.V.R COR.ESPONDS*
*Convenablement choisie dans la meme colonne*

Inscribed on bottom of lower plate, in white paint:
*.IR CAR.E LONGSEA*
*F.NE, HEA., O.SQUE*
*TE.U S.ARP BAR AIN*
*Remplacer chaque point par une lettre*

Cat: L 129, S 238

Ex coll: Louise and Walter Arensberg, New York, as early as 1918

Philadelphia Museum of Art, The Louise and Walter Arensberg Collection

"WITH HIDDEN NOISE IS THE TITLE FOR THIS ASSISTED READYMADE: A BALL OF TWINE BETWEEN TWO BRASS PLATES JOINED BY FOUR LONG SCREWS. INSIDE THE BALL OF TWINE WALTER ARENSBERG ADDED SECRETLY A SMALL OBJECT THAT MAKES A NOISE WHEN YOU SHAKE IT. AND TO THIS DAY I DON'T KNOW WHAT IT IS, NOR, I IMAGINE DOES ANYONE ELSE.

"ON THE BRASS PLAQUES I WROTE THREE SHORT SENTENCES IN WHICH LETTERS WERE OCCASIONALLY MISSING LIKE IN A NEON SIGN WHEN ONE LETTER IS NOT LIT AND MAKES THE WORD UNINTELLIGIBLE."

117. TRAVELER'S FOLDING ITEM, 1916 (New York)

Original lost; 2nd version: Ulf Linde, Stockholm, 1962; 3rd version: Galleria Schwarz, Milan, edition of 8 signed and numbered replicas, 1964, of which this is 2/8

Readymade: Underwood typewriter cover, $9\frac{1}{16}$ in. h. (23 cm)

Inscribed inside lower edge, in white ink:
*Marcel Duchamp 1964*

Cat: L 133, S 240

Exh: New York, Bourgeois Galleries, "Exhibition of Modern Art," April 3–29, 1916, cat. no. 50 (?)

The Mary Sisler Collection, courtesy Fourcade, Droll, Inc., New York

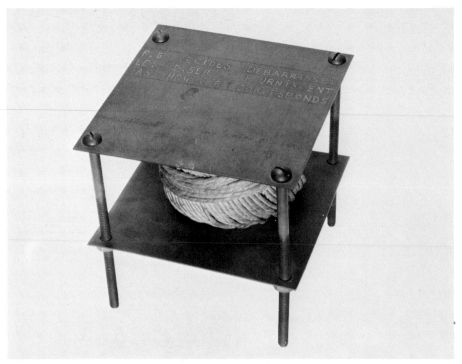

116  *Reproduced in color facing page 288.*

117

Duchamp remarked in an unpublished interview with Harriet, Sidney, and Carroll Janis in 1953: "I thought it would be a good idea to introduce softness in the Readymade—in other words not altogether hardness—porcelain or iron or things like that— why not use something flexible as a new shape—changing shape, so that's why the typewriter cover came into existence."

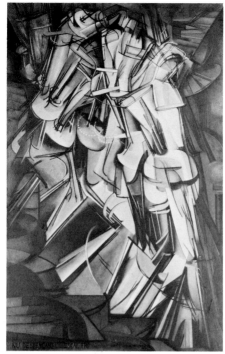

118

118. NU DESCENDANT UN ESCALIER (NUDE DESCENDING A STAIRCASE [No. 3]), 1916 (New York)
Watercolor, ink, pencil, and pastel over photographic base, 57⅞ x 35⁷⁄₁₆ in. (147 x 90 cm)
Inscribed bottom center: *MARCEL DUCHAMP [FILS]/1912–1916*; inscribed lower left: *NU DESCENDANT UN ESCALIER*
Cat: L 89, S 241
Ex coll: Louise and Walter Arensberg, New York, commissioned in 1916

Philadelphia Museum of Art, The Louise and Walter Arensberg Collection

This replica was executed at Arensberg's request, when the latter regretted that he had not yet succeeded in acquiring the original for his collection. Duchamp made one further replica in 1918: a minute version for the doll's house of Miss Carrie Stettheimer, now in the collection of the Museum of the City of New York.

119. APOLINÈRE ENAMELED, 1916–17 (New York)
2nd version: Galleria Schwarz, Milan, edition of 8 signed and numbered replicas, 1965
Rectified Readymade: pencil on cardboard and painted tin, 9⅝ x 13⅜ in. (24.5 x 33.9 cm)
Cat: L 130, S 243
Ex coll: Louise and Walter Arensberg, New York, as early as 1918

Philadelphia Museum of Art, The Louise and Walter Arensberg Collection

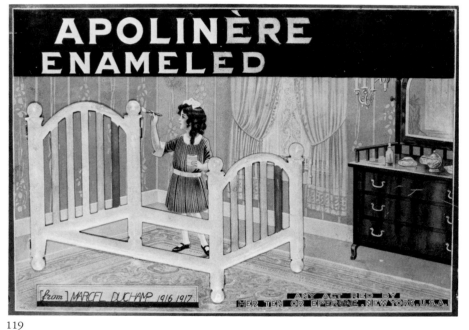

119

"THIS IS ANOTHER ASSISTED READYMADE, DATED 1916–1917. I CHANGED THE LETTERING IN AN ADVERTISEMENT FOR 'SAPOLIN PAINTS', MISSPELLING INTENTIONALLY THE NAME OF GUILLAUME APPOLLINAIRE AND ALSO ADDING THE REFLECTION OF THE LITTLE GIRL'S HAIR IN THE MIRROR. I AM SORRY APOLLINAIRE NEVER SAW IT—HE DIED IN 1918 IN FRANCE."

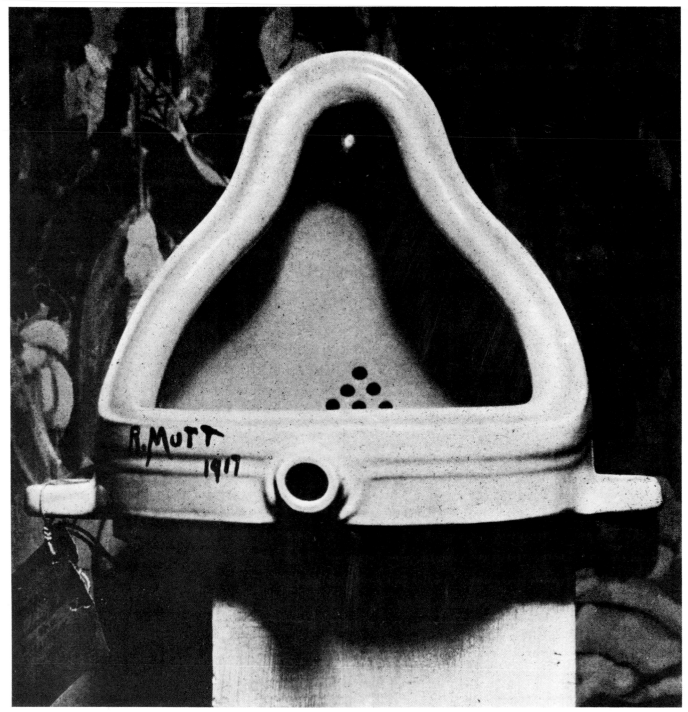

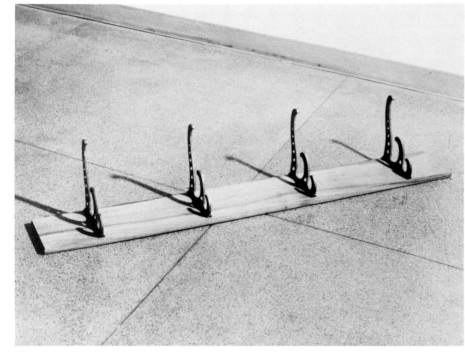

121

120. FOUNTAIN, 1917 (New York)
Original lost; 2nd version: Sidney Janis, New York, 1951; 3rd version: Galleria Schwarz, Milan, edition of 8 signed and numbered replicas, 1964
Readymade: porcelain urinal on its back
Inscribed on upper edge, in black paint: *R. MUTT/1917*
Cat: L 132, S 244

Sidney Janis Gallery, New York

The urinal, purchased from "Mott Works" company in New York and signed "R. Mutt," was submitted to the jury-free 1917 Independents exhibition but was suppressed by the hanging committee. The photograph reproduced here was taken by Alfred Stieglitz shortly after *Fountain* was rejected, and it illustrated an anonymous article in the second issue of *The Blind Man* (published in May 1917 by Duchamp, Beatrice Wood, and H.-P. Roché) which came to the defense:

"Now Mr. Mutt's fountain is not immoral, that is absurd, no more than a bathtub is immoral. It is a fixture that you see every day in plumbers' show windows.

"Whether Mr. Mutt with his own hands made the fountain or not has no importance. He CHOSE it. He took an ordinary article of life, placed it so that its useful significance disappeared under the new title and point of view—created a new thought for that object."

121. TRÉBUCHET (TRAP), 1917 (New York)
Original lost; 2nd version: Galleria Schwarz, Milan, edition of 8 signed and numbered replicas, 1964, of which this is 2/8
Readymade: coat rack, wood and metal, $4\frac{5}{8}$ x $39\frac{3}{8}$ in. (11.7 x 100 cm.)
Inscribed on front edge, in black ink: *Marcel Duchamp 1964*
Cat: L 134, S 248

The Mary Sisler Collection, courtesy Fourcade, Droll, Inc., New York

"Trébuchet" is a chess term for a pawn placed so as to "trip" an opponent's piece. This Readymade was nailed to the floor in Duchamp's New York studio, 33 West 67th Street.

Duchamp described the genesis of this item to Harriet Janis in the unpublished interview of 1953: ". . . a real coat hanger that I wanted sometime to put on the wall and hang my things on but I never did come to that—so it was on the floor and I would kick it every minute, every time I went out—I got crazy about it and I said the Hell with it, if it wants to stay there and bore me, I'll nail it down . . . and then the association with the Readymade came and it was that. It was not bought to be a Readymade—it

was a natural thing . . . it was nailed where
it was and then the idea came . . ."

122. Hat Rack, 1917
Original lost; 2nd version: Galleria Schwarz,
Milan, edition of 8 signed and numbered
replicas, 1964, of which this is 2/8
Readymade: wooden hat rack, 9¼ x 5½ in.
(23.5 x 14 cm)
Inscribed verso, in black ink: *Marcel Du-
champ, 1964*
Cat: L 135, S 249
Ex coll: Mary Sisler Collection, New York

The Australian National Gallery, Canberra,
Australia

This Readymade was suspended from the
ceiling of Duchamp's New York studio.

123. Recette (Recipe), 1918 (New York)
Manuscript note, ink on photographic film,
5¼ x 5⅜ in. (13.3 x 13.6 cm)
Inscribed in ink, lower left: *Marcel Du-
champ/1918*
Cat: L 136, S 251
Ex coll: Louise and Walter Arensberg, New
York, probably acquired c. 1918

Philadelphia Museum of Art, The Louise
and Walter Arensberg Collection

An improbable recipe calling for three
pounds of "plume" (feather or pen), five
meters of string weighing ten grams, and
twenty-five "candles of electric light." It ap-
pears to be written on a fragment of one of
the photographs for the Draft Pistons.

124. Tu m' (You—me), 1918 (New York)
Oil and pencil on canvas, with bottle brush,
three safety pins, and a bolt, 27½ x 122¾
in. (69.8 x 313 cm)
Inscribed lower left, in white paint: *Tu m'
Marcel Duchamp 1918*
The hand was painted by a professional sign-
painter who signed in pencil: *A. Klang.*
Cat: L 137, S 253
Ex coll: Katherine S. Dreier, West Redding,
Connecticut, commissioned in 1918

Yale University Art Gallery, New Haven,
Connecticut, Bequest of Katherine S.
Dreier, 1953

*Tu m'* was designed to fit above a bookcase
in Katherine Dreier's library. His last paint-
ing on canvas, it combines a number of Du-
champ's interests in encyclopedic fashion.
The outlines of the *3 Standard Stoppages* ap-
pear at the bottom left and are used again in
the curious perspectival studies at the right.
Shadows of two actual Readymades (*Bicycle
Wheel* and *Hat Rack*) were projected onto
the canvas and their shapes traced in pencil,

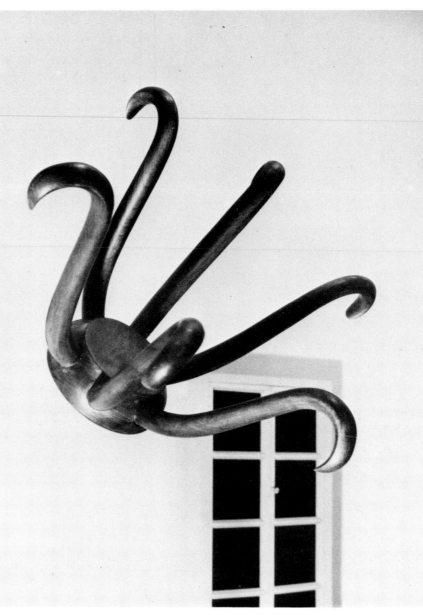

122

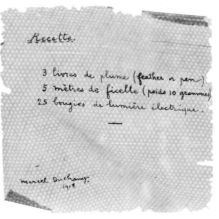

123

284

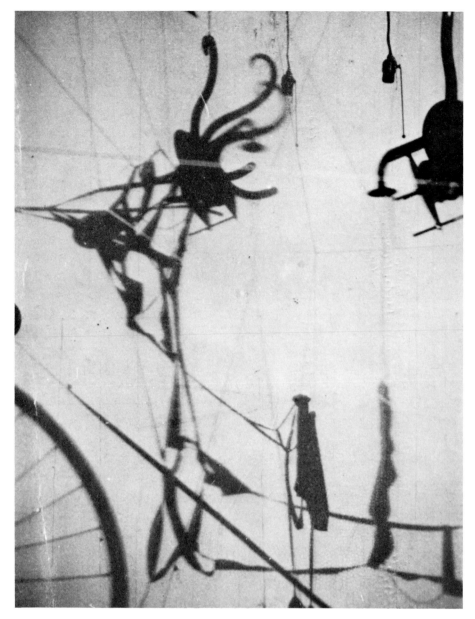

"Shadows of Readymades." Photograph taken in Duchamp's studio, 33 West 67th Street, New York, 1918.

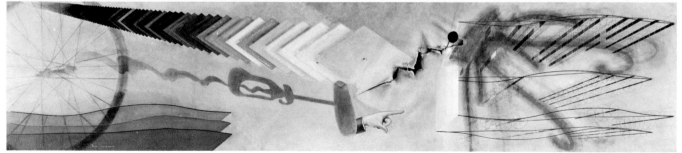

124    *Reproduced in color facing page 289.*

while a nonexistent Readymade (a cork-screw) is presented in the same way. Duchamp plays on the concept of *trompe l'oeil*: real safety pins close a painted tear in the canvas, a real bolt passes through the center of the first of a row of painted color samples.

125. SCULPTURE FOR TRAVELING, 1918
(New York)
Rubber and string, dimensions *ad lib.*
Cat: L 138, S 234

A collapsible sculpture made from colored strips of rubber cut from bathing caps. It could be arranged in any configuration by tying the strings attached to it to various points in a room. Duchamp took it to Buenos Aires with him in 1918.

The original (shown at right in a photograph of the New York studio, 33 West 67th Street) disintegrated after a few years. A copy was made by Richard Hamilton in 1966 for the retrospective exhibition of Duchamp's work at the Tate Gallery, London.

126. ADIEU À FLORINE (FAREWELL TO FLORINE), August 1918
Ink and colored pencils on paper, $8\frac{11}{16}$ x $5\frac{11}{16}$ in. (22.1 x 14.5 cm)
Inscribed bottom right, in ink: *adieu à Florine/Marcel Duchamp/13 aout 1918*
Ex coll: Florine Stettheimer, New York

Collection Mme Marcel Duchamp, Villiers-sous-Grez

A previously uncataloged drawing, executed for his friend, the painter Florine Stettheimer, on the eve of Duchamp's departure by boat for Buenos Aires.

127. A REGARDER (L'AUTRE CÔTÉ DU VERRE) D'UN OEIL, DE PRÈS, PENDANT PRESQUE UNE HEURE (TO BE LOOKED AT [FROM THE OTHER SIDE OF THE GLASS] WITH ONE EYE, CLOSE TO, FOR ALMOST AN HOUR), 1918 (Buenos Aires)
Oil paint, silver leaf, lead wire, and magnifying lens on glass (cracked), $19\frac{1}{2}$ x $15\frac{5}{8}$ in. (49.5 x 39.7 cm), mounted between two panes of glass in a standing metal frame, $20\frac{1}{8}$ x $16\frac{1}{4}$ x $1\frac{1}{2}$ in. d. (51 x 41.2 x 3.7 cm) on a painted wood base, $1\frac{7}{8}$ x $17\frac{7}{8}$ x $4\frac{1}{2}$ in. d., overall height 22 in. (55.8 cm)
Inscribed on strip of metal glued across the painting, in ink: *A REGARDER (L'AUTRE COTE DU VERRE) D'UN OEIL, DE PRES, PENDANT PRESQUE UNE HEURE./Marcel Duchamp/BA. 1918*
Cat: L 139, S 256
Ex coll: Katherine S. Dreier, West Redding, Connecticut

The Museum of Modern Art, New York, Katherine S. Dreier Bequest, 1953

125

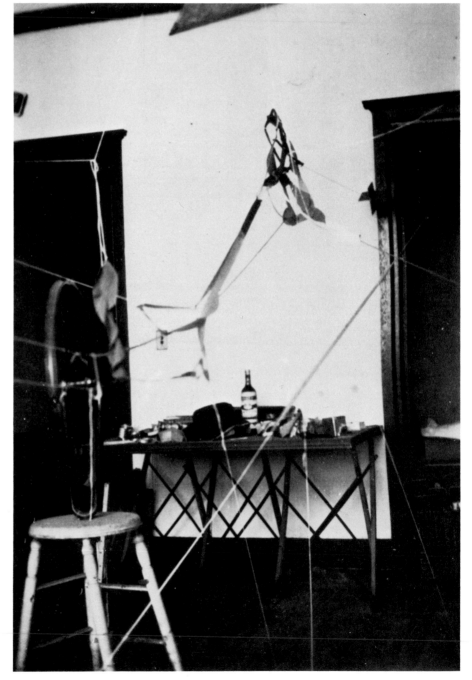

286

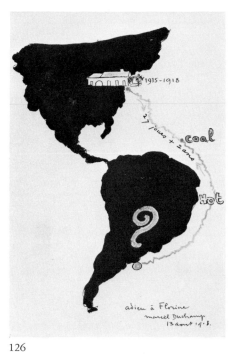

126

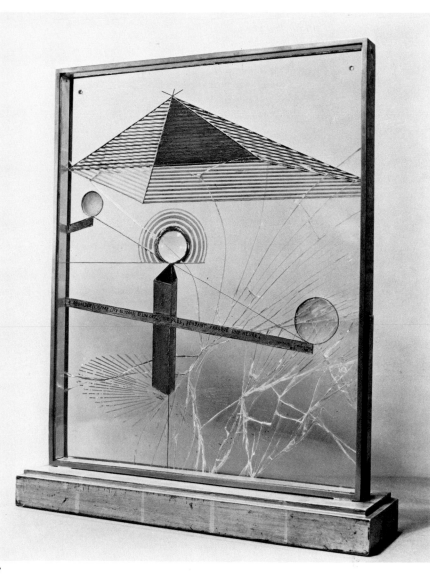

127

127

A study for the right-hand section of the lower half of the *Large Glass,* introducing an interest in optical phenomena which was to preoccupy Duchamp over the next decade.

Photograph at bottom, page 287, was taken in Buenos Aires in 1918–19 and shows the glass suspended on a hotel balcony. It was cracked later in transit to New York.

128. HANDMADE STEREOPTICON SLIDE (HAND STEREOSCOPY), 1918–19 (Buenos Aires)
Rectified Readymade: pencil over photographic stereopticon slide, each image 2¼ x 2¼ in. (5.7 x 5.7 cm), in a cardboard mount, 2¹¹⁄₁₆ x 6¾ in. (6.8 x 17.2 cm)
Inscribed verso, in pencil: *Original*
Cat: L 140, S 258
Ex coll: Katherine S. Dreier, West Redding, Connecticut

The Museum of Modern Art, New York, Katherine S. Dreier Bequest, 1953

Despite his contempt for "retinal" painting which appealed only to the eye, Duchamp displayed a lifelong fascination with the phenomena of vision. This handmade slide is the first of a series of experiments with the illusion of depth obtainable through stereoscopy.

129. CHESSMEN, 1918–19 (Buenos Aires)
Wood chessmen, various heights from 4 in. to 2½ in. (10.1 cm to 6.3 cm)
Cat: S 259

Collection Mme Marcel Duchamp, Villiers-sous-Grez

In Buenos Aires, where Duchamp knew no one and barely spoke the language, he devoted his time to studies for the *Large Glass* and an increasing passion for chess. He carved his own chess pieces (except for the knights, which were executed by a local craftsman) and designed a set of rubber stamps for use in playing chess by mail. All his life Duchamp enjoyed making "by hand" things that eluded definition as art.

130. UNHAPPY READYMADE, 1919 (Buenos Aires–Paris)
Readymade: geometry textbook
Original destroyed.
Cat: L 144, S 260

Duchamp sent instructions from Buenos Aires for a Readymade to be executed by his sister Suzanne and her husband Jean Crotti in Paris: a geometry book was to be hung out on the balcony of their apartment. Duchamp described this work in an interview with Pierre Cabanne:

". . . the wind had to go through the book,

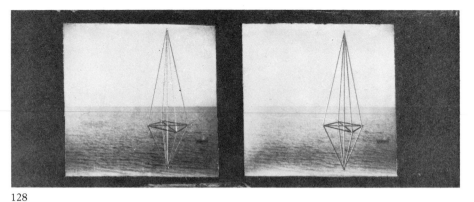

128

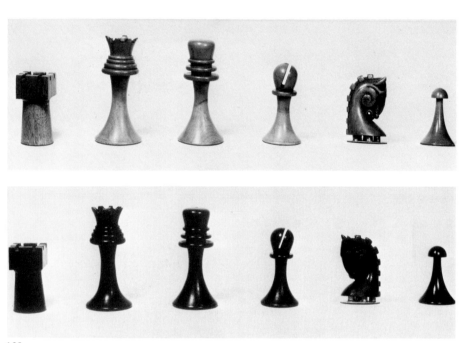

129

130

*With Hidden Noise.* 1916. Assisted Readymade: ball of twine between 2 brass plates, joined by 4 long screws, containing a small unknown object added by Walter Arensberg, 5¹⁄₁₆ x 5⅛ x 4½ in. Philadelphia Museum of Art, The Louise and Walter Arensberg Collection. Cat. 116.

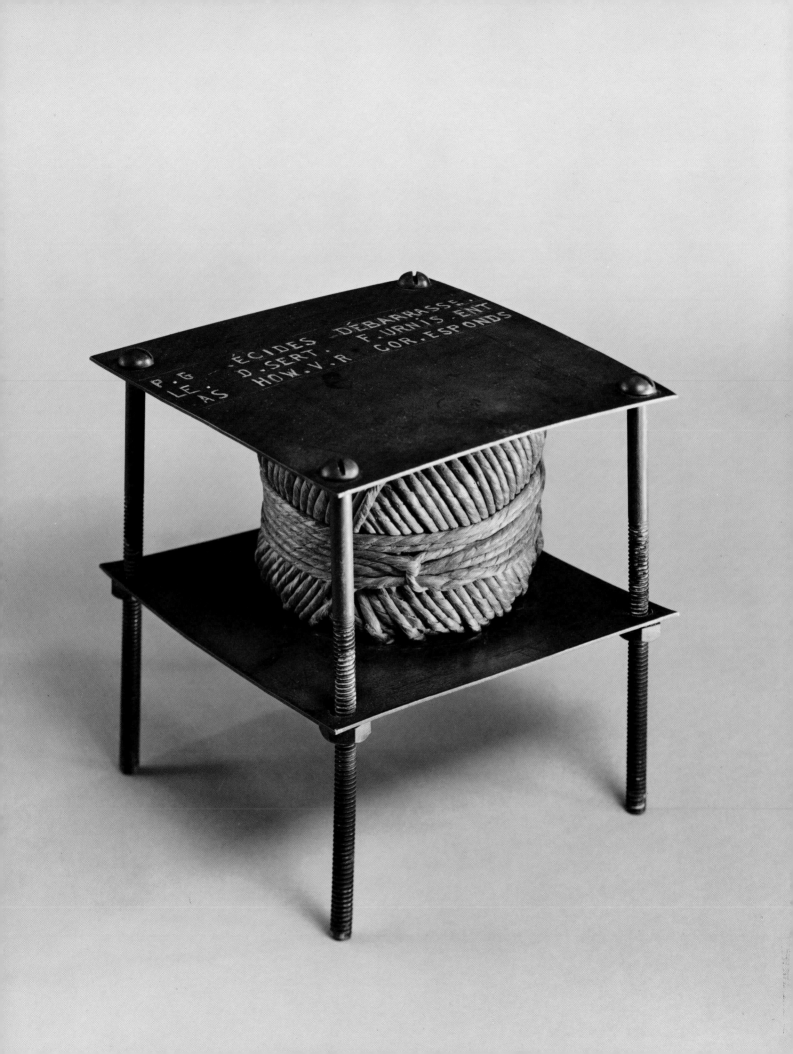

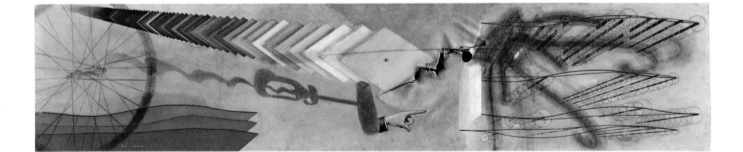

choose its own problems, turn and tear out the pages. Suzanne did a small painting of it, 'Marcel's Unhappy Readymade.' That's all that's left, since the wind tore it up. It amused me to bring the idea of happy and unhappy into readymades, and then the rain, the wind, the pages flying, it was an amusing idea . . ." (See bibl. 54, p. 61.)

Suzanne Duchamp's painting, *Le Ready-made malheureux de Marcel,* of 1920, is in the collection of Professor Guido Rossi, Milan, and is closely related to the photograph reproduced at bottom of page 288.

131    *Reproduced in color facing page 128.*

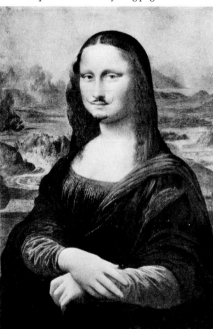

**131. L.H.O.O.Q., 1919 (Paris)**
Rectified Readymade: pencil on a reproduction, 7¾ x 4⅞ in. (19.7 x 12.4 cm)
Inscribed lower right, in pencil: *Marcel Duchamp/1919*; inscribed lower left: *Paris*; inscribed below, in pencil: *L.H.O.O.Q.*
Cat: L 141, S 261
Ex coll: The artist; Cordier & Ekstrom, Inc., New York; The Mary Sisler Collection, New York

Private collection, Paris

"IN 1919 I WAS BACK IN PARIS AND THE DADA MOVEMENT HAD JUST MADE ITS FIRST APPEARANCE THERE: TRISTAN TZARA WHO HAD ARRIVED FROM SWITZERLAND, WHERE THE MOVEMENT HAD STARTED IN 1916, JOINED THE GROUP AROUND ANDRÉ BRETON IN PARIS. PICABIA AND I HAD ALREADY SHOWN IN AMERICA OUR SYMPATHY FOR THE DADAS.

"THIS MONA LISA WITH A MOUSTACHE AND A GOATEE IS A COMBINATION READYMADE AND ICONOCLASTIC DADAISM. THE ORIGINAL, I MEAN THE ORIGINAL READYMADE IS A CHEAP CHROMO 8 X 5 ON WHICH I INSCRIBED AT THE BOTTOM FOUR [SIC] LETTERS WHICH PRONOUNCED LIKE INITIALS IN FRENCH, MADE A VERY RISQUÉ JOKE ON THE GIOCONDA."

Duchamp made a second, larger version for Louis Aragon on the occasion of the exhibition "La Peinture au défi" in Paris in 1930.

**132. TZANCK CHECK, December 3, 1919 (Paris)**
Ink on paper, 8¼ x 15¹⁄₁₆ in. (21 x 38.2 cm)
Cat: L 142, S 263
Ex coll: Dr. Daniel Tzanck, Paris, acquired in 1919; the artist; Cordier & Ekstrom, Inc., New York; The Mary Sisler Collection, New York

Galleria Schwarz, Milan

This enlarged handmade check was presented to Dr. Daniel Tzanck in payment for dental work. A working drawing for the check is also owned by the Galleria Schwarz.

132

*Tu m'.* 1918. Oil and pencil on canvas, with bottle brush, 3 safety pins, and a bolt, 27½ x 122¾ in. Yale University Art Gallery, New Haven, Connecticut, Bequest of Katherine S. Dreier. Cat. 124.

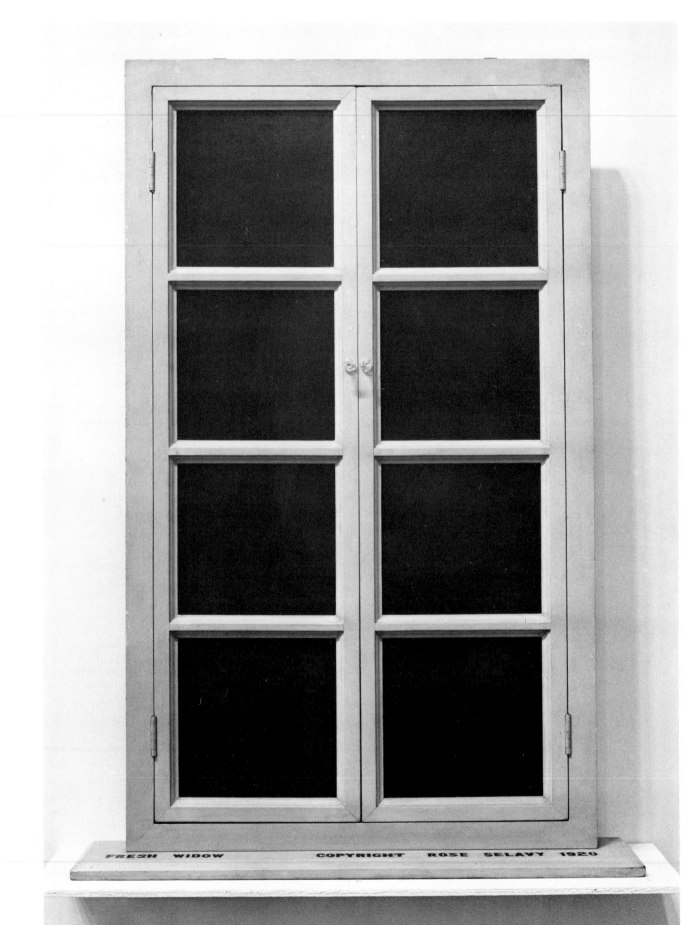

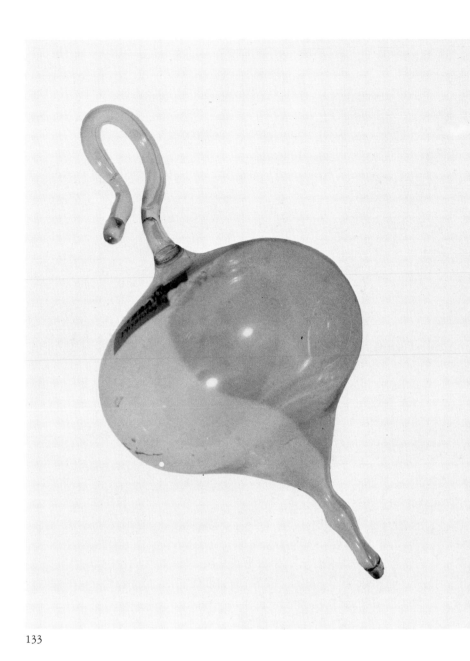

133

133. Air de Paris (50 cc of Paris Air), December 1919 (Paris)
2nd version: Marcel Duchamp, New York, 1949 (for Walter Arensberg); 3rd version: Ulf Linde, Stockholm, 1963; 4th version: Galleria Schwarz, Milan, edition of 8 signed and numbered replicas, 1964
Readymade: glass ampoule (broken and mended), 5¼ in. h. (13.3 cm)
On printed label: "Serum Physiologique"
Cat: L 143, S 264
Ex coll: Louise and Walter Arensberg, New York, gift of the artist in 1920

Philadelphia Museum of Art, The Louise and Walter Arensberg Collection

"AT THE END OF . . . 1919 I LEFT AGAIN FOR AMERICA, AND WANTING TO BRING BACK A PRESENT TO MY FRIENDS THE ARENSBERGS, I ASKED A PARISIAN PHARMACIST TO EMPTY A GLASS CONTAINER FULL OF SERUM AND TO SEAL IT AGAIN.
"THIS IS THE PRECIOUS AMPOULE OF FIFTY CUBIC CENTIMETERS OF AIR OF PARIS, I BROUGHT BACK TO THE ARENSBERGS IN 1919."

134. Fresh Widow, 1920 (New York)
2nd version: Ulf Linde and P. O. Ultvedt, Stockholm, 1961; 3rd version: Galleria Schwarz, Milan, edition of 8 signed and numbered replicas, 1964
Miniature French window, painted wood frame and eight panes of glass covered with black leather, 30½ x 17⅝ in. (77.5 x 45 cm) on wood sill ¾ x 21 x 4 in. (1.9 x 53.3 x 10.2 cm)
Inscribed across sill, applied in black paper-tape letters: FRESH WIDOW COPYRIGHT ROSE SELAVY 1920
Cat: L 145, S 265
Ex coll: Katherine S. Dreier, West Redding, Connecticut

The Museum of Modern Art, New York, Katherine S. Dreier Bequest, 1953

"THIS SMALL MODEL OF A FRENCH WINDOW WAS MADE BY A CARPENTER IN NEW YORK IN 1920. TO COMPLETE IT I REPLACED THE GLASS PANES BY PANES MADE OF LEATHER WHICH I INSISTED SHOULD BE SHINED EVERY DAY LIKE SHOES. FRENCH WINDOW WAS CALLED FRESH WIDOW, AN OBVIOUS ENOUGH PUN."
*Fresh Widow* was the first work to be signed by Rose Sélavy, Duchamp's feminine alter-ego, whom he invented in New York in 1920.

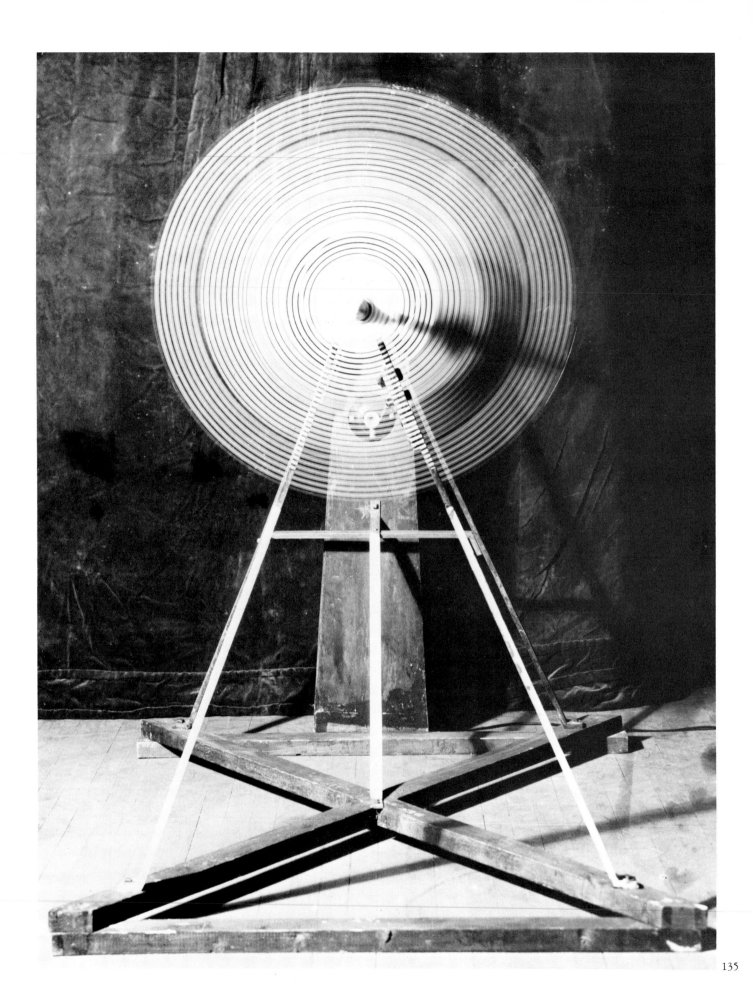

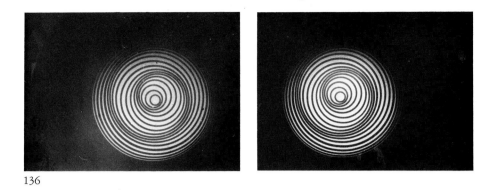

136

137

135. ROTATIVE PLAQUE VERRE (OPTIQUE
DE PRÉCISION) (ROTARY GLASS PLATES
[PRECISION OPTICS]), 1920 (New York,
with Man Ray)
Motorized optical device: five painted glass
plates, wood and metal braces, turning on
a metal axis, electrically operated, $47\frac{1}{2}$ x
$72\frac{1}{2}$ in. (120.6 x 184.1 cm). Largest glass
plate: length 39 in., width $5\frac{1}{2}$ in. (99 x 14
cm)
Cat: L 148, S 268
Ex coll: Société Anonyme, purchased from
the artist, 1925

Yale University Art Gallery, New Haven,
Connecticut, Gift of Collection Société
Anonyme, 1941

Duchamp's first motorized machine. When
the device is in motion and seen from a dis-
tance of one meter, the lines painted on the
five rotating plates appear as continuous
concentric circles.

136. FRAMES FROM AN INCOMPLETED STER-
EOSCOPIC FILM, 1920 (New York)
Film with holder, $3\frac{3}{4}$ x $7\frac{1}{4}$ in. (9.6 x 18.5
cm)

Collection Man Ray, Paris

With two cameras, Duchamp and Man Ray
attempted the simultaneous filming of a sin-
gle object from two slightly different view-
points. Most of the film was accidentally de-
stroyed during the development process.
The left frame is green, the right, red.

137. TÉMOINS OCULISTES (OCULIST WIT-
NESSES), 1920 (New York)
Pencil on reverse of carbon paper, $19\frac{11}{16}$ x
$14\frac{3}{4}$ in. (50 x 37.5 cm)
Inscribed lower left, in pencil: ROSE
SELAVY
Cat: L 147, S 270
Ex coll: Man Ray, Paris; Louise and Walter
Arensberg, Hollywood, acquired through
the artist in 1936

Philadelphia Museum of Art, The Louise
and Walter Arensberg Collection

Study of oculist charts in perspective for a
detail of the *Large Glass*. This sheet of carbon
paper was actually used to transfer his design
to a silvered section of the glass surface. The
excess silvering was then laboriously scraped
away around the outlines.

138. ELEVAGE DE POUSSIÈRE (DUST BREED-
ING), 1920 (New York)
Photograph by Man Ray
Cat: L 146, S 269

The photograph records several months' ac-
cumulation of dust on the lower section of

the *Large Glass* as it lay on its face in Duchamp's New York studio. Duchamp later cleaned the *Glass* except for the area occupied by the Sieves, where he affixed the dust with varnish, giving them "a kind of color." An edition of ten prints, signed by Man Ray and Duchamp, was issued by the Galleria Schwarz, Milan, in 1964.

139. BELLE HALEINE, EAU DE VOILETTE (BEAUTIFUL BREATH, VEIL WATER), 1921 (New York)
Photo-collage, 11⅝ x 7⅞ in. (29.6 x 20 cm)
Inscribed lower left in pencil, in 1964: *Marcel Duchamp/en collaboration avec Man/Rrose Sélavy*
Inscribed lower right in pencil, by Man Ray: *à André Breton/Man Ray*
Cat: L 149, S 271
Ex coll: André Breton, Paris

Collection C. F. Reutersward, Lausanne

Man Ray's photograph of Duchamp as Rrose Sélavy, mounted on a large facsimile of a perfume-bottle label.

140. BELLE HALEINE, EAU DE VOILETTE (BEAUTIFUL BREATH, VEIL WATER), 1921 (New York)
Assisted Readymade: perfume bottle with label, in oval box, 6⁷⁄₁₆ x 4⁷⁄₁₆ in. (16.3 x 11.2 cm)
Inscribed (after 1945) on gold label, back of cardboard box: *Rrose/Sélavy/1921*
Cat: L 149, S 272
Ex coll: Mrs. Yvonne Lyon, London; Cordier & Ekstrom, Inc., New York; The Mary Sisler Collection, New York

Private collection, Paris

The fabricated label, photographed and reduced, is here pasted on a Rigaud perfume bottle. The bottle was then photographed in turn for the cover of *New York Dada*. The photograph shown here is by Man Ray.

141. WHY NOT SNEEZE ROSE SÉLAVY?, 1921 (New York)
2nd version: Ulf Linde, Stockholm, 1963; 3rd version: Galleria Schwarz, Milan, edition of 8 signed replicas, 1964
Assisted Readymade: painted metal birdcage, marble cubes, thermometer, and cuttlebone, 4⅞ x 8¾ x 6⅜ in. (12.4 x 22.2 x 16.2 cm)
Inscribed bottom of cage in black paper-tape letters: *WHY/NOT/SNEEZE/ROSE SÉLAVY?/1921*
Cat: L 150, S 274
Ex coll: Dorothea Dreier, West Redding, Connecticut, 1921; Katherine S. Dreier, West Redding, Connecticut, 1921; Henri-

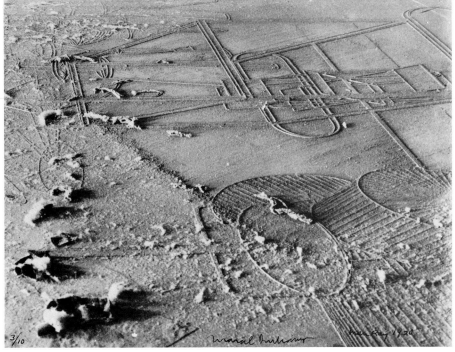

138

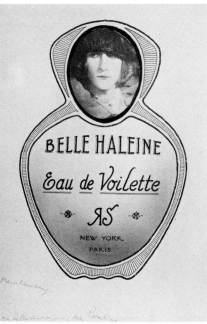

139

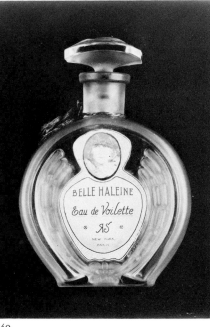

140

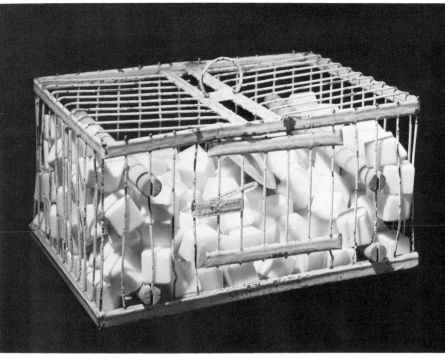

141

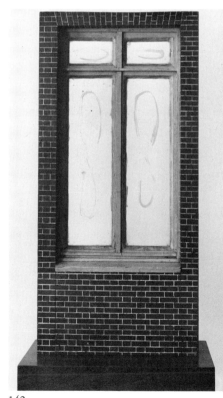

142

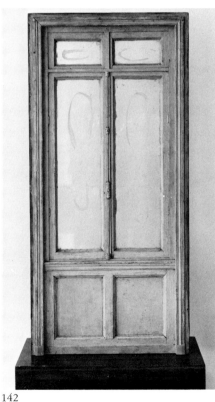

142

Pierre Roché, Paris; Louise and Walter Arensberg, Hollywood, acquired through the artist in 1936.

Philadelphia Museum of Art, The Louise and Walter Arensberg Collection

"THIS LITTLE BIRDCAGE IS FILLED WITH SUGAR LUMPS . . . BUT THE SUGAR LUMPS ARE MADE OF MARBLE AND WHEN YOU LIFT IT, YOU ARE SURPRISED BY THE UNEXPECTED WEIGHT.

"THE THERMOMETER IS TO REGISTER THE TEMPERATURE OF THE MARBLE. THE TITLE IS: WHY NOT SNEEZE. DONE IN 1923 [SIC], IT IS A READYMADE VERY MUCH AIDED SINCE EXCEPT FOR THE BIRDCAGE, THE SUGAR LUMPS HAD TO BE CUT FROM MARBLE PIECES AND THE THERMOMETER HAD TO BE ADDED . . ."

142. LA BAGARRE D'AUSTERLITZ (THE BRAWL AT AUSTERLITZ), 1921 (Paris)
Miniature window: oil on wood and glass, $24\frac{3}{4}$ x $11\frac{5}{16}$ x $2\frac{1}{2}$ in. (62.8 x 28.7 x 6.3 cm)
Inscribed below on one side, in white paint: *Marcel Duchamp;* inscribed below on other side: *Rrose Sélavy/Paris 1921*
Cat: L 152, S 276
Ex coll: Mme Marie Sarlet, Brussels; George W. Staempfli, New York

Private collection, New York

"I HAD ANOTHER SMALL WINDOW MADE, QUITE DIFFERENT FROM THIS ONE [FRESH WIDOW], WITH A BRICK WALL. I CALLED IT THE BRAWL AT AUSTERLITZ IN FRENCH BAGARRE D'AUSTERLITZ WHICH IS A SIMPLE ALLITERATION ON GARE D'AUSTERLITZ, AN IMPORTANT RAILROAD STATION IN PARIS."

Duchamp expanded on his use of the window in the unpublished interview of 1953 with Harriet Janis: "I used the idea of the window to take a point of departure, as . . . I used a brush, or I used a form, a specific form of expression, the way oil paint is, a very specific term, specific conception. See, in other words, I could have made twenty windows with a different idea in each one, the windows being called 'my windows' the way you say 'my etchings' . . ."

143. LA MARIÉE MISE À NU PAR SES CÉLIBATAIRES, MÊME (LE GRAND VERRE) (THE BRIDE STRIPPED BARE BY HER BACHELORS, EVEN [THE LARGE GLASS]), 1915–23 (New York)
Oil, varnish, lead foil, lead wire, and dust on two glass panels (cracked), each mounted between two glass panels, with five glass strips, aluminum foil, and a wood and steel frame, $109\frac{1}{4}$ x $69\frac{1}{4}$ in. (227.5 x 175.8 cm)

Inscribed on reverse of lower panel (on the Chocolate Grinder) in black paint: *LA MARIEE MISE A NU PAR/SES CELI-BATAIRES, MEME/MARCEL DU-CHAMP/1915–1923/ —inachevé/ —cassé 1931/ —réparé 1936.*

Exh: Brooklyn, "International Exhibition of Modern Art," Brooklyn Museum, November 17, 1926–January 9, 1927

Cat: L 155, S 279

Ex coll: Louise and Walter Arensberg, New York, acquired around 1918; Katherine S. Dreier, West Redding, Connecticut, acquired in 1921

Philadelphia Museum of Art, Bequest of Katherine S. Dreier, 1953

"WHEN I CAME TO NEW YORK IN 1915, I STARTED THIS PAINTING, REPEATING AND GROUPING TOGETHER IN THEIR FINAL POSITION THE DIFFERENT DETAILS . . . NINE FEET HIGH, THE PAINTING IS MADE OF TWO LARGE PIECES OF PLATE GLASS ABOVE ONE ANOTHER. I BEGAN TO WORK ON IT IN 1915 BUT IT WAS NOT FINISHED IN 1923 WHEN I FINALLY ABANDONED IT, IN THE STATE YOU SEE IT TODAY.

"ALL ALONG, WHILE PAINTING IT, I WROTE A NUMBER OF NOTES WHICH WERE TO COMPLEMENT THE VISUAL EXPERIENCE LIKE A GUIDE BOOK."

Duchamp's remarks above are a model of the understatement. For one discussion of the *Large Glass,* see the essay by Richard Hamilton in this volume.

Two full-scale copies of the *Large Glass* have been made with Duchamp's approval. The first was executed by Ulf Linde in 1961 on the occasion of the exhibition "Art in Motion" at Moderna Museet, Stockholm. The second was constructed in Newcastle-upon-Tyne by Richard Hamilton for the exhibition "The Almost Complete Works of Marcel Duchamp" at the Tate Gallery, London, in 1966. Both replicas have been shown in subsequent exhibitions, since the original is too fragile to travel.

144. WANTED/$2,000 REWARD, 1923 (New York)

Rectified Readymade: 2 photographs of Duchamp, pasted on joke "Wanted" poster, 19½ x 14 in. (49.5 x 35.5 cm)

Cat: L 154, S 278

Collection Mrs. Louise Hellstrom, U.S.A.(?)

This item is unlocated, but a reproduction was included by Duchamp in the *Box in a Valise* and was used for the poster of his retrospective exhibition at the Pasadena Museum in 1963. See page 326.

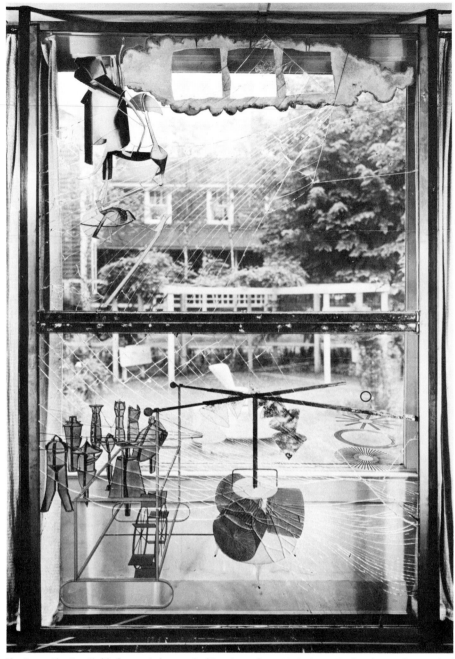

The *Large Glass* installed before a window overlooking the garden at Katherine S. Dreier's home, photographed sometime in the 1930s.

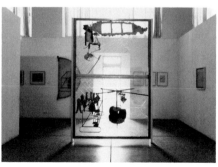

The *Large Glass* (front view) in its permanent installation at the Philadelphia Museum of Art.

143    *Reproduced in color facing page 64.*

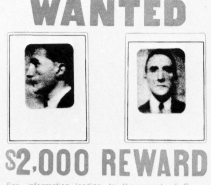

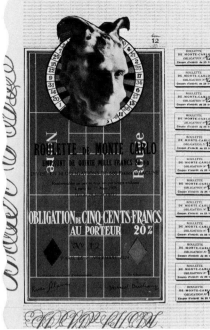

144

146

145. DISKS BEARING SPIRALS, 1923 (Paris)
Ink and pencil, on 7 white paper disks, irregularly cut diameter from 8½ in. (21.6 cm) to 12½ in. (31.7 cm), each mounted on a blue paper disk, mounted on paper board 42⅝ x 42⅝ in. (108.2 x 108.2 cm).
Inscribed on right or left edge of each disk: *Marcel Duchamp 1923*
Cat: S 286
Ex coll: Francis Picabia, Paris, until 1953; Zoe Dusanne Gallery, Seattle; Dr. Richard E. Fuller, Seattle, acquired in 1959

Seattle Art Museum, Seattle, Washington, Eugene Fuller Memorial Collection

Preliminary studies for the ten optical disks which appear in Duchamp's film *Anémic Cinéma* of 1926, where they alternate with nine disks inscribed with puns.

146. OBLIGATIONS POUR LA ROULETTE DE MONTE CARLO (MONTE CARLO BOND), 1924 (Paris)
Photo-collage on colored lithograph (no. 12/30), 12¼ x 7¾ in. (31.1 x 19.7 cm)
Inscribed lower left in ink: *Rrose Sélavy;* inscribed lower right in ink: *Marcel Duchamp*
Cat: L 156, S 280

The Museum of Modern Art, New York, Gift of the artist, 1939

"ONE OF THIRTY BONDS ISSUED FOR THE EXPLOITATION OF A SYSTEM TO BREAK THE BANK IN MONTE CARLO.

"AFTER WORKING OUT THE SYSTEM, I ISSUED THESE BONDS WHICH WERE TO BRING A TWENTY PER CENT DIVIDEND, TAKEN FROM MY EVENTUAL WINNINGS AT ROULETTE. UNFORTUNATELY, THE SYSTEM WAS TOO SLOW TO HAVE ANY PRACTICAL VALUE, SOMETIMES HAVING TO WAIT A HALF HOUR FOR THE PROPITIOUS FIGURE TO APPEAR IN THE SUCCESSION OF BLACKS AND REDS. AND THE FEW WEEKS I SPENT IN MONTE CARLO WERE SO BORING THAT I SOON GAVE UP, FORTUNATELY BREAKING EVEN."

Duchamp's head with horns and beard of shaving cream was photographed for the bond by Man Ray.

147. CROQUIS POUR "OPTIQUE DE PRÉCISION" (SKETCH FOR "PRECISION OPTICS"), 1925 (Paris)
India ink on paper, 10⅝ x 8³⁄₁₆ in. (27 x 20.8 cm)
Inscribed lower right, in ink: *Croquis pour "Optique de précision" 1925/Marcel Duchamp*
Cat: L 158, S 282
Ex coll: Louise and Walter Arensberg, Hollywood, acquired after 1935

Philadelphia Museum of Art, The Louise and Walter Arensberg Collection

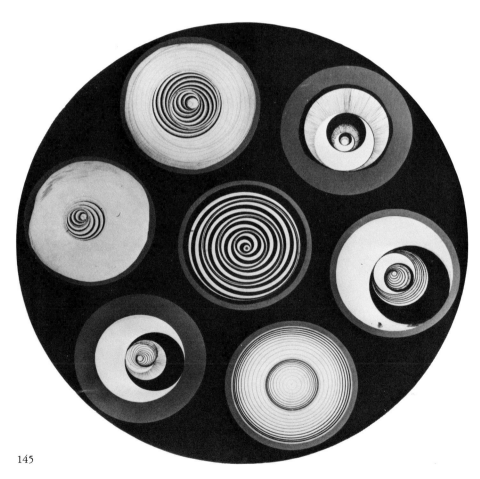

145

148. ROTATIVE DEMISPHERE (OPTIQUE DE PRÉCISION) (ROTARY DEMISPHERE [PRECISION OPTICS]), 1925 (Paris)
Motorized construction: painted wood demisphere, fitted on black velvet disk, copper collar with plexiglass dome, motor, pulley, and metal stand, 58½ x 25¼ x 24 in. (148.6 x 64.2 x 60.9 cm)
Engraved on front edge of the copper disk: *RROSE SELAVY ET MOI ESQUIVONS LES ECCHYMOSES DES ESQUIMAUX AUX MOTS EXQUIS*
Cat: L 159, S 284
Ex coll: Jacques Doucet, Paris, commissioned in 1924; Henri-Pierre Roché, Paris; Cordier & Ekstrom, Inc., New York; The Mary Sisler Collection, New York

The Museum of Modern Art, New York, Gift of Mrs. William Sisler and Purchase, 1970

When this machine is in operation, the black eccentric circles painted on the rotating demisphere appear to undulate, producing a hypnotic illusion of space and depth.

149. NOUS NOUS CAJOLIONS (WE WERE COAXING ONE ANOTHER), c. 1925 (Paris)
Violet ink on paper with photographic collage, 7¹⁄₁₆ x 5³⁄₁₆ in. (18 x 13.2 cm)
Inscribed lower right margin, in ink: *Rrose Sélavy;* inscribed center right, in ink: *NOUS NOUS CAJOLIONS*
Cat: L 160, S 285
Ex coll: Pierre de Massot, Paris

The Solomon R. Guggenheim Museum, New York

A visual and verbal pun, juxtaposed with a photograph of graffiti from the public lavatory in the Lincoln Arcade Building in New York, where Duchamp had a studio. The caption, pronounced aloud, sounds like *nounou cage aux lions* (Nanny lion's cage).

150a–h. DISKS INSCRIBED WITH PUNS, 1926 (Paris)
White letters pasted on eight black cardboard disks, each 11¹³⁄₁₆ in. diameter (30 cm)
Cat: L 162, S 288
Ex coll: Michel Tapié, Paris

Private collection, New York

Eight of the nine disks (one has been lost) used in Duchamp's film *Anémic Cinéma* of 1926, where they alternated with ten disks with optical patterns.

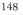

147

149

148

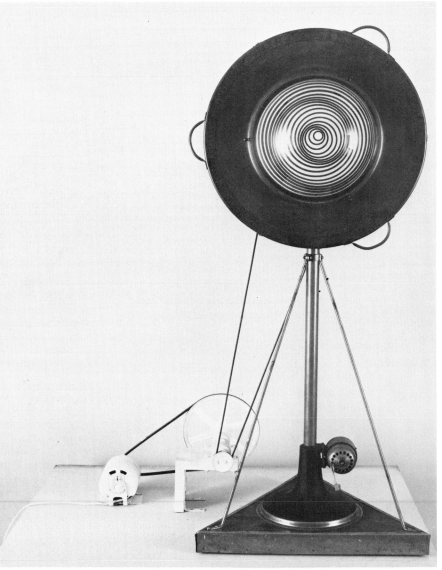

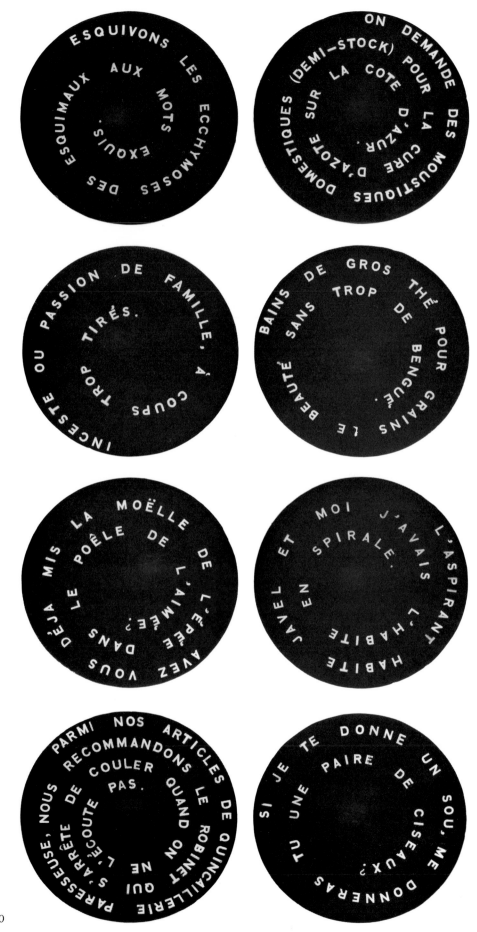

ESQUIVONS LES ECCHYMOSES DES ESQUIMAUX AUX MOTS EXQUIS.

ON DEMANDE DES MOUSTIQUES DOMESTIQUES (DEMI-STOCK) POUR LA CURE D'AZOTE SUR LA COTE D'AZUR.

INCESTE OU PASSION DE FAMILLE, À COUPS TROP TIRÉS.

BAINS DE GROS THÉ POUR GRAINS DE BEAUTÉ SANS TROP DE BENGUÉ LE.

DÉJÀ MIS LA MOËLLE DE L'ÉPÉE DANS LE POÊLE DE L'AIMÉE? VOUS AVEZ

HABITE JAVEL ET MOI J'AVAIS L'ASPIRANT L'HABITE EN SPIRALE.

PARMI NOS ARTICLES DE QUINCAILLERIE NOUS RECOMMANDONS LE ROBINET QUI NE S'ARRÊTE DE COULER QUAND ON NE L'ÉCOUTE PAS. PARESSEUSE, NOUS

SI JE TE DONNE UN SOU, ME DONNERAS TU UNE PAIRE DE CISEAUX?

151. ANÉMIC CINÉMA, 1926 (Paris)
Seven-minute film, made in collaboration
 with Man Ray and Marc Allégret
Cat: L 163, S 289

The Museum of Modern Art Film Library,
New York

The only complete film among several ex-
periments made by Duchamp and Man Ray
in the 1920s, *Anémic Cinéma* is an extension
of Duchamp's preoccupation with optics. "I
wasn't interested in making movies as such,"
he remarked to Pierre Cabanne; "it was sim-
ply a more practical way of achieving my
optical results." (See bibl. 54, p. 68.) Du-
champ again contrives to couple the verbal
and the visual: the witty, often suggestive
ambiguity of the puns teases the mind, while
the pulsating images of the revolving spirals
tantalize the eye. The stills reproduced show
the title frame and the final frames with the
copyright and Duchamp's thumbprint.

152. PORTRAIT OF FLORINE STETTHEIMER,
 1926 (New York)
Charcoal on paper, 20$\frac{1}{16}$ x 13$\frac{3}{4}$ in. (51 x 35
 cm)
Inscribed lower right, in ink: *Chère Florine à
 Virgil/Marcel Duchamp/1952/(done around
 1925)*
Cat: S 290

Collection Virgil Thomson, New York

One of Duchamp's occasional, unexpected
forays into naturalism.

153. DOOR, 11 RUE LARREY, 1927 (Paris)
Wooden door made by a carpenter following
 Duchamp's specifications, 86$\frac{5}{8}$ x 24$\frac{11}{16}$
 in. (220 x 62.7 cm)
Cat: L 164, S 291
Ex coll: The artist; Cordier & Ekstrom,
 Inc., New York; The Mary Sisler Collec-
 tion, New York

Galerie Schmela, Düsseldorf

In the small Paris apartment where he lived
between 1927 and 1942, Duchamp installed
a door which served two doorways (between
the studio and the bedroom, and the studio
and the bathroom). The door could be both
open and closed at the same time, thus pro-
viding Duchamp with household paradox as
well as a practical space-saving device. The
door was removed in 1963 and exhibited as
an independent object, after a full-scale re-
production was made of it *in situ*.

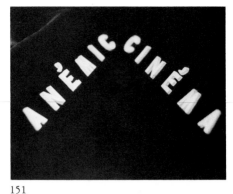

151

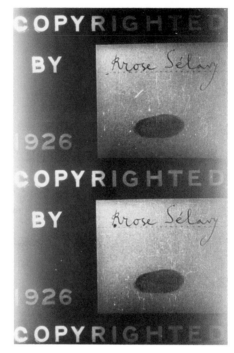

152

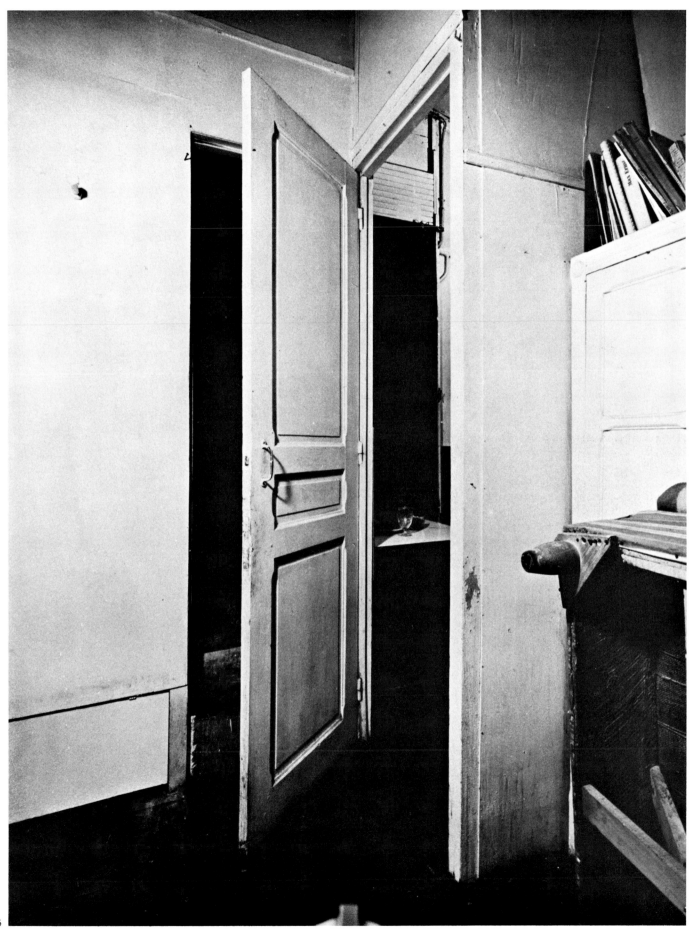

154. L'Opposition et les cases conjugées sont réconciliées par M. Duchamp & V. Halberstadt (Opposition and Sister Squares are Reconciled by M. Duchamp & V. Halberstadt), 1932 (Paris)
11 x 9⅝ in. (28 x 24.5 cm)
Brussels: L'Echiquier/Edmond Lancel, 1932 (St-Germain-en-Laye: Gaston Legrain).
Printed in French with parallel texts in German and English. Deluxe edition of 30 signed and numbered copies; regular unnumbered edition of 1,000.
Cat: L 165, S 292

A treatise on a very special end-game problem in chess, which Henri-Pierre Roché described as follows:

"There comes a time toward the end of the game when there is almost nothing left on the board, and when the outcome depends on the fact that the King can or cannot occupy a certain square opposite to, and at a given distance from, the opposing King. Only sometimes the King has a choice between two moves and may act in such a way as to suggest he has completely lost interest in winning the game. Then the other King, if he too is a true sovereign, can give the appearance of being even less interested, and so on. Thus the two monarchs can waltz carelessly one by one across the board as though they weren't at all engaged in mortal combat. However, there are rules governing each step they take and the slightest mistake is instantly fatal. One must provoke the other to commit that blunder and keep his own head at all times. These are the rules that Duchamp brought to light (the free and forbidden squares) all to amplify this haughty junket of the kings." (See bibl. 52, p. 83.)

Duchamp himself remarked:

"But the end games in which it works would interest no chess player. That's the funny part. There are only three or four people in the world who have tried to do the same research as Halberstadt, who wrote the book with me, and myself. Even the chess champions don't read the book, since the problem it poses really only comes up once in a lifetime. They're end-game problems of possible games but so rare as to be nearly Utopian." (See bibl. 54, pp. 77–78.)

Duchamp designed the cover of the book, and oversaw its publication, with as much care as he devoted to more overtly aesthetic productions. The first and final manuscripts of this treatise, as well as the original proofs and diagrams with many notes in Duchamp's handwriting, are contained in a cardboard box bearing the label of a Paris department store, "Old England." This box

154

154

*The Box of 1932.*

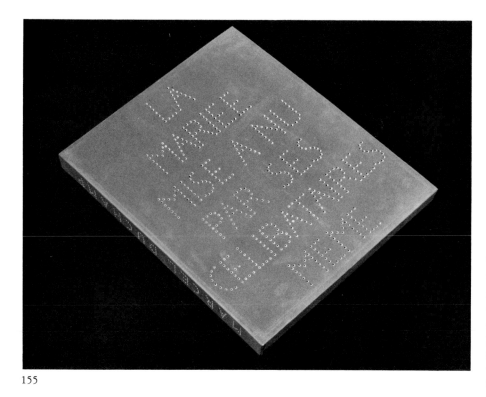

155

155

156

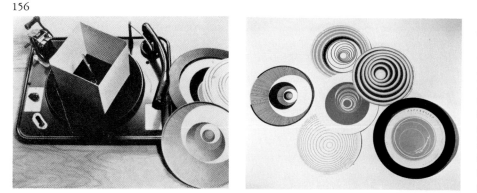

was titled by Duchamp *The Box of 1932*. It was formerly in a Paris private collection and is now owned by Fourcade, Droll, Inc., New York.

155. LA MARIÉE MISE À NU PAR SES CÉLI-BATAIRES, MÊME (THE BRIDE STRIPPED BARE BY HER BACHELORS, EVEN [THE GREEN BOX]), September 1934 (Paris)
One color plate and 93 facsimiles of manu-script notes, drawings, and photographs, contained in a green flocked cardboard box, $13\frac{1}{16}$ x 11 x 1 in. (33.2 x 28 x 2.5 cm)
Deluxe edition of 20; regular edition of 300.
Inscribed on the spine, inside the box, in red pencil: *Marcel Duchamp Paris 1934*
Cat: L 166, S 293

The companion piece to the *Large Glass,* the *Green Box* was intended to serve as a guide through its intricacies. Notes, sketches, and detailed studies from the years 1911–20, primarily related to the *Glass,* were selected and painstakingly reproduced. A template was made for each note on an irregular scrap of paper, and the facsimiles were individually torn around the template (320 times for each note reproduced). The results were then assembled in random order within each box, leaving the reader to create his own sequence.

Duchamp regarded the *Green Box* as a kind of Sears, Roebuck catalog: "I wanted that album to go with the 'Glass,' and to be consulted when seeing the 'Glass' because, as I see it, it must not be 'looked at' in the aesthetic sense of the word. One must consult the book, and see the two together. The conjunction of the two things entirely removes the retinal aspect that I don't like." (See bibl. 54, pp. 42–43.)

156. ROTORELIEFS (OPTICAL DISKS), 1935 (Paris)
Set of six cardboard disks, printed by offset lithography on both sides, each $7\frac{7}{8}$ in. (20 cm) diameter
First edition: 500 unnumbered sets, Paris, 1935; second edition: 1,000 unnumbered sets (over half accidentally destroyed), produced by Enrico Donati, New York, 1953
Cat: L 167, S 294

An extension of the rotating spiral disks in *Anémic Cinéma,* the *Rotoreliefs* also reveal Duchamp's taste for mass production "on a modest scale." They were printed inexpensively in a large edition and were first presented to the public at an inventor's fair in Paris. When viewed (preferably with one eye) at a rotating speed of 40–60 rpm, the disks present an optical illusion of depth, and in a few cases, of three-dimensional ob-

jects: a fishbowl, a light bulb, a balloon.

The *Rotoreliefs* appear in the Duchamp sequence of Hans Richter's film *Dreams That Money Can Buy,* and also in Jean Cocteau's film *The Blood of a Poet.*

157. DOOR FOR GRADIVA, 1937 (Paris)
Replica of 1968 after destroyed original
Plexiglass, 78 x 52 in. (198 x 132 cm)
Inscribed lower right: *Marcel Duchamp/1968*
Cat: L 172, S 301

Collection Dieter and Miriam Keller, Stuttgart

Duchamp designed this glass doorway in the shape of a pair of lovers for André Breton's gallery Gradiva at 31 Rue de Seine, Paris. The original was destroyed at Duchamp's request after the gallery was closed. The plexiglass replica was made for the exhibition "Doors" at Cordier & Ekstrom, Inc., New York (March 19–April 20, 1968). A pencil sketch by Duchamp for the 1968 replica is in the collection of Mme Duchamp.

157

158. BOÎTE-EN-VALISE (BOX IN A VALISE), 1941 (New York)
Leather valise containing miniature replicas, photographs, and color reproductions of works by Duchamp, 16 x 15 x 4 in. (40.7 x 38.1 x 10.2 cm)
Deluxe edition of 20; regular edition not to exceed 300 (still in production)
Cat: L 173, S 311

Duchamp worked for five years (1935–40) in Paris on the material for his "portable museum," assembling photographs and supervising color reproductions of his works. The *Large Glass, Nine Malic Molds,* and the *Glider* were reproduced on sheets of transparent plastic, and diminutive models were made of three Readymades (*Air de Paris, Traveler's Folding Item,* and *Fountain*).

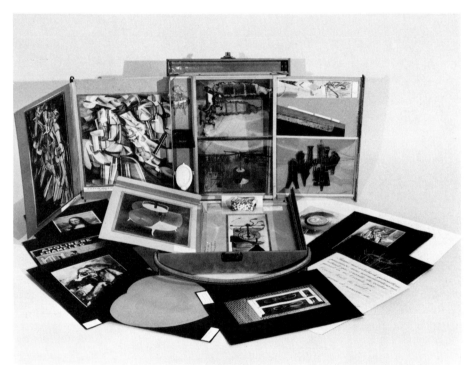

158

159. MOUSTACHE AND BEARD OF L.H.O.O.Q., May 1941 (Paris)
Stencil, $1\frac{9}{16}$ x $2\frac{9}{16}$ in. (4 x 6.5 cm)
Cat: S 310

Galleria Schwarz, Milan

This drawing was used as a frontispiece for a poem by Georges Hugnet, entitled *Marcel Duchamp,* November 8, 1939, published by Hugnet in 1941. Like the smile of the Cheshire Cat, Duchamp's graffiti additions to the Mona Lisa now hover in space.

158

159

304

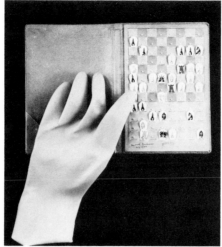

160                    162

161

160. A LA MANIÈRE DE DELVAUX (IN THE MANNER OF DELVAUX), 1942 (New York)
Collage of tinfoil and photograph on cardboard, 13⅜ x 13⅜ in. (34 x 34 cm)
Inscribed lower left, in pencil: *Marcel Duchamp*
Cat: L 179, S 312
Ex coll: André Breton, Paris

Galleria Schwarz, Milan

This item was made to be reproduced in the catalog *First Papers of Surrealism*. The image of a woman's breast in a mirror was inspired by Paul Delvaux's painting *Dawn*, 1937, in the collection of the Peggy Guggenheim Foundation, Venice.

161. ALLÉGORIE DE GENRE (GENRE ALLEGORY [GEORGE WASHINGTON]), 1943 (New York)
Assemblage: cardboard, gauze, nails, iodine, and gilt stars, 20¹⁵⁄₁₆ x 15¹⁵⁄₁₆ in. (53.2 x 40.5 cm)
Inscribed verso, upper right, in ink: *Allégorie de genre/Marcel Duchamp/N.Y. 1943*
Cat: L 184, S 319
Ex coll: André Breton, Paris

Private collection, Paris

Rejected by *Vogue* magazine as a commission for a George Washington cover, this collage fuses the profile of the first President with an outline of the United States and the stars and stripes. The suggestion of bloodstained bandages apparently alarmed the editors.

162. POCKET CHESS SET WITH RUBBER GLOVE, 1944 (New York)
Replica of 1966 after lost original
Assemblage: *Pocket Chess Set* with rubber glove in a box, 14 x 13⅝ x 3 in. (35.5 x 34.7 x 7.6 cm)
Inscribed lower left, in ink: *Marcel Duchamp/N.Y. 1944;* inscribed on the back of the box: *Vu aimé et approuvé Marcel Duchamp 13 Octobre 1966*
Cat: L 182 (note), S 321

Collection Robert Lebel, Paris

An assemblage executed for the exhibition "Imagery of Chess" at the Julien Levy Gallery, New York, December 1944. It incorporates one of about twenty-five *Pocket Chess Sets* which Duchamp designed in 1943 (for peripatetic chess games). The heads of the pins hold and prevent the chessmen from falling out of the slots. A second series of ten chessboards on magnetized plastic was finished in 1964, using the chessmen printed in 1943 but glued onto metal bases. The squares of the chessboard of this second series were hand-painted by Duchamp.

163. PLASTER MODEL FOR "PRIÈRE DE TOUCHER," 1947
Plaster, 8⅝ x 7⅛ in. (21.9 x 18.2 cm), mounted on velvet in a wood and glass box, 16 x 16 x 4 in. (40.6 x 40.6 x 10.2 cm)
Inscribed in lower right corner (incised in plaster): *Marcel Duchamp/1947*

Collection Enrico Donati, New York

Previously uncataloged "study" for the cover of the deluxe edition of the catalog *Le Surréalisme en 1947*. It has an obvious affinity to the treatment of the nude figure in *Etant donnés*, on which Duchamp was beginning to work at this time.

164. PRIÈRE DE TOUCHER (PLEASE TOUCH), 1947 (New York)
Collage of foam rubber and velvet on cardboard, 9¼ x 8¹/₁₆ in. (23.5 x 20.5 cm)
Cat: L 191, S 328

Exactly 999 hand-colored foam-rubber breasts were prepared by Duchamp and Enrico Donati for the cover of the catalog *Le Surréalisme en 1947*. This photograph of one collage was taken by Man Ray.

165. ETANT DONNÉS LE GAZ D'ÉCLAIRAGE ET LA CHUTE D'EAU (GIVEN THE ILLUMINATING GAS AND THE WATERFALL), 1948–49 (New York)

Painted leather over plaster relief, mounted on velvet, 9¹¹/₁₆ x 12³/₁₆ in. (50 x 31 cm)
Inscribed on reverse: *Cette dame appartient à Maria Martins/avec toutes mes affections/Marcel Duchamp 1948–49*
Cat: L 222, S 330
Ex coll: Mme Maria Martins, Rio de Janeiro

Collection Mme Nora Martins Lobo, Sofia, Bulgaria

The first known elaborate study for Duchamp's last major work, which he began in New York in 1946. An earlier drawing for the nude figure also belonged to Mme Maria Martins. The figure was apparently the first element of the complex assemblage *Etant donnés* to occupy Duchamp's attention. The landscape background and the construction of the whole tableau were to follow at a later date. It seems likely, however, that a clear plan for the layout of the entire assemblage existed from an early stage of its evolution, since the figure was fabricated with regard to its eventual position in the tableau and to the viewpoint of the observer.

163

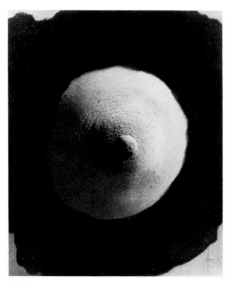

164

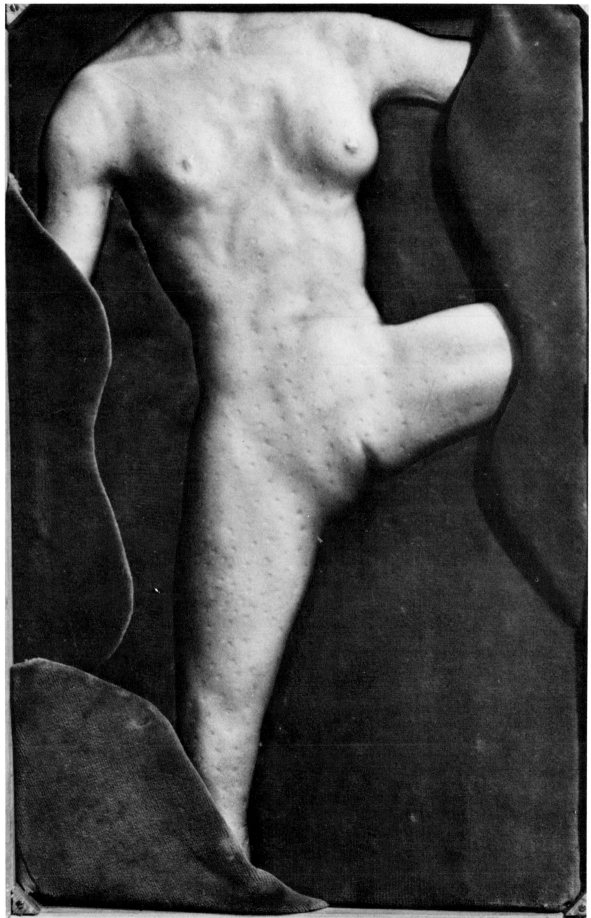

166. Preparatory Study for the Figure
in "Etant donnés: 1° la chute d'eau,
2° le gaz d'éclairage," c. 1950 (?)
Gouache on transparent perforated plexi-
glass, 36 x 22 in. (91.3 x 55.9 cm)
Inscribed upper left corner: *HAUTE
GAUCHE* (scratched into plastic)

Collection Mme Marcel Duchamp, Villiers-
sous-Grez

Used to determine the outline and form of
the molded figure at one stage of the con-
struction of the assemblage, this sheet of
plexiglass constitutes a working tool rather
than a work in itself and is yet another ex-
ample of Duchamp's painstaking approach
to each project.

167.  Not a Shoe, 1950 (New York)
Galvanized plaster, 2³⁄₄ x 2 x 1 in. (7 x 5.1 x
2.5 cm)
Inscribed flat side: NOT/A SHOE/
MARCEL/DUCHAMP/1950
Cat: S 331

Collection Mr. and Mrs. Julien Levy,
Bridgewater, Connecticut

An early version of the wedge section of the
erotic sculpture *Wedge of Chastity.*

168. Feuille de vigne femelle (Female
Fig Leaf), 1950 (New York)
Galvanized plaster, 3⁹⁄₁₆ x 5¹⁄₂ x 4¹⁵⁄₁₆ in.
(9 x 14 x 12.5 cm)
Inscribed on the bottom: *Feuille de Vigne
Femelle/M.D./1950*
Cat: L 196, S 332
Ex coll: Man Ray, Paris, gift of the artist in
1951; Cordier & Ekstrom, Inc., New York;
The Mary Sisler Collection, New York

Collection D. R. A. Wierdsma, New York

Duchamp made two of these plaster sculp-
tures. He gave one to Man Ray as a farewell
present when the latter left New York for
Paris in 1951, and kept the other for himself
as an artist's proof (now in the collection of
Mme Duchamp, reproduced in color facing
page 145). He authorized Man Ray to
make an edition of ten plaster casts in Paris
in 1951, and a subsequent edition of eight
bronze casts was made in 1961 by the Galerie
Rive Droite, Paris.

169. Objet-Dard, 1951 (New York)
Galvanized plaster, 2¹⁵⁄₁₆ x 7¹⁵⁄₁₆ x 2³⁄₈ in.
(7.5 x 20.1 x 6 cm)
Inscribed on top: *OBJET-DARD/
MARCEL DUCHAMP/51*
Cat: L 195, S 335

Collection Mme Marcel Duchamp, Villiers-
sous-Grez

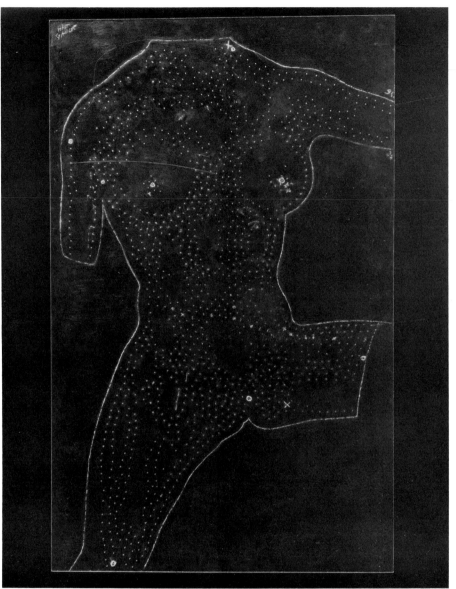

166

167

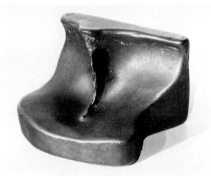

168   *Artist's proof of this item reproduced in color
facing page 145.*

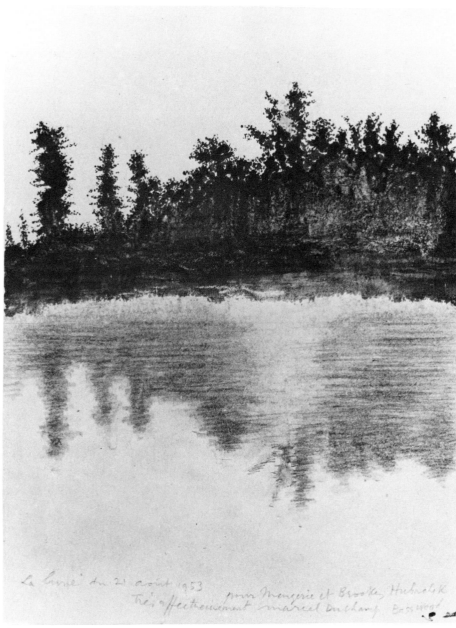

170

An erotic object which appeared as a by-product of the complex fabrication of the nude figure in *Etant donnés*. The punning title makes this work both an "art object" and a "dart object." An edition of eight signed and numbered bronze casts was issued by the Galleria Schwarz, Milan, in 1962.

170. MOONLIGHT ON THE BAY AT BASS-WOOD, August 1953 (Basswood, Minnesota)
Ink, pencil, crayon, talcum powder, and chocolate on blue blotting paper, $10^3/_8$ x $7^1/_4$ in. (26.4 x 18.4 cm)
Inscribed lower left, in pencil: *La lune du 21 août 1953/pour Margerie et Brookes Hubachek/Très affectueusement Marcel Duchamp. Basswood*
Cat: L 198, S 337

Collection Frank Brookes Hubachek, Chicago

The shoreline of a Minnesota lake was drawn by Duchamp from his vantage point on a houseboat during a summer visit to friends. The landscape has affinities with the photocollage background of *Etant donnés,* a project on which he was then engaged.

171. COIN DE CHASTETÉ (WEDGE OF CHASTITY), 1954 (New York)
Sculpture in two interlocking sections: galvanized plaster and dental plastic, $2^3/_{16}$ x $3^3/_8$ x $1^5/_8$ in. (5.6 x 8.5 x 4.2 cm)
Inscribed on top: *pour Teeny/16 Jan. 1954/Marcel;* inscribed to the right: *coin de chasteté*
Cat: L 199, S 338

Collection Mme Marcel Duchamp, Villiers-sous-Grez

Another of the erotic objects produced during the early fifties. In reply to a question about the importance of eroticism in his work, Duchamp remarked:
"I believe in eroticism a lot, because it's truly a rather widespread thing throughout the world, a thing that everyone understands. It replaces, if you wish, what other literary schools called Symbolism, Romanticism. It could be another 'ism' so to speak." (See bibl. 54, p. 88.)
An edition of eight signed and numbered replicas in bronze and dental plastic was issued by the Galleria Schwarz, Milan, in 1963. The plaster model for this sculpture is in the collection of The Museum of Modern Art, New York.

169

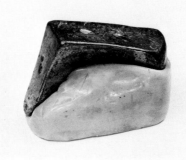

171

172. JAQUETTE (JACKET), 1956 (New York)
Ink on tracing paper over paper, 2 drawings
   (mounted together), each 10⅝ x 8 1/16 in.
   (27 x 20.5 cm)
Inscribed lower left, in india ink: *Jaquette;*
   inscribed inside collar: *Marcel/Duchamp*
Cat: L 200, S 339
Ex coll: Rudi Blesh, New York

Private collection, New York

As well as a neat visual pun, the empty din-
ner jacket in an elegant pose is another ironic
image in the vein of the Malic Molds. The
drawing was a design for the book jacket of
*Modern Art U.S.A.* by Rudi Blesh, but was
rejected by the publisher, Alfred A. Knopf.

173. WAISTCOAT, 1958 (New York)
Rectified Readymade: wool waistcoat with 5
   lead type buttons bearing the letters
   "TEENY," 23⅝ in. (60 cm) long
Cat: L 207, S 342

Collection Mme Marcel Duchamp, Villiers-
   sous-Grez

Paul Matisse has pointed out that this is the
only Readymade which requires a human
presence for completion. Like the 9 *Malic
Molds* waiting to receive the "illuminating
gas," the Waistcoat depends on its wearer to
animate it. Three other *Waistcoats* were pre-
pared by Duchamp, including one for the
Surrealist poet Benjamin Peret, which was
sold at a Paris auction for his benefit in 1959.
(See bibl. 53, p. 531.)

174. SELF-PORTRAIT IN PROFILE, 1958
Torn paper, 5⅝ x 4⅞ in. (14.3 x 12.5 cm)
Inscribed lower right in ink: *Marcel to Julien
   1958*
Cat: L 202, S 344

Collection Mr. and Mrs. Julien Levy,
   Bridgewater, Connecticut

Duchamp first prepared this self-portrait for
the special edition of Robert Lebel's mono-
graph *Sur Marcel Duchamp,* by tearing paper
around a metal template of his profile—just
as he had torn the paper for the *Green Box*
notes. He later repeated the collage for spe-
cial editions by Ulf Linde (1963) and Shuzo
Takiguchi (1968), and occasionally executed
individual examples for friends.

175. EAU & GAZ À TOUS LES ÉTAGES (WATER
   & GAS ON EVERY FLOOR), 1958 (Paris)
Imitated Readymade: white lettering on
   blue enamel plate, 5⅞ x 7⅞ in. (15 x 20
   cm)
Inscribed lower right, in white paint: *M.D.*
Cat: L 206, S 347

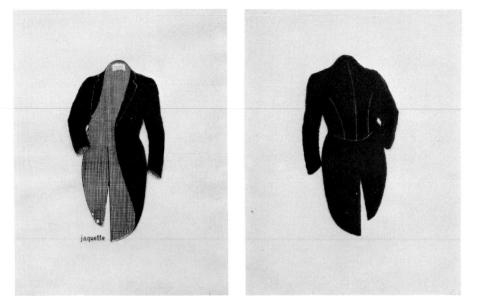

172

176

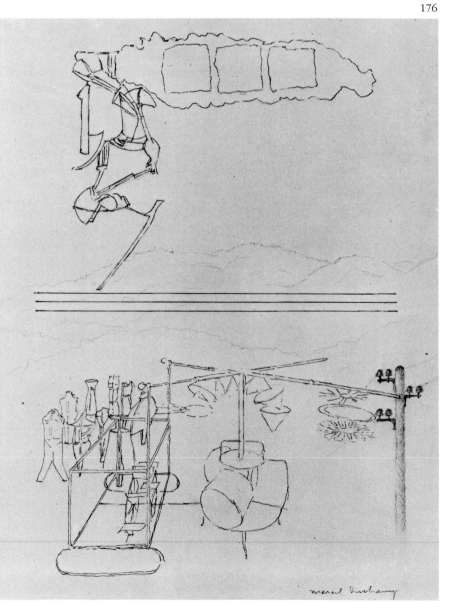

173

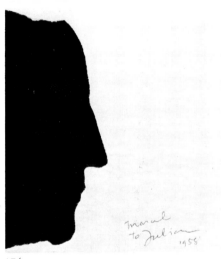

174

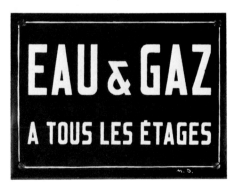

175

178

Collection Mme Marcel Duchamp, Villiers-sous-Grez

A facsimile of the plaques affixed to apartment houses in France in the late nineteenth century, with appropriate reference to both a major theme of the *Large Glass* and the title of the (then secret) assemblage still in progress in Duchamp's New York studio: *Etant donnés: 1° la chute d'eau, 2° le gaz d'éclairage.* The plaques were made for the lids of the boxes containing the special edition of Robert Lebel's *Sur Marcel Duchamp.*

176. COLS ALITÉS (BEDRIDDEN MOUNTAINS), 1959 (Le Tignet [Grasse])
Pen and pencil on paper, $12\frac{5}{8} \times 9\frac{5}{8}$ in. (32 x 24.5 cm)
Inscribed lower right: *Marcel Duchamp;* inscribed verso: *COLS ALITES/Projet pour le modèle 1959 de "La Mariée mise à nu par ses célibataires, même."*
Cat: L 226, S 351

Collection Robert Lebel, Paris

A faint landscape of hills has been outlined behind the *Large Glass,* and the Bachelor Apparatus appears to be hooked up to an electrical pole. As the "project for the 1959 model of *The Bride Stripped Bare by Her Bachelors, Even,*" the drawing provided yet another hint at the secret existence of *Etant donnés.* The title *Cols alités* is a pun on the word *causalité.*

177. WITH MY TONGUE IN MY CHEEK, 1959 (Cadaqués)
Plaster, pencil and paper, mounted on wood, $9\frac{13}{16} \times 5\frac{7}{8} \times 2$ in. (25 x 15 x 5.1 cm)
Inscribed lower center, in ink: *with my tongue in my cheek Marcel Duchamp 59*
Cat: L 223, S 353

Collection Robert Lebel, Paris

Executed during experiments with plaster-casting related to work on the figure for *Etant donnés,* this three-dimensional pun is a further, quite literal exploration of the mysteries of the molding process. This and the following two items were made for a book, as yet unpublished, by Robert Lebel.

178. TORTURE-MORTE, 1959 (Cadaqués)
Painted plaster and flies, on paper mounted on wood, $11\frac{5}{8} \times 5\frac{5}{16} \times 2\frac{3}{16}$ in. (29.5 x 13.5 x 5.5 cm)
Inscribed, lower center, in white paint: *TORTURE-MORTE/Marcel Duchamp 59*
Cat: L 224, S 354

Collection Robert Lebel, Paris

The title is a play on *nature morte,* the French term for still life.

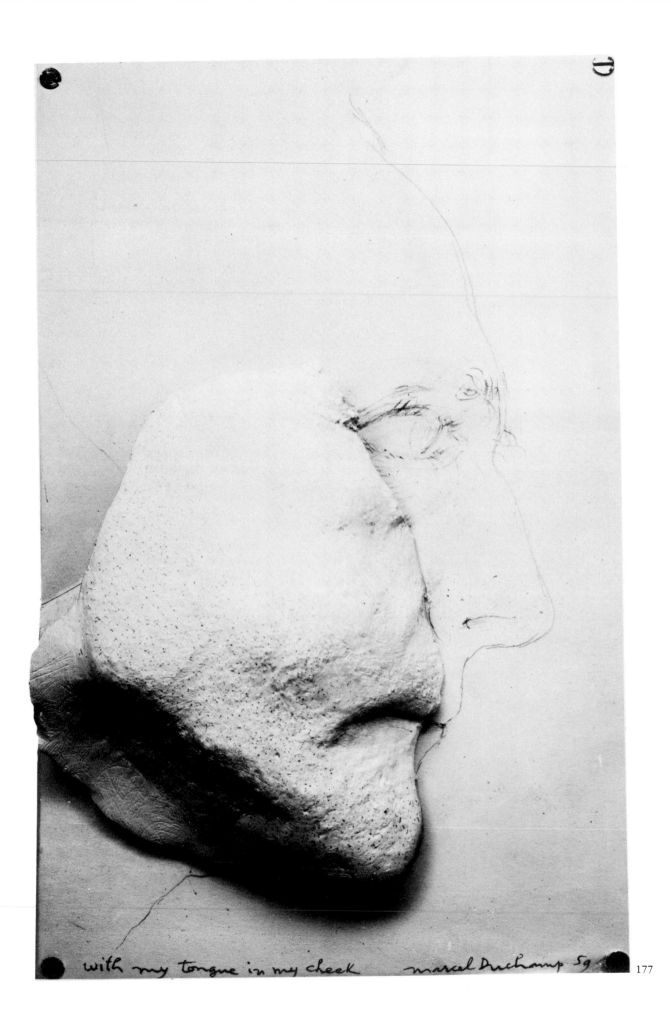

with my tongue in my cheek    marcel Duchamp 59

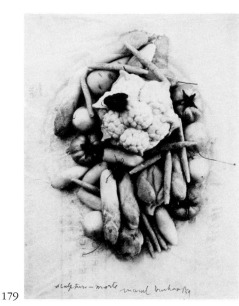

179

180

181

179. SCULPTURE-MORTE, 1959 (Cadaqués)
Marzipan and insects on paper, mounted on
masonite, 13³⁄₁₆ x 8⁷⁄₈ x 2³⁄₁₆ in. (33.5 x
22.5 x 5.5 cm)
Inscribed lower center, in ink: *sculpture-
morte/Marcel Duchamp/59*
Cat: L 255, S 355

Collection Robert Lebel, Paris

A fantastic head in the style of Arcimboldo,
created with marzipan vegetables.

180. COUPLE OF LAUNDRESS' APRONS, 1959
(Paris)
Readymade in two parts (male and female):
cloth, fur, and zipper, each c. 8 x 7 in.
(20.3 x 17.7 cm)
Inscribed on reverse, upper right: *Marcel
Duchamp 59*
Cat: L 229, S 356

The Mary Sisler Collection, courtesy Four-
cade, Droll, Inc., New York

Selected by Duchamp as his contribution to
the twenty copies of the deluxe edition *Boîte
alerte* of the catalog for the "Exposition In-
ternational de Surréalisme" at the Galerie
Daniel Cordier, Paris. These "male" and
"female" potholders were bought in a New
York novelty shop.

181. ANAGRAMME, FOR PIERRE DE MASSOT,
1961 (New York)
Gouache on black paper, covered by waxed
paper with incised drawing, 8⁵⁄₁₆ x 7⁹⁄₁₆ in.
(21.1 x 19.2 cm)
Inscribed lower right, on waxed paper:
*Marcel Duchamp/1961;* inscribed on street
urinal: *de Ma/Pissot ierre/j'aperçois/Pierre de
Massot*
Cat: L 231, S 359
Ex coll: David Hayes, New York

Collection Miss Sarah Goodwin Austin,
New York

Another visual pun, executed by Duchamp
for a Paris auction to benefit his old friend,
the Surrealist poet Pierre de Massot, "au-
thor" of *The Wonderful Book/Reflections on
Rrose Sélavy,* 1924. (See bibl. 171.) A prelim-
inary sketch for this work is in the collection
of Mme Marcel Duchamp.

182. Aimer tes héros (Love Your Heroes), 1963 (New York)
Pencil and ink on paper, 12⁵⁄₁₆ x 10¼ in. (31.3 x 26 cm)
Inscribed lower center in pencil: *Marcel Duchamp 63*
Cat: L 233, S 362
Ex coll: Cordier & Ekstrom, Inc., New York; The Mary Sisler Collection, New York

Galleria Schwarz, Milan

A design for the cover of the magazine *Metro,* which was to publish an issue devoted to Duchamp. (The project was abandoned.) The title is a phonetic rendition of the letters M.E.T.R.O., illustrated by the sequence of small sketches at the top of the drawing: two lovers (*aimer,* "to love"), a baby at its mother's breast (*téter,* "to suckle"), and two hanged figures (the unfortunate heroes). The cover was eventually used for the ninth issue of the magazine (April 1965).

183. Pulled at Four Pins, 1964 (Milan)
Etching, 12⁵⁄₈ x 9 in. (32 x 22.8 cm) (plate size), total printing limited to 115
Inscribed lower right, in pencil: *Marcel Duchamp*
Cat: S 372

Galleria Schwarz, Milan

This etching is the only record of a lost Readymade of 1915 executed in New York: a ventilator inscribed "Pulled at Four Pins" which Duchamp gave to Louise Varèse. The inscription is a literal translation of the French idiom "Tiré à quatre épingles," whose English equivalent would be "dressed to the nines."

184. Drawing for "La Pendule de profil" (Drawing for "The Clock in Profile"), 1964 (Paris)
Pencil and collage on paper with engraved background, 11 x 8¾ in. (28 x 22.2 cm)
Inscribed along left edge in pencil: *Marcel Duchamp 64*
Cat: L 236, S 373

Collection Robert Lebel, Paris

To illustrate the concept of "L'Inventeur du temps gratuit" (the inventor of free time) in the deluxe edition of Robert Lebel's book *La Double Vue,* Duchamp produced a late realization of one of his *Green Box* notes: "The Clock *in profile,* and the *Inspector* of Space." The clock was made in the form of a *pliage,* a piece of stiff paper which can be folded to stand upright, and several elaborate working studies for this also exist. The photograph on the right shows one of the *pliages* in its intended position. Duchamp clarified the meaning of the *Green Box* note

182

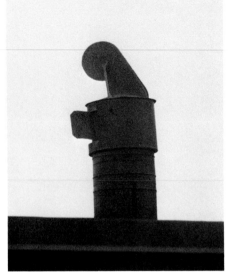

A ventilator on Fire Island, New York, similar to the lost Readymade of 1915.

183

184

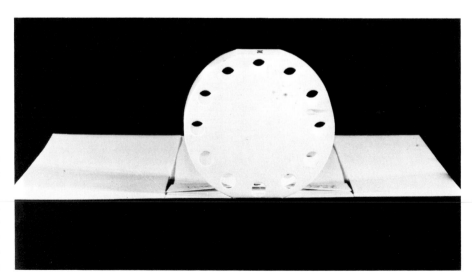

rasée
L.H.O.O.Q.

marcel duchamp

185

186 *Reproduced in color facing page 144.*

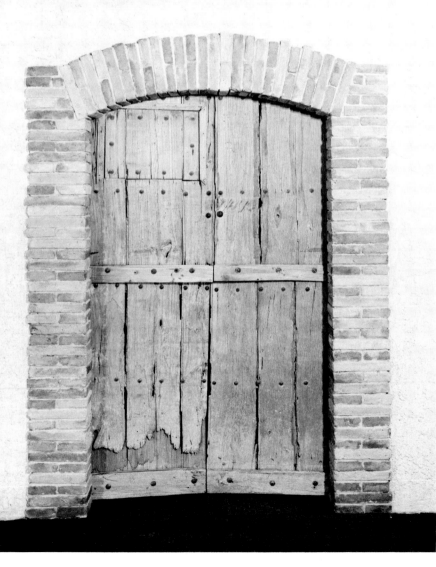

in 1958: "When a clock is seen from the side (in profile) it no longer tells the time." (See bibl. 9.)

185. L.H.O.O.Q. SHAVED, 1965 (New York)
Readymade: playing card, $3\frac{1}{2}$ x $2\frac{7}{16}$ in. (8.8 x 6.2 cm), mounted on folded paper, $8\frac{1}{4}$ x $5\frac{1}{2}$ in. (21 x 13.8 cm)
Inscribed lower right, in ink, on invitation card: *Marcel Duchamp*
Inscribed center, in ink: *rasée/L.H.O.O.Q.*
Cat: S 375
Ex coll: Philip Johnson, New Canaan, Connecticut

The Museum of Modern Art, New York, Gift of Philip Johnson, 1970

The Mona Lisa shorn of her beard and moustache appeared on the invitation card to preview "Not Seen and/or Less Seen of/by Marcel Duchamp/Rrose Sélavy 1904–64: Mary Sisler Collection" at Cordier & Ekstrom, Inc., New York, on January 13, 1965. About one hundred were prepared.

186. ETANT DONNÉS: 1° LA CHUTE D'EAU, 2° LE GAZ D'ÉCLAIRAGE (GIVEN: 1. THE WATERFALL, 2. THE ILLUMINATING GAS), 1946–66 (New York)
Mixed-media assemblage, approximately $95\frac{1}{2}$ in. (242.5 cm) high, 70 in. (177.8 cm) wide, including: an old wooden door, bricks, velvet, wood, leather stretched over an armature of metal and other material, twigs, aluminum, iron, glass, plexiglass, linoleum, cotton, electric lights, gas lamp (Bec Auer type), motor, etc.
Cat: S 392

Philadelphia Museum of Art, Gift of the Cassandra Foundation, 1969

Duchamp's last major work was executed in complete secrecy in New York over a twenty-year period during which it was assumed that he had essentially given up "art." The title derives from an early note in the *Green Box* and points to the intimate connection between the imagery and themes of this assemblage and those of the *Large Glass*. No notes accompany the tableau (only a practical book of instructions for its assembly), and Duchamp maintained an absolute silence on the subject until his death. The viewer must seek any explication of its meaning in the clues offered by the remainder of Duchamp's oeuvre.

*Etant donnés* presents the greatest possible visual contrast to the *Large Glass*. The abstracted, mechanical forms on the transparent plane of the *Glass* are replaced by an intensely realistic figure in a three-dimensional space. Yet Duchamp's late work

have thought of making an anaglyph (red and green) apropos of a Spanish chimney of which I have made a sketch in three dimensions for the mason who is executing it in our new summer home. This handmade anaglyph should produce a three-dimensional effect when viewed through a pair of spectacles with red and green filters." (See bibl. 53, p. 579.) Duchamp planned to execute 110 of these drawings by hand for the edition, but his death prevented the completion of this project. Full-size reproductions of the drawing were substituted.

The chimney itself, like the windbreak which he constructed on his Cadaqués porch, was another result of Duchamp's pleasure in tinkering—"making" things that could not be considered "art."

192

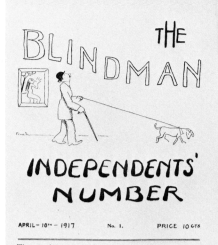

BOOK AND MAGAZINE COVERS

Cover for *The Blind Man,* no. 1 (Independents' Number), New York, 1917
11¼ x 8³⁄₁₆ in. (28.5 x 20.7 cm) (bibl. 79)

The first issue of the magazine published by Henri-Pierre Roché in collaboration with Marcel Duchamp and Beatrice Wood.

Cover for *The Blind Man,* no. 2 (P.B.T.), New York, 1917
11¹⁄₁₆ x 8¹⁄₁₆ in. (28.1 x 20.5 cm) (bibl. 79)

The initials P.B.T. stand for Henri-Pierre Roché, Beatrice Wood, and "Totor" (from Victor), Roché's nickname for Duchamp. This issue carried the editorial "The Richard Mutt Case," which discussed the rejection of Duchamp's *Fountain* by the Independents jury.

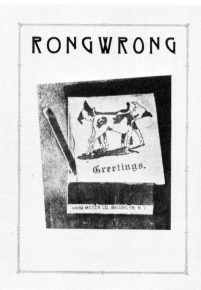

Cover for *Rongwrong,* New York, 1917
11¹⁄₁₆ x 8 in. (28.1 x 20.3 cm) (bibl. 80)

A review of only one issue, edited by Duchamp, Henri-Pierre Roché, and Beatrice Wood. The original title *Wrong Wrong* became transformed through a printer's error.

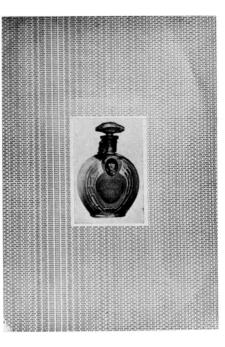

Cover for *New York Dada,* New York, 1921
14½ x 10⅟₁₆ in. (36.8 x 25.5 cm) (bibl. 81)

Another unique publication, edited by
Duchamp and Man Ray. It consisted of one
large sheet printed on one side only and
folded twice. Among other contributions
there is an article by Tristan Tzara translated
into English by Man Ray and Duchamp.

Layout for *Some French Moderns Says McBride,*
 New York, 1922
11¹³⁄₁₆ x 9¼ in. (30 x 23.5 cm)

This manila file contains a collection of es-
says by the art critic Henry McBride. Each
essay is printed in bolder type than the pre-
vious one, but because of space limitations
the type of the last essay suddenly becomes
extremely minute. The text is accompanied
by seven photographs taken by Charles
Sheeler. The format was copyrighted by
Rrose Sélavy. Published by the Société
Anonyme Inc.

Bookbinding for *Ubu Roi* by Alfred Jarry,
 Paris, 1935
7⅞ x 5¼ in. (20 x 13.3 cm)

The binding was designed by Duchamp and
executed in full tan morocco leather by Mary
Reynolds. Two examples were made: one is
in the Mary Reynolds Collection of The Art
Institute of Chicago, and the other in The
Louise and Walter Arensberg Collection of
the Philadelphia Museum of Art.

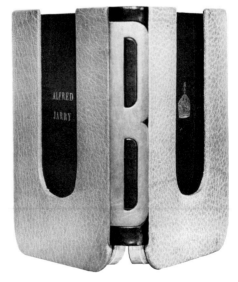

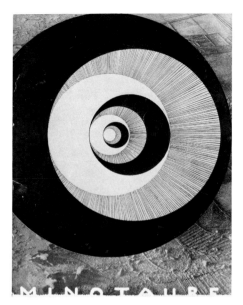

Cover for *Minotaure,* vol. II, no. 6, Paris, 1935
12½ x 9⅝ in. (31.7 x 24.5 cm) (bibl. 91)

A reproduction of *Corolles,* one of the Rotoreliefs which Duchamp had just introduced at the Paris inventors' fair, is superimposed on a background of Man Ray's photograph *Dust Breeding,* 1920.

Covers for *La Septième Face du dé/Poèmes-découpages* by Georges Hugnet, Paris, 1936
11⁹⁄₁₆ x 8⁷⁄₁₆ in. (29.3 x 21.4 cm)

A reproduction of *Why Not Sneeze Rose Sélavy?,* 1921, is pasted on the front cover, and a supplementary cover is composed from two color photographs of cigarettes stripped bare.

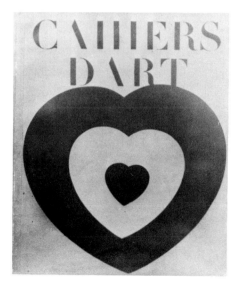

Cover for *Cahiers d'Art,* vol. XI, nos. 1–2, Paris, 1936
12⅜ x 9⅝ in. (31.5 x 24.5 cm)

This issue includes an essay by Gabrielle Buffet on Duchamp's optical works, "Coeurs volants" (Fluttering Hearts). Duchamp designed a collage of paper hearts for the cover, juxtaposing red and blue hues of such intensity that the images appear to vibrate. A full-scale color reproduction of the collage was included in the *Box in a Valise.*

Cover for *Transition,* no. 26, New York, 1937
$8^{7}/_{16}$ x $6^{1}/_{8}$ in. (21.5 x 15.5 cm)

The cover reproduces the Readymade *Comb.*

Covers for the catalog of the exhibition "First Papers of Surrealism," New York, 1942
$10^{1}/_{2}$ x $7^{1}/_{4}$ in. (26.6 x 18.4 cm)

The front cover is a photograph of the wall of Kurt Seligmann's barn, Sugar Loaf, New York, with five rifle shots fired by Duchamp, the cover being perforated to conform to the shots. The back cover is a photograph of Gruyère cheese.

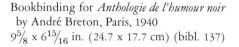

Bookbinding for *Anthologie de l'humour noir* by André Breton, Paris, 1940
$9^{5}/_{8}$ x $6^{15}/_{16}$ in. (24.7 x 17.7 cm) (bibl. 137)

The binding was designed by Duchamp and executed by Mary Reynolds. Only one example was made, which belonged to André Breton. It is now in a private collection in Paris.

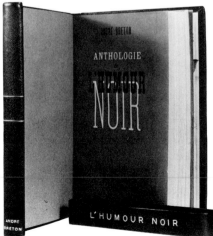

Covers for *VVV,* nos. 2–3 (Almanac for 1943), New York, 1943
11 x 8$\frac{7}{16}$ in. (28 x 21.5 cm) (bibl. 83)

The front cover uses an anonymous etching with an allegorical figure of death clothed in the American flag. The back cover, made in collaboration with Frederick Kiesler, is a cutout of a woman's torso drawn by Duchamp, with chicken wire inserted in the opening.

Cover for the catalog of the Man Ray exhibition "Objects of My Affection," New York, 1945
11$\frac{9}{16}$ x 9$\frac{1}{16}$ in. (29.4 x 32 cm)

The cover uses a photograph from a film by Hackenschmeid. Like the covers of *View,* it is a reference to Duchamp's interest in the "infra-thin."

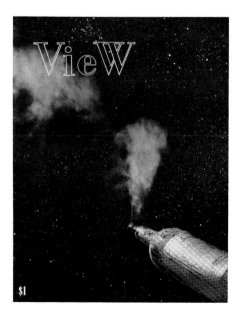

Covers for *View,* ser. V, no. 1 (Marcel Duchamp Number), New York, March 1945
12 x 9$\frac{1}{16}$ in. (30.5 x 23 cm) (bibl. 84)

The label on the bottle (Duchamp's military service record) and the Milky Way background suggest references to the Bachelor Apparatus and the Bride. The back cover bears an aphorism by Duchamp referring to the category of "infra-thin."

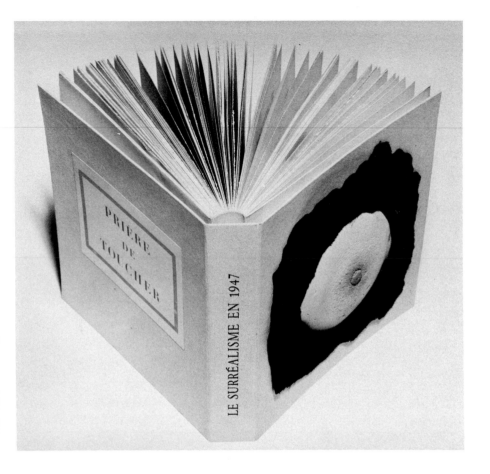

Cover for the catalog of the exhibition "Le
 Surréalisme en 1947," Paris, 1947
9¼ x 8¹⁄₁₆ in. (23.5 x 20.5 cm)

The front cover is a hand-colored foam-
rubber breast showing through a piece of
irregularly shaped black velvet. The back
cover bears the request "Prière de Toucher"
(Please Touch).

Cover for the catalog of the exhibition "Sur-
realist Intrusion in the Enchanters' Do-
main," New York, 1960
7 x 7 in. (17.8 x 17.8 cm)

Designed for an exhibition at the D'Arcy
Galleries (November 28, 1960, to January 14,
1961) directed by André Breton and Marcel
Duchamp. The object reproduced in relief is
used in France to signify a tobacco shop.
Another "Readymade"?

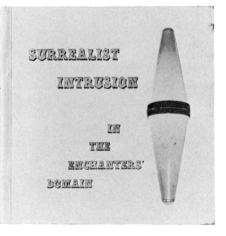

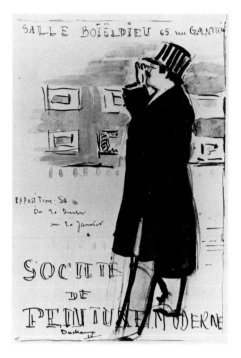

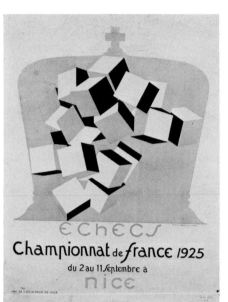

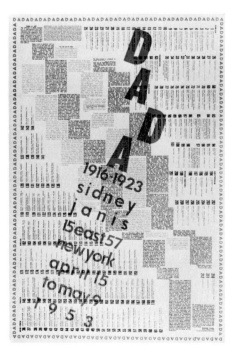

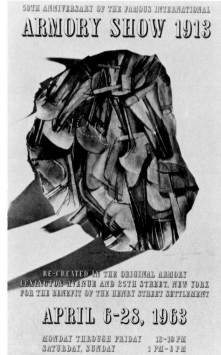

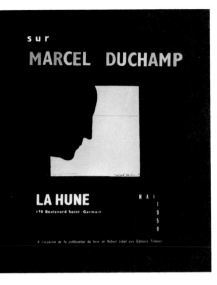

Poster for the exhibition at the Librairie La Hune, Paris, on the occasion of the publication of *Sur Marcel Duchamp* by Robert Lebel, 1959
25⁹⁄₁₆ x 19¹¹⁄₁₆ in. (65 x 50 cm)

Poster for Duchamp's retrospective exhibition at the Pasadena Art Museum, Pasadena, California, 1963
34⁷⁄₁₆ x 27³⁄₁₆ in. (87.5 x 69 cm)

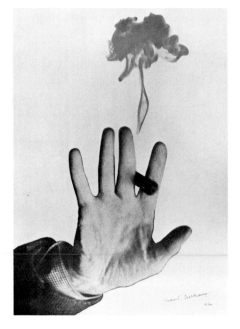

Poster for the exhibition "Editions de et sur Marcel Duchamp" at the Galerie Givaudan, Paris, June 8–September 30, 1967
27³⁄₈ x 18¹⁵⁄₁₆ in. (69.5 x 48 cm)

# BIBLIOGRAPHY

Bernard Karpel

FORTUNATELY, considerable information has been published on Duchamp, documentation to which the present compiler contributed as early as 1949 (bibl. 105) and as late as 1971 (bibl. 54). Within recent years, substantial data have accumulated in distinctive, almost magisterial works, notably Lebel (bibl. 51–52) and Schwarz (bibl. 53). For all practical purposes, their listings may be considered, if not total, exhaustive in scope. One must rate equally significant the scholarly bibliography compiled by Poupard-Lieussou for the definitive anthology *Marchand du Sel* (bibl. 8), along with the expansive data contained in the doctoral dissertation by Steefel (bibl. 66). Unfortunately, no detailed inventory has been made available for the archives of primarily unpublished materials in the Bibliothèque Littéraire Jacques Doucet in Paris, the Dreier and Stettheimer collections at Yale University, the Arensberg archive at the Francis Bacon Library and the Philadelphia Museum of Art, or the comprehensive holdings of Arturo Schwarz in Milan. Other references containing bibliographies, especially the vital contributions of the collectors and the museums—e.g., Chicago (bibl. 149), London (bibl. 72), and New York (bibl. 74)—are not overlooked in the following citations, which for convenience are presented in these groupings:

WRITINGS BY DUCHAMP
Collections and Major Texts   (bibl. 1–11)
Selected Articles and Miscellanea   (bibl. 12–21)
Interviews and Conversations   (bibl. 22–40)
Films, Recordings, and Tapes   (bibl. 41–50)
COMPREHENSIVE STUDIES: Oeuvre Catalogs   (bibl. 51–53)
MONOGRAPHS AND DISSERTATIONS   (bibl. 54–68)
INDIVIDUAL EXHIBITIONS   (bibl. 69–78)
SPECIAL NUMBERS   (bibl. 79–87)
ARTICLES AND REVIEWS   (bibl. 88–130)
GENERAL REFERENCES   (bibl. 131–197)

WRITINGS BY DUCHAMP

For a comprehensive list of 188 citations, see Schwarz (bibl. 53).

COLLECTIONS AND MAJOR TEXTS

1. *Boîte de 1914.* [1913–14?].
Manuscript notes and one drawing. Original and three photocopies. Reprinted (one illus.) in *Marchand du Sel,* pp. 29–33 (bibl. 8).

2. *L'Opposition et les cases conjuguées sont ré-conciliées.* Par M. Duchamp et V. Halberstadt. Paris and Brussels: Edition de l'Echiquier, 1932.
Limited edition on chess written with V. Halberstadt. Text in French, English, and German. Portion published in *Le Surréalisme au Service de la Révolution* (Paris), no. 2, October 1930, pp. 18–19, and *Marchand du Sel* (bibl. 8) between pp. 184 and 185.

3. *La Mariée mise à nu par ses célibataires, même.* Paris: Edition Rrose Sélavy, 1934.
Facsimile notes from 1911–15 in box covered with green flock paper (*Boîte verte*). Edition of 300 generally called the *Green Box,* containing 94 documents—photographs, drawings, manuscripts—in varying, irregular sizes. Also published in book format as bibl. 7, 9.

4. *Rrose Sélavy.* Paris: Editions G.L.M., 1939.
Verso t.p.: "Oculisme de précision, Rrose Sélavy, New York–Paris. Poils et coups de pied en tous genres." Collection of puns dated 1914–39. Limited edition. Also reprinted in bibl. 159.

5. *Boîte-en-valise.* New York: 1941.
Deluxe edition of 20 copies in leather box, with extra original, distributed by Art of This Century Gallery. Other copies, in linen or leather container, issued at varying intervals later (regular edition not to exceed 300). Detailed description of contents in *Catalogue 11.* Paris: Librairie Nicaise, 1964, pp. 48–52 (illus.), item no. 136, and in bibl. 53, pp. 511–13.

6. Yale University. Art Gallery. *Collection of the Société Anonyme.* New Haven: Associates of Fine Arts at Yale University, 1950.
Brief statements on 33 artists written by Duchamp, 1943–49. Reprinted, in alphabetical order, in *Marchand du Sel* (bibl. 8), pp. 116–48.

7. *From the Green Box.* Translated and with a Preface by George Heard Hamilton. New Haven: Readymade Press, 1957.
Edition of 400 containing 25 notations from bibl. 3. Translations approved by Duchamp. Hamilton addenda in bibl. 9.

8. *Marchand du Sel.* Ecrits de Marcel Duchamp, réunis et présentés par Michel Sanouillet. Bibliographie de Poupard-Lieussou. Paris: Le Terrain Vague, 1958.
Contents include: *La Mariée mise à nu par ses célibataires, même.*—"Rrose Sélavy."—"Jugements et critiques" (Société Anonyme, etc.).—Duchamp-Sweeney interviews.—"The Creative Act," etc. Numerous texts in French and English. Edition: 2,000; 40 deluxe; 10 hors commerce.

9. *The Bride Stripped Bare by Her Bachelors, Even.* A typographical version by Richard Hamilton of Duchamp's *Green Box.* Translated by George Heard Hamilton. London: Lund, Humphries; New York, Wittenborn, 1960.
Appendixes by R. Hamilton and G. H. Hamilton.
"This version of the Green Box is as accurate a translation of the meaning and form of the original notes as supervision by the author can make it" (Duchamp).

10. *A l'infinitif.* New York: Cordier & Ekstrom, 1966.
Unpublished notes from 1912 to 1920. Facsimile reproduction in deluxe edition (150 copies) called the *White Box,* with English translation by Cleve Gray. Partly published in *Art in America* (New York), vol. 54, no. 2, March–April 1966, pp. 72–75, as "Speculations."

11. *Notes and Projects for the Large Glass.* Selected, ordered, and with an Introduction by Arturo Schwarz. New York: Abrams, 1969.
Written 1912–20. Facsimiles of 144 notes in French with English translations opposite. Companion volume to monograph (bibl. 53). Also limited edition, 1967 (bibl. 63).

SELECTED ARTICLES AND MISCELLANEA

12. "A Complete Reversal of Art Opinions by Marcel Duchamp, Iconoclast," *Arts and Decoration* (New York), vol. 5, no. 11, September 1915, pp. 427–28, 442.
Earliest known published interview with Duchamp.

13. [Caption: "Another Invader: Marcel Duchamp"], *Literary Digest* (New York), vol. 51, November 27, 1915, pp. 1224–25.
Photograph with his statement about war in article on "The European Art-Invasion."

14. "Can a Photograph Have the Significance of Art?" *Manuscripts* (New York), no. 4, December 1922, p. 2.
Response to question from Alfred Stieglitz by Marcel Duchamp and others.

15. "The Bride Stripped Bare by Her Bachelors, Even," *This Quarter* (Paris), vol. 5, no. 1, September 1932, pp. 189–92.
Preface by André Breton for translation of notes from the *Green Box.* Special Surrealist number also reprinted by Arno Press (New York, 1969).

16. "La Mariée mise à nu par ses célibataires, même," *Le Surréalisme au Service de la Révolution* (Paris), no. 5, May 15, 1933, pp. 1–2.
Extract from as yet unpublished notes,

briefly introduced by André Breton. Includes the phrase "Etant donnés 1° la chute d'eau . . ." dated 1915. Also note bibl. 3.

17. *L'Homme qui a perdu son squelette.* Roman par Arp, Duchamp, Eluard, Ernst, Hugnet, Pastoureau, Prassinos, etc. *Plastique* (Paris–New York), nos. 4–5, 1939.

Collective novel. Duchamp denied participation.

18. ["A Tribute to the Artist," 1949]. In *Charles Demuth.* New York: The Museum of Modern Art, 1950, p. 17.

19. "Une Lettre de Marcel Duchamp," *Medium* (Paris), n.s., no. 4, January 1955, p. 33.

To Breton about his own work and discussion of it by Carrouges (bibl. 143). Also in *Marchand du Sel* (bibl. 8).

20. "The Creative Act," *Art News* (New York), vol. 56, no. 4, Summer 1957, pp. 28–29.

Frequently reprinted, e.g., Lebel, both editions (bibl. 52); Sanouillet (bibl. 8), both in English and French by Duchamp; a recording inserted in *Aspen* (New York), nos. 5–6, 1967. Also in *The New Art: A Critical Anthology,* edited by Gregory Battcock. New York: Dutton, 1966.

21. "Apropos of Readymades" (October 1961?). In *Art and Artists* (London), vol. 1, no. 4, July 1966 (see bibl. 85), with article by Simon Watson Taylor.

Also in Coutts-Smith (bibl. 146), as typescript and letterpress.

See also Duchamp contributions in Special Numbers (bibl. 79–87) and reprints of puns in Breton (bibl. 137) and de Massot (bibl. 171).

INTERVIEWS AND CONVERSATIONS

This is a selected list; for the comprehensive record, see Schwarz (bibl. 53).

22. With Pierre Cabanne, see bibl. 54.

23. With William A. Camfield, see bibl. 142.

24. With Hubert Crehan, "Dada," *Evidence* (Toronto), no. 3, Fall 1961, pp. 36–38.

25. With Otto Hahn, "Marcel Duchamp," *L'Express* (Paris), no. 684, July 1964, pp. 22–23.

Also in *Art and Artists,* July 1966 (bibl. 85).

26. With Alain Jouffroy, "Marcel Duchamp," *Arts* (Paris), no. 694, October 29–November 4, 1958, p. 12.

Supplemented by bibl. 163.

27. With Katharine Kuh, "Marcel Duchamp," in *The Artist's Voice.* New York: Harper & Row, 1962, pp. 81–93.

28. With Robert Lebel, "Marcel Duchamp, maintenant et ici," *L'Oeil* (Paris), no. 149, May 1967, pp. 18–23, 77.

29. With Daniel MacMorris, "Marcel Duchamp's Frankenstein," *Art Digest* (New York), vol. 12, no. 7, January 1938, p. 2.

30. With Dorothy Norman, "Interview," *Art in America* (New York), vol. 57, no. 4, July–August 1969, p. 38.

31. With André Parinaud, "Entretien avec Marcel Duchamp," in *Omaggio a André Breton.* Milan: Galleria Schwarz, 1967, pp. 19–46.

In French, English, and Italian. Also see "Duchamp raconte Breton," *Arts, Loisirs* (Paris), no. 54, October 5, 1966.

32. With Colette Roberts, "Interview," *Art in America* (New York), vol. 57, no. 4, July–August 1969, p. 39.

An excerpt from one of many still unpublished interviews.

33. With Francis Roberts, "I Propose to Strain the Laws of Physics," *Art News* (New York), vol. 67, no. 8, December 1968, pp. 46–47, 62–64.

34. With Michel Sanouillet, "Dans l'atelier de Marcel Duchamp," *Les Nouvelles Littéraires* (Paris), no. 1424, December 16, 1954, p. 5.

35. With Jean Schuster, "Marcel Duchamp, vite," *Le Surréalisme, même* (Paris), no. 2, Spring 1957, pp. 143–45.

36. With William C. Seitz, "What's Happened to Art?" *Vogue* (New York), vol. 141, February 15, 1963, pp. 110–13, 129–31.

37. With Jeanne Siegel, "Some Late Thoughts of Marcel Duchamp," *Arts Magazine* (New York), vol. 43, no. 3, December 1968–January 1969, pp. 21–22.

38. With Francis Steegmuller, "Duchamp Fifty Years Later," *Show* (New York), vol. 3, no. 2, February 1963, pp. 28–29.

39. With James Johnson Sweeney, "Interview," *The Museum of Modern Art Bulletin* (New York), vol. 13, nos. 4–5, 1946, pp. 19–21.

For 1955 filmed interview, see bibl. 44.

40. With Juan Josep Tharrats, "Marcel Duchamp," *Art Actuel International* (Lausanne), no. 6, 1958, p. 1.

FILMS, RECORDINGS, AND TAPES

41. With René Clair, *Entr'acte,* 1924. Director: René Clair; scenario: Francis Picabia; music: Erik Satie; actors: Picabia, Satie, Duchamp, Man Ray, Joan Borlin. Illustrated in bibl. 194.

42. With Man Ray and Marc Allegret, *Anémic Cinéma,* 1925. Director: Marcel Duchamp. Collection: The Museum of Modern Art Film Library, New York. Documented, illus., in bibl. 191.

43. With Hans Richter, *Dreams That Money Can Buy,* 1944–46. Director: Hans Richter; distributor: McGraw Hill/Contemporary Films, New York. Dream sequence 4: Disks and nudes descending the staircase. Documented, illus., in bibl. 191 and publicity brochure (New York, n.d.).

44. With James Johnson Sweeney, Interview at the Philadelphia Museum of Art. Filmed by the National Broadcasting Company, 1955. Broadcast on American TV, "Wisdom Series," January 1956.

Also published in *Wisdom: Conversations with Elder Wise Men of Our Day,* edited by James Nelson. New York: Norton, 1958, pp. 89–99. For variant French version, see Sanouillet (bibl. 8), pp. 149–61.

45. With Hans Richter, *8 x 8,* 1956–57. Director: Hans Richter; distributor: McGraw Hill/Contemporary Films, New York. Marcel Duchamp participated as actor and adviser in "a chess sonata for film" consisting of eight improvisations, playing the White King in "First Move."

46. With Hans Richter, *Dadascope,* 1956–61. Director: Hans Richter. Described as a cinematographic collage of Dadaist readings and art. Participants include Marcel Duchamp, reading in part I (1956?) English and French puns.

47. With William C. Seitz, Art of Assemblage Symposium. New York: The Museum of Modern Art, October 19, 1961. Five parts.

Panel: Marcel Duchamp, Charles R. Huelsenbeck, Robert Rauschenberg, and Roger Shattuck. Four tapes and typed transcript.

48. With Jean-Marie Drot, *Jeu d'échecs avec Marcel Duchamp,* 1963. Filmed interview first broadcast by Radio Télévision Française, June 8, 1964.

49. With Tristram Powell, *Rebel Readymade,* 1966. Film for BBC Television on occasion of Tate Gallery retrospective, June 23, 1966.

50. With *Aspen* magazine, recording (33⅓ rpm), *The Creative Act* and verso, *Some Texts from "A l'infinitif,"* 1912–20. Insert in *Aspen* (New York), nos. 5–6, November 1967.

Recording: See also "Reunion" (bibl. 59).

Unpublished tapes: These include the following interviews: with Harriet Janis (1953); with George Heard Hamilton and Richard Hamilton for the BBC (1959);

with Richard Hamilton for BBC Monitor (1961); with Robert Melville, William Coldstream, David Sylvester, Ronald Kitaj, and Richard Hamilton for the Arts Council of Great Britain (1966).

COMPREHENSIVE STUDIES:
Oeuvre Catalogs

51. Lebel, Robert. *Sur Marcel Duchamp.* Paris: Trianon, 1959.

Original edition of 137 copies with Duchamp self-profile, torn by hand and signed. Also deluxe edition: 10 copies, plus several hors commerce, with hand-colored and signed print of the *Large Glass* and a signed Readymade enamel plaque, *Eau & gaz à tous les étages.* Also variant trade editions: French (Trianon), English (Trianon), Italian (Schwarz), American (Grove, bibl. 52), and a second German edition (bibl. 60) with bibliography updated to 1972.

52. Lebel, Robert. *Marcel Duchamp.* New York: Grove Press in conjunction with Trianon Press, London and Paris, 1959.

With chapters by Marcel Duchamp, André Breton, and H.-P. Roché. Catalogue raisonné. Bibliography. Translated from limited edition: *Sur Marcel Duchamp.* Also Paragraphic Books edition, revised American and Canadian paperback format, omitting color plates, extending catalog, 1967.

53. Schwarz, Arturo. *The Complete Works of Marcel Duchamp.* New York: Abrams, 1969; 2nd rev. ed., 1970.

Critical catalogue raisonné, pp. 372–580. Descriptive bibliography of Duchamp's writings, lectures, translations, interviews, pp. 583–606. Bibliography on Duchamp, pp. 607–17. Also Continental editions, e.g., bibl. 64. Actually projected as the first of a two-volume study completed by bibl. 11. Other works in progress based on unique archives.

MONOGRAPHS AND DISSERTATIONS

54. Cabanne, Pierre. *Dialogues with Marcel Duchamp.* New York: Viking, 1971.

Documents of 20th Century Art. Introduction by Robert Motherwell; preface by Salvador Dali; appreciation by Jasper Johns. Bibliography by Bernard Karpel. Text translated by Ron Padgett from French edition (Paris: Belfond, 1967).

55. Dreier, Katherine S., and Matta Echaurren. *Duchamp's Glass: La Mariée mise à nu par ses célibataires, même. An Analytical Reflection.* [New York]: Société Anonyme, 1944.

Reprinted in *Société Anonyme, Volume III: Monographs & Brochure.* New York: Arno Press, 1972.

56. Golding, John. *Duchamp: The Bride Stripped Bare by Her Bachelors, Even.* London: Penguin, 1972; New York: Viking, 1973.

An analysis for the Art in Context series; includes full-color foldout of the *Large Glass.*

57. *Hommage à Marcel Duchamp.* Alès: P.A.B. (Editions), 1969.

Contributions by P.-A. Benoit, Gabrielle Buffet, Alexander Calder, Robert Lebel, Man Ray, and Pierre de Massot.

58. Hopps, Walter, Ulf Linde, and Arturo Schwarz. *Marcel Duchamp: Ready-mades, etc. (1913-1964).* Paris: Le Terrain Vague, 1964.

Published on the occasion of an exhibition at the Galleria Schwarz, June 5–September 31, 1964. Also deluxe edition of 100 copies with Duchamp original.

59. Kubota, Shigeko. *Marcel Duchamp and John Cage.* [Tokyo: Takeyoshi Miyazawa], n.d.

"Reunion along with Teeny Duchamp, David Tudor, Gordon Mumma, David Behrman, Lowell Cross . . . March 5th, 1968 . . . Ryerson Theatre in Toronto. Chessboard by Lowell Cross. Photographs copyright 1968 by Shigeko Kubota. Recorded by David Behrman." Insert: 33⅓ rpm record, "Reunion, Toronto, 1968." 36 pages of typescript and 36 pages of photos, introduced by "John Cage. 36 acrostics re and not re Duchamp. Spoleto, July 1970." Boxed edition of 500 copies.

60. Lebel, Robert. *Marcel Duchamp, mit Texten von André Breton und H.-P. Roché.* Cologne: DuMont Schauberg, 1972.

Enlarged reissue of 1962 German translation of *Sur Marcel Duchamp* (bibl. 51) as DuMont Dokumente (paperback) with cover-title: "Von der Erscheinung zur Konzeption." Bibliography, pp. 205–31, includes references until 1972.

61. Paz, Octavio. *Marcel Duchamp.* Mexico City: Era, 1968. Six parts (boxed).

Contents—1, Paz: Marcel Duchamp o el castillo de la pureza.—2, Duchamp: Textos.—3, 4, 5, 6: Reproducciones (facsimile, port.). Boxed folio designed by Vicente Rojo.

62. Paz, Octavio. *Marcel Duchamp or The Castle of Purity.* London: Cape Goliard Press, in association with New York: Grossman, 1970.

Translated from the Spanish. French edition: Paris: Givaudan, 1967; also *Deux Transparents* [Duchamp and Lévi-Strauss], 1970.

63. Schwarz, Arturo. *The Complete Works of Marcel Duchamp.* See bibl. 53.

64. Schwarz, Arturo, ed. *The Large Glass and Related Works, with Nine Original Etchings by Marcel Duchamp.* Milan: Galleria Schwarz, 1967.

Deluxe edition (135 copies) includes "144 facsimile reproductions of Duchamp's notes (with parallel English translation)." Comparable edition issued as bibl. 11.

64. Schwarz, Arturo. *Marcel Duchamp.* Milan: Fabbri, 1968.

Text translated by Tommaso Trini. Footnotes; bibliography. Plates same as pp. 207–370 in Abrams edition (bibl. 53). Similar French edition: Paris: Hachette, 1969, including Henri Coulonges, "Souvenirs des frères Duchamp." Fabbri also issued a *Marcel Duchamp* brochure (brief Schwarz text and large color plates) in the series "I Maestri del colore."

65. Schwarz, Arturo, ed. *Notes and Projects for the Large Glass.* New York: Abrams, 1969. See bibl. 11.

66. Steefel, Lawrence D., Jr. *The Position of "La Mariée mise à nu par ses célibataires, même" (1915-1923) in the Stylistic and Iconographic Development of the Art of Marcel Duchamp.* Princeton: Princeton University, 1960.

Doctoral dissertation. Bibliographical notes, pp. 292–423. Also available as microfilm and xerox title from University Microfilms (Ann Arbor, Mich.).

67. Takiguchi, Shuzo. *To and from Rrose Sélavy.* Tokyo, 1968. Japanese text.

Limited edition of 500 copies; also deluxe edition of 60 copies. Text by Takiguchi, writings by Duchamp, special graphics. Detailed description in Lebel (bibl. 60, reference 144).

68. Tomkins, Calvin, and the Editors of Time–Life Books. *The World of Marcel Duchamp, 1887– New York: Time Inc., 1966.
Bibliography.

INDIVIDUAL EXHIBITIONS

This is a record of recent exhibition catalogs. For a comprehensive exhibition list, beginning 1909, see Lebel's 1967 American edition (bibl. 52) and second German edition (bibl. 60).

69. The Hague. Gemeentemuseum. *Marcel Duchamp: schilderijen, tekeningen, ready-mades,*

documenten. February 3–March 15, 1965. Also shown at Eindhoven, March 20–May 3, 1965. Chronology, bibliography.

70. Hannover. Kestner-Gesellschaft. *Marcel Duchamp, même.* September 7–28, 1965.
Text by Wieland Schmied. Chronology, 185 exhibits, bibliography.

71. Jerusalem. Israel Museum. *Marcel Duchamp: Drawings, Etchings for the Large Glass, Ready-Mades.* March–May 1972.

72. London. Tate Gallery. *The Almost Complete Works of Marcel Duchamp.* 2nd ed. Arts Council of Great Britain, June 18–July 31, 1966.
Introduction and catalog text for 243 items by Richard Hamilton. Extensive bibliography by Arturo Schwarz of "written and spoken items by and not on the artist," pp. 92–109.

73. Milan. Galleria Schwarz. *Marcel Duchamp: 66 Creative Years.* Milan, December 12, 1972–February 28, 1973.
"From the first painting to the last drawing. Over 260 items." 104 pp., 280 illus.

74. New York. Cordier & Ekstrom. *Not Seen and/or Less Seen of/by Marcel Duchamp/Rrose Sélavy 1904–1964: Mary Sisler Collection.* January 14–February 13, 1965.
Foreword and catalog texts by Richard Hamilton. Another edition for Milwaukee Art Center, September 9–October 8, 1965. The exhibit data include significant bibliographical information.

75. Pasadena. Art Museum. *Marcel Duchamp: A Retrospective Exhibition.* October 8–November 3, 1963.
Includes dialogue between Richard Hamilton and Duchamp; text by Walter Hopps; chronology; catalog based on Lebel's inventory (bibl. 52).

76. Paris. Musée National d'Art Moderne. *Raymond Duchamp-Villon—Marcel Duchamp.* June 7–July 2, 1967.
Text by Bernard Dorival and Jean Cassou. Biographies, bibliographies. Modified version of *Les Duchamps.* Rouen, April 15–June 1, 1967.

77. Turin. Il Fauno (Galleria d'Arte). *Marcel Duchamp.* March 20–April 20, 1972.
Preface by "Janus" (5 pp.). Checklist: nos. 1–68.

78. Zurich. Kunstgewerbemuseum. *Dokumentation über Marcel Duchamp.* June 30–August 28, 1960.
Texts by Duchamp, Max Bill, Hans Fischli, and Serge Stauffer.

## Special Numbers

Extensive details are reported by Poupard-Lieussou in Sanouillet (bibl. 8), pp. 209–11.

79. *The Blind Man* (New York), nos. 1–2, April–May 1917.
Directors: H.-Pierre Roché, Beatrice Wood, and Marcel Duchamp. No. 2 also issued in 50 deluxe copies. Edited in part by Marcel Duchamp, with participation of Man Ray and others. No. 2 contains the article by Louise Norton, "Buddha of the Bathroom," and an editorial, "The Richard Mutt Case." Facsimile issued by Arturo Schwarz, Milan, 1970, in series "Documenti e Periodici Dada."

80. *Rongwrong* (New York), no. 1, 1917.
Directors: H.-Pierre Roché, Beatrice Wood, and Marcel Duchamp. Published in 100 copies. Cover reproduced in Lebel (bibl. 52), Motherwell (bibl. 172), etc. Facsimile issued by Arturo Schwarz, Milan, 1970, in series "Documenti e Periodici Dada."

81. *New York Dada* (New York), April 1921.
Only one issue, edited by Marcel Duchamp and Man Ray. Article by Tristan Tzara; cover by Duchamp; miscellanea by Man Ray. Facsimile issued by Arturo Schwarz, Milan, 1970, in series "Documenti e Periodici Dada." Reduced reproduction in bibl. 172.

82. *Orbes* (Paris), ser. 2, no. 4, Summer 1935.
Cover by Duchamp. Articles by Jean van Heeckeren, Jacques-H. Levesque, and Pierre de Massot.

83. *VVV* (New York), 1942–44.
Edited by David Hare. Editorial advisers: André Breton, Marcel Duchamp, and Max Ernst. No. 1, June 1942; nos. 2–3, March 1943; no. 4, January 1944. Participants listed by Poupard-Lieussou (bibl. 8). Cover of nos. 2–3 by Duchamp.

84. *View* (New York), ser. 5, no. 1, March 1945.
Major contributions by Breton, Buffet, Calas, Desnos, Ford, Janis, Kiesler, and Soby. Cover by Duchamp. Also "Duchampiana" (Man Ray, Parker, Levy, and Waste, i.e., Stettheimer). Also limited edition of 100 in boards, signed by contributors, with a Duchamp Readymade (signed reproduction of *Pharmacy*).

85. *Art and Artists* (London), vol. 1, no. 4, July 1966.
Contributions by Otto Hahn, André Breton, Robert Lebel, Brian O'Doherty, Richard Hamilton, George Heard Hamilton, Alexander Watt, Simon Watson Taylor, Toby Mussman, and Christopher Finch. Cover by Man Ray.

86. *Philadelphia Museum of Art Bulletin,* vol. 64, nos. 299–300, April–September 1969.
"Etant donnés: 1° la chute d'eau, 2° le gaz d'éclairage. Reflections on a New Work by Marcel Duchamp," by Anne d'Harnoncourt and Walter Hopps. Also preface by Evan H. Turner and extensive notes.

87. *Art in America* (New York), vol. 57, no. 4, July–August 1969.
Feature edited by Cleve Gray: "Marcel Duchamp, 1887–1968." Texts by Cleve Gray, Walter Hopps (chronology), Alexander Calder, Jasper Johns, Nicolas Calas, William Copley, Dorothy Norman, Colette Roberts, Hans Richter, and Man Ray.

## Articles and Reviews

88. Amaya, Mario. "Son of the Bride Stripped Bare," *Art and Artists* (London), vol. 1, no. 4, July 1966, pp. 22–28, illus.
An interview with Richard Hamilton on his reconstruction of the *Large Glass* for the Tate Gallery show.

89. "The Armory Show," *Art in America* (New York), vol. 51, no. 1, 1963, pp. 29–63, illus.

90. Breton, André. "Marcel Duchamp," *Littérature* (Paris), no. 5, October 1922, pp. 7–10.
Includes puns and photograph "Dust Breeding" by Man Ray. Revised reprint in *Les Pas perdus* (text translated in *View,* bibl. 84).

91. Breton, André. "Phare de La Mariée," *Minotaure* (Paris), vol. 2, no. 6, Winter 1935, pp. 45–49.
Translation in *View* (bibl. 84), reprinted in Lebel (bibl. 52) and Guggenheim catalog (bibl. 178).

92. Buffet, Gabrielle. "La Section d'Or," *Art d'Aujourd'hui* (Paris), vol. 4, nos. 3–4, May–June 1953, pp. 74–76, illus.

93. Burn, Guy. "Marcel Duchamp: Marchand du Sel, Profile," *Arts Review* (London), vol. 18, no. 12, June 25, 1966, pp. 306–7, illus.

94. Burnham, Jack. "Duchamp's Bride Stripped Bare," *Arts Magazine* (New York), vol. 46, no. 5, March 1972, pp. 28–32; no. 6, April 1972, pp. 41–45; no. 7, May 1972, pp. 58–61.
Bibliographical footnotes, illus.

95. Burnham, Jack. "True Ready Made?" *Art and Artists* (London), vol. 6, no. 11, February 1972, pp. 26–31, illus.
Bibliographical footnotes.

96. Burnham, Jack. "The Semiotics of 'End-Game' Art," *Arts Magazine* (New York), vol. 47, no. 2, November 1972, pp. 38–43.
"A discussion of Marcel Duchamp's premonitions about modern art." Footnotes.

97. Burnham, Jack. "Unveiling the Consort," *Artforum* (New York)—part I: vol. 9, no. 7, March 1971, pp. 55–60, illus.—part II: vol. 9, no. 8, April 1971, pp. 42–51.
References. Reply: J. Schorr, vol. 9, no. 9, June 1971, p. 10.

98. Cage, John. "26 Statements Re Duchamp," *Art and Literature* (Paris), no. 3, Autumn–Winter 1964, pp. 9–10.

99. Crowninshield, Frank. "The Scandalous Armory Show of 1913," *Vogue* (New York), vol. 96, September 15, 1940, pp. 68–71.
Section on "The Much Maligned *Nude*." Reprinted in vol. 3, bibl. 134. Also see "The Great Armory Show of 1913," *Life* (New York), vol. 28, no. 1, January 2, 1950, pp. 58–63.

100. Dali, Salvador. "The King and Queen Traversed by Swift Nudes," *Art News* (New York), vol. 58, no. 2, April 1959, pp. 22–25, illus.

D'Harnoncourt, Anne. See bibl. 86.

101. Davidson, Abraham A. "Marcel Duchamp: His Final Gambit at the Philadelphia Museum of Art," *Arts Magazine* (New York), vol. 44, no. 1, September–October 1969, pp. 44–45, illus.

102. Desnos, Robert. "Rrose Sélavy," *Littérature* (Paris), n.s., no. 7, December 1922, pp. 14–22.

103. Domingo, Willis. "Meaning in the Art of Duchamp," *Artforum* (New York)—part I: vol. 10, no. 4, December 1971, pp. 72–77, illus.—part II: vol. 10, no. 5, January 1972, pp. 63–68, illus.

104. Dorfles, Gillo. "Il ready-made di Duchamp e il suo rapporto con l'arte d'oggi," *Art International* (Lugano), vol. 8, no. 10, December 1964, pp. 40–42, illus.

105. Dreier, Katherine S. "Marcel Duchamp," in *Collection of the Société Anonyme*, pp. 148–50 (bibl. 6).
Bibliography (1912–49) with contributions by Bernard Karpel.

106. Hamilton, George Heard. "In Advance of Whose Broken Arm?" *Art and Artists* (London), vol. 1, no. 4, July 1966, pp. 29–31, illus.

107. Hamilton, Richard. "Duchamp," *Art International* (Lugano), vol. 7, no. 10, January 1964, pp. 22–28, illus.

Hopps, Walter. See bibl. 86.

108. Johns, Jasper. "Marcel Duchamp," *Artforum* (New York), vol. 7, no. 3, November 1968, p. 6.
Also bibl. 54.

109. Keneas, Alexander. "The Grand Dada (Marcel Duchamp, Art Giant, Dies)," *New York Times*, October 2, 1968, p. 51.
Comprehensive obituary includes quotes.

110. Kozloff, Max. "Johns and Duchamp," *Art International* (Lugano), vol. 8, no. 2, March 1964, pp. 42–45.

111. Kuh, Katharine. "Four Versions of *Nude Descending a Staircase*," *Magazine of Art* (New York), vol. 42, no. 7, November 1949, pp. 264–65, illus.

112. Lebel, Robert. "Dernière Soirée avec Marcel Duchamp," *L'Oeil* (Paris), no. 167, November 1968, pp. 18–21, illus.
Also texts in no. 112 (1964), no. 183 (1970), and no. 193 (1971).

113. Lebel, Robert. "L'Humour absurde de Marcel Duchamp," *XXᵉ Siècle* (Paris), n.s., no. 8, January 1957, pp. 9–12, illus.
Also text in no. 13, Christmas 1959, pp. 63–64.

114. Lebel, Robert. "Marcel Duchamp: Premiers Essais . . .," *Le Surréalisme, même* (Paris), no. 3, Autumn 1957, pp. 21–31, illus.

115. Leiris, Michel. "Arts et métiers de Marcel Duchamp," *Fontaine* (Paris), no. 54, Summer 1946, pp. 188–93.

116. Millet, Catherine, and Marcelin Pleynet. "Le Fétiche Duchamp," *Art Press* (Paris), no. 1, December 1972–January 1973, pp. 4–7, illus. (port.).

117. Müller, Grégoire. "Reflections on a Broken Mirror," *Arts Magazine* (New York), vol. 46, no. 6, April 1972, pp. 33–35, illus.

118. Nordland, Gerald. "Marcel Duchamp and Common Object Art," *Art International* (Lugano), vol. 8, no. 1, February 1964, pp. 30–31.
On the occasion of the Pasadena retrospective.

119. "Raymond Roussel" (special number), *Bizarre* (Paris), nos. 34–35, 1964, 159 pp.
Also note bibl. 150

120. Richter, Hans. "In Memory of Marcel Duchamp," *Form* (Cambridge, England), no. 9, April 1969, pp. 4–5.
Also "In Memory of a Friend," *Art in America* (New York), vol. 57, no. 4, July–August 1969, pp. 40–41.

121. Roché, Henri-Pierre. "Souvenirs sur Marcel Duchamp," *La Nouvelle Revue Française* (Paris), vol. 1, no. 6, June 1953, pp. 1133–38.
Supplemented by "Vie de Marcel Duchamp," *La Parisienne* (Paris), no. 24, January 1955, pp. 63–69. Also note bibl. 52, 148.

122. Rubin, William S. "Reflections on Marcel Duchamp," *Art International* (Lugano), vol. 4, no. 9, November 1960, pp. 49–53, illus.

123. Sargeant, Winthrop. "Dada's Daddy: A New Tribute Is Paid to Duchamp, Pioneer of Nonsense and Nihilism," *Life* (New York), vol. 32, no. 17, April 28, 1952, pp. 100–111, illus.

124. Spector, Jack L. "Freud and Duchamp: The Mona Lisa 'Exposed,'" *Artforum* (New York), vol. 6, no. 8, April 1968, pp. 54–56, illus.

125. Staber, Margit. "Marcel Duchamp," *Das Kunstwerk* (Baden-Baden), vol. 14, no. 7, January 1961, pp. 3–10, illus.

126. Steefel, Lawrence D., Jr. "The Art of Marcel Duchamp," *Art Journal* (New York), vol. 22, no. 2, Winter 1962–63, pp. 72–80.
Part of doctoral dissertation (bibl. 66).

127. Taylor, Simon Watson. "Marcel Duchamp, 1887–1968," *Art and Artists* (London), vol. 3, no. 8, November 1968, p. 53.

128. Tomkins, Calvin. "Profiles: Not Seen and/or Less Seen," *New Yorker* (New York), vol. 41, February 6, 1965, pp. 37 ff.
Modified version in bibl. 192.

129. Trini, Tommaso. "Duchamp dall' oltreporta, intervista con Arturo Schwarz sull' ultima opera di Marcel Duchamp: "Etant donnés . . .," *Domus* (Milan), no. 478, September 1969, pp. 45–46, illus.
On the artist's last work at the Philadelphia Museum. Also English text.

130. Vallier, Dora. "Marcel Duchamp et son frère Raymond," *XXᵉ Siècle* (Paris), no. 29, December 1967, pp. 99–102, illus.

GENERAL REFERENCES

131. Admussen, Richard L. *Les Petites Revues littéraires, 1914–1939. Répertoire descriptif.* St. Louis: Washington University Press; Paris: Nizet, 1970. p. 142 (index).

132. Amherst College. Department of Fine Arts and American Studies. *The 1913 Armory Show in Retrospect.* February 17–March 17, 1958.

No. 12, Duchamp: *Nude Descending a Staircase.* Exhibition and commentary by Frank Anderson Trapp. Brief quotation. Catalog reprinted in vol. 3, bibl. 134.

133. Apollinaire, Guillaume. *Les Peintres cubistes: Méditations esthétiques.* Paris: Figuière, 1913.

Translation by Lionel Abel. Documents of Modern Art. New York: Wittenborn, Schultz, 1949. Other editions, 1944, 1962. Reprinted by Chipp (bibl. 145).

134. *The Armory Show: International Exhibition of Modern Art, 1913.* New York: Arno Press, 1972. 3 vols.

Reprints of basic references, edited and introduced by Bernard Karpel. Vol. I: Catalogs.—II: Pamphlets.—III: Contemporary and retrospective documents.

135. Barr, Alfred H., Jr. *Cubism and Abstract Art.* New York: The Museum of Modern Art, 1936, 1966.

With catalog of the exhibition, including five Duchamps. Reprint edition, New York: Arno Press, 1966.

136. Breton, André. *Les Pas perdus.* Paris: Gallimard, 1924.

Marcel Duchamp, pp. 141–46.

137. Breton, André. *Anthologie de l'humour noir.* Paris: Sagittaire, 1940; reprint, 1950.

Commentary and Duchamp epigrams, pp. 221–25.

138. Breton, André. *Le Surréalisme et la peinture.* Nouv. ed. New York: Brentano's, 1945.

On "La Mariée," pp. 107–24, first published in *View* (bibl. 84). Augmented edition, Paris: Gallimard, 1965.

139. Brisset, Jean-Pierre. *La Science de Dieu, ou La Création de l'homme.* Paris: Chamuet, 1900.

In Mary Reynolds binding (see bibl. 149). Other Brisset titles, called by Duchamp "my ideal library," might include *Les Prophéties accomplies* (1906) and *Les Origines humaines* (1913).

140. Brown, Milton W. *The Story of the Armory Show.* New York: Hirshhorn Foundation, distributed by New York Graphic Society, 1963. p. 316 (index).

141. Buffet-Picabia, Gabrielle. *Aires abstraites.* Geneva: Cailler, 1957.

Chapters on "Coeurs volants" (Duchamp) and "L'Epoque pre-dada à New York." Similarly in Motherwell (bibl. 172): "Some Memories of Pre-Dada: Picabia and Duchamp."

142. Camfield, William A. *La Section d'Or.* New Haven: Yale University, 1961.

Unpublished M.A. thesis. Appendix C: Interview with Marcel Duchamp and letters. Bibliography, pp. 144–54.

143. Carrouges, Michel. *Les Machines célibataires.* Paris: Arcanes, 1951.

Includes "Franz Kafka et Marcel Duchamp" and "Raymond Roussel." Reviewed by Jehan Mayoux in *Bizarre* (Paris), no. 1, May 1955, pp. 73–83; no. 2, October 1955, pp. 81–96.

144. Chicago. Art Institute. *20th Century Art from the Louise and Walter Arensberg Collection.* October 20–December 18, 1949. Essay on Duchamp by Katharine Kuh. Exhibits nos. 52–81 (17 illus.).

145. Chipp, Herschel B. *Theories of Modern Art.* Berkeley and Los Angeles: University of California Press, 1968. p. 662 (index).

Includes Sweeney, *The Museum of Modern Art Bulletin* interview (bibl. 39), and Apollinaire's critique (bibl. 133; 1944), pp. 245–46.

146. Coutts-Smith, Kenneth. *Dada.* London: Studio Vista; New York: Dutton, 1970.

"New York—Duchamp and Philosophical Irony," pp. 49–72, includes 1961 "Apropos of Readymades" (typescript and transcript), collection Simon Watson Taylor (see bibl. 85).

147. Cummings, Paul, ed. *A Dictionary of Contemporary American Artists.* 2nd ed. New York: St. Martin's Press, 1971. pp. 120–21. Bibliography.

148. *Dictionary of Modern Painting.* Carleton Lake and Robert Maillard, eds. New York: Paris Book Center, 1955.

Translation from Hazan edition (Paris, 1954). Contribution by H.-Pierre Roché on Duchamp, pp. 104–5. Also later editions.

149. Edwards, Hugh. *Surrealism and Its Affinities: The Mary Reynolds Collection. A Bibliography.* Chicago: Art Institute, 1956. Foreword by Duchamp, pp. 5–6. Second edition, 1973.

150. Ferry, Jean. *Une Etude sur Raymond Roussel.* Paris: 1953.

Preface by André Breton. Also note essay by Michel Leiris: "Conception et réalité chez Raymond Roussel," *Critique* (Paris), vol. X, no. 89, October 1954, p. 828.

151. Gershmann, Herbert S. *The Surrealist Revolution in France.* Ann Arbor: University of Michigan Press, 1969. p. 251 (index).

152. Gold, Laurence Stephen. *A Discussion of Marcel Duchamp's Views on the Nature of Reality and Their Relation to the Course of His Artistic Career.* B.A. dissertation. Princeton University, 1958. [72 pp.]

Appendix: Interview with Marcel Duchamp, pp. i-xiii. Bibliography.

153. Golding, John. *Cubism: A History and an Analysis, 1907-1914.* Boston: Boston Book and Art Shop, 1968. p. 205 (index). Rev. ed. Originally London: Faber & Faber; New York, Wittenborn, 1959.

154. Hamilton, George Heard. *19th and 20th Century Art: Painting, Sculpture, Architecture.* New York: Abrams, 1970. p. 469 (index).

155. Hamilton, Richard. *The Bride Stripped Bare by Her Bachelors, Even.* See bibl. 9.

156. Hartley, Marsden. *The Spangle of Existence.* [n.p., 1942].

Unpublished typescript, pp. 106–11: "And the Nude Has Descended the Staircase," originally a lecture at The Museum of Modern Art, New York.

157. *History of Modern Painting.* [vol. 3]: *From Picasso to Surrealism.* Geneva: Skira, 1950. p. 208 (index).

Text by Maurice Raynal, documentation. "Information supplied by the artist and Mrs. Katherine S. Dreier." Also Continental editions.

158. Hoffman, Klaus. *Kunst-im-Kopf: Aspekte der Realkunst.* Cologne: DuMont Schauberg, 1972. p. 198 (index).

159. Hugnet, Georges. *L'Aventure dada (1916-1922).* Paris: Seghers, 1957.

"Marcel Duchamp," pp. 157–62, reprints text of *Rrose Sélavy* (bibl. 4).

160. Huyghe, René. *Histoire de l'art contemporain: La Peinture.* Avec le concurs de Germain Bazin. Paris: Alcan, 1935. p. 521 (index).

Documentation, p. 343.

161. Jean, Marcel. *The History of Surrealist Painting.* London: Weidenfeld & Nicolson; New York: Grove, 1960. p. 379 (index).

Translated from the French. Paris: Editions du Seuil, 1959.

162. Josephson, Matthew. *Life among the Surrealists: A Memoir.* New York: Holt, Rinehart and Winston, 1962. p. 396 (index).

163. Jouffroy, Alain. *Une Révolution du regard.* Paris: Gallimard, 1964. pp. 107–24.

"Conversations avec Marcel Duchamp."

164. Kozloff, Max. *Renderings: Critical Essays on a Century of Modern Art.* New York: Simon and Schuster, 1968.

Duchamp, pp. 119–27.

165. Kuh, Katharine. *The Open Eye.* New York: Harper & Row, 1971. p. 265 (index).

On Walter Arensberg and Marcel Duchamp, pp. 56–61.

166. Levy, Julien. *Surrealism.* New York: Black Sun Press, 1936. p. 190 (index).

Reprint: New York: Arno–Worldwide, 1968.

167. Linde, Ulf. *Marcel Duchamp.* Stockholm: Galerie Buren, 1963.

Swedish text. For his commentary in English, see bibl. 58.

168. Lippard, Lucy, ed. *Surrealists on Art.* Englewood Cliffs, N.J.: Prentice-Hall, 1970.

Section on Marcel Duchamp, pp. 111–17, includes "The Creative Act" and "Notes on Surrealist Artists: Société Anonyme."

169. Lippard, Lucy R. *Dadas on Art.* New York: Prentice-Hall, 1971.

Duchamp, pp. 139–54, comprises J. J. Sweeney interview (bibl. 39), part of *The Blind Man* (bibl. 79), and notes.

170. Man Ray. *Self-Portrait.* Boston: Little, Brown, 1963.

171. de Massot, Pierre. *The Wonderful Book. Reflections on Rrose Sélavy.* Paris: The author, 1924. [20 pp.]

In addition to blank pages (January–December), there is a brief introduction by "A woman of no importance" and one-half page of Duchamp puns.

172. Motherwell, Robert, ed. *The Dada Painters and Poets.* New York: Wittenborn, Schultz, 1951. p. 384 (index).

Contributions by Breton, Buffet, Duchamp, Hugnet, and others. Illustrations include Duchamp items. Bibliography by Bernard Karpel. Reprinted 1967. Revision in process for Viking Press, New York.

173. Motherwell, Robert, Ad Reinhardt, and Bernard Karpel, eds. *Modern Artists in America.* First Series. New York: Wittenborn, Schultz, 1951.

Includes "The Western Round Table on Modern Art," pp. 25–37, edited proceedings of the San Francisco Art Association in which Duchamp participated. The proceedings were separately issued in mimeographed form by the Association.

174. New York. The Museum of Modern Art. *The Art of Assemblage.* 1961. p. 174 (index).

Exhibition and publication by William Seitz. Nos. 74–86 by Duchamp. Bibliography.

175. New York. The Museum of Modern Art. *Dada, Surrealism, and Their Heritage.* 1968. p. 245 (index).

Exhibition and publication by William Rubin. Chronology and bibliography by Irene Gordon. Also note Rubin essay (bibl. 122).

176. New York. The Museum of Modern Art. *Fantastic Art, Dada, Surrealism.* 1937. Exhibition and publication by Alfred H. Barr, Jr. Exhibits nos. 216–55 by Duchamp. Second edition with Georges Hugnet essay, 1937; third and trade edition for Simon and Schuster, 1947; reprint edition, Arno Press, 1969. Bibliography.

177. New York. The Museum of Modern Art. *The Machine as Seen at the End of the Mechanical Age.* 1968. p. 212 (index).

Exhibition and publication by K. G. Pontus Hultén. Major works by Duchamp. General documentation.

178. New York. Solomon R. Guggenheim Museum. *Jacques Villon, Raymond Duchamp-Villon, Marcel Duchamp.* New York, January 8–February 17; Houston, March 8–April 8, 1957.

Preface by James Johnson Sweeney. Breton's "Lighthouse of the Bride" from *Minotaure* (bibl. 91), chronology, 1914 document, plates, general bibliography.

179. Pach, Walter. *Queer Thing, Painting: Forty Years in the World of Art.* New York: Harper, 1938.

180. Philadelphia. Philadelphia Museum of Art. *The Arensberg Collection.* 1954.

Introduction by Henry Clifford. Bequest received 1950, including 43 works by Duchamp.

Ray, Man. See Man Ray.

181. Richter, Hans. *Dada-Profile.* Zurich: Verlag der Arche, 1961.

Chapter on "Marcel Duchamp le magicien."

182. Richter, Hans. *Dada: Art and Anti-Art.* London: Thames and Hudson, 1965.

German edition: Cologne: Dumont Schauberg, 1964.

183. Rotzler, Willy. *Objekt-Kunst von Duchamp bis Kienholz.* Cologne: DuMont Schauberg, 1972.

Marcel Duchamp, pp. 27–32, 208, and passim.

184. Roussel, Raymond. *Impressions d' Afrique.* Paris: Lemerre, 1910.

"It was fundamentally Roussel who was responsible for my large glass 'La Mariée.' ... From his *Impressions d'Afrique* I got the general approach" (Duchamp, bibl. 38). Reissued 1963 by Pauvert (Paris); also other Roussel titles.

185. Roussel, Raymond. *Comment j'ai écrit certains de mes livres.* Paris: Lemerre, 1935.

186. Rubin, William. *Dada and Surrealist Art.* New York: Abrams, 1968. p. 516 (index).

Bibliography. See also bibl. 175.

187. Sanouillet, Michel. *391: Revue publiée de 1917 à 1924 par Francis Picabia.* Paris: Le Terrain Vague, 1960.

Vol. I: p. 148 (index). Also Vol. II: *Francis Picabia et 391.* Paris: Eric Losfeld, 1966. p. 280 (index).

188. Sanouillet, Michel. *Dada à Paris.* Paris: Pauvert, 1965. p. 633 (index).

Sanouillet, Michel. *Marchand du Sel.* See bibl. 8.

189. Smith, Horatio, ed. *Columbia Dictionary of Modern European Literature.* New York: Columbia University Press, 1947.

Article on Raymond Roussel, with bibliography.

190. Société Anonyme. *Selected Publications [in Reprint].* New York: Arno, 1972. 3 vols.

Vol. I: Documents.—II: Pamphlets.—III: Monographs & Brochure. Duchamp references passim, including bibl. 55.

Solomon R. Guggenheim Museum. See bibl. 178.

191. Stauffacher, Frank, ed. *Art in Cinema.* San Francisco: San Francisco Museum of Art, 1947; reprint: New York: Arno, 1968. p. 103 (index).

Program notes in a symposium on avant-garde film with references to "Anaemic Cinema," "Dreams That Money Can Buy," and "Entr'acte."

192. Tomkins, Calvin. *The Bride and the Bachelors: The Heretical Courtship in Modern Art.* New York: Viking, 1965.

On Marcel Duchamp, John Cage, Jean Tinguely, and Robert Rauschenberg. Modified version of texts from the *New Yorker* magazine. Paperback edition, 1968.

193. de Torre, Guillermo. *Historia de la literatura de vanguardia.* Madrid; Guadarrama, 1965. p. 917 (index).

194. Viazzi, Glauco, ed. *René Clair: Entr'acte.* Milan: Foligono, 1945.

195. Waddington, Conrad H. *Behind Appearance.* Edinburgh: Edinburgh University Press, 1970. p. 250 (index).

"A study of the relations between painting and the natural sciences in this century."

196. Waldberg, Patrick. *Mains et merveilles: Peintres et sculpteurs de notre temps.* Paris: Mercure de France, 1961.

Commentary on Duchamp. Also *Surrealism* (Geneva: Skira, 1962) and *Surrealism* (New York: McGraw-Hill, 1965).

197. Weinberg, Herman G. *An Index to the Creative Work of Hans Richter.* New York: Film Culture Magazine, 1957.

Brochure; revision of index published in

*Index Series,* no. 6; London: British Film Institute, 1946. References to "Dreams That Money Can Buy," "Dadascope," "8 x 8."

198. Wescher, Herta. *Collage.* New York: Abrams [1969?]. p. 411 (index).
  Translated from the German: Cologne: DuMont Schauberg, 1968.

Yale University. Art Gallery. *Collection of the Société Anonyme.* See bibl. 6.

# LIST OF ILLUSTRATIONS

THE FOLLOWING LIST is divided into three sections. The first is an alphabetical listing of all Duchamp's works which appear in the book. Titles are given in both French and English where possible. The second section lists works by other artists, alphabetized by name of artist. The third section, arranged by page number, comprises all other documentary material, mainly photographs, many of which Mme Marcel Duchamp has kindly made available.

## WORKS BY DUCHAMP

## WORKS BY OTHER ARTISTS

## DOCUMENTARY ILLUSTRATIONS

# PHOTOGRAPHIC CREDITS

PHOTOGRAPHS of the works of art reproduced have been supplied, in the majority of cases, by the owners or custodians of the works, as cited in the captions or catalog entries. The following list applies to documentary photographs and to photographs of art works for which a separate acknowledgment is due. The Museum of Modern Art, New York, and the Philadelphia Museum of Art are here abbreviated as MoMA and PMA.

12: Top, courtesy Mme Marcel Duchamp, Villiers-sous-Grez; bottom, courtesy Dr. Robert Jullien, Paris.

13: Top and center, courtesy Mme Duchamp; bottom, Bibliothèque Nationale, Paris.

14: Top, courtesy Mme Duchamp; center, Jacqueline Hyde, Paris; bottom, MoMA.

15: Top, Lockwood Memorial Library, SUNYAB, Buffalo, N.Y.; bottom, courtesy Mme Duchamp.

16: Top, courtesy Mme Duchamp; bottom, Man Ray, courtesy Timothy Baum, New York.

17: Top, Stettheimer Archive, Beinecke Library, Yale University; bottom, courtesy Mme Duchamp.

18: Top, Man Ray, courtesy Mme Duchamp; center, MoMA; bottom, courtesy Mme Duchamp.

19: Top, courtesy Mme Duchamp; bottom, Man Ray, Dreier Archive, Beinecke Library, Yale University.

20: Top, The Art Institute of Chicago; bottom, Collection Société Anonyme Archive, Yale University.

21: Courtesy Mme Duchamp.

22: Top, Denise Bellon—Images et Textes, Bazainville; bottom, courtesy Mme Duchamp.

23: Top, John Schiff, New York; center left, courtesy Peggy Guggenheim; center right, Peter Hujar, New York; bottom, MoMA.

24: Top, courtesy Alfred H. Barr, Jr.; bottom, left, courtesy Mme Duchamp.

25: Top, Denise Bellon—Images et Textes, Bazainville; bottom, courtesy Mme Duchamp.

26: Courtesy Mme Duchamp.

27: Courtesy Mme Duchamp.

29: Top, courtesy Betty Asher, Los Angeles; bottom, courtesy Mme Duchamp.

30: Top, Shigeko Kubota, New York; bottom, Oscar Bailey, Lutz, Fla.

31: Courtesy Mme Duchamp.

49–53: Courtesy Michel Sanouillet.

Facing 64–65: Malcolm Varon, New York.

70: Courtesy Robert Lebel, Paris.

72: MoMA.

75: PMA.

76: Courtesy Robert Lebel.

77: Courtesy Mme Duchamp.

Facing 80–81: Courtesy Arturo Schwarz, Milan.

85–88, 92: Courtesy Arturo Schwarz.

116–123: Courtesy Lucy R. Lippard, New York.

126: Bottom, Peter A. Juley, New York.

127: MoMA (Soichi Sunami).

128: Courtesy Mme Duchamp.

Facing 129: PMA (A. J. Wyatt).

130: Julian Wasser, Los Angeles.

131: Courtesy Mrs. Ugo Mulas, Milan.

132: Galleria Schwarz, Milan.

136: Courtesy Robert Lebel.

137: Courtesy Mme Duchamp.

138: Courtesy Robert Lebel.

139: MoMA.

140: Galleria Schwarz.

Facing 144: Malcolm Varon.

Facing 145: Courtesy Mme Duchamp.

160: Top and bottom, MoMA (Soichi Sunami).

161: Top, John Mahtesian, Chicago; bottom, Attilio Bacci, Milan.

163: PMA (A. J. Wyatt).

165: Rudolph Burckhardt, New York.

166: Top, Rudolph Burckhardt; bottom, Tate Gallery, London.

167: Tate Gallery.

168: Rudolph Burckhardt.

170: Top, MoMA (James Mathews); bottom, David Gahr, New York.

171: Top, Nathan Rabin, New York.

172: J.-J. Strauch, Nice.

173: Gianmaria Fontana, Milan.

174: Top, Rudolph Burckhardt; bottom, Shunk-Kender, New York.

175: Top, John Schiff; bottom, Leo Castelli Gallery, New York; right, Eric Pollitzer, Garden City Park, N.Y.

176: Top, Claudio Abate, courtesy *Data* Magazine, Milan; bottom, Manfred Tischer, Düsseldorf.

185: MoMA (Soichi Sunami).

190: MoMA.

191: Courtesy Helen Wright, New York.

192: MoMA.

197: Courtesy Enrico Donati, New York.

198: Top: MoMA (Soichi Sunami); bottom, MoMA.

199: MoMA (James Mathews).

206: MoMA (Kate Keller).

208: MoMA.

213: Courtesy Georgia O'Keeffe.

215: Yale University Art Gallery (Joseph Szaszfai).

216: The Art Institute of Chicago.

217: Courtesy Carl Frederik Reuterswärd.

220: PMA (A. J. Wyatt).

221: MoMA (Soichi Sunami).

222: Nathan Rabin.

223: MoMA.

227: Courtesy Ronnie Cutrone and Pat Hackett, New York.

229: MoMA (Kate Keller).

232: Top, Attilio Bacci; bottom, Galleria Schwarz.

234: Top left, PMA; top right, MoMA.

235: Top left, Galleria Schwarz; top right, Geoffrey Clements, New York; bottom left, Attilio Bacci; bottom right, Nathan Rabin.

236: Top and bottom left, Geoffrey Clements; bottom right, Attilio Bacci.

237: Top and center left, Geoffrey Clements; center right, Galleria Schwarz; bottom, Attilio Bacci.

238: Geoffrey Clements.

239: Top, Attilio Bacci; bottom, Geoffrey Clements.

240: bottom left, Attilio Bacci; bottom right, Galleria Schwarz.

241: Top, Galleria Schwarz; center left, Attilio Bacci; bottom, Geoffrey Clements.

242: Top, Geoffrey Clements; bottom, Galleria Schwarz.

243: Top, Geoffrey Clements.

244: Top left, Galleria Schwarz; top right, Geoffrey Clements; bottom left, Nathan Rabin.

245: Top, Geoffrey Clements.

247: Top, PMA (A. J. Wyatt); bottom left, Geoffrey Clements; bottom right, Frank J. Thomas, Los Angeles.

248: Top, MoMA (Soichi Sunami); bottom, PMA (A. J. Wyatt).

249: Bottom, MoMA (Kate Keller).

250: Top right, Bernès, Marouteau, Paris.

252: PMA (A. J. Wyatt).

253: Top left, Galleria Schwarz; top right, PMA (A. J. Wyatt); center right, Nathan Rabin; below right, PMA; bottom, Réunion des Musées Nationaux, Paris.

254: Top, PMA (A. J. Wyatt); bottom, Attilio Bacci.

255: Bottom right, Galleria Schwarz.

256: Top, The Solomon R. Guggenheim Museum, New York; bottom, PMA (A. J. Wyatt).

258: Top, Galleria Schwarz; bottom, Nathan Rabin.

259: Top, Galleria Schwarz.

260: PMA (A. J. Wyatt).

261: Geoffrey Clements.

262: Top left, PMA (A. J. Wyatt); bottom, MoMA (Soichi Sunami).

263: Right, Frank J. Thomas.

264: Top, PMA; bottom, MoMA (Kate Keller).

266: Nathan Rabin.

268: Geoffrey Clements.

270: MoMA (James Mathews).

271: Top left, Nathan Rabin; top right, PMA (A. J. Wyatt); bottom, Serge Béguier, Paris.

272: Top right, Walter Klein, Düsseldorf; bottom, PMA (A. J. Wyatt).

Facing 272: PMA (A. J. Wyatt).

Facing 273: Malcolm Varon.

273: MoMA (Soichi Sunami).

274: Top, MoMA (James Mathews); bottom left, Geoffrey Clements; bottom right, courtesy Mme Duchamp.

275: MoMA (Soichi Sunami).

276: Bottom, MoMA (James Mathews).

277: Top, Galleria Schwarz.

278: Bottom, PMA (A. J. Wyatt).

280: Bottom, Attilio Bacci.

281: Top, PMA (A. J. Wyatt).

282: MoMA.

283: Cordier & Ekstrom, Inc., New York.

284: Top, Cordier & Ekstrom, Inc.

285: Top, courtesy Mme Duchamp; bottom, Yale University Art Gallery (Joseph Szaszfai).

286: Courtesy Mme Duchamp.

287: Top left, PMA; top right, MoMA (Soichi Sunami); bottom, Yale University Art Gallery.

288: Top, MoMA (Soichi Sunami); center, courtesy Mme Duchamp; bottom, Galleria Schwarz.

Facing 288: PMA (A. J. Wyatt).

289: Top, Geoffrey Clements; bottom, Attilio Bacci.

290: MoMA (Soichi Sunami).

293: Top, MoMA.

294: Top and bottom left, Attilio Bacci; bottom right, Man Ray.

295: Top, PMA (A. J. Wyatt); bottom, Nathan Rabin.

296: Top, courtesy Mme Duchamp; bottom, Malcolm Varon.

297: Top left, Nathan Rabin; top right, MoMA (Soichi Sunami).

298: Top left, PMA (A. J. Wyatt); bottom, MoMA (James Mathews).

299: Nathan Rabin.

300: Bottom, Nathan Rabin.

301: Galleria Schwarz.

302: Top, PMA; center, Nathan Rabin; bottom, MoMA.

303: Top, Geoffrey Clements; bottom left, PMA; bottom right, PMA (A. J. Wyatt).

304: Center, Nathan Rabin; bottom left, PMA (A. J. Wyatt); bottom right, Attilio Bacci.

305: Top left, Attilio Bacci; bottom, Galleria Schwarz.

306: Top, MoMA (Kate Keller); bottom, Man Ray.

307: John Webb, London.

308: Top, PMA (Will Brown); bottom left, Galleria Schwarz; bottom right, Nathan Rabin.

309: Top, Galleria Schwarz; bottom left, Nathan Rabin; bottom right, PMA.

310: Top, Geoffrey Clements.

311: Top, Attilio Bacci; center left, Nathan Rabin; bottom left, PMA (A. J. Wyatt).

313: Center and bottom, Geoffrey Clements.

314: Top left, Attilio Bacci; top right, Peter Hujar; center left, Geoffrey Clements.

315: Top, MoMA (James Mathews); bottom, PMA (A. J. Wyatt).

316: Top, PMA (A. J. Wyatt); bottom, Attilio Bacci.

317: Attilio Bacci.

318: Attilio Bacci.

319: PMA (A. J. Wyatt).

320: Top, Attilio Bacci; center, MoMA; bottom, PMA.

321: Top, Attilio Bacci; center and bottom, Galleria Schwarz.

322: Top and bottom, Galleria Schwarz; center, Attilio Bacci.

323: Top, Attilio Bacci; center, MoMA (Kate Keller); bottom left, MoMA; bottom right, PMA.

324: Top, Geoffrey Clements; bottom, Galleria Schwarz.

325: Top left, Galleria Schwarz; top right, MoMA; bottom, Attilio Bacci.

326: Top and bottom, Attilio Bacci; center, MoMA (James Mathews).

348: Ugo Mulas, courtesy Mrs. Ugo Mulas.

Endpapers: MoMA.